AMERICAN ART

A Cultural History

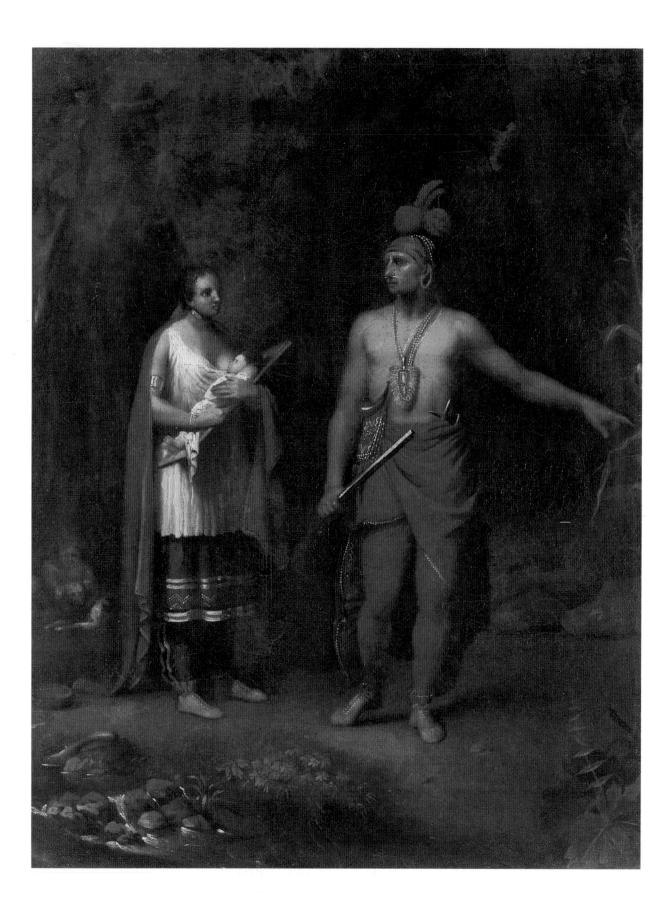

AMERICAN ART

A Cultural History

DAVID BJELAJAC

Library of Congress Cataloging-in-Publication Data Bielajac, David.

American art: a cultural history / David Bjelajac. p. cm.

Includes bibliographical references and index. ISBN 0-8109-4214-3 (Abrams : hardcover) — ISBN 0-13-083816-0 (Ph pbk.)

1. Art and society—United States—History. 2. Art, American. I. Title.

N72.S6 B55 2000 701' .03'0973-dc21

00-22802

Copyright © 2001 Calmann & King Ltd

Published in 2001 by Harry N. Abrams, Inc., New York. All rights reserved. No part of the contents of this book may be reproduced without written permission of the publisher.

This book was designed and produced by CALMANN & KING, LTD, London

Editors: Richard Mason, Damian Thompson

Picture Researcher: Peter Kent Interior Designer: Ian Hunt

Cover Designer: Angus Hyland/Pentagram

Printed and bound in Italy

Frontispiece: Benjamin West, The Savage Chief (The Indian Family), c. 1761. Oil on canvas, $23\% \times 18\%$ in $(60 \times 48 \text{ cm})$. Trustees of the Hunterian Collection and Council of the Royal College of Surgeons of England.

Harry N. Abrams, Inc. 100 Fifth Avenue New York, N.Y. 10011 www.abramsbooks.com

Acknowledgments

While working on this book, I also participated in "The Visual Culture of American Religions" project organized by David Morgan and Sally Promey and funded by the Henry Luce Foundation and Lilly Endowment. Conferences and individual discussions with other project participants benefited the conceptualization and writing of this text. In addition to Sally and David, I would like to thank other members of the research group, including Gretchen Buggeln, John Davis, Erika Doss, Claire Farago, Paul Gutjahr, Stewart Hoover, Harvey Markowitz, Leigh Eric Schmidt, Ellen Smith, and Thomas Tweed. For their continued professional help and encouragement I am also indebted to Lois Fink, Brandon Brame Fortune, Patricia Hills, Arthur S. Marks, Ellen Miles, and Alan Wallach. Thanks are owed to the faculty and administration of George Washington University for providing necessary research funding. Lilien Robinson, Chair of the Fine Arts and Art History Department, supported my grant proposals for writing this book.

The editors and production staff at Calmann & King, London, have been extremely helpful throughout this project. I wish to extend special thanks to Lee Ripley Greenfield, Ian Hunt, Peter Kent, Richard Mason, Damian Thompson, and Melanie White. As my principal development editor, Damian particularly helped to shape my prose and clarify my arguments.

Most of all, however, I wish to thank Louis A. Dellaguzzo. Without Lou's research, editorial, and computer assistance, I would never have been able to make my deadlines or, indeed, finish writing at all. This book is dedicated to him and his continued friendship.

> David Bjelajac July 2000

Contents

Introduction	Ģ
CHAPTER 1	
The Invention and Mapping of America 1492-1760	13
The First Americans Native American Mapping Diversity of Housing Types: The Wigwam and Algonquin Village Life Southwestern Pueblo Architecture Earthworks and Burial Mounds America and the European Imagination Colonial Portraits of Native Americans and Anglo-French Rivalry White Colonists as Native Americans	14 18 16 17 19 22 32 36
CHAPTER 2	
Religious Rituals and the Visual Arts in Colonial America ¹⁶²⁰⁻¹⁷⁶⁰	39
Colonial Alternatives to Christianity	42
African-American Religion and the Visual Arts	43
Colonial Magic and the Christian Response	43
Catholic Art in Spanish America The Mission Church of San Estevan	46
Native American Resistance and the Christian Reconquest	49
El Santo Entierro and Hispanic-Catholic Ritual	5.
Moravian Missions and the Depiction of the Crucified Christ	52
Protestant Iconoclasm and the Private Display of Biblical Art The Colonial Landscape Made Sacred: Anglo-American Churches	54
and Meetinghouses	57
God's Word in New England Portraits	68
Colonial Gravestones: Emblems of Morality Jewish-Christian Collaboration: Touro Synagogue	7:
CHAPTER 3	
Art and the Consumer Revolution	
in Colonial America 1700-75	7
Aristocratic Aspirations of Wealthy Colonists Social Clubs as Vehicles for Self-Cultivation	78 82

Freemasonry and the Visual Education of the American Public	83
Domestic Architecture as a Moral Force	90
Political Portraiture: Colonial Governors as Pillars of State	99
John Smibert and the Portraitist as Man of Learning	101
Portraiture and Middle-Class Social Aspirations	107
John Singleton Copley and the Sanctification of the Consumer Revolution	109
CHAPTER 4	
Revolutionary Icons and the Representation	
of Republican Virtue	115
, -	115
1765-1825	
Propaganda in the Pre-Revolutionary War Era	118
Republican Motherhood: Women as Symbols in the Revolutionary Era	120
Patience Wright and the Personification of Liberty	121
Classical Austerity and Republican Virtue: the Founding Fathers	122
The All-Seeing Eye: Freemasonry and Symbolism in the Early Republic	124
History Painting in the Pre-Revolutionary and Revolutionary Eras	127
Benjamin West and the Revolution in History Painting	129
John Singleton Copley: Images of Revolution and Independence	133
Fraternal Friendship in the Work of John Trumbull	138
George Washington and Republican Citizenship	142
Educating the Public and Selling Art: Problems in Public and	4.47
Private Exhibitions	147
Rembrandt Peale: Images of Female Sexuality and Moral Reform John Vanderlyn and the Moral Ambiguity of Early	149
Nineteenth-Century History Painting	150
Washington Allston and Biblical Painting	155
Charles Robert Leslie and Samuel Morse: The Symbolism of	
Color and Light	159
CHAPTER 5	
National Identity and Private Interests	
in Antebellum America	163
1825-65	
Historical Styles and Functional Architecture	167
Economic Modernization and the Arts	171
Rochester, New York, as a Boom Town	175
Greek-Revival Architecture and the Southern Plantation Economy	176
Architecture and Suburban Space	177
Phrenology and the Octagon	180
The Rural Cemetery Movement and the Arts	182
The National Academy of Design and the Art Market	185
Catholic Icons and Hispanic Resistance to U.S. Culture	187

Artists and Domestic Virtue	189
Landscape Painting and National Identity	192
Thomas Cole	193
Artists and Imperial Expansion	198
George Caleb Bingham	203
Visions of Millennial Progress and Religious Conflict	205
Transcendentalism, Spiritualism, and American Art	210
Frederic Church	213
Abolitionist and Feminist Art	215
Photography and the Democratization of Art	220
CHAPTER 6	
Art and Commerce in the Cilded Age	227
Art and Commerce in the Gilded Age 1865–1905	227
Commercialization and the Uninterrupted Progress of Art	233
Economic Modernization and the Appropriation of European Architecture	235
Images of Renewal and the Family in the Aftermath of War	241
Science, Capitalism, and Masculine Identity	248
Thomas Eakins's Circle and the Human Figure	250
War Memorials and the Heroic White Male	260
Henry Ossawa Tanner and the Expression of African-American Creativity	264
Cosmopolitanism and the Lure of French Art	265
The Society of American Artists: Art as Religion	269
Whistler and the Triumph of Aestheticism	274
CHAPTER 7	
Modernist Art and Politics	205
1905–41	285
Modernization and Architecture as Imperial Symbols	286
New York Realists and Modern Urban Life	288
The Modernist Turn from Realism	293
Alfred Stieglitz, Photography, and the 291 Gallery	295
The Influence of Futurism	300
Modernism and Political Radicalism	304
Modernist Art and World War I	306
Synchromism	307
Modernism for the Masses	308
Marcel Duchamp and New York Dada	310
Romancing the Machine in Art and Architecture	312
Fordism	314
The Aesthetics of the Hole	316
The Société Anonyme	317
Regionalism versus Social Realism	318
Modernism and the Defense of Democracy	326

CHAPTER 8

Modernism, Postmodernism, and the Survival		
of a Critical Vision	329	
, 1941–2000		
Art and Propaganda During World War II	330	
Modernism and Post-war Architecture	332	
American Realism's Darker Visions	337	
Cultural Crisis and the Emergence of Abstract Expressionism	340	
Abstract Expressionism and the Surrealist Unconscious	342	
Abstract Expressionism and Cold War Politics	345	
The Masculine Bias of Abstract Expressionism	353	
Abstract Expressionism and Right-wing Attacks on Modernist Art	355	
Formalist Criticism and the Objectivity of Abstract Art	357	
The Return of Dadaist Dissent: Happenings, Performances,		
and Readymade Assemblages	359	
Readymade Signs, Minimalist Objects, and Real Space	361	
Pop Art and the Culture of Mass Consumerism	367	
Pop Art and Postmodernist Architecture	372	
Conceptual and Earth Art as Cultural Criticism	375	
Art and the Vietnam War: from Protest to Commemoration	377	
Feminist Art and Politics	380	
Neo-Expressionism and the Revival of Painting	385	
Postmodernist Meditations on Death	386	
Sexual Politics, Family Values, and Contemporary Art	388	
Contemporary Art and Architecture and the Disney Vision	389	
Timeline: Chronology of American Art	392	
Bibliography	402	
Picture credits	407	
Index	408	

Introduction

This book explores the diverse, conflicted history of American art and architecture within the United States from the European voyages of discovery and colonial conquest to the present dawn of a new millennium. Unlike earlier surveys, my interdisciplinary narrative does not outline the stylistic evolution of American art. Drawing on socio-economic and political studies as well as histories of religion, science, literature, and popular culture, I analyze individual art works within their specific historical contexts. I relate the visual arts of painting, sculpture, architecture, and photography to other material artifacts and cultural practices. I suggest how artists and architects, intentionally or not, composed works that visually expressed various social and political values. Similarly, it must be recognized that beholders expressed their own differing values and interests when they experienced or interpreted these same artworks.

Following the lead of many revisionist art historians (upon whose scholarly labors I have heavily depended), I do not explain the visual arts in terms of who influenced whom in a chain of aesthetic development that formally connects one landmark work to the next. Formalistic accounts have tended to abstractly isolate high art from the taint of politics, popular culture, and other dimensions of historical experience. Artworks that once were extremely popular during the period in which they were produced, such as Hiram Powers's The Greek Slave (see fig. 5.61), have often been retrospectively dismissed by art historians preoccupied by the progressive advancement of American art toward more innovative, modern styles. By contrast, revisionist scholars have avoided fabricating grand stylistic schemes and patterns. They have instead preferred to analyze the popular success or failure of individual art objects by interpreting their creation and reception in historical depth from multiple cultural, political, and social viewpoints.

Readers will nonetheless encounter in this book many familiar works that have long enjoyed canonical status as masterpieces of American art. However, in analyzing the style and subject matter of renowned and lesser-known art objects, I have not sought to endow them with supposedly transcendent aesthetic qualities beyond historical time and space. Nor do I wish to argue

for the existence of a distinctively American taste for realism, neoclassicism, or some other visual style. Ever since the American Revolution, numerous artists and cultural critics have been eager to create a nationally unifying style of art. However, failed attempts to define a singular national vision demonstrate how the purported Americanness of American art and architecture has been arbitrarily constructed and reconstructed from differing aesthetic and ideological perspectives for assorted social and cultural purposes. The varied richness of visual culture in the pluralistic communities and regions of the United States has also ultimately defeated art historians' efforts to distill a characteristic national style or mode of perception from any of the arts.

The chapters that follow include generous quotations from primary sources. I wish to show how various artists and beholders from different backgrounds have interpreted specific artworks or generally talked about the cultural purposes of art. To that end, I examine contemporaneous criticism and art commentaries to demonstrate how artworks were consumed as well as produced in relation to particular political and social conditions, especially struggles over class, race, and gender.

The arrangement of chapters is both thematic and chronological. Particularly in the early chapters, there is some time overlap due to the exploration of contemporaneous cultural issues. Rather than compartmentalizing the different media in separate chapters, I have sought to thematically interrelate the arts of architecture, painting, sculpture, and photography. An integrated discussion of the visual arts makes an explanation and understanding of a number of cultural phenomena that much easier. For instance, the rural cemetery movement of the nineteenth century brought together historical-revival architecture and neoclassical sculpture, at the same time inspiring paintings and photographs of grave monuments and picturesquely landscaped grounds. Earlier in the text, the consideration of colonial art and architecture as a means of religious expression is facilitated by an examination of different worship spaces and of media ranging from paintings and gravestones to samplers, boundary markers, and book illustrations. Throughout the book, this integrated approach has been enhanced by the inclusion of

numerous objects from material culture such as maps, cartoons, posters, aprons, furniture, and other visual artifacts.

The opening chapter describes the European invention and mapping of America. Space limitations have allowed only a highly selective examination of aboriginal art to demonstrate that Native Americans, prior to Christopher Columbus's 1492 voyage, had already settled significant portions of the territories that later constituted the United States. In their conquest, white settlers overlaid diagrammatic drawings of former Indian lands with European names. The drawings featured networks of new boundary, property, and transportation lines. Colonial maps, prints, and paintings appropriated the New World for European civilization and represented Native Americans as, at best, noble savages.

The diversity of religious expression in Colonial American art constitutes the thematic content for Chapter 2. Unlike traditional art surveys, I analyze the iconography and formal qualities of religious art and architecture in relation to the spiritual beliefs and ritualistic practices of different groups. These comprise New Mexican Spanish Catholics; New York Dutch Protestants; Pennsylvania Quakers and Moravians; Virginia and South Carolina Anglicans; New England Puritans; African-American animists; and Newport, Rhode Island, Jews. By exploring visual expressions of religious faith, I wish to suggest the magical power of images for colonists who sought evidence of the spiritual within harsh, hostile environments.

Concluding the discussion of colonial era art, Chapter 3 details the eighteenth-century consumer revolution stimulated by the growth in trade between Great Britain and its North American colonies. Aspiring to emulate the English aristocracy and landed gentry, increasingly wealthy American merchants and property holders constructed large, lavishly furnished mansions. They also commissioned ennobling family portraits that expressed both their elevated social status and their cultural acquisition of refined manners and taste. Their patronage of art and architecture enabled elite Americans to fashion public self-images as pillars of civic virtue destined for political leadership. Although generally ignored by most art historians, Freemasonry and other social clubs and fraternities played an important role in the visual education of colonial Americans. For affluent consumers as well as skilled artists and craftsmen. Freemasonry's elaborate visual symbolism promoted the moral virtues of classical architecture and good design, associating aesthetic values with social and political stability and the divine harmony of God's universe.

Chapter 4 is devoted to the art and architecture of the Revolutionary era and the early national period when the United States struggled for its cultural as well as political independence. Artists and architects were now called upon to create symbols that unified the new republic and commemorated the American Revolution's heroic events, personalities, and ideals. The chapter situates revolutionary history paintings, portraits, sculptures, and public monuments within a broader visual culture of political cartoons, paper currency, government seals, and Masonic decorative arts. During this period, Freemasonry played a particularly significant role in popularizing images of fraternity and virtuous self-sacrifice for the public, national good. George Washington, the nation's first president and leading Freemason, particularly personified republican selflessness. On the other hand, as the Revolution became a more distant memory, a new generation of artists produced works that expressed anxiety over the social and cultural dangers of American democracy's empowerment of unrefined lower- and middle-class white men. Artists and elite patrons founded museums, art academies, and other cultural institutions to educate the American public and to establish themselves as the enlightened guardians of taste and moral virtue.

Covering the period from the opening of the Erie Canal in 1825 to the end of the Civil War in 1865, Chapter 5 interprets how the visual arts developed in relation to themes of cultural democratization and the expanding urban-industrial economy. During these four decades, New York City became the art capital of the nation. New York entrepreneurs, who financed the construction of canals, railroads, and western economic development, patronized artists who produced nationalist representations of the American landscape and its people. Neoclassical public buildings and mansions in such newly settled towns as Rochester, New York, emulated those constructed in the older and larger coastal cities of the East. Their elegant designs visually manifested the national taming of the wilderness. Meanwhile, racial, feminist, and class politics, as well as ethnic and religious pluralism, shaped the production and consumption of American art. These dissenting voices challenged the socially exclusionary nationalism of the country's wealthy northeastern financiers and art patrons.

Chapter 6, comprising America's Gilded Age from 1865 to 1905, continues many of the same themes involving the interrelationship between art and com-

merce. However, after the Civil War, the separation between high art and popular culture became more pronounced, as American capitalists accumulated vast fortunes through monopolistic corporations invested in railroads, oil, steel, and other commodities. During the 1870s, these wealthy men founded major museums that appealed primarily to cosmopolitan elite tastes for classical and European or Renaissance-style art. America's multimillionaires also built enormous mansions, filling them with paintings, sculptures, and decorative arts imported from Asia and Europe. As the United States became an imperial power, its artists and architects produced ambitious works that suggested America's inheritance of Europe's classical, Renaissance tradition. Painters and sculptors memorialized Civil War heroes and suggested the post-war renewal of American life. These artists produced idealized representations of families and healthy children, as well as vigorous youthsstrong, intelligent men and beautiful, culturally refined women. Most dramatically, architects pronounced America's regeneration and claim to economic and cultural leadership by inventing the modern, steel-frame skyscraper. Nevertheless, as America developed a bureaucratic, corporate culture, art became a therapeutic medium for alleviating the tensions and anxieties generated by urbanization and industrialization.

Chapter 7 situates Modernist art's attack on traditional academic ideals and conventions within a broader cultural matrix of political and social rebellion, and technological, scientific innovation. Revolutionary changes in transportation and communication, and new discoveries in physics and geometry, radically altered concepts of space, time, and matter. Scientists and intellectuals cast doubts upon notions of objective truth and recast reality in more dynamic, relativistic terms. In response, artists developed experimental, subjective styles that sharply departed from Renaissance illusionism and conventional imitations of nature and the human figure. Even anti-academic painters and photographers who created realist images stressed their subjective responses to modern urban life. Following the lead of the European avant-garde, rebellious American artists attempted to ally their attack against the genteel idealism of Gilded Age art with socialist, working-class politics. Modernist painters especially jarred cultural conservatives. They produced works with abstract, fragmented forms, non-naturalistic colors, and compositions that suggested the interpenetration of space and matter or, perhaps, the juxtaposition of multiple, competing perspectives. Although the devastating effects of World War I led some artists toward a pessimistic rejection of formal beauty and reason, many painters, sculptors, and architects during the 1920s optimistically embraced a futuristic machine aesthetic. Even the Great Depression of the 1930s failed to discourage artists from celebrating the virtues of industrial technology, while others more grimly represented the plight of the unemployed and homeless. Supported by federal arts programs, artists renewed their political activism, producing works that directly or indirectly promoted working-class causes and opposed the rise of European fascism.

Chapter 8's narrative, from World War II to the end of the century, also interweaves art, politics, and social history. During the 1940s, with the Nazi occupation of Paris, New York became the capital of Modernist art. The Abstract Expressionist movement, centered in New York, seemed to epitomize Modernism's masculine cult of spontaneity, originality, and artistic genius. However, already during the 1950s and 1960s, the Modernist religion of individual creativity was being questioned and satirized by artists who rejected the notion of a high art beyond popular culture, advertising, and mass media. By the 1970s, the term Postmodernism broadly defined the cultural break with Modernist notions of formal purity and avant-garde alienation from mass culture. Some Postmodernists have adopted mass-media techniques and imagery to subvert repressive cultural stereotypes that represented feminine weakness or racial inferiority. Others have created spiritually poignant cultural allegories over the failed ambitions of outmoded or thoroughly commercialized Modernist art movements. Meanwhile, still other Postmodernists, disclaiming ironic, critical intentions, have frankly embraced the commercialization of art and the corporate shaping of the visual landscape.

Given the diversity of contemporary art and the demise of a Modernist faith in art's evolutionary progress, the book ends with no overarching summary or grand resolution. While wishing the survival of a politically and critically engaged art community, I have resisted the temptation of prophesying the future direction of art during the new millennium. Instead, this revisionist history addresses major cultural and social themes in the art and architecture of America's past half-millennium.

David Bjelajac The George Washington University July 2000

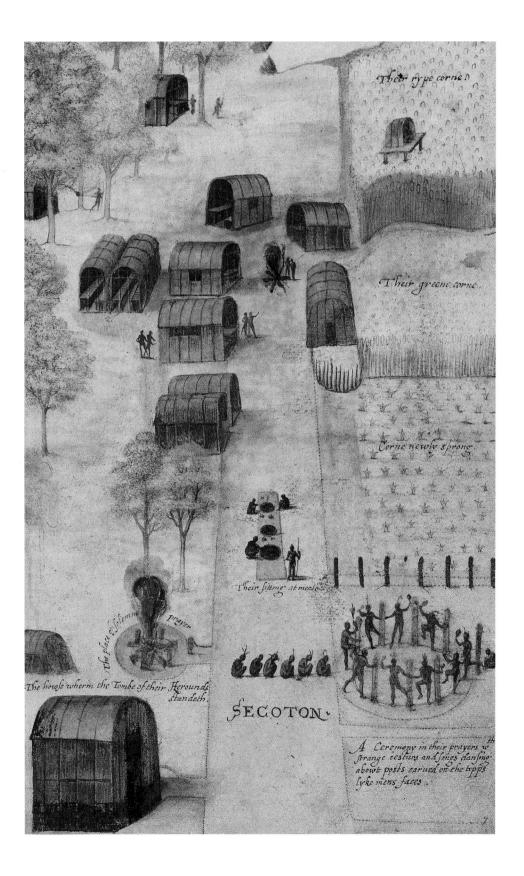

CHAPTER 1

The Invention and Mapping of America

1492-1760

n October 12, 1492, after sailing westward from Spain for over two months and 3,000 miles at sea, Christopher Columbus arrived with three ships at a small island that its native inhabitants called Guanahani. However, no artist was present to record the historic event, or to document the flora and fauna of the island that Columbus renamed San Salvador in honor of Jesus Christ, the Christian Son of God. Over 500 years later, we still don't know with certainty which island in the Bahamas first received the small crew of ninety sailors, since their commander not only failed to erect a stone monument marking the site but also neglected to make or record any navigational measurements locating the island's geographical position. Five days after exploring Guanahani and other nearby islands, Columbus mistakenly concluded that he had reached Asia or "the Indies" (cited in Sale, p. 23). The people who inhabited these islands became the first ethnic or cultural group in the Western Hemisphere to be misnamed "Indians" (cited in Sale, p. 64). In renaming these islands and their inhabitants, Columbus effectively took possession of them on behalf of his patrons, King Ferdinand and Queen Isabella of Spain. Lacking drawings or pictorial documentation, he returned to Spain with Indian captives and other specimens or visual proofs of his discovery.

Initially, Columbus had no idea that he had discovered a New World. Despite the fact that Norsemen had established short-lived settlements at sites in present-day Labrador, Newfoundland, and New England as early as the eleventh century, their explorations had gone unnoticed by European contemporaries. Before Columbus's epoch-making voyage, ships from Portugal, Bristol in England, Brittany, and elsewhere along the coast of Europe had already sighted and even landed on western islands and territories, but these relatively unpublicized events failed to make much impact on contemporary cartographers, whose maps give no hint that two major continents existed in a western hemisphere between Europe and Asia.

Upon his return, Columbus wrote a brief account of his voyage, which was first published in the Castilian language of the Spanish court and then in Latin in cities throughout western Europe. Attracting a limited readership of learned men, Columbus's travelogue was written in a fashion that caused no sudden intellectual sensation or reevaluation of traditional concepts of world geography. His text sought to underscore resemblances, not differences, between Europe and the western islands he had encountered. Columbus described Hispaniola (present-day Haiti and the Dominican Republic) in literary terms, as similar to the earthly paradises imagined in the Bible and ancient Greek and Roman literature. Nevertheless, overwhelmed by the diversity and strangeness of the flora and fauna, he found himself struggling to find words adequate to the task of description. Everything appeared "marvellous" or "beyond comparison" (cited in Myers, p. 62).

John White

Indian Village of Secoton, c. 1585. Watercolor, $12\% \times 7\%$ in (32.4 \times 19.7 cm). British Museum, London.

On later voyages to the Caribbean islands and the Central and South American coasts, Columbus began to conclude that he had reached a new, gold-rich continent between Asia and the shores of western Europe. Yet he continued to assimilate this dawning realization in terms of ancient texts. When he encountered the mouth of the Orinoco River along the coast of present-day Venezuela, he believed it to be one of the four biblical rivers of Paradise that would lead him inland toward the Garden of Eden, birthplace of Adam and Eve, the original parents of the human race.

America was an invention of the European imagination, of both its verbal and visual representations, which mirrored European desires and fears rather than any objective reality. Thousands of years before the German geographer Martin Waldseemüller coined the name "America" in 1507 to honor the Italian explorer Amerigo Vespucci, the so-called "New World" had been inhabited by diverse peoples, numbered in millions. Primarily, this chapter explores the cultural construction of America from the point of view of white explorers and colonists. However, it is important to understand that in 1492, America was far from being a wilderness devoid of human settlements. This book does not survey the wide array of Native American arts and crafts, such as pottery, painted animal hides, woven fabrics, basketry, wood carvings, bead and quill work, and bone and horn sculptures. However, a brief discussion of rock art, monumental earthworks, and architectural practices will demonstrate how the "first Americans" adapted their tribes and communities to different landscapes before the European invasion. As we shall see, aboriginal peoples created a variety of complex societies and visually rich cultures. Ultimately, their settlements, maps, and intimate knowledge of the land facilitated European invaders' adaptation to this alien environment.

Yet European explorers and settlers tended to regard native peoples as little more than primitive savages with no true culture of their own. Most associated the naked or semi-naked peoples they encountered with a long literary and pictorial tradition of fantastic stories and images depicting "wild men" (Sale, p. 134), cannibals, and subhuman beings who lived outside civilized society in an untamed state of nature. Europeans concluded that America was less a ready-made paradise than a hostile wilderness that would have to be shaped into an ideal landscape modeled, with improvements, on the homes and towns of the Old World.

European maps and visual representations were not neutral records but contributed to the domination of aboriginal peoples. Artistic portrayals, mostly disseminated in prints and illustrated books, encouraged and justified the conquest of exotic savages. Nonetheless, visual artists also demonstrated a strong attraction to Native American culture by sympathetically representing tribal customs. Often, dignified representations of aboriginal leaders commemorated military, political, and commercial alliances. Furthermore, during the course of the eighteenth century, colonists in British North America also came to identify themselves as "native" Americans. For many, "Indians" personified the social and political freedom of the western frontier, its moral distance from the corruptions and injustices of Old World culture.

The First Americans

The diverse American tribes and cultures that European explorers mistakenly identified as Indian actually did possess a distant Asian ancestry. Perhaps as early as 40,000 years ago, as the earth's atmosphere cooled and sea levels ebbed during the

last ice age, nomadic hunters began populating the American continents by crossing a land bridge or vast, low-lying plain over the Bering Strait from present-day Siberia into Alaska and beyond toward warmer, more southern latitudes. By 1492, nearly 75 million Indians were living in the Americas, with approximately 5 to 10 million inhabiting the contiguous territories that would become the United States. No pre-Columbian culture in North America attained the visual splendor and power of the Aztec, Mayan, and Incan civilizations in Central and South America, but in the colder climate of North America, hundreds of tribes speaking diverse languages developed socially complex cultures. They ranged from nomadic hunting and foodgathering economies to relatively sedentary and semi-nomadic economies based on agriculture and trade. Many tribes constructed monumental earthworks and spectacular architectural spaces.

Native American Mapping

As the original settlers of an unpopulated and untamed wilderness, North American Indians preceded Europeans as the mapmakers and architects of a New World in the Western Hemisphere. By naming and mapping their environment, they created webs of meaningful relationships with the natural world. Their maps established regional networks of trade and communication. Few Native American maps survive today because they were part of an oral tradition which described the landscape in experiential terms, associating different sites with specific spiritual forces and gods as well as animal, vegetable, and mineral resources. When necessary, maps were sketched from memory in the dirt or sand or, more permanently, on other natural materials such as animal skins, tree bark, and rocks.

At a site on the Snake River near Givens Hot Springs, Idaho, pre-Columbian Shoshone Indians covered a large basalt boulder with pictographic signs (fig. 1.1). Known as Map Rock, this petroglyph, or example of rock art with deeply etched markings, apparently represents the Shoshone's tribal territory centered on the Snake and Salmon Rivers. Situated within a field of other petroglyphs and near the architectural remains of Indian lodges that date from 4,000 years ago, Map Rock also depicts human figures and animals such as buffalo, deer, antelope, elk, and mountain sheep. These images suggest that the rock possessed pragmatic ritualistic

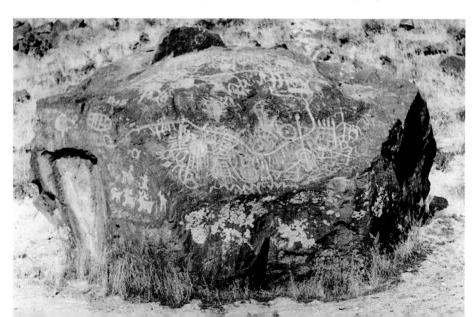

1.1 Map RockNative American petroglyph near Givens Hot Springs, Idaho, c. 1400 C.E (?). 10 × 9 × 5 ft (3 × 2.7 × 1.5 m). Idaho State Historical Society.

significance, guaranteeing successful hunts, while demonstrating spiritual harmony between the territory's human and animal realms.

Rather than attempting to conquer or set themselves above nature, Native Americans sought to find their place within the natural processes of earth, water, and sky. They did not regard land as a commodity that could be sold or traded for the exclusive use of an individual owner. Land was communally owned by members of a tribe, although its resources and use might be shared with other tribes through mutual agreement. No Indian group was entirely sedentary. Depending on the source of food, tribes generally occupied more than one home, village, or town and moved with the change of seasons between summer and winter living sites.

Diversity of Housing Types: The Wigwam and Algonquin Village Life

Architectural forms expressed these communal social values and Indians' careful adaptation to diverse, often harsh environments. Housing types varied from region to region and from one culture to another. Conically shaped tipis made from long wooden poles and tanned stretched buffalo hides were especially suitable for nomadic hunting tribes such as the Apaches of the western Plains. However, many other tribes developed agricultural and trading economies that made possible more permanent homes and settlements. During the late sixteenth century an English artist, John White (active 1570s–93), made a detailed drawing of Secoton, an Algonquin Indian village on the Pamlico River near the coast of North Carolina (see p. 12). The village was governed by Powhatan, a powerful chief who reigned over nearly 200 small villages along the southeastern seaboard of what became the United States. Connected by a broad central avenue and situated next to fields of corn, oblong wigwams served Secoton villagers not only as one- or two-family homes but also as sacred, devotional spaces. The large wigwam at the bottom of White's watercolor represents a tomb, where former leaders were buried.

The wigwam was a common building type among the tribes and cultures of the eastern Woodlands, encompassing territory from Canada to the Carolinas and westward to the Mississippi River. Wigwams varied in shape and size, but essentially they were constructed with a frame of flexible sapling poles that were stuck into the ground and then bent and lashed together for the desired configuration. Horizontal "stringers" tied in tiers to the vertical supports strengthened the frame, which was covered with grass and reed matting or, alternatively, sheets of tree bark. As seen in a number of the wigwams depicted in White's watercolor, the grass covering could be removed from one or more of the walls for better ventilation and light. Wigwam construction was a sensible, economical means of sheltering families in this densely wooded region of North America. When English settlers first arrived in Massachusetts during the early seventeenth century, they initially built wigwams that closely resembled the homes of their Indian neighbors. In White's watercolor, groups of Indians perform ritual dances and prayers within ceremonial circles, while others tend to food preparation and hunting. In the upper left, large wigwams seem to blend in with the surrounding wilderness, thereby suggesting that Native Americans did not clear and map village spaces according to a fixed geometric grid.

Anthropologists and historians have praised this and other White watercolors for their accuracy in rendering Indian life. However, as we shall see later (see fig. 1.13), White's images should not be interpreted as disinterested, objective renderings. They expressed his particular purposes and values. Furthermore, his representations were borrowed and recirculated by writers and printmakers who had their own ideological agendas in clearing the eastern Woodlands of forests, wildlife, and Native Americans.

Southwestern Pueblo Architecture

When, during the sixteenth century, Spaniards from Mexico City entered New Mexico, the northern frontier of New Spain, they encountered Hopi and Zuni Indian villages and towns composed of sprawling, multistory, multiroom dwellings constructed from adobe, a sun-dried mixture of mud, clay, and straw. The Spanish termed these large apartment complexes and the tribes who lived in them "pueblos." Derived from the Latin word populus, pueblo literally means people, but Spaniards also employed the word to refer to a village or communal dwelling. Taos Pueblo in the Rio Grande valley seventy miles north of Santa Fe, New Mexico, probably had originated before 1400, over a century before Columbus's first voyage (fig. 1.2). Mimicking the sacred, mountainous terrain of the surrounding landscape, residents of the village gradually created a nest of rectangular housing blocks rising in tiers to as high as six stories. Pueblo rooftops doubled as terraces for residents living in the upper stories of the stepped-back, irregular pyramid.

Pueblo-style architecture had spectacular origins roughly 1,000 years ago in the rugged canyon landscape of the Four Corners area, where the state borders of Utah, Colorado, Arizona, and New Mexico now meet. Taos itself may have been built by refugees from Chaco Canyon, New Mexico, the site of monumental "Great Houses" or Pueblo complexes made with thick walls of stone rather than adobe. At Mesa Verde in southwestern Colorado and at Canyon de Chelly in northeastern Arizona, Anasazi Indians, the so-called ancient ones, also employed dry masonry to construct multi-room cliff dwellings within shallow recesses of canyon walls. Although these sites were gradually abandoned after 1300 c.E., various tribes sporadically

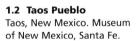

Adobe, or mud construction, is one of the oldest architectural materials and techniques. The word adobe has roots in Egyptian hieroglyphs and, later, in the Arabic word atob, meaning mud or sticky glob. The earliest remains of adobe structures, dating to 7100 B.C.E., have been found at the sites of late Stone Age farming villages in Mesopotamia. In the Western Hemisphere, adobe was first used in the Chicama Valley of Peru around 3000 B.C.E.

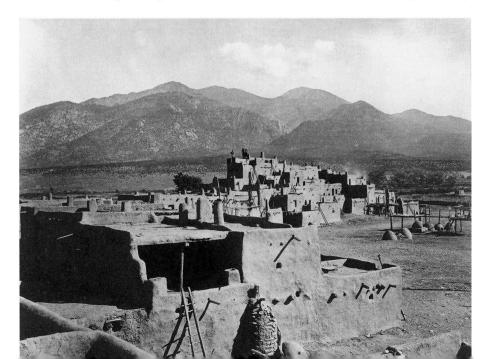

continued to use Canyon de Chelly until the mideighteenth century. During the nineteenth century, after the United States had annexed this territory, artists joined government surveyors in visually documenting the ancient Pueblo ruins. The photographer Timothy O'Sullivan (1840–82) chose a distant view of the rectangular stone housing blocks at Canyon de Chelly to express the virtually seamless continuity between Native American habitation and the geology or natural history of the site (fig. 1.3). The dark, womb-like opening for the pueblo nestling within the canyon's massive, striated walls implies the birth of Pueblo culture from Mother Earth.

Architectural historians have concluded that Pueblo dwellings, like other Native American building types, possess ancestral roots in the subterranean pit houses of Siberia. This architecture spatially expressed the religious belief that every home replicated the cosmos. Whether subterranean

or above ground, the home's center vertically connected the "earth-navel" with a "sky door" or "sun hole" (cited in Nabokov and Easton, p. 38). Originally circular, pit houses were entered through the smoke hole or sky-door opening in the roof. Below, at the center of the living space, a *sipapu* or shallow posthole magically facilitated the emergence of ancestral spirits from the earth's vitalistic core. Though they moved into above-ground dwellings, Pueblo tribes continued to employ circular subterranean structures as kivas, or ritual spaces, where religious leaders descended into the earth to communicate with sacred clan animals or ancestral spirits (fig. 1.4). The cliff dwellings at Mesa Verde comprised the Pueblo living spaces above

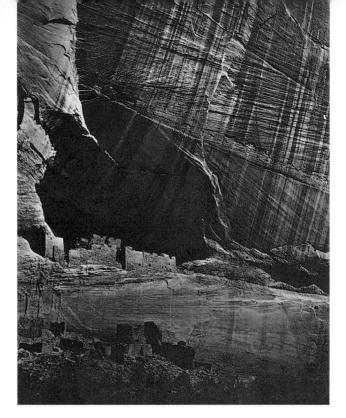

1.3 Timothy O'Sullivan Ancient Ruins in the Canyon de Chelly, New Mexico, 1873. Photograph, $10\% \times 8$ in $(27.6 \times 20.3 \text{ cm})$. Museum of Modern Art, New York. Gift of Ansel Adams in memory of Albert M. Bender.

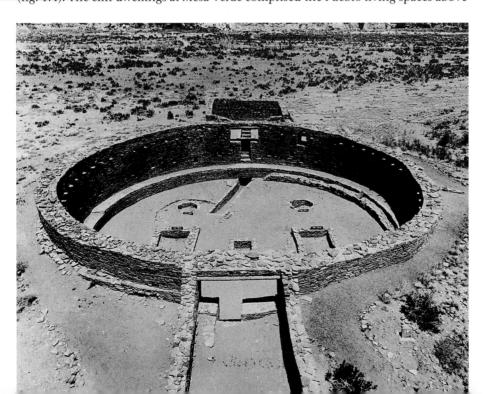

1.4 Great Kiva

near Pueblo Bonito, Chaco Canyon, New Mexico. Diameter approx. 63 ft (19.2 m). National Park Service.

Known as Casa Rinconada, this communal, religious structure has masonry construction partially sunken into the earth. Its interior is ringed by benches for seating during sacred ceremonies. Within the circular space is a masonry compartment for the lighting of fires during ceremonies, and rectangular vaults for the storage of foot drums made of skins or logs. A subfloor passageway probably facilitated the staging of dramatic ceremonial rituals.

1.5 Cliff Palace Courtyards and kivas, Mesa Verde, Colorado, c. 1250 C.E.

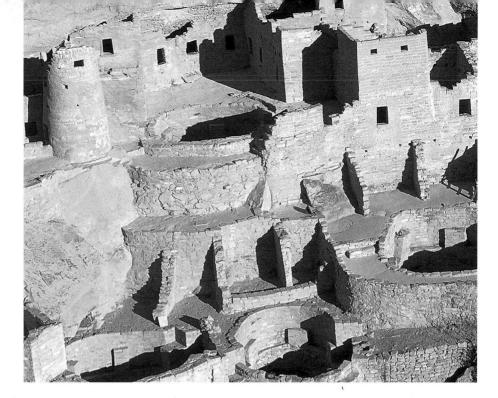

ground and the kivas (fig. 1.5). The kiva roofs, penetrated by ladders, served above ground as communal plazas. Here, men, women, and children socialized, worked, and prepared food. But architectural historians have imagined these courtyards also as urban theaters, where the tribe's leading men would suddenly appear from below, climbing upward from the kiva's smoke hole to reenact the gods' act of creation. On the plazas, dancers performed rituals to the rhythmic accompaniment of drums, while spectators, mostly women and children, watched from the pueblo doorways above.

Earthworks and Burial Mounds

Elsewhere, in the Mississippi and Ohio River valleys, Native American cultures expressed animistic religious beliefs through the construction of monumental earthworks or temple and burial mounds. A few miles east of St. Louis, Missouri, the pre-Columbian settlement remains of Cahokia testify to the cultural complexity of perhaps the largest Native American city north of the Rio Grande River. Founded around 600 c.e., Cahokia, at its peak in 1100, possessed approximately one hundred large earth mounds and an urban core of six square miles. Although scholars have debated the size and population density of Cahokia, estimates have ranged as high as 30–40,000 people, though many may have been living in outlying areas. Before its complete abandonment around 1500, Cahokia had served as a political, trading, and religious center for a large number of villages and towns along the Mississippi, Illinois, and Missouri Rivers. Its largest mound, later named Monk's Mound by French Trappist monks, rose in terraces to create a grand pyramid over 100 feet high, 1,000 feet long, and 700 feet wide (fig. 1.6). More than twice the size of any other mound at Cahokia, Monk's Mound was built in stages or added onto over three centuries by thousands of women and men carrying and spreading buckets of earth, amounting to nearly 22 million cubic feet. At its crest, the mammoth pyramid had a platform for a large temple or royal residence constructed from wattleand-daub, a wooden frame of young saplings filled in with dried mud. Together with lesser mounds, Monk's Mound looked over a grand open plaza, where ritualistic games and ceremonies were performed. Archeological excavation of the mounds has demonstrated that the inhabitants of Cahokia engaged in elaborate burials and practiced human sacrifice. At the funerals of tribal leaders, close relatives were apparently sacrificed to create a royal entourage into the underworld. Human remains were accompanied by shell beads, arrowheads, gleaming mica sheets, and polished stone disks that may have been employed in spear-throwing games.

Similar artifacts have been found at other North American earthworks or mound sites. In the Hopewell and

Adena cultures, which once flourished in the area of present-day Ohio, burial grounds lacked rectangular platforms for temples. Instead of building pyramids, these Woodland peoples frequently shaped earth mounds into effigies of birds, snakes, and other animals. Though only a few feet high, they generally ranged from forty to 500 feet long. However, the largest mound, the Great Serpent Mound near Locust Grove, Ohio, writhed for 1,254 feet over a long, rocky ridge and strangely contained no actual burials (fig. 1.7). The snake's jaws surround an egg-shaped mound, perhaps suggesting fertility and birth in the midst of death. Seeking to communicate with the gods of both the sky world and the underworld, mound builders may also have designed effigies in response to astronomical phenomena such as comets, meteors, and unusually luminous supernova.

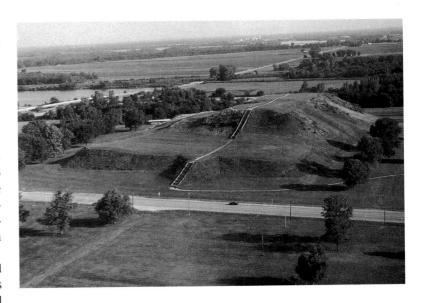

1.6 Monk's MoundCahokia, Illinois, c. 900–1200
C.E. Cahokia Mounds State
Historic Site.

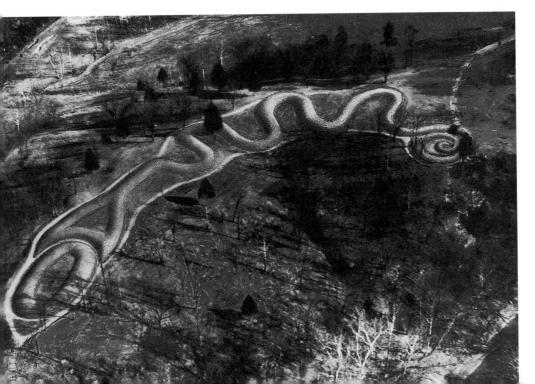

1.7 Great Serpent Mound near Locust Grove, Ohio. Length approx. 1254 ft (382 m). Ohio Historical Society, Columbus, Ohio.

Recent radiocarbon dating has suggested that the Serpent Mound may have been built around 1070 c.E., which actually postdates the Adena and Hopewell cultures. Scholars further theorize that this mound of the Mississippian Period may represent the celestial appearance of Halley's Comet in 1066.

One of the most striking artifacts from an Ohio burial mound is a translucent mica image of an elongated human hand (fig. 1.8). As if asserting their magical control over the forces of nature, Native Americans often painted their own hand prints onto rock surfaces at sites throughout the Americas. An incised gorget, or neck pendant, from a pre-Columbian site in Oklahoma, features a human hand decorated with an eye in the middle of the palm (fig. 1.9). Made of shell, the pendant was probably worn by a tribal priest or chief as a symbol of his creative power. Sharp, penetrating vision, coordinated with the human ability to manipulate the materials of the earth, enabled Native Americans to survive and flourish in harsh environments. However, after 1492, they encountered the highly mechanized magic of European explorers and settlers, which forced them to adapt to new technologies and the hostile invasion of an alien civilization. (Unfortunately, limited space precludes further consideration of Native American art.)

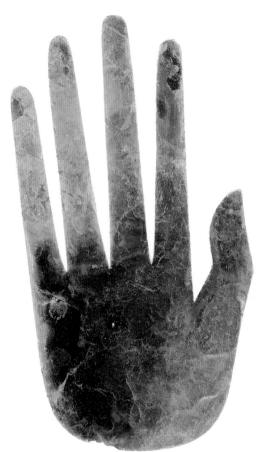

1.8 Hand shape

Ohio Hopewell culture, 200 B.C.E.—400 C.E. Sheet mica, 11½ in (29 cm) high, 6½ in (16 cm) wide. Ohio Historical Society, Columbus, Ohio.

Representations of the human hand date from the earliest periods of art or image making. In 1994, archaeologists discovered thousands of prehistoric finger tracings in the Cosquer cave near Marseilles, France. Dating from 27,000 years ago, many of these hand images were in inaccessible areas of the cave, suggesting a magical, religious purpose or significance.

1.9 Gorget, or neck pendant

Spiro Site, Oklahoma, c.1200–1350. Shell, diameter 4½ in. Minneapolis Institute of Arts, Minneapolis, Minnesota.

A fairly common motif in the ritual objects of various
Native American cultures, the human hand, animated by an eye, also appears in Asian art.
Buddhist divinities are often represented with five additional eyes on their hands, feet, and foreheads as signs of spiritual enlightenment.

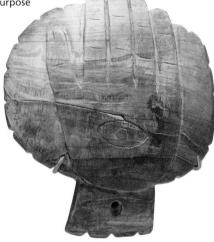

America and the European Imagination

Nearly a century after Christopher Columbus's 1492 voyage, a Flemish artist, Jan van der Straet or Johannes Stradanus (1523–1605), celebrated European exploration and conquest of the Americas in a series of engravings entitled Nova Reperta (New Discoveries) (fig. 1.10). In the title page for the series, Stradanus suggests that the discovery of America has introduced a new age of knowledge, science, military power, and commercial wealth. A gesturing, seminude woman draws our attention to a circular map of North and South America. Her youthful energy may be interpreted as a personification of the European Renaissance, the "rebirth" of learning and the arts, which supposedly had been moribund since the fall of the ancient Roman empire during the fifth century. For over a millennium, pagan antiquity's relatively optimistic faith in humanity's godlike dignity and creativeness had been supplanted by Christianity's dogmatic subordination of sinful, depraved humanity to the biblical God of the Old and New Testaments. In harmony with humanist scholars who reconciled the Christian faith with renewed interest in ancient Greek and Roman authors, fifteenth- and sixteenth-century painters and sculptors revived antiquity's reverence for the idealized human figure as an expression of divine beauty and of moral and intellectual perfection.

In Stradanus's picture, both the striding nude woman and the male personification of the Old World, who exits to the right, are reminiscent of the muscular figures in paintings and sculptures by the Florentine artist Michelangelo Buonarroti (1475–1564), whose career had just begun when Columbus, a native of Genoa, Italy, embarked on his epochal voyage. Though born in Spanish-controlled Flanders, Stradanus had established a successful career in Florence, where the flowering of Renaissance arts and letters had begun.

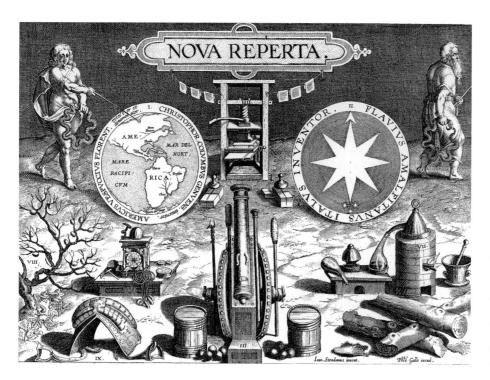

1.10 Johannes Stradanus (Jan van der Straet)

Title page from *Nova Reperta*, Antwerp, 1600. Folger Shakespeare Library, Washington, D.C.

Latin inscriptions encircle the map of North and South America on the left side of the print. They identify Christopher Columbus of Genoa as the discoverer and Amerigo Vespucci of Florence as the discloser and namer of the Americas. On the right side, a Latin inscription encircling the magnetic compass commemorates Flavius Amalfitanus, or Flavio Gioia d'Amalfi, a fabled Italian mariner traditionally credited with inventing or popularizing the compass.

Stradanus's title page to *Nova Reperta* reads like an encyclopedic catalogue of recent inventions and accomplishments. The map of the Americas is balanced on the right side by the circular, radiating shape of a magnetic compass, an essential navigational instrument for the age of exploration. A printing press and the iron barrel of a cannon form a central axis that symmetrically divides the illustration into two halves. Both of these recent inventions were crucial for European conquest and domination of the Americas. Complementing the physical force of the military hardware, the printed dissemination of words and images representing the New World fueled the desire for conquest and the appropriation of America's wealth, particularly its gold. A saddle with stirrups in the lower-left corner of the picture alludes to the horse power that Spaniards employed to overwhelm Native American opposition. Before the European invasion, horses had been unknown in the Americas. Armored Spanish soldiers mounted on horseback initially appeared invulnerable and godlike to American Indian tribes.

Underscoring European thirst for precious American commodities, Stradanus depicts logs of dyewood in the lower-right foreground. Used for manufacturing pigments and dyes, dyewood was particularly valued by the French, who, during the mid-sixteenth century, established a South American outpost in Brazil to log the product for export to the port city of Rouen, the key marketplace for the French dye trade. Brazil itself was named after the brasel or bresel tree, a red dyewood that Europeans imported from the East Indies.

Directly above the dyewood logs, Stradanus represents an alchemical apparatus featuring a furnace, a crucible, and glass retorts. As predecessor to the science of chemistry, the art of alchemy was largely devoted to the heating and reheating of "base" metals such as lead in hopes of transmuting or refining them into the higher, perfected state of gold. Significantly, each of the two human figures in Stradanus's print holds a circular, though writhing, serpent that bites its own tail. Often associated with the practice of alchemy, this strange emblem represented the cycles of nature and the alchemical transmutation of matter. Nourishing itself by eating its old skin, the serpent expressed the cyclical processes of alchemy, whereby base or primary matter underwent a repetitive, circular path of fiery dissolution and regeneration that ultimately produced the perfection of nature symbolized by incorruptible gold. For Europeans, the American wilderness constituted an alchemical base material that could be refined into an ideal, utopian state of being. Just as Stradanus's print celebrates the measurement and assimilation of vast geographical spaces, so do the metal clockworks at the left; and the human figures underscore the importance of controlling the orderly passage of time or history's progress toward higher states of civilization. While the old man of Europe's past quietly departs the scene, the vibrant, fertile-appearing woman symbolizes its future. Previously ignorant of the American continents' existence, Europe has become regenerated by the wealth and resources of this New World. The print's circular map represents an open invitation for European viewers not simply to regard the Americas as an extension of their own world, but rather to envision a paradisiacal renewal or renaissance, the creation of a New Spain or a New France.

In perhaps the most famous engraving from the *Nova Reperta* series, Stradanus represented Amerigo Vespucci awakening America as personified by an Indian woman wearing only a belt and feather cap (fig. 1.11). Awkwardly rising from her hammock, the startled nude figure dramatically contrasts with the self-assured masculinity of the fully clothed Italian explorer. As he stands and gazes down on a vulnerable America, Vespucci authoritatively holds a Christian banner in one hand and

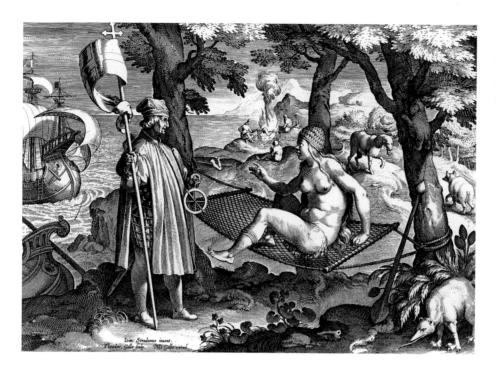

1.11 Johannes Stradanus (Jan van der Straet) Amerigo Vespucci Awakens a Sleeping America from Nova Reperta, Antwerp, 1600. Folger Shakespeare Library, Washington, D.C.

an astrolabe in the other. The circular navigational instrument dangles like a magical charm between the two figures. Like a magnet, its power has finally drawn European ships and technology toward America's shores. Stradanus suggests the providential necessity and justness of European conquest. Represented as indolent savages, the native peoples appear to have no culture worth preserving. Scarcely different from the exotic wild animals that live among them, Stradanus's natives are mere cannibals. In the background, they can be seen roasting human body parts over a fire. On the basis of hearsay rather than evidence, Vespucci published sensational tales of Indian cannibalism in Mundus Novus (New World), an account of his 1501 expedition to the Caribbean and South America. Translated into several languages and appearing in scores of editions, Vespucci's travelogue was far more widely read than Columbus's published letter recounting his 1492 voyage. Finally declaring the discovery of a New World, Vespucci also excited readers with provocative stories of Indian sexuality: "The women as I have said go about naked and are very libidinous; yet they have bodies which are tolerably beautiful and cleanly. . . . When they had the opportunity of copulating with Christians, urged by excessive lust, they defiled and prostituted themselves" (cited in Sale, p. 141).

Vespucci conveniently projects the desire for sex onto the strange victims of European conquest. The invading Christians apparently have no resistance to these shameless Indian women. Stradanus's engraving represents Vespucci's discovery as a sexual encounter. In contrast to the dignified explorer's rational pose, America's nudity, long, flowing hair, and placement on a hammock-bed erotically imply her character as a wanton seductress. Having been named after Amerigo Vespucci, the voluptuous America is already his possession, a feminine object willing to be dominated and exploited.

Unlike Stradanus, the Frenchman Jacques Le Moyne de Morgues (1533–88) was one of the few professional artists to observe and visually represent Native American life first hand. In 1564, Le Moyne joined an expedition under the command of René

Goulaine de Laudonnière, who was seeking to reinforce an earlier expedition led by Captain Jean Ribaut. The French erected forts and commemorative monuments at the mouth of the St. John's River, near present-day Jacksonville, Florida, and further north near present-day Beaufort, South Carolina.

Laudonnière assigned Le Moyne the task of mapping the territory's important navigational features. In the process, the artist-cartographer executed a number of sketches that later, on his return to Europe, he converted into forty-two finished gouache or watercolor drawings. The pictures were subsequently engraved and published with Le Moyne's own written narrative. Only one of the gouache drawings, a scene of Indian submission and friendship, has survived (fig. 1.12). The exotic, brightly colored image should be viewed in conjunction with the artist's explanatory account:

When the French came to Florida the second time, they were commanded by Laudonnière. Upon their arrival crowds of Indians gathered on the shore to welcome them. They assured Laudonnière that they bore no enmity against him. So he went ashore with twenty harquebusiers [musketeers] where he was met by the chief, Athore. After presents had been exchanged and promises of friendship given, the chief asked the French to go with him. This they agreed to do, though as Athore was accompanied by a great number of men, they acted with great caution.

The chief took them to the island where Ribaut had set up the stone column with the arms of the King of France. When the French came closer to the column, they found Indians worshiping the stone as an idol. Athore kissed the stone with the same reverence that his subjects showed him. His men also kissed the column, and they asked us to do likewise. In front of the monument lay offerings of fruits, edible and medicinal roots, jars of perfumed oils, a bow and arrows; the stone was wreathed with flowers and boughs of the choicest trees. (cited in Lorant, p. 51)

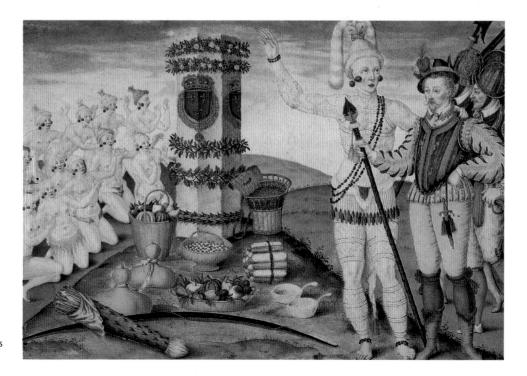

1.12 Jacques Le Moyne de Morgues

René de Laudonnière and the Indian Chief Athore Visit Ribaut's Column, 27 June 1564. Gouache and metallic inks on vellum, with traces of black chalk outlines, 7 × 10½ in (17.8 × 26 cm). New York Public Library. Astor, Lenox, and Tilden Foundation. Bequest of James Hazen Hyde.

For Indian peoples who had known nothing of horses, gunpowder, cannon-bearing sailing ships, and mechanical navigational instruments, invading Europeans initially did appear to be deities or beings in possession of godlike powers. European explorers quickly learned to take advantage of Native American awe and deference. Though Le Moyne states that Chief Athore also invited his French guests to kiss the phallic column honoring the King of France, Laudonnière and his heavily armed men stand cautiously at a distance from the kneeling Timucuan natives' act of worship. Athore places an arm around Laudonnière's shoulder, but the captain shows no sign of reciprocal friendship. Instead, he holds a long, pointed spear immediately in front of Athore's body. Le Moyne describes Athore as "very handsome, wise, honorable, and strong, and at least half a foot taller than the tallest of our men" (cited in Lorant, p. 51). Yet the visual representation of Athore's semi-nude, painted, and bejeweled body implies cultural inferiority to the dapper, fully clothed French captain. Despite the chief's statuesque nobility, Le Moyne emphasizes Athore's primitive closeness to the animal kingdom. In addition to the feather skirt and animal-tail hat, he sharply details the chief's long, clawlike fingernails and toenails. In his narrative, he informed readers that Athore had "married his own mother and had a number of sons and daughters by her" (cited in Lorant, p. 51). Like other reports of sexual license, stories of incest served the propagandistic purpose of justifying European conquest and conversion of Native Americans to the Christian faith. Indeed, Laudonnière's expedition had intended to establish a religious refuge in the New World for French Protestants or other Christians who were dissenting from the doctrines of the dominant Catholic Church. Le Moyne's image of idol worship and submission to French power could only have encouraged Christian missionary zeal. Furthermore, the rich offerings of flower garlands, fruits, and vegetables surrounding the stone column reassured viewers that America was a garden-like paradise readily available for European settlers.

Unfortunately for Laudonnière and the French, Spanish military forces dominating the Florida peninsula were far less welcoming than Athore and his Timucuan tribesmen. Fearing the plundering of its territorial possessions and interference with shipments of American gold, Spain, by 1565, drove the French out of Florida and the Carolinas. Jealously guarding its dominant position in exploiting New World resources, it understood its possession of Florida to include all of southeastern North America, from the Panuco River on the western edge of the Gulf of Mexico to Delaware Bay on the Atlantic coast.

Nevertheless, as national rivalries intensified and the extent of American wealth became more widely appreciated and coveted, other European powers, especially France and England, challenged Spain's dominant presence in the New World. Jean Ribaut, the French captain who had erected the monument worshiped by the Timucuans, visited London in 1563. His tales of American gold, silver, and precious gems generated a "Florida fever" among English speculators and merchants. Led by John Hawkins and Sir Francis Drake, English ship captains began during the 1560s to intercept Spanish gold shipments. Subsequently, the English navy's defeat of the Spanish Armada in 1588 dramatically weakened Spain's presence in North America.

With the encouragement of Queen Elizabeth I, the English adventurers Sir Humphrey Gilbert and his half-brother Sir Walter Raleigh envisioned permanent English colonies in America. In 1584 Raleigh voyaged to a territory that he named Virginia in honor of Elizabeth, England's "Virgin Queen." The next year, he organized a second expedition to Virginia, which explored the potential for a colony on Roanoke Island off the coast of present-day North Carolina. The artist-cartographer

1.13 John White *The Sorcerer*, c. 1585–7.
Watercolor, 7¾ in (20 cm) high. British Museum,
London.

White's sorcerer wears a small bird on the side of his head. While this winged creature was a traditional, honorific emblem of a high spiritual office, Europeans may have been more inclined to interpret the adornment as a devilish symbol of pagan nature worship.

John White played a key role in the expedition. White's detailed watercolor drawings of the flora, fauna, and native inhabitants of Roanoke and the coastal mainland were both informational and promotional in purpose. The pictures were intended as advertisements for attracting English settlers to Virginia and Roanoke Colony. White's *Indian Village of Secoton* (see page 12) and other scenes of Native American life suggest a fruitful land abundant with natural resources. Furthermore, according to White's associate, Thomas Hariot, whose reassuring narrative later accompanied engraved reproductions of these images:

They [the native peoples] seem very ingenious. For although they have no such tools, nor any such crafts, sciences, and arts as we, yet in those things they do, they show excellency of wit. And by how much they upon due consideration shall find our manner of knowledges and crafts to exceed theirs in perfection, and speed for doing or execution, by so much the more is it probable that they should desire our friendship and love, and have the greater respect for pleasing and obeying us. Whereby may be hoped, if means of good government be used, that they may in short time be brought to civility and the embracing of true religion. (cited in Gunn, p. 62)

The elevated, bird's-eye view in White's *Indian Village of Secoton* implicitly expresses Hariot's condescending attitude toward Native American culture. Twentieth-century scholars have praised White for the anthropological accuracy of his representations. Yet this detached, "objective" viewpoint ideologically

identified the artist as one of Hariot's superior men of science and knowledge. Though he lived among them and enjoyed their hospitality, White stood back from his Native American subjects and made them the visual objects of his investigation. Armed with these attractive, colorful images of peace and plenty, he joined with Raleigh and Hariot in planning to subject his native hosts to English authority. Certainly White's representation of a Native American sorcerer stirred Christian missionary zeal (fig. 1.13). According to Hariot's commentary: "They have sorcerers or jugglers who use strange gestures and whose enchantments often go against the laws of nature. For they are very familiar with devils, from whom they obtain knowledge about their enemies' movements" (cited in Lorant, p. 247). In 1587, after a brief visit to London, White was appointed governor of Roanoke Island and led a small group of settlers to the colony. Virginia Dare, White's granddaughter, was the first English child born in North America. The following year, the artist returned to England so that he could resupply the fledgling settlement with necessary goods. But war with Spain delayed his return. By 1590, when White finally made it back to Roanoke, he found no trace of the colonists and spent the next several years futilely searching for them. Roanoke's "Lost Colony" may have succumbed to famine, disease, or a natural disaster. However, Native Americans also may have decided that the aggressive colonists were no longer welcome to the land and its resources.

Despite Roanoke's failure, engraved reproductions of White's pictures kept circulating. In 1590, the Flemish engraver Theodore de Bry (1528–98) published altered and embellished copies of the original drawings in conjunction with a reprinting of Thomas Hariot's 1588 treatise, *A Brief and True Report of the New Found*

Land of Virginia. Being "directed to the investors, farmers, and well-wishers of the project of colonizing and planting there" (cited in Lorant, p. 227), Hariot's text, with de Bry's engravings after White, were inspirational for the 1607 founding of Jamestown, Virginia, the first successful English colony in America. Established primarily for commercial reasons by a joint stock company, the Virginia Company of London, Jamestown established trade with the native Algonquin tribes and survived through the cultivation of tobacco. English entrepreneurs had learned to appreciate tobacco from the Algonquins, who valued it for religious, "medicinal," and pleasurable social reasons. In copying John White's *Indian Village of Secoton*, de Bry took the liberty of adding a large field of tobacco at the top of the engraving, thereby suggesting to white settlers the commodity's profitable cultivation.

The Jamestown colonial leader Captain John Smith (1580–1631) drew a map of Virginia reliant on White's earlier cartography and upon "information of the *Savages* . . . set downe according to their instructions" (cited in Warhus, p. 144). Furthermore, Native American figures borrowed from de Bry's reproductions of White variously decorate different editions of Smith's Virginia map. However, departing from the objectivity generated by White's relatively detached representations, English engravers of Smith's map selectively appropriated, embellished, and recombined the imagery to project a far more antagonistic attitude toward the Algonquin tribes.

Robert Vaughan's engraving of "Ould Virginia," published in John Smith's *The Generall Historie of Virginia, New-England, and the Summer Isles* (1624), surrounds a map of Virginia with historical vignettes recounting Smith's heroic struggle against hostile Indian warriors and his 1607 imprisonment at the hands of the powerful Chief Powhatan (fig. 1.14). For the scene in the upper-left corner, Vaughan appropriated the ritualistic circle of dancers in White's *Indian Village of Secoton* to

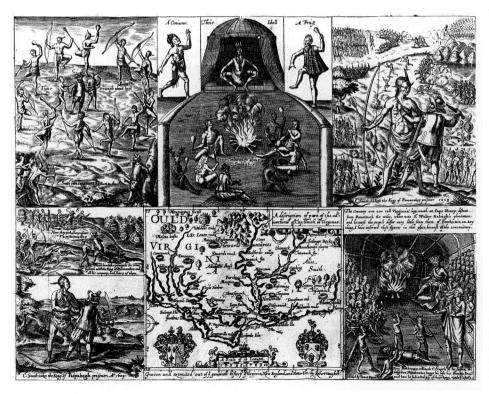

1.14 Robert Vaughan "Ould Virginia" from John Smith, *The Generall Historie* of Virginia, New-England, and the Summer Isles, 1624. Newberry Library, Chicago.

1.15 Simon van de Passe Map of New England from John Smith, *The Generall Historie of Virginia, New-England, and the Summer Isles*, 1627. American Antiquarian Society, Worcester, Massachusetts.

represent Smith surrounded by belligerent warriors. Vaughan also borrowed the figure of White's sorcerer for the central vignette of idol worship and heathen ritual at the top of the engraving. Within the space at the bottom right, Vaughan represents the legend of how Smith escaped execution at the hands of the Algonquins, when Pocahontas, Powhatan's daughter, interceded upon his behalf. This imaginative composition foregrounding a kneeling Pocahontas next to Smith's prone body is the least dependent upon White's prototypes. Vaughan's violent, combative images complement the central map, which is inscribed as "a description of part of the adventures of Cap. Smith in Virginia." Unlike White's earlier, relatively empty map of Virginia, Smith's map is covered with signs of settlement and English place-names. In 1622, angered by escalating intrusions on their land, Powhatan

warriors attacked the Jamestown colony, killing almost one quarter of the residents. Intermittent warfare between native tribes and white settlers continued for decades, yet the very title of Vaughan's "Ould Virginia" reassuringly suggests historical continuity and cultural permanence. In fact, by 1677, Virginians had confined the once-powerful Powhatans to a small reservation and forced them to pay a tribute or tax for using the land they once possessed.

John Smith's ambition led him beyond Virginia. In 1614, he traveled north to Cape Cod and Penobscot Bay, areas along the North American coast that were still devoid of successful English settlements. Even though Dutch and French explorers were making territorial claims, Smith bestowed an English character on the region when he published a map of New England (fig. 1.15). Despite the absence of actual English towns and villages, Smith's New England map is everywhere inscribed with English place-names. On the orders of Prince Charles, the future King Charles I, Captain Smith renamed Native American settlements to create an Anglicized land-scape with such familiar sites as "Oxford," "London," "Boston," and "Plimouth." The map is decorated with a royal coat of arms and a portrait of Captain Smith, who is also given the title "Admirall of New England."

Both map and portrait were engraved by Simon van de Passe (c.1595–c.1647). This Dutch artist-engraver spent much of his career in England creating small, waist-length portraits of stiffly posed figures. His tight, linear drawing style was suitable for mapping fine details of face, costume, and New England topography. The same year that Smith first published his New England map, van de Passe also engraved a portrait of Pocahontas (fig. 1.16). In 1614, the Virginia colonist John Rolfe had stated his intention to marry the celebrated daughter of Chief Powhatan, not for "the unbridled desire of carnal affection: but for the good of this plantation, for the honour of our country, for the glory of God, for my own salvation, and for converting to the true knowledge of God and Jesus Christ, an unbelieving creature, namely Pokahuntas" (cited in Middleton, p. 59). Van de Passe drew the portrait of the Indian princess after her husband had introduced her to the royal court of James I (r.1603–25).

In contrast to pictures of nude or seminude Native Americans, van de Passe completely covers Pocahontas with a thick armor of intricately embroidered English costume. As if responding to Rolfe's moral fear of carnal lust, the portraitist represents a virtually desexualized and Anglicized woman. Indeed, the portrait's Latin and English inscriptions inform viewers that the daughter of Powhatan has been renamed Rebecca. The popular biblical name associated the Indian princess with the Old Testament mother of Jacob, patriarch of the ancient Israelites. European settlers in America habitually compared themselves to the Hebrews, the "chosen people" of the Old Testament, who also had survived wilderness conditions. thanks to God's divine protection. In appropriating America, Europeans renamed both land and people. As Rebecca, the Christianized Pocahontas personified the civilizing purification of the American wilderness. However, for Pocahontas, civilization had its own dangers. While in London, she died of smallpox, one of many European diseases that had been exported to the New World, where it depopulated Native American villages and towns. From the European perspective, the diseases that ravaged aboriginal peoples were providential, since they left empty settlements that could easily be taken over by arriving settlers.

Even as epidemics of smallpox, measles, and bubonic plague were devastating Algonquin tribes along the New England coast, John Smith was peddling thousands of his

maps to prospective English colonists and trading companies. Few expressed interest in colonization except for a small group of Pilgrims, or religious dissenters from the Church of England. On September 6, 1620, approximately one hundred Pilgrims departed on the Mayflower from Plymouth, England. Over two months later, they landed off the Cape Cod peninsula on the New England coast and established Plymouth Colony "for the glory of God, and advancement of the Christian faith" (cited in Middleton, p. 77). Smith's map already had supplied the name of Plymouth as a replacement for the Algonquin village of Patuxet. Erased by this map, Patuxet was literally destroyed by a series of epidemics during the three or four years prior to the Pilgrims' landfall. Plymouth was constructed from the ruins of the former village and survived with the help of Native American survivors, who taught Pilgrims how to grow corn and acquire other useful goods. Nearly ten years later, in 1629, the Massachusetts Bay Company received a royal charter to establish a New England colony north of Plymouth. The company's seal featured the lonely figure of an Indian holding a bow and arrow while standing over several small trees (fig. 1.17). A speech bubble emerging from the figure's mouth beseeches prospective white settlers to "come over and help us." Like the portrait of Pocahontas, the seal represented Native Americans as amenable, even eager, for the spiritual and material benefits of European civilization.

However, neither the Pilgrims of Plymouth nor the founders of Massachusetts Bay Colony demonstrated much interest in helping or converting Native Americans to Christianity. As we shall see in the next chapter, Massachusetts became a refuge for Puritans or radical Protestants, who were protesting the corruption of the

1.16 Simon van de Passe Pocahontas, 1618. Engraving, $6\frac{3}{4} \times 4\frac{3}{4}$ in (17.5 × 12.06 cm). National Portrait Gallery, Smithsonian Institution, Washington D.C.

Pocahontas was a nickname: her real name was Matoaka. The Latin inscription is translated and expanded upon in the English legend below the image.

Roman Catholic Church and its influence on the Church of England. Rather than carrying out missionary work among native tribes, Puritans turned spiritually inward to purify and protect themselves from the physical and moral wilderness of American life. Nevertheless, they fiercely pursued their territorial and commercial interests against hostile Native American tribes. Boston, the commercial hub of Massachusetts, had replaced Shawmut, another Algonquin village that had been devastated by the epidemics of 1616–19. A smallpox epidemic during the fall and winter of 1633–4 cleared the New England landscape of several thousand more Native Americans, enabling white colonists to take over deserted settlements and cultivated fields.

Soon afterward, however, Puritan settlers actively assisted the deadly work of European diseases. In 1637, shortly after a dissident group of Massachusetts Puritans founded Connecticut Colony in southern New England, officials from both colonies purposely provoked a genocidal war against the Pequots, a hostile tribe whose power over other Native American groups threatened English colonists' economic and political interests. Under the command of Captains John Underhill and John Mason, Connecticut and Massachusetts troops chose not to engage in direct combat with Pequot warriors. Instead, they launched an early-morning attack on the Pequots' fortified coastal village at the mouth of the Mystic River. At the time, Mystic Fort was occupied by about four hundred Pequots, most of them women, children, and older men. Setting fire to the town, the Puritans killed virtually everyone who attempted to escape.

Afterward, Captain Underhill published an unapologetic narrative of the slaughter and illustrated it with a remarkable maplike drawing (fig. 1.18). From a bird's-eye perspective, the diagrammatic picture represents two concentric rings of figures surrounding the circular Pequot fort. The outer ring represents Narragansett warriors, each poised with a bow and arrow. As the unreliable allies of the Puritans,

the Narragansetts actually played an uncooperative, passive role in the attack, since they refused to enter the fort and later condemned the massacre. Puritan militiamen constitute the inner ring of figures encircling the palisades of the fort. They are also pictured within the village itself, firing muskets at figures misrepresented exclusively as armed warriors. Defenseless women, children, and village elders are not represented.

Nevertheless, Underhill openly admitted in his narrative that "Many were burnt in the fort, both men, women, and children. Others [were] forced out, and came in troops to the [Narragansett] Indians, twenty and thirty at a time, which our soldiers received and entertained with the point of the sword. Down fell men, women and children" (cited in Kibbey, p. 104). From the Puritan point of view, the killing of women and children was justified since Pequots and other Native Americans were not humans created in the image of God. Puritans regarded themselves as God's "elect." American enemies, such as the Pequots, were in league with the devil or the dark forces of evil. Puritans purposely targeted children and child-bearing women as a means of destroying the potency and fertility of the Pequot peoples.

1.17 Seal of the Massachusetts Bay Company

1629. Massachusetts Historical Society, Boston.

The Latin inscription surrounding the image translates as "A Seal of the Governor and Society of Massachusetts Bay in New England." This early seal was annulled once Massachusetts became a royal colony later in the seventeenth century. A new seal featured the royal coat of arms to signify the colony's direct rule by the monarchy.

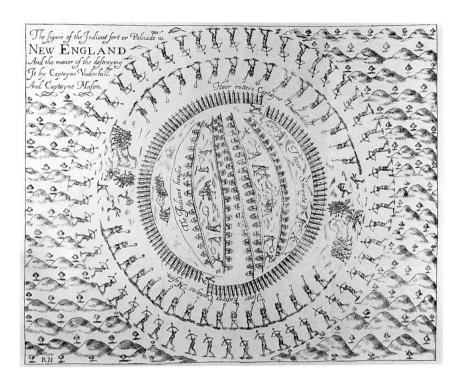

1.18 Indian fort
"The figure of the Indians'
fort or Palisado in New
England and the maner of
the destroying it by Captayne
Underhill and Captayne
Mason" from News from
America; or a new discoverie
of New England, London,
1638. New England Historic

Genealogical Society, Boston.

Viewed as a whole, Underhill's pictorial representation of the massacre suggests a sexual rape. Tiny, spermlike figures penetrate openings to the village core, which strongly resembles the lips of the female genitalia. As discussed earlier in the chapter, the European imagination tended to justify conquest of the Americas by feminizing the aboriginal peoples, associating them with the dark, sinful forces of nature and sexual desire. As historian Ann Kibbey has observed, the sexual symbolism of the Puritans' genocidal act is only implicitly or subverbally expressed in Underhill's vagina-like drawing. However, in their narratives, leaders of the massacre adopted a rapist's perspective by entirely blaming the victim for inviting the assault. Invoking the anger of a masculine, patriarchal God, Captain Mason insisted that the ungodly Pequots had brought "the mischief they plotted, and the violence they offered and exercised, upon their own heads in a moment: burning them up in the fire of His wrath, and dunging the ground with their flesh: it was the Lord's doings, and it is marvelous in our eyes!" (cited in Sanders, p. 338). New England Puritans later extended their genocidal war against other aboriginal tribes, including their former allies, the Narragansetts. Underhill's verbal and visual representation of the Pequot War apparently served as a model for the Narragansetts' defeat. In December, 1675, colonial troops surrounded the Narragansetts' village in Rhode Island and burned it to the ground, killing hundreds of people in the process.

Colonial Portraits of Native Americans and Anglo-French Rivalry

English settlers perpetually worried that their best efforts to civilize the American wilderness could be subverted by chaotic wilderness forces. Even after they had subdued or slaughtered New England's native tribes, Puritan colonists were threatened

1.19 (/eft) John Simon after John Verelst

Etow Oh Koam, King of the River Nation, 1710. Mezzotint, $15\% \times 91\%$ in $(40 \times 25$ cm). American Antiquarian Society, Worcester, Massachusetts.

Standing in a forested wilderness, Etow Oh Koam is portrayed as a proud warrior, who holds a club as a sign of his power. A small background vignette represents a figure brandishing a club against an enemy. Immediately behind the king of the River Nation, a large tortoise represents a sacred animal or clan totem. The chief's akimbo pose, with one hand on the hip and the elbow turned outward, commonly signified aristocratic or royal status in European portraiture.

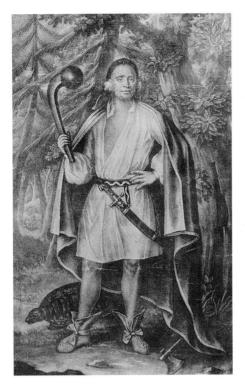

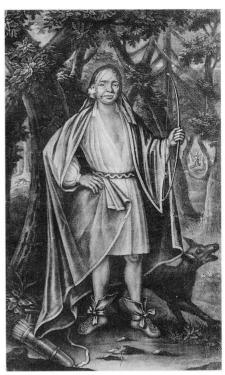

1.20 (right) John Simon after John Verelst

Ho Nee Yeath Taw No Row, King of the Generethgarich, 1710. Mezzotint, second state, 15¾ × 9½ in (40 × 25 cm). American Antiquarian Society, Worcester, Massachusetts.

This Mohawk Indian king also holds a formal aristocratic pose with one hand placed akimbo while the other holds a small bow. A guiver of arrows lies in the foreground. Meanwhile, a wild, snarling wolf in the lower-right corner of the print represents the king's clan totem. In the distant background at the far right, the small figure of a hunter can be seen aiming his bow and arrow toward a wolflike creature at the far left.

by hostile tribes beyond their borders in French Canada. Native Americans survived and even prospered for a time by exploiting European rivalries, playing one colonial power against another. Establishing a network of alliances with Indian tribes, France during the seventeenth century had built a North American empire stretching from the mouth of the St. Lawrence River in the north to the Mississippi delta in the south. French Canada, or "New France," especially profited from the fur trade, but the colony was forced to compete with New York and New England for the precious and limited supply of furs. Competition benefited Native Americans, who could charge white traders higher prices for furs, while paying less for European manufactured goods. Particularly during periods of European warfare abroad, the North American colonies also became theaters of violent conflict over territory and trade. French officials in Quebec and Montreal cultivated alliances with native tribes north of New England and New York, while also befriending refugees or vengeful remnants of those peoples conquered by Massachusetts and Connecticut colonists.

French-sponsored Indian raids on settlements in western and northern New England motivated English colonists to cultivate their own alliances with tribes hostile to the French. By the early eighteenth century, as Anglo-Americans became wealthier and more active consumers of the visual arts, they occasionally celebrated these strategic alliances by purchasing or commissioning sympathetic portraits of Native American sachems or chiefs.

In Portsmouth, New Hampshire, Captain Archibald Macpheadris, a wealthy fur trader, hired an unknown artist to paint the central staircase of his new mansion with a series of murals (fig. 1.21). Portraits of two oversized Mohawk sachems flank a window illuminating the staircase landing. Painted with bright colors and rich brushwork, the pictures were loosely copied from a popular series of portrait prints

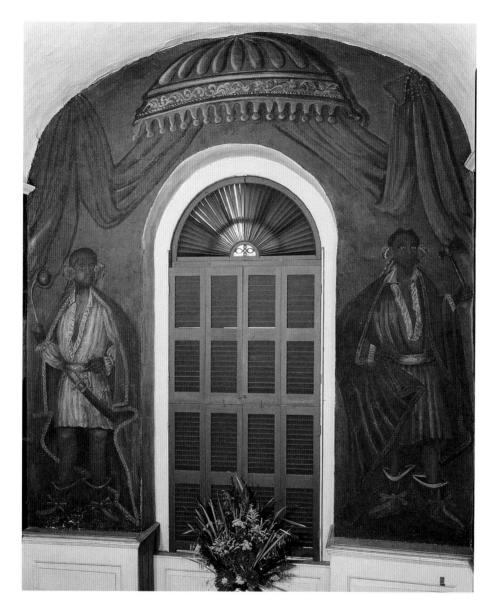

1.21 Mohawk Indian Kings' Mural Macpheadris-Warner House,

Macpheadris-Warner House Portsmouth, New Hampshire, c.1716. Warner House Association, Portsmouth.

In addition to these portraits of Indian sachems, three other mural scenes decorate the central staircase: a farm woman seated at a spinning wheel; the biblical Hebrew patriarch Abraham about to sacrifice his son Isaac (Genesis 22); and the equestrian portrait of an unidentified colonial officer. The paintings were all executed by an unknown, self-taught artist. The unusual combination of subjects makes it difficult to interpret the overall decorative scheme.

designed in London by the painter John Verelst (1648–1734) and the engraver John Simon (1675–c.1755) (figs. 1.19–1.20). Altogether, Verelst and Simon produced images of four sachems representing a confederation of Iroquois people in northern and western New York, including Mohawk, Oneida, Onondaga, Cayuga, and Seneca tribesmen. Colonial leaders from New York and elsewhere escorted the Iroquois leaders to London as a means of generating greater material support for the ongoing war against French Canadians and their Indian allies. Concerned by French intrusions on their own hunting and trading interests, the Iroquois chiefs, speaking through translators, personally petitioned Queen Anne's help, for otherwise "we must, with our Families, forsake our Country and seek other Habitations" (cited in Bond, p. 1).

Several London artists painted portraits of the "Four Indian Kings" (cited in Bond, p. 67) and then printed inexpensive engravings to be marketed throughout

Britain and the American colonies. Prints of Verelst's full-length, standing portraits were displayed in private homes as well as in colonial government buildings from New Hampshire, Connecticut, and Rhode Island southward to Pennsylvania and New Jersey. Freely adapted and simplified for Captain Macpheadris's Portsmouth mansion, the two painted copies of Verelst's portraits appear to function as exotic guardians of the rich domestic environment. Each figure holds a weapon, one a tomahawk and the other a club. Yet their gentle, somewhat feminine features and long, flowing garments suggest a ceremonial presence consistent with their placement on a staircase landing designed for dignified processions of family members and guests.

Two decades later, Gustavus Hesselius (1682–1755), a London-trained artist from Sweden, painted two portraits of Delaware Indians for John Penn, a proprietor of the colony of Pennsylvania and son of its original founder, William Penn. Penn commissioned the portraits in 1735, shortly after he and his brother Thomas began negotiating a land dispute with the subjects of the works, Lapowinsa and Tishcohan, prominent Delaware chiefs. Within two years, Pennsylvania colonists and the Delaware tribes had signed the "Walking Purchase" treaty, which stipulated that white settlers' territory was to be expanded into Indian hunting grounds by as much of the terrain as a man could walk across in a day and a half. The Penns, however, chose athletic runners rather than walkers to claim over sixty miles of property, twice the distance that the swindled Delaware chiefs had expected.

Hesselius's two portraits (figs. 1.22–1.23) have been praised for their naturalism and their transcendence of conventional stereotypes. As Philadelphia's leading

1.22 (left) **Gustavus Hesselius** *Tishcohan*, 1735.

Tishcohan, 1735. Oil on canvas, 33 \times 25 in (83.8 \times 63.5 cm). Historical Society of Pennsylvania, Philadelphia.

1.23 (right) Gustavus Hesselius

Lapowinsa, 1735.
Oil on canvas, 33×25 in (83.8 x 63.5 cm). Historical Society of Pennsylvania, Philadelphia.

portraitist, he already had achieved a reputation for realism. James Logan, a jurist and William Penn's former secretary, wrote to his brother in 1733: "We have a Swedish painter here, no bad hand, who generally does Justice to the men, especially to their blemishes, which he never fails showing in the fullest light" (cited in McCoubrey, p. 5). A deeply religious man, Hesselius later associated himself with the Moravian community in Bethlehem, Pennsylvania (see pp. 52–54). This devout, mystical group of immigrants from Central Europe established close ties with Native American tribes, the better to convert them to Christianity.

Hesselius's *Tishcohan* represents the features of an aging man with a wrinkled brow, bulbous nose, and sunken, careworn eyes (see fig. 1.22). But the figure's firmly set jaw and piercing gaze also suggest a powerful individual who directly engages us and demands our respect. The painting glows with light reflected from the brick-red flesh of Tishcohan's face and bared torso. Hesselius derived this red pigment from pyrite, a locally available mineral popularly known as fool's gold because its color often deceived excited gold prospectors. Hesselius alchemically transformed lowly pyrite into a precious pigment by burning, pounding, and grinding the iron and sulphur compound into a fine powder, which he then mixed with his binding oil medium.

Thanks to the radiant color and light, Tishcohan emerges from the darkened background as a spiritual as well as physical presence. Hanging from his neck, a chipmunk-hide pouch holds a small white tobacco pipe. The bowl of the pipe directs our attention toward the area of the heart, that organ of the body most often associated with an individual's spirit or soul. For John Penn, Hesselius's patron, the pipe's positioning may have signified Tishcohan's honesty and sincerity as a negotiator. Diplomatic treaties and trading agreements between white settlers and native tribes typically were sealed with the ceremonial smoking of tobacco. Given the fact that the Penns were attempting to gain the trust and confidence of Tishcohan and Lapowinsa, it is not surprising that Hesselius attempted to achieve dignified, sympathetic representations of the two chiefs. John Penn also may have insisted on naturalistic detail so that he could possess an accurate visual record of the characters with whom he was negotiating. Representations of facial features and expressions typically were valued as reliable indicators of states of mind and moral worth.

Whatever John Penn's deceptive intentions in negotiating with Lapowinsa and Tishcohan, Hesselius had his own reasons for representing the chiefs with such unprecedented care and dignity. As a painter who found and prepared his own colors, he may have discussed with his sitters the best local materials for making pigments. Hesselius's *Lapowinsa* represents the Delaware chief with strange markings or signs painted across his face (see fig. 1.23). Hesselius's naturalistic but exotic and mysterious portraits expressed the fascination that white settlers felt for native peoples. Many colonists believed that aboriginal Americans possessed an ancient, secret wisdom of the land and its resources. The sphinxlike silence of Hesselius's Indian chiefs contributes to their aura as wise men and guardians of nature's hidden secrets.

White Colonists as Native Americans

Anglo-American artists soon learned how to foster their own reputations for creative genius by associating themselves with the natural wisdom of noble savages. Benjamin West (1738–1820), representing the next generation of Philadelphia painters, claimed that during his youth in Springfield, Pennsylvania, a group of Indians had given him his first lessons in preparing pigments, particularly the reds and yellows "with which they

1.24 Benjamin West, The Savage Chief (The Indian Family), c. 1761. Oil on canvas, 23% × 18% in (60 × 48 cm). Hunterian Collection trustees, Council of Royal College of Surgeons of England.

West here alludes to ancient Greco-Roman sculpture as a means of ennobling his subjects and demonstrating his mastery of the idealized human figure. West's Indian warrior is stockier and fleshier than the youthful, androgynous Apollo Belvedere (see fig. 4.33). The artist establishes an ominous mood with the gloomy wilderness setting. As the worried father departs for war rather than the hunt, a child in the shadowy hut entrance at the left attempts to restrain the hunting dog from following his master.

painted their ornaments" (Galt, p. 18). From these humble, primitive origins, West became an internationally famous painter and president of the Royal Academy of Art in London. According to West's official, often fanciful, biography, written at the end of his career: "a Painter who would embody the metaphor of an Artist instructed by Nature, could scarcely imagine any thing more picturesque than the real incident of the Indians instructing West to prepare the prismatic colours" (Galt, p. 18).

As we shall see in Chapter 4, West patriotically distinguished himself as an American artist working in London by sympathetically portraying both Native Americans and white colonists wearing Indian costume (see fig. 4.21). West became a collector of moccasins, beaded hat bands, and other Native American artifacts. Visiting Rome in 1760, the artist apparently startled the city's critics and connoisseurs by brashly comparing the *Apollo Belvedere* (see fig. 4.33), a celebrated example of ancient Greek sculpture, to "a young Mohawk warrior" (cited in Alberts, p. 34). Indeed, one of the first pictures that he painted in Rome represented the family of an American Indian chief, who strikes the pose of the Greek sun god Apollo (fig. 1.24). The painting was commissioned by Colonel Joseph Shippen of the Pennsylvania militia, whose encyclopedic interest in Indian costumes, ornaments, and weapons encouraged the young West's careful portrayal of Native American figures and artifacts.

Trading and negotiating with native tribes on the frontiers of British North America, many colonists chose to dress like their Indian neighbors. During the eighteenth century, startled European visitors concluded that the untamed wilderness was regressively reshaping white settlers into the image of red savages. However, for West and many other

colonists, American Indians personified freedom from European corruption and decadence. By the eve of the American Revolution, colonists rebelling against British rule consciously identified themselves as "native" Americans. In appealing for military support from leaders of the Mohawk, Seneca, Delaware, and Shawnee tribes, colonial rebels in 1776 claimed a bond of brotherhood by virtue of the land they shared: "We are sprung from one common mother; we were all born in this big Island" (cited in Calloway, p. 1).

However, any notion of brotherhood quickly evaporated after the American Revolution. Native Americans lost their ability to play the middle ground between French and British imperial rivalries. They now faced a United States government aggressively determined to appropriate the entire continent. Motivated primarily by economic and political factors, land-hungry citizens also claimed that they had a mission to spread the Word of God and His providential rule all the way to the Pacific Ocean. However, already during the seventeenth and eighteenth centuries, religious art and architecture were transforming the American landscape. Colonial churches, meetinghouses, and devotional images expressed many immigrants' belief that the American continent rightly belonged to Christian peoples preparing for the millennium or the glorious thousand-year rule of Jesus Christ.

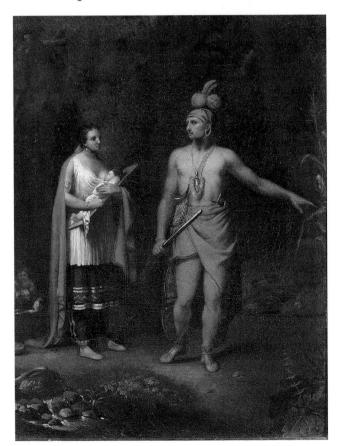

CHAPTER 2

Religious Rituals and the Visual Arts in Colonial America

1620-1760

n 1744, when Alexander Hamilton (1712–56), a Scottish-born medical doctor from Annapolis, Maryland, visited the city of Philadelphia, he wrote in his diary:

I dined at a tavern with a very mixed company of different nations and religions. There were Scots, English, Dutch, Germans, and Irish; there were Roman Catholics, Churchmen, Presbyterians, Quakers, Newlightmen, Methodists, Seventhdaymen, Moravians, Anabaptists, and one Jew. The whole company consisted of twenty-five, planted round an oblong table, in a great hall well stocked with flies. (cited in Horner and Bain, p. 363)

For Dr. Hamilton, who also traveled to Boston, Massachusetts, and Albany, New York, architecture and the visual arts merely underscored this startling lack of religious unity in America. Some "genteel" congregations of the Christian faithful favored steepled, richly decorated churches (fig. 2.1). More austere religious groups such as the Quakers seemed "to shun ornament in their public edifices as well as in their apparel or dress" (cited in Horner and Bain, p. 363) (fig. 2.2). Still others, though rejecting church decorations, purchased religious paintings for their homes (see fig. 2.13). As we shall see in this chapter, Hamilton's travelogue only begins to suggest the multicultural diversity of colonial American religious life and its material expression in the visual arts.

In large measure, the religious mosaic witnessed by Hamilton was the product of the sixteenth-century Protestant Reformation in Europe, which had shattered Christianity into a host of competing denominations of churches and sects united by charismatic leaders or strict religious practices and principles. Initially led by the German monk Martin Luther, Protestant reformers had objected to the worldly and corrupt practices of the Catholic Church headed by the pope, who, from his Vatican palace in Rome, claimed to rule over all of Christendom as Christ's vicar or representative on earth. The Catholic Church not only regulated the spiritual lives of individuals from birth to death, but also exercised enormous power in the secular realm. Popes ruled like princes over the papal states of central Italy. They formed diplomatic alliances and engaged in military warfare to promote territorial, financial, and political interests. Lower in the Catholic hierarchy, other church officials also became government leaders and bureaucrats, pursuing worldly careers rather than the spiritual welfare of individual souls. Religious practice itself became

Samuel King

Portrait of the Reverend Ezra Stiles, 1771. Oil on canvas, $33\frac{1}{2} \times 27\frac{1}{2}$ in (85.1 \times 69.9 cm). Yale University Art Gallery, New Haven, Connecticut. Bequest of Dr. Charles Jenkins Foote, B.A. 1883, M.D. 1890.

On a pillar to Stiles's right, King drew an emblem of the planetary system. In the background, the Hebraic name of God is encircled by flamelike spots and lines that signify the intellectual world's inclination towards the divine. The words ALL HAPPY IN GOD arch over the Hebrew letters. Christ's cross stands at the bottom of the emblematic circle, while a black spot to the left of the cross symbolizes moral evil, a space infinitely smaller than God's perfected universe.

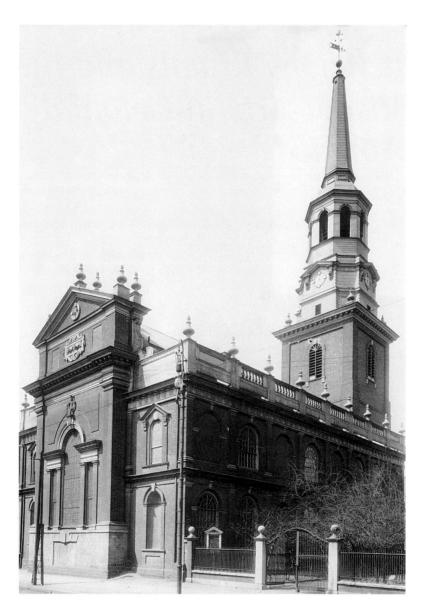

2.1 Dr. John Kearsley Christ Church, Philadelphia. Pennsylvania, 1727-54. The Essex Institute, Salem, Massachusetts

This Anglican church, with its 196-foot-tall steeple, was designed after classical, Renaissance-inspired English structures by the London architects Sir Christopher Wren (1632-1723) and James Gibbs (1682-1754), particularly Gibbs's templelike masterpiece, St. Martins' in-the-Fields (1726). At Christ Church's east end, beneath a triangular pediment and heavy cornice, a large tripartite window, styled in the manner of the Italian Renaissance architect Andrea Palladio (1508-80), pierces the wall to illuminate the chancel, site of the altar's sacramental rituals.

corrupted by the Church's increasing need for money. The Vatican treasury benefited enormously from the systematic sale of "indulgences," or pardons, which officially remitted God's just punishment for a person's sins. The wealthy particularly had the power to purchase indulgences, "buying" their way through heaven's gates.

Cementing his political alliance with Spain, Pope Alexander VI issued a bull, or declaration, in 1493 granting the unexplored western lands discovered by Columbus to Queen Isabella and King Ferdinand. In return, the Spanish king and queen promised to convert native inhabitants of these new territories to Christianity. With the European discovery and conquest of the New World led by Catholic Spain, the Vatican could envision global missions and a truly universal Church. On the other hand, doctrinally and ethnically diverse Protestants viewed America as a tabula rasa, where a true Christianity could begin afresh by returning to its primitive, biblical origins antedating papal corruption.

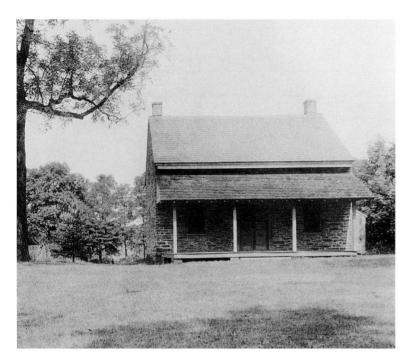

2.2 Quaker Meetinghouse Stony Brook, New Jersey, 1760. New Jersey Historical Society.

Many Protestant denominations became established in Europe as state churches under the protection and governance of Protestant princes and monarchs. Protestant faiths displaced Catholicism primarily in northern Europe, including Scandinavia; the Netherlands; various parts of Germany; Scotland; and England. Founded as a state church by King Henry VIII, the Anglican Church, or Church of England, became officially Protestant in 1559 under Elizabeth I. Nevertheless, the Anglican Church retained many aspects of Catholic ritual and organization, including a hierarchical governing structure of bishops and archbishops that enforced religious uniformity and laws against heresy and blasphemy. In America, Anglicanism became the established, tax-supported religion in England's various middle and southern

colonies. Virginia was the first colony to legislate a formal establishment of the Church of England, in 1632. Others followed much later, but not without much dissension from non-Anglicans: New York (1693), Maryland (1702), North Carolina (1701), South Carolina (1706), and Georgia (1758).

European Protestant state churches generated intense opposition from more radical reform groups, further fracturing Christian unity. "Puritan" reformers became dissatisfied with the Church of England's failure to purge religious practice of Catholic, "popish" rituals. Following the teachings of the theologian John Calvin in Geneva, Switzerland, most Protestants in England, the Netherlands, and elsewhere sought to reform the sacrament of Holy Communion, which reenacted the sacrificial death of Christ, the Son of God. During the ceremony, the officiating priest placed bread and wine upon the altar and through an act of "transubstantiation" miraculously facilitated the divine transformation of food and drink. While the bread and wine maintained their "accidental" physical appearance, they now contained the body and blood of Christ, or His "real presence." Though only priests drank the wine, members of the congregation ingested the body of Christ, spiritually nourishing themselves with His supernatural being.

The Swiss reformer Ulrich Zwingli charged that Catholics committed not only idolatry but also cannibalism when they insisted that Christ was literally present in the sacramental bread and wine. For Calvin, Christ was only spiritually present when the bread and wine were converted into a symbol of God's infinitely higher being. The Church of England generally adopted the Calvinist interpretation of Holy Communion but retained many of Catholicism's ceremonial trappings despite the objections of Puritans. Puritans refused to kneel at the altar before the bread and wine because this worshipful gesture suggested the veneration of idols. In their own observances, Puritans preferred to perform the sacrament as a "Last Supper," or communal meal of both the bread and the wine. This dinner ritual stressed spiritual sharing rather than the mystical authority of officiating priests.

Protestants feared the idolatrous potential of religious images in the church. They regarded these as priestly instruments for keeping worshipers, particularly the illiterate, from knowing the true Word of God as written in the Holy Bible. Puritans objected even to the Anglican clergy's Catholic practice of making the hand sign of the cross. Like the act of transubstantiation, this gesture of blessing was condemned as a form of magical trickery, because it suggested that priests possessed power to conjure forth the presence of Christ, who had suffered and died upon the cross.

During the seventeenth century, many Puritans followed dissenting Separatist groups such as the Pilgrims to America, particularly to New England, where they hoped to found a spiritual beacon of religious truth and purity for the rest of the world. New England Puritans and Pilgrims rejected the authoritarian powers of bishops by adopting a Congregationalist form of self-government whereby each local congregation hired its own clergyman and controlled religious life within the community. However, the network of Congregationalist churches in Massachusetts, Connecticut, and New Hampshire also became an established, tax-supported religion that tended to be intolerant of dissenting views. Called upon by the Massachusetts legislative assembly, Congregationalist clergymen met at a synod in 1648 to pass the Cambridge Platform, a mission statement to guide the practices of local churches.

Many dissenters from New England orthodoxy, particularly Baptists and Quakers, fled to Rhode Island, where Roger Williams (1603–83), the colony's clergyman-founder and governor, instituted religious freedom and a separation of Church and state. Elsewhere, in Pennsylvania, the Quakers, under the leadership of William Penn, had also established a colonial government that promoted religious toleration. Having suffered persecution in both England and New England, American Quakers taught pacifism and an inner-light faith of direct communication between individual souls and God without the need for clergymen to act as intermediaries. Before his arrival in Pennsylvania, Penn had published an important treatise, *The Great Case of Liberty of Conscience* (1670), which argued for the right of all individuals to be left free of coercion in matters of religious belief. Nevertheless, as we shall see, Quakers observed strict moral practices within their own communities and harbored a strong distrust of the visual arts as a form of luxury.

Colonial Alternatives to Christianity

The presence of a Jew at Alexander Hamilton's dinner table emphasizes the fact that Christianity faced more challenges than just its own internal divisions. Non-Christian religions and secular systems of belief contributed to the cultural diversity of colonial America. In cosmopolitan Philadelphia, Hamilton discovered urbane colonists, who were happily unaffiliated with any Christian church or meetinghouse:

I intended to have gone to church or [Quaker] meeting to edify by the Word, but was diverted from my good purpose by some polite company I fell into, who were all utter strangers to churches and meetings. But I understood that my negro Dromo very piously stepped into the Lutheran Church to be edified with a sermon preached in High Dutch, which, I believe, when dressed up in the fashion of a discourse, he understood every bit as well as English, and so might edify as much with the one as he could have done with the other. (cited in Horner and Bain, p. 364)

2.3 Anonymous Wrought-iron figure, Alexandria, Virginia, late 18th century. Height 11 in (27.9 cm). Smithsonian Institution, Washington, D.C.

Despite Hamilton's suggestion that his black servant was instinctually drawn to virtually any Christian religious service no matter what the particular church or language, African Americans were not inherently attracted to Christianity. While slavery largely destroyed traditional African religions in America, many slave owners were reluctant to have their slaves instructed in the Christian faith, fearing that biblical stories such as the Jews' exodus from servitude in Egypt would only encourage rebellion.

Visual remnants of African religious practices have been discovered in colonial America. In Alexandria, Virginia, a wrought-iron figure was excavated from what was once the site of a blacksmith's shop and slave quarters (fig. 2.3). The figure's stiff, ritualistic pose and formal characteristics suggest its cultural kinship with West African iron figurines crafted by Bamana blacksmiths in Mali. The Bamana, members of the Mande peoples, constituted a significant percentage of Africans sold into American slavery. Though its precise meaning and purpose remain unknown, the

American slaves sought to communicate with African spirits and gods through cult objects and ceremonies. Other excavations of slave quarters in Maryland, Virginia, and South Carolina have uncovered polished stones, crystals, beads, shells, pierced coins, and ceramic objects that archeologists have related to bun-

Virginia wrought-iron man suggests that some

dles of magical charms. Deriving from West African religious practice, cloth- or leaf-bound bundles of objects were created as *nkisi*, or sacred medicine. Placed near hearths and doorways, the bundles protected households against disease and misfortune. Seeking to manipulate spirits inhabiting the earth, creators of bundles chose both organic and inorganic materials to divine secrets and predict the future. Colored crystals were especially prized for their prophetic and healing powers, while white buttons, stones, shells, bones, and other materials signified the vitalistic life of the underworld. Forced to submit to the humiliation of slavery, African Americans attempted to empower themselves through occult practices that magically manipulated nature's spiritual forces.

Colonial Magic and the Christian Response

However, interest in magic and the occult was not confined to African slaves. Throughout the Anglo-American colonies, clergymen were forced to compete with fortune-tellers, healers, and other "wise" men and women, who practiced various forms of popular magic and folk medicine. In seventeenth-century New England,

farmers sometimes erected "spirit stones" featuring crudely carved figures and magical signs that were intended to protect property and homes from evil spells and demons (fig. 2.4). Colonists also warded off unwanted spirits by decorating doorposts or entrances with horseshoes and other potent charms. Families purchased yearly almanacs filled with occult folklore and illustrated with astrological charts and signs of the zodiac, which prophetically aligned individuals and their future lives with movements of the planets and stars (fig. 2.5). While Protestant clergymen often denounced non-Christian occultism and Catholic superstitions, most colonial almanacs were actually written by ministers, who also enthralled readers with tales of God's many wonders that seemed to foretell future events and even the end of the world. Convinced that the Bible was the literal truth or inspired Word of God, colonial clergymen believed that the universe was filled with both good and evil spirits: angels; ghosts; and Satan, the prince of evil, who could magically disguise himself in almost any form. Since miraculous events and supernatural phenomena fill the pages of the Bible, colonists were inclined to give credence to contemporary wonder-inducing stories such as that of a thirty-week-old child prophesying in clear English: "it will be an hard world & you shall know it" (cited in Hall, p. 83). Laymen and clergymen alike gazed upward into the skies, interpreting comets, meteors, and violent flashes of lightning as ominous supernatural portents of things to come.

From Virginia to Massachusetts, institutional Christianity attempted to root out pagan occult practices by conducting witch-hunts and witch trials. The Bible warned of the existence of witches and the terror of Satanic or demonic possession.

In Virginia from 1626 through 1705, at least nineteen people were charged with witchcraft. However, in New England, hundreds stood accused of black magic or of casting evil spells. In Salem, Massachusetts, colonial witch-hunting hysteria reached a peak in 1692, when 200 individuals were executed after inquisitorial trials that admitted as evidence forced confessions and purported eyewitness accounts of ghostly, spectral images. By a ratio of more than four to one, witch trials targeted women. Women were stereotypically defined by their bodies or sexual natures and were, therefore, regarded as more vulnerable to the temptations of demonic beings.

During the eighteenth century, the fear of witches declined among the educated elite. However, various occult practices and beliefs continued to appeal to a wide spectrum of the population. Toward the end of the century, the Reverend Ezra Stiles, president of Yale College from 1778 to 1795, was one of many intellectuals who expressed strong interest in the occult science of alchemy. An avid letter writer, the Congregationalist clergyman was in correspondence with American alchemists who claimed to possess a magical "philosopher's stone" that enabled them to transform base metals into gold or, alternatively, to create a universal elixir to cure all illnesses and prolong human life. Stiles even communicated with a Jewish rabbi from Poland about alchemical secrets and became interested in the Jewish mystical tradition of the Kabbala, which alchemists frequently relied upon as a source of divine wisdom and uni2.4 Boundary marker
Newbury, Massachusetts,
1636–50. Diorite, 51½ in
(130.8 cm) high, 28½ in (72.4 cm) wide, 11½ in (29.2 cm)
deep. Witchstone Farm,
Byfield Parish, Newbury,
Massachusetts. American
Antiquarian Society. The D.
and J. L. Farber Collection of
Gravestone Photographs.

This undated boundary stone belonged to Richard Dummer (1598-1679), a farmer and mill owner from Newbury. It relates to four stone thresholds, the earliest dated 1636, that once guarded doorways to his house. All feature mysterious signs. In the upright boundary marker, trespassers or evil spirits would have encountered the stern, glaring image of a man standing with arms akimbo in a confrontational pose.

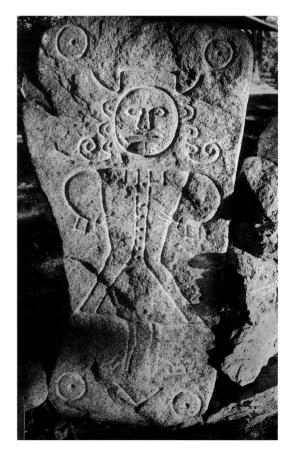

2.5 John Foster

"The Dominion of the Moon in Man's Body," from An Almanac of Coelestial Motions for the Year of the Christian Epocha 1678, Boston, 1678. American Antiquarian Society, Worcester. Massachusetts.

Since the Middle Ages, almanacs, or calendars of the heavens, included the Man of Signs, who personifies the ancient belief that human health is connected with the motions of the universe. Foster's figure is encircled by the twelve names and signs of the zodiac corresponding to twelve constellations and twelve parts of the body. Fortune-tellers and doctors warned that different organs or limbs were vulnerable to affliction, depending on lunar, stellar, and planetary movements.

versal knowledge of God's creation. Before becoming president of Yale, the Newport, Rhode Island, clergyman had his portrait painted by Samuel King (1749–1819), a largely self-taught artist (see p. 38). Under Stiles's direction, King included in the portrait occult, Kabbalistic symbols of the cosmos centered on the mysterious tetragrammaton, or the Hebraic holy name of God. Alchemical treatises of the seventeenth and eighteenth centuries often included illustrations of the tetragrammaton, from which God's attributes and creation were held magically to flow. While Stiles reconciled alchemy and Jewish mysticism with Christianity, other eighteenth-century Americans cultivated an interest in such esoteric subjects as a means of discovering religious truths historically antedating and superseding Christianity. Thus, the itinerant Dr. Hamilton (as we shall see in the next chapter) belonged to the secret fraternity of Freemasons, whose devotion to ancient, occult wisdom offered many colonial men a potential alternative or supplement to traditional Christianity.

Catholic Art in Spanish America

During the sixteenth century, before the English settlement of North America, Catholic Spain had established New Spain, a vast imperial territory that stretched from Peru in South America northward to the area of the Colorado River. The northern part of New Spain, which later in the nineteenth century became part of the United States, was a sparsely populated frontier. It consisted of small settlements of farmers and soldiers as well as mission churches constructed by Indian labor, mostly under the direction of Franciscan friars. Founded in the thirteenth century by St. Francis of Assisi, the Franciscans were an order of Catholic brothers. They took vows

of chastity and poverty and dedicated themselves to the itinerant preaching of the Christian faith. By the 1630s, dozens of mission churches had been constructed in Florida and New Mexico. While the Spanish monarchy primarily valued its American colonies for their gold and silver, missionaries hoped that the conversion of Native Americans would signify the advent of a new millennial age in the history of Christianity. During this thousand-year period, Christ's Word would spread to the four corners of the world in preparation for God's Last Judgment. During the millennium, all peoples of the earth would have the opportunity to convert to Christ, thereby escaping eternal damnation in Hell.

The Mission Church of San Estevan

No site in New Spain appeared more like one of the remote four corners of the world than the mission church of San Estevan at Acoma, New Mexico, a small Pueblo Indian village southwest of Santa Fe (figs. 2.6–2.7). Friar Francisco Atanasio

2.6 San Estevan
Acoma Pueblo, New Mexico.
Photograph by Ferenz Fedor,
c. 1940. Museum of New
Mexico, Santa Fe, New
Mexico.

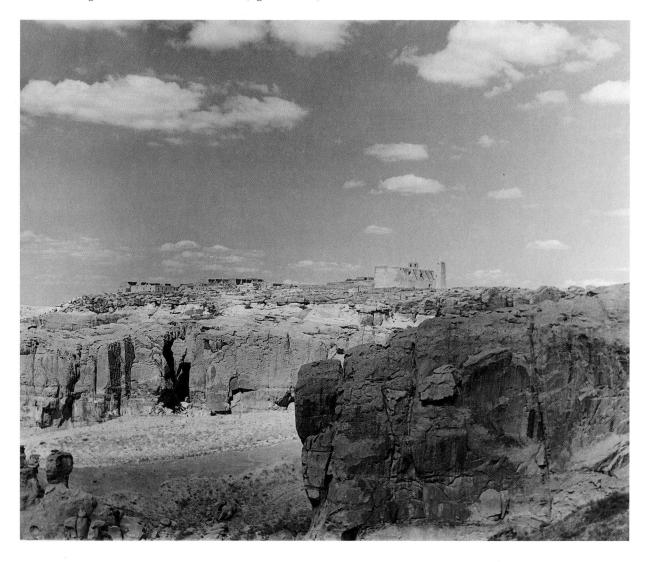

2.7 San EstevanAcoma, New Mexico, 1629-42.
Museum of New Mexico,
Santa Fe, New Mexico.

Though far different in its unornamented austerity, San Estevan's twin-tower facade distantly descends from the cathedrals of medieval Europe. More immediately, it originated from churches in Spain and Mexico, particularly the great cathedral in Mexico City, begun during the late sixteenth century. Minimal fenestration contributed to the mission's military defense and helped insulate the building against temperature extremes. A single small window pierces the main facade to illuminate the choir loft, while only two south windows light the nave.

Domínguez (1740–c.1805), a Mexican-born Franciscan, observed in 1776 that the buildings of Acoma are situated high above the surrounding desert plain "on the flat top of a mesa" 350 feet high (p. 188). Resembling a cliff with "such horrible precipices that it is not possible to look over them for fear of the steep drop" (p. 189), the mesa conveyed the image of an almost impregnable fortress:

The ascent . . . is a sandy and very difficult slope (there are many footpaths leading up, which only the Indians manage with skill). It begins on the west side of the mesa, ascends almost halfway, and from there on makes a number of boxed-in turns, so difficult that in some places they have made wide steps so that the pack animals may ascend with comparative ease. (p. 188)

Domínguez described Acoma as an incomparably difficult mission site, since "there is not even a brook, earth to make adobes, or a good cart road. . . . This makes what the Indians have built here of adobes with perfection, strength and grandeur, at the expense of their own backs, worthy of admiration" (p. 189).

Despite Acoma's forbidding geography, Spanish soldiers under the leadership of the explorer-conquistador Juan de Oñate successfully overcame Native American resistance and captured the mesa in 1599, killing 500 men and 300 women and children. The 580 Indian survivors, most of whom were women and children, were forced into servitude. Surviving men over the age of twenty-five also suffered mutilation, as Spaniards severed one foot from each as insurance against future rebellion.

Understandably, after this violent beginning, missionary activity was slow to bear fruit at Acoma. However, thirty years after the 1599 conquest, Friar Juan Ramírez supervised newly converted Acoma Indians in the construction of a large, two-towered church, made from fieldstones and adobe. The adobe mixture of clay, sand, and water was "puddled," or layered, by Indian women to create walls many feet thick. Since there was neither sufficient water nor loose rocks and soil on top of the mesa, most of the building materials had to be transported up the narrow trail from the valley floor below. The massive, severe church was approximately 145 feet long, 45 feet wide, and 30 feet high. Situated at a short distance from the Pueblo village, the structure loomed over the lowprofile communal dwellings of the native population. Missionaries intended these monumental, fortresslike churches to awe Native Americans with the superior grandeur of the Christian God.

Borrowing from a long tradition of Catholic architecture in Europe, the building's longitudinal plan was designed to accommodate impressive ceremonial processions between the eastern entrance and the sacred, western end of the church (fig. 2.8). The long nave, consisting of a central aisle and space for worshipers, led to the sanctuary, where the clergy conducted Mass, or the sacrament of Holy Communion, over an altar decorated with Christian symbols and images. This sacramental ritual reenacting Christ's sacrificial death originally was illuminated by a hidden transverse clerestory or high window located between the roof of the nave and the somewhat higher roof of the sanctuary. Indiscernible from the nave, where the Indian congregation stood in worship, the window dramatically focused upon the altar and the sacrament of Holy Communion the light of a morning sun that metaphorically expressed Christ's ultimate Resurrection or triumph over the darkness of death. Hidden light sources were commonplace in seventeenth-century European churches and chapels. But this conventional association of sunlight with Christ fortuitously created a visual and religious bridge with Native American traditions of sun worship. Pueblo Indians assimilated the alien Christian faith and adapted it to their own spiritual needs by drawing upon their own religious experiences.

A Spanish colonial document dated 1664 reported that "the beautiful rock of Acoma has on its summit the church which is the most handsome, the paraphernalia of worship is abundant and unusual; [the church] has a choir and an organ" (cited in Kubler, p. 94). By 1680, however, the Acoma church stood in partial ruin, with its roof and clerestory window damaged or destroyed. That year, Pueblo Indians throughout New Mexico rebelled against Spanish occupation soldiers, settlers, and missionaries, killing hundreds and forcing survivors to retreat eastward to the village of El Paso in present-day Texas. The Revolt of 1680 liberated New Mexico from European domination for over a decade. According to the recorded testimony of a Pueblo Indian captured by the Spanish, Popé, the Indian rebel leader, traveled to every mission church and Pueblo village. At each location, he ordered followers to "instantly break up and burn the images of the holy Christ, the Virgin Mary and the other saints, the crosses, and everything pertaining to Christianity, and that

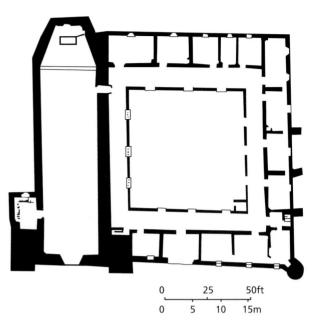

2.8 San Estevan Acoma, New Mexico, 1629–42. Plan of the church and cloister

they burn the temples, break up the bells, and separate from the wives whom God had given them in marriage and take those whom they desired" (cited in Weber, p. 136).

Native American Resistance and the Christian Reconquest

In large measure, the Revolt of 1680 was triggered by the Pueblo Indians' rejection of Christianity and its strict prohibition against native deities and customs such as polygamy. While assimilating the sun and other emblems of nature, missionaries had attempted to destroy many traditional symbols of Indian religious life. The friars particularly attacked the idolatrous kachina dolls and masks that Indians crafted to ensure good harvests by honoring spirits and ancestors from the underworld. Franciscans attempted to focus the attention of Indian converts exclusively upon the imagery of Jesus Christ, His holy mother the Virgin Mary, and a host of saintly martyrs who had died for the Christian faith. They promised Native Americans that Christian rituals, relics, and visual images surpassed the magical powers of their traditional nature gods in healing the sick, bringing rain, and guaranteeing successful harvests and hunts. Sacraments such as Baptism and Holy Communion would bring converts physical healing and prosperity as well as an eternal spiritual afterlife in heaven.

However, by 1680, most Pueblos had concluded that Christianity had not worked for them and, indeed, had become a harmful burden. Since the arrival of the Franciscan friars in New Mexico, the Pueblo population had declined by half to

17,000. In addition to war casualties inflicted by Spanish soldiers and nomadic Indian tribes, Pueblo villagers succumbed to European diseases and suffered from the forced labor demanded by missionaries and colonial officials. Despite the friars' prayers for rain, droughts were a persistent fact of nature in semiarid New Mexico. Christian magic did not surpass the efficacy of traditional religious practices in preventing crop failures or hunger.

Virtually the only Christian image to escape destruction during the Pueblo Revolt of 1680 was a small statue of the Virgin Mary, popularly known as *La Conquistadora*, or Our Lady of the Conquest (fig. 2.9). Made from painted wood and wearing a wig, colorful clothing, and jewels, the sculpture had been brought to Santa Fe from Mexico City by Friar Alonso de Benavides, who, in 1626, became chief administrator of Franciscan missions in New Mexico. In a "Memorial" that he wrote in 1630 and later revised in 1634, Benavides recalled that this image of the Virgin, which he "had placed in a chapel in the church in the villa of Santa Fe" was received with "reverence" by Indian converts, who spread word of its "great beauty" (cited in Espinosa, p. 11).

Nevertheless, by 1680, *La Conquistadora* had to be rescued from disenchanted Native American rebels. Loyal Spanish refugees built a chapel for her outside of El Paso while preparing for her triumphant return to Santa Fe. In

2.9 Anonymous *La Conquistadora*, early 17th century. Museum of New Mexico, Santa Fe, New Mexico.

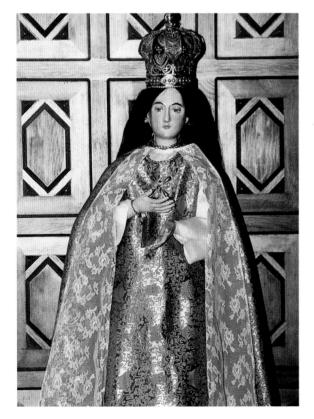

1693, General Diego de Vargas led the reconquest of New Mexico.

Back in Santa Fe, he executed seventy Native Americans who had refused to surrender. He also spent the better part of 1694 waging a military campaign against pockets of rebel resistance throughout the rest of New Mexico. However, in 1696, another organized Indian rebellion resulted in the burning of more churches and Christian icons. Afterward, colonial officials eased demands on Indian laborers and more pragmatic Franciscan friars decided to relent in their determination to eradicate traditional Pueblo religious beliefs and rituals. By the eighteenth century, Hispanic devotion to Christ tended to coexist with Pueblo reverence for ancient nature gods.

Vargas and colonial officials in Santa Fe credited their victory and the return of peace to *La Conquistadora*. Ever since the thirteenth century, the Franciscans and other religious orders had promoted a cult of the Virgin Mary. In conquering New Spain and its northern frontier of New Mexico during the sixteenth and seventeenth centuries, Franciscan friars instituted specific practices honoring the mother of Christ, including daily recitation of the rosary, a series of devotional prayers directed toward the Virgin. Indeed, the Hispanic Catholics who venerated *La Conquistadora* also called her *Nuestra Señora del Rosario*, Our Lady of the Rosary, and recited rosary prayers in her presence.

The Virgin Mary represented the Christian faith in a more benevolent, nurturing guise. In San Antonio, Texas, where Franciscans and Indian laborers constructed several mission churches, the Marian cult received one of its most elaborate expressions in the richly decorated facade of San José y San Miguel de Aguayo (fig. 2.10). Pedro Huizar, a Mexican-trained sculptor, carved the facade's many sculptures. In addition to the Virgin's welcoming image immediately over the entrance, St. Joachim and St. Anne, the Virgin's parents, flank the portal doors. The church as a whole is dedicated to the Virgin's husband, St. Joseph, who appears atop an oval window in the facade's upper level. In visually representing Mary and Joseph, the human parents of Christ, Franciscan missionaries reassured Indian converts with comforting parental intercessors or defenders of humanity before an otherwise distant Christian God.

2.10 Pedro Huizar

Portal sculpture, San José y San Miguel de Aguayo, San Antonio, Texas, c. 1770–75.

The facade of this mission church seems more sculptural than architectural. The saintly figures surrounding the portal and oval window are sculpted in high relief and appear to float within a fluid, spiritually animated space of organic, sensuous ornamentation. Although Huizar's provincial style derives from medieval Gothic sculpture, the dense figural abundance of San José's portal bears close comparison with contemporaneous Catholic Baroque churches in Spain.

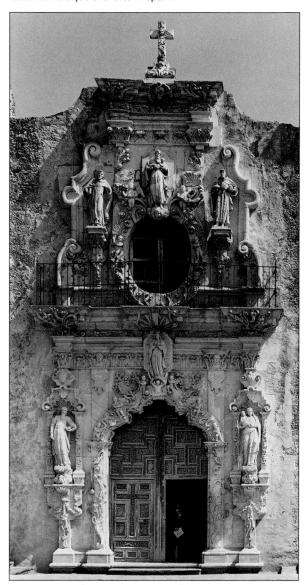

At the time of the Pueblo Revolt of 1680, no more than 3,000 Spaniards were living in all of New Mexico, and the number grew only modestly following the Reconquest. By the end of the eighteenth century, the town of Santa Fe, where

Hispanic colonists were concentrated, had a population that numbered a mere 6,000. Nevertheless, at the beginning of that century, the Spanish residents of Santa Fe celebrated their victorious return to New Mexico by initiating an annual fiesta honoring *La Conquistadora*. They also constructed a special chapel to house the cult statue. The Rosario chapel built within La Parroquía, a Santa Fe parish church dedicated to St. Francis, was completed around 1717 to facilitate civic and religious veneration of the sculpture.

El Santo Entierro and Hispanic-Catholic Ritual

While La Conquistadora had been a Mexican import, by the eighteenth century the demand for sacred images was so great that local craftsmen were increasingly called on to decorate churches and supply devotional objects. The Mexican-born Franciscan friar Andrés García (active 1747-79) took up residence in various New Mexican missions, where he crafted numerous religious images, including a sculpture of El Santo Entierro, a conventional popular type of image representing the dead Christ lying in his sepulcher (fig. 2.11). The lifesize wooden figure, which rests in the mission church of Santa Cruz, New Mexico, was carved and painted for maximum emotional effect. García liberally dripped red paint over the crucified Christ's emaciated corpse. He then placed the pitiable figure on a mattress and pillow within an open wooden casket. During Holy Week, the annual commemoration of Christ's death and Resurrection, penitents traditionally carried the sculpture in procession, seeking forgiveness for their sins. Eighteenth-century processions included flagellants, who whipped or scourged themselves as a means of physically identifying with Christ's suffering, literally mimicking the bloody corpus painted by the artist.

Such imagery had little meaning for those Indians who continued to be abused and exploited by colonial officials and wealthy Spanish landowners. In an official report written in 1750 to his religious superior within the Franciscan order, Friar Carlos Delgado blamed Spanish governors and civil authorities for

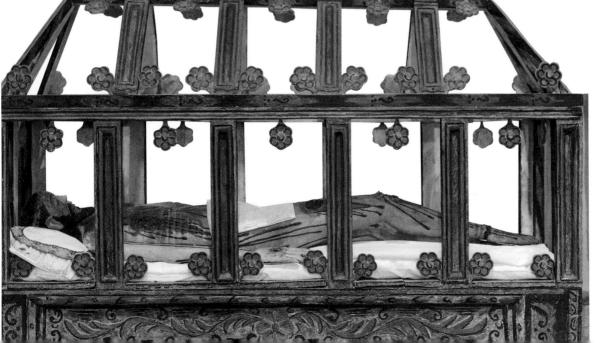

impoverishing Indians with forced labor and the confiscation of crops. As a result of these abuses, Delgado complained, the Indians "turn their backs to our holy mother, the Church, abandon their pueblos and missions, and flee to the heathen, there to worship the devil, and, most lamentable of all, to confirm in idolatries those who have never been illumined by the light of our holy faith, so that they will never give ear or credit to the preaching of the gospel" (cited in Gunn, p. 308). Unsurprisingly, most New Mexican artists were of Spanish rather than Indian heritage. Later in California, however, where Catholic missions were more successful, there was significant Indian participation in the decoration of churches.

Moravian Missions and the Depiction of the Crucified Christ

In contrast to the plethora of devotional icons in the churches of Catholic New Spain, such imagery was rarely seen in the British colonies of North America. Although Maryland was founded in 1632 as a refuge for Catholics from Protestant England, few Catholic dissenters actually settled in the colony. The anti-Catholic majority of Marylanders often resorted to vigilante violence against Catholic priests and the few Catholic churches and chapels that were constructed in the colony. The hostile atmosphere forced Maryland Catholics to worship privately and to avoid public displays of their faith.

Yet religious paintings similar to Hispano-Catholic representations of the crucified Christ did appear within the ethnically and religiously diverse culture of Pennsylvania. The Polish-born, German-trained artist John Valentine Haidt (1700-80) arrived in Bethlehem, Pennsylvania, in 1754 to support the missionary work of the Moravian Church. John Dillenberger, a theologian and historian of religion and art, has defined the Moravian Church as a "Protestant version of the Catholic tradition" (p. 35). Originating in reform movements that antedated the Lutheran Reformation of the sixteenth century, Moravian religious practice had much in common with Catholicism, including a refusal to ban biblical and devotional imagery from worship spaces. Under the leadership of the German aristocrat Count Nikolaus Zinzendorf (1700-60), settlers from Moravia in Central Europe had sought to escape religious conflict in the Old World. Establishing enduring communities in North Carolina as well as Pennsylvania, these German-speaking Moravians reacted against religious divisions within Christianity. Within Protestantism, they associated themselves with Pietism, a movement that emphasized individual piety, Bible reading, and a holy life filled with good works. Establishing missionary outposts that stretched from Greenland to South Africa and the West Indies, Moravians believed that all members of their faith had an obligation to spread Christ's message of universal salvation. More than most Protestants, they sought to convert Native Americans and African Americans to Christianity. On the Caribbean islands and later in North Carolina, converted African-American slaves became preachers or missionaries within their own communities. While many plantation owners nervously suspected Moravians of secretly plotting to abolish slavery, the European missionaries themselves became slave owners and generally remained focused on African Americans' heavenly future rather than their present bondage.

2.12 John Valentine Haidt Lamentation over Christ's Body, c. 1760. Oil on canvas, 29×33 in $(73.7 \times 83.2$ cm). The Moravian Historical Society, Nazareth, Pennsylvania.

This subject relates to the Pietà, in which the Virgin Mary mourns over Christ's body. She is here at the picture's apex but diminished in scale. The praying Mary Magdalene, a prostitute who converted to Christ, looms as a far larger presence, lower left. Haidt's distortion of scale expresses the Moravians' missionary goal of Christian conversion.

Haidt regarded his paintings as a form of religious preaching. The pictures were intended for public display in Moravian churches and mission chapels. Like his contemporary Andrés García, Haidt represented the emotion-laden subject of Christ's suffering and death upon the cross. One of his most poignant and intimate compositions is the *Lamentation over Christ's Body*, which features the Virgin Mary, Mary Magdalene, and other mourners displaying Christ's mortal wounds for the contemplative beholder (fig. 2.12). Haidt presses Christ's torn and blood-stained corpse painfully close to the picture plane, virtually inviting viewers to reach into the picture so that they might themselves touch or support the sacred body. Created for a place of worship, the Moravian Brethren's House in Nazareth, Pennsylvania, Haidt's painting visually complements the verbal imagery of Moravian hymns, which emphasize the sacrificial spilling of Christ's blood.

Though identifying with Protestantism, Moravians followed Catholic tradition by frequently practicing the sacrament of Holy Communion. Haidt's graphic, devotional representation of the dead Christ would have encouraged Moravians to believe that in eating and drinking the communal bread and wine they were

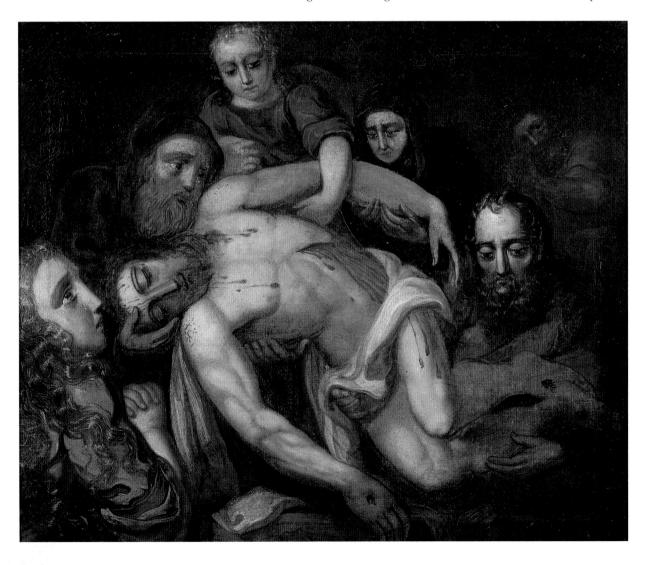

ingesting Christ's body and blood or real presence. As in the Franciscan mission churches of New Spain, intense meditation on verbal descriptions and visual images of Christ's sacrificial body led the Moravian faithful to a mystical identification with God and His visible manifestation in human flesh.

Protestant Iconoclasm and the Private Display of Biblical Art

Most Protestants attacked the idolatrous nature of Catholic religious imagery. During the sixteenth century, European Protestants became avid iconoclasts. They destroyed church icons of Christ and the Virgin Mary that decorated church facades and altars or were carried in religious processions. Reformers ridiculed Catholic priests and monks for promoting the superstitious belief that icons could facilitate miracles or magically promote health and prosperity. They feared that images within the church functioned as idols for public worship. As idols, these visual cult objects became false, material substitutes for God's infinite and essentially invisible spiritual reality.

In Boston, Massachusetts, the Puritan clergyman Samuel Willard (1640–1707) expressed strong reservations against religious images, exclaiming in one of his sermons "how very unsuitable is it to represent the Divine Nature by any Corporeal similitude." Willard rhetorically asked: "how is it possible rightly to shadow a Spirit? Whoever was able rightly to decipher the form or shape of a being which is invisible!" He ominously warned that "it is a madness and wickedness to offer . . . any Image or Representation of God" because it is essentially "Idolatrous" (cited in McCoubrey, p. 3).

Nevertheless, Willard and other followers of Calvinist theology in Europe and America made it clear that their prohibition against religious imagery applied only to ecclesiastical spaces for public worship. When Dr. Alexander Hamilton visited Albany, New York, in 1744, he saw homes of Dutch Calvinists that were decorated with paintings of biblical subjects. Calvinist reformers permitted the civil or private display of religious images as long as they represented the truths of the Bible and taught useful moral lessons.

Constituting the largest body of religious painting in British colonial America, nearly forty New York Dutch biblical pictures have survived from the first half of the eighteenth century. While the English had taken over the New Netherlands in 1664 (renaming it New York), Dutch colonial culture along the upper Hudson River valley survived well into the next century. The New York Dutch continued to use their own language and worshiped in the Dutch Reformed Church. This state church of the Netherlands had been established after 1609, when northern provinces of the Netherlands had declared their independence from Catholic Spain and established the Protestant Dutch Republic. Freed from foreign domination, the seafaring republic soon established a worldwide commercial empire and a flourishing industry in the visual arts.

When Dutch settlers arrived in America, they brought with them their taste for paintings, prints, and illustrated Bibles. During the seventeenth century, they imported art works from the Netherlands. However, by the early eighteenth century, immigrant painters from England and self-taught New York Dutch artists increasingly satisfied the market for religious pictures.

In contrast to Hispano-Catholic and Moravian artists' devotional icons focusing on the miracle-working body of Christ or the cult of the Virgin Mary, colonial New York Dutch paintings represented complex, multi-figure compositions based on popular biblical narratives. During their struggles with Catholic Spain and later with the English, the Dutch developed their national identity in relation to the stories of the Bible. They especially identified with the trials and tribulations of the ancient Israelites, as chronicled in the Old Testament.

Many of the surviving New York Dutch religious paintings represent Old Testament themes of God's interventions on behalf of the Jews, His "chosen people." Borrowing his composition from an imported European print, the anonymous painter of *Belshazzar's Feast* represented a scene from the fifth chapter of the book of Daniel, which prophesies the fall of Babylon, Israel's enemy and captor (fig. 2.13). Belshazzar, the Babylonian king, who sits at the far left of the composition, has been interrupted from hosting a lavish court banquet by the sudden appearance of a hand mysteriously writing a message on the far wall in the painting's upper-right corner. As later interpreted by the Jewish prophet Daniel, God's message foretells the death of Belshazzar and the abrupt collapse of his empire. With the fall of Babylon, God liberates the Jews from their captivity, enabling them

2.13 Anonymous Belshazzar's Feast, c. 1742. Oil on canvas, $31\% \times 41$ in (80 \times 104.1 cm). Albany Institute of History and Art, Albany, New York.

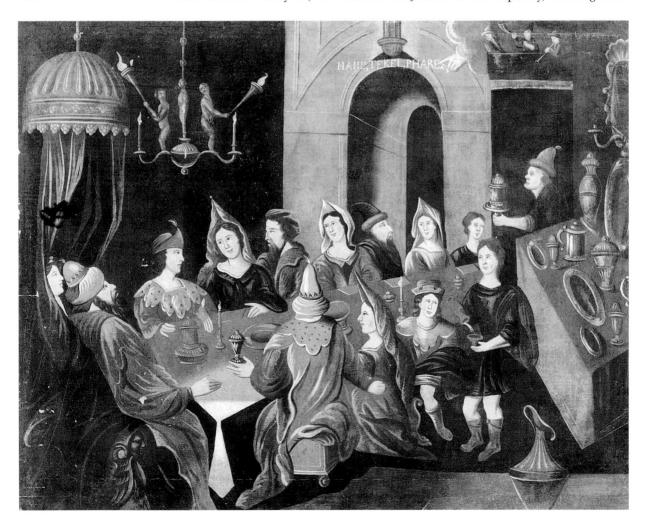

to rebuild their temple in the holy city of Jerusalem. In both the Old and New Testaments, Babylon was a code name for human sin and corruption. The visual representation of God's judgment against Belshazzar would have been appreciated as a useful reminder of the moral dangers of pride and luxury. However, for the New York Dutch patron who purchased the work, this painting also may have evoked historical associations with the Netherlands' struggle for national independence from Catholic Spain. Protestant clergyman often denounced the Catholic Church as the "Whore of Babylon" (Jeffrey, p. 827). They derived these sexual epithets from the book of Revelation, the final, visionary book of the Bible, which prophesies the Apocalypse, or the violent events leading to the end of the world and God's "Last Judgment" of humankind. Personifying the prideful, luxurious vanities of worldly evil, the Whore of Babylon appears "arrayed in purple and scarlet colour, and decked with gold and precious stones and pearls, having a golden cup in her hand full of abominations and filthiness of her fornication" (Revelation 17:4). In the Old Testament book of Daniel, on which the New Testament book of Revelation is partially based, the sinful city of Babylon stands in moral contrast to the holy city of Jerusalem.

The anonymous painter of *Belshazzar's Feast* expressed Protestant anxieties regarding idolatry and worldly corruption. Within the picture, a golden chandelier is decorated with erotic, nude figurines. The sensuous idols hold torches to illuminate a banqueting table laden with gold and silver vessels. Having been confiscated from the Jewish temple in Jerusalem, these religious artifacts are now being misused by the Babylonians for an unholy feast at which Belshazzar's "wives and his concubines" (Daniel 5:3) were among the guests.

In displaying biblical paintings within their homes, affluent New York Dutch families attempted to establish their moral standing as a pious, godly people. During the American Revolution, Peter van Schaack (1747–1832), from New York's Hudson River valley, justified the value of religious images even within churches. Remaining loyal to the British government, van Schaack was living in temporary exile in London when, in 1779, he expressed admiration for the biblical pictures decorating the stained-glass windows of Westminster Abbey. He confessed the appropriateness of such imagery in this royal church where the monarchs of England had been crowned since the Middle Ages:

The paintings on the window, against which we are apt to conceive a prejudice, as being a relic of popish superstition, have a very happy effect. Few can abstract their minds so totally from sensible objects, as to not require every external aid to their mental devotion. These should therefore be made auxiliary and subservient to the main purpose, and pour in virtue to the attentive eye. . . . The colors are vastly beautiful, and of an endless variety, no two of them being exactly alike; the light which is admitted through them is extremely pleasing to the sight, and the most interesting scenes from sacred history are there painted. (cited in Piwonka and Blackburn, p. 17)

Though not painted with biblical narratives, the glass windows of the Dutch Reformed Church in Albany were decorated with coats of arms or heraldic emblems that symbolized the European genealogical heritage and social conservatism of New York Dutch families. As suggested by van Schaack's admiration for Westminster Abbey, the Church of England took the lead in visually transforming the landscape of the British colonies with explicitly religious forms and symbols.

The Colonial Landscape Made Sacred: Anglo-American Churches and Meetinghouses

Though most early-seventeenth-century founders of the English colonies expressly dedicated themselves to the propagation of Christianity, for decades much of colonial North America remained barren of church architecture and other symbols of Christian zeal. In New England, Puritans met in meetinghouses rather than churches. For John Winthrop, the first governor of Massachusetts Bay Colony, the term "church" referred not to a building for public assembly but rather to a congregation or body of people who have sworn a covenant of faith with God. Puritans did not wish to idolize works of architecture by characterizing them as sacred places. Paid for by public taxes imposed on both church members and nonmembers, New England meetinghouses were initially designed like large homes. In fact, Winthrop's own home or parlor served for a time as a meetinghouse. Modest and crudely built, seventeenth-century meetinghouses neither appeared distinctively religious nor served exclusively religious purposes. They were regularly sites for town meetings, court trials, and other secular activities. Standing at the center of community life and its defense, meetinghouses were even used as storehouses for gunpowder.

Other denominations, such as the Baptists and Quakers in Rhode Island, Pennsylvania, and elsewhere also met in meetinghouses that purposely blended with the domestic architecture of secular life. The house form especially appealed to radical Protestant groups, who identified with the persecuted early Christians of ancient Rome and their simple worship services in private homes. The exterior of the small Quaker meetinghouse at Stony Brook, New Jersey, near Princeton, suggests nothing of its interior, religious purpose (see fig. 2.2).

Quakers particularly suffered from persecution in both England and New England. Between 1659 and 1661, Puritan authorities executed four Quakers who refused to leave the Massachusetts Bay Colony. Founded in England in 1652 by the charismatic leader George Fox, Quakerism represented an extreme form of Puritanism. Not only did Quakers reject lavish art and architecture for a humble religious aesthetic of plainness but they also abolished all church sacraments and subordinated the Bible, or the written Word of God, to the notion that every individual's inner light was a sufficient guide to absolute truth. Bible-wielding Puritans feared Quakerism's egalitarianism, which dispensed with a formal clergy and extended the privilege of meetinghouse preaching to both men and women.

Within Quaker meetinghouses, there was no grand pulpit for sermons delivered by a professional clergyman. Instead, the rectangular space was defined by rows of wooden benches grouped in sections that segregated members by sex and by age or degree of spiritual prestige. All were free to speak when moved by their inner spirit, or light; but still, all were not equal. Meetinghouse elders, overseers, and articulate lay ministers generally sat on elevated platforms at the far end of the meetinghouse facing the main body of Quakers in the central area. While Puritans and other Protestants feared the anarchic potential of Quakerism's relative egalitarianism, an individual Quaker's expression of spiritual enlightenment was carefully monitored by group approval and the collective wisdom of the meetinghouse elders. Though Quakers did not regard the meetinghouse as a sacred space, the building's unadorned interior became an emotionally charged cultural site for communally experiencing and testing statements of spiritual truth.

During the eighteenth century, as the colonies became increasingly wealthy from expanded trade with Britain, Quakers did not deny themselves the pleasures of the visual arts. But they did attempt to regulate the consumption of luxuries by recalling the words of William Penn: "are not they who sell vain and superfluous Things, exposing them at Door and Windows, Tempters of the People to the Lust of the Eye and pride of Life" (cited in Pointon, p. 407). Thus, when a young Philadelphia Quaker by the name of Elizabeth Hudson (1721–83) stitched together a silk sampler of needlework, she combined the serpentine, naturalistic pattern of leaves, buds, and flowers with a moralistic poem that warned against the vanity of "rich attire": "They in whose noble breast true vertue dwells need not so much adorn their outward shells" (fig. 2.16) (cited in Philadelphia Museum of Art, p. 44). Hudson's father was an overseer of a public school founded by Quakers. Her sampler was probably made in the school, since needlework was regarded as essential for a girl's education. While Quaker women could speak at meetings, their lives were still devoted to the domestic duties of being a good housewife and mother.

In the middle and southern colonies, where the Church of England sought to establish itself as the dominant denomination, religious conflict and spiritual lethargy left the seventeenth-century landscape largely barren of church architecture. Beginning in 1642, the English Civil War disrupted the Anglican Church's contacts with the American colonies. In 1649, Puritans and other radical Protestants forced the trial and execution of King Charles I, who had warred against the political rights of Parliament. The victorious House of Commons established a republic that officially abolished the monarchy and the Anglican Church.

The monarchy and Church of England were restored in 1660 under King Charles II. Nearly thirty years later, the Glorious Revolution of 1688–9 saw Parliament remove the Catholic sympathizer James II from the English throne in favor of two Protestants from the Netherlands, William of Orange and Mary. This more moderate revolution defended rather than attacked the Anglican Church establishment, while guaranteeing the principle of a constitutional or parliamentary monarchy.

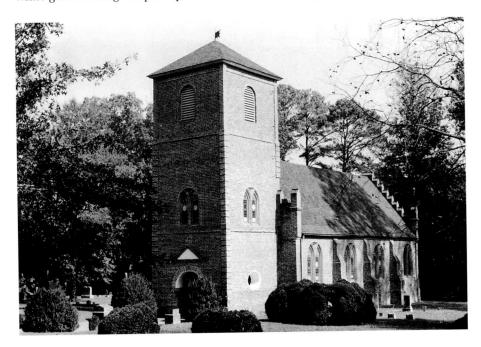

2.14 St. Luke's Church Newport Parish, Smithfield, Isle of Wight County, Virginia, c. 1680. Library of Congress, Washington, D.C.

After 1660, a revitalized Church of England began turning its attention to the American colonies. In 1650, Virginia had fewer than ten Anglican clergymen for the entire colony. By 1680, however, the number had more than tripled to thirty-five, while the number of church parishes or administrative districts mushroomed from twelve to fifty. As new parishes were established, Church of England buildings were constructed to serve the religious needs of expanding settlements and wealthier immigrant families. By 1680, approximately thirty-five Anglican churches dotted the Virginia landscape, with the number nearly doubling by 1725. Furthermore, the small wooden structures that had been built during the early decades of the seventeenth century were replaced by larger, more elegant and richly furnished churches. Aristocratic Virginians regarded houses of God as reflections of their own gentlemanly status. According to the architectural historian Dell Upton, "The Anglican Christ was an English Lord" and His residence was that "of the greatest gentleman in the neighborhood" (p. 164). The vestrymen, or wealthy parishioners who administered church affairs, conducted parish business meetings like an exclusive social club and often had their names inscribed on plagues affixed to church walls.

St. Luke's Church in Newport parish, Isle of Wight County, is Virginia's oldest surviving church (fig. 2.14). Many have claimed that this small parish church, located in a rural setting, dates from 1632, but recent scholarship strongly suggests

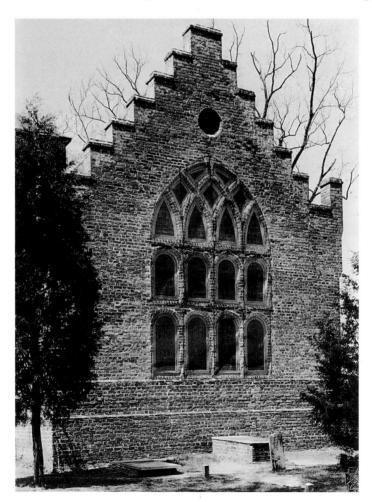

2.15 St. Luke's ChurchNewport Parish, c. 1680.
Exterior view of southeastern end. Library of Congress,
Washington, D.C.

St. Luke's stepped gable creates a parapet, or low wall, along the steeply pitched roof. This decorative motif was imported, via England, from Flanders and the Netherlands. The Virginia church's gabled profile closely resembles those of earlier and contemporaneous English parish churches.

that it was built fifty years later. During the early seventeenth century, Virginians were economically and architecturally ill-prepared to undertake construction of brick buildings, particularly on the elaborate scale of St. Luke's with its lofty tower and ornamental tracery windows. Like the Catholic mission churches of New Spain, St. Luke's openly announced its religious purpose as a sacred space or house of God. The church's threestory tower was a rarity in Virginia and surely had the intended effect of inspiring reverential awe within most parishioners, who traveled from small, wooden homes to the relatively grand religious site. In deciding St. Luke's design, church vestrymen sought to establish continuity with rural England's parish churches and chapels, which were dignified by sturdy medieval towers, wall buttresses, and tracery windows. Following the religious strife of the English Civil War, St. Luke's architectural forms evoked comforting associations with the traditional piety and pre-Reformation harmony of the Middle Ages. On the other hand, a small triangular pediment over a round-arch doorway triggered even more ancient and venerable associations with classical Greek and Roman temples and with the churches of early Christian Rome. The art of ancient Rome had been revived during the Renaissance as an expression of rational geometric order and

clear, simplified forms. During the eighteenth century, following the lead of London architects and builders, Virginia Anglicans would reject medieval decorative elements in favor of more austere church exteriors that had classical, pedimented doorways as their dominant feature.

St. Luke's substantial presence within the Virginia countryside reassuringly symbolized the apparently irreversible taming of the American wilderness. Almost twice as long as it is wide, St. Luke's was designed for church rituals and processions that focused on an altar at the far eastern end of the church. On the building's exterior, heavy, stepped buttresses alternate with round-arch, tracery windows to divide the side walls into four bays, thereby emphasizing the length of the church and its ceremonial purpose. A three-tiered tracery window (fig. 2.15) illuminates the altar wall with an eastern, morning light. The intersecting Y-shaped tracery of brick flames upward to the arched top of the window, creating a pronounced visual climax for the church's exterior and interior. Above the large window, a small oculus, or circular window, floats beneath the pyramidal, "crow-stepped" gable, terminating the high-pitched roof.

Like the Franciscan mission church in Acoma, New Mexico (see fig. 2.7), St. Luke's generous illumination of the chancel or altar area metaphorically equated

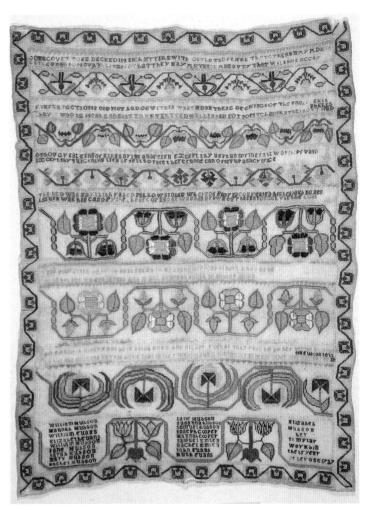

2.16 Elizabeth Hudson

Sampler, 1737. Linen plain weave with silk embroidery in satin, 15½ × 11½ in (39.4 x 28.6 cm). Philadelphia Museum of Art, Pennsylvania. Purchased with funds from Robert L. McNeil, Jr., Trusts.

The lines of Hudson's moralistic poem alternate with the horizontal bands of floral motifs. The verses were based on Genesis 28:10-12. This biblical text narrates the story of Jacob, the Jewish patriarch, who rested on a stone pillow in the wilderness and dreamt of a ladder rising toward heaven.

the light of the sun with the divine light of Christ. Like St. Luke's tower, the vertical thrust of both the three-tiered window and the stepped gable expresses Christianity's traditional desire for spiritual ascent beyond the dark confines of mere earthly life. Mimicking the shape of the sun or God's "all-seeing" eye, the oculus provides an additional geometric accent to suggest that the parishioners of St. Luke's are in moral harmony with Divine Providence. During the eighteenth century, partly inspired by English design books, ocular images decorated pulpits in several colonial churches and meetinghouses (fig. 2.17). The circular symbol, projecting rays of light, conveyed the sobering lesson that all of humanity is under God's constant surveillance. As we shall see in the next chapter, the all-seeing eye became especially popular among colonial Freemasons, a religious-minded fraternity that equated God with light and enlightened wisdom (see fig. 3.30).

2.17 Hexangular pulpit with all-seeing eye decorating the sounding board or type. Plate CXIV from Batty Langley's City and Country Builder's and Workman's Treasury of Designs, 3rd edition (London, 1750). Henry Francis du Pont Winterthur Museum Library. Collection of Printed Books.

The construction of Anglican churches accelerated in the British colonies with the foundation in 1701 of the Society for the Propagation of the Gospel in Foreign Parts (SPG). As a missionary force for the Church of England, the SPG recruited clergymen for Christian preaching and supported the construction of parish churches in new and distant settlements. With encouragement from the SPG, the small St. James's Church in Goose Creek, South Carolina, was designed and financed by wealthy plantation owners who had recently emigrated from the island of Barbados in the British West Indies (fig. 2.18). Construction of the church began shortly after 1706, when the South Carolina General Assembly declared the Church of England

the established, tax-supported religion of the colony. Following instructions from the Barbados planters, carpenters and craftsmen built the church with bricks, which they then covered with a smooth stucco that was originally painted brick red with white ornamental accents.

Unlike St. Luke's stylistic evocation of the Middle Ages, St. James's Church typified the English and colonial American trend toward a classical vocabulary of architectural forms. Borrowing from Greek temple architecture, the entrance to Goose Creek Church is enframed by two pilasters (engaged columns) that support an entablature (a decorative horizontal beam) and a pediment (a triangular space for displaying sculpture). This borrowing of classical motifs from ancient temples recalled the apostolic period of early Christianity, when Christ's apostles or disciples, led by St. Paul, pioneered as Christian missionaries, preaching the message of Jesus in Greek cities and other settlements throughout the Roman Empire. For England's leading architect of the late seventeenth century, Sir Christopher Wren (1632-1723), classical architecture and its revival during the Italian Renaissance of the fifteenth and sixteenth centuries suggested a purer, more human form of Christian practice rooted in the sermon and the spoken Word of God. Following the violent

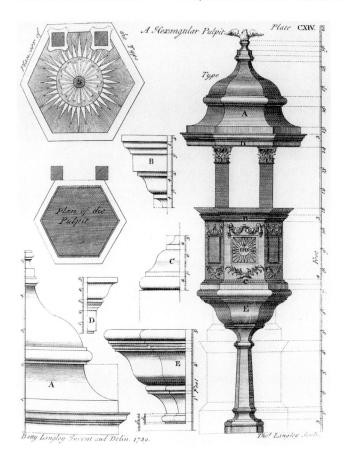

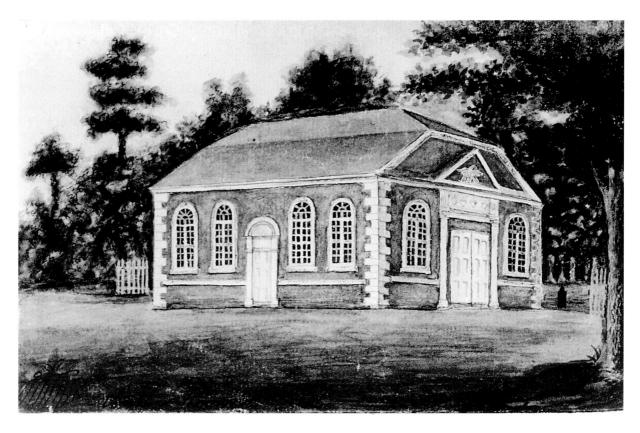

religious zealotry of the English Civil War, most Anglicans in England and America chose classical designs and motifs for their churches because they reassuringly expressed social and cultural ideals of rational harmony and emotional balance.

The "Goose Creek Men," the South Carolina plantation owners who supervised construction of their parish church, explicitly declared their allegiance to the Anglican Church and its missionary goal of civilizing America with Christian emblems and classical forms. Within the triangular pediment over the entrance door, a relief sculpture representing a pelican feeding a nest of young with its own blood greets visitors to the church. This image is a traditional symbol signifying Christ's selfless act of sacrifice for the salvation of humankind. Images of the Christlike pelican were sometimes engraved onto silver vessels carrying the wine for the sacrament of Holy Communion (fig. 2.19). More specifically, however, the SPG had appropriated the image of the self-sacrificing bird as its official emblem. The Goose Creek Church demonstrates that American Protestants could overcome their fears of idolatry by decorating their houses of worship with visual signs or mysterious emblems of the Christian faith, rather than with imagery based on Christ's human form. Craftsmen also modified the classical frieze or horizontal band immediately below the pediment to include a row of flaming hearts, which may commemorate the Christian Pentecost, when, according to the Bible, "cloven tongues" (Acts 2:3) of fire miraculously descended upon the heads of Christ's apostles, symbolizing their hearts' infusion with the Holy Spirit and their mission to preach the word of God with "other tongues" (Acts 2:4) or languages. Finally, the keystones at the top of each arched window are carved with small heads of cherubs, or angels. Compared

2.18 Charles Fraser

St. James's Church, Goose Creek, South Carolina, 1708-19. Watercolor on paper, c. 1800. Gibbs Museum of Art/Carolina Art Association, Charleston, South Carolina.

Despite its small size and lack of a bell tower, St. James's Church possesses a certain monumental grandeur, thanks to the generous round-arched windows, pedimented entranceway, and the use of quoins, or large, dressed stones at the corners of the building. Charles Fraser (1782-1860) was a Charleston, South Carolina artist, who mostly painted miniature portraits in addition to architectural, topographical views such as this one.

with the elaborate facades of some Catholic mission churches in Hispanic America (see fig. 2.10), these Christian sculptural motifs do little to disrupt the cool, rational austerity of St. James's exterior design.

Having originated from within the Anglican Church, even New England Puritans were not the rigid iconoclasts caricatured in traditional accounts of American colonial history. Far from rejecting art and architecture, Puritans developed a "plain" style in the arts that shared in the taste for classical order and clarity. The Old Ship Meetinghouse in Hingham, Massachusetts, the only surviving seventeenth-century meetinghouse, visually expresses Puritan strictures against Catholic rituals and religious images (figs. 2.20–2.21). But the building's plain interior was itself an image that positively symbolized the Puritans' return to early Christian first principles or the "primitive" order of worship sanctioned in the Bible. The rectangular, virtually square, plan of the Hingham meetinghouse was specifically intended to discourage the idea of elaborate religious ceremonies. The main entrance is on one of the long sides of the building, while the pulpit inside is directly opposite. Thus, unlike Catholic or Anglican worship spaces, the Hingham meetinghouse has no long nave or central aisle for priestly processions. Nor did it have a fixed altar for the celebration of Holy Communion. Like domestic diningroom tables, Puritan communion tables were made of wood and could easily be moved for the convenience of the congregation. With a lofty ceiling shaped like an inverted ship's hull, the Hingham meetinghouse was designed primarily as an auditorium for the preaching, singing, and hearing of God's Word.

While the Hingham meetinghouse is free of paintings and sculptures, one must imagine this austere space enlivened by worshipers seated in the rows of wooden

box pews. For Puritan clergymen, God's image was everywhere, engraved on the hearts of the Christian faithful. Members of New England's Congregationalist churches thought of themselves as living images of God. Especially during religious services God's glory manifested itself visually through the spiritual radiance and moral bearing of God's elect, singing psalms or listening intently to sermons. As ardent Calvinists, Puritan Congregationalists believed that God had predestined or elected to save only a chosen few from eternal damnation. Membership in the congregation was restricted to those saints who could prove to church elders that they had experienced a genuine religious conversion to Christ. The conversionary experience was not an act of personal will but was entirely the work of God, whose predestined grace made it possible for an individual sinner to become spiritually reborn. Puritan clergymen became experienced connoisseurs or critics in reading human faces and bodily gestures for visible signs of God's election.

By the early 1680s, when the Old Ship Meetinghouse was first constructed, most New England congregations had relaxed membership requirements to include individuals who had been baptized but had not yet undergone a religious conversionary experience. This new inclusiveness intensified debates over who was truly elect. Many argued that these so-called half-way members (Butler, p. 60) were

2.19 John Potwine
Silver flagon, c. 1720–30,
13% in (34.6 cm) high, 4% in
(11 cm) diameter. The Gift of
Mrs. Lemon to the First
Church of Christ in
Charlestown, Massachusetts.
Yale University Art Gallery,
New Haven, Connecticut.

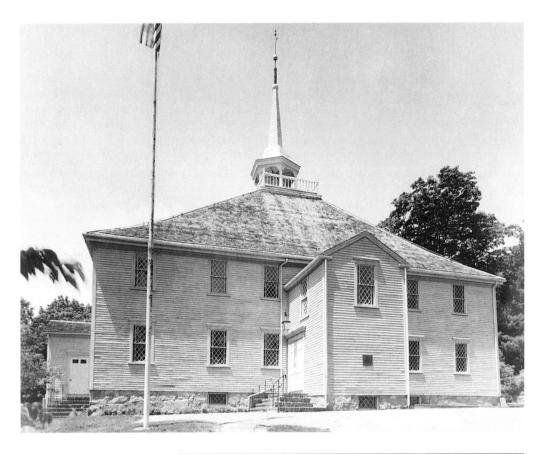

2.20 (top) **Old Ship Meetinghouse**Hingham, Massachusetts,
1681, with additions of 1731
and 1755. Library of
Congress, Washington, b.c.

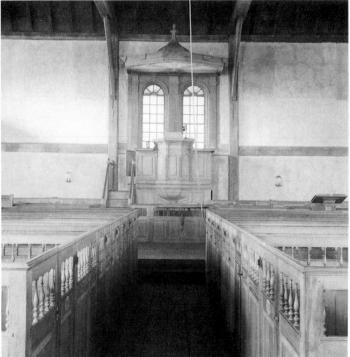

2.21 Old Ship MeetinghouseInterior. Library of Congress,
Washington, D.C.

not sufficiently worthy to partake in the communal sacrament of the Last Supper. Nevertheless, with the passing of the first generation of Puritan immigrants and the growing power of an affluent merchant elite, New England congregations expressed the more liberalized spirit by building larger and more visually striking meeting-houses. The Hingham structure was constructed at the beginning of a period of economic expansion that soon blossomed during the eighteenth century with increased trade between Britain and her American colonies. As both population and wealth increased, Hingham church members expanded their meetinghouse in 1731 and again in 1755. But their first alteration was to cover over the exposed timbers of the ceiling so that the distinctive, inverted-ship design was hidden from view until an early-twentieth-century restoration.

As demonstrated by the Goose Creek plantation owners who designed St. James's Church, American colonists were developing a new taste for lighter, more refined architectural forms derived from the classical tradition. At Hingham, the heavy, unpainted wooden beams of the original ceiling must have begun to appear as crude reminders of the American wilderness, too primitive for the more sophisticated tastes of colonists who wished to display their new wealth by emulating architectural styles fashionable in England.

Hingham dwarfed most earlier New England meetinghouses. Its finely carved and polished boxed pews, massive wooden pulpit, and other decorative elements expressed the affluence of its members. During the eighteenth century, the building's material richness was enhanced by a reshaped, pyramidal roof capped by a classical balustrade and a domed belfry with its spire ascending to a fine point.

In Topsfield, Massachusetts, the Parson Capen House, dating from 1683, is a further surviving sign of the social and cultural power enjoyed by the New England clergy (figs. 2.22–2.23). Distinguished by its size and central location on the town common, this wooden clapboard house was built by the community for the Reverend Joseph Capen, a Harvard-educated preacher and successful farmer, who occupied the home until his death in 1725. Although constructed according to English medieval framing methods, the Parson Capen House included a modern parlor to the left of the entrance porch. Among the New England middle class and social elite, parlors had become fashionable domestic spaces employed primarily for the formal entertainment of guests.

By 1691, the political and religious power of the Puritan clergy was diminished when Massachusetts finally lost its church-dominated tradition of self-government. Under a new charter, it became a royal colony with its governor appointed by the king. Voting rights for a representative assembly were based on the possession of property rather than membership in a church congregation. Furthermore, the established churches of New England Congregationalism were now forced to compete more equally with Anglican, Baptist, and other churches. Protestants who dissented from the established religion were granted tax relief so that they would not be forced to pay for the construction and maintenance of Congregational meeting-houses. During the eighteenth century, meetinghouses gradually lost their role as communal centers of both secular and religious life. As new public buildings or town halls displaced the meetinghouse as sites for government and community affairs, Congregationalist meetinghouses were increasingly referred to, and designed as, churches. Architects chose explicitly religious forms for edifices that were now almost exclusively dedicated to sacramental, worshipful purposes.

In Boston, the construction of Old South Meetinghouse strongly expressed this transformation of the meetinghouse form (fig. 2.24). Like the Old Ship

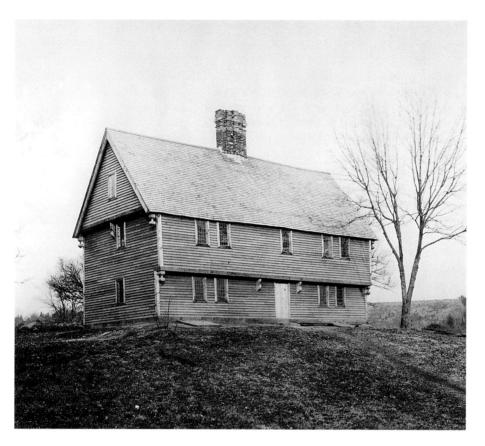

2.22 Parson Capen House Topsfield, Massachusetts, 1683. Society for the Preservation of New England Antiquities, Boston, Massachusetts.

This New England parsonage derives from medieval, woodframe building traditions. It is similar to late sixteenthcentury wooden clapboard houses that still stand in Essex, England. Essex was a source of Puritan migration into Massachusetts. The medieval design is irregular, as the chimney and main door are not strictly aligned along a central axis to symmetrically divide the building. On either side of the door, brackets support the overhanging second story.

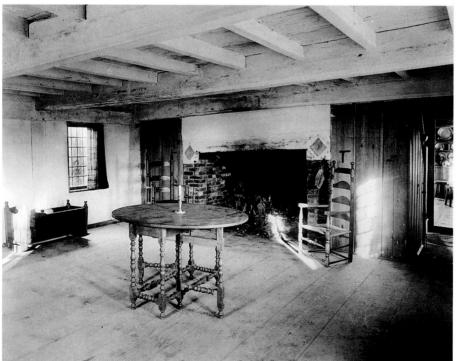

2.23 Parson Capen House

View of parlor, Topsfield, Massachusetts, 1683. Society for the Preservation of New England Antiquities, Boston, Massachusetts.

While the exterior of the Parson Capen House suggests impressively spacious living quarters, the interior feels relatively cramped. The parlor's low ceiling and heavy wooden beams weigh down the space but also help preserve heat during the cold New England winters. In the parlor, as in the other firstfloor rooms, a large brick fireplace dominates the space, providing a protective sense of security as well as necessary warmth.

Meetinghouse, Old South is almost square in plan and has its main entrance on the long side with a high pulpit opposite. This orientation across the width rather than the length of the meetinghouse intentionally discouraged the practice of liturgical processions or ritualistic parades. However, the architect of Old South dramatically contradicted this meetinghouse tradition by designing a lofty brick tower and wooden spire at the building's west end. Inspired by the tower and spire of Old North, an Anglican church in Boston's North End, Old South's tower entrance unmistakably announces the religious purpose of the space, while confusingly detracting attention from the main entrance on the long south side.

With the proliferation of steepled churches and meetinghouses in Boston and other colonial towns, cartographers and painters of topographical views documented the sacralization of the American landscape. Before 1699 and the construction of the Brattle Street Meetinghouse (demolished in 1772), the Boston skyline had been devoid of towering church steeples. By 1723, before the construction of Old South, the painter William Burgis recorded seven tall church spires overlooking Boston harbor (fig. 2.25). These prominent vertical accents significantly compete for attention with the rigging and tall mastheads of merchant sail ships, symbolically encapsulating the tension between religious faith and commercial wealth.

2.24 Robert TwelvesOld South Meetinghouse,
Boston, 1729-30. Society for
the Preservation of New
England Antiquities, Boston,
Massachusetts.

Above Old South's five-level, squarebrick tower rises a wooden, octagonal spire that springs from a colonnaded, eight-arched belfry. Eight pedimented dormer windows pierce the steeple, which soars 180 feet into the sky. Old South's octagonal spire was widely copied elsewhere in New England. Since early Christianity, baptismal fonts often possessed octagonal forms. In ecclesiastical architecture, the octagon symbolized purification and spiritual rebirth.

God's Word in New England Portraits

Portraiture was a means for colonial Americans to resolve difficulties in reconciling material prosperity and worldly success with spiritual purity and moral commitment. Given the Puritan notion that members of God's elect were living images of Christ, portraiture became a form of religious expression sanctioned and encouraged by the New England clergy. In 1670, the Boston printmaker John Foster (1648–81) produced the earliest known print in the British colonies (fig. 2.26). The woodcut represents the Reverend Richard Mather, who, like many other Puritans, had suffered religious persecution for refusing to conform to the religious practices of the Church of England. Having fled England for Massachusetts in 1635, Mather became a leading spokesman for New England Congregationalism. Foster's print originally may have been conceived as an illustration or frontispiece for a memorial tribute to the recently deceased minister written by his son. According to Increase Mather, who also became a clergyman, Richard Mather's "way of Preaching was plain, aiming to shoot his Arrows not over his people's heads, but into their Hearts and Consciences. Whence he studiously avoided obscure phrases, Exotic Words, or an unnecessary citation of Latin Sentences, which some men addict themselves to the use of" (cited in Horner and Bain, pp. 70–71).

Emulating the clergyman's reputation for a plain, unpretentious preaching style, Foster captured the massive bulk of Mather's body with flattened, simple shapes and minimal contrasts of light and shadow in the rounded hands and face. Rather than the official, ceremonial vestments of the Anglican Church, Mather wears the more

2.25 William Burgis
(attributed), A North East
View of the Great Town of
Boston, c.1723. Engraving,
13½ in (34.9 cm) high, 9½ in
(25.1 cm) wide. Peabody
Essex Museum, Salem,
Massachusetts.

Burgis, a major but relatively obscure figure in colonial printmaking, appears to have included a representation of himself in his northeastern view of Boston harbor (a companion to a southeastern view). Beneath a foreground tree at the far right, the seated, gentlemanly figure of an artist can be seen sketching the busy scene of harbor life. Burgis's artistic ambitions beyond mapping the town's skyline are evident in the atmospheric, breezy rendering of the cloudy sky.

austere, black costume of a scholar devoted to God's Word. Pointing with his right index finger to the open book that he holds in his left hand, Mather is also represented as a dedicated teacher, whose close interpretation of the Bible and theological texts has made him dependent on a tiny pair of reading glasses that gleam like two beacons of light at the center of his body.

Foster's portrait of Mather reminds us of the religious importance of books and reading for Protestants in colonial America. Reformers in Europe had attacked the fact that the Catholic Mass was conducted entirely in Latin and not in the national and regional languages of everyday life. Furthermore, the Vulgate, or Roman Catholic Bible, was also written in Latin, making it inaccessible to common men and women. Believing in the priesthood of all believers, Protestants preached God's Word in the everyday languages of ordinary people. They also undertook to translate and inexpensively publish the Bible in the vernacular so that literate members of the laity could read holy scriptures in private without the intrusive presence of a priest. Although there were earlier English translations, the publication in 1611 of the King James Bible, under the patronage of King James I, was crucially important in the dissemination of God's Word in England and America. In 1623, Governor John Winthrop of Massachusetts received a London edition of the King James Bible as a gift from his father (fig. 2.27). Its visually complex title page is enframed by twenty-four square images, half representing the leaders of the twelve tribes of Israel, the other half portraying Christ's twelve disciples. Together they signify the complementary nature of the Bible's Old and New Testaments. However, the title page also signifies the spiritual superiority of the New Testament story of Christ over

2.26 John Foster Richard Mather, c.1670. Woodcut, 7½ in (18.2 cm) high, 5½ in (13.7 cm) wide. The Houghton Library, Harvard University, Cambridge, Massachusetts.

the Old Testament's history of the Jews. The central images exclusively depict Christian personalities and symbols. Around the heart in the middle of the title page are images of Saints Matthew, Mark, Luke, and John, whose Gospels narrate the life, death, and Resurrection of Christ. An emblem of Christ as the Lamb of God is situated at the base of the heart-shaped title, while the dove of the Holy Spirit flies within a luminous cloud over the heart's crest. These animal emblems were accepted by most Protestants as purely allegorical or symbolic allusions to God.

In American portraiture, displays of literacy and of biblically educated piety became commonplace. Of the fifty or so portraits surviving from the seventeenth century, the most religiously explicit in its interplay between verbal expression and visual imagery is the *Self-Portrait* of Captain Thomas Smith (fig. 2.28). Little is known of Thomas Smith (d.1691) except that he was a sea captain who also worked as a portraitist in Boston and Cambridge, where Harvard College had been established in 1636 as America's first institution of higher learning. Within this literate atmosphere, Smith portrayed himself as a poet as well as a devout gentleman of some social standing. Dressed in black with a fancy lace jabot, or neckpiece, the

aging but formidable Captain Smith sits close to the picture plane in front of an open window that reveals a naval battle in the distance.

Scholars have been unable to agree with absolute certainty if Smith's window view represents a specific sea battle in which the captain may have participated. However, the ships bear English and Dutch flags, while one of the flags flying over the monumental fortress below displays three crescents, alluding to an Islamic military force. The English and Dutch had been imperial rivals in a series of wars that led to the English takeover of the New Netherlands in 1664. But, in 1670, the two naval powers had collaborated in an attack on the Islamic Barbary States on the north coast of Africa.

Through this historical association, Smith identifies himself as a Christian soldier in the centuries-old crusade against the infidels of Islam. Opposition to Islam unites two European commercial rivals, who ought to be allies as Protestant defenders of the Christian faith. Immediately below this distant view of religious combat, Smith has placed his right hand on a human skull that rests on the table in front of him. While he silently gazes toward us, the skull seems to speak for him like a hand puppet. The written words of a poem signed with Smith's initials flow from the skull's mouth and are clearly visible for beholders to read:

2.27 Title page
The Bible, printed by Robert
Barker, London, 1614–15.
Massachusetts Historical
Society, Boston,
Massachusetts.

Why why should I the World be minding therein a World of Evils Finding.

Then Farwell World; Farwell thy Jarres thy Joies thy Toies thy Wiles thy Warrs,

Truth Sounds Retreat: I am not sorye.

The Eternall Drawes to him my heart

By Faith (which can thy Force Subvert)

To Crowne me (after Grace) with Glory. (cited in Stein, p. 317)

Significantly, the sheet of poetry reaches out to the viewer as it falls over the edge of the red table, virtually commanding our attention, drawing our eyes away from the relatively obscure and distant battle scene. Visually and verbally, the skull's poem diminishes the importance of the background view. In conformity with Calvinist doctrine, Smith's affirmation of Christian faith takes precedence over the good deeds of his life at sea. He dismisses the cares and woes of his past and of his present pilgrimage on earth and embraces death like a welcome friend. Apparently confident that he is one of God's elect, the beneficiary of God's grace, Smith looks forward to his future life in heaven, where there are no wars or other evils.

The verbal, religious imagery of Smith's poem regulates our interpretation of the visible world. Inspired by the Bible, Puritan sermons, and devotional themes, the poem of death leads the viewer's mind beyond the transient earthly realm accessible to the eye. Smith has

drawn the skull's nose in the shape of an inverted heart that points upward and outward beyond the picture frame, visually underscoring the poetic thought that "the Eternall Drawes to him my heart." The painting is part of an emblematic tradition

2.28 Thomas Smith Self-Portrait, c.1680–90. Oil on canvas, $24\% \times 23\%$ in $(62.9 \times 60.4 \text{ cm})$. Worcester Art Museum, Worcester, Massachusetts. Museum purchase.

Smith's self-portrait demonstrates familiarity with contemporary European techniques of pictorial composition and threedimensional illusionism. The artist created a pattern of formal repetitions to link foreground and background spaces. Puffs of clouds and white smoke from the battle scene echo Smith's flowing white hair and lace neckcloth. The bell shape of the jabot is repeated in the red tassel dangling from the curtain behind Smith's head.

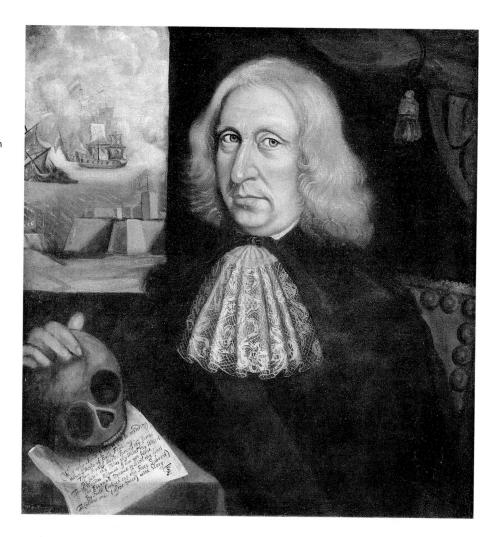

in literature and the visual arts that associates images or signs with implicit or explicit verbal moral messages. The human skull is a conventional emblem, a *memento mori*.

Smith's visual sermon may be compared with the earlier, more worldly portraits of John and Elizabeth Freake and their daughter (figs. 2.29–2.30). These anonymously painted pictures of a Boston merchant family are a frank display of wealth and social standing. The self-taught colonial "limner," or painter, focuses particularly on the figures' elaborate imported clothing and jewelry. Nevertheless, the artists' stiff representation of sober facial expressions suggests that these sitters, like Thomas Smith, are virtuous members of God's elect, uncorrupted by riches.

Colonial Gravestones: Emblems of Morality

Skeletons and skulls appeared most frequently on colonial gravestones not only in New England but also in the other colonies along the eastern seaboard. Although graveyards were usually located next to meetinghouses and churches, Protestants, unlike Catholics, regarded the funeral as a secular, civil ritual outside the power of

2.29 Anonymous

Portrait of John Freake, c.1671–74. Oil on canvas, 42½ × 36½ in (107.9 × 93.4 cm). Worcester Art Museum, Worcester, Massachusetts. Sarah C. Garver Fund.

The unknown painter of the Freake family adopted a relatively flat, medieval style. Its linear sharpness and plainly represented forms expressed English middleclass distrust of sensuous, painterly surfaces and threedimensional illusionism. Those qualities were associated with Catholic and courtly art. Mr. Freake's sartorial finery and shoulderlength hair distinguish him from the lower classes and Puritan extremism. But the Boston merchant also differentiated himself from England's aristocratic elite by sporting neither a wig nor curly, long lovelocks.

religious authority. Clergymen encouraged grave imagery for their useful spiritual messages directed toward the living. Stone carvers developed their trade by copying traditional images of death and resurrection from emblem books onto the slate grave markers. Coupling engraved visual images with moralistic, explanatory texts, English emblem books circulated widely in the British colonies during the seventeenth and eighteenth centuries.

Joseph Lamson (1658–1722) of Charlestown, Massachusetts, was the founding father of four generations of stone carvers in New England. Drawing on popular convention, he shaped his grave markers into doorways that suggested the entrance of human souls into a new heavenly home. Lamson's 1694 gravestone for Timothy Cutler features a winged skull in the curved tympanum at the top of the doorshaped stone (fig. 2.31). Immediately below, two angelic figures carry a coffin as if they are loading it for the skull's or the soul's flight beyond the grave. Latin mottoes inscribed next to an hourglass and a pair of crossed bones remind the viewer of death and of the flight of time. Along the door jambs on either side of the stone's epitaph, floral decorations capped by two pudgy, childlike faces suggest the promise of spiritual rebirth and everlasting life.

While New England colonial gravestones are often associated with the Puritan tradition, the stone carvers' vocabulary of visual motifs is neither distinctively

2.30 Anonymous Elizabeth Freake and Baby Mary, c.1671–74. Oil on canvas, 42½ × 36¾ in (107.9 × 93.4 cm). Worcester Art Museum, Worcester, Massachusetts. Gift of Mr. and Mrs. Albert W. Rice.

As a marriage portrait, this picture originally represented only Elizabeth Freake, daughter of the Boston merchant Thomas Clarke. (The picture was the companion to her husband's portrait; see fig. 2.29.) However, three years later, in 1674, when their daughter Mary was born, the Freakes commissioned their portraitist to depict the baby on her mother's lap. Mrs. Freake, dressed in satin and lace, sits in an expensive but locally made chair upholstered with imported English woolen fabric called Turkey work. because it imitated exotic Middle Eastern designs.

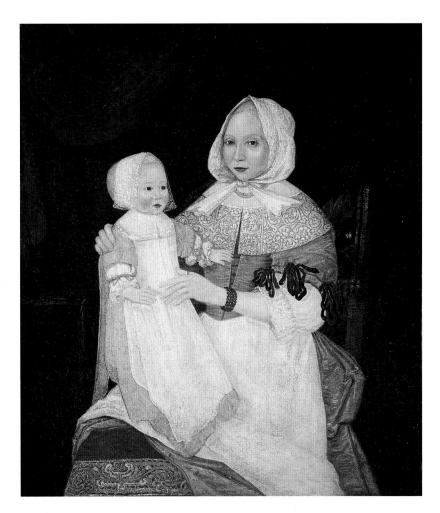

Protestant nor even Christian. In Newport, Rhode Island, the stone carver John Stevens II (1702–28) sculpted grave markers for Jewish families that appear similar in every respect to Christian stones, except for the Hebraic inscription of the epitaph (fig. 2.32). The gravestone of Rebecca Polock is also shaped like a doorway, with floral motifs in the jambs and a winged cherub signifying the soul within the stone's arched tympanum.

Jewish-Christian Collaboration: Touro Synagogue

Polock was buried in the cemetery next to Touro Synagogue, the oldest Jewish synagogue in America (fig. 2.33). With only a thousand Jews living in all of British colonial America, it is scarcely surprising that the handful of Jewish families residing in Newport and other American cities relied heavily on Christian craftsmen, artists, and architects. Touro Synagogue was designed by the English-born architect Peter Harrison (1716–76), who had earlier designed Anglican and Congregational churches in Boston and Cambridge. For both Christian and Jewish worship spaces,

Harrison employed the architectural vocabulary of classical antiquity as reinterpreted by Renaissance masters and the leading contemporary architects and designers of Great Britain.

Sir Isaac Newton and other eighteenth-century Britons regarded the ancient Jewish temple of King Solomon in Jerusalem as the original source of all architectural knowledge (see fig. 3.7). Harrison owned a copy of the Constitutions of Freemasons (1725), which traced the art of architecture from Solomon and the Hebrews to the Greeks and the Romans. The Romans supposedly perfected the art during

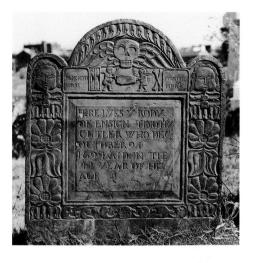

2.31 Joseph Lamson (attributed), Gravestone of Timothy Cutler, 1694. Slate, 23 in (58.4 cm) high, 23½ in (59.7 cm) wide, 5 in (12.7 cm) deep. Phipps Street Burial Grounds, Charlestown, Massachusetts.

the imperial reign of Augustus Caesar at the dawn of Christianity. The Constitutions was written by the Scottish clergyman James Anderson for members of the Masonic order, a secret social fraternity that is discussed in the following chapter. However, the book also appealed to non-Masons who were interested in the ancient lore of architecture and the building trades. Thanks, in part, to Anderson's popular treatise, classical architecture could be seen as a virtually universal language of design that was equally valid for craftsmen and builders of the eighteenth century.

Therefore, Harrison saw little contradiction in adapting Greco-Roman forms to the religious needs of Newport's Jewish community. The Anglican architect shared the tolerant, cosmopolitan spirit of his contemporary Dr. Alexander Hamilton. Stimulated by the religious and ethnic diversity of Newport, Harrison worked for free and received instruction on the layout of Sephardic, or Spanish and Portuguese Jewish, synagogues

from Rabbi Isaac Touro, who had studied Judaism at the Rabbinical Academy in Amsterdam. Following Touro's liturgical requirements, Harrison designed an elevated table or reading desk, surrounded by a balustrade at the center of the worship space, where Jewish law was read and prayers were chanted. Facing toward Jerusalem, the Ark of the Covenant commands the eastern end of the synagogue. In designing this most sacred space, where the Torah, or scrolls of God's law, are stored, Harrison borrowed classical forms that he had seen in British pattern books and that he had earlier employed for King's Chapel, an Anglican church in Boston. The towering upper half of the ark displays an image of the written laws of God with classical columns and arches. The ornamental frame is capped by a small pediment, which appears cramped by a lack of wall space, being blocked by the molded cornice above. Facing toward the center and the east, men sat in pews on the other three sides of the interior space. Women sat separately in the balconies above. Twelve columns support the balcony on the first and second floors, symbolizing the twelve tribes of ancient Israel.

When Touro Synagogue was dedicated on December 2, 1763, Christians as well as Jews attended the services. On December 5, a Newport newspaper described the dedication ceremonies as a moment of profound religious and social concord:

2.32 John Stevens II (attributed), Gravestone of Rebecca Polock, c. 1764. Rubbing, 37 imes 27 in (94 imes68.5 cm). Burial Ground of Touro Synagogue. American Antiquarian Society. From the Daniel and Jesse Lie Farber Collection of Gravestone Photographs.

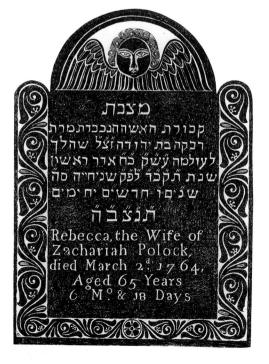

In the afternoon was the dedication of the new Synagogue in this town. It began by a handsome procession in which was carried the Books of the Law to be deposited in the Ark. Several Portions of Scripture, and of their Service with a prayer for the Royal Family were read and finely sung by the Priest and People. There were present many Gentlemen and Ladies. The Order and Decorum, the Harmony and Solemnity of the Music, together with a handsome assembly of People, in the Edifice the most perfect of the Temple kind in America, and splendidly illuminated, could not but raise in the Mind a faint Idea of the Majesty and Grandeur of the ancient Jewish Worship mentioned in Scripture. (cited in *Touro Synagogue*, p. 21)

As is suggested by this sympathetic account, the Christian majority in colonial America had long cultivated an identification with ancient Israel. Like most Britons, Protestant Americans tended to regard themselves in biblical terms as the new Israelites or God's new chosen people. However, the Newport newspaper primarily chose to focus on the refined tone created by Harrison's temple architecture, the solemn religious services, and the handsome appearance of the congregation. By 1763, Americans had distanced themselves from the relatively primitive living conditions endured by the first generation of settlers in the British colonies. During the eighteenth century, wealthy colonists not only built larger and more elegant places of worship but also constructed spacious mansions decorated with family portraits. As we shall see, American colonists began to define themselves less by their ethnic and religious differences than by their common consumption of British goods and genteel emulation of English manners and taste.

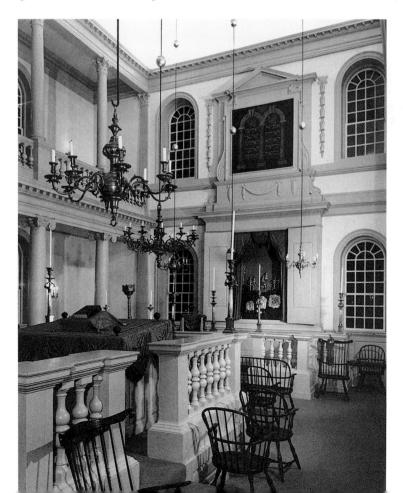

2.33 Peter HarrisonTouro Synagogue, Newport, Rhode Island, 1759-63.
Interior. Library of Congress, Washington, D.C.

CHAPTER 3

Art and the Consumer Revolution in Colonial America

1700-75

uring the first three quarters of the eighteenth century, demographic and economic expansion in the American colonies created a more liberal moral climate for consuming luxuries and patronizing art and architecture. From 1700 until the eve of the Revolution in 1775, the colonial population multiplied almost ninefold from 250,000 to well over 2 million. Though still small by modern standards, most colonial towns doubled or even tripled in size. A village of 4,000 in 1690, Philadelphia grew into the largest metropolis, with a population of 40,000 by 1775. New York and Boston were the nearest competitors, with populations of 20,000 and 16,000 respectively by the 1770s.

From 1689 to 1760, colonial trade with Great Britain grew by 700 percent. Affluent artisans, farmers, and small shopkeepers all became eager consumers of British textiles, ceramics, glassware, tea, and other consumer goods. Per capita American expenditure on imports rose by at least fifty percent from 1720 to 1770. British exports to the American colonies doubled between 1750 and 1760, when England's Industrial Revolution was beginning to take off.

Colonial America still witnessed a marked disparity between rich and poor, with most wealth concentrated in the top one to five percent of the population. For instance, in the city of Boston, five percent of property owners possessed twenty-five percent of the city's wealth in 1687. By 1770, just one percent of Boston property owners controlled forty-four percent of the wealth. During the same period in Virginia and Maryland, approximately thirty percent of the population was poor, while wealth was concentrated in the hands of a few rich families with ties to the English aristocracy. As a sign of growing elite wealth in colonial America, the population of black slaves dramatically increased from eight percent of the population in 1690 to twenty-one percent in 1770.

Nevertheless, for most white colonists, improved living standards during the eighteenth century created opportunities for social advancement. From 1689 to 1760, per capita income in the American colonies rose half a percent per year in real terms. Over the entire period, the standard of living improved for most of the population by between fifty to one hundred percent. Ordinary, middle-class Americans could begin to emulate their aristocratic superiors in purchasing luxuries that would distinguish them from the propertyless poor. While most seventeenth-century colonists had lived without or created substitutes for imported goods, eighteenth-century demand for British manufactures and commodities contributed to the "anglicization" of American culture. Colonial consumers demanded that American artists, craftsmen, and builders conform to British standards of fashion and taste.

Justus Engelhardt Kühn Henry Darnall III, c. 1710. Oil on canvas, $53\% \times 44$ in (136 \times 111.8 cm). Maryland Historical Society, Baltimore, Maryland.

The fictive formal garden and architecture were borrowed from European prints. The garden may allude to the Roman goddess Venus's Garden of Love, a Renaissance symbolic tradition that eventually influenced English illustrated books for the moral education of youth. Within this context, Henry's bow and arrows would then identify him with Cupid, the son of Venus. Whether represented dead or alive, birds accompanying children pictorially signified the morally desirable pursuit of love and friendship.

With the increase of wealth and social affluence, clergymen warned against the moral dangers associated with immoderate consumption of luxuries. Excessive entertainments and expenditures within the middle and upper classes potentially threatened public virtue and the rule of law. During the booming decade of the 1750s, the native-born artist John Greenwood (1727–92) painted a rare representation of common misbehavior in Sea Captains Carousing in Surinam (fig. 3.1). This South American tavern scene depicts a group of mostly Rhode Island mariners, several of whom would gain important posts in colonial affairs. Greenwood's chaotic and self-critical image of overturned chairs, spilled glasses, and retching, inebriated patrons implicitly admonishes viewers about the consequences of overconsumption. In the background doorway of the picture, Greenwood represented himself vomiting from too much rum. The painting is similar to the popular print A Midnight Modern Conversation, by the London artist William Hogarth (1697–1764), who was famous for his pictorial satires of social morals and manners. Hogarth's engraving was widely reproduced throughout the British empire. American colonists imported ceramic punch bowls decorated with the Hogarth composition as a humorous reminder of the moral and physical dangers of consuming too much alcohol (fig. 3.2). The punch bowls taught friends and guests the virtues of moderate consumption, which contributed to social harmony and good feeling. If excess was an evil extreme, so, too, was puritanical self-denial. As we shall see, during the eighteenth-century consumer revolution, frugality was increasingly criticized as a selfish, anti-social form of behavior.

Aristocratic Aspirations of Wealthy Colonists

During the early seventeenth century, British settlers were preoccupied by the problems of merely surviving the American wilderness. However, within a few decades affluent colonists in Virginia, Maryland, and elsewhere could imagine living in the

3.1 John Greenwood Sea Captains Carousing in Surinam, c 1758. Oil on bed ticking, $37\% \times 75\%$ in (95.9 \times

ticking, 37¾ × 75¼ in (95.9 191.1 cm). Saint Louis Art Museum, Missouri.

Greenwood spent over six years in the Dutch colony of Surinam painting 113 portraits of local plantation owners and visiting traders. Although these individual portraits are unlocated, this tavern scene contains numerous likenesses. Just to the right of center, a Captain Ambrose Page vomits into the coat pocket of Jonas Wanton of Newport, Rhode Island. Stephen Hopkins, Rhode Island's governor and a future signatory to the Declaration of Independence, simultaneously pours a bowl of rum over the hapless, seated Wanton.

3.2 Punch bowl

Liverpool, England, c. 1750. Tin-glazed earthenware with design featuring Hogarth's *A Midnight Modern Conversation*. Winterthur Museum, Delaware.

Hogarth's comedic engraving, originally published in London in 1733, represents the inebriated members of a London drinking club. Hogarth's stated intention was not to ridicule specific persons but rather to criticize harmful vices and human weaknesses. Pirated copies of the popular print led the artist to seek passage of a copyright law protecting authorial rights. However, the law's enactment in 1735 did not prevent the English punch bowl manufacturer from employing a crude copy of Hogarth's design.

manner of the English aristocracy or landed gentry. In 1641, Sir William Berkeley, descendant of one of England's oldest noble families, arrived in Virginia as the colony's new royal governor. With a population of only 8,000, Virginia's social life suffered from a poor economy and a corrupt culture of violence, lawlessness, and heavy drinking. Over the course of Berkeley's thirty-five-year tenure, Virginia's population quintupled to 40,000. The governor attempted to create a hierarchical socioeconomic order by recruiting a powerful ruling elite from the younger sons of wealthy English families. Like Berkeley himself, younger sons lost inheritance rights to older brothers and were compelled to leave family estates to seek their fortunes or vocations elsewhere. In 1663, Berkeley published a Virginia recruiting pamphlet which promised Englishmen that "a small sum of money will enable a younger brother to erect a flourishing family in a new world" (cited in Fischer, p. 214). Earlier, during the 1650s, the Civil War in England had already contributed significantly to immigration to Virginia. Thousands of cavaliers, or aristocratic royalists, fled Britain following the execution of Charles I in 1649 and the subsequent establishment of a Puritan Commonwealth under the military dictator Oliver Cromwell. Though most royalist emigrés sought refuge in Europe, Governor Berkeley was able to lure many of them to Virginia. With the Restoration of the English monarchy in 1660, most of these wealthy immigrants were persuaded to remain and form Virginia's "first families" (Fischer, p. 218). While not among the original founders of the colony, the Byrds, the Washingtons, the Lees, and other families were "first" in the sense of social prestige and political influence. By 1700, fifty wealthy families, most with connections to the English aristocracy or rural gentry, dominated Virginia life. Owners of vast, slave-operated plantations, the leading men of these families served as local magistrates and sat on the Virginia governor's council.

Together with Maryland to the north, Virginia was part of a larger regional society centered on the vast Chesapeake Bay and its many navigable waterways. With the

encouragement of Sir William Berkeley's social recruiting policies in Virginia, Maryland also developed a hierarchical society and plantation economy dependent upon slave labor and the

cultivation of tobacco as an export crop. Maryland was ruled by an aris-

tocratic proprietor, whose right to total control of the colony originated from a 1632 land grant of 10 million acres given by King Charles I to Cecil Calvert, the second Lord Baltimore. Like Berkeley in Virginia, Lord Baltimore envisioned Maryland as an aristocratic utopia of wealthy, genteel families who would be granted large estates of 2,000 acres or more. In reality, during most of the seventeenth century, small family farms of fifty to one hundred acres typified the Maryland econ-

omy. However, following the Restoration, Maryland also experienced an influx of wealthy "great" families, not only from England but also from the European mainland. By the eighteenth century, large plantations of over 1,000 acres, each with a labor force of fifty or more slaves, became economically dominant in the colony. Accordingly, Maryland's slave population increased nearly tenfold between 1707 and 1755 from 4,600 to 43,000, becoming an ever-larger percentage of the total population. White indentured servants who had arrived in Maryland during the 1640s and 1650s often became small landowners once they had fulfilled the contractual terms of their servitude. However, by the end of the century, most servants remained landless even after ten years of legal freedom and were forced to work as tenant-farmers for large plantation owners.

A portrait of young Henry Darnall III (1702–c.88), heir to a Maryland plantation family, vividly demonstrates the aristocratic pretensions of wealthy American colonists (see p. 76). Henry Darnall II hired a German immigrant artist, Justus Engelhardt Kühn (active c.1708–17), to portray his son as the future master of Woodyard Plantation in Calvert County (today Prince George's County), Maryland. Dressed in rich, imported clothing, Henry Darnall III stands in front of a sculpted stone balustrade overlooking a lavish formal garden and stately buildings in the far background. He holds a bow and arrow, masculine emblems of the hunt, a leisure sport associated with the British aristocracy. On the other side of the balustrade, an African-American slave holds a dead quail while gazing upward toward his young master in loyal admiration. America's genteel civilization of consumer luxuries depended upon the human barbarism of slavery. The African youth wears a shiny silver collar around his neck, an emblem of his servitude and a reminder of the iron clamps and chains used on southern plantations and American slave ships.

Benefiting from their connections to England's aristocracy and landed gentry, a number of second- and third-generation, native-born colonists accumulated sufficient capital through trade, land speculation, slave labor, family inheritance, and strategic marriages to begin to live like English aristocrats. The Darnall family was fortunate in that it had kinship ties to Charles Calvert, the third Lord Baltimore, from Maryland's founding family. Like other colonial portraits, Kühn's portrait of Henry Darnall III represented the aspirations of a social class rather than objective reality. The painting's formal gardens and stone architecture are fictive, copied from imported portrait prints. But these conventional motifs expressed the colonial elite's desire to transform the American wilderness into a replica of English aristocratic culture.

As the western periphery of the British empire, the North American colonies still constituted the violent margins of European civilization. In 1737, one exasperated royal governor described North Carolina backwoodsmen living in the manner of Indian traders on the borders of the wilderness as "the lowest scum and rabble . . . [who] build themselves sorry hutts and live in a beastly sort of plenty . . . devoted to calumny, lying, and the vilest tricking and cheating; a people into whose heads no human means can beat the notion of a publick interest or persuade to live like men" (cited in Bailyn, p. 117). Throughout the colonies, travelers to frontier outposts complained of bandits and horse thieves, public drunkenness, fighting, and the complete absence of civil behavior. The British judicial system perpetuated the image and reality of American wildness and lawlessness by exporting thousands of convicts to the colonies as indentured servants. Having sold their labor for transportation to the New World, indentured servants worked years without pay, depending upon the terms of their contract, which bound them to serve a particular master. With thousands of poor immigrants arriving in coastal ports, the prob-

lem of urban disorder and crime led towns throughout the colonies to increase night patrols against robbers and burglars.

Yet among the eighteenth-century immigrants from the British Isles and the European continent, skilled artisans overshadowed the convicts. Emigration to the New World became less of a financial risk for artists and those who already had established careers in the Old World. During the eighteenth century, colonial merchants busily recruited immigrants skilled in the building trades, decorative arts, and semi-artistic crafts. The arrival of immigrant carpenters, masons, plasterers, bricklayers, joiners, gold- and silversmiths, bookbinders, engravers, musical-instrument makers, and portrait painters signified that the American colonies had crossed an economic threshold in leaving behind the wilderness environment of the seventeenth century.

Nevertheless, native-born and immigrant painters often found themselves painting houses and signs rather than easel pictures that demonstrated their mastery of art. Justus. Engelhardt Kühn's modest talents as a painter of the Maryland gentry (see p. 76) failed to provide him with sufficient income. The artist, deeply in debt, was forced to paint coats of arms for families wanting traditional signs of aristocratic social status. In mid-century, the Boston painter John Greenwood (see fig. 3.1) abandoned America altogether. After his interlude in the Dutch colony of Surinam, he headed for London and a more lucrative art career than he could have hoped for in Boston. Sometime after 1762, he opened an art dealership in the British capital.

During the first three quarters of the eighteenth century, less than one percent of the colonial American population had their portraits painted. Probably fewer than 8,000 portraits were painted, at least half of which are now lost or destroyed. Yet, with only fifty portraits surviving from the previous century, this represents a significant increase in production. As American towns grew larger, the market for portraits could sustain the careers of a small but growing number of artists. Except for the limited number of biblical paintings discussed in Chapter 2, demand for pictures other than portraits remained negligible.

Mansions and the portraits that lined their walls created social and political credibility for merchants and landowners attempting to maintain or construct an aristocratic family pedigree. Wealthy colonists visually asserted their "natural" right to manage local and provincial public affairs by designing homes that rivaled the architectural grandeur of statehouses and governors' mansions. More than aesthetic objects signifying cultivated taste, portraits visually preserved for posterity the family tree and documented the transmission of family wealth from one generation to the next. Set against the constant threat of lawlessness and social violence, stable elite families became models for the sound political architecture of good government. Colonists often talked of the human body, the family, and the state in architectural terms as sacred temples or pillars of beauty and virtue. James Bowdoin II (1726–90), a member of the Boston mercantile elite, wrote a wedding poem praising the architecture of his new, seventeen-year-old wife: "Her comely neck, with symmetry and grace, / Rises majestic on its noble base, / And, like a column of superior art, / Does to the eye a fine effect impart" (cited in Sadik, p. 49). Around the same time, Bowdoin also commissioned marriage portraits that represented the couple with erect, columnar postures and relatively hard, marblelike flesh (figs. 3.3–3.4). Robert Feke (1705–51), the New York-born painter of these pictures, rendered the illusion of luxurious fabrics and expensive imported clothing, while still conveying the impression of moral sobriety in the sitters' still, dignified poses and emotionally cool expressions.

Social Clubs as Vehicles for Self-Cultivation

Royal governors stood at the apex of colonial society. As surrogates for the British monarch, they set the standard for manners and taste. In Philadelphia, the provincial governor of Pennsylvania was the weekly featured guest of the Governor's Club, a gentlemen's society that met to discuss English poetry, novels, and other subjects of cultural interest.

Along with etiquette books and portrait prints imported from London, social clubs and fraternities inspired by London's cosmopolitan culture taught socially mobile Americans how to dress and conduct themselves like refined individuals. In Annapolis, Maryland, Dr. Alexander Hamilton, formerly of Edinburgh, Scotland, founded in 1745 the Tuesday Club in hopes of introducing gentlemanly conversation and culture to this "barbarous and desolate corner of the world" (p. xii). The Tuesday Club attracted many prominent members of Maryland's social and political elite, including government officials, merchants, newspaper publishers, judges, lawyers, and clergymen. Club meetings consisted of entertainments in which members delivered humorous poems

and speeches, conducted mock trials, performed musical compositions, and sang popular songs. Hamilton wrote a satirical history of the Tuesday Club in the manner of the English comic novel *Tom Jones* (1749) by Henry Fielding. The amateurish, cartoonlike pictures that Hamilton sketched to illustrate the club history suggest the often rowdy and bawdy nature of the evening's entertainments. However, for Hamilton, social organizations like the Tuesday Club were schools of manners that taught members how to control rather than repress their emotions. Hamilton modeled himself after Democritus, the ancient Greek philosopher, who could goodnaturedly observe the world of human folly "without Laughing Immoderately" (p. 295). According to the fourth earl of Chesterfield (1694–1733), whose book on manners was religiously read in Britain and America, "Frequent and loud laughter is the characteristic of folly and ill manners: it is the manner in which the mob express their silly joy, at silly things" (cited in Kasson, p. 163).

Controlling anger and violence was also an important lesson to be learned from the group dynamics of the Tuesday Club. According to Hamilton, his drawing of "Mr Neilson's Anger Restrained by Philosophy" represents a man with a "Sharp visage" and "peaked chin" who temporarily lost his temper over jokes about "the oddity of his appearance"(p. 28) (fig. 3.5). Just as he is about to unsheath his sword, a female personification of Philosophy pulls him away from the violent act. Philosophy, or the love of wisdom, overcomes the passions and composes even the ugliest countenance with a degree of dignity.

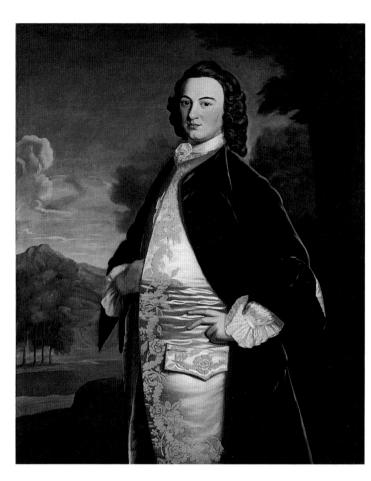

3.3 Robert Feke James Bowdoin II, 1748. Oil on canvas, 50 × 40 in (127 × 1016 cm) Roywdoin College

on canvas, 50×40 in (127 \times 101.6 cm). Bowdoin College Museum of Art, Brunswick, Maine.

Bowdoin supplemented his mercantile career with an avid pursuit of science. Feke situates him next to a tall background tree. Although painted flatly in contrast to Bowdoin's three-dimensional bulk, the tree trunk echoes his stately body. The sweeping vertical lines of brown velvet coat and ivory satin waistcoat further suggest masculine strength. The waistcoat's golden, foliated embroidery expresses Bowdoin's youthful, cultivated vigor and appears more animated than the leafy background vegetation.

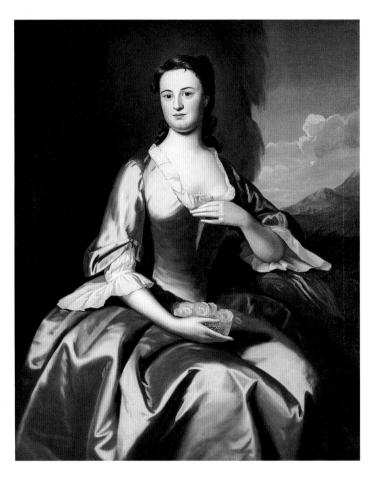

Society clubs and behavior manuals taught portraitists and their sitters that immoderate passions and facial expressions of any kind adversely affected personal appearance. Hamilton and other members of the Tuesday Club assumed that the arts and letters were moderating influences upon the passions. They contributed to social order and good government. However, club members also believed that the arts could flourish only within a fraternal atmosphere of political liberty. During the late seventeenth century, Maryland's Protestant majority had rallied around its legislative assembly to oppose Lord Baltimore, the colony's Catholic proprietor, whose claims to absolute political power had rested upon royalist doctrine that the King and his appointees governed by the will of God. In England and its American colonies, the authoritarian principle of "divine right" collapsed during the Glorious Revolution of 1688-9, when the Parliament in London overthrew the absolutist Catholic monarch James II in favor of the Protestant monarchs William III and Mary II. Following the Parliament's establishment of authority, the legislative assembly in Maryland asserted its rights in limiting the colony's proprietor's powers.

3.4 Robert Feke
Mrs. James Bowdoin
(Elizabeth Erving), 1748. Oil
on canvas, 50½ × 40½ in (129
× 103 cm). Bowdoin College
Museum of Art, Brunswick,
Maine.

Elizabeth Erving Bowdoin wears a pastel-blue satin dress. Feke employed a pose borrowed from imported prints portraying English aristocrats. Elizabeth's elongated fingers symbolically express her genteel cultural refinement. With one delicate hand, she places a pink rose between her breasts. With her other hand, she cradles a basket of blossoms in her lap. Associated with Venus, the goddess of love, roses were an appropriate symbol for a marriage portrait.

Freemasonry and the Visual Education of the American Public

Hamilton and other members of the Tuesday Club also joined the fraternity of Freemasons. In late-seventeenth- and early-eighteenth-century Scotland and England, Freemasonry had transformed itself from a labor guild of "operative" or professional stonemasons into a social and religious fraternity of philosophically "speculative" gentlemen (Bullock, p. 10). Influential aristocrats and, eventually, members of the British royal family became Freemasons.

Freemasonry did not fully blossom in America until after the Revolution, during the early period of the new republic from 1790 to 1826. However, already during the colonial era, the fraternity formed an important part of America's developing culture of genteel manners and refined taste. By the 1730s, London's Grand Lodge, Masonry's most important administrative body, had "warranted" or chartered provincial American lodges in Philadelphia, Boston, New York, Charleston, Savannah, and in Cape Fear, North Carolina (Bullock, p. 46). As Masons, American men could claim a fraternal bond with English aristocrats, political leaders, and even royalty. Though he did not organize a colonial lodge, the fourth Lord Baltimore, Maryland's governor from 1715 to 1751, became a Freemason in England

3.5 Alexander Hamilton "Mr. Neilson's Anger Restrained by Philosophy," from *The History of the Tuesday Club*, Vol. 1, pt. 1, bk. 2. John Work Garrett Library, Johns Hopkins University, Baltimore, Maryland.

in 1730 and, seven years later, assisted in the Masonic initiation ceremony for Frederick Louis, Prince of Wales, the son of George II and father of George III.

Along with numerous local clubs and literary and scientific societies, Freemasonry contributed to the cultural refinement of colonial society. Although colonial Masonry grew slowly and haltingly during the 1730s and 1740s, the next several decades witnessed growth with the founding of new lodges not only in coastal towns but also in the more remote communities of the western interior. The fraternity's exclusiveness appealed to local elites and socially aspiring members of the middle class. High initiation fees effectively barred lower-class men from membership. Within the fraternity itself, egalitarianism among the brothers was limited by the hierarchy of lodge officers and by the fraternity's hierarchical system of degrees, which began with the craft rankings of "Entered Apprentice," "Fellow Craft" (journeyman), and "Master Mason" (Bullock, pp. 16-18) and eventually, in some lodges, included higher degrees of secret knowledge with titles derived from medieval knighthood and other lofty historical sources. Far from dispensing with the notion of aristocratic superiority, Freemasons simply replaced the traditional notion of a fixed social hierarchy based upon birth or inherited wealth with a meritbased hierarchy nominally grounded upon individual achievement and virtue. Of course, wealth, whether inherited or not, automatically tended to signify virtue and achievement. Freemasonry thereby encouraged members of the colonial elite to assume that they constituted a "natural," meritorious aristocracy.

With increased travel, trade, and urban growth undermining traditional town and village life, local Masonic lodges became friendly refuges where successful men on the move could establish social and business contacts. Masonry was particularly designed to channel the energies of restless young men seeking entrance into public life. Teaching principles of morality, politeness, learning, and aesthetics, Masonic

rituals and fellowships sought to shape malleable colonial youths into stable pillars of civic virtue.

Because of the fragmentary nature of colonial lodge records, historians have had difficulty in assessing Masonry's numerical strength. However, in 1784, just after the American Revolution, the Reverend Ezra Stiles (see p. 38), president of Yale College and an admirer of Freemasonry, estimated that of the over 1,500 Masonic lodges then existing worldwide, 187 were in America, with each averaging around thirty members. More recently, Masonic scholars have calculated that, by the beginning of the Revolution in 1775, there were at least one hundred American lodges.

Freemasonry thus constituted only a fraction of the colonial male population. But the social and political prestige of its membership elevated the fraternity's cultural importance and public visibility. Though Masons gathered secretly in lodges, meeting primarily at taverns and inns, reports or exposés of their rituals and secrets appeared in colonial newspapers and journals. Furthermore, Freemasons organized well-publicized events at town halls, churches, and public theaters, generally involving colorful street processions for cornerstone-laying ceremonies, funerals, and celebrations honoring their biblical patrons, St. John the Baptist and St. John the Evangelist. Inaugurating the first Masonic hall constructed in America, Philadelphia Freemasons in 1755 conducted one of the fraternity's largest parades, led by Pennsylvania's leading men, including chief justice William Allen, the current governor, Robert Hunter Morris, and the former governor, James Hamilton. In addition to the marching bands, decorated carriages, chariots, and troops of richly dressed Freemasons, lodge officers also carried models of Doric, Ionic, and Corinthian columns from classical Greek and Roman architecture, respectively symbolizing strength, wisdom, and beauty. This public display of aesthetic taste encouraged Masons and non-Masonic spectators alike to associate the visual arts with moral virtue.

Since there was no professional school for training architects, Freemasonry became an apt vehicle for promoting principles of good design. Numerous eighteenth-century British architects and builders were Freemasons, including James Gibbs (1682–1754) and Batty Langley (1696–1751). Both published design books that were influential for American colonial architecture. Langley's Ancient masonry, both in the theory and practice, demonstrating the useful rules of aritmetick, geometry, and architecture, in the proportions and orders of the most eminent masters of all nations (1736) was just one of many architectural treatises sold in American bookstores. Masonic symbols decorated the frontispiece to one of Langley's most popular manuals, The Builder's Jewel (1746).

Masonry elevated the social status of the visual arts by associating the ancient craft lore of stonemasonry and the secrets of geometry and light with the divine architecture of the universe and the revolutionary new science of Sir Isaac Newton. Opposing religious sectarianism in favor of a universal, rational religion, Freemasons searched for empirical evidence that a Supreme Architect had designed creation. They favored a classical Roman and Renaissance style in architecture because it seemed to correspond with the Newtonian model of a universe governed by predictable natural laws and mathematical principles.

Many English historians credited the ancient Romans with the unification and Christianization of the British Isles. Roman classical architecture constituted a British national style, which had to be "reborn" following the Middle Ages. This period in European history had begun when the Visigoths, a nomadic German tribe,

sacked Rome in 410 c.e. Called "barbarians" by the Romans, the Goths, Vandals, Huns, and other Germanic peoples came to personify for British historians the Middle Ages' cultural darkness and political disunity. Protestant Britons and colonial Americans generally believed that the authoritarian, papal hierarchy of the Catholic Church had thrived on medieval ignorance and superstition stemming from the period's anarchic, barbarian origins. By contrast, Anglo-American Protestants equated the Renaissance and its revival of ancient art and learning with religious and political freedom and individual enlightenment. First flowering within Catholic Italy, Renaissance thought often conflicted with traditional church doctrine. The ongoing struggle against Catholic France and Spain for control of North America undoubtedly contributed to Anglo-American taste for an architecture free of associations with the Middle Ages.

British and American Freemasons adopted as spiritual brothers the founding fathers of British architecture, Inigo Jones (1573–1652) and Sir Christopher Wren. Both men were credited with expunging medieval stylistic features from modern design in favor of Renaissance clarity and balance. For the advocates of classicism, the term "Gothic" had become synonymous with a barbaric lack of taste and refinement. Wren especially personified the Masonic equation between science and modern architecture. A professor of astronomy at Oxford and a founding member of the scientific Royal Society, he became Surveyor General of the King's Works. He was responsible for rebuilding London's St. Paul's Cathedral and designing numerous other churches and public buildings.

Wren's classical style had a major impact on the American colonies. In the new Virginia capital of Williamsburg, Wren's name became attached to the central building of the College of William and Mary (fig. 3.6). In 1722, the college's first professor of mathematics, Hugh Jones, wrote that "the building is beautiful and commodious, being first modeled by Sir Christopher Wren, adapted to the Nature of the country by the Gentlemen there" (cited in Pierson, Jr., p. 71). The Wren Building, with its central pavilion and towering cupola, may have been based on a plan submitted by the London architect. However, colonial builders modified Wren's classicism according to provincial building traditions and local craft practices. The steeply pitched slope of the pavilion pediment lacks the classical ease typical of Wren's style.

The mythology of Freemasonry made it easier for Anglo-American Protestants to dissociate classical Roman architecture from the taint of paganism. Alexander Hamilton and other Freemasons commonly traced the origins of their fraternity to the earliest builders mentioned in the Bible, particularly King Solomon, who had ordered architects and stonemasons to construct the Jewish temple in Jerusalem. In *The Chronology of Ancient Kingdoms Amended* (1728), Isaac Newton stirred the Masonic imagination by attempting to reconstruct from ancient sources what the lost temple must have looked like. The mathematician wrote that Solomon's Temple was the prototype for classical architecture. Its proportions mirrored the divine architecture of the universe and even prophesied the future of humankind. Inspired by his reading of Old Testament texts, Newton drew a floor plan of the temple, believing that its dimensions and geometric ratios provided clues for biblical prophecies and timelines regarding Christ's second coming and the apocalyptic end of history, or God's final day of judgment.

This floor plan descended from a long tradition of speculation equating Solomon's Temple with the harmony of God's creation. Furthermore, during the late sixteenth century, European and English philosophers seeking to reconcile the

3.6 Wren Building 1695-98 (restored 1931 and 1968). College of William and Mary, Williamsburg, Virginia.

pagan and Christian traditions were already proposing that the Greek and Roman architectural orders originated in the divine proportions of Solomon's Temple. Before Newton's floor plan, the seventeenth century witnessed a number of attempts to reconstruct the appearance of Solomon's Temple as an emblem of cosmic order and prophetic wisdom.

In 1724–5 and again in 1729–30, following the posthumous publication of Newton's treatise, competing architectural models of Solomon's Temple were exhibited in London. The large, classically designed wooden models had been constructed during the previous century by Dutch and German designers. Their exhibition during the eighteenth century stimulated public interest in Freemasonry and the fraternity's claims to Solomonic origins. Leading English Freemasons began publishing prints of Solomon's Temple in Masonic publications (fig. 3.7). This image circulated in America and later appeared on Masonic aprons that members wore during lodge meetings, public parades, and initiation rituals. In a revolutionary-era apron from Massachusetts (fig. 3.8), the symmetrical, rectangular block representing Solomon's Temple possesses a mosaic forecourt supported by classical pillars and ancient mythological figures: Minerva, Roman goddess of wisdom; Hercules, the Greek hero personifying strength; and Venus, Roman goddess of beauty.

Before the Revolution, few Masonic aprons were so elaborately decorated. However, colonial Freemasons already adopted mythic gods and heroes for teaching various moral and intellectual principles. When Alexander Hamilton visited the Newport, Rhode Island, studio of Robert Feke, he became excited by the artist's

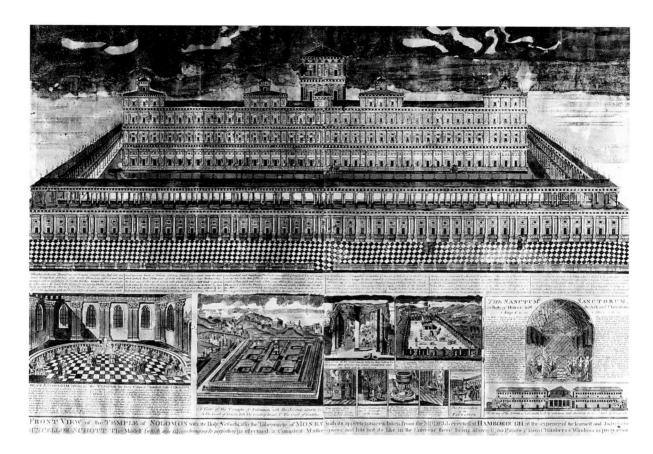

3.7 (top) **John Senex** A Front View of the Temple of Solomon, 1725. Hand-colored engraving on paper, $8\% \times 13\%$ in (20.9 \times 34.3 cm). Museum of Our National Heritage, Lexington, Massachusetts.

John Senex (d.1741), a London publisher of Masonic texts, copied the facade and courtyard view from a contemporary guidebook describing a 20-foot-square model of Solomon's Temple erected at the expense of Gerhard Schott (1641-1702), an opera patron from Hamburg, Germany. Schott had been inspired by scenery for an operatic production representing the destruction of Jerusalem. However, the original design for the temple reconstruction has been credited to the famed German humanist Desiderius Erasmus (1466?-1536).

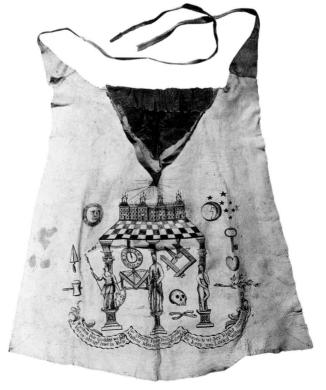

3.8 Anonymous

Master Mason's apron, c. 1780. Ink and watercolor on leather. Scottish Rite Museum of Our National Heritage, Lexington, Massachusetts.

This apron, with its handdrawn design, belonged to Richard Harris, Master of Philanthropic Lodge in Marblehead, Massachusetts from 1778-81. Beneath Hercules, the inscription reads "Let Critics sport & Fools deride / Masons alone in strength confide." The three sculptural figures refer to the Master and other supporting officers of a Masonic lodge. Emblems of the sun and the moon flank Solomon's temple, symbolizing the harmony and divine architecture of the universe.

3.9 Simon Gribelin
The Judgment of Hercules.
Engraving after a painting by
Paolo de Matthais
(1662–1728) for the
frontispiece of Lord
Shaftesbury's Characteristicks
of Men, Manners, Opinions,
Times (1711), vol. 3, treatise
7. Library of Congress,
Washington, D.C.

Judgment of Hercules, a picture later destroyed in a fire. In this rare attempt at history painting, Feke copied a European print of the subject (fig. 3.9). Hamilton and other Freemasons identified with this popular image of Hercules because the classical hero had demonstrated moral strength in choosing the difficult mountainous path pointed to by Virtue rather than the sensual pleasures of the flesh as personified by the recumbent figure of Vice. In the Massachusetts apron, the central figure of Hercules turns toward the Roman goddess of wisdom. The inscription beneath her reads: "Wisdom fair Goddess we Persue / Virtue always have in View." Eighteenthcentury Freemasons gave priority to Minerva, but they also embraced Venus as a personification of aesthetic beauty and chaste, divine love. Counteracting Vice, Venus represented the purification of nature and the senses to a higher state of spiritual being. Beneath the nude Venus, who modestly covers herself, the Masonic apron's inscription affirmed the rights of beauty "Lock'd within our hearts." During the eighteenth and nineteenth centuries, Freemasons became leading proponents of the arts, defending the claims of beauty against puritanical moralists, who believed that art was an unnecessary luxury allied with vice. As we shall see, colonial portraits often alluded to the spiritual ideals and virtues associated with the goddesses Venus and Minerva.

Domestic Architecture as a Moral Force

During the spring and autumn of 1728, the English-educated Virginian William Byrd II (1674–1744) led a surveying expedition to establish the dividing line between North Carolina and Virginia. Byrd kept a travel journal of his experiences along the trail from the Great Dismal Swamp toward the Appalachian Mountains. He decided to publish the travelogue for the benefit of his aristocratic friends in London, many of whom were Newtonian men of science and members of the Royal Society, Britain's leading scientific organization. Byrd himself had gained Royal Society membership in 1696 in recognition of his interest in the natural history of the American continent. By the time that he undertook his surveying expedition, he had collected over 4,000 books on science, architecture, and other subjects, the largest library in the American colonies.

The learned tobacco planter's *History of the Dividing Line* (1729) contrasted his beloved Virginia with North Carolina, which he derisively called "Lubberland" (cited in Lockridge, p. 138). While Byrd portrayed Virginia as a biblical paradise, Lubberland was a virtual wilderness, where oafish, "indolent wretches" lived in close proximity to cattle and hogs and "where there is neither church, chapel, mosque, synagogue, or any other place of public worship of any sect or religion whatsoever" (cited in Lockridge, p. 138). In Edenton, North Carolina, Byrd observed that "a citizen here is counted extravagant if he has ambition enough to aspire to a brick chimney. Justice herself is but indifferently lodged, the courthouse having much of the air of a common tobacco house" (cited in Lockridge, p. 139).

North Carolina's dearth of public and domestic architecture signified an irreligious, lawless, and dangerously democratic society that treated governors "with all

3.10 Westover

Riverfront facade, Charles City County, Virginia, 1730–34. Cook Collection, Valentine Museum, Richmond, Virginia.

Although Sir Christopher Wren was never known to have designed small houses, his name became stylistically associated with the simple, rectangular-block houses popular among the English middle class and country gentry during the late seventeenth and early eighteenth centuries. With its hipped roof, red brick, and white stone materials, and carefully proportioned facade, Westover bears comparison with Minster House in the city of Winchester, England, a small, detached home influenced by Wren's elegant classicism.

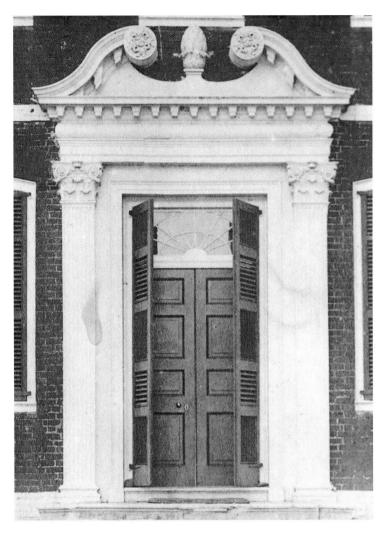

3.11 WestoverRiverfront door, Charles City
County, Virginia, 1730–34.
Cook Collection, Valentine
Museum, Richmond, Virginia.

the excesses of freedom and familiarity" (cited in Lockridge, p. 139). Byrd told the story of one "bold magistrate" who ordered "a fellow to the stocks for being disorderly in his drink" only to be "carried thither himself," where he "narrowly escaped being whipped by the rabble into the bargain" (cited in Lockridge, p. 139).

Returning to Westover, his tobacco plantation on the James River just west of Williamsburg, Byrd acted to guarantee that Virginia would remain safe from the Scottish and Irish settlers of North Carolina and Pennsylvania, whom he compared to the barbarian "Goths and Vandals of old" (cited in Lockridge, p. 140). He ordered his father's old wooden manor house torn down and replaced by an elegant and spacious redbrick mansion (fig. 3.10) designed after the Renaissance-inspired style of Sir Christopher Wren's architecture. Wren's classicism, which Freemasons and Royal Society brothers promoted in concert, symbolized the modern triumph of civilization and the rational order of the Newtonian universe over barbarism.

This classical style of architecture, often named "Georgian" after the eighteenthcentury German Protestant kings of Great Britain, expressed itself at Westover in the symmetrical arrangement of large sash windows that surround an elaborately decorated stone entrance on the mansion's

riverfront facade (fig. 3.11). The expensive Portland stone was imported from England. A London craftsman probably carved the fluted Corinthian pilasters on the sides and the broken "swan's-neck" pediment overhead. Topping off the doorway's central axis, a pineapple finial welcomes visitors as a rich, exotic symbol of the hospitality that awaits them beyond the threshold.

The door would have reminded Byrd of the many years he had spent in London, since its design was based on a type that had been popular in the British metropolis years earlier. Built on a far smaller scale than the mansions of the English aristocracy, Westover's two and one-half stories nevertheless represented a significant increase in living space for wealthy Virginians. At the time, the vast majority of Virginia's propertied elite still resided in one- and one-and-a-half-story houses, with just two rooms on the ground floor. In most areas of the colonies, small, unpainted wooden houses with small windows continued to dominate the eighteenth-century American countryside, even as the richest citizens increasingly built larger, multiroom mansions of brick or painted wood. Byrd, who coveted the office of royal governor, modeled Westover after the Governor's Palace in Williamsburg and thereby established a prestigious model for subsequent mansion architecture. In styling

their private homes after the public architecture of government buildings, wealthy colonists proclaimed their inherent right to political power. Unlike the virtual social anarchy he witnessed in the wilds of North Carolina, the slave-owning Byrd easily envisioned himself as master of his domain at Westover and a leader of colonial Virginia:

Like one of the patriarchs, I have my flocks and my herds, my bond-men and bondwomen, and every soart of trade amongst my own servants, so that I live in a kind of independence on every one, but Providence. However tho' this soart of life is without expence yet it is attended with a great deal of trouble. I must take care to keep all my people to their duty, to set all the springs in motion, and to make every one draw his equal share to carry the machine forward. But then tis an amusement in this silent country, and a continual exercise of our patience and economy. (cited in Lockridge, p. 123)

Keeping the plantation "machine" in motion meant the repeated beating of black house servants and field slaves. We know this because Byrd kept a secret, coded diary that recorded his methodical daily routine, which consistently began with readings in Greek and Hebrew and generally ended with prayers thanking God for his blessings. In response to disobedient or lazy slaves, he matter-of-factly describes whippings and other brutal punishments, such as hot-iron brandings and the use of iron boots, bits, and clamps. The harmonic, Newtonian architectural order of

3.12 Drayton Hall Ashley River, land facade, 1738-42. Charleston, South Carolina.

Two-story porticoes were a rarity in Great Britain, where the relatively cold, damp climate made large, airy porches impractical. Drayton Hall's temple-design portico was modeled after Andrea Palladio's Villa Pisani in Montagnana, Italy. The first English edition of Palladio's architectural designs appeared in 1715. As the earliest Palladian temple portico in the colonies, Drayton Hall helped establish the fashion for the classical villa style.

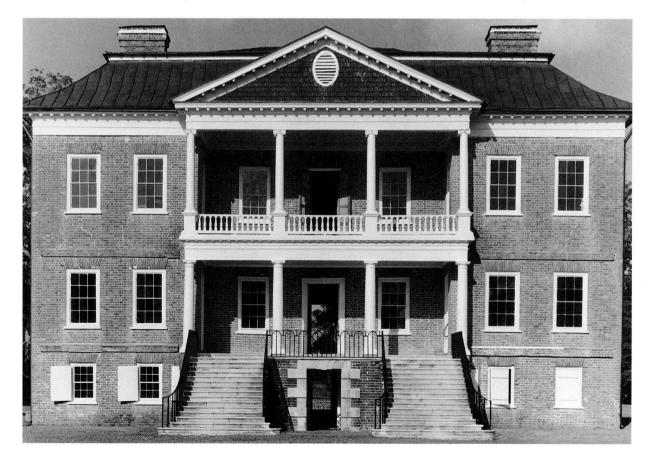

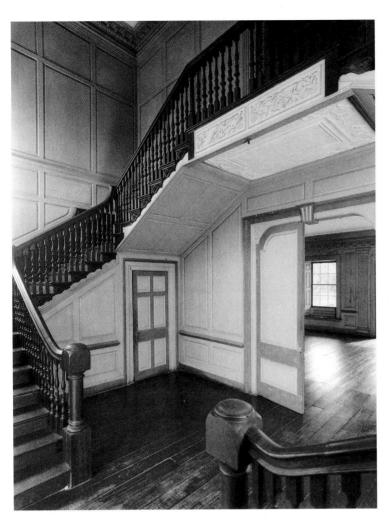

3.13 Drayton Hall Interior staircase, 1738–42. Charleston, South Carolina.

Westover's classical design symbolized Byrd's gentlemanly status and his membership in London's Royal Society, but the master's hospitality came at a terrible human price.

Soon southern slave owners were building houses that looked like Roman temples. On the Ashley River close to Charleston, South Carolina, John Drayton, heir to twenty plantations, constructed a two-story, redbrick mansion elevated high above the ground by a basement floor (fig. 3.12). Two exterior staircases invited guests upward toward the two-tiered, central portico, or entrance porch. Greek Doric columns, austere symbols of masculine strength, frame the lower-story entrance. Slender-proportioned Ionic columns, expressing wisdom and refinement, ennoble the second-floor balcony, which is capped by a gently sloping pediment. The portico's elegant vertical thrust is more than balanced by the horizontal breadth of the mansion and the generous square spacing between columns in both portico tiers.

The builders of Drayton Hall relied on the Renaissance villa designs of the Italian architect Andrea Palladio (1508–80), which were first promoted in seventeenthcentury England by Inigo Jones and then popularized in the eighteenth century by

Richard Boyle, third earl of Burlington (1694–1753), and his circle of architect friends, many of whom were Freemasons. Burlington sponsored the publication of design books, which helped spread Palladian villa architecture to the American colonies. Drayton Hall and other colonial mansions served as domestic, semi-private theaters for the display of luxuries and the performance of refined manners. Whereas single- and double-room house plans forced most colonists to combine a number of living functions—sleeping, dining, and entertaining—in a single large hall, the new multiroom mansions enabled wealthy merchants and landowners to create lavish parlors, dining rooms, and upper-story ballrooms for entertaining guests. Matching the ceremonial grandeur of Drayton Hall's exterior staircases, a dual-branched interior staircase (fig. 3.13) led visitors to a classically ornamented second-floor doorway, through which were more rooms for dancing, conversation, and card playing.

Emulating the hospitality and largesse of the English aristocracy, propertied colonists demonstrated their elite status through the expenditure of money for maintaining a convivial house open to peers, friends, relatives, and other guests. In 1744, Alexander Hamilton traveled to Albany, New York, where he found the predominantly Dutch population wanting in gentility. The doctor's appraisal is worth

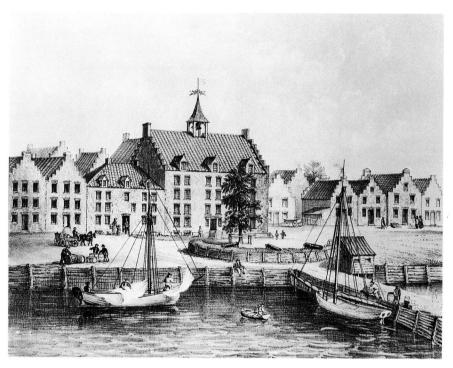

quoting at length, since it reveals important cultural and social attitudes regarding the role that art, architecture, and consumer luxuries played in colonial life:

The Dutch here keep their houses very neat and clean, both without and within. Their chamber floors are generally laid with rough plank, which in time, by constant rubbing and scrubbing, becomes as smooth as if it had been planed. Their chambers and rooms are large and handsome. They have their beds generally in alcoves, so that you may go thro' all the rooms of a great house and see never a bed. They affect pictures much, particularly scripture history, with which they adorn their rooms. They set out their cabinets and *buffets* much with china. Their kitchens are likewise very clean, and there they hang earthen or delft plates and dishes all round the walls, in manner of pictures, having a hole drilled thro' the edge of the plate or dish and a loop of ribbon put into it to hang it by; but notwithstanding all this nicety and cleanliness in their houses, they are in their persons slovenly and dirty. They live here very frugally and plain, for the chief merit among them seems to be riches, which they spare no pains or trouble to acquire, but are a civil and hospitable people in their way, but at best rustic and unpolished . . .

They live in their houses in Albany as if it were in prisons, all their doors and windows being perpetually shut. But the reason of this may be the little desire they have for conversation and society, their whole thoughts being turned upon profit and gain, which necessarily makes them live retired and frugal. (cited in Horner and Bain, p. 365)

In Hamilton's view, the Albany Dutch failed to qualify for social elite status despite their considerable wealth and patronage of religious art. Their allegedly unkempt appearance and lack of personal hygiene signified not only a rustic lack of polish but also a lack of interest in wanting to please others. Hamilton suggests that their

3.14 Stadt Huys (City Hall)

New Amsterdam (New York), 1679. Lithograph by George Hayward, 1869. J. Clarence Davies Collection, Museum of the City of New York.

This nineteenth-century lithographic representation of New Amsterdam is based upon a 1679 sketch by a minor Netherlandish artist. The cityscape recalls more famous urban views by Jan Vermeer (1632-1675)-such as View of Delft— and by other Dutch painters. The distinctive stepped-gable design of colonial Dutch architecture was adopted by English and Anglo-American builders of Anglican parish churches, as seen in St. Luke's Church in Newport Parish, Virginia (see fig. 2.15).

frugality masked a selfish materialism, since they care only for "profit and gain" and little for real hospitality. The Albany Dutch retreated from conversation and social life to imprison themselves like misers and misanthropes behind shuttered windows and bolted doors. Though neat and clean, their tall, narrow town houses lacked the classical ornamentation that Hamilton elsewhere associated with gracious living and refined taste. No Dutch-American town houses have survived in Albany or New York City. However, a nineteenth-century lithograph has preserved a view of the seventeenth-century Stadt Huys in New Amsterdam (New York) (fig. 3.14). The stepped-gable town houses surrounding the City Hall constituted a Dutch building type that continued into the eighteenth century, when Hamilton toured Albany. This was only one of many local building traditions associated with various ethnic groups that stood in contrast to the Anglophile Palladianism of colonial elite mansions.

American men of wealth imported more than London-published design books of Palladian architecture. They also imported skilled carpenters and other craftsmen, who could transform abstract plans into elegantly decorated homes. The London-trained carpenter and joiner William Buckland (1734–74) arrived at the Virginia plantation of George Mason as an indentured servant bound to work four years without pay as a carpenter and joiner on Mason's new mansion, Gunston Hall. After working sixteen years for various Virginia patrons and establishing his own workshop of skilled craftsmen, Buckland, in 1771, began working in Annapolis, Maryland, for Edward Lloyd, a learned gentleman who corresponded with members of London's Royal Society and had been an active participant in the Masonic culture of the Tuesday Club. Lloyd hired Buckland to finish construction of a massive, three-story brick town house, originally begun by Samuel Chase, whose debts had forced him to sell the property (fig. 3.15).

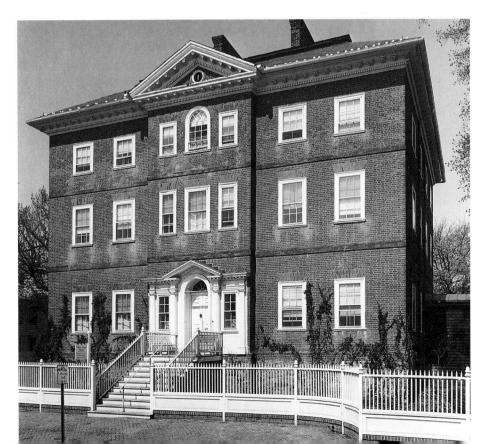

3.15 William Buckland Samuel Chase-Edward Lloyd House, Annapolis, Maryland, 1769–73. Historic Annapolis Foundation.

The mansion's exterior features a Palladian or Venetianstyle entrance, with two narrow windows flanking the arched central door. Ionic columns and pilasters, or flattened, rectangular columns, frame the entrance windows and door, which is capped by a modest, gently sloping pediment. A far more substantial pediment adorns the middle of the roof to accentuate the projecting central block and the building's classical symmetry. The grandeur of the entrance is continued in the interior entrance hall and stairway (fig. 3.16). Dramatically framed by an Ionic columnar screen, the stately stairway leads to a half-story landing illuminated by a Palladian window motif corresponding to the exterior's three-part entrance. The ceremonial stairway then divides into two parallel side flights that are cantilevered back over the entrance hall and upward to the second floor. Buckland supervised all the decorative wood carving to create one of the most elegant interiors in colonial America. Study of the architectural design books that Buckland was known to have had in his

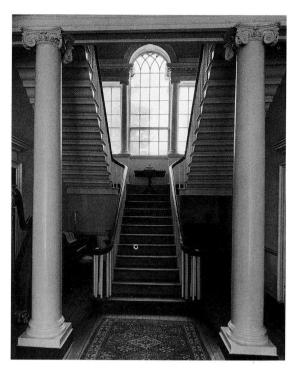

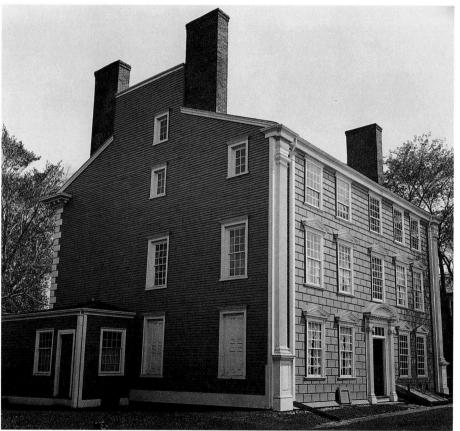

3.16 (top) William Buckland Interior entrance hall and stairway, Samuel ChaseEdward Lloyd House, 1769–73. Historic Annapolis Foundation.

3.17 Isaac Royall HouseGarden (west) facade, Medford, Massachusetts, 1733–37. Society for the Preservation of New England Antiquities, Boston.

Palladian in design, the west facade is flanked at either end by tall wooden pilasters and features pedimented windows on the first two stories. The classically ornamented entranceway was modeled after an illustration in William Solomon's *Palladio Londinensis* (1734), a popular pattern book of Palladian designs.

3.18 Isaac Royall House Great chamber, Medford, Massachusetts, 1733–37. Society for the Preservation of New England Antiquities, Boston.

In remodeling and expanding the original seventeenth-century farmhouse, Isaac Royall was forced to work with its low ceilings. In the second-story "great chamber," which functioned as a bedroom, the painted wooden pilasters flanking the fireplace appear relatively squat. However, the cramped feeling is eased by the room's large windows framed by wide, rounded archways that lead into shallow alcoves.

library has led scholars to conclude that he modeled the stairway's Palladian window after engravings in *City and Country Builder's and Workman's Treasury* (1745) by Batty Langley, English builder-designer and active promoter of Freemasonry.

By painting wooden columns, pilasters, and classical ornaments white, American builders mimicked the marble or stone architecture of ancient temples. In colonial New England, most mansions were primarily wooden constructions rather than of the red brick generally found in the South. However, for the west or garden facade of the Isaac Royall house in Medford, Massachusetts, builders shaped wooden boards to imitate horizontal rows of masonry stones (fig. 3.17). Royall, a merchant in the rum and slave trade, enlarged the family's original two-and-a-halfstory brick house from the late seventeenth century into a much larger three-story mansion ornamented with classical details. In addition to simulating stonemasonry on the western facade, Royall decorated his "great chamber" (Pierson, Jr., p. 94) on the second floor with wooden Corinthian pilasters painted to imitate elegant marble (fig. 3.18). Imitative painting to create faux marble or stone was also practiced by the lesser gentry in England. Rather than being regarded as a deception, the technique signified Royall's refined, Anglophile taste for the ancient traditions of stonemasonry and temple architecture. Though separated by hundreds of miles, Royall was the spiritual brother of William Byrd, who believed that the classical style of Sir Christopher Wren was a cultural defense against American barbarism.

A group portrait of *Isaac Royall and His Family* by Robert Feke represents the young master of the Medford mansion standing next to his wife and baby daughter (fig. 3.19). His sister-in-law and sister sit at the far left of the painting. The stiffly posed figures appear to have been shaped by the fashionable taste for classical

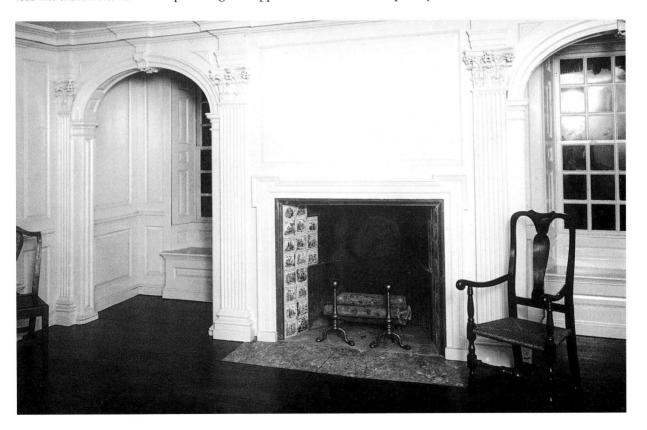

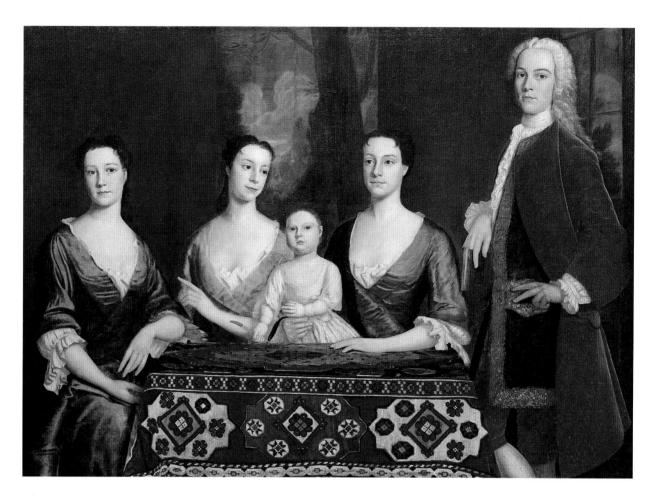

formality and balanced order. The English author John Evelyn, a friend of Sir Christopher Wren, had argued against the asymmetry and alleged lack of proportion in medieval or Gothic-style buildings because they contributed to irregular behavior in the people who occupied them. In Feke's group portrait, there is little evidence of emotional irregularity. The elongated necks of the expressionless women may remind us of James Bowdoin's poem dedicated to his wife (see p. 81). The rectilinear forms of the composition, from the table in the immediate foreground to the rectangular window panes in the background, suggest the Royall household's dominance over nature. The geometric, symmetrical design of the Turkish carpet simultaneously signifies Isaac Royall's possession of imported luxuries and his virtuous desire for clarity and order. The painting makes a clear distinction between male and female social roles. The seated, more passive women are essentially defined by association with the baby as domestic caregivers, while the young patriarch stands with a book as a worldly man of learning and public affairs. Feke's crisply linear style and tight control of the paint surface accentuate the impression that the New England wilderness has been subdued by a civilized, moral aesthetic. As we shall soon see, Feke appropriated the composition of his ambitious group portrait from the work of John Smibert, an immigrant Scottish artist who introduced a higher level of sophistication and academic learning into American portraiture.

3.19 Robert Feke

Isaac Royall and His Family, 1741. Oil on canvas, $56\% \times 77\%$ in (142.7 \times 197.5 cm). Harvard Law Art Collection, Cambridge, Massachusetts. Gift of Dr. George Stevens Jones.

Although intent on capturing convincing likenesses, Feke demonstrated little interest in plumbing the depths of the individual psyche. The family's virtually expressionless, emotionally cool faces reveal nothing of interior psychological states. Instead, the artist's emphasis is on establishing social class, gender, and age distinctions. The pictorial prominence of the Turkish carpet was no idle boast because a 1739 family estate inventory listed three such carpets.

Political Portraiture: Colonial Governors as Pillars of State

Beginning during the late seventeenth century, portraits of royal governors were exhibited in government buildings as symbols of state authority. They usually were hung near official portraits of the King and Queen sent from London as royal gifts. To commemorate the one-hundredth anniversary of the founding of Massachusetts Bay Colony in 1730, portraits of King George II and Queen Caroline arrived in Boston to decorate the walls of the governor's council chamber. Shortly thereafter, the new governor of Massachusetts, Jonathan Belcher, commissioned a full-length portrait of himself. This son of a wealthy Boston merchant thereby accrued for himself the political benefit of basking in royalty's reflected glory.

In addition to formal state portraits, images of rulers and public notables were also disseminated through the medium of prints imported from London. Before his formal installation as royal governor of Massachusetts in 1730, Jonathan Belcher sat for a smaller, half-length portrait painting by the Irish artist Richard Philips (1681–1741). Four years later, Belcher's son hired the London printmaker John Faber (1695–1756) to engrave a mezzotint of this portrait (fig. 3.20). A mezzotint is a type of print that emphasizes fluid, painterly qualities based on subtle tonal gradations from light to dark areas. Mezzotint reproductions of paintings were a popular learning tool for self-taught American painters who lacked academic training and could not travel abroad to see original works of art. American painters often borrowed compositions from imported mezzotints to create more fashionable portraits for status-conscious patrons. Faber's mezzotint presents Belcher as a model of aristocratic gentility and state authority. Holding his government commission as if it were a royal scepter, Belcher commands a background view of Boston harbor, where a British naval ship fires its cannon in salute. His costume is distinguished by a long periwig with lavish curls, a velvet waistcoat with gold brocade, and a fine lace jabot. In the lower-right corner, near Belcher's family crest at the bottom of the print, the seal of King George II seems suspended from the hand holding the royal commission.

Despite his willingness to sit for portrait paintings, Belcher worried that the print would not be well received by citizens, who routinely warned against the moral dangers of pride and luxury. On August 7, 1734, he angrily chastised his son for commissioning the mezzotint without his permission:

I am surprised & much displeased at . . . your having my Picture done on a Copper Plate—how cou'd you presume to do such a thing without my special leave and Order—you should be wise and consider the consequences of things before you put 'em in Execution, such a foolish affair will pull down much Envy, and give occasion to your Father's Enemies to squirt & Squib & what not—It is therefore my order, if this comes to hand timely that you destroy the plate & burn all the Impressions taken from it. (cited in Saunders and Miles, p. 24)

Unlike paintings of royal governors exhibited in public buildings, inexpensive prints could be marketed like other commodities to a far larger audience that included friends and foes alike. Belcher's enemies might have been quick to point out that his portrait print masked his merchant middle-class origins. He had not been born with an aristocratic pedigree or even with a genealogical tie to the first

leaders of Massachusetts. Nevertheless, Belcher imaginatively asserted descent from English nobility and prominently advertised this claim with a family coat of arms below his portrait. His son did not destroy the portrait print of his father. The governor's temper cooled to the degree that, in 1735, he requested a dozen copies of the engraving and the copper plate itself, from which he could print still more images for friends and political allies. By possessing the copper plate, Belcher could better control the print's future reproduction and distribution. Ultimately, the governor's anxiety about the symbolic power of such images was very prescient because most portraits of royalty and royal government officials would be destroyed during the American Revolution.

Portrait prints and official, state portraits of royal governors were intended as imposing images of both power and beauty. In *Government the Pillar of the Earth* (1730), a sermon celebrating Belcher's inauguration as governor, the Reverend Benjamin Colman, one of Boston's most prominent Congregationalist clergymen, employed architectural metaphors to characterize the promise of his regime:

The governments and rulers of the earth are it's [sic] pillars for ornament, to adorn it. Pillars in a fine building are made as

beautiful as may be; they are plan'd and polish'd, wrought and carv'd with much art and cost, painted and gilded, for sight as well as use. As the legs are to a body comely in it's [sic] goings: Such are pillars in a stately structure for beauty to the eye . . . Solomon . . . had built the temple of God with all it's [sic] pillars. They represented the strength of Christ and his stability, to bear the weight of government laid upon him . . . So those in power and magistracy are to be supposed, men adorn'd with superior gifts, powers and beauties of mind: Men that adorn the world wherein they live, and the offices which they sustain. And then their office adorns them also, and sets them in conspicuous places, where what is great and good in them is seen of all. (cited in Sandoz, pp. 14–15)

Like a portraitist or architect, Colman transforms government authority into an aesthetic composition. Quoting the biblical Song of Solomon, the clergyman compared the wise ruler to a "beloved" husband, whose adoring wife exclaims "His Legs are as Pillars of Marble, set upon Sockets of fine Gold" (cited in Sandoz, p. 15). Colman defined effective government not in terms of coercion or the fear of punishment

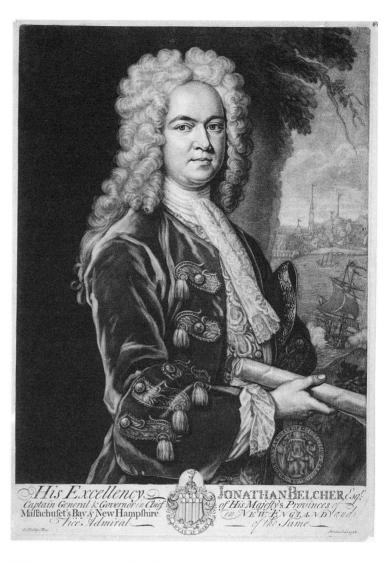

3.20 John Faber (after Richard Philips), *Governor Jonathan Belcher*, 1734. Mezzotint, 16 × 10% in (40.6 × 26.3 cm). Special Collections, Princeton University Library, Princeton, New Jersey.

but as the offspring of attractive, magnetic forces, an aesthetic love for the beautifully ordered and proportioned body politic. Colman's liberal use of architectural metaphors and repeated allusions to Solomon and Solomon's Temple implicitly acknowledged Governor Belcher's membership in Freemasonry. Belcher had joined a Masonic lodge in London in 1704 and played a prominent role in establishing the fraternity's prestige in America. Freemasonry contributed to the notion that government worked best when motivated by the positive, socially binding feelings of friendship and brotherhood.

John Smibert and the Portraitist as Man of Learning

When, in 1730, Governor Belcher ordered the official full-length standing portrait of himself to exhibit publicly next to the King and Queen's, he did not have to return to London to find a qualified painter. John Smibert (1688–1751), the first fully trained professional artist to work in America, had arrived in Boston in 1729 after a brief residence in Newport, Rhode Island. A native of Edinburgh, Scotland, Smibert had begun his career humbly as an apprentice to a house painter and plasterer. But after moving to London in 1709, he attended the art academy of the court painter Sir Godfrey Kneller (c.1646–1723) and immersed himself in London's Masonic culture of fraternal societies and clubs. Smibert belonged to the Rose and the Crown, a brotherhood of young artists and connoisseurs who met weekly at a tavern in Covent Garden. He also joined the London Society of Antiquaries, a learned organization that met one evening per week "to cultivate the knowledge of antiquities of England" (Saunders, p. 53). The Society, like Freemasonry, promoted public interest in architecture. It sponsored publication of prints that represented the ancient buildings and ruins of the British Isles. The Society of Antiquaries enabled Smibert to educate himself in the art of architectural design.

When Smibert established his Boston painting studio in 1729, he immediately joined the Scots Charitable Society, a brotherhood that united Scottish-American men throughout the colonies. The Freemason Alexander Hamilton was also a member of the Society and became an admirer of Smibert's paintings. Smibert impressed studio visitors and future patrons by exhibiting copies of Old Master paintings that he had made while touring the European continent. He also displayed an ambitious group portrait, The Bermuda Group, representing himself in the company of Dean George Berkeley, prominent philosopher and Anglican clergyman (fig. 3.21). Berkeley had arrived in Newport in 1729 with plans to found a university on the island of Bermuda, pending funding from the British Parliament. Berkeley envisioned the island as an ideal and paradisiacal site for educating children of American plantation owners and for training missionaries to convert Indian tribes to Christianity. Foreseeing an important role for the visual arts, the Irish-born churchman asked Smibert to direct an art academy on the island, teaching painting and the arts of design.

The Bermuda project languished and died in Newport while Berkeley waited in vain for parliamentary funding. But Smibert's group portrait commemorated the clergyman's leadership as a New World educator. The painting had been commissioned in 1728 by John Wainwright, an English admirer of Berkeley, who remained in London and apparently desired a visual remembrance of the philosopher and his entourage.

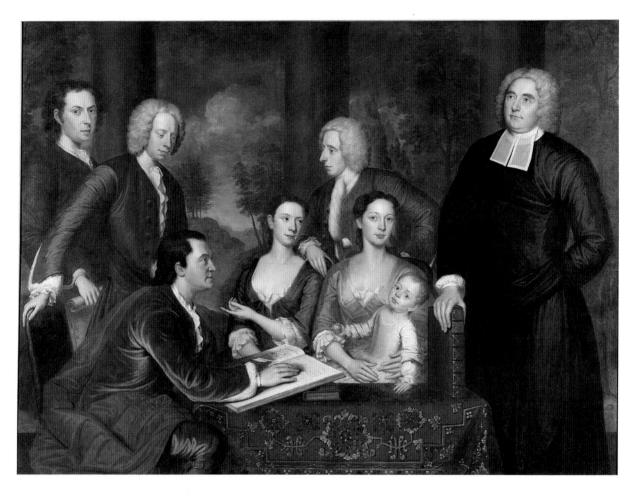

Standing at the far-right side of the painting, dressed in black clerical costume, Berkeley dominates the composition by appearing to lecture or dictate his thoughts before other members of the group. Despite his refusal to travel with the group to Newport, John Wainwright serves as Berkeley's earnest secretary. Sitting at the far left with quill in hand, he leans forward over a large, open notebook, waiting expectantly for the words of the clergyman, who has paused from speaking and seems lost in thought.

Averting his gaze upward in apparent communion with divine ideas, Berkeley appears oblivious to the other figures in the portrait, including his wife, who sits at the table next to her husband holding their newborn son, Henry. Mrs. Berkeley's traveling companion, a Miss Handcock, sits in the middle of the painting. Standing immediately behind the two women and Wainwright are Richard Dalton and John James, "Men of Fortune" or "gentlemen of substance," who traveled to America "partly for their health & partly out of their great respect for [Berkeley] & his Design" (cited in Saunders and Miles, p. 118). Significantly, at the far left, Smibert painted a portrait of himself. He stares at us with penetrating eyes and prominently displays a sketch with one hand, visually linking himself with Berkeley, who grasps one of his sturdy philosophy books on the table in front of him. Smibert's selfportrait within The Bermuda Group implicitly asserts the cultural equality of the visual and verbal arts and affirms his proposed status as a professor of the design arts. As if to underscore the fact that he was more than a mere craftsman, Smibert

3.21 John Smibert

The Bermuda Group: Dean George Berkeley and his Family, 1729. Oil on canvas, 5 ft 9½ in \times 7 ft 9 in (1.76 \times 2.36 m). Yale University Art Gallery, New Haven, Connecticut. Gift of Isaac Lothrop.

Contemporaries referred to this intimate, informal type of group portrait as a conversation piece. Set within leisurely domestic interiors or garden, parklike spaces, the casual conversation piece distinguished itself from the formal look of official, ceremonial group portraits. Although it had precedents in Renaissance painting, the conversation piece gained popularity in eighteenthcentury England.

signed his name on the end of a book resting on the table at the center of the composition.

Smibert's picture should be interpreted in relation to a poem that Berkeley composed while planning the Bermuda project. Expressing dissatisfaction with the corrupt state of European civilization, Berkeley's "Verses on the Prospect of Planting Arts and Learning in America" prophesied the westward progression of history toward a perfected fulfillment in the New World:

> The Muse, disgusted at an age and clime, Barren of every glorious theme, In distant lands now waits a better time, Producing subjects worthy fame:

In happy climes, where from the genial sun And virgin earth such scenes ensue, The force of art by nature seems outdone, And fancied beauties by the true:

In happy climes the seat of innocence, Where nature guides and virtue rules, Where men shall not impose for truth and sense, The pedantry of courts and schools:

There shall be sung another golden age, The rise of empire and of arts, The good and great inspiring epic rage, The wisest heads and noblest hearts.

Not such as Europe breeds in her decay; Such as she bred when fresh and young, When heav'nly flame did animate her clay, By future poets shall be sung.

Westward the course of empire takes its way; The four first acts already past, A fifth shall close the drama with the day; Time's noblest offspring is the last. (cited in Silverman, p. xix)

Berkeley's poem became one of the most widely quoted in the American colonies and inspired generations of American artists well into the nineteenth century. Smibert's The Bermuda Group seems to share Berkeley's conviction that the history of civilization was traveling westward with the sun toward the American continent.

At the center of the painting, Miss Handcock gestures with her left hand, drawing our attention to a New England landscape of water, rocks, evergreen trees, and a golden horizon that suggests either a sunrise or sunset. The painting's composition proposes the alchemical power of the arts and letters to transform America's "virgin earth" into Berkeley's "golden age" or final world empire. In the middle ground, three columns serve as a mediating screen between the community of learning and refinement in the foreground and the rocky Rhode Island landscape in the background. The stone pillars create a protective temple of learning in a harsh environment. They mathematically order the pictorial space and anchor the eight human pillars into three groups, dominated by the singular presence of Berkeley, who stands alone in front of the right-hand column, almost obscuring it with his height and erect posture. Within the triangular middle group of figures, Berkeley's wife and son gaze directly outward toward the beholder. Henry, who was born in Newport in 1729, appears to offer us a golden piece of fruit, an emblem of the golden age prophesied by Berkeley. Henry's hair is also golden, as is the color of his mother's dress. The color scheme links them both with the sunlit horizon, symbolizing the future and the progression of history. As the youngest and only nativeborn American in the group, Henry personifies the western fruition of human destiny or "Time's noblest offspring" in the New World.

Smibert never shipped *The Bermuda Group* to London, perhaps because Wainwright, the politically ambitious patron of the painting, no longer wished to be associated with Berkeley's failed Bermuda project. The portrait remained in Smibert's Boston studio, where it could be admired by potential portrait clients and emulated by younger American painters such as Robert Feke (see fig. 3.19). Even if they knew or cared little about George Berkeley and his Bermuda project, Bostonians would have found much to admire in the composition, which grandly associated the human figure with the classical columns of temple architecture. *The Bermuda Group* is the visual equivalent of Reverend Benjamin Colman's sermon on governments and rulers as earthly pillars.

The painting's spatial illusionism; luminous color harmony of reds, golden yellows, and blues; complex interweaving of figures; and convincing representation of fabrics and textures impressed Boston spectators. Certainly, Smibert's ennobling pillars must have appealed to Governor Belcher, proclaimed the leading Massachusetts pillar of wisdom. By November of 1730, three months after the governor's inauguration and Colman's sermon, Smibert was completing Belcher's full-length standing portrait.

Smibert's portrait of Belcher has been lost, but we may gain some indication of its appearance by briefly examining another of the artist's full-length standing portraits. In his portrait of William Browne, one of New England's wealthiest landowners, Smibert posed his subject within a sharply rectilinear architectural space open to a rich landscape view of the Massachusetts countryside (fig. 3.23). Browne's erect posture is accentuated both by a palatial mansion wall and by a tall tree meeting the straight edge of the building. Browne's legs are carefully posed according to the recommendations of illustrated etiquette books, offering viewers both a profile and frontal view. The shapely legs, gleaming in silver-white stockings and terminating in golden-buckled shoes, recall the words from Reverend Colman's sermon: "His Legs are as Pillars of Marble, set upon Sockets of fine Gold" (cited in Sandoz, p. 15). Browne stands firmly upright, in moral harmony with the austere geometry of classical architecture and in confident possession of the land beyond his outstretched hand. The russet brown of his suit gleams with richly painted highlights, visually connecting him with the warm, glowing horizon line in the distance. While Smibert was painting the portrait, Browne was in the process of constructing a country estate in Danvers, Massachusetts. Browne Hall's most distinctive exterior feature was a porch supported by fifteen-foot-high columns in the style of the Greek Ionic order. Browne's portrait as well as a companion portrait of his wife were to hang in Browne Hall, the site of lavish social entertainments.

Altogether, Smibert painted approximately 240 portraits in America. Though his yearly income fluctuated and he supplemented his portrait fees by selling painters'

pigments and engraved reproductions of art, he was able to live in the manner of a fairly successful merchant. Support from leading public figures such as Governor Belcher and Boston's Congregationalist clergymen was crucial for his success in gaining significant portrait commissions.

In 1734, Smibert painted a portrait of Reverend Colman, one of a series of ministerial portraits that were reproduced by Peter Pelham (c.1697-1751), a Londontrained printmaker who had arrived in Boston in 1727 (fig. 3.22). Pelham became a leading Boston Freemason and not only engraved prints but also ran a "finishing" school for teaching Boston children refined manners and various cultural attainments. The portrait prints of Boston clergymen were marketed to admiring parishioners as uplifting personifications of moral virtue. However, the richly modeled portraits also signaled New England's growing sophistication in matters of fashion and taste.

Reverend Colman's son-in-law, the Reverend Ebenezer Turrell, enthused that Smibert had perfectly captured Colman's likeness. Furthermore, he praised Pelham's portrait print and observed that it was on display in many Boston homes. Smibert portrayed Colman with a suitably stern expression, but he softened the moral severity of the clergyman by richly dressing him in a long, flowing wig and black satin cloak or robe. Puritan clergymen from the seventeeth century had rejected the wearing of wigs as an aristocratic, prideful affectation. By the eighteenth century, however, Congregationalist ministers were accommodating themselves to the new

3.22 Peter Pelham (after John Smibert), The Reverend Benjamin Colman, 1735. Mezzotint on laid paper, 11×9 in (29.8×23.8) cm). Museum of Fine Arts, Boston. Bequest of Mr. Abram Edmands Cutter.

consumerism of the middle and upper classes. Colman's rich costume situated him within the affluent social circles of Governor Belcher and New England's merchant elite. Unlike earlier clergymen, who had warned against the moral dangers of visual images, Colman became an avid collector of pictures. He owned several Smibert paintings as well as Peter Pelham prints reproducing other Smibert portraits.

The Boston clergy functioned as supportive painting critics. In 1730, Mather Byles, who became minister for the Hollis Street Church established by Governor Belcher, published a poem in Boston newspapers welcoming Smibert's providential arrival for the hundredth anniversary of the founding of Massachusetts Bay Colony. Elevating Smibert beyond the social status of mere craftsman, Byles wrote that painting was the "Sister-Art" to poetry:

'Tis yours, Great Master, in just Lines to trace
The rising Prospect, or the lovely Face,
In the Fair Round to swell the glowing cheek,
Give Thought to Shades, and bid the Colors speak. (cited in
McCoubrey, p. 7)

Byles attributed godlike powers to Smibert's brush. From within his canvases "Crowds of new Beings lift their dawning Heads, / In conscious Forms, and animated Shades" (cited in McCoubrey, p. 7). Smibert's figures seem to breathe and speak. His brush is like a magic wand through which life's blended colors glow with warmth. With Smibert's presence in Boston,

a land that had once been "a barbarous Desert" devoid of the arts was drawing closer to a state of civilized refinement (cited in McCoubrey, p. 6).

In his portrait of Daniel, Peter, and Andrew Oliver, Smibert acted as a necromancer, who could conjure forth shades of the dead (fig. 3.24). Sons of merchant wealth and nephews of Governor Belcher, the three Oliver brothers were reunited

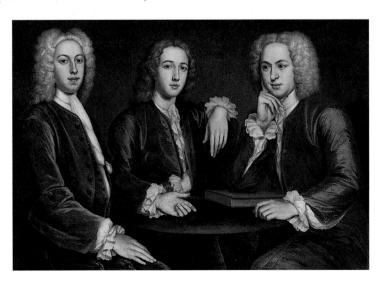

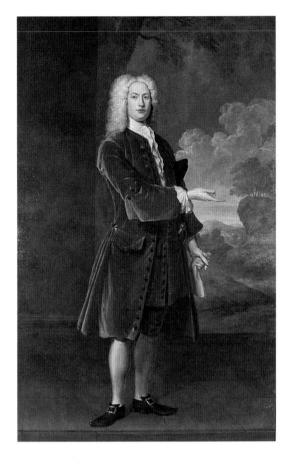

3.23 John Smibert William Browne, 1734. Oil on canvas, $92\% \times 57$ in $(234.9 \times 144.8 \text{ cm})$. The Baltimore Museum of Art. George A. Lucas Collection.

3.24 John Smibert

Daniel, Peter, and Andrew Oliver, 1732. Oil on canvas, $39\% \times 56\%$ in $(99.7 \times 144.5$ cm). Museum of Fine Arts, Boston. Emily L. Ainsley Fund.

Situated near the center of the picture, Peter Oliver's dangling left hand calls attention to itself. With his foreshortened forearm invisible and his wrist enframed by a flowerlike shirt sleeve cuff, the delicate, elongated hand seems to float in space, pointing to the book. With simple gestures, Smibert creates a mood of refinement.

on canvas by Smibert's magical paintbrush. Daniel, the eldest, on the left, had died six years earlier in 1726. Working from a miniature portrait of the deceased, Smibert restored him to life. Ironically, of the three, it is Daniel who seems as if he is about to speak. Gazing directly at us, he rests his left hand on the round table in front of him and seems to make a rhetorical gesture with his index finger. Opposite Daniel, Andrew is silently lost in thought. His right elbow rests upon a closed book, while his hand cradles his learned head to suggest the contemplation of intellectual truths. Meanwhile, Peter, the youngest, dressed in a cool, dark-blue suit, appears the most relaxed and informal of the three. Unlike his elder brothers, he wears no wig. He casually drapes an elegant hand over the back of his chair, while tucking the other inside his coat. Smibert's curvilinear arrangement of refined hand gestures spiritually and physically unites the brothers around the small table. Round tables became increasingly popular in colonial America because they were non-hierarchical. At a circular table, there was no head or preferred seat placement for a master or a mistress. All seats were equal in rank for informal gatherings of family and friends.

3.25 William Williams Deborah Hall, 1766. Oil on canvas, $71\% \times 46\%$ in (180.9 \times 118.1 cm). Brooklyn Museum of Art, New York. Dick S. Ramsay Fund.

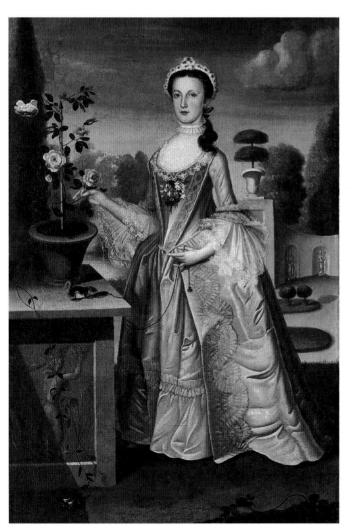

In Smibert's intimate group portrait, the circular table expresses brotherhood, an egalitarian ideal that Andrew and Peter Oliver carried into adulthood when both

> became Freemasons. However, the brothers' notion of fraternity and egalitarianism did not extend far beyond their own lodge. They conceived of colonial Freemasonry as a relatively exclusive order primarily for elite gentlemen. Boston's Masonic fraternity solidified the Olivers' social ties to other successful men of influence who remained loyal to British colonial rule. Nevertheless, dissident Masonic lodges formed by socially aspiring middle-class men would soon challenge the elite domination of Freemasonry.

Portraiture and Middle-Class Social Aspirations

Symptomatic of the rapid economic growth occurring during the 1750s, urban artisans and other middle-class men began to assert themselves more forcefully in colonial society and culture. In Philadelphia, where an increasing number of men were identifying themselves as gentlemen, the printer David Hall celebrated the establishment of his own printing firm by commissioning grand, full-length portraits of his three children, including his daughter, Deborah (fig. 3.25). Painted by the self-taught Englishborn artist William Williams (1727-91), the portrait of Deborah Hall represents an adolescent girl who is about to enter the society of marriageable women. Unlike the relatively spare portrait of the young Oliver brothers, David Hall's daughter is accompanied by a host of mysterious emblems, borrowed from various illustrated books, that define her moral and physical character. According to the art historian Roland Fleischer, Williams identifies his subject as an incarnation of Venus. The impressive enclosed garden in the background alludes to Venus's Garden of Love, while the rose that Deborah Hall delicately holds with her right hand also is an emblem of beauty and love. Hall's fancy satin gown shares the flower's luminous pink color. Standing stiffly like a living pillar of virtue, she holds with her other hand the leash of a pet squirrel, who sits quietly upon a stone plinth. The squirrel makes no effort to tug at its leash, symbolically expressing the taming of animal nature. Immediately below the squirrel, in a partial view of a relief sculpture, Williams portrays the mythological story of Apollo and Daphne, a moral tale on the virtue of chastity before marriage. The beautiful virgin Daphne is shown being transformed into a laurel tree before the god Apollo can subdue her for his sexual pleasure. A vine falls loosely over the figure of Daphne as an emblem of female dependency. According to the conventional symbolism of moralizing books and European marriage portraits, just as vines require trees to cling to permanently, so women need men and the institution of marriage to control and direct their lives.

Williams's portraits were displayed in David Hall's home as a lavish advertisement for prospective suitors seeking a beautiful, chaste wife from a socially prominent and culturally refined family. The painting's moralizing signs were especially common in colonial portraits of women and children, whose natures reputedly required greater monitoring. Women were particularly defined in terms of their sexual, animal natures. In contrast to men, they supposedly remained essentially childlike, with minds dominated more by unstable emotions and desires than by cool, objective reason.

The plethora of pictorial emblems appealed to men like David Hall, who were attuned to the secret rituals and visual symbolism of Freemasonry. Hall had been a business partner of the famous printer and man of science Benjamin Franklin, who had been active in Philadelphia Freemasonry since the early 1730s. Hall became part of a more socially inclusive movement known as "ancient Masonry" that challenged the authority of the traditional colonial elite to dominate the fraternity (Bullock, p. 97). Ancient Masons claimed a more mystical, deeper knowledge of Freemasonry's divine principles than that of so-called Modern Masons (Bullock, p. 85), whose lodges tended to exclude artisans and other men outside the inner circles of social and political power. The aristocratic ambience of Williams's portrait is a fictive space that pronounced the Hall family's genteel social status and consumerist devotion to the cult of beauty.

Colonial consumerism was not simply the expression of a profane, selfish materialism. Eighteenth-century colonists saw no necessary conflict between religious values and their acquisition of fashionable clothes, portraits, and other commodities. Consumer goods and luxuries represented the refinement and redemption of raw matter for human use and enjoyment. Assuming a sympathetic relationship between people and their material environment, colonists generally believed that luxuries or beautiful, refined objects could morally elevate individuals beyond their animalistic needs and appetites. Moderate enjoyment of the visual arts particularly signified the alchemical transmutation of the individual self to a higher state of spiritual being. Colonial families and communities prided themselves in the notion that America was becoming less of a wilderness and more of a paradisiacal garden populated by angelic, godlike beings.

John Singleton Copley and the Sanctification of the Consumer Revolution

No artist more forcefully resolved the spiritual ambivalence of the eighteenthcentury consumer revolution than did the Boston painter John Singleton Copley (1738-1815). Stepson of the printmaker and Freemason Peter Pelham, Copley expressed his artistic ambition early, at the age of sixteen, when he began painting copies of mythological subjects reproduced in European engravings that may have been in Pelham's collection of prints. Copley's The Forge of Vulcan focused on the nude figure of Venus, whose beauty and secret love potion subdued Mars, god of war (fig. 3.27). Pelham taught his talented stepson that the beautiful art of painting was also a magical potion that could overcome violent passions and generate sociable feelings of harmony and love. Pelham would have introduced Copley to the ideas of English philosophers and Anglo-American Freemasons, who believed that the arts contributed to civic virtue and the cultivation of genteel individuals.

Learning by studying the portraits of John Smibert, Robert Feke, and other artists who worked in Boston, Copley soon began to surpass his predecessors in the degree of pictorial illusionism and individual expression. Copley's 1761 Portrait of Mrs. Samuel Quincy (fig. 3.26) was partly inspired by copies or imitations of a portrait by the Flemish master Peter Paul Rubens (1577-1640). However, Copley demonstrated his own mastery by diverging considerably from the earlier prototypes. The portrait was commissioned by Samuel Quincy at the time of his marriage to

Hannah Hill, daughter of a wealthy Boston distiller and landowner. Quincy was a Harvard graduate, successful lawyer, and prominent Boston Freemason, who was known for his urbane manners and refined taste. Copley's fashion-conscious portrayal of Quincy's bride strongly contrasts the sitter's radiant, European-style costume with the austere, darkened background behind her. Unlike the relatively wooden, impersonal portrayals of young women in earlier colonial portraits, Copley's portrait suggests a certain depth of individual personality. The figure's columnar stiffness is modified by the relaxed crossing of the hands, the mysterious half-smile, the large, moist eyes, and the luminous face that is sensitively shaded by the surrounding darkness to suggest an introspective woman of great intelligence. Indeed, Hannah Hill's early love for reading literature had gained her the nickname of "Sophy" or "Sophia," Greek for wisdom.

Despite Copley's more convincing naturalistic technique, Sophy still personified the abstract moral and intellectual virtues associated with philosophy and the Roman goddess Minerva, beloved by Freemasons. In her left hand, Mrs. Quincy holds a sprig of larkspur, which eighteenth-century books on the symbolic language of flowers associated with marriage vows or devotion to one's spouse.

3.26 John Singleton Copley

Portrait of Mrs. Samuel Quincy (Hannah Hill), c.1761. Oil on canvas, $35\% \times 27\%$ in $(90.2 \times 70.8 \text{ cm})$. Museum of Fine Arts, Boston. Bequest of Miss Grace W. Treadwell.

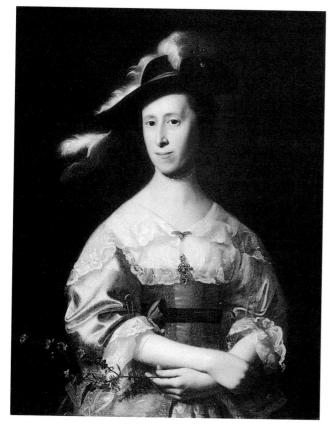

3.27 John Singleton Copley

Mars, Venus, and Vulcan: The Forge of Vulcan, 1754. Oil on canvas, 30×24 in (76.2 \times 61 cm). Sotheby's, Inc., New York.

Copley's painting replicates a print by the French engraver Nicolas-Henry Tardieu (1675-1749), who copied The Forge of Vulcan by Charles-Antoine Coypel (1694-1752), former First Painter to the King of France. In the composition, Venus coats a love arrow with her chemical brew much like a painter dipping a brush into a palette of pigments. With a cupid overhead asking for silence, Venus is like an artisan possessing powerful craft secrets.

Nevertheless, the independent-minded Sophia eventually separated from her husband for political reasons. With the advent of the American Revolution in 1775, Samuel Quincy, a Loyalist, fled to England, leaving behind his wife, who supported the struggle for national independence.

As we shall see in the next chapter, Copley also eventually emigrated to London. But his reasons were professional as well as political. Already, in 1766, he tested his career prospects abroad by sending a portrait of his half brother, Henry Pelham (1749–1806), to the spring exhibition of the London Society of Artists. Entitled *Boy with a Squirrel* (fig. 3.28), the picture won Copley critical praise and election as a "fellow" to the Society. However, Joshua Reynolds (1723–92), one of Britain's leading portraitists, advised the young American that his painting suffered from a "Hardness in the Drawing" and "an over minuteness" in its many parts (cited in McCoubrey, p. 11). Reynolds was referring to Copley's obsessive naturalism in the careful representation of virtually every detail of the painting, including the fur and whiskers of the American flying squirrel eating a peanut on the red mahogany table in the foreground. English-school painters favored a more generalized, painterly rendering of subordinate details so that they did not call attention to themselves and visually compete with the centrally important subject of the picture, in this case the idealized portrait of a daydreaming youth.

3.28 John Singleton Copley

Boy with a Squirrel (Henry Pelham), 1765. Oil on canvas, $30\% \times 25$ in (76.8 \times 63.5 cm). Museum of Fine Arts, Boston. Anonymous Gift.

3.29 John Singleton Copley

Portrait of Paul Revere, 1768. Oil on canvas, $35 \times 28\%$ in (88.9 \times 72.4 cm). Museum of Fine Arts, Boston. Gift of Joseph W., William B., and Edward H.R. Revere.

This portrayal of Revere compositionally resembles a portrait print of John Theophilus Desaguliers (1683-1744) by Copley's stepfather, Peter Pelham. Desaguliers, a man of science and father of modern Freemasonry in England, was depicted seated at a table while holding a large magnifying glass. In a manner similar to Revere's gleaming silver teapot, Desagulier's hand-held circular glass brightly reflects light as an emblem of intellectual, creative insight.

Rather than painting a conventional, generic squirrel borrowed from traditional emblem books, Copley attempted to impress his London audience with the representation of a species native to the eastern United States. The American flying squirrel is a nocturnal animal that can glide from tree to tree due to a thin membrane that functions like a parachute. Copley called viewers' attention to this species by shaping the bright white edge of the squirrel's gliding membrane into a shape that echoes the configuration of Henry Pelham's ear. Copley thus complicated and modified the emblematic meaning of the pet, whose delicate gold chain Pelham elegantly holds with the fingers of his right hand.

The retracted gliding membrane of a flying squirrel symbolically suggests the physical and spiritual potential for metamorphosis and the presence of a higher state of being hidden within earthly life. The squirrel's act of cracking the outer husk of a peanut to eat the nourishing food within reinforces this theme that at the core of nature's every detail there is a powerful, vitalistic force. Since this image of reverie is pervaded by a profound sense of silence, Copley's half brother appears to be listening for inner, spiritual voices or sounds. Pelham's prominently displayed ear invites the viewer inward like the opening to a mysterious cave, the site of internal membranes that vibrate with barely audible sounds and cause the human mind to soar with noble ideas and emotions. The intensely red swag of curtain behind Pelham, covered with vivid, almost electric, strokes of paint, seems to take flight. The diagonal folds of the curtain appear to form flaming wings emerging from his back. More than a colorful decorative background, the ascending red cloth becomes a visual metaphor for the meditative reverie that transforms an American youth into an angelic being.

Several years later, in his *Portrait of Paul Revere*, Copley focused his attention on the transformative power of the human eye (fig. 3.29). Like Henry Pelham's ear, the Boston silversmith-engraver's right eye seems to rest at the apex of a compositional triangle. The arched, penetrating eye is akin to the all-seeing, providential eye that often decorated Masonic aprons, engravings, and other artifacts. Near the time of Copley's portrait, Paul Revere (1735–1818) himself had engraved a Masonic lodge notification that featured an all-seeing eye amid a host of other mysterious signs (fig. 3.30). The all-seeing eye symbolized God's creative power as Supreme Architect. Like the sun, the Masonic eye projects life-giving rays of light outward into space.

Similarly, in Copley's portrait, Revere's right eye projects a powerful gaze toward the viewer. The silversmith, informally dressed in clean work clothes, has apparently been interrupted in his creative work by our presence. Revere holds a globular teapot with his left hand while his right hand lightly supports his head in a gesture of thoughtful contemplation. On the red mahogany table, three engraving tools point their sharp tips away from Revere and toward the silver teapot. In another moment, the craftsman will incise an elaborate design, projecting the light of his godlike eye and mind into the receptive material surface of the consumer object. Copley's painting is not simply a portrait of Revere but a moral vindication of the visual arts and the fabrication of luxury goods. Copley's airless space, meticulous illusionism, and mysterious contrast of intense light and dark create a religious aura of silent meditation, thereby redeeming the production and appreciation of luxuries from the taint of materialism.

As expressed in Copley's portraits and in Revere's Masonic engraving, where a cherub at the left gestures for silence, moral virtue and spiritual illumination were generally associated with silence. Silent communication ensured the purity of thought or the ability to hear the inner voice of conscience connecting humanity

3.30 Paul Revere Masonic Lodge 169 notification, late 1760s. Engraving, $8\frac{3}{4} \times 6\frac{7}{6}$ in (22.2) \times 17.5 cm). American Antiquarian Society, Worcester, Massachusetts.

The inscription beneath the arch invites Brother A. B. to a meeting of Lodge 169 of the Ancient York Masons. Ancient Masons identified with the English city of York because it was regarded as the site of a purer form of Freemasonry than the purportedly corrupted and modernized rituals of the London Grand Lodge. The two Corinthian columns supporting the arch and an Ionic order temple at the upper left also reaffirm the Masonic taste for ancient, classical architecture.

with the divine. Copley's hyperrealism, the apparent product of his all-seeing eye, was a persuasive stylistic means for achieving virtuous social and cultural ends. Revere's and Copley's godlike eyes remind viewers that all are under moral surveillance, subject not only to the providential eye of God but also to the close observation of fellow humans. Copley's seemingly magical ability to transmute raw, earthly pigments into a visual language of radiant light and reflecting surfaces spiritually generated an intimate communal bond, magnetically connecting beholders with both the portrait subject and the painter himself. Revere's Masonic engraving is dominated by a grand stone arch inscribed "Cemented with Love." Similarly, Copley conceived art in relation to Venus, the goddess of love and beauty, whose secret potion overcame the violent god of war. Venus personified the attractive forces of nature that reconciled the apparent conflict between the spiritual and material realms. In Copley's Portrait of Paul Revere, physical objects gleam with a reflected light that symbolizes their harmonic relationship with the semi-divine powers of the human mind.

However, by the time that Copley had painted Revere's portrait, political conflict between rebellious Americans and the British colonial government was already well underway. Revere would play an instrumental role as a messenger for the revolutionaries during the opening battles of Lexington and Concord in 1775. Revere's Masonic engraving represented emblems for the higher, "Royal Arch" degrees invented by the more socially inclusive lodges of Ancient Masonry founded outside the administrative control of London's Grand Lodge. The mystical degrees became popular with middle-class Americans, who were more inclined to challenge British

colonial domination. Beginning during the revolutionary period, initiation rituals for the degrees dramatized the Old Testament Jews' release from captivity in Babylon and their subsequent rebuilding of Solomon's temple in Jerusalem. This biblical theme of national liberation was also pronounced from American pulpits and contributed to dreams of building an independent republic self-governed by Solomonic citizens.

Copley did not share Revere's revolutionary fervor. As we shall see in the next chapter, the artist attempted to maintain a position of neutrality. Nevertheless, his Portrait of Paul Revere is a significant social departure from aristocratic portraits of colonial wealth. Copley's painting represents a democratic shift toward elevating the social status of labor and of craftsmen, the producers of consumer goods. At the same time, by visually expressing the notion that the crafters of luxuries were moral, dignified individuals, Copley reassured wealthy patrons that portraits, silver teapots, and other luxury items were manifestations of virtue rather than vice. The consumer revolution of the eighteenth century helped refine and Anglicize colonial culture, but it also emboldened increasingly self-confident Americans to demand the political rights associated with British liberties.

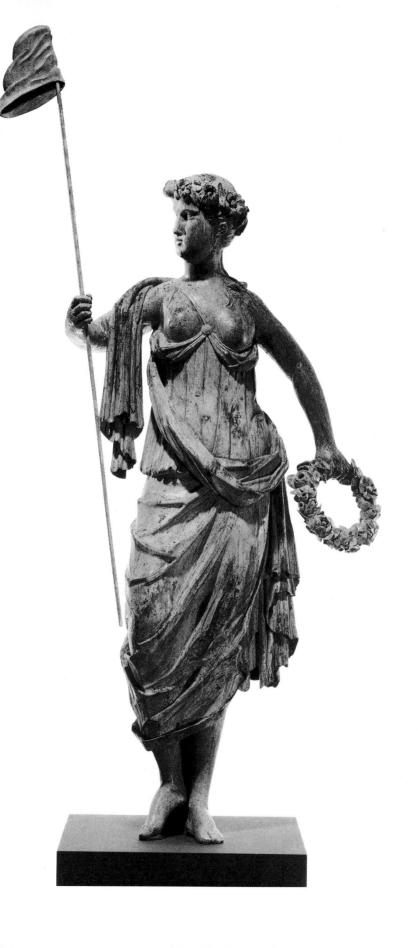

Revolutionary Icons and the Representation of Republican Virtue

1765-1825

n July 9, 1776, a mob of soldiers, artisans, and laborers in New York City tore down an equestrian sculpture of King George III. Decapitating the bullet-ridden sculpture of the British monarch, New Yorkers removed its imperial crown of laurel leaves and paraded the head to a tavern in northern Manhattan. Later, the gilt-lead sculpture was melted down into 42,088 bullets for the revolutionary army. A German printmaker, Franz Xaver Habermann (1721–96), misleadingly represented the event, attempting to inflame European opinion against the American rebels (fig. 4.1). Among the print's many inaccuracies is Habermann's imaginative recording of a non-equestrian royal statue being pulled down by seminude, dark-skinned servants, acting under the calm direction of well-dressed New York citizens.

New York's symbolic act of regicide occurred just five days after the Continental Congress, meeting in Philadelphia, approved the Declaration of Independence. Written primarily by Thomas Jefferson (1743–1826) of Virginia, the Declaration proclaimed that the American colonies were now states and "that they are absolved from all allegiance to the British crown" (cited in Fliegelman, p. 208). During the early months of the Revolutionary War, following the battles at Lexington and Concord, Massachusetts, on April 19, 1775, rumors had circulated that radical British sympathizers were plotting to overthrow George III. But the rumors proved false and the writers of the Declaration of Independence indicted not only the King and his ministers but also their "British brethren," who had become "deaf to the voice of justice and consanguinity" (cited in Fliegelman, p. 206–207). Severing ties to the British Empire, America would become a republic, a government "instituted among men, deriving their just powers from the consent of the governed" (cited in Fliegelman, p. 203).

Like all revolutions, the American Revolution engendered the iconoclastic destruction of traditional symbols of political authority. In 1765, a decade before the Revolutionary War, anti-British image-breaking had begun in earnest. Launching a new policy of governing the colonies directly from London, George III's ministers ordered imperial agents to enforce the revenue-raising Stamp Act. Taxing newspapers, pamphlets, almanacs, and all legal and commercial documents, the Stamp Act particularly angered colonial printers, lawyers, and merchants. Ignoring colonial assemblies, the British government enacted the tax through Parliament in London, where Americans had no direct representation.

Local colonial elites found their traditional legislative powers subordinated to the centralizing authority of British ministers. Protestors throughout America tarred

Anonymous

Liberty, c. 1790–1800. Bass wood, 58 in (147.3 cm) high. Museum of Fine Arts, Boston, Massachusetts. H.E. Bolles Fund.

Liberty holds a victory wreath in one hand. Her staff and liberty cap are museum replacements for lost originals. The nearly freestanding figure was probably intended for attachment to a wall or architectural support, perhaps for a courthouse. Borrowing ideas from the Salem, Massachusetts, carver Samuel McIntire (1757-1811), Liberty's sculptor employed a neoclassical, modular system of measurements and proportion, in which a given unit of the body was multiplied to create all the parts of the ideal whole.

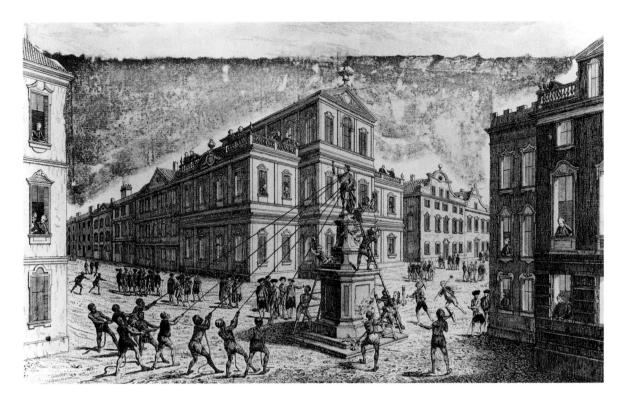

and feathered Stamp Act distributors. In mock executions, they hung and burned effigies not only of the local tax agents but also of the British prime minister, George Grenville.

From 1756 to 1763, the Seven Years' War, or French and Indian War, devastated North America in an imperial struggle between Britain and France. Though Indian tribes mostly sided against them, British and American forces wrested control of Quebec, Canada, from the French royal army. After the war, Britain expected Americans to pay new taxes for defense of the northwestern frontier. At the same time, the British government sought to appease the Indians by prohibiting landhungry colonists from settling west of the Appalachian Mountains, beyond imperial control. In this chapter, I shall discuss, among other figures, the American history painter Benjamin West (1738–1820), whose celebrated painting of the battle of Quebec underscored the competitive friction between the American colonies and the mother country.

In 1766, Parliament repealed the Stamp Act but simultaneously reaffirmed its sole authority to legislate colonial policies, in quartering British army troops in the restive coastal cities and towns. After 1767, when Parliament passed the Townshend Acts, which levied new duties on colonial imports, Americans boycotted British goods and clashed with British soldiers. Political cartoons convey the violent, antiauthoritarian spirit of popular protests, which often were directed by colonial businessmen angered by the monopolistic privileges granted British merchants.

The polarization of colonial society into Loyalists versus revolutionary patriots deeply affected artists. While the Boston silversmith-engraver Paul Revere published a series of anti-British prints, the painter John Singleton Copley married into a Loyalist family. Nevertheless, Copley attempted to remain politically neutral, a tenuous position that he visually expressed in a complex allegory of the Revolution.

4.1 Franz Xaver Habermann

La Destruction de la Statue Royale à Nouvelle York, 1776. Hand-colored engraving, $11\frac{1}{4} \times 16$ in (28.6 \times 40.6 cm). New York Historical Society, New York.

Habermann's print was one of a series that he published on the American Revolution from a perspective sympathetic to the British cause. Nevertheless, despite the print's fanciful topography, architecture, and exotic-looking characters, contemporaries with an opposing, revolutionary point of view interpreted the representation in positive terms as a symbolic repudiation of monarchical despotism. The image may have gained even greater popularity in America after the War of Independence.

Before the Revolution ended with the British surrender at Yorktown, Virginia, in October 1781, the thirteen American states had organized themselves under the Articles of Confederation. This loose confederation created a weak central government dominated by a single-house Congress, which lacked the vital authority to levy taxes and regulate commerce.

Once Great Britain officially recognized American independence in September 1783, American artists accelerated efforts to memorialize key events, heroes, and symbols of the Revolution. From the perspective of the propertied elite, efforts to create unifying images of nationhood became all the more urgent during the economic depression that followed the war. In 1786, indebted laborers and farmers from western Massachusetts, led by Daniel Shays, staged an insurrection against the state government, which was dominated by creditors who wished to foreclose on farm mortgages.

Shays' Rebellion called attention to the weakness of government authority under the Articles of Confederation. In 1787, delegates from every state met in Philadelphia for a Constitutional Convention. Presided over by George Washington, the fifty-five "Founding Fathers" wrote a new constitution that created a stronger federal government. Approved in 1788, the Constitution's architectural balance of state and federal powers, and of executive, legislative, and judicial branches, found symbolic expression in the urban design for the District of Columbia and its focal building, the United States Capitol.

Artists of the revolutionary generation, led by the painters Benjamin West, John Trumbull (1756-1843), Gilbert Stuart (1755-1828), and Charles Willson Peale (1741–1827), attempted to become spokesmen for the new nation. Artists and architects often competed against more professionally trained European immigrants for commissions to design government buildings and patriotic monuments. Whether native or foreign-born, painters and sculptors started to exhibit in museums, galleries, and art academies founded by civic-minded patrons and entrepreneurs.

Yet many Americans who distrusted the cosmopolitan manners of the wealthy few defined republicanism in iconoclastic opposition to the refined world of art. They insistently associated the visual arts with sensual luxuries, a self-indulgent aristocracy, and the corrupt despotism of monarchy and empire. Portraits and history paintings of contemporary subjects often drew hostile responses from politically divided audiences. Even representations of the nation's first president, George Washington, aroused popular fears that glorification of any hero invited dictatorship rather than the impersonal rule of law.

The visual commemoration of national heroes excluded or marginalized poor men and soldiers, whose lack of property barred them from voting and holding political office under most state constitutions. To an even greater degree, representations of subservient African Americans belied the appropriateness of Liberty as a figurative symbol of American independence. Female personifications of Liberty, Wisdom, and other abstract virtues also masked the constitutional exclusion of women from electoral politics, despite contributions to the revolutionary cause from activists such as the wax sculptor Patience Wright (1725–86).

By the early nineteenth century, American artists belonging to the postrevolutionary generation composed paintings that expressed doubts regarding the legacy of the Founding Fathers. Artists such as Washington Allston (1779–1843), John Vanderlyn (1775–1852), and Rembrandt Peale (1778–1860) explored themes of moral weakness and individual ambition rather than the heroic virtues of the Revolution. Bitterly divided by political parties and conflicting socioeconomic interests, the United States struggled to maintain the republican faith in citizens' selfless devotion to the public good.

Propaganda in the Pre-Revolutionary War Era

The pre-war decade from 1765 to 1775 witnessed a proliferation of visual media to propagandize against British tyranny. Printmakers published political cartoons in newspapers, magazines, and broadsides posted in shops, taverns, and coffeehouses. The printer and almanac publisher Benjamin Franklin responded to Parliament's arbitrary taxation of the colonies by representing the British Empire as a dismembered woman (fig. 4.2). With her ships idle in the background, Britannia leans helplessly against a globe she once dominated. A spear suicidally points toward her breast. Severed arms and legs signifying the American colonies lie scattered upon the ground. Though critical of Britain's self-destructive imperial policies, Franklin's image suggests that most who initially denounced Parliament's imposition of taxes and trade duties did not envision political independence. For Franklin in 1765, the colonies were only separate limbs, entirely dependent upon the healthy body politic of the mother country.

However, as protests against trade duties and the monopolies enjoyed by London merchants intensified, political prints satirized the colonial model of dependency upon the mother country. On December 16, 1773, a group of Boston men, disguised as Mohawk Indians, secretly boarded ships of the East India Company, throwing into Boston harbor the duty-laden tea that symbolized Britain's monopolistic control of colonial trade. Following the Boston Tea Party, Paul Revere, one of the participants, personified America as a violated Indian princess (fig. 4.3).

4.2 Benjamin FranklinMagna Britannia: Her
Colonies Reduc'd, c. 1766.
Engraving, 4% × 5% in (10.2 × 14.7 cm). Library Company of Philadelphia.

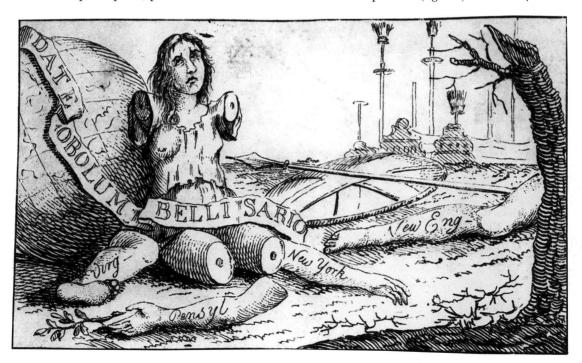

4.3 Paul Revere

The Able Doctor, or America Swallowing the Bitter Draught. 1774. Engraving, $7 \times 4\%$ in (17.7 × 12.1 cm). Massachusetts Historical Society, Boston, Massachusetts.

4.4 William Rush

books, Wisdom gazes

Wisdom, 1824. Painted pine, 8 ft (2.43 m) high. Philadelphia Museum of Art, lent by Fairmount Park Commission.

Rush carved Wisdom for a triumphal arch welcoming to Philadelphia the Marquis de Lafayette, French hero of the American Revolution. Alluding to the Greek goddess Athena, Wisdom holds the head of a snake, suggesting her civilizing power over nature. Standing next to a pillar stacked with

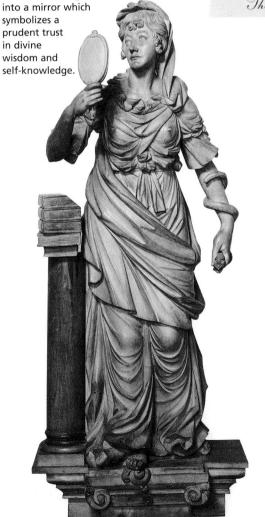

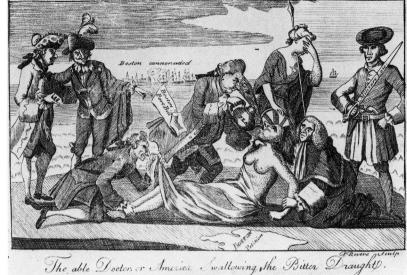

America's mother, Britannia, stands by helplessly while her daughter is sexually abused. British government officials look up her dress and force tea down her throat. After independence, printmakers, painters, and sculptors transformed the personification of America into a Greek or Roman goddess, symbolizing Western civilization and the ideals of Liberty and Wisdom. American wood carvers who normally crafted the figureheads of ships were now called upon to decorate courthouses and other public buildings with personifications of Liberty (see p. 114) and Wisdom (fig. 4.4). With white pine and paint, they mimicked the pristine marble of classical sculpture.

After the Seven Years' War, which forced Catholic France to abandon Canada, Americans dreamed of territorial expansion far beyond the eastern seaboard, proclaiming that the course of civilization was moving westward with the sun. Magazines and newspapers quoted "Verses on the Prospect of Planting Arts and Learning in America," by George Berkeley, the philosopher-cleric celebrated in John Smibert's The Bermuda Group (see fig. 3.21). Berkeley contrasted a decaying Europe with America's "virgin earth," fertile for a millennial "golden age" (see p. 103). Colonial clergymen echoed Berkeley. They defined the future Christian millennium as a period when the arts and letters would flourish in the New World. Political orators and pamphleteers asserted that Britain's imperial policy of taxation without representation was driving Liberty and the arts toward sanctuary in America. In a post-revolutionary painting, the Philadelphia artist

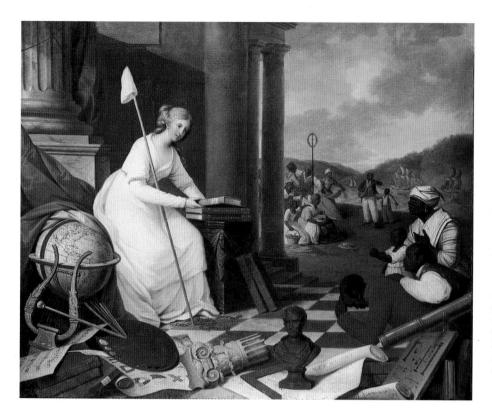

4.5 Samuel Jennings
Liberty Displaying the Arts
and Sciences, 1790-92. 60% ×
73 in (153 × 185.4 cm).
Library Company of
Philadelphia, Pennsylvania.

In ancient Rome, liberty caps were worn by freed slaves. Liberty's cap and staff stand triumphantly over broken chains lying on the floor. Painted for the Library Company of Philadelphia, Jennings's Quaker-inspired picture allied Liberty with learning and abolitionist politics. On the pedestal next to Liberty are books on philosophy and agriculture. Emblems of music, painting, architecture, sculpture, geometry, geography, and astronomy clutter the foreground. In the background, a group of African Americans listen and dance to music.

Samuel Jennings represented Liberty as the patroness of the arts and sciences, who promises the future abolition of slavery before a grateful group of African Americans (fig. 4.5).

Republican Motherhood: Women as Symbols in the Revolutionary Era

Together with African Americans, American women continued to exist outside the active public life of electoral politics. Women's political rights were ignored in the Declaration of Independence and the U.S. Constitution. Suffrage qualifications were the prerogative of state and local governments, which barred women from voting, even if they held property or paid taxes apart from a husband. Women were relegated to the private domestic realm of republican motherhood to rear virtuous sons, the nation's future citizens. Protected from the world of commerce and politics, women more easily personified the bloodless, abstract ideals of Liberty and Wisdom or the cardinal virtues of Faith, Hope, and Charity.

Women's political and social influence was private, secret, and virtually invisible. Supposedly lacking their own independent wills, women were stereotyped as silent muses who motivated male heroism, chivalry, and patriotic self-sacrifice. In his *Portrait of Thomas Jefferson*, the American painter Mather Brown (1761–1831) represents the author of the Declaration of Independence seated next to a marble figurine of Liberty (fig. 4.6). Her head turned toward Jefferson's ear, she appears to inspire him without unduly calling attention to herself.

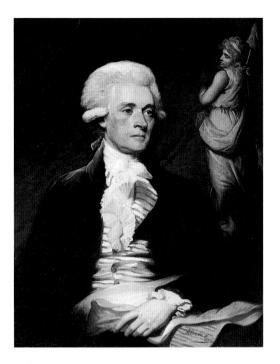

4.6 (top) Mather Brown Portrait of Thomas Jefferson, 1786. Oil on canvas. $35\% \times$ 28½ in (90.8 \times 72.4 cm). National Portrait Gallery, Smithsonian Institution. Bequest of Charles Adams.

The original 1786 portrait, commissioned by Jefferson, is lost. This version was painted for John Adams, Jefferson's friend. Influenced by the American Gilbert Stuart and other English-school painters, the London-based Brown employed vivid brushwork and color to create a sensuous image of Jefferson's energy and charisma. The intense, deeply saturated background curtain accentuates the warm, ruddy cheeks of the sitter, who turns away as if lost in thought.

Patience Wright and the Personification of Liberty

While male artists sought to address a broader public during the revolutionary era, women's art remained domestic in medium and audience. Women primarily created quilts, needlework, small watercolors, and private mourning images that memorialized loved ones and, occasionally, national heroes. The New Jersey-born wax sculptor Patience Wright was the major exception to the rule. In fact, during the revolutionary era, she was the only American sculptor to achieve international fame or infamy. Played out in the spotlight of London's fashionable West End, Wright's career brought attention to a populist American art.

The daughter of a Quaker farmer, Wright created a profitable museum of wax figures representing contemporary and historical notables dressed in period costume and placed in theatrical settings. Having exhibited in several American cities, she moved her effigies to London in 1772, attracting large crowds and even the patronage of the royal court. The King, Queen, and Prince of Wales all sat for portraits. However, only Wright's

> memorial effigy of William Pitt the Elder, the Earl of Chatham (1708–78), parliamentary defender of America, still survives (fig. 4.7).

4.7 Patience Wright William Pitt, Earl of Chatham, 1779. Wax effigy, life-size. Westminster Abbey, London.

Pitt, the first Earl of Chatham, is dressed in a parliamentary robe and wig. He is posed as an orator, holding a scroll in his right hand. Although the trunk of the body beneath the robes is made of wood, the figure's wax head and hands were carefully crafted with realistic details. Wright used pieces of hair and bluetinted underslips to mimic veins. The commemorative sculpture was placed in Westminster Abbey a year after Pitt's death.

Wright's sitters, including Benjamin Franklin, Benjamin West, and other Americans, were attracted as much by her sexually suggestive and quasi-magical technique as by her illusionistic realism. Kneading the wax like dough, Wright manipulated portrait busts underneath her apron between her thighs, keeping the wax warm and malleable. She then dramatically gave birth to her creations. Emerging from its womb, the wax head received the finishing touches that gave it life: glass eyes, hair, color, and an appropriately clothed body.

The painter Sir Joshua Reynolds, President of the Royal Academy of Art, warned connoisseurs and aspiring artists that waxwork figures fell outside the category of true sculpture. Members of London's Royal Academy taught art students the ancient and Renaissance traditions of idealized marble and bronze sculptures. The unstable wax medium, by contrast, triggered unwanted associations with lower-class effigies crafted for festivals, parades, and popular protests. Like Wright's, these popular, anonymously produced effigies were often praised for their convincing realism.

In a portrait drawing by a young admirer, Wright visually and verbally identified herself with the personification of Liberty: "Liberty I am and Liberty is [W]Right" (fig. 4.8). During the Revolution, she worked as a spy, sending American friends secret mes-

sages hidden within wax busts. Meanwhile, other prints represented Wright with the decapitated heads of corrupt government officials (fig. 4.9).

However, for Abigail Adams, wife of future president John Adams (1735–1826), Wright fell far short of Liberty as a model of republican motherhood. After a visit to the London wax museum, she concluded that Wright was the "queen of sluts" (cited in Sellers, 1976, p. 210). Besides her "slattern" appearance, Wright offended Adams by crudely giving "a hearty buss" or kiss to each lady and gentleman in Adams's party (cited in Sellers, 1976, p. 209). Finally, Wright's sculptures disrupted Adams's emotional equilibrium: "There was an old clergyman sitting reading a paper in the middle of the room; and though I went prepared to see strong representations of real life, I was effectually deceived in this wax figure for ten minutes, and was finally told that it was only wax" (cited in Sellers, 1976, p. 210).

Classical Austerity and Republican Virtue: the Founding Fathers

Art that embarrassed and deceived could not win the unqualified endorsement of genteel American beholders. Adams, Jefferson, and other traveling statesmen were acutely aware that American art was now being judged by a skeptical international audience dominated by royalist and aristocratic opinion. Even those Europeans

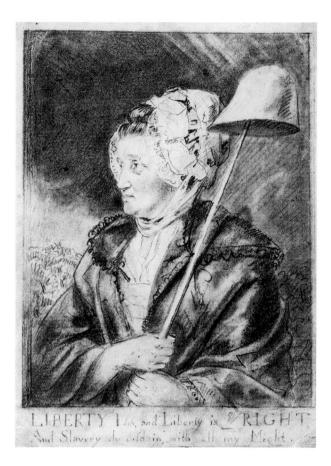

4.8 John Downman Patience Wright, 1777. Drawing, 9×7 in (22.9 \times 17.8 cm). British Museum, London

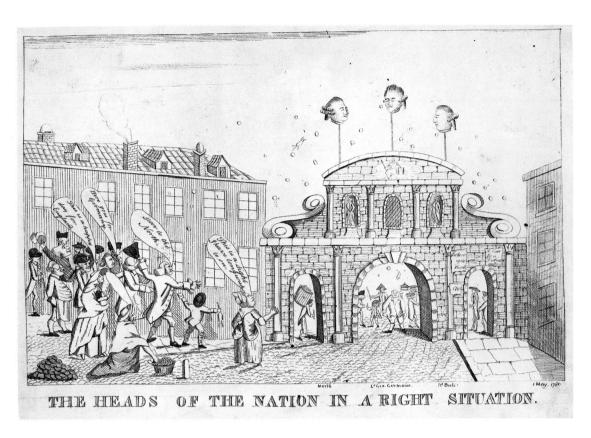

4.9 John Williams

The "Right" Situation, 1780. Engraving, $8\% \times 13\%$ in (22 × 35 cm). British Museum, London

Patience Wright stands in the left foreground of this political cartoon. As she gazes at the trio of British officials' heads, she exclaims that "This is a sight I have long wish [sic] to see."

sympathetic to the Revolution tended to regard America as a degenerative wilderness inhospitable to the arts and sciences.

Ironically, American taste tended toward the traditional classicism of Sir Joshua Reynolds, whose Royal Academy lectures in London emphasized imitation of the ancient Greeks and Romans and study of Renaissance masters. Post-revolutionary artists, critics, and patrons defended the visual arts against traditional associations with luxury, sensuality, and moral decay. Classical austerity, severe geometric forms, or a simple, plain style best expressed the nation's devotion to selfless republican virtue. Rather than the disorienting illusions of Patience Wright and other popular entertainments, citizens of the new republic required a visual environment that encouraged polite, rational behavior based upon deference to men of merit and virtue.

As the pageantmasters of the new republic, painters, sculptors, and architects canonized American revolutionary leaders as the "Founding Fathers," the constructors, not destroyers, of a new empire in the West. Commissioned by state and local governments, artists designed patriotic street decorations and public monuments and buildings to compete with the grandeur of classical antiquity and the European Renaissance. In 1789, the Boston architect Charles Bulfinch (1763-1844) designed a triumphal arch next to the Massachusetts State House welcoming the nation's first president, George Washington (fig. 4.10). Over the central arch rose a twenty-foothigh canopy crowned by an American eagle with its shield of thirteen stripes. An oval tablet above the central rusticated arch bears the inscription: "TO THE MAN WHO UNITED ALL HEARTS." The individual masonry stones symbolize the national union of hearts cemented by love for George Washington.

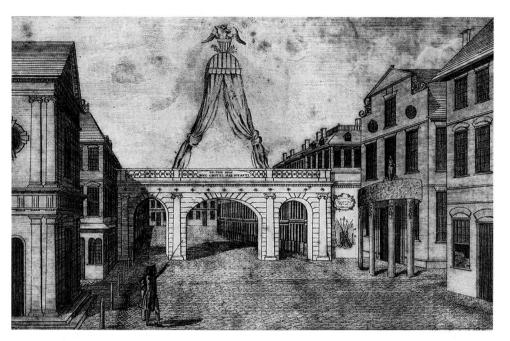

Bulfinch's inscribed arch borrows from the architectural symbolism of Freemasonry as seen in Paul Revere's Lodge engravings (see p. 113) and in Boston Masonic armchairs, the latter's arched mahogany backs mimicking fraternal masonry stones (fig. 4.11). Several years later, Bulfinch participated in the Masonic cornerstone-laying ceremony for his new, golden-domed State House on Beacon Hill (fig. 4.12). Revere presided as the grand master of the Grand Lodge of Massachusetts.

The All-Seeing Eye: Freemasonry and Symbolism in the Early Republic

Elevated to national prominence by the august membership of George Washington, Benjamin Franklin, and other Founding Fathers, the fraternal order of Freemasonry dramatically grew in popularity during the post-revolutionary era. During the early republic, Freemasons constituted a civic priesthood, presiding over cornerstonelaying rituals not only for public buildings and monuments, but also for civic-minded engineering projects. On April 15th, 1791, the grand master of the Masonic lodge at Alexandria, Virginia, led a ceremony to lay the first milestone for the District of Columbia. Over two years later, wearing a Masonic apron, Washington himself laid

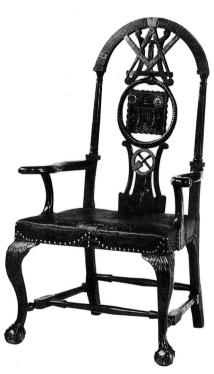

4.10 Samuel Hill

(after Charles Bulfinch), View of the Triumphal Arch and Colonnade, 1790. Engraving, 5% × 8% in (13.7 × 20.8 cm). Massachusetts Historical Society, Boston, Massachusetts.

Measuring eighteen feet high and fourteen feet wide, the central passageway of Boston's triumphal arch was flanked by two narrower. seven-foot-wide openings. Ionic-order pilasters decorated the arch's piers. while a frieze immediately above was ornamented with thirteen stars set against a blue ground. On the opposite side of the triumphal arch, a second oval tablet over the central passageway read "TO COLUMBIA'S FAVORITE SON," thereby linking Washington and America to the New World legacy of Columbus.

4.11 Anonymous

Armchair, c. 1765-85.
Mahogany with maple and gilding, original webbing, liner, and horsehair cover, 50½ in (128.2 cm) high, 25½ in (64.7 cm) wide, 19½ in (49.5 cm) deep.
Private collection.

The back of this chair juxtaposes a number of Masonic symbols. The circular serpent biting its own tail signifies the eternal cycle of life. Within this circle, a square block shows Solomon's temple, symbolized by two small columns set in front of a checkered pavement. The sun and moon loom overhead. The splat is also ornamented with various tools of the Mason's craft.

4.12 Charles Bulfinch Massachusetts State House, Boston, 1795-8. Massachusetts Historical Society, Boston,

Massachusetts.

Bulfinch modeled the State House on English sources, particularly William Chambers's Somerset House (1786), then a government building near the Thames in London. The temple-like facade rises from an arcaded basement to a broad. colonnaded pavilion with slender Corinthian columns. Above a pedimented upper story, the gilded wood dome has a light, strongly vertical profile, accentuated by a

crowning belfry. Cost factors probably dictated the red brick and wood construction rather than the use of the preferred, but more expensive, stone.

the cornerstone for the United States Capitol. Deriving from Roman temple architecture, the U.S. Capitol was to be the American Pantheon, a temple to civic virtue, liberty, and national unity. Under the supervision of Thomas Jefferson, Washington's secretary of state, the French architect Pierre Charles L'Enfant (1754–1825) planned the District of Columbia as a city of grand public spaces and state-named avenues centering upon a domed Capitol (fig. 4.13). Situated high upon a hill, the Capitol would overlook a city designed as a microcosm of the nation. A 1795 "Essay on the City of Washington" described L'Enfant's plan as an allegory for the constitutional governance of the American empire:

Each street is also an emblem of the facility, with which the Capitol may be approached, in every respect, and at all times, by every individual, who shall live under the protection of the Union . . . The capitol [sic] and the President's house are so situated, that the President may have continually in his view, the temple where are deposited the laws, the execution of which is committed to him; and it seems, that by the multiplicity of the streets and their diverging direction, it was intended to remind him constantly of the importance of directing his official views to the most distant parts of the Empire; and this ingenious allegory, in its inverted sense, will call to his mind, at the same time, that his actions, are continually and unavoidably open to general inspection. (cited in Scott, p. 47)

The nation's survival depended upon a clarity of vision that extended to the furthest reaches of the empire and a self-conscious awareness that all government actions are visible to the all-seeing eye of the public. An experienced gentleman architect, Jefferson was simultaneously building Monticello, his own domed templelike mansion, situated high atop a mountain for maximum visibility and symbolic control over the surrounding Virginia countryside (fig. 4.16). As envisioned by Jefferson and a series of architects working under his direction, the Capitol's central domed Rotunda, joining the Senate and House wings, was designed as a great hall of the people, the architectural expression of "e pluribus unum" (one out of many) (fig. 4.17).

Charles Bulfinch designed the final appearance of the Capitol's first dome and Rotunda. Though he made some modifications, the Boston architect followed the plans of Benjamin Henry Latrobe (1764–1820), the architect responsible for restoring the Capitol after invading British troops burned the building in 1814 during the War of 1812, a "second war for independence," (Berens, p. 12) triggered by British interference with American shipping. Made of wood and sheathed in copper, the first Capitol dome was crowned by a balustrade surrounding a circular skylight twenty-four feet in diameter. The dome's viewing platform offered panoramic views of both city and countryside, expansively suggesting national unity and strength.

Illuminated from above by an oculus open to the sun, the domed Rotunda's visual and symbolic preeminence over the federal city and nation parallels the symbolism of the Great Seal of the United States (fig. 4.14). Designed by several congressional committees with the aid of both French and American artists, the Great Seal appropriated the international Masonic emblem of an all-seeing eye. The eye forms a radiant, triangular apex over an Egyptian pyramid composed of thirteen courses of dressed masonry stones inscribed with the year 1776 in Roman numerals. Solar light emblems decorated earlier congressional meeting places such as Federal Hall in New York, site of Washington's first inauguration as president. In this earlier commission, L'Enfant filled the exterior pediment with a synthesis of motifs from the Great Seal. The design depicted an American eagle set against light rays from a rising sun (fig. 4.15).

4.13 Pierre Charles L'EnfantPlan of the City of
Washington, 1791. Library of
Congress, Washington, p.c.

4.14 The Great Seal of the United States, 1776-82. U.S. State Department, Washington, D.C.

Along the top of the Great Seal's reverse side, the words ANNUIT COEPTIS reassured Americans that "He (God) has smiled on our undertakings." The Latin motto on the scroll beneath the pyramid, NOVUS ORDO SECLORUM, declares "A new cycle of the ages." The all-seeing eye appears on Paul Revere's Masonic lodge notification (see fig. 3.30), typifying Masonry's extensive use of the ancient symbol with its roots in Egyptian imagery and in Christian visual references to God's omnipresence.

In his designs for the Capitol's interior, Latrobe attempted to connect the new Western empire with the Eastern origins of art and architecture in ancient Egypt. An English-born Freemason who had been profes-

sionally trained in Europe, Latrobe proposed designing the original Library of Congress in the Capitol's north wing with Egyptianrevival decorations such as lotus and papyrus columns. Though this plan was never realized, Latrobe successfully developed corn and tobacco orders for the capitals of columns elsewhere in the Capitol (figs. 4.18–4.19). Striking a note of cultural independence from Europe, the aesthetic elevation of native plants and crops testified to the agricultural and commercial bounty of the American continent. The corn and tobacco orders contradicted persistent European perceptions of America as a desolate wilderness. Corn was also rich in Masonic associations. As a golden grain, seemingly infused by solar light, corn (as well as wine and oil) was sacra-

mentally poured during Masonic cornerstone-laying ceremonies, symbolizing the foundation stone's harmonic balance between heaven and earth. The fruits of agriculture metaphorically signify the cultivation of individuals through architecture and the fine arts.

4.15 Amos Doolittle "View of the Federal Edifice in New York," 1789, from The Columbian Magazine (Philadelphia), August 1789. Library of Congress, Washington, D.C.

History Painting in the Pre-Revolutionary and Revolutionary Eras

By studying European art treatises and fine-art prints, American history painters and portraitists learned to represent the human body as a sacred temple infused by divine light. Eighteenth-century America lacked art academies and collections of original Old Master paintings and sculptures. Ambitious artists seeking to rival ancient and Renaissance art traveled abroad, touring Europe, then settled in

4.16 Thomas Jefferson

Monticello, near Charlottesville, Virginia, 1770–82, 1796–1809. Thomas Jefferson Memorial Foundation, Inc.

In situating his mansion upon a mountain, Jefferson was attempting to replicate the ancient Roman villa tradition, as represented, for instance, by Emperor Hadrian's secondcentury villa near Tivoli, Italy. The Italian name Monticello means "little mountain." From his lofty villa perspective, Jefferson could gaze toward the panorama of nature's wildlife and the distant Blue Ridge Mountains. Yet Monticello was also a working farm, symbolizing Jefferson's ideal of an agrarian America.

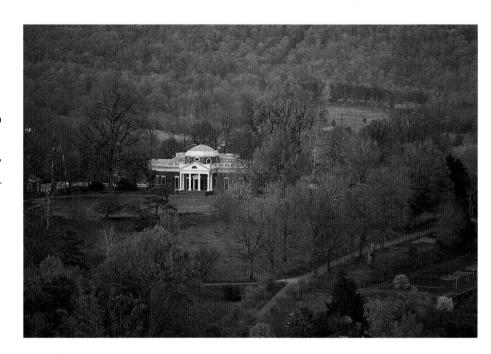

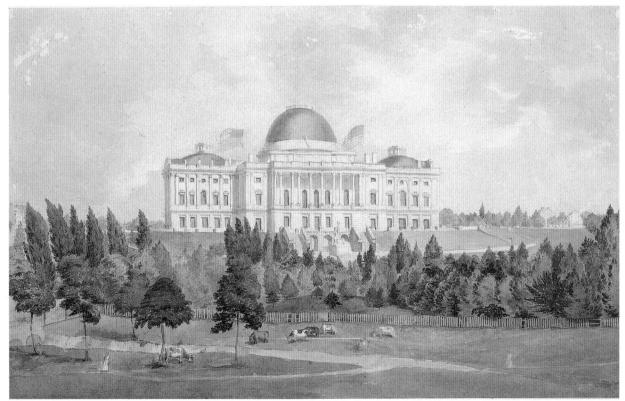

4.17 John Rubens Smith

View of the East Front of the Capitol, c. 1828. Watercolor on paper, $16\% \times 23\%$ in (41.9 \times 59 cm). Library of Congress, Washington, p.c. Gift of the Madison Council and Mrs. Joseph Carson.

4.18 Benjamin Henry Latrobe

Corn-capital vestibule to the Supreme Court, 1808. U.S. Capitol, Washington, D.C. Courtesy of the Architect of the Capitol.

The Supreme Court was once housed in the north wing of the U.S. Capitol, on the ground floor immediately below the Senate Chamber.

4.19 Benjamin Henry Latrobe

Tobacco-leaf capital, c. 1815. Sandstone, $18 \times 21 \times 21$ in $(45.7 \times 53.3 \times 53.3 \text{ cm}).$ Thomas Jefferson Foundation, Charlottesville, Virginia.

London to study at the Royal Academy. Working within the English school of painting, Americans created a revolution in history painting: they chose modern subjects that portrayed the New World as a land of millennial promise, redemption, and brotherhood. Painters also elevated portraiture toward the moral seriousness of history painting, creating an American pantheon of virtuous patriots and notables.

Benjamin West and the Revolution in History Painting

Before the Revolution, Benjamin West became the founder of an American school of painting. But he did so only after he left his native Pennsylvania for Europe, never to return. Born to humble innkeepers, West received basic instruction from the Philadelphia painter William Williams. More importantly, West's early interest in history painting and the academic tradition brought him to the attention of the Anglican clergyman William Smith, provost of the College of Philadelphia and a Masonic chaplain of the Grand Lodge of Pennsylvania. Smith mentored West in ancient history, but he also taught the aspiring painter that America was a sacred space, a remote refuge for Liberty and pure religion.

Financed by Smith and other prominent Philadelphians, West traveled to Italy in 1760 to study the great masterpieces of antiquity and the Renaissance. Three years later, moving to London, he helped to establish the academic tradition of grand-manner history painting in Britain. His London studio became a magnet for aspiring American artists seeking

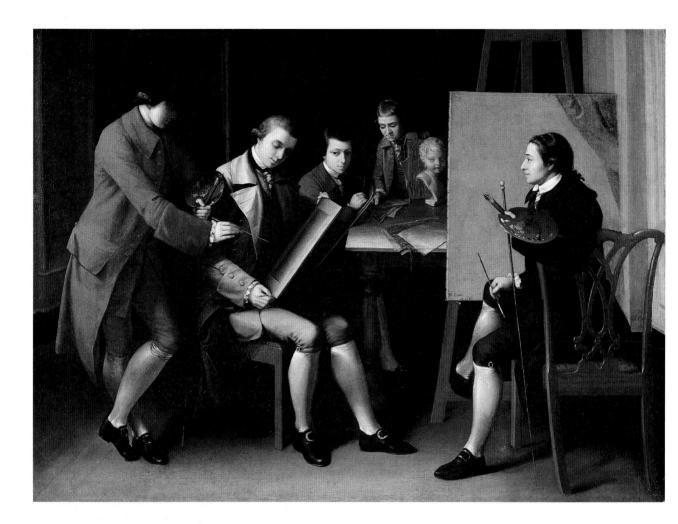

instruction in drawing and painting. West's first American pupil, Matthew Pratt (1734–1805), represented him instructing four young men in *The American School*, a painting exhibited in London in 1766 (fig. 4.20). Pratt portrays West standing at the left. He is wearing a green suit and tricorn hat, which signifies the Pennsylvanian's self-identification with the Quaker founders of that colony. Quaker reliance upon an inner voice or spiritual light appealed to an artist who wished to assert his independence from the material luxuries of European civilization.

Moralizing subjects such as *The Departure of Regulus from Rome* won West the patronage of George III, who was renowned for his religious piety (fig. 4.22). The painting's depiction of an ancient Roman hero solemnly departing for a certain death during the Punic Wars pleased the British monarch's desire for patriotic, self-sacrificing subjects; and soon afterward, he named West court history painter.

A year after *Regulus*, in 1770, West disturbed both his royal patron and the Royal Academy president with *The Death of General Wolfe*, a painting that radically paralleled Anglo-American agitation for political democratization (fig. 4.21). West's painting appealed to a far wider audience because he chose a celebrated modern subject, the victory over the French at the Battle of Quebec on September 13, 1759, and dared to clothe the figures in contemporary costume. Sir Joshua Reynolds

4.20 Matthew Pratt

The American School, 1765. Oil on canvas, $36 \times 50\%$ in (91.4 \times 127.6 cm). Metropolitan Museum of Art, New York. Gift of Samuel P. Avery, 1897.

Pratt represented four students whose identities are uncertain. The right-hand figure opposite the standing West has sometimes been identified as Pratt. With palette and brushes in hand, this young man sits before a virtually empty canvas that bears Pratt's signature and enframes the youth's profile. West's pupils are absorbed by the moral seriousness of the painter's craft.

4.21 Benjamin West The Death of General Wolfe, 1770. Oil on canvas, 60 imes84½ in (152.6 \times 214.5 cm). National Gallery of Canada, Ottawa. Gift of the Second Duke of Westminster.

West, through his official biographer, claimed that George III initially rejected his painting for representing noble heroes in common breeches and coats. Yet the painting's colorful pageantry is formally composed according to traditional Renaissance and academic conventions. General Wolfe's body is tended to by a pyramid of attentive figures. Extending this pyramid, the billowing banners overhead evoke associations with Christ's cross.

regarded West's turn toward realism as a vulgarization of high art, a descent from the universal ideals of classicism.

West's aesthetic rebellion against Reynolds and European academic tradition served the cause of American nationalism. He argued that the pivotal battle of Quebec, which decided the Seven Years' War, occurred:

in a region of the world unknown to the Greeks and the Romans, and at a period of time when no such nations, nor heroes in their costumes, any longer existed. The subject I have to represent is the conquest of a great province of America by the British troops. It is a topic that history will proudly record, and the same truth that guides the pen of the historian should govern the pencil of the artist. I consider myself as undertaking to tell this great event to the eye of the world; but if, instead of the facts of the transaction, I represent classical fictions, how shall I be understood by posterity! (cited in Alberts, p. 107)

West insisted upon representing both the geographical specificity and historical uniqueness of the New World. However, far from being non-fictional, his picture imaginatively manipulated facts. Beholders recognized the composition's religious associations with representations of Christ's disciples lamenting over his crucified body. As an immortalized type for Christ's sacrifice, Wolfe's martyred blood

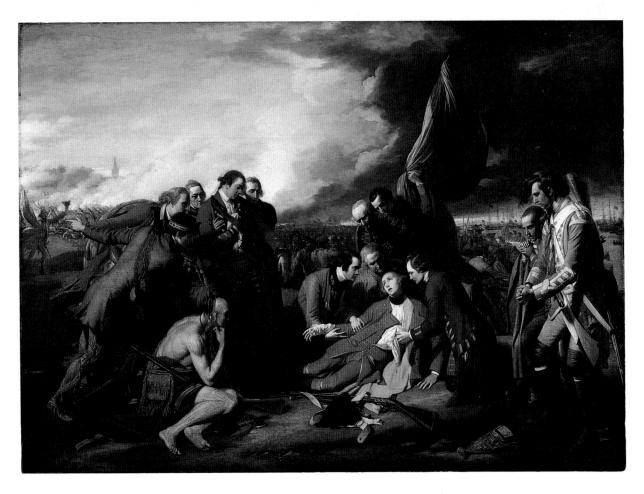

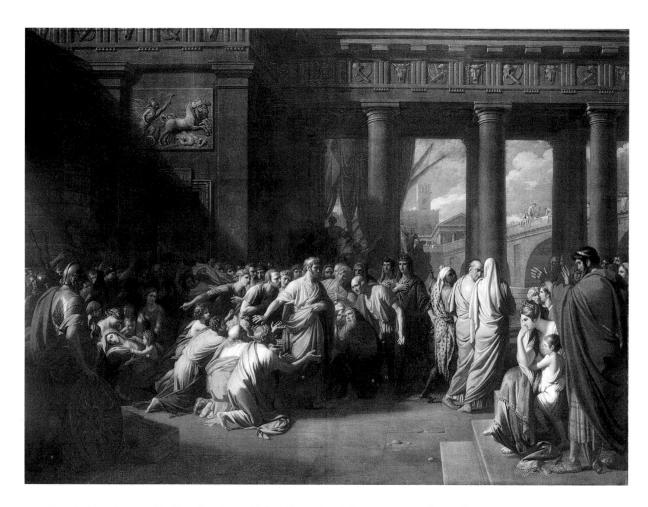

sanctified American soil. The battle, which West sketchily represented in the background, was fought outside Quebec's walls upon the "Plains of Abraham," evoking Old Testament associations for Anglo-Americans, who traditionally identified themselves as God's new chosen people. Over the conquered city, the dark storm clouds and battle smoke clear for the divine light of Providence to proclaim Britain's victory.

West created a strongly competing secondary focus at the far left of the composition to underscore the specifically American nature of the victory. A seminude Iroquois Indian, wearing body paint and red feathers, gazes contemplatively upon the dying general. Romantically associating Indians with a higher, secret knowledge of nature's vitalistic powers, West identified his art with the image of the noble Indian. The muscular warrior, in a dignified and melancholic pose, personifies the ancient ideal of a spartan lifestyle. A man of Nature, West's deferential Indian universalizes the selfless moral content of Wolfe's martyrdom, while his red flesh and exotic costume insistently specify the North American locale. Hovering over the Indian, wearing a green jacket, moccasins, and beaded breeches, stands a white man, whom West explicitly identifies as William Johnson. His name and a map with the geographical names "Mohawk Valley" and "Ontario" are inscribed upon the powder horn strapped to his body, equating Johnson's personal identity with property ceded to him by the Mohawk Indians. As a superintendent of Indian

4.22 Benjamin West

The Departure of Regulus from Rome, 1769. Oil on canvas, 88½ × 120 in (224.8 × 304.8 cm). The Royal Collection © 1999, Her Majesty Queen Elizabeth II.

At the center of West's composition, the Roman consul Regulus stands surrounded by admirers urging him to stay in Rome. Having been taken prisoner by the Carthaginians, Regulus had been sent back to Rome by his captors on condition that he negotiate a treaty favorable to Carthaginian interests. Regulus instead advised the Roman Senate to reject it as dishonorable. He then announced his return to imprisonment and death in Carthage.

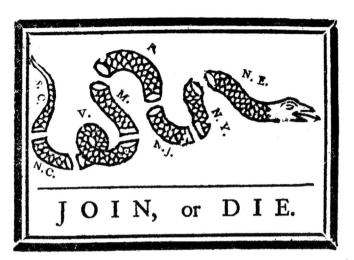

4.23 Benjamin Franklin "Join or Die," from Pennsylvania Gazette, May 9, 1754. Newspaper, $2\% \times 2$ in $(7.3 \times 5 \text{ cm})$. Library of Congress, Washington, D.C.

4.24 Anonymous Pearlware mug with print showing General Wolfe's death, c. 1800. Winterthur Museum, Delaware.

affairs, Johnson had learned Iroquois customs and language and married a Mohawk woman, more easily enabling him to convince some Native Americans to ally with Britain against France.

West's explicit inclusion of this colonial New Yorker belied the fact that Johnson, the hero of earlier battles at Lake George and Fort Niagara, was not actually present at the Battle of Quebec. Ignoring literal details of the battle, West was politically motivated to foreground the heroic American role in the Seven Years' War lest that fact be forgotten by imperial policymakers and the British public. A painted snake that decorates the Indian's back recalls Benjamin Franklin's widely published print Join or Die, which equates

a segmented snake with the politically divided American colonies (fig. 4.23). Only by uniting into a sinuous whole could America defend itself against French and Indian threats.

Although an English aristocrat purchased *The Death of General Wolfe* and George III later ordered a copy, West began the original painting without a commission or certain patron. Through public exhibition and engraved prints of the composition, he reached out for a wider, international audience that included the growing middle class. The central portion of the painting even decorated English ceramic mugs and earthenware for the domestic and export market (fig. 4.24).

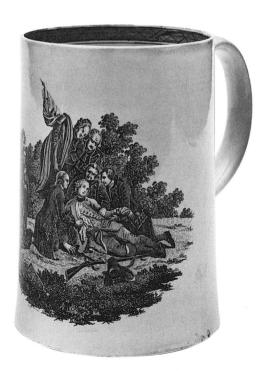

John Singleton Copley: Images of Revolution and Independence

West's success intensified John Singleton Copley's desire to escape the heated environment of Boston for a career abroad (see p. 110). The Boston Massacre of 1770 had dramatically intensified the conflict, as British troops shot and killed five Boston laborers protesting the army occupation. The polarizing event made life more difficult for a painter heavily dependent upon the patronage of the colonial political establishment. Copley's half brother Henry Pelham designed an engraving of The Bloody Massacre that was rapidly plagiarized by Paul Revere (fig. 4.25). Unlike Pelham and Copley, Revere enthusiastically supported the colonial rebels and added the sign "Butcher's Hall" over the heads of the British troops.

The massacre divided Boston along class, ethnic, and racial lines. Even critics of imperial rule feared mob violence and supported the British version of events that soldiers had fired in self-defense at a rowdy mob. The number of poor adult males in Boston, many of them African Americans and Irish Catholics, had doubled since 1687 to almost one-third of the adult male population. John Adams probably spoke for most of the Boston elite when he denigrated the massacre victims as

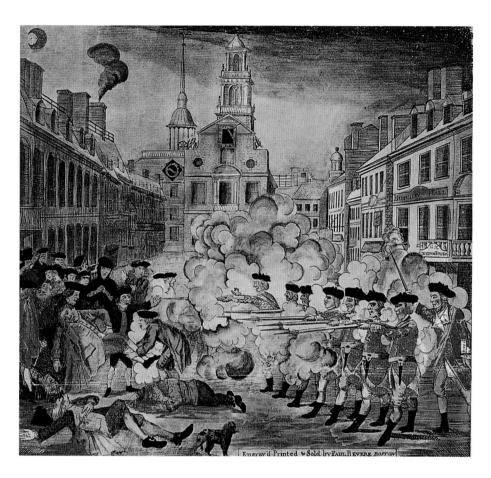

4.25 Paul RevereBloody Massacre, 1770. U.S.
State Department,
Washington, p.c.

Revere produced over seventy engravings between c.1762 and 1780, almost all of them copies from cartoons and prints imported from Britain. In the background, Boston's Old State House and the steeple of the First Church bear witness to the horror below. The church clock stands at 10:20 at night with a crescent moon hovering at the upper left. Shadows and a dark plume of chimney smoke signify the dark fate of the victims on the left side of the composition.

"a motley rabble of saucy boys, negroes and mulattoes, Irish teagues and outlandish jack tarrs" (cited in Kaplan and Kaplan, p. 8). Defending the British troops in court, he sarcastically singled out an escaped African-American slave, Crispus Attucks, who "appears to have undertaken to be the hero of the night; and to lead this army with banners . . . and march them up to *King street* with their clubs" (cited in Kaplan and Kaplan, p. 8).

Three years later, during the Boston Tea Party, Revere and other Sons of Liberty threw into Boston harbor a shipment of tea belonging to Copley's father-in-law, Richard Clarke, a merchant for London's East India Company. Copley left America for Europe. First studying art in Italy, he then settled in London, and like West, never returned to his native land.

Copley's first major history painting in London demonstrated his commitment to modern American subject matter and contemporary costume, emulating West's *The Death of General Wolfe*. During the Revolution, Copley enigmatically elevated a black man to the top of a visual pyramid in his history painting *Watson and the Shark* (fig. 4.26). A political and religious allegory, the picture's symbolism of white-black or light-dark expresses the tension between imperial order and revolutionary chaos. Painted for Brook Watson, a wealthy London merchant and Tory critic of the Revolution, Copley's composition tells the story of how Watson, as a young cabin boy, had lost his right leg to a shark while swimming near his ship anchored in the harbor at Havana, Cuba.

4.26 John Singleton Copley

Watson and the Shark, 1778. Oil on canvas, $71\% \times 90\%$ in (182.2 \times 229.8 cm). National Gallery of Art, Washington, p.c. Ferdinand Lammot Belin Fund.

Copley appropriated biblical ideas for his painting from Peter Paul Rubens' Jonah and the Whale (1618-19). The Old Testament figure of Jonah survived three days inside the belly of a whale. Foreshadowing Christ's death and resurrection, Jonah provided Copley with a further parallel for Brook Watson's miraculous rescue.

As described by London notices of the 1778 Royal Academy exhibition, Copley's painting represents the dramatic moment when a group of sailors in a rowboat finally rescued Watson "at the very instant he was about to be seized the third time," and "the shark was struck with the boat hook, and driven from his prey" (cited in Miles, p. 56). London newspapers emphasized the success of the third rescue attempt, implicitly comparing Watson's plight with Christ's Resurrection on the third day. Further borrowing from Christian iconography, Copley heroicized the lowly sailors, one of whom is about to spear the shark like St. George or St. Michael slaying the dragon. Above the dark waters, the dawn's golden light promises salvation. The cross-shaped masts of ships on the horizon join the crosses of Havana's cathedral and convent towers. They suggest that Watson's rescue symbolized his spiritual rebirth during the Christian voyage of life.

On a political level, Brook Watson's dismembered body symbolized the damaged body politic of the British Empire, which was founded upon the shipping and commercial wealth of Watson and other London merchants. Watson's lost leg evoked associations with numerous revolutionary-era prints of a dismembered Britannia such as Benjamin Franklin's Magna Britannia (see fig. 4.2). By 1778, when Watson and the Shark was exhibited, France had allied with America, and British troops had

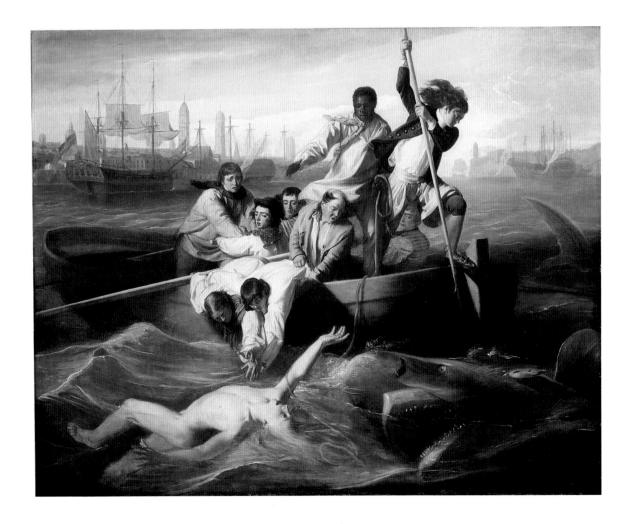

lost the previous year's pivotal Battle of Saratoga. Furthermore, the French threatened British control of the West Indies, including Caribbean ports such as Havana, the setting for Copley's painting.

Watson and the Shark encouraged contemporary beholders to identify with Watson's fate, knowing that this cabin boy more than survived despite the loss of a leg. The British Empire also would renew itself through revolutionary trial by fire. Similarly, after the initial 1775 battles at Lexington and Concord, Copley had prophesied from his safe haven in London that America "will finally emerge from her present Callamity and become a Mighty Empire. And it is a pleasing reflection that I shall stand amongst the first of the Artists that shall have led the country to the knowledge and cultivation of the fine Arts" (cited in Prown, 1966, II, pp. 255–256).

Copley's optimistic faith in divine providence led him to believe that both America and Britain would prosper once the revolutionary floodwaters had subsided. He interpreted the American Revolution as a divinely ordained natural disaster akin to the biblical Flood or to the drowning of a youth in shark-infested waters.

Copley's fatalistic view of the Revolution as an unavoidable act of God or Nature may explain why a black man stands at the compositional apex of the picture. London reviewers criticized the relative passivity of his black sailor: "It would not be unnatural to place a woman in the attitude of the black; but he, instead of being terrified, ought, in our opinion, to be busy. He has thrown a rope over to the boy. It is held, unsailorlike . . . and he makes no use of it" (cited in Miles, p. 65). For London critics, Copley's "idle Black" was like a child or a woman, too frozen by fear to take action. While not blatantly caricatured, the black sailor's passivity made him appear less a man than an abstract personification of the emotional horror associated with the shark. Both the shark and the black sailor symbolized the darkness of the underworld. Critics also referred to the African's fellow sailors as "tars," short for tarpaulin sails. But the word also punned with the visual image of the black to suggest sticky, oily tar, a dangerously combustible, yet healing black substance that was used to caulk leaking ships and cauterize amputation wounds. Copley had heard John Adams employ the term "tar" to characterize the politically volatile racial mixture that triggered the Boston massacre. Indeed, Watson's helpless nude body is strikingly similar to the figure of the dying man in the left foreground of Revere's The Bloody Massacre, originally composed by Copley's half brother.

Headed by the African who holds a serpentine towline, the sailors form part of an elemental circle connecting them with the monstrous shark that surrounds the boat. While the shark's open jaws approach the youth, his tail in middle ground points upward toward the harpoonist and African at the top of the compositional circuit. Beholders may have associated this violent circle of fiery tars versus watery serpentine monster with the emblematic *uroboros* or circular serpent. Biting its own tail to form a perfect circle, the serpent regenerated itself, eating its old skin to signify nature's seasonal cycle or daily revolution from night to day. The circular serpent often decorated Masonic lodge certificates and furniture (see fig. 4.11), expressing Freemasons' faith that nature's cyclical laws were divinely ordained. During the Revolution, the *uroboros* appeared on the mastheads of city newspapers and government treasury notes (fig. 4.27). This image reassured citizens that a millennial dawn was emerging from the darkness of revolutionary violence.

In addition to the original version sold to Watson, Copley hung a replica of Watson and the Shark in his studio and sold engraved prints of the composition. Thanks to the success of "the Shark painting," Copley became a favorite with

London merchants, painting their portraits and histories of their martyred heroes. At the same time, Copley portrayed statesmen and citizens of the new republic. Four years after Watson and the Shark, he painted the portrait of an entirely different Watson, a young American merchant, who wished to commemorate the dawn of a new empire (fig. 4.28). Elkanah Watson later recalled the circumstances of the portrait in his journal:

The painting was finished in most admirable style, except the background, which Copley and I designed to represent a ship, bearing to America the intelligence of the acknowledgement of independence, with a sun just rising upon the stripes of the Union, streaming from her gaff. All was complete save the flag, which Copley did not deem prudent to hoist under present circumstances, as his gallery is a constant resort of the royal family and the nobility. I dined with the artist, on the glorious 5th of December, 1782, after listening with him to the speech of the King, formally recognizing the United States of America as in the rank of nations. . . . he invited me into his studio; and there with a bold hand, a master's touch, and I believe an American heart, attached to the ship the Stars and Stripes. This was, I imagine, the first American flag hoisted in Old England. (cited in Neff, p. 122)

Elkanah Watson implicitly contrasts Copley's "bold hand" and "master's touch" with the artist's political timidity and unwillingness to jeopardize lucrative commissions from the British aristocracy. Copley's reputation in the United States soon suffered precisely because more radical nationalists questioned the sincerity of the artist's "American heart." Though the painting elevated his career beyond portraiture, Watson and the Shark became fodder for Copley's American critics, who condemned its heroic commemoration of a British Tory. William Dunlap (1766–1839), the first historian of American art, perpetuated the myth that "Copley was, when removed to England no longer an American painter in feeling" (vol. I, p. 117). Yet Copley, like West, could never shed his American identity while living in London

4.27 Massachusetts **Treasury Note** December 4, 1777. Engraving, 9×6 in (22.8 \times 15.2 cm). American Antiquarian Society, Worcester, Massachusetts.

even if he had wanted to, since English critics often referred to his American origins.

Fraternal Friendship in the Work of John Trumbull

Benjamin West also exercised diplomatic caution for fear of offending wealthy British patrons. But, during the summer of 1783, he corresponded with his former student Charles Willson Peale, who had painted portraits of George Washington and other officers while serving in the revolutionary army. West wished assistance in conceiving a visual narrative of the Revolutionary War. He asked Peale for:

The most exact knowledge of the custumes of the American Armys, [and] portraits in small (either painting or drawing) of the conspicuous charectors necessary to be introduced into such a work . . . I mean the arrangement of the subjects most expressive and most pointed, as for instance—the cause of the Quarel, the commencement of it, the carrying it on, the Battles, alliances . . . to form one work, to be given in eligent engravings-call'd the American revolu-

tion—this work I mean to do at my one expence, and to imploy the first engravers in Europe to carry them into execution, not having the least dout, as the subject has engaged all the powers of Europe all will be interested in seeing the event so portraid. (cited in Prown, 1982, p. 29)

West stressed an international audience for the series not only for the purpose of turning a profit, but also to establish the new republic's political and cultural presence within a skeptical world community dominated by despotic monarchs and princes. Even many American citizens, knowing the fates of the Greek and Roman republics, doubted the survival of a nation governed by relatively weak state and federal governments.

West began but did not finish one of the subjects for the series, a group portrait of The American Commissioners of the Preliminary Peace Negotiations with Great Britain, featuring his friend Benjamin Franklin seated next to the portly John Adams (fig. 4.29). Ultimately West, like Copley, preferred not to risk losing royal and aristocratic patrons. Instead, he bestowed the project upon another student, John Trumbull, son of the governor of Connecticut and a 1773 Harvard graduate, who had briefly served as an officer and cartographer in the revolutionary army. Trumbull planned to represent the key events of the American Revolution. He hoped to turn a profit by exhibiting and selling the paintings, while marketing engraved prints to a broad national and international audience.

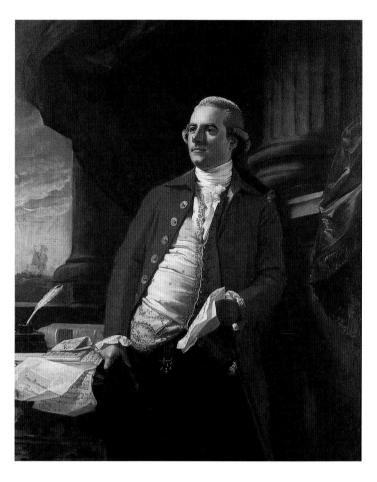

4.28 John Singleton

Portrait of Elkanah Watson, 1782. The Art Museum, Princeton University, Princeton, New Jersey.

As a partner in the French-American mercantile firm of Watson and Cassoul, Elkanah Watson, a Freemason, stands proudly next to a lofty fluted column ascending beyond the picture space. His bright-red overcoat and golden, embroidered waistcoat reinforce the warmly flushed luminosity of his face. Watson's gleaming visage is bathed by the distant rising sun as he holds documents relating to his business enterprise.

4.29 Benjamin West American Commissioners of the Preliminary Peace Negotiations with Great Britain, 1783-4. Oil on canvas, 28% imes 36% in (72.1 imes92.2 cm). Winterthur Museum, Delaware.

Behind John Adams and Benjamin Franklin stand John Jay, future Supreme Court Chief Justice, and Henry Laurens, former president of the Continental Congress. The young man in the middle is Franklin's grandson. The right side was unfinished due to the failure of British representatives to cooperate.

4.30 John Trumbull

The Death of General Joseph Warren at the Battle of Bunker's Hill, June 17, 1775, 1786. Oil on canvas, 25×34 in (63.5 imes 36.4 cm). Yale University Art Gallery, New Haven. Trumbull Collection.

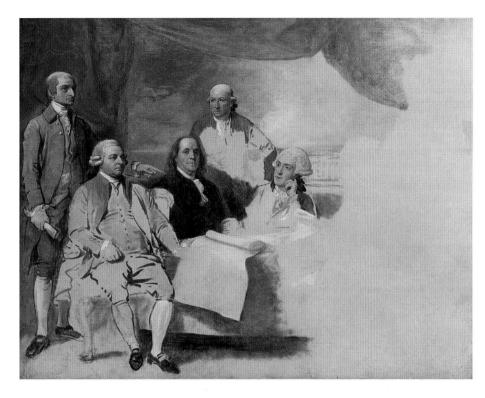

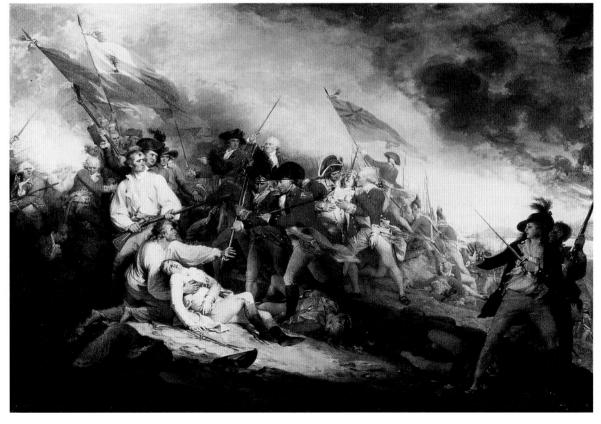

The artist's most dramatic and politically complex painting from the series depicted a British victory. Having witnessed from a safe distance the Battle of Bunker Hill at Charlestown, Massachusetts, on June 17, 1775, Trumbull painted in West's London studio in 1785–6 *The Death of General Joseph Warren at the Battle of Bunker's Hill* (fig. 4.30). Trumbull represented a martyred general, posed as a sacrificial type for Christ. However, the picture differs from West's *The Death of General Wolfe* in its extreme violence, enhanced by more vigorous brushstrokes and fiery red pigments. Rather than resting within a quiet semicircle of admiring officers, the dying American general lies at the base of a collapsing pyramid of figures as his troops retreat before the final British onslaught. Warren dies in defeat, not victory. Only the magnanimous gesture of a British officer, Colonel John Small, prevents a grenadier from ignominiously bayoneting Warren, whose body is protectively cradled by a barefoot muscular patriot.

Nevertheless, Trumbull also suggests that this early battle represented a moral victory for the Americans, who still had not organized themselves into a regular army and yet had inflicted heavy losses upon Britain's professional force. The light-colored figures of Warren and the patriots immediately behind him are bathed in providential light. Above them, the retreating flag of Massachusetts points toward the sun and dramatically displays its emblematic pine tree against a white background. The evergreen, like the serpent that encircled it on Massachusetts Treasury notes, symbolized New England's faith in regeneration and everlasting life. Parallel to the cyclical theme of Copley's *Watson and the Shark*, Trumbull's painting prophesies that from the jaws of death the rugged Americans would live to fight another day, emerging victorious despite Britain's superior firepower.

More than the particular details of battle, Trumbull portrayed the moral characters of its participants. Trumbull later wrote in his Autobiography that "those eminent patriots who had given their lives for their country at Bunker Hill" and elsewhere reminded him of "the beautiful language of our Savior, in his last conversation with his disciples, as recorded by St. John, 'that greater love hath no man than this, that a man lay down his life for his friends" (p. 287). The theme of fraternal friendship pervades Trumbull's paintings of the Revolution, even uniting opponents. Colonel Small's brotherly gesture preserves the nobility of Warren's death and acknowledges that these Americans are no longer the unruly children of the mother country. They have grown into sturdy young adults capable of governing themselves. Supplanting the parent-child metaphor of colonialism, fraternity implied the liberty and equality of national independence and republican selfgovernment. General Warren particularly personified the fraternal ideal. A physician, he also had been grand master of the Massachusetts Freemasons. He had led the newer, more socially inclusive network of Masonic lodges that multiplied the number of initiation rites, the better to construct a social order based upon degrees of merit rather than wealth and noble birth. These "ancient" Masons also organized military field lodges to facilitate the fraternal bond between officers and troops.

Trumbull's painting represents class differences within the anarchic violence of battle. Yet the Masonic spirit of brotherhood signifies the emergence from revolutionary chaos of a new, more egalitarian social order. Personifying the professional middle class, Dr. Warren's bleeding body joins together protective members of opposing classes and armies as represented by a barefoot American yeoman and a British gentleman officer. At the far right, a young American lieutenant stands awestruck by this sublime scene of martyrdom and brotherhood.

4.31 John Trumbull The Declaration of Independence 4 July 1776. 1787-1820. Oil on canvas, $21\% \times 31\%$ in (53.7 \times 79.1 cm). Yale University Art Gallery, New Haven. Trumbull

Collection.

Probably at Thomas Jefferson's suggestion, the artist embellished the painting with flags and trophies confiscated from British troops. Yet, these symbols of American triumph were not present in the Assembly Room of the Pennsylvania State House in 1776. Trumbull also covered the windows with expensive draperies and supplied more elegant furnishings than had existed. John Hancock's gilded chair exemplifies the elevation in social stature of the Declaration's signatories.

But the republican brotherhood envisioned by Trumbull and other socially conservative revolutionaries excluded entire groups from political participation, including African Americans. Trumbull marginalized the presence of African Americans at the Battle of Bunker Hill, contrary to historical accounts that credited two former slaves, Peter Salem and Salem Poor, for particular bravery. In Trumbull's painting, a frightened black servant stands behind his master at the far right. Another African-American face is barely visible, hidden beneath the flags at the far left of the picture. Trumbull's acknowledgment of African-American participation serves only to underscore their relative invisibility and exclusion from the pantheon of American heroes.

In 1817, over three decades after he had painted the initial sketches for the Revolutionary War series, Trumbull was commissioned by Congress to paint four large murals of that war for the U.S. Capitol Rotunda. The commission excluded violent subjects such as The Death of General Warren, which represented an American defeat, however noble. During the War of 1812, invading British troops had destroyed much of the Capitol and the White House. Consequently, Trumbull's theme of fraternalism between British and American officers failed to satisfy nationalist fervor for cultural and political independence.

By contrast, Trumbull's The Declaration of Independence suited the temple architecture and republican meaning of the Rotunda, the American Pantheon. Originally conceived in a smaller 1787 version (fig. 4.31), the painting visualized a government of prosperous white gentlemen, aging Founding Fathers, rather than the

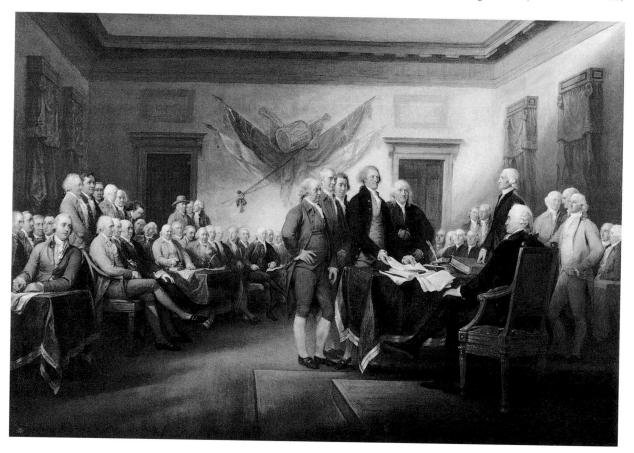

vibrant, fraternal heroes of Bunker Hill. Enclosed within an austere neoclassical space, members of the Continental Congress stiffly stand or sit like living stones, forming the architectural foundation of the new nation. Thomas Jefferson, the author of the Declaration, acts in concert with John Adams, Benjamin Franklin, and other members of the drafting committee, submitting the document to John Hancock, president of the Congress. Trumbull soberly represents the central act of the American Revolution as a rational, legal act undertaken by a republican aristocracy who wished to preserve rather than disrupt the "natural" social order.

George Washington and Republican Citizenship

Post-revolutionary government commissions tended to favor simple, realistic portraits of American patriots. Grandly heroic, idealizing portraits held little appeal for American middle-class audiences distrustful of the propertied elite's aristocratic pre-

tensions. Trumbull approached *The Declaration of Independence* more as a group portrait than a bravura history painting, spending years collecting accurate likenesses of the signatories and nonsignatories to the Declaration. When he painted a commissioned historical portrait of *General George Washington at the Battle of Trenton*, the city of Charleston, South Carolina, voted to reject the painting, telling Trumbull that it "would be better satisfied with a more matter-of-fact likeness . . . calm, tranquil, peaceful" (cited in Cooper, p. 120) (fig. 4.32). Charlestonians desired a friendlier, approachable Washington with whom they could identify as admiring brothers.

But Trumbull's patriarchal Washington appears to assume godlike powers beyond the constitutional rule of law. His commanding pose resembles the *Apollo Belvedere*, one of the most celebrated sculptures from classical antiquity (fig. 4.33). Washington's buff-yellow uniform and golden telescope further encourage this comparison. Like the triumphant sun god, Washington stands high above the battlefield, his omniscient gaze equivalent to the solar all-seeing eye that decorates both the Great Seal and Washington's own Masonic apron.

After Washington's death in 1799, artists and architects more frequently represented him as a god or demigod. In 1800, Benjamin Latrobe, the Anglo-American architect and Freemason, designed a grand pyramidal mausoleum for Washington's remains (fig. 4.34). Latrobe's pyramid borrowed both from the Great Seal of the

4.32 John Trumbull
General George Washington
at the Battle of Trenton,
1792. Oil on canvas, 92½ ×
63 in (235 × 160 cm).
Yale University Art Gallery,
New Haven, Connecticut.
Gift of the Society of the
Cincinnati in Connecticut.

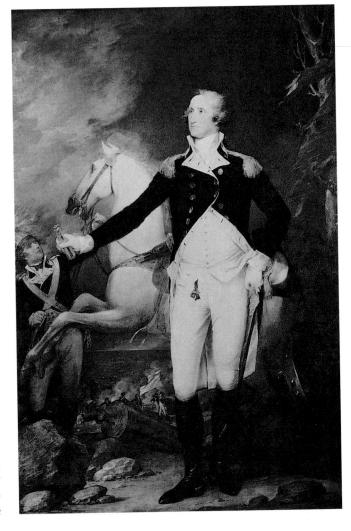

4.33 Apollo Belvedere Roman copy of Greek original, c. 1st century B.C.E. Marble, 7 ft 41/4 in (2.24 m) high. Vatican Museums.

4.34 Benjamin Henry Latrobe

Proposal for a Washington Mausoleum, c. 1800. Watercolor, $11 \times 21\%$ in (27.9 \times 53.9 cm). Library of Congress, Washington, D.C.

Latrobe's stepped pyramid was to have risen 100 feet high. Latrobe's imaginary view of the proposed Egyptian-revival structure unites the pyramid's apex with the sky above. Not until later in the century was Robert Mills' Washington Monument (1848-1885), a towering Egyptian obelisk, constructed on the Mall in Washington, D.C.

United States and from the funerary architecture of the French Freemason Étienne-Louis Boullée (1728–99), whose pyramidal monuments served the new religion of hero worship. Fearing mob violence and the social radicalism of the French Revolution, American conservatives increasingly favored images of patriarchal authority rather than egalitarian brotherhood.

However, political democrats objected to the deification of any mortal. Later in the nineteenth century, the young American sculptor Horatio Greenough (1805-52) was severely criticized for his Zeuslike portrayal of a seminude Washington (fig. 4.35). Commissioned by Congress, Greenough's marble monument originally sat in the middle of the Capitol Rotunda partly under the assumption that Washington's remains might be transferred from Mount Vernon to a crypt beneath the Rotunda floor. But six years after its installation, Greenough's unpopular sculpture was transferred to the grounds outside the Capitol and now sits in relative obscurity in the basement of the National Museum of American History.

The novelist Nathaniel Hawthorne later rhetorically asked, "Did anybody ever see Washington nude? It is inconceivable. He had no nakedness, but I imagine he was born with his clothes on, and his hair powdered, and made a stately bow on his first appearance in the world. His costume, at all events, was a part of his character," including his "coat and breeches, and masonic emblems" (cited in McCoubrey, pp. 86–87).

Washington's public image was shaped by the scrutiny of fellow citizens, who believed that the nation's president was equally subject to the Constitution and the providential all-seeing eye. Debate over Washington's authority divided the artistic community. In 1795, the

Philadelphia portraitist Charles Willson Peale failed to extend the existence of the Columbianum, the nation's first art academy, beyond the year of its origin. Its first and last annual exhibition of 137 works by thirty artists opened in late April for six weeks in the Pennsylvania State House. Afterward, the academy fatally split into two political factions: those who wished to solicit Washington's support as a kind of royal patron

of the academy versus those who refused to tarnish Washington's republican image with the authoritarian trappings of royalty.

The Rhode Island native Gilbert Stuart, yet another Benjamin West student, created the most enduring images of Washington as republican citizen. Stuart's "Vaughan" portrait of Washington, named after its first owner, represents the president in his black inauguration suit (fig. 4.36). Otherwise, the portrait bust is devoid of the official trappings of power associated with the nation's chief executive. Stuart preferred to focus upon the face as the emblematic handwriting of God or mirror of the soul. His melting brushstrokes model a sensitive, half-smiling face, warmly radiating a spiritual energy indicated especially by the flushed cheeks and the red glow of light surrounding Washington's head.

In a full-length portrait, Stuart represented the president in the manner remembered by Hawthorne. Washington is dressed in a plain black suit with powdered wig and ceremonial sword. He politely stands with an open gesture of welcome (fig. 4.38). Behind the grand columnar architecture, a rainbow signifies God's covenant with the new nation after the revolutionary flood. Stuart placed a copy of the Constitution beneath the table and volumes of *The Federalist* and the *Journal of Congress* on it, indicating the equality of the branches of government and Washington's deference to the public will.

Most Americans feared that glorifying a singular military hero could encourage one-man dictatorship. The Society of the Cincinnati, an order of Revolutionary War officers and their eldest male descendants, generated republican fears of military despotism. Nevertheless, the Society of the Cincinnati's ancient name acknowledged the danger. The ancient Roman exemplar Cincinnatus had preferred private rural retirement to the public glory of military and political power.

Artists often represented Washington as a modern Cincinnatus, who retired to the land, voluntarily subjecting himself to the public will. Even Greenough's Zeus-like sculpture represents Washington in the act of surrendering the sword of governmental authority to the viewing public. In its original setting, Greenough's sculpture reinforced the political message of a second mural for the Capitol Rotunda. Trumbull's The Resignation of General Washington, December 23, 1783, represents the resigning commander in chief standing deferentially before a session of Congress (fig. 4.37). The neoclassical setting and anti-heroic lack of action underscore the rule of

4.35 Horatio Greenough *George Washington*, 1840. Marble, 11 ft 4 in (3.45 m) high. National Museum of American History, Smithsonian Institution, Washington, D.C.

4.36 Gilbert Stuart
George Washington
(Vaughan-Sinclair portrait),
1795-96. Oil on canvas, 29% ×
24% in (74.2 × 61.5 cm).
National Gallery of Art,
Washington, D.C. Andrew W.
Mellon Collection.

law and George Washington's gentlemanly indifference to personal power.

Commissioned by the state of Virginia, the French sculptor Jean-Antoine Houdon (1741-1828) designed a marble statue of Washington as a modern Cincinnatus (fig. 4.39). Mixing contemporary costume with classical allusions, he reassuringly implied the general's rejection of military dictatorship for rural retirement at Mount Vernon. A plow, emblematically signifying the peaceful pursuit of agriculture, supports the back of the sculpture. Washington has taken off his sword and military riding coat, which he drapes over the fasces, the bound rods of discipline that symbolized Roman republican justice. He has, instead, taken up his walking stick, which he employed while supervising the cultivation of his Mount Vernon plantation. Situated within Thomas Jefferson's Roman-temple rotunda for the Virginia State Capitol, Houdon's statue expressed conservative Americans' conviction that state and national stability depended upon the political authority of independent men of property, whose wealth was rooted in the land.

Even merchants submitted to this agrarian ideology, using their commercial wealth to purchase country estates in modest emulation of Washington's Mount Vernon or Jefferson's Monticello. In 1788, before his election to Congress, the Baltimore merchant William Smith asked Charles Willson Peale to paint him as a country gentleman attended by his grandson. In the portrait, the child holds a peach harvested from the farm orchard in the background (fig. 4.40). Peale equates agricultural cultivation with self-cultivation and the education of republican youth, heirs to the revolutionary legacy of the Founding Fathers. Temporary rural retirement also enabled men of property to pose as disinterested citizens, who did not actively run for office but selflessly offered to serve, if the public, in its wisdom, so asked. While Peale's Smith sits in a green garden chair, the fictive classical architecture of the setting alludes to the subject's public identity as a member of the governing establishment.

4.37 John Trumbull The Resignation of General Washington, 1822-24. Oil on canvas, 12 imes 18 ft (3.65 imes5.48 m). U.S. Capitol Rotunda, Architect of the Capitol, Washington, D.C.

Standing within the classically designed Senate Chamber of the State House in Annapolis, Maryland, Washington presents his letter of resignation to the group of congressmen at the left. He is accompanied by other **Revolutionary War officers** and members of his own family. Altough they were not actually at Annapolis for the event, Washington's wife, Martha, and her grandchildren may be seen in the spectator's balcony at the upper right of the picture.

Peale, Stuart, and other portraitists of the post-revolutionary era sought to represent human physiognomy as a transparent barometer of moral character and truth. Peale adopted an austere "plain style" (Fortune, p. 607), attempting to divest American portraiture of its subservient, colonial association with the English school's aristocratic flattery. His many portraits of revolutionary heroes and statesmen were both realistic and philosophical in meaning. A man of science as well as art, Peale sought to canonize lovers of wisdom, patriotic men of learning, who also belonged to the universal republic of letters. Commissioned by the American Philosophical Society in Philadelphia, he portrayed Benjamin Franklin as a man of science, the discoverer of electricity and inventor of the lightning rod (fig. 4.41). While a bolt of lightning strikes a large building in the background, Franklin calmly holds a miniature lightning rod. Another rod rests on the writing table, drawing attention to a manuscript page of Franklin's famous 1769 treatise on

4.38 (left) Gilbert Stuart George Washington (Lansdowne portrait), 1796. Oil on canvas laid on wood, 96×60 in. (243.8 imes 152.4 cm). Pennsylvania Academy of the Fine Arts, Philadelphia. Bequest of William Bingham.

Washington's right hand almost touches a guill rising out of a silver inkwell. These suggest a ship and its sail. Connected with the rainbow, these objects evoke the biblical Flood and Noah's Ark. Washington was regarded as a savior following the revolutionary floodwaters.

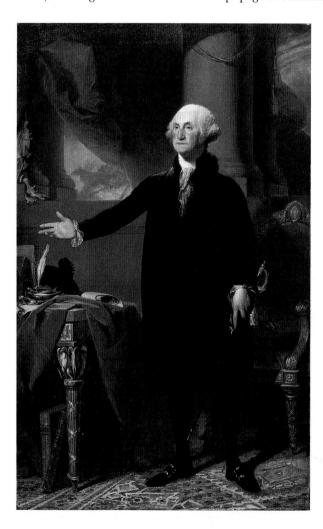

4.39 (right) Jean-Antoine Houdon George Washington, 1788. Marble, lifesize. Virginia State Capitol, Richmond, Virginia.

4.40 (left) Charles Willson Peale

William Smith and his Grandson, 1788. Oil on canvas, 51½ imes 40¾ in (130.2 imes102.5 cm). Virginia Museum of Fine Arts, Richmond, Virginia. The Cabell Foundation and the Glasgow Fund.

4.41 (right) Charles Willson Peale

Benjamin Franklin, 1789. Oil on canvas, 36 imes 27 in (91.4 imes68.5 cm). Historical Society of Pennsylvania, Philadelphia.

Franklin, mortally ill, was unable to pose, so Peale based his likeness on a 1785 portrait. Unfortunately, Franklin's words on the paper before him have faded over time to the point of illegibility.

electricity. Peale's sedate portrait implies that the Founding Fathers acted rationally upon principles of natural law and divine providence. In words that could allude to the federal union of states, Franklin wrote in the manuscript page visible in Peale's painting that lightning rods fail to prevent explosions only "by reason of their being incompleat, disunited, too small, or not of the best materials for conducting" (cited in Sellers, 1962, p. 351).

Educating the Public and Selling Art: Problems in Public and Private Exhibitions

Beginning in 1786, Peale opened a museum in a building next to his house at Third and Lombard Street, Philadelphia. An early admission pass dramatically announced that for six months the museum patron could enjoy "the wondrous work" of nature (fig. 4.42). At the top of the ticket, an open book of "Nature" radiates the light of divine wisdom over a menagerie below.

Peale had the civic-minded goal of educating the public by marrying natural history with art and private enterprise with popular entertainment. His profitable museum attained scientific and national respectability when it moved to the American Philosophical Society's Philosophical Hall in 1794 and then, in 1802, to Independence Hall. It was at the latter hall that Jefferson, Franklin, and other

signatories had declared national independence by invoking "the laws of nature and nature's god" (cited in Fliegelman, p. 203).

In 1822, when Peale's private museum became incorporated as the Philadelphia Museum, the trustees of the new public institution commissioned the eighty-one-year-old artist to paint a full length self-portrait for the museum (fig. 4.43). The museum had been a collective effort involving contributions of natural-history specimens and anthropological curiosities from members of Peale's audience and the collaborative labor of his large family. Yet Peale portrays himself as the heroic prime mover. Receding in deep perspective, rows of gold-framed portraits crown a hier-

archical exhibition of Nature's Great Chain of Being. Rivaling Noah's Ark, the museum's Long Room preserves God's creation, including extinct species. Stuffed birds in display cages line the lower walls, while various mammals appear on the right between the skeletal legs of a giant mastodon, an extinct relative of the elephant. Peale teases the beholder with a theatrical curtain, partially hiding the sublime sights that paying customers may fully view. Conservatives had attacked Peale's Museum for being a circuslike menagerie, the cultural expression of Jeffersonian democracy's indiscriminate social leveling. Having outlasted most of

4.42 AnonymousSix-month admission ticket for Peale's museum, 1813. Engraving. Massachusetts Historical Society.

4.43 Charles Willson Peale The Artist in his Museum, 1822. Oil on canvas, 103¾ × 79½ in (263.5 × 202.9 cm). Pennsylvania Academy of the Fine Arts, Philadelphia. Gift of Mrs. Sarah Harrison (The Joseph Harrison, Jr., Collection).

In the immediate left foreground, Peale placed a dead turkey on a chest of taxidermy tools. Peale's son, Titian, had acquired the distinctively American bird for the museum on a western expedition to the state of Missouri. As suggested by the long rows of cages filled with stuffed bird specimens, the presently limp turkey will soon be reanimated by the taxidermist's craft into an artful museum display, signifying the harmony and variety of the universe.

4.44 Thomas Jefferson Plan of University of Virginia, 1817-26. Engraving, 1825. Thomas Jefferson papers, University of Virginia Library, Charlottesville, Virginia.

his critics, Peale visually refuted claims that his museum lacked educational value. In the background, tiny figures gaze upon the exhibits: a contemplative man of learning, a father teaching his son, and a young woman awed by the mastodon bones and, perhaps, by Peale's godlike mastery of art and science.

Peale's long perspective view of a communal space for learning parallels Thomas Jefferson's contemporaneous design for the University of Virginia (fig. 4.44). At Charlottesville, Jefferson created an "academical village" (cited in Roth, p. 76), a rectangle of classically designed pavilions, classrooms, and dormitories headed by a Pantheon-domed library that overlooked a long lawn originally open to the landscape beyond. Like Jefferson, with whom he corresponded, Peale asserted the vitality of America's natural environment, exposing the narrow prejudices of European naturalists who argued that species degenerated in the hostile American wilderness.

While Jefferson's design for the Virginia campus embraces the surrounding world, Peale's self-portrait foregrounds the American wild turkey as an emblem of New World bounty. Similarly, Peale's own mammoth stature and octogenarian longevity visually refuted European claims of American degeneracy.

Peale's large family, led by his artist-sons, also founded art galleries and museums in Philadelphia, Baltimore, and New York. But the work of Peale's sons did not always meet with the patriarch's approval. The revolutionary generation of painters represented virtuous subjects. By contrast, the post-revolutionary generation of artists, including Rembrandt Peale, John Vanderlyn, and Washington Allston, turned increasingly toward subjects that expressed anxiety and ambivalence regarding the nation's political and cultural future. Wealthy patrons founded the American Academy of the Fine Arts in New York (1802) and the Pennsylvania Academy of Fine Arts in Philadelphia (1805), but the new generation of American artists suffered from American patrons' preference for European Old Master paintings. Meanwhile, to reach a broader, middle-class audience, artists continued to develop marketing strategies that mixed the fine arts with the theater and popular entertainments.

Rembrandt Peale: Images of Female Sexuality and Moral Reform

Rembrandt Peale, second oldest son of Charles Willson Peale, angered his father when he opened his own Philadelphia art gallery to exhibit The Roman Daughter, among other paintings (fig. 4.45). Popularized in theatrical productions, the subject focused upon female sexuality but, at the same time, was a moral story of filial devotion and charity. The large neoclassical painting represents a loyal daughter secretly breastfeeding her starving, unjustly imprisoned father. Beholders who regarded the theater as a source of moral corruption criticized the painting's perversion of republican motherhood. According to the critic for the Monthly Anthology and Boston Review, "The figure of an old man, placed in the situation of an unconscious infant, is perfectly disgusting" (cited in Miller, p. 111). Charles Willson Peale warned

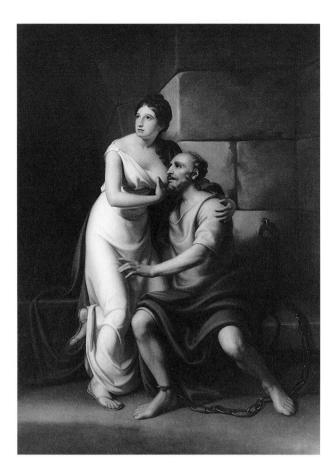

4.45 Rembrandt Peale The Roman Daughter, 1811. Oil on canvas, $84\% \times 62\%$ in $(210 \times 159.8 \text{ cm})$. National Museum of American Art, Washington, D.C. Gift of the James Smithson Society.

Despite misgivings over the sexual nature of the subject, Charles Willson Peale posed for the figure of the father. Having recently returned from a trip to Paris, Rembrandt Peale adopted a simplified style inspired by the paintings of Jacques-Louis David (1748-1825) and the French school of neoclassicism.

his son against the painting's nudity and quasi-incestuous subject matter, fearing that moral and religious societies would be roused to act against the evils of art.

Rembrandt Peale learned his lesson. Years later in his Baltimore museum, he began to exhibit *The Court of Death*, a huge painting that self-consciously advocated a host of moral reforms to promote the health and well-being of American citizens (fig. 4.46). Presided over by the enthroned figure of Death, who rests his foot upon the corpse of a young man, the painting is a vast allegory filled with personifications symbolizing the fatal evils that prematurely take the lives of the young, including War, Conflagration, Famine, Pestilence, Suicide, and Intemperance. The beseeching figures of Old Age and Faith stand as virtuous alternatives to the gloomy congregation of moral and physical diseases. Supported by the sermons of clergymen and a host of favorable newspaper reviews, the traveling painting attracted a broad, middle-class audience in cities throughout the United States.

John Vanderlyn and the Moral Ambiguity of Early-nineteenth-century History Painting

The New York painter John Vanderlyn also attempted to lure audiences with provocative subjects and the marriage of high art with popular spectacles. Having studied in revolutionary Paris during the late 1790s, Vanderlyn chose violent, anti-British subject matter that first expressed itself in *The Death of Jane McCrea*, painted in Paris in 1804 (fig. 4.47). That year Britain resumed its war with revolutionary France. Begun in 1789, the French Revolution had developed violently into a

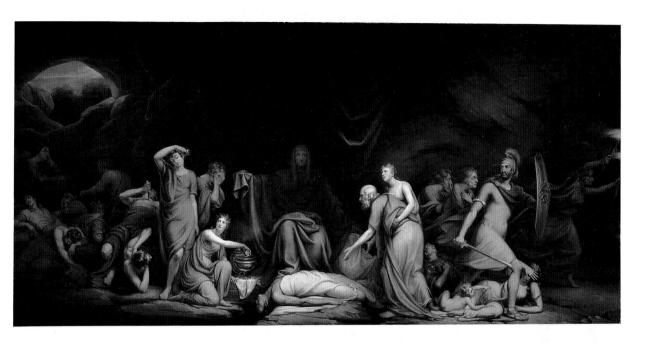

4.46 Rembrandt Peale The Court of Death, 1820. Oil on canvas, 11 ft 6 in \times 23 ft 5 in (3.5 \times 7.1 m). Detroit Institute of Art, Detroit, Michigan.

4.47 John Vanderlyn The Death of Jane McCrea, 1804. Oil on canvas, 32 imes26½ in (81.2 \times 67.3 cm). Purchased by the Wadsworth Atheneum, Hartford, Connecticut.

Schooled in French neoclassical art, Vanderlyn modeled his figures after Ancient Greek and Hellenistic sculptures. The foreground composition as a whole has the look of a classical frieze. However, the intense violence, strong emotions, and murky wilderness environment subvert traditional notions of classical order and calm. In the background to the right, the small figure of a soldier may be seen running toward us, but his distance precludes any possible rescue of Jane McCrea.

Many Americans who bitterly recalled British behavior during the American Revolution supported Napoleon Bonaparte's campaign to conquer the royal families of Britain and Europe. Exhibited in Paris, Vanderlyn's *The Death of Jane McCrea* attacked the moral standing of Britain. The painting represents a horrific scene from *The Columbiad*, an epic poem of the American Revolution by Joel Barlow, Thomas Jefferson's diplomatic envoy to France. Vanderlyn rejected West's romantic image of the noble savage for a caricatured representation of Indian viciousness. Selfishly motivated by the British bounty placed upon American scalps, the dark-skinned warriors murder an innocent white woman against the gloom of the New York wilderness.

Vanderlyn's anti-British theme expressed his political identification with the Francophile foreign policy of Jefferson. The year before he executed his painting for Barlow, Vanderlyn had carried diplomatic letters to Paris facilitating the Louisiana Purchase from France. Acquisition of the vast Louisiana Territory meant that the United States instantly doubled in size, extending beyond the Mississippi River to the Rocky Mountains. The Louisiana Purchase dramatically increased the probability that the United States would ultimately stretch westward all the way to the Pacific Ocean. Having thrown most of their support to the British during the American Revolution, Indian tribes more than ever loomed as obstacles to national

expansion. In Vanderlyn's propagandistic painting, the helpless Jane McCrea personifies the vulnerability of America or Liberty to a satanic red menace.

Washington Allston, a very different American painter, traveled with Vanderlyn to Paris and then Rome. In contrast to Vanderlyn's New York middle-class origins and Jeffersonian republicanism, Allston was the scion of a wealthy South Carolina rice-plantation family and a political conservative who feared the anti-aristocratic rhetoric of Americans sympathetic to the French Revolution. Unlike Vanderlyn's French training, Allston studied painting in London under Benjamin West, adopting the style of the English school. Yet both Vanderlyn and Allston painted brooding pictures of violent outlaws and renegades that questioned the earlier revolutionary generation's confidence in human reason and hopes for a millennial age of harmony. In 1800, the year he graduated from Harvard College, Allston painted a small study of human madness, Tragic Figure in Chains, in apparent allusion to conservative fears that America might be abandoning its identity as God's chosen nation by following the French Revolution's anti-Christian cult of human reason (fig. 4.48). Earlier, in 1798, frightened conservatives responded to rumors of impending war with France and warnings that

4.48 Washington Allston *Tragic Figure in Chains*, 1800. Watercolor on paper mounted on panel, 12% × 9% in (32 × 24.4 cm). Addison Gallery of American Art, Phillips Academy, Andover, Massachusetts.

Jeffersonian supporters of the French Revolution were conspiring with foreign radicals to overthrow the established social order of church, family, and state. Congress passed the Alien and Sedition Acts, making it easier to deport immigrants and to revoke freedom of speech and press for political dissidents.

The Alien and Sedition Acts were repealed and President Jefferson's moderate social policies allayed the propertied elite's anxieties regarding another, more radical American revolution. However, commercial warfare between Britain and Napoleonic France continued to divide Americans into opposing political factions. Responding to British interference with American shipping, the United States declared war against Britain in 1812. The War of 1812, America's second war for independence, would not end until 1815, the same year that Napoleon Bonaparte's fall from power brought peace to war-torn Europe.

American artists chose subjects that expressed the conspiratorial atmosphere of political paranoia pervading Europe and America during the first fifteen years of the nineteenth century. In Rome, under Washington Allston's influence, John Vanderlyn painted Marius amid the Ruins of Carthage, representing a Roman general who was the moral opposite of Cincinnatus and George Washington (fig. 4.49). According to the ancient Roman biographer Plutarch, Marius had been a powerhungry military leader banished to the ruined North African city of Carthage. Vanderlyn later stated that he intended to represent "the instability of human grandeur—a city in ruins and a fallen general. I endeavoured to express in the countenance of Marius the bitterness of disappointed ambitions mixed with the meditation of revenge" (cited in Simpson, Mills, and Saville, p. 56).

Vanderlyn probably intended *Marius* as a melancholic political allegory of his former patron Aaron Burr, Jefferson's vice-president. Burr's political ambitions had collapsed in 1804, when he killed Treasury secretary Alexander Hamilton in a duel. Burr fled in an unsuccessful attempt to establish his own political empire in the American Southwest. Tried for treason, he managed an acquittal but decided to live in European exile like a brooding Marius. In Paris, Burr again met Vanderlyn, whose Marius had won a gold medal from the French government at the Salon of 1808. The painting's reception may have been aided by Napoleon's admiration for the ancient Roman general, who had been the first to create a professional, citizens' army composed primarily of proletarians, or men without property.

In 1815, following the fall of Napoleon Bonaparte and the collapse of the French Empire, Vanderlyn returned to New York with Marius and several other history paintings in hand, including a classical nude subject, Ariadne Asleep on the Island of Naxos (fig. 4.50). But his career foundered as American critics questioned the moral content of his paintings. Marius failed to find an American buyer until 1834. The painting's grim anti-hero, draped in red, tensely clutching his sword, represented an unappealing, violent character, the antithesis of civic-minded republicanism. Meanwhile, Vanderlyn's voluptuous Ariadne aroused the opposition of moralists, not simply because it represented a female nude, but also because it clearly represented the mythic Greek princess in a state of postcoital pleasure. Vanderlyn reduced Theseus, whom Ariadne had saved from the Cretan labyrinth, to a tiny figure in the background. Having seduced Ariadne, he secretly boards a ship for the return to Athens. Ariadne's curvaceous body represented another labyrinth that the Athenian hero ultimately had to escape for the sake of Western civilization. Vanderlyn's sensual representation of Ariadne's pink, glowing flesh boldly foregrounds the private temptation of sexual pleasure at the expense of the hero's public duty to the Athenian city-state. When he began the Ariadne in 1805,

4.49 John Vanderlyn
Marius amid the Ruins of
Carthage, 1807. Oil on
canvas, 87 × 68½ in (220 ×
173.9 cm). Fine Arts Museums
of San Francisco, California.
Gift of M.H. de Young.

Vanderlyn appears to have appropriated this brooding figural type from the figure of Brutus in Jacques-Louis David's The Lictors Returning to Brutus the Bodies of His Sons (1789). But unlike David's Brutus, who heroically sacrificed private family interests for the good of the Roman Republic, Vanderlyn's Marius appears as a totally self-absorbed, obsessive character, whose dark, destructive thoughts are echoed by the gloomy ruins of a past empire.

Vanderlyn wrote to a friend: "The subject may not be chaste enough for the more chaste and modest Americans, at least to be displayed in the house of any private individual, to either the company of the parlor or drawing room, but on that account it may attract a greater crowd if exhibited publickly" (cited in Lubin, p. 12).

Yet *Ariadne* failed to produce the scandalous publicity that may have drawn large crowds, since Vanderlyn also intended to educate the American public in the Renaissance ideals of high art. His painting was partially purified through arthistorical associations with sixteenth-century Venetian nudes by Giorgione and Titian. Realizing that *Ariadne* and *Marius* would fail to attract a sufficient audience, Vanderlyn painted large panoramas that imaginatively transported viewers to European cities and tourist sites such as Versailles Palace. But after a decade, Vanderlyn's New York rotunda of circular panoramas and ideal history paintings went bankrupt, forcing the artist to salvage his career through portraiture.

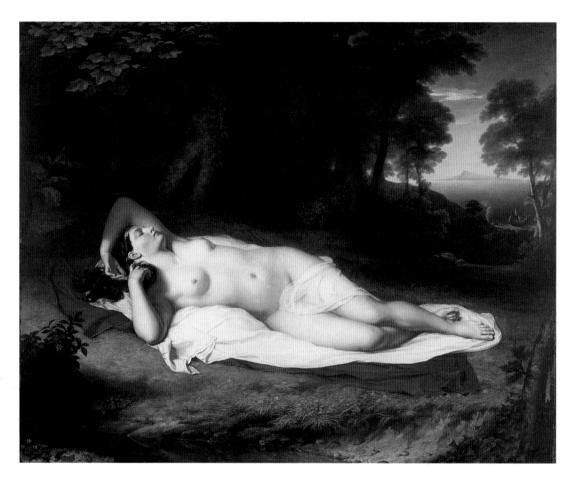

4.50 John Vanderlyn Ariadne Asleep on the Island of Naxos, 1809-14. Oil on canvas, 68% imes 87 in (173.9 imes220.9 cm). Pennsylvania Academy of the Fine Arts, Philadelphia. Gift of Mrs. Sarah Harrison (The Joseph Harrison, Jr., Collection).

Washington Allston and Biblical Painting

When Washington Allston returned from Europe to Boston in 1818, he, too, complained of a lack of patronage and the vulgarity of American materialism. After 1815, with the arrival of peace, an entrepreneurial market economy increasingly challenged traditional republican values of civic-minded virtue. As an antidote to the capitalist political economy of private self-interest, Allston returned to the Old Testament imagery of New England's Puritan founders. In 1817, in London, he began his most famous biblical painting, Belshazzar's Feast (fig. 4.51). Allston depicted the Jewish prophet Daniel interpreting God's handwritten message, which foretold the doom of the pagan King Belshazzar and his Babylonian empire. The artist excitedly asked the New York author Washington Irving:

Don't you think it a fine subject? I know not any that so happily unites the magnificent and the awful: a mighty sovereign, surrounded by his whole court, intoxicated with his own state—in the midst of his revellings, palsied in a moment under the spell of a preternatural hand suddenly tracing his doom on the wall before him; his powerless limbs, like a wounded spider's, shrunk up to his whole body, while his heart, compressed to a point, is only kept from vanishing by the terrific suspense that animates it during the interpretation of his mysterious sentence: his less guilty, but scarcely less agitated queen, the panic-struck courtiers and concubines, the splendid

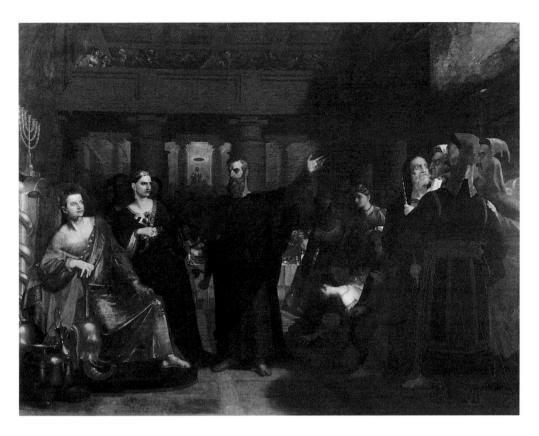

and deserted banquet table, the half-arrogant, half-astounded magicians, the holy vessels of the Temple, (shining, as it were, in triumph through the gloom) and the calm, solemn contrast of the Prophet, standing like an animated pillar in the midst, breathing forth the oracular destruction of the empire! (cited in Bjelajac, 1988, p. 101)

Over a quarter-century later, when he died in 1843, Allston was still working on this large masterpiece representing the book of Daniel's prophetic tale of divine retribution. The artist had labored upon the painting during the 1820s only to abandon it in frustration for most of the 1830s. Yet, during the last four years of his life, he sacrificed other commissions to perfect this single painting.

Allston conceived the painting as a visual sermon. Originally inspired by the fall of Napoleon Bonaparte, Belshazzar warned Americans against the French Revolution's prideful cult of human reason. The painting expressed the religious fervor of the Second Great Awakening, when evangelical clergymen and laymen's missionary societies called upon Americans to renew their covenant with the Old Testament Jehovah. More than a painting of divine judgment, Belshazzar represented the Jews' liberation from their Babylonian captivity, promising their restoration to Jerusalem and their rebuilding of Solomon's Temple. Allston's golden, supernatural light calls attention to the gleaming vessels from the Jewish temple and to a group of grateful Jews led by reverent women, who bow before Daniel.

Allied with the clergy, women played a crucial role in America's religious revival, not only as organizers of reform societies, but also as exemplars of moral virtue. Stereotypically, women seemed innately drawn toward a religion of the heart. Bornagain, conversionary experiences represented Americans' liberation from a spiritual

4.51 Washington Allston Belshazzar's Feast, 1817-43. Oil on canvas, 12 ft $\frac{1}{2}$ in \times 16 ft $\frac{1}{2}$ in (3.67 \times 4.88 m). Detroit Institute of Arts, Detroit, Michigan. Gift of the Allston Trust.

In the distant background, tiny figures run along two flights of steps leading to a pagan idol. Allston identified these figures as Jews, who celebrate both the overthrow of idolatry and their prospective return to Jerusalem. The fiery chandelier illuminating the idol represents a competing light source to the foreground's divine light. The enthroned idol echoes the pose of the evil king Belshazzar, whose recoiling body draws him closer to a Satanic serpent coiled around the post of his throne.

Babylon of material luxury and imperial hubris. Protestants interpreted the restoration of the Jews as a prophetic type for the Christian millennium, when a spiritual Jerusalem would be built in the new American Israel.

Unlike West or Trumbull, Allston refused to memorialize an event in America's national history. Only by turning to the prophetic stories of the Old Testament could he allegorically suggest America's central role in the fulfillment of providential history. Belshazzar was collectively funded by a group of Boston merchants who also sponsored such patriotic projects as the Bunker Hill Monument (see p. 162). Allston was on the design committee that chose an Egyptian obelisk to honor the martyred heroes of Bunker Hill. The artist had planned to finish Belshazzar in 1825 for the fiftieth anniversary of the battle and for the monument's Masonic cornerstone-laying ceremony led by the Marquis de Lafayette, the aging French hero of the American Revolution. Allston's representation of Jewish liberation from Babylon fortuitously appealed to Freemasons' legendary ties to the building and rebuilding of Solomon's Temple. But, by continually repainting, Allston failed to finish Belshazzar. Gilbert Stuart accurately prophesied to a friend that Allston would never finish it: "Mr. Allston's mind grows by, and beyond his work. What he does in one month, becomes imperfect to the next, by the very growth of his mind" (cited in Bjelajac, 1988, p. 2).

Frustrating his wealthy Boston patrons, Allston increasingly lost faith in the efficacy of biblical symbolism. In one of his many poems, he mused that "Things blank and imageless in human speech / Have oft a truth imperative in might" (cited in Bjelajac, 1988, p. 16). Deeply religious, Allston may have seen a positive moral value in perpetually reworking but never finishing Belshazzar. After the artist's death, the Unitarian clergyman C. A. Bartol wrote a sermon based upon Allston's Belshazzar asking how is it possible to "turn the Words of the rapt prophet into colors?" (cited in Bjelajac, 1988, p. 16). Arguing against a theology of human perfectionism, Bartol cited the unfinished masterpiece: "the idea is, not that we should grasp perfection as an immediate result, but make it our aim" (cited in Bjelajac, 1988, p. 16). Remarkably, Allston's patrons posthumously exhibited Belshazzar in its unfinished state as Christian testament to the artist's spiritual striving.

Far from generating national consensus, biblical pictures aroused contentious debate and traditional Protestant fears of idolatrous image worship. Allston acknowledged this fear in representing a grotesque pagan idol in the background of Belshazzar's Babylonian court. Furthermore, he conceived the picture's divine message in the non-visual terms of a formless handwriting or immaterial light, orally interpreted by the voice of a prophet.

Allston may have halted work upon Belshazzar during the late 1820s and 1830s because anti-Masonic and anti-Catholic Protestants were attacking alleged abuses of biblical imagery. Former president John Quincy Adams criticized Masonic initiation ceremonies for theatrically dramatizing Holy Scripture, blaspheming against the pure, incorporeal essence of the Word. Harboring anti-Catholic prejudices, Allston's former student Samuel F. B. Morse (1791-1872), president of New York's National Academy of Design, refused to paint biblical subjects. Morse published a series of letters that accused the papacy of conspiring to subvert the United States by encouraging the emigration of paupers from Catholic Europe. A flood of Catholic icons threatened to undermine Protestants' vision of America as a nation of God's elect.

Meanwhile, a congressional majority opposed the New England clergy's attempts to formally ally the federal government with the Protestant establishment.

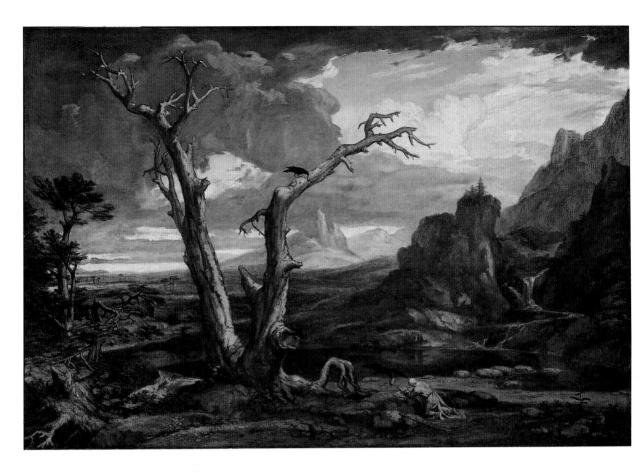

Shortly after Protestant evangelicals' Sabbatarian movement had failed to halt Sunday mail service, Allston unsuccessfully proposed the three Marys at Christ's tomb for one of the four remaining murals in the U.S. Capitol Rotunda. Admitting his proposal was "a forlorn hope" (cited in Bjelajac, 1988, p. 161), he sought to recast the subject of Christ's Resurrection in the more abstract terms of color and chiaroscuro:

The ... preternatural brightness [of the angel] ... the streak of distant daybreak, lighting the city of Jerusalem out of the darkness, and the deep-toned spell of the chiaroscuro mingling as it were the night with the day, I see now before me; I wish I could see them on the walls at Washington. (cited in Bjelajac, 1988, p. 160)

Illuminated by the oculus of the Capitol's dome, Allston's representation of daylight breaking over the skyline of Jerusalem would have symbolized America as the new Jerusalem bringing the world to the dawn of the millennial age.

Besides Belshazzar, Allston painted other Old Testament subjects, but more emphatically subordinated biblical narrative to the suggestive power of paint. In Elijah in the Desert, Allston experimented with skim milk as a medium for his pigments, while puzzling his Boston audience by diminishing the size of the hermit-prophet relative to a wilderness landscape (fig. 4.52). According to the clergyman-critic William Ware, the title of the painting raised "false expectations" and "disappointment. . . . when looking upon the picture, no Elijah was to be seen; at

4.52 Washington Allston Elijah in the Desert, 1817-18. Oil on canvas, $48\% \times 72\%$ in $(123.8 \times 184.1 \text{ cm})$. Museum of fine Arts, Boston, Massachusetts. Gift of Mrs. Samuel Hooper and Miss Alice Hooper.

4.53 Samuel F. B. Morse The Old House of Representatives, 1822. Oil on canvas, $86\% \times 130\%$ in (219.7 imes 332.1 cm). The Corcoran Gallery of Art, Washington,

Morse's painting celebrates the restoration of the United States Capitol after its burning by the British during the War of 1812. The old House of Representatives chamber, now serving as Statuary Hall, was rebuilt by Charles Bulfinch according to the original design of Benjamin Latrobe. Morse carefully painted the half-domed space supported by tall Corinthian columns. The powerful sweeping lines of the chamber's cornice contribute to the pictorial unity and grandeur of the composition.

least you had to search for him as among the subordinate objects" (cited in Bjelajac, 1992, p. 123).

However, for Allston, the drama of God's Word was embedded in the dense milky brushstrokes overlaid with thin, transparent oil glazes. He employed a system of painting based upon the three primary colors and the combination of all three into tertiary colors—olive, citrine, and russet—to suggest the corresponding harmony of the universe ruled by a Christian God defined as three persons, Father, Son, and Holy Ghost, in one Holy Trinity. In Elijah, the russet browns and olive greens of the desert wilderness are reflected in the dark clouds above. The milky pigments and golden-yellow highlights in the foreground and middle ground lead the eye in a diagonal zigzag toward the cream-yellow horizon, a blurred margin that unites heaven and earth. Allston's additional mixture of skim milk in this unique painting symbolically evoked St. Peter's admonition in the New Testament: "As newborn babes, desire the sincere milk of the word, that ye may grow thereby" (cited in Bjelajac, 1997, p. 121). Men of learning like Allston associated the Bible's spiritual milk with Sophia or "Sapientia," the female personification of God's luminous Word.

Charles Robert Leslie and Samuel Morse: The Symbolism of Color and Light

In American colleges, student societies dedicated themselves to the love of wisdom. During Allston's residence in London, his close colleague Charles Robert Leslie

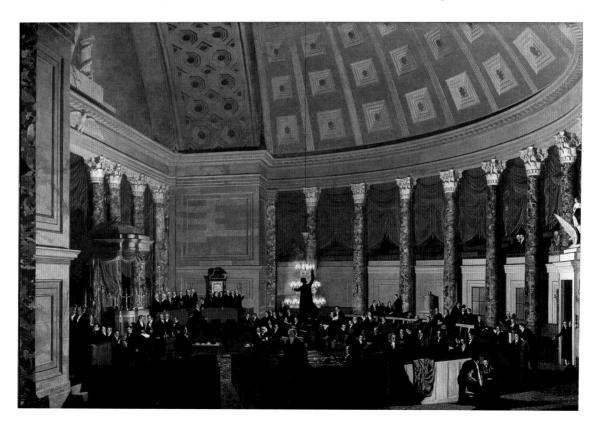

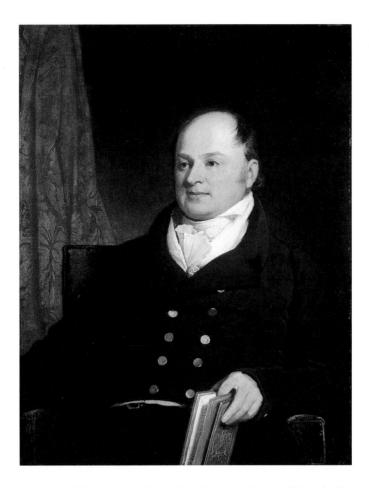

4.54 Charles Robert Leslie John Quincy Adams, 1816. Oil on canvas, 37×29 in (94×73.7 cm). U.S. State Department, Washington, p.c.

(1794–1859) painted a portrait of future president John Quincy Adams, Allston's Phi Beta Kappa brother (fig. 4.54). Founded in 1776, the year of American independence, the Phi Beta Kappa Society borrowed secret rituals and handshakes from Freemasonry to establish a philosophical fraternity of students and alumni. In Leslie's portrait, Adams holds a book decorated with a "Pythagorean emblem," "the Lyre of Orpheus" applied to "the American political Constellation" of "thirteen original stars" (cited in Conger and Rollins, p. 412). Employing signs of immaterial music and celestial light, Adams's seal symbolized the harmony of the American union and the Phi Beta Kappa brotherhood's devotion to Pythagoras, Greek founder of the first secret society of philosophers.

Having been an apprentice in Allston's London studio, Samuel F. B. Morse also turned from dramatic narrative paintings toward the philosophical symbolism of color and light. Though he rejected biblical subjects, he insisted with Allston that the mixture of the three primary colors could bear the weight of political and religious truth, proving both the theological doctrine of the Holy Trinity and the providential nature of America's harmonically balanced government.

Inspired by Trumbull's *The Declaration of Independence*, Morse traveled to Washington, D.C., to paint a large exhibition picture, *The Old House of Representatives* (fig. 4.53). Both paintings are group portraits of American legislators and statesmen; but Morse represented the informal scene of a congressional recess rather than the official public actions of a legislative body.

Morse typified the skepticism of conservatives toward the actual practice of American democracy. The artist implicitly contrasted the harmonic architecture of America's tripartite system of government with the dissonant reality of democratic debate and partisan politics. Morse's painting focuses upon the architecture and luminous space of the Capitol as emblematic of America's balance of legislative. executive, and judicial branches of government. Morse had planned two further pictures of the Senate and executive branch. Meanwhile, his nighttime scene of the House illuminates portraits of six Supreme Court justices as well as sixty-eight legislators.

Representing recent diplomatic achievements of the executive branch, Morse also portrayed on the House floor the negotiator of the 1819 treaty with Spain that ceded Florida to the United States. At the far right of Morse's painting, sitting in the visitors' gallery, Petalesharo, chief of the Pawnee Indians, gazes quietly upon the scene below as a guest of President James Monroe, with whom he had signed a peace treaty. By including these two figures, Morse optimistically suggests that an expanding American empire might be peacefully accepted by awed, Christianized Indians. In 1820, the year before Morse undertook The House of Representatives, Congress had passed the Missouri Compromise, which allowed Missouri to enter the union as a slave state, counterbalancing Maine's entrance as a free state. Morse's painting represented an apparent moment of political harmony. The contentious issue of slavery dividing the North from the slave states in the South temporarily receded from congressional debate. Within the happy spirit of a national recess from bitter sectional conflict, the central action of Morse's painting is not the passage of legislation but the lighting of the chandelier that casts a golden glow over the House interior as if it were the heavenly temple of Jerusalem descended to earth.

Despite his hopes for profitable exhibition in various American cities, Morse's emblematic painting failed to excite the public. In contrast to the popular sensationalism and middle-class reformism of Rembrandt Peale's The Court of Death (see fig. 4.46), The House of Representatives silently mirrored the American elite's ideal world of polite sociability. Only by representing a recess in congressional debate could Morse represent a unified body politic. Members of opposing parties and different regions harmoniously mix together in private conversation. Morse's grand architectural salon suggests that national unity is dependent upon the private cultivation of genteel manners. In his universe, the age of revolution and heroic self-sacrifice has been superseded by the polite arts of cultural domestication.

During the early nineteenth century, as a new professional class of politicians rose to displace the traditional aristocracy from public office, American artists also attempted to establish their own professional independence from both patrons and the people. Despite his failure as a history painter, Morse led American artists in establishing the National Academy of Design in 1825. Intended to educate both future artists and the public at large, the academy's founding virtually coincided with the opening of the Erie Canal. The canal immediately elevated New York to its position of economic and cultural power, connecting the city to the commercial wealth of westward expansion. Aided by art academies that claimed to be national and American, New York artists, critics, and patrons successfully promoted a nationalist art that masked northeastern entrepreneurs' economic interest in western development. As we shall see in the next chapter, artists optimistically represented the expanding American landscape, its pioneers, and diverse inhabitants in the millennialist terms of an undivided nation that surmounted narrow self-interest.

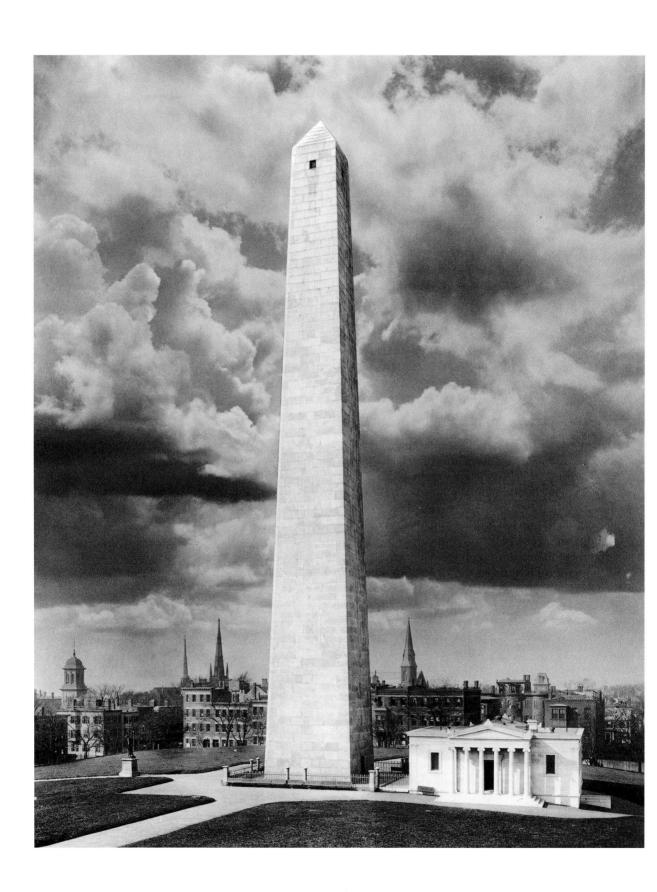

CHAPTER 5

National Identity and Private Interests in Antebellum America

1825-65

new era in the American visual arts began in 1825 as painters, sculptors, and architects searched for a national style distinguished from European tradition. That year, Americans commemorated the fiftieth anniversary of the opening battles of the American Revolution, but more importantly, they celebrated the opening of the Erie Canal, which facilitated the nation's expansion westward. The devastation of the Civil War from 1861 to 1865 marked the era's terminal point, when the new invention of photography brutally recorded the war's battlefields and a nation divided between North and South. In retrospect, antebellum, or pre-Civil War, American art scarcely masked the growing chasm between Northern and Southern states.

During this four-decade period, American expansion toward the Pacific Ocean motivated artists' quests for national forms of expression while politically dividing North and South further over the spread of slavery to new western territories and states. Expansionist ideology was sustained by venture capitalists and evangelical Christians, who assumed that the private pursuit of wealth and the conquest of the West would translate into national happiness as long as America remained a Protestant nation governed by white Anglo-Saxon men.

Art patrons who grew wealthy from canal and railroad construction, textile factories, and the commercialization of agriculture promoted paintings and sculptures replete with moral messages. Decorating private homes and public spaces, these works reminded beholders that domestic prosperity still depended upon individual virtue and a national covenant with God. Sculptors and painters expressed faith in American exceptionalism, which taught that Americans were God's new chosen people, succeeding the ancient Israelites of the Old Testament. During the early 1860s, after the Southern states had seceded from the Union, the German-born artist Emanuel Gottlieb Leutze (1816–68) painted a mural for the U.S. Capitol in Washington which expressed this nationalist faith (fig. 5.1). Westward the Course of Empire Takes Its Way represents American pioneers as if they are the children of Israel about to enter the Promised Land after years of wandering in the wilderness. In the mural's decorative frame, a scene of "Moses leading the Israelites through the desert" (cited in Fryd, p. 211) foreshadows Americans' settlement of the West.

In addition to the popular national analogies with Old Testament Israel, historical-revival architecture—whether Greek-Revival, Gothic-Revival, or some other revival style—conservatively situated antebellum Americans within a settled New World landscape that symbolized the fulfillment of Western civilization. State capitols, banks, and even textile towns were designed to evoke reassuring

Bunker Hill Monument Charlestown, Massachusetts, 1825–43. Courtesy of the Library of Congress.

Horatio Greenough originally conceived the Egyptian obelisk form for this Revolutionary War monument. The young sculptor later wrote that the ancient form probably had originated for some astronomical purpose, although he also readily conceded the obelisk's phallic associations as a symbol for patriarchal power. In building the monument, planners took into account the structure's relationship to the earth's rotation around the sun and how it would be seen from great distances in the Boston area.

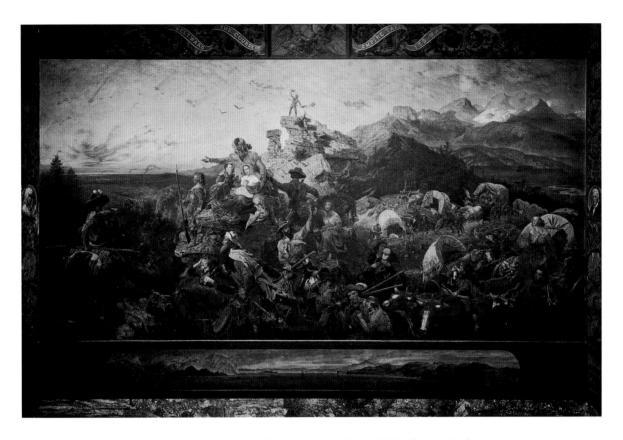

associations with classical Greece, Rome, and Renaissance Italy. With the nation's population nearly quadrupling between 1814 and 1860 to over 31 million, cities grew denser with foreign immigrants. During this period, 5 million people arrived in the United States, approximately half from England and four-fifths of the remainder from Ireland. The tide of immigrants rose during the 1830s and 1840s, cresting in 1854 when nearly 428,000 arrived. The Irish potato famine of 1845–48 contributed to a flood of impoverished people seeking new lives in American towns. The first American suburbs were built by middle- and upper-class families seeking a semirural refuge from the urban poor and working classes. The American suburb originated in the genteel taste for country estates, rural cemeteries, and architecture that appeared rooted in nature and the pre-industrial past.

While Americans industrialized and expanded westward, artists organized themselves professionally and socially. By establishing art academies and exhibition spaces, they assumed leadership roles in American culture. To distinguish themselves from mere craftsmen and manual laborers, many artists claimed the magical, godlike powers of genius. Writing to his sister from Rome, the New York sculptor Thomas Crawford (1813–57) described in 1839 his ideal sculpture, representing Orpheus rushing through the gates of hell (fig. 5.3):

I am writing in the midst of a terrible thunder storm, and can scarcely proceed, for the incessant flashes of lightning which dart every moment into the window of my studio: my statue of Orpheus is before me, and when I look upon it in the midst of this thick darkness, which is brightened occasionally by a glare of rapid red light, it is difficult to persuade myself, that this inanimate creation of mine is not starting

5.1 Emanuel LeutzeWestward the Course of
Empire Takes Its Way, 1861–2.
Fresco, 20 × 30 ft (6 × 9.1 m).

Fresco, 20×30 ft $(6 \times 9.1 \text{ m})$ Architect of the Capitol, Washington, D.C.

At the apex of Leutze's pyramidal composition, the small figure of a young man celebrates the pioneers' crossing of the Rocky Mountains by triumphantly waving one arm and reaching for an American flag with the other. Closer to the foreground, a frontiersman, protecting a praying Madonna-like mother, gestures toward the distant, golden horizon. In the crowd below, a free African American leads the donkey of an Irishwoman, thereby suggesting the racial-ethnic openness of the Promised

from its pedestal, and actually rushing into the realms of Pluto. The thunder is getting really awful, and I must stop to compose myself. I have been thinking of the story about Phidias and his wonderful statue of Jove. You know that upon finishing it, he requested some sign from the god, to know if he were pleased with the representation: it seems the nod was given, for at that moment the statue was circled by lightning, which came and passed off with such a noise as could only be produced by heaven's artillery. Were we living in that age, or were ours the religion of the ancient Greeks, I too might interpret the sign in my favor. (cited in Dimmick, pp. 54-56)

Crawford's dramatic account sounds a note of envy for the ancient Greek sculptor's confident ability to represent and communicate with the most powerful god. In antebellum America, Crawford and other artists were forced to contend with an even more demanding critic, a fractious public schooled in Protestant and republican fears of art's sensual, immoral effects. Crawford's Orpheus was a commission for the Boston Athenaeum, a private library and art gallery for the city's wealthiest patrons and most sophisticated connoisseurs. Yet Crawford felt compelled to accommodate American prudishness by providing a fig leaf to cover Orpheus's genitals. Furthermore, like many other American artists, he still looked to Europe for his art education and inspiration. Lacking adequate teaching academies and museums in the United States, aspiring sculptors established studios in Florence and Rome to create an expatriate school of American marble sculpture.

In searching for an independent American style and subject matter, some artists, such as the Long Island, New York, genre painter William Sidney Mount (1807-68), self-consciously chose not to travel abroad. Selecting only Long Island subjects for his paintings, Mount even avoided using imported pigments for his palette. In an 1848 letter to a local historian, he wrote that beginning in 1836, when he painted Farmers Nooning (fig. 5.2), he used pigments that he had extracted from Long Island sandstones and dunes. Thus, Farmers Nooning and subsequent pictures did not

5.2 William Sidney Mount Farmers Nooning, 1836. Oil on canvas, $20\% \times 24\%$ in (51.4 \times 62.2 cm). Museums at Stony Brook, New York. Gift of Frederick Sturges, Jr.

In contrast to the lazy, sleeping African American, the industrious young yeoman farmer at the far left sands a scythe sharpener, preparing for an afternoon of hard work. The scythe itself hangs from one of the branches of the apple tree that shades the figures from the noontime sun. Traditionally associated with Death or the Grim Reaper, the scythe may have suggested the potential dangers of abolitionist agitation.

simply represent Long Island's life and landscape. Mount's paintings literally were Long Island, being composed of its soil and elements.

From 1825 until the advent of the Civil War, American nationalism expressed itself in terms of a diverse unity of specific locales and regional cultures interconnected by new systems of transportation and communication. However, Mount's sunlit pictures of Long Island's farm life were also purposeful political statements that expressed the fatal disharmony within this national union of local cultures. At the center of Farmers Nooning, Mount stereotypically portraved a lazy African American as a propagandistic attack upon Northern abolitionists, who campaigned to abolish slavery. As the art historian Elizabeth Johns has shown, Mount's little boy with the Scottish tam personified the popular belief that abolitionists were foreign, un-American troublemakers who threatened to awaken black slaves politically by tickling their ears with dangerous, radical ideas.

American artists were not godlike geniuses who could expect universal critical assent to their art. Individual creativity negotiated its claims for recognition with an expanding audience whose conflicting tastes and politics represented the development of an increasingly pluralistic society. In The Painter's Triumph (fig. 5.4), Mount portrayed a professional artist seeking the approval of American democracy's common man. On the back wall of the studio, a drawing of the head of the Apollo Belvedere indifferently looks away in the opposite direction. Repeatedly copied or alluded to by earlier American painters (see fig. 4.32), the Apollo Belvedere (see fig. 4.33) represented the Greek sun god and symbolized the divine light of reason. While Mount refused to travel abroad, he acknowledged the American artist's need to maintain contact with master-

pieces of the Western tradition, beginning with the art of ancient Greece and Rome. At the same time, the Long Island artist appealed to the diverse, relatively untutored tastes of the American public as personified by the grinning, unsophisticated farmer, who seems amazed by the painter's power to simulate reality. Rather than grandiose mythological or historical subjects, Mount chose to paint luminous scenes from everyday life, which he could more easily market to a broad

5.3 Thomas Crawford Orpheus, 1839-43. Marble, 67½ in (171.4 cm) high. Museum of Fine Arts, Boston, Massachusetts, on loan from the Boston Athenaeum.

5.4 William Sidney Mount

The Painter's Triumph, 1838. Oil on wood, $19\% \times 23\%$ in $(49.5 \times 59.7 \text{ cm})$. Pennsylvania Academy of the Fine Arts, Philadelphia. Bequest of Henry C. Carey (The Carey Collection).

Mount modeled the young artist in this painting after himself. Standing with his legs wide apart and his right arm dramatically gesturing toward the canvas, he acts the role of a powerful magician whose genius awes his less sophisticated visitor. The painter's hair seems electrified while his forehead is intensely illuminated. The artist's extended arms provide an energetic, creative conduit between the palette of pigments and the apparently finished painting.

audience seeking expressions of regional and national harmony. However, despite the optimistic, consensual rhetoric of mainstream American culture, dissenting voices resisted easy assimilation into nationalist ideology. Religious nonconformists, feminists, abolitionists, and other reformers and radicals challenged the exclusionary limits of the nation's fragile union.

Historical Styles and Functional Architecture

During the spring and summer months of 1825, Americans celebrated the fiftieth anniversary of the American Revolution as the aging Marquis de Lafayette toured the nation's cities and towns. Lafayette had first endeared himself to American patriots in 1777 by leaving France and volunteering for service in the revolutionary army. He had sacrificed his comfortable life as a wealthy aristocrat to fight for liberty under the command of George Washington, who became a kind of father figure to the young Frenchman. After the war, Lafayette expressed his continuing friendship with Washington by giving the American general a Masonic apron. Now, five decades after the battles of Lexington, Concord, and Bunker Hill, the French general had returned to receive the accolades of grateful United States citizens. In city after city, he led parades and cornerstone-laying ceremonies for numerous public buildings and patriotic memorials such as the Bunker Hill Monument overlooking Boston Harbor (see p. 162).

Made of granite from a local quarry in Quincy, Massachusetts, the Bunker Hill obelisk was constructed as a patriotic synthesis of ancient wisdom and modern Yankee ingenuity. As in the Great Seal of the United States (see fig. 4.14), an Egyptian pyramidal form tapers upward toward a central point, drawing downward the enlightening rays of God's providential eye. At the same time, the monument was made possible by modern processes of industrialization. Solomon Willard (1783–1861), elected the monument's architect in 1825, operated the Quincy granite quarry as a modern, mechanized system of stone-cutting and handling that helped to revolutionize the building trades. The monument in turn inspired construction of the first railroad in the United States linking the granite quarries of Quincy with the commercial shipping wharves of Massachusetts Bay.

Stone construction could create a more monumental effect for public buildings than wood or red brick. Alexander Parris (1789-1852), who prepared the cornerstone for the Bunker Hill Monument, employed large blocks of Quincy granite for Boston's new Faneuil Hall Market, popularly known as Quincy Market, in the harbor district (fig. 5.5). The market's central building was designed with Greek-Revival facades at both ends of its long, rectangular plan. Extending beyond the facade, the market's main shopping arcade was defined by a granite skeleton of massive piers and lintels framing two stories of windows. The functional plan was divided by a central block capped by a low, circular dome. Two-story Doric columns support triangular pediments to create the image of a sanctified temple for commerce. Boston merchants habitually defined their investments and private interests in terms of civic virtue or the public good.

Ever since the eighteenth century, Americans had learned to associate the ancient Greek city-states with the origins of republican government and of Western civilization and the arts. The clarity, simplicity, and symmetry of classical Greek architecture symbolized those personal qualities of strength, wisdom, selfdiscipline, and eloquence regarded as necessary for citizens to govern themselves.

The fashion for Greek rather than Roman classicism was more immediately stimulated by the struggle of modern Greece for political independence from the Turks. The conflict, which lasted over a decade from 1821 until 1833, captured the European and American imaginations. While touring the United States in 1824–5, the Marquis de Lafayette repeatedly toasted contemporary Greek heroes as genuine descendants of ancient Spartan warriors and praised Greece itself as the birthplace of the arts and sciences.

By 1825, Boston was no longer a town where the wealthy and learned few could assume paternalistic leadership roles in town meetings at Faneuil Hall, the eighteenth-century building adjacent to Quincy Market. Serving a growing city of 50,000, Quincy Market was named for Boston's mayor, Josiah Quincy (1772–1864), who attained office by appealing to the "Middling Interest" (Cayton, pp. 143–167) of shopkeepers and artisans. The austere geometry of Quincy Market's spare Doric order, the oldest order of Greek temple architecture, spoke to middle-class Americans' taste for republican simplicity and rational order.

In 1824, Quincy sat for a portrait by the elderly Gilbert Stuart, who represented the energetic mayor next to a view of the proposed market (fig. 5.6). In his hands, Quincy holds a drawing for the plan and elevation of the new building. Like his uncle Samuel Quincy, who had commissioned portraits from the hand of John Singleton Copley (see fig. 3.26), Mayor Quincy was a Freemason, having joined St. John's Lodge of Boston in 1795. For Masons in particular, classical stone architecture expressed enlightened thought, refined taste, and high moral values. Complementing the geometric clarity of the market's design, Stuart painted a fluid, brilliantly illuminated portrait, with Quincy's ruddy face reflecting sunlight against a bright blue sky. Because the market would be constituted from Quincy granite, the building facade in the background also functioned as a highly personal emblem. In 1792, the nearby town of Quincy, Massachusetts, had been named after Josiah Quincy's wealthy and distinguished family. The mayor's ancestors had been among

5.5 AnonymousQuincy Market, Boston,
Massachusetts, 1825–6.
Engraving, $3\% \times 5\%$ in
(8.9 × 14.6 cm). Bostonian
Society/Old State House,
Boston, Massachusetts.

the early-seventeenth-century settlers of Massachusetts Bay Colony, and his father, also named Josiah Quincy (1744-75), had been a celebrated American patriot during the years leading up to the Revolutionary War. Seated next to a stone column dramatically entwined with a rose-colored drapery, Mayor Quincy is posed as a wise and strong pillar of city government, representing a family that helped build Massachusetts and the new nation.

The popularity of austere geometric forms for commercial enterprises, government offices, and private homes contributed to a modern, functionalist aesthetic in architecture. The sculptor Horatio Greenough (1805-52) became a leading spokesman for a national architecture, which taught that form should follow naturally from a building's function. Casting his argument in seafaring terms that practical American merchants could readily grasp, Greenough urged his readers in an 1843 journal article to:

5.6 Gilbert Stuart Portrait of Josiah Quincy, 1824. Oil on canvas, $36\% \times$ 28% in $(91.4 \times 71.1 \text{ cm})$. Museum of Fine Arts, Boston, Massachusetts. Gift of Miss Eliza Susan Quincy.

Observe a ship at sea! Mark the majestic form of her hull as she rushes through the water, observe the graceful bend of her body, the gentle transition from round to flat, the grasp of her keel, the leap of her bows, the symmetry and rich tracery of her spars and rigging, and those grand wind muscles, her sails. Behold an organization second only to that of an animal, obedient as the horse, swift as the stag, and bearing the burden of a thousand camels from pole to pole! What academy of design, what research of connoisseurship, what imitation of the Greeks produced this marvel of

> construction? Here is the result of the study of man upon the great deep, where Nature spake of the laws of building, not in the feather and in the flower, but in winds and waves, and he bent all his mind to hear and to obey. Could we carry into our civil architecture the responsibilities that weigh upon our shipbuilding, we should ere long have edifices as superior to the Parthenon, for the purposes that we require. . . . Instead of forcing the functions of every sort of building into one general form, adopting an outward shape for the sake of the eye or of association, without reference to the inner distribution, let us begin from the heart as the nucleus, and work outward. (cited in Greenough, pp. 60–62)

> Greenough conceived buildings in terms of nature rather than historical styles and associations. The study of Greek, Roman, or any other period architecture was valuable only insofar as it revealed the functional, organic principles of construction, which Greenough termed "the law of adaptation . . . the fundamental law of nature in all structure" (cited in Greenough, p. 58).

> Responding to the growing social needs of an urbanizing mass society, American architects were already developing a functional aesthetic during the 1820s and 1830s, even if building

5.7 John HavilandEastern Penitentiary,
Philadelphia,
1821–37. Engraving, $4\% \times 5\%$ in (10.5 × 15 cm). Historical Society
of Pennsylvania,
Philadelphia.

exteriors were ornamented with historical motifs. In Philadelphia, the architect John Haviland (1792–1852) designed the Eastern State Penitentiary in the guise of a medieval castle with octagonal turrets, battlemented towers, and massive black ashlar walls (fig. 5.7).

Haviland's castle-prison anticipated Greenough's organic principle that the architect should work outward from the heart or nucleus (fig. 5.8). Haviland devised

a radial plan stemming from a central rotunda or guards' tower conceived as a panoptic or all-seeing eye. Like spokes from the hub of a wheel, seven elongated blocks containing a series of eight-by-ten-foot cells radiated outward toward the prison walls. Under constant surveillance from the central watchtower, prisoners were expected to communicate only with their consciences, which were instructed by a Bible left in each isolated cell.

Creating an institution that entirely controlled the movements of all inmates through time and space, prison officials in Philadelphia, Boston, and other cities were in the vanguard, promoting a "moral architecture" (Rothman, p. 84) for modifying human behavior. During the early years of the republic, the Founding Fathers expressed concern that democratic federal and state governments would be unable to control the anarchic tendencies of a geographically dispersed mass society. The managerial aspiration to control the living environment through the fine and useful arts preoccupied American educators. According to the Philadelphia

5.8 John HavilandPlan, Eastern Penitentiary,
Philadelphia, 1821–37.
Historical Society of
Pennsylvania, Philadelphia.

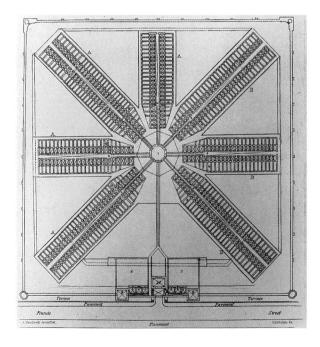

man of letters Benjamin Rush (1746–1813), education made it "possible to convert men into republican machines. This must be done," he said, "if we expect them to perform their parts properly, in the great machine of the government of the state" (cited in Cremin, p. 118).

Between 1825 and 1865, new technology forced the fine arts to compete with the mechanical or useful arts for public admiration. In struggling for professional recognition from practical-minded Americans, artists attempted, often vainly, to distinguish themselves from engineers, mechanics, and inventors, who magically transformed American life before the Civil War.

Economic Modernization and the Arts

By the autumn of 1825, national commemoration of the opening battles of the American Revolution gave way to the grand opening of the Erie Canal, which marked a revolution in transportation and facilitated new settlements in the West. Public discourse shifted from retrospection over the revolutionary Founding Fathers to prophecies of the nation's future westward expansion.

In Albany, New York, on the cold and blustery morning of November 2, 1825, a flotilla of boats arrived at the last lock of the newly completed Erie Canal. A week earlier, the flotilla had departed from Buffalo, New York, on Lake Erie, the canal's western point of origin. Throughout the inaugural procession of canal boats, cities and towns celebrated with parades, speeches, and festive street decorations. In Albany, Governor DeWitt Clinton, the canal's principal advocate, was among the thousands of spectators who witnessed a Masonic ceremony marking the completion of a commemorative canal

monument. Afterward, the boats glided through the last canal lock and into the Hudson River. Two days later, on November 4, the journey ended in New York City with a climactic street parade to greet the flotilla. Every tradesmen's association marched together next to gigantic floats

decorated with emblematic murals and symbols.

Demonstrating the public's keen familiarity with the visual language of classical antiquity, boys attending the Printers' Society float wore the winged costume of Mercury, Roman god of transportation, commerce, and the arts and sciences.

During the Erie Canal celebration, New York City merchants presented Governor Clinton with a large silver vase honoring his central role in the building of the canal (fig. 5.9).

An American eagle sits on a globe at the top of the vase, while female personifications of Fame and History flank a view of the aqueduct at Cohoes Falls, meeting point of the newly tamed Mohawk and Hudson rivers. On the back, an American Indian, personifying the wilderness, joins a figure of Plenty to suggest the transformation of nature into a cornucopia of commodities for urban markets. Next to the beehive of Industry, Mercury teaches the flute to a figure at the base of the presentation vase. God of both commerce and the arts, Mercury personified the cultural benefits of transport and communications technology. Designed by the Philadelphia silversmiths Thomas Fletcher (1787-1866) and Sidney Gardiner (1785-1827), the vase

5.9 Thomas Fletcher and

DeWitt Clinton presentation 20½ in (60.4 \times 52 cm). Metropolitan Museum of Art, New York. Gift of the Erving and Joyce Wolf Foundation,

1988

Sidney Gardiner vase, c. 1825. Silver, $23\frac{3}{4}$ \times

was displayed in the great hall of New York City's Chamber of Commerce by merchants grateful for the governor's development of state resources.

In Philadelphia, William Rush (1756–1833), one of the founders of the Pennsylvania Academy of Fine Arts, also celebrated the harnessing of water power. Rush carved two sculptures from Spanish cedar for the Fairmount Waterworks in 1825. He painted both of them white to simulate marble or stone. *The Schuylkill Enchained* (fig. 5.10) represents a bearded river god, who is chained to his bed of rocks by the uncontrolled rapids of the Schuylkill River. *The Schuylkill Freed* represents a seated woman, dressed in classical clothing, who personifies the waterworks, or the taming of the river, through modern technology (fig. 5.11). She serenely tends a waterwheel and conduit that allow the water to run "freely" for human needs. Behind her, the water flows into a classical urn symbolizing the Fairmount reservoir. Rush's sculptures expressed the entrepreneurial conviction that nature must not lie dormant or undeveloped. Only through civilization may Mother Nature realize her true potential. For urban developers and advocates of cultural refinement, she was freest when she served humanity, God's highest form of being in the visible hierarchy of creation.

Industrialization and a growing national transportation network of canals and railroads forced formerly self-sufficient yeoman farmers into growing cash crops for

5.10 William Rush

The Schuylkill Enchained, 1825. White-painted Spanish cedar, $39\% \times 87\% \times 26\%$ in. ($100 \times 221.6 \times 67$ cm). Philadelphia Museum of Art, Philadelphia. Commissioners of Fairmount Park, Philadelphia.

The pained expression and uncomfortable pose of the aged male figure suggests the ancient Schuylkill River's unproductive, wild character. By contrast, the old man is accompanied by a vibrant American eagle. Undoubtedly inspired by the imagery of the Great Seal of the United States (see fig. 4.14), the eagle, with outspread wings, promises national progress and the river's liberation from uncontrolled nature.

5.11 William Rush

The Schuylkill Freed, 1825. White-painted Spanish cedar, $39\% \times 87\% \times 26\%$ in. (100 \times 221.6 \times 67 cm). Philadelphia Museum of Art, Philadelphia. Commissioners of Fairmount Park, Philadelphia.

The woman's youth and grace suggest that the Schuylkill River has been channeled and elevated into a higher plane of being. Striking a relaxed pose, the figure's horizontally extended arm seems in turn to mirror and calm the river below. Her hand appears to bless the waterwheel. Like a cornucopia of plenty, the diagonally tilted water main behind her promises a bountiful supply of water for productive human purposes.

sale in distant markets. Unlucky farmers who became indebted to city bankers often failed to survive the volatility of the market. Many entered factories or workshops as wage laborers, while others decided to move further west, where land was cheaper and more plentiful. In New England, Boston industrialists purposely chose rural sites for textile factories, better enabling them to recruit the daughters of financially strapped farm families to operate mill machinery.

Thomas Doughty (1793–1856), one of the earliest artists to specialize in landscape painting, depicted the new mill town of Lowell, Massachusetts, as a quiet, pastoral utopia of factory buildings and obelisk-like smokestacks surrounded by trees and placid waterways (fig. 5.12). With factory labor well hidden from view, the standing boatman in the foreground seems reminiscent of a gondolier navigating a Venetian canal. Seeking to create industrial communities that evaded Britain's history of labor strife and overcrowded manufacturing cities, Boston capitalists financed company towns that amazed British and European tourists. Compared with Britain's polluted industrial cities, pastoral Lowell during the 1820s and 1830s appeared to be a workers' paradise brightly lit by what one tourist described as sootfree "Italian skies" (cited in Josephson, p. 183). Most astonishing for European eyes, young women operated the textile mill machinery. Boston industrialists assumed that unmarried daughters of New England farmers constituted a more manageable and cheaper labor force than male workers. Nevertheless, young women took advantage of factory work to free themselves from the restrictions of family life. In 1848, the year that the first women's rights convention was held in Seneca Falls, New York, the Vermont-born mill operative Margaret Foley (c.1827–77) left Lowell's

5.12 Thomas Doughty Mill Pond and Mills, Lowell, Massachusetts, c. 1833. Oil on canvas, 26 imes 35½ in (66 imes90.2 cm). Harvard Business School, Cambridge, Massachusetts.

Doughty's atmospheric view of this early factory town's terrain contains no suggestion of industrially polluted air or water. The water's mirrorlike reflections of trees and buildings reinforce the impression of order and balance between man and nature.

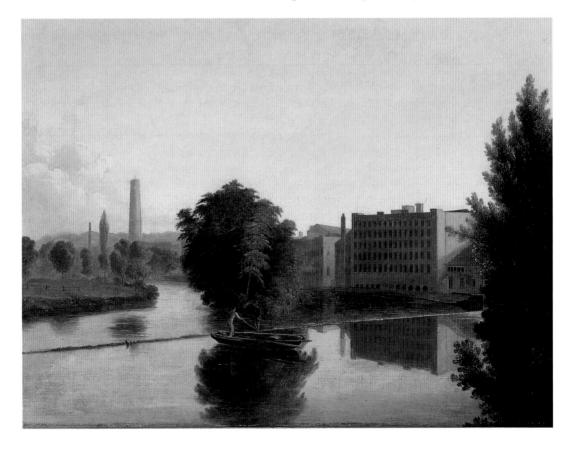

textile factories for Boston and a career as a sculptor. Yet she maintained contact with the Lowell community and received a portrait commission from a local Lowell hospital. Moving to Rome in 1860, Foley joined other American women artists in producing neoclassical marble sculptures. Foley's austere portrait bust Cleopatra represents the ancient, Greek-born queen of Egypt (fig. 5.13). Exhibited in Philadelphia at the 1876 centennial celebration of American independence, Cleopatra metaphorically expressed the former Lowell operative's assertion of feminine power and independence. Foley's career path suggests that the northeast's capitalist economy was generating a more mobile labor force and new professional opportunities in its major cities. While women artists faced major social obstacles in their careers, we shall see that Foley's success was not an isolated phenomenon.

Complicating New England manufacturers' search for an adequate labor force, the Erie Canal lured restless New England farm families to western New York and the Great Lakes, where land was cheaper, more abundant, and more productive. However, farmers were also lured by supernatural tales and folk legends to search for buried treasure in the territory opened up

by the canal. In 1831 a Palmyra, New York, newspaper reported that "moneydigging" had become a "mania" (cited in Taylor, pp. 8–9). The following year, John Quidor (1801-81), a New York painter who specialized in scenes of Hudson River folk legends, produced a Gothic-comic picture entitled Money Diggers (fig. 5.15). Basing the painting upon a short story by the New York author Washington Irving (1783–1859), Quidor represents a nocturnal hunt in Long Island for a pirate's buried treasure. The hunt has been comically interrupted by the pirate's ghost in the upperright corner, frightening the three money diggers. At the upper rim of the picture's central black hole, a divining rod and a book of magical incantations have fallen to the ground. While Quidor caricatures the figures for maximum comic effect, his painterly representation of moonlit earth, rocks, and trees suggests a shared belief in the animistic, spiritual powers hidden within Nature. Economically marginal farmers who failed to adapt to the modernization of agriculture were especially prone to seek quick fixes for their mortgaged farms. Treasure hunting was a byproduct of the economic booms and busts that jarred traditional folk ways and farming methods, especially in western New York and northern New England.

From a very early age, John Quidor would have been attuned to myths and folk legends of buried treasure, since he had spent his early boyhood living on a farm in western New York. After a fire destroyed his studio in Canal Street in 1835, Quidor moved to Adams County in western Illinois, where he farmed and continued to paint fantastic pictures of the occult and supernatural. Quidor's failure as an Illinois farmer led him in 1850 to return to his marginally successful painting career in New York City. However, in 1863, while living on West 43rd Street, Quidor was listed as a farmer in the city directory. Like other New York City residents, he periodically moved further and further away from the congestion and noise of Lower Manhattan in search of suburban or semirural spaces uptown. Quidor's paintings of

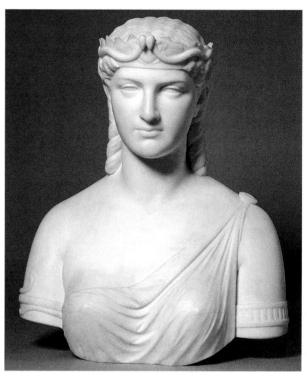

5.13 Margaret Foley Cleopatra, 1876. Marble, 23¾ in (60.3 cm) high, 19¾ in (49.8 cm) wide, 11¾ in (30.2 cm) deep. National Museum of American Art, Washington, p.c.

rural folk tales and his continued professional identification with agriculture suggest strong cultural and social resistance to economic modernization in antebellum America. Almost twenty-five years after his 1832 version of Money Diggers, Quidor painted a second, larger picture of the subject with even more mysterious, irrational light effects.

Rochester, New York, as a Boom Town

In western New York, the city of Rochester vividly exemplified the new market economy's ability to generate commercial and industrial wealth during the "canal boom" of the 1820s. Rochester capitalists purchased wheat from the rich farms of the Genesee River valley and grew wealthy by operating flour mills that processed wheat for export to New York City, the nation's largest metropolis and commercial banking center. Within a decade or so, Rochester's population had ballooned from a few hundred to over 20,000. During the late 1820s, the painter and future art historian William Dunlap (1766–1839), a student of Benjamin West, exhibited largescale religious pictures in cities along the Hudson River and Erie Canal. In his diary, and later in his two-volume A History of the Rise and Progress of the Arts of Design in the United States (1834), Dunlap claimed that other cities within this freshly tamed wilderness "sink into insignificance in comparison with Rochester.... In 1815 it was unknown: now the canal, bridges, court house, hotels, all upon a great scale, excite my astonishment anew at the wonders of the west" (I, p. 299).

Expressing their new social status, Rochester's merchant-industrial elite patronized the arts, choosing historical-revival designs for both public buildings and their own private residences. Benjamin Campbell, a Rochester flour-mill owner, ordered his mansion constructed in the guise of a Greek temple (fig. 5.14). In western New York, where there were few professional architects, pattern or design books provided masons and carpenters with engraved illustrations of floor plans, elevations, and decorative ornaments. Campbell's home was modeled from a design book published by a carpenter and self-trained architect from upstate New York, Minard Lafever (1798-1854).

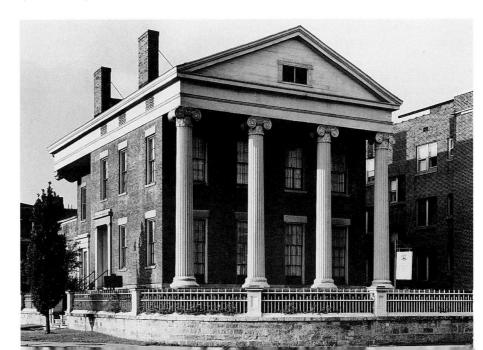

5.14 Campbell-Whittlesey House Rochester, New York,

1835-36. The Landmark Society of Western New York.

5.15 John Quidor *Money Diggers*, 1832. Oil on canvas, $16\% \times 21\%$ in $(42.2 \times 54.6$ cm). Brooklyn Museum of Art, New York. Gift of Mr. and Mrs. Alastair Bradley Martin.

The figure awkwardly climbing out of the black hole is an African American, Black Fisherman Sam.

African Americans were stereotypically identified with fish, reptiles, and other dark creatures of the underworld (see fig. 4.26). Significantly, a frog or toad has perched itself prominently in the immediate foreground, at the opposite edge of the hole, and directs its gaze toward Black Fisherman Sam.

Greek-Revival Architecture and the Southern Plantation Economy

For nearly three decades from 1829 to 1855, multiple editions of Lafever's pattern books helped to popularize local variations upon the Greek-Revival style throughout the Northeast; westward into the Great Lakes territories of Ohio, Michigan, and Wisconsin; and southward to the Gulf Coast states of Mississippi and Alabama. During the 1820s and 1830s, Greek-Revival architecture attained national popularity. The ancient classical style symbolized republican values of moral rectitude and self-discipline and alluded to the origins of democracy in the Greek city-states. In Demopolis, Alabama, a town named to honor the democratic principles of the Greek city-state, a slave owner, planter, and amateur architect, Nathan Bryan Whitfield, borrowed ideas from Lafever's pattern books to construct a Greek-Revival mansion for Gaineswood, his cotton plantation (fig. 5.16). With a multiroom, irreg-

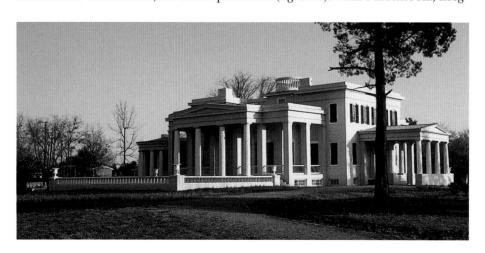

5.16 GaineswoodDemopolis, Alabama,
1843–59. Courtesy Alabama
Historical Commission.

ular floor plan and many-columned porticoes on every side, Whitfield's plantation house dwarfs Benjamin Campbell's smaller and far simpler Rochester home. Southern plantation owners growing wealthy through the exportation of cotton, tobacco, and other cash crops cultivated aristocratic lifestyles that emulated the English and European nobility. Since the Greek city-states also had depended upon slave labor, white Southerners could argue that their plantation slaves possessed no rights to the political inheritance of Greek democracy. Nevertheless, African Americans worked as skilled craftsmen in the building and decoration of Greek-Revival plantation houses. At Gaineswood, most of the interior ornamental plasterwork was executed by an African-American slave named Sandy.

In the South, art and architecture increasingly represented sectional pride in opposition to the economic, political, and cultural dominance of the North. Stylistically, public and domestic architecture differed little between North and South. However, as the art historian Jessie Poesch has observed, grand, whitepillared mansions, located both in towns and on virtually self-sufficient country plantations, came to symbolize the leisurely, aristocratic lifestyle and power of wealthy slave owners. Greek-Revival and other revival-style mansions prominently decorated rivers and roads in the deep South, casting into cultural shadow the far more modest homes of the majority of white Southerners who owned no or few slaves. In 1850, there were 8,000 landowners who possessed fifty or more slaves, and this socioeconomic elite set the South's sectionalist political agenda. Rejecting the sanctity of American nationalism in favor of every individual state's right to nullify objectionable federal laws and to secede from the Union, Southerners admired the decentralized nature of Greek democracy: the fierce independence of Athens, Sparta, and other city-states.

Northern industrial superiority over the agricultural South translated into the North's cultural dominance. Southern plantation owners had less liquid capital than Northern capitalists. Except for the border cities of Baltimore and Washington, D.C., the nation's capital, southeastern cities offered few opportunities for painters and sculptors beyond the limited market for portraiture. In the decades leading to the Civil War, the city of Charleston, South Carolina, which had been a vital seaport before 1812, declined in economic power and failed to support the visual arts. In 1848, a writer for the Southern Literary Gazette complained "that we not only derived our Paintings and Statuary from the North and from Europe, but even form our conceptions of excellence in these departments by the standard of others" (cited in L. Miller, pp. 229-230).

Architecture and Suburban Space

New canals, railroads, and roads gave more farms, villages, and towns access to commercial metropolitan hubs. The growing transportation network caused artists and architects in New York, Boston, and Philadelphia to envision a burgeoning national market for their work that extended to new western cities such as Cincinnati, Pittsburgh, Detroit, New Orleans, and St. Louis. However, cultural critics were concerned that national mobility and social restlessness adversely affected the stability of American home life. The New England landscape architect Andrew Jackson Downing (1815–52) published several design books which sought to foster Americans' "love of home." He asserted in The Architecture of Country Houses (1850) that the home was a "powerful means of civilization," for "so long as men are forced

to dwell in log huts and follow a hunter's life, we must not be surprised by lynch law and the use of the bowie knife. But, when smiling lawns and tasteful cottages begin to embellish a country, we know that order and culture are established" (cited in Schuyler, p. 135).

Downing's treatises on landscape gardening, country cottages, and villas spoke to middle- and upper-class families, who moved outward from urban centers to the greener periphery of a suburban environment. Improved transportation facilitated the creation of suburbs. Outside of Boston, during the 1830s and 1840s, wealthy inhabitants of Cambridgeport and the old village of Cambridge pioneered the American tradition of commuting between private, suburban residences and urban places of business. Meanwhile, with the New York City metropolitan area's population surpassing 1 million by 1860, affluent families moved further northward beyond the older areas of downtown Manhattan and westward across the Hudson River to new communities in New Jersey.

The New York architect Alexander Jackson Davis (1803–92) supplied many of the house designs that illustrated Downing's popular pattern books. Davis's Gothic-Revival cottage for the landscape painter Edward W. Nicholls typifies the models illustrated in Downing's books and copied with variations by builders throughout the nation (fig. 5.17). Located in the suburban community of Llewellyn Park, Orange, New Jersey, within commuting distance from New York City, the spacious English Gothic cottage, with steeply pitched roofs and gables, arched lancet windows, and ornamented porches, strongly contrasts with the geometric regularity and simplicity of Greek-Revival homes. The picturesque irregularity of Davis's cottage suggests a living organism in harmony with the varied nature of the surrounding lawn and gardens. Llewellyn Haskell, a chemical manufacturer and real-estate developer, financed Llewellyn Park (fig. 5.18) as a picturesque escape

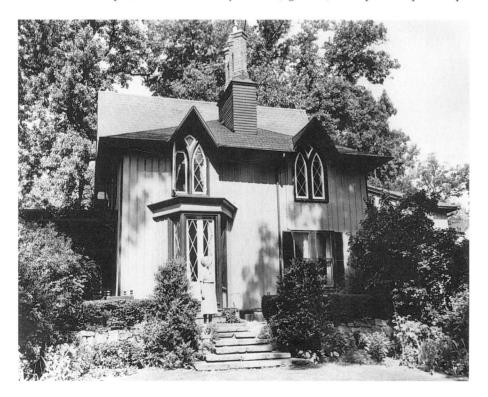

5.17 Alexander Jackson Davis

Edward W. Nicholls House, Llewellyn Park, Orange, New Jersey, 1858–59. Courtesy Newark Public Library, Newark, New Jersey.

Instead of horizontal clapboards, vertical board and batten siding contributes to the building's ornamental mixture of aspiring Gothic forms. The roof's three clustered chimney pots are elongated for decorative effect, while the narrow, pointed lancet windows featuring diamond-shaped panes echo the look of Gothic-style parish churches.

5.18 Plan of **Liewellyn Park** Orange, New Jersey, 1852-69. New Jersey Historical Society.

from New York City's congested streets. The planned community consisted of a fifty-acre central park called the Ramble and about fifty houses situated within unfenced, spacious lots connected by winding streets. According to the real-estate prospectus, the communally owned Ramble allowed a "family occupying a small place in the country, costing only a few thousand dollars, to enjoy all the advantages of an extensive country seat, without the expense or trouble attending the latter" (cited in Schuyler, p. 209). Davis designed all of the original buildings for Llewellyn Park, including his own home and various rustic buildings for the park such as a gatehouse that seems to mushroom naturally from within the shaded garden environment (fig. 5.19).

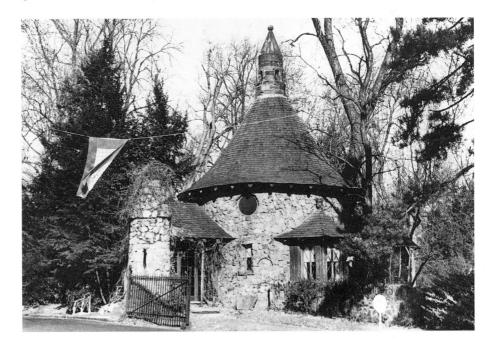

5.19 Alexander Jackson **Davis** Gatehouse, Llewellyn Park, Orange, New Jersey, 1853. Courtesy Newark Public Library, Newark, New Jersey.

Phrenology and the Octagon

The conception of a building as a living natural organism, advocated by Horatio Greenough and other writers, also undergirded the popularity of the octagon as an architectural form during the 1850s. With expansion westward and the suburbanization of the American landscape, octagonal buildings appeared to address the ecological problem of the growing scarcity of trees and lumber for constructing wooden houses. Advocates of the octagon argued that it was a particularly suitable building type for the new era of urban and suburban growth because it lent itself to inexpensive gravel and cement construction.

Taking advantage of public thirst for advice books on designing new homes, the American phrenologist Orson S. Fowler (1809–87) published *The Octagon House: A Home for All*, which went through new editions every year between 1848 and 1857. Phrenology measured the shape and size of the human skull, mapping its protuberances as a means for deciphering personality traits and intelligence (fig. 5.20). Many American artists were drawn to phrenological theory and practice so that they could produce more "objective," accurate renderings of both the external appearance and internal character of the human figure. John Quidor attempted to establish a phrenological society in Columbus, Illinois. Working in Washington, D.C., during the mid-1830s, the Vermont-born sculptor Hiram Powers (1805–73) created portrait busts of American statesmen based on phrenological principles. His sculpture of Daniel

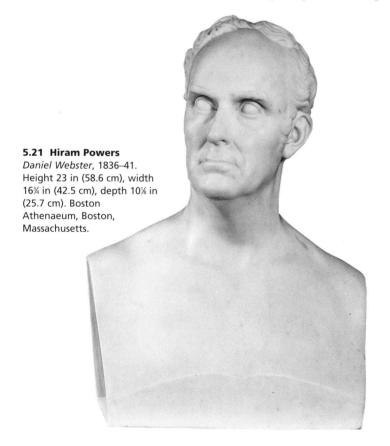

5.20 Asa AmesPhrenological Head, 1847–50.

Polychromed pine. Museum of American Folk Art, New York, New York. Bequest of Jeanette Virgin.

The woodcarver painted the skull of this girl with a multicolored pattern of forms to demonstrate how different parts of the brain are governed by particular mental qualities and character traits. Ames marked each of the colored areas with identifying inscriptions, including (among other human tendencies) conscientiousness, caution, and secretiveness.

Webster accentuated the Massachusetts senator's massive forehead (fig. 5.21). For Powers, the fiery orator's sizable cranium signified Webster's genius and superior intellectual faculties.

Hoping to reform American society by encouraging the proper exercise and development of the brain, Fowler saw architecture as a moral science that could stimulate desirable brain "organs" and character traits. Though Fowler had no previous experience as an architect, he insisted that "Phrenology points out an organ of Inhabitiveness, or love of Home, as well as of Constructiveness, so that building cheap houses, and telling the Poor—for it also points out an organ of Benevolence how to build themselves cheap and good houses, comes properly within its sphere" (p. 86).

Fowler criticized confining, boxlike houses in favor of a freer, more spacious octagon plan suitable for suburban villas and cottages. He praised the nearspherical form of the octagon as being closer to nature's "fruits, eggs, tubers, nuts, grains, seeds, trees, etc." (p. 82). Fowler associated the circular nature of the octagon with the social values of family harmony, friendship, and sociability:

The nearer we can approach the *circular* form the better. To gather around a spherical or elliptical table, occasions more harmony and agreeable sensations than around a square one. To have a truly agreeable chit-chat, we require to form into a circle. Why our universal use of "the family circle," "circle around the fireside," and the like, but that this circular arrangement of the parties facilitates that magnetic flux and reflux of emotion which creates these delights? As in magnetic and electrical experiments we must complete a circle, so, that several minds may act in concert, it is requisite that they form around and face a common center. (p. 151)

Benefiting from the fame he enjoyed as a leading phrenologist, Fowler's architectural advice created a national building craze for the octagonal form, from Watertown, Wisconsin, in the North (fig. 5.22) to Natchez, Mississippi, in the South

5.22 John Richards Watertown, Wisconsin, 1854-56. Watertown Historical Society, Watertown, Wisconsin.

When first built by John Richards, this octagon was claimed as the largest singlefamily home in the state of Wisconsin. At the center of the interior, a cantilevered, spiral staircase leads to a small, balustraded lookout over the roof. The substantial brick building is generously illuminated on its two main stories with tall, shuttered windows, thereby contributing to the octagonal ideal of airy openness.

(fig. 5.23). Designed by the Philadelphia architect Samuel Sloan (1815–84), the "Longwood" octagon at Natchez rose three stories before being capped by a central tower and an oriental, onion-style dome. Fowler's own octagonal home in Fishkill, New York, also helped to popularize an inexpensive concrete mixture of gravel, broken slate, sand, and lime for supporting walls. Thanks to Fowler's advocacy, concrete soon became an important modern material, especially for building foundations.

5.23 Samuel Sloan
Longwood, Natchez,
Mississippi, begun 1860.
Historic New Orleans
Collection, New Orleans,
Louisiana. Kemper and Leila
Williams Foundation.

The Rural Cemetery Movement and the Arts

The suburban search for green space transformed the American way of death as well as life. Beginning in 1825, a small group of wealthy Bostonians explored the practicality of establishing a major cemetery outside city limits. They had concluded that the old city graveyards next to churches were seriously overcrowded and ill-suited for properly respectful monuments to the dead. By 1831, under the auspices of the Massachusetts Horticultural Society, Bostonians finally established Mount Auburn Cemetery in Cambridge as burial grounds that doubled as a park with gardens and romantic, pastoral walking trails (fig. 5.24). Dr. Jacob Bigelow, a Harvard medical school professor and primary founder of Mount Auburn, designed the Egyptian-Revival gateway (fig. 5.25). The ancient Egyptians were regarded as experts in the funerary arts and in the building of monumental architecture for the dead.

Attracted by Mount Auburn's spacious, parklike atmosphere, upper-class families eagerly purchased burial plots where they could erect ennobling sculptures and monuments for deceased loved ones. Many of the earliest memorials were small-scale replicas of the Bunker Hill obelisk. Ultimately, however, Mount Auburn and

5.24 Thomas Chambers Mount Auburn Cemetery, c. 1850. Oil on canvas, $14 \times 18\%$ in (35.6 × 46 cm). National Gallery of Art, Washington, D.C. Gift of Edgar William and Bernice Chrysler Garbisch.

Thomas Chambers (1808-after 1866), an Englishborn painter, copied this scene of Mount Auburn from a published engraving. Similar in shape to a figure eight, the pond at the center of the picture establishes the serpentine character of the walking paths that wind around the cemetery's hilly, verdant grounds.

5.25 Jacob Bigelow Gateway, Mount Auburn Cemetery, 1831. Cambridge, Massachusetts. Courtesy Mount Auburn Cemetery.

other rural cemeteries in New York, Philadelphia, and elsewhere helped create a new market for marble sculptures. For a grave in Greenmount Cemetery in Baltimore, the Maryland sculptor William Henry Rinehart (1825-74) commemorated the deaths of two children born to Hugh and Sarah Sisson (fig. 5.26). Like Crawford, Rinehart also worked in Rome, where he made at least twenty-five replicas of Sleeping Children for other bereaved clients. The recumbent, pure-white sculpture portrays death as a deep, restful sleep. Partially covered by a shroud-blanket, the pudgy, Cupid-like infants rest comfortably upon pillows and a mattress, enabling

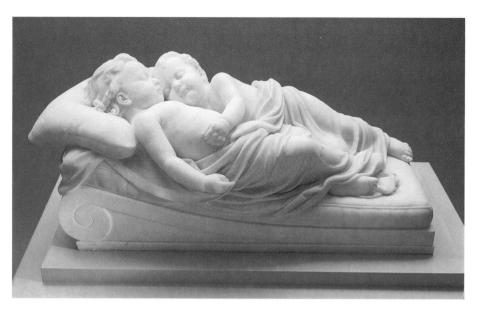

grieving parents to imagine their imminent reawakening. Rural cemeteries became tourist sites and virtual galleries of art and architecture, attracting painters and later, photographers, who recorded the more impressive memorials and landscape views (fig. 5.27). Mount Auburn and other idyllic cemeteries became suburban escapes from the cares and woes of contemporary urban life. Within their shaded spaces, mourners and visitors learned to appreciate the beauty of art as a means of spiritual communication.

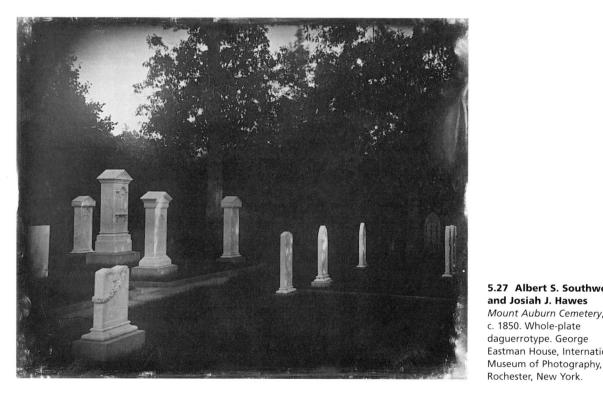

5.26 William Henry Rinehart

Sleeping Children, 1869. Marble. National Museum of American Art, Washington, D.C.

As was customary for American sculptors working in Rome and Florence. Rinehart conceived the design of the marble group, but the actual cutting and polishing of the stone was carried out by hired Italian craftsmen. The sleeping figures are reminiscent of amors, winged children that decorated ancient Roman funerary sculptures. Amors symbolized the soul's transcendence of earthly desire.

5.27 Albert S. Southworth and Josiah J. Hawes Mount Auburn Cemetery, c. 1850. Whole-plate daguerrotype. George Eastman House, International

The National Academy of Design and the Art Market

5.28 Richard Caton Woodville

War News from Mexico, 1848. Oil on canvas, $27 \times 24\%$ in (68.6 \times 62.9 cm). National Gallery of Art, Washington, D.C. Loan, Manoogian foundation, New York.

Below the small post office sign affixed to the wooden post to the left, a small printed broadside, or leaflet, summons volunteers for the war against Mexico. The picture's explosive news is barely contained by the rickety but classically designed porch that already suggests American expansion into cruder, less settled western territories. The pyramidal arrangement of figures is repeated by the rustic wooden pediment decorated with the hotel sign and its American eagle.

Thanks to western development and the wealth generated by the transportation revolution, New York City became the nation's financial capital and most lucrative art market. In 1825, New York artists capitalized upon public euphoria over the Erie Canal and the fiftieth anniversary of the American Revolution to found the National Academy of Design, the nation's only art academy managed exclusively by and for artists. Over two decades earlier, in 1802, the American Academy of the Fine Arts had been founded in New York by wealthy art patrons whose private tastes and collections tended toward the European Old Masters more than contemporary American art. The American Academy's aristocratic indifference to the professional needs of American artists motivated the founders of the National Academy of Design, who established an artistic brotherhood devoted to the instruction of young artists and the exhibition of original works by living American artists. The academy's "Antique School" taught "the universal language" of the human body. Students learned to copy expressive gestures and figural poses from plaster casts of famous ancient sculptures.

With the growth of illustrated periodicals and the rise of the penny press, artacademy exhibitions generated an unprecedented level of publicity for American artists. The encouraging words of sympathetic editors and critics soon reached a mass audience. By the 1840s, a publishing industry dominated by a corporate, market-oriented elite had displaced local aristocrats or community leaders as the primary molders of public opinion. American genre painters such as the Baltimore native Richard Caton Woodville (1825–55) often represented newspapers as

American artists recognized the expanding art market as a function of the socio-economic expansion westward. After his biblical paintings had toured the boomtowns along the Erie Canal and Great Lakes, William Dunlap, the oldest founding member of the National Academy, insisted in his history of American art that in

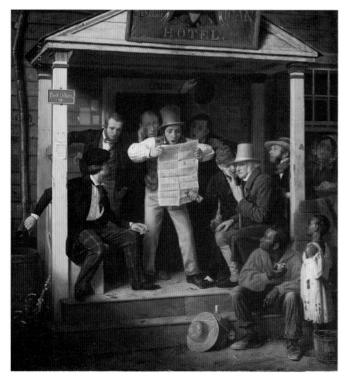

The laws are here the only protectors. Industry, virtue, and talents, the only patrons. The ignorant, the afflicted, the weak, the unfortunate may want aid, instruction, protection, from the strong, and the rich, and the wise; but the artist—the man who possesses the genius, skill, and knowledge which entitles him to that name—will look to be honoured and esteemed by his fellow-citizens; not seeking protection, from them; or acknowledging superiority, except in superior worth.

... The artist who feels the necessity of patronage, must do one of two things—abandon his high and responsible character, bow to the golden calf that he may partake of the bread and wine set before the idol, or abandon his profession—grasp the axe and the plough, instead of the crayon and pencil. The agriculturist, the mechanic, the sailor, the cartman, the sawyer, the chimney-sweeper, need no protectors. When they are wanted they are sought for—so should it be with the artist; at least let him be as independent as the last. (I, pp. 16–17)

Dunlap embraced capitalist laws of supply and demand as a liberation from personal servility to rich connoisseurs. Rejecting their protection as a sign of weakness, he optimistically assumed that industry, virtue, and talent would guarantee artists sufficient buyers for their labor. Yet Dunlap was not naively unaware that market demand often went flat, even for the best of artists. He therefore granted them an escape clause denied to mechanics and chimney-sweeps: "the man who is blessed with taste and benevolence, and with riches to gratify both, cheerfully assists struggling genius through the impediments poverty throws in his way, and enjoys in conscious rectitude the reward which the good deed assuredly brings, but he never boasts or assumes the title of patron" (II, p. 109).

Claiming the mantle of genius, American artists sought to displace wealthy collectors as the arbiters of taste without challenging the social hierarchies of class, race, and gender. Together, professional artists and their philanthropic benefactors intended to educate the untutored masses in the morally edifying principles of high art. However, American artists often found themselves railing vainly against newspapers and magazines that pandered to the low-brow tastes of consumers who preferred more sensational entertainments to the morally refining atmosphere of art exhibitions. In his The Anatomy of Art Appreciation, 'The Vanity of the Artist's Dream,' the Washington, D.C., painter Charles Bird King (1785–1862) represented the forlorn head of the Apollo Belvedere crammed into a cupboard filled with tattered books, stale bread, and other signs of an artist's failed ambitions (fig. 5.29). While the pioneering still-life paintings of Raphaelle Peale (1774-1825) expressed the enlightened moral values of restraint, simplicity, and order (fig. 5.30), King's confused jumble of objects purposely expressed the emotionally distraught state of an impoverished artist. Illusionistically tacked to the cupboard's

5.29 Charles Bird King
The Anatomy of Art
Appreciation, 'The Vanity of
the Artist's Dream,' 1830.
Oil on canvas, 35 × 29½ in
(89.2 × 74.9 cm). Fogg Art
Museum, Harvard University,
Cambridge, Massachusetts.
Gift of Grenville L. Winthrop.

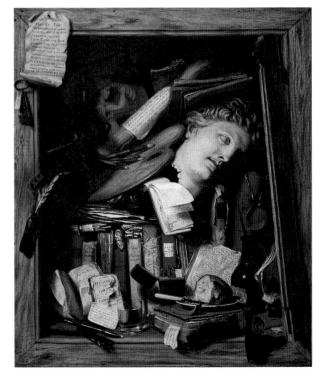

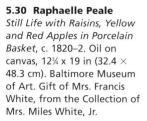

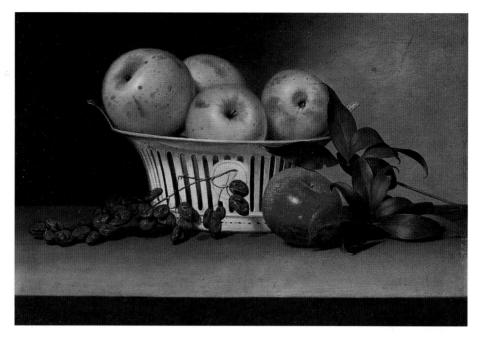

wooden frame, the foreclosure announcement of a "Sheriff's Sale" lists the artist's few assets for auction and payment of debts. Though King himself was a relatively affluent artist, he was a friend of Washington Allston (see Chapter 4) and other artists who repeatedly complained of indebtedness.

Catholic Icons and Hispanic Resistance to U.S. Culture

Samuel F. B. Morse, the first president of the National Academy of Design, became one of the nation's leading missionaries for the moral value of high art, which he contrasted with vulgar, lower-class entertainments and with the rituals and idolatrous imagery of the Catholic Church. When he toured Italy in 1830 and visited Milan Cathedral, he condemned its paintings and sculpture for creating a theatrical effect as a substitute for God's Word:

I am sometimes even constrained to doubt the lawfulness of my own art when I perceive its prostitution, were I not fully persuaded that the art itself, when used for its legitimate purposes, is one of the greatest correctors of grossness and promoters of refinement. I have been led, since I have been in Italy, to think much of the propriety of introducing pictures into churches in aid of devotion. I have certainly every inducement to decide in favor of the practice did I consult alone the seeming interest of art. That pictures may and do have the effect upon some rightly to raise the affections, I have no doubt, and, abstractly considered, the practice would not merely be harmless but useful; but, knowing that man is led astray by his imagination more than by any other of his other faculties, I consider it so dangerous to his best interests that I had rather sacrifice the interests of the arts, if there is any collision, than run the risk of endangering those compared with which all others are not for a moment to be considered. (cited in Mabee, pp. 131–132)

More than the educated elite, the lower classes were deemed especially vulnerable to the enchantments of visual images. Back in America, Morse associated Catholic veneration of cult images and relics with illiterate foreign immigrants from Ireland and southern Europe, whose dependence upon an autocratic priesthood and loyalty to the Roman papacy seemed to threaten America's republican institutions.

After 1846, when the United States began to occupy the territories of California and New Mexico, Anglo-American Protestant culture clashed with the indigenous Hispanic Catholic population. Led by the Brotherhood of Our Father Jesus Nazarene, a Catholic lay fraternity, Hispanic artists resisted assimilation into U.S. culture. They continued to produce *santos*, or religious icons that concentrated upon the poignant suffering and crucifixion of Christ and offered comforting images of the Virgin Mary.

In the Santa Cruz Valley of New Mexico, José Rafael Aragón (c.1795–1862) decorated numerous mountain village chapels and churches with colorful wooden sculptures and *retablos*, or panel paintings. Aragón's charming, brightly painted picture of *The Flight into Egypt* (fig. 5.31) focuses on the maternal figure of the Virgin Mary, who cradles a sleeping baby Jesus in her arms while she rides upon a donkey being led by a guardian angel. According to the Bible (Matthew 2:13–14), an angel of God had appeared to Joseph, Mary's husband, to warn the holy family that the jealous King Herod was seeking to destroy the newborn child, fearing he would become King of the Jews. In Aragón's symmetrically balanced picture, Joseph appears on the left, deferentially walking behind the Virgin and Christ child, and he protectively raises his hand toward Mary's back.

In this cartoonlike, spatially flattened image, the artist appears less concerned with the literal details of the biblical narrative than with the visionary splendor of the holy figures and accompanying decorative elements. Red polka-dot curtains with blue and red fringe and red tassels frame the painting's upper register, while plumes of vivid blue and red fill a crest at the top of the picture frame. The red-and-blue color harmony continues in the costume of the Virgin Mary, who appears crowned as the Queen of Heaven despite her ride upon a humble donkey. Immediately above Mary's crown and halo, or spiritual light rays, the descending dove of the Holy Ghost signifies the supernatural character of Mary as the mother of Jesus Christ, the Son of God. In the lower register of the painting, a lush garden implicitly prophesies the heavenly paradisiacal future awaiting faithful believers in Christ's divinity. Colorfully painted santos were devotional objects that visually bridged the moral and spiritual distance between heaven and earth. Worshipers often attributed miraculous powers to such sacred imagery, believing that it manifested the presence of the holy person being portrayed. By contrast, Protestant, Anglo-American settlers generally ridiculed these crude-appearing images as relics of superstition and unenlightened craftsmanship.

5.31 Rafael Aragón The Flight into Egypt, c. 1850. Tempera and gesso on wood, $20\% \times 8\%$ in (52×22.6 cm). Museum of International Folk Art, Santa Fe, New Mexico.

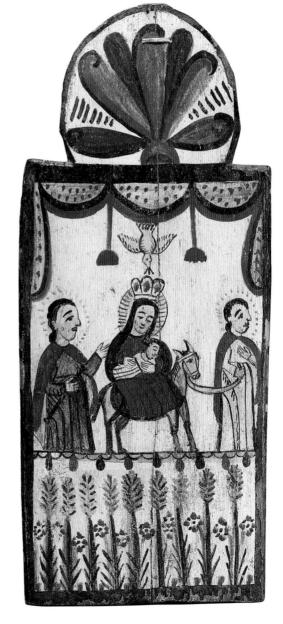

Artists and Domestic Virtue

Nevertheless, despite many reservations expressed by Anglo-American painters, the spiritual power of religious icons motivated a number of artists to represent not only biblical subjects but also images of Catholic piety. Even Samuel Morse sympathetically painted the Chapel of the Virgin at Subiaco, while on his tour of Italy (fig. 5.32). Though the picture is primarily a landscape, it emphasizes a roadside shrine dedicated to the Virgin Mary. In the golden-yellow background, obscured by the morning haze, a Catholic monastery in Subiaco forms a towering, mountainous peak. A pious woman, kneeling in front of the small shrine, serves as the painting's central figure. Rather than featuring a view of the shrine's cult statue, Morse was primarily interested in representing an image of popular piety. Though suspicious of the Catholic Church and the overwhelming visual grandeur of its cathedrals, the National Academy president was clearly convinced that the visual arts had an important role in stirring religious feelings and encouraging moral behavior. As selfproclaimed guardians of national virtue, painters and sculptors in New York and other cities socially elevated themselves above the ranks of mere craftsmen. Artists joined clergymen, lawyers, and other college-educated men of learning as members of the professional classes responsible for the republic's moral direction. When the National Academy was first organized in 1825, America was already in the midst of a Protestant religious revival that found its most profound expression in Rochester, New York, and other boomtowns along the Erie Canal. Made anxious by the rapidity of modernization, Americans in northwestern New York and elsewhere turned for reassurance not only to a religion of the heart but also to virtuous and idealizing themes in literature and the visual arts.

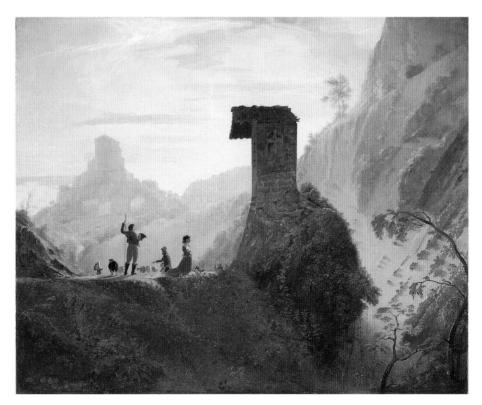

5.32 Samuel Morse Chapel of the Virgin at Subiaco, 1830. Oil on canvas, $29\% \times 37$ in (76 \times 94 cm). Worcester Art Museum, Massachusetts. Bequest of Stephen Salisbury III.

This pilgrimage shrine near the village of Subiaco, about 45 miles east of Rome, was popular with visiting artists who, according to Morse, admired its rustic, picturesque character. The shrine's dark masonry structure appears to grow out of the red earth of a cliff. Behind the kneeling woman, a well-dressed young man also pays homage to the shrine by doffing his hat.

Encouraged by clergymen and moral reformers. artists and architects attempted to foster the love of home life as a counterweight to the destabilizing forces of social and economic change. Jeremiah Pearson Hardy (1800-88), a former student of Samuel Morse in New York, took his academic training to Bangor, Maine, where he painted a luminous portrait of his wife and daughter seated comfortably upon a parlor couch (fig. 5.33). Silhouetted against the radiant view of the Penobscot River, the relatively homely figures seem transfigured by the light. The Hardy home has become a temple or sanctuary for private reveries stimulated by the spiritual beauties of Nature and the arts. Growing up within this aesthetic environment and encouraged by her father, the daughter in Hardy's portrait, Anne Eliza Hardy

(1839–1934), became a painter of fruit and flower still lifes. Such humble subjects were widely regarded as suitable for women artists. Fruit and flower arrangements were domestic displays for dining rooms and parlors, social spaces normally associated with the feminine sphere.

Nevertheless, women's cultural influence in the home was challenged by the tradition of patriarchal authority. The large Portrait of Reverend John Atwood and His Family by self-taught Massachusetts artist Henry F. Darby (1829–97) represents a New Hampshire Baptist minister and his family seated around a parlor table with Bibles open for private devotions (fig. 5.34). While paintings and sculptures were still discouraged in most Protestant churches, two pictures hanging prominently behind the Atwoods signify the importance of the visual arts in supplementing their reading of God's Word. On the right, a mourning picture of a funerary memorial reminds us of the role rural cemeteries had in popularizing art as a form of spiritual expression. More surprisingly, on the left hangs a colored mezzotint print of an Old Testament subject, Samson Carrying off the Gates of Gaza, by an English artistengraver. The violent biblical story of the Hebrew strongman contributes a disturbing counterpoint to the pious quiet of the domestic space. As agent of God's revenge against the Philistines, Samson reinforces the stern image of patriarchal authority personified by Reverend Atwood, who also served as chaplain of the state prison in Concord, New Hampshire.

The painter Lilly Martin Spencer (1822–1902) addressed female audiences by rejecting such images of patriarchal dominance. Spencer, who began her career in Cincinnati before moving to New York in 1849, also dissented from the morally restrictive tendency in art to represent women as idealized domestic saints. While Jeremiah Hardy hermetically isolated his wife and daughter from real life, Spencer frankly represented women as working housewives or cooks who prepare meals in kitchens cluttered with ingredients and utensils. In Shake Hands?, a smiling woman boldly greets beholders as real visitors (fig. 5.35). Her flour-covered hand reaches out to us from the picture space. Spencer does not liberate her subject from the

5.33 Jeremiah Pearson

Catherine Wheeler Hardy and Her Daughter, 1842. Oil on canvas, $29\% \times 36\%$ in $(74.3 \times 91.8 \text{ cm}).$ Museum of Fine Arts, Boston, Massachusetts. Gift of Maxim Karolik for the Mr. and Mrs. Karolik Collection of American Paintings, 1815-1865.

5.34 Henry F. Darby Portrait of Reverend John Atwood and His Family, 1845. Oil on canvas, $72 \times 96\%$ in (182 8 \times 244.4 cm). Museum of Fine Arts, Boston, Massachusetts, Gift of Maxim Karolik for the Mr. and Mrs. Karolik Collection of American Paintings. 1815-1865.

The moral sobriety of this New England clergyman's family is expressed in part by the relatively austere, rectilinear, boxlike space of the parlor. The small, framed biblical images are widely separated and call attention to the largely empty wall space, against which they float.

domestic sphere, but Shake Hands? humorously asserts a limited social equality. Genteel American critics found Spencer's "grinning housemaids" vulgar and offensive (cited in Lubin, p. 173). A critic for The Crayon, an artists' journal, asked, "Is

> ness, no tearful aspiration, to the expression of which she may give her pencil?" (cited in Lubin, p. 173). Far from being selfeffacing personifications of religious feeling, Spencer's assertive women dare to speak with a physical directness that shocked moralists and art connoisseurs alike. Shake Hands? and similar Spencer paintings of domestic life found a receptive audience among quite unsophisticated middle-class viewers. The Cosmopolitan Art Association, which sought to popularize the arts, commissioned an inexpensive engraving of Shake Hands? and distributed it to subscribers. The organization advertised the painting in the Cosmopolitan Art Journal for a readership composed primarily of women.

there in her woman's soul no serene grave thought, no quiet happi-

Though her French-born parents were social radicals supporting feminist and abolitionist causes, Spencer was not a political activist. Writing to her mother, she claimed that she was too preoccupied by her painting career to attend women's rights meetings. Nevertheless, her paintings challenged patriarchal control over family life, and her career within a male-dominated profession unconventionally supported a husband, who performed domestic chores and helped care for their numerous children.

Landscape Painting and National Identity

During the second third of the nineteenth century, landscape paintings of American scenery also reached a wide middle-class audience. Preceding the Cosmopolitan Art Association, the American Art-Union from 1839 to 1851 achieved a national membership of 20,000 by offering inexpensive prints of contemporary American paintings and annual lotteries for winning original oil paintings. Founded by the portraitist James Herring (1794–1867), a prominent Freemason, and directed by a group of wealthy New York businessmen, the American Art-Union urged its middleclass membership to purchase landscape paintings as a therapeutic antidote to urbanization.

For city residents confined by congested streets and a relatively polluted, noisy environment, parlors decorated with serene landscape views would soothe tense nerves and uplift depressed spirits. Pictures of country life were deemed a vicarious healthful substitute for actually owning a country home. Furthermore, landscapes encouraged the nationalist love of America's diverse beauties and scenic views.

Since the late eighteenth century, periodicals in New York, Philadelphia, and Boston had begun publishing engravings of America's unique natural beauty. Pictures of aristocratic country seats, new roads or waterways, and striking tourist sites were intended to instill in Americans a cultural pride of place. In 1808, the history painter John Trumbull (1756-1843) finished two panoramic views of Niagara Falls. Thanks to Trumbull and many other painters, Niagara Falls would become a sacred icon of American nationalism. Measuring fourteen feet long, Trumbull's View of the Falls of Niagara From Under Table Rock (fig. 5.36) was a preparatory study for a never-finished circular panorama.

First developed as a popular form of entertainment in eighteenth-century London, panoramas were enormous paintings that anticipated the illusionism of modern cinema. They were usually exhibited in the round within circular spaces or specially built rotundas. Dramatic lighting and elevated viewing platforms visually transported spectators to imagine that they commanded an "all-seeing," 360-degree view of the actual site. Kept at a distance from the paint surface, beholders could not see individual brushstrokes or other signs of the painter's artifice. Though Trumbull never transformed his study into a theatrically scaled work, panoramas became popular entertainments in antebellum America. In 1829, the Boston artist Robert Salmon (1775–c.1848) exhibited a large, semicircular battle painting in the rotunda of Alexander Parris's Quincy Market. By the 1830s and 1840s, American panoramas were increasingly representing scenes of the national landscape. Their popularity coincided with the development in America of a loosely organized school of landscape painting. After the Civil War, critics retrospectively designated this group of landscapists who painted primarily in New York and New England as the Hudson River School.

5.36 John Trumbull View of the Falls of Niagara From Under Table Rock, c. 1808. Oil on canvas, 29 imes168 in $(73.7 \times 426.7 \text{ cm})$. New York Historical Society, New York.

The term "panorama," formed by the Greek roots pan (all) and horama (view). was not used until the 1780s to refer to a type of landscape painting that reproduced a full, 360-degree perspective. The Scottish landscapist Robert Barker, who began exhibiting panoramas in London in 1787, has sometimes been credited with coining the term. Trumbull undoubtedly visited Barker's permanent circular exhibition space in Leicester Square, since Trumbull's teacher, Benjamin West, was a frequent customer.

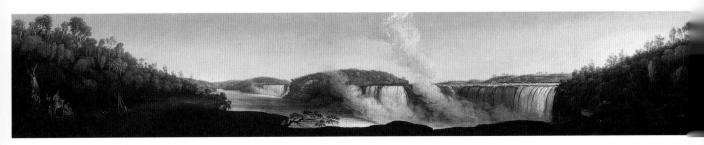

Thomas Cole

The birth of the Hudson River School may be traced to the 1825 Erie Canal celebration, when John Trumbull, President of the American Academy of the Fine Arts, visited the shop of a New York art dealer. There he saw three pictures of the Hudson River and Catskill Mountains region by Thomas Cole (1801-48), a young painter who had just arrived in New York from Philadelphia. Cole and his dealer, William Colman, had timed this exhibition of upstate New York landscapes to coincide with the state's celebration, from October 26 to November 4, of the opening of the Erie Canal.

William Dunlap, who joined Trumbull in purchasing one of Cole's paintings, reported in the November 22 issue of the New-York Evening Post: "These pictures will now be seen with delight by those who visit our Academy, and they will be astonished when they compare them with the works of the first European masters, in the Gallery, to find that an American boy, comparatively speaking, for such truly is a man of twenty-two, has equalled those works which have been the boast of Europe and the admiration of ages." Dunlap's article mythologized Cole as an "untutored" American genius, quoting Trumbull's deferential judgment that "this youth has done at once, and without instruction, what I cannot do after 50 years' practice" (cited in Parry, p. 26).

In fact, Cole was neither an American nor an untutored prodigy. He had been born in Lancashire, England, and had begun his career in the industrial arts, learning to engrave designs for a calico printworks in Liverpool, England. In 1818, Cole and his family emigrated to the United States, but not until 1834 did he actually become an American citizen. Dunlap's insistence that the immigrant Cole was an "American boy" expressed both the United States' persistent familial identification with "Mother England" and the national desire to discover an American art distinct from European models. For Trumbull and Dunlap, Cole's landscapes of American scenery could be used to wean wealthy Anglophile patrons away from collecting European Old Masters in favor of collecting contemporary American art.

A replica of the lost Cole painting that Trumbull purchased in 1825 represents a view of Kaaterskill Falls in the Catskill Mountains from under a cavern (fig. 5.37). Although the picture represents a wilderness untainted by signs of tourism or European settlement, the cavern's natural pointed arch enframes an awe-inspiring view of God's handiwork that surpasses in grandeur the Gothic architecture of European cathedrals. While demonstrating for connoisseurs a proper reverence for European tradition, Cole simultaneously appealed to Americans' national pride in a wilderness that was rapidly disappearing through economic development. He later asserted by way of contrast that in "civilized Europe" the morally elevating remnants of God's original creation "have long since been destroyed or modified" (cited in McCoubrey, p. 102).

The British-born fraternity of Freemasonry facilitated Cole's assimilation into American society and its art circles. Working as an itinerant portraitist in Ohio during the early 1820s, Cole had joined a Masonic lodge in Zanesville. As was the case for eighteenth-century portraitists in England and America (see Chapter 3), early-nineteenth-century Masonic lodges continued to assist artists with loans, commissions for emblematic engravings, costumes, and decorations, and introductions to affluent, potential clients. In antebellum America, many itinerant painters such as the young Cole and the aging Dunlap could rely on Freemasonry as a useful patronage and communications network.

Cole's paintings evoke associations with Freemasonry's mythology and symbolism. The arched, cathedral-like view of *Kaaterskill Falls* with its sunlit horizon recalls the architectural and light symbolism of Masonic lodge certificates such as the late-eighteenth-century example by Paul Revere (see fig. 3.30). In 1826, Cole celebrated a patron saint of Freemasonry, St. John the Baptist, whose baptismal initiation rituals created the first Christian brotherhood.

Inspired by the scenery of upstate New York and New England, Cole's imaginative landscape composition *St. John in the Wilderness* (fig. 5.38) visualizes the words of St. Matthew's Gospel: "In those days came John the Baptist, preaching in the wilderness of Judea, and saying 'Repent for the kingdom of heaven is at hand'" (Matt. 3:1–2). Cole was a devout Protestant as well as a Freemason. His representation of St. John preaching in the wilderness to a group of emotionally wrought sinners bears thematic comparison to contemporaneous pictures of outdoor revivalist camp meetings (fig. 5.40). Listeners excitedly respond to the heated words and gestures of St. John, who stands aloft upon an overhanging rock pulpit. Cole roughly shaped this natural stone pulpit into the craggy profile of a face, staring downward into the valley below. The human-appearing face draws our attention to minute but brightly illuminated figures reminiscent of Christ's holy family on the road to Bethlehem.

Throughout Cole's career, landscape forms expressed the spiritual content of spoken and written words. In the architectural, craft symbolism of Freemasonry,

5.37 Thomas Cole

Kaaterskill Falls, 1826.
Oil on canvas, 25½ × 36¾ in
(64.2 × 91.9 cm). Wadsworth
Atheneum, Hartford,
Connecticut. Bequest of
Daniel Wadsworth.

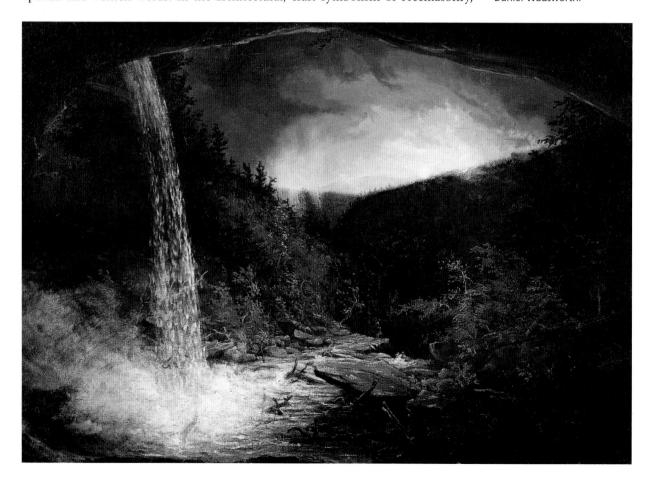

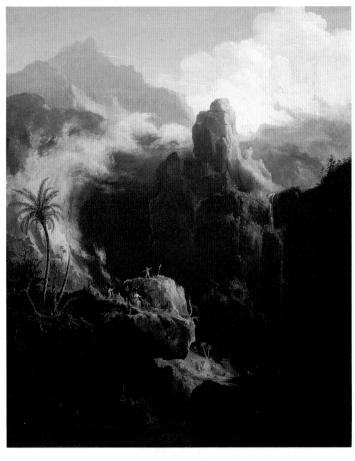

rough ashlar stones symbolized humankind in its imperfect, natural state after the expulsion of Adam and Eve from the Garden of Eden. Masonic brothers referred to themselves as living stones, who aspired to shape themselves into the perfected masonry stones of monumental temple and cathedral architecture. High above the dark abyss against which St. John preaches, Cole painted a large natural column of rock rising into the clouds. Further back, a pyramidal mountain reaches heavenward into the blue sky.

During the nineteenth century, Americans identified their natural topography with the biblical landscape of the Holy Land. Local adopted communities the names Bethlehem, Canaan, and Goshen to identify their towns with the sacred history of the Old and New Testaments. Evangelical Protestants harbored the belief that Americans, the new chosen people, would begin the thousandyear reign of Christ by converting the Jews to Christianity.

Cole rejected the idea of American chosenness but believed that the wilderness constituted a moral environment for meditating on the Hebraic origins of literature and the visual arts. In a lecture he later wrote for the

5.38 (top) Thomas Cole St. John in the Wilderness, 1827, Oil on canvas, 36×28^{15} /₁₆ in $(91.4 \times 73.4 \text{ cm}).$ Wadsworth Atheneum. Hartford, Connecticut. Beguest of Daniel Wadsworth.

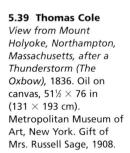

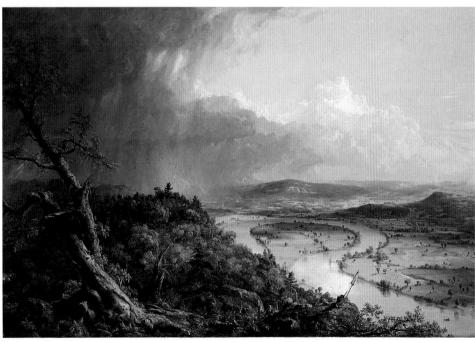

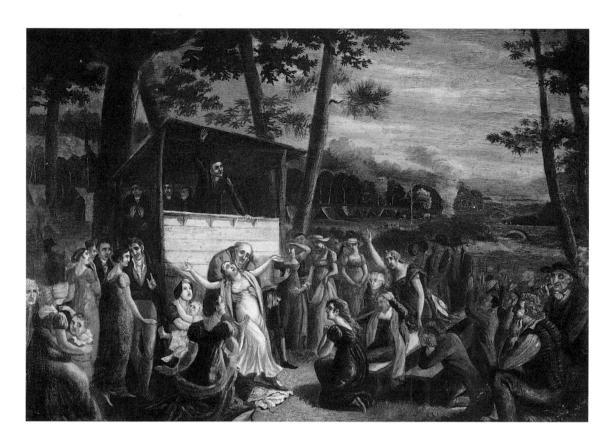

National Academy of Design, the painter described the roots of all languages in relation to the Hebrew letters of the Old Testament because each Hebraic letter "was the representation of some object, or animal, whose spoken name commenced with it" (p. 105). The study of Hebrew demonstrated that all human languages derived from the imitation of nature or the arts of design.

In his panoramic View from Mount Holyoke, Northampton, Massachusetts, after a Thunderstorm (The Oxbow), Cole inscribed Hebrew letters into the gently rising hillside above the oxbow loop of the meandering Connecticut River (fig. 5.39). Right side up, the letters roughly spell the name "Noah," the Old Testament hero who survived the Flood described in the book of Genesis. Upside down, the same Hebraic letters spell the name "Shaddai," meaning the Almighty. Since the 1820s, Mount Holyoke had become a popular tourist site; its commanding view of the Connecticut River valley was celebrated by travel writers in typically biblical terms, suggesting, like Cole's Hebraic inscriptions, that the American landscape was a holy text revealing God's Word.

Situating a tiny representation of himself and his sketching equipment toward the lower right of the picture, Cole visually confirmed his direct experience of Mount Holyoke's moral effects. The dramatic composition diagonally divides the rich, placid farmland of the Connecticut River valley from the storm-drenched, rugged mountain peak. Cole purposefully ignored the fact that Mount Holyoke itself had become relatively tamed by the steady stream of tourists. He thereby created a stark contrast between the violent wilderness and the valley's pastoral calm. While his patrons regarded the pastoral balance of man and nature as the ideal state of human civilization, Cole's calm presence on the wilderness side of the canvas

5.40 Jeremiah Paul Evangelist Campmeeting. Oil on canvas, 18×26 in $(45.7 \times 66 \text{ cm})$. Courtesy the Billy Graham Center Museum, Wheaton, Illinois.

As suggested by the fainting woman at the center of this composition, revivalist camp meetings were characterized by strong emotional displays beyond the decorum of normal middle- and upperclass behavior. Freed from the restrictive tradition-bound spaces of church architecture, participants clearly seemed to experience more direct spiritual communications in the relatively primitive, rural settings.

visually expressed his belief that "the most distinctive . . . most impressive characteristic of American scenery is its wildness" (cited in McCoubrey, p. 102). He worried in an essay on American scenery written the year before he painted View from Mount Holyoke that the advance of civilization westward would obliterate what made the wilderness morally distinctive:

There are those who regret that with the improvements of cultivation the sublimity of the wilderness should pass away: for those scenes of solitude from which the hand of nature has never been lifted, affect the mind with a more deep toned emotion than aught which the hand of man has touched. Amid them the consequent associations are of God the creator—they are his undefiled works, and the mind is cast into the contemplation of eternal things. (cited in McCoubrey, p. 102)

Comfortably at home in an American wilderness that had virtually disappeared in the East, the politically conservative Cole feared the dangers of a rootless urbanindustrial society. Writing in 1836 to one of his most important patrons, a wholesale grocery merchant named Luman Reed, the artist especially condemned the railroad's intrusion into the Catskill Mountains, where he spent his summers and early autumns sketching. He referred to the owners of the Catskill and Canajoharie Railroad as "the copper-hearted barbarians" who "are cutting all the trees down in the beautiful valley on which I have looked so often with a loving eye" (cited in Wallach, p. 73). That same year, Cole completed for Reed a pessimistic series of five large historical landscapes collectively entitled *The Course of Empire*. The series traces the cyclical birth and death of an ancient civilization through five stages: The Savage State (fig. 5.41), The Pastoral or Arcadian State, The Consummation of Empire (fig. 5.42), Destruction, and Desolation. The last three panels expressed Cole's conservative opinion that human pride and greed were poison seeds for civilization's self-destruction. He arranged the series according to the seasons of the year and the times of the day. The Consummation of Empire, the central panel, represents the high noon of an overheated summer's day. Nature's presence has been marginalized by lavish, nonfunctional architecture. Evoking associations with the last days of the Roman Empire, Cole tightly paints an orgy of tiny human figures celebrating the military conquests of an emperor, whose procession through a gaudy triumphal arch can be seen in the lower-left foreground.

According to the art historians Angela Miller and Alan Wallach, Cole probably intended his imperial conqueror as a veiled reference to President Andrew Jackson. First elected president in 1828, Jackson incurred the fears and wrath of political conservatives. While rhetorically appealing to the common man, Jackson largely ignored the nation's aristocratic elite in making appointments to political office. Instead of genteel society's elite, he rewarded Democratic Party loyalists and social upstarts with the spoils of office. Jackson's administration angered orthodox Protestants by refusing to halt the Sunday mail service and insisting upon the constitutional separation of church and state. On the other hand, the President's aggressive campaign to extend American power westward disturbed supporters of the Supreme Court. Defying the constitutional rule of law, Jackson openly encouraged the state of Georgia to ignore a decision written by Supreme Court Justice John Marshall which would have prevented the expulsion of Cherokee Indians from native lands. By 1838, Jackson's cruel policy had removed 70,000 Native Americans into territories west of the Mississippi, causing thousands of deaths during the forced march.

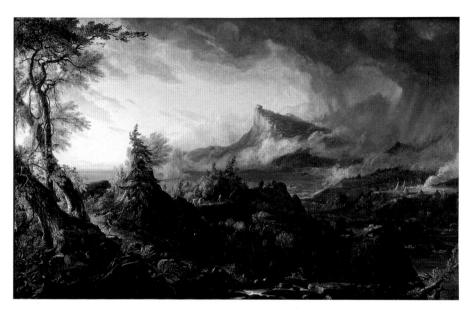

Artists and Imperial Expansion

Cole's *The Course of Empire: The Savage State* (fig. 5.41) does not explicitly represent Native American huntsmen, but the first painting in the series does prophesy the inevitable extinction of primitive, nomadic tribesmen. Within the middle ground of the imaginative wilderness, a circle of tiny teepees alludes to Indian rituals and domestic life, which will soon disappear with the more settled civilization of the *Pastoral State*. Other painters took a more anthropological approach to the plight of Native Americans. Artists rushed to meet the public's demand for a visual record of Indian rituals, customs, and costumes. Most famously, the Pennsylvania-born artist

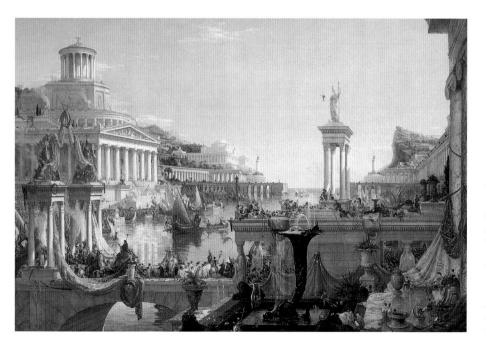

5.41 Thomas Cole

The Course of Empire: The Savage State, 1834. Oil on canvas, $39\% \times 63\%$ in (99.7 \times 160.6 cm). The New York Historical Society, New York.

Symbolizing the beginnings of civilization, this first painting in The Course of Empire cycle is set at dawn during early springtime. With the swirling, dark storm clouds and rugged, uncultivated appearance of nature, human life precariously depends on the fortunes of the hunt as personified by the running figure at the far left. The huntsman's prey, a frightened deer, leaps over a rocky stream in the central foreground. The clearing dawn sky promises the hope of future human progress.

5.42 Thomas Cole

The Course of Empire: The Consummation of Empire, 1835–36. Oil on canvas, 51½ × 76 in (130.2 × 193 cm). The New York Historical Society, New York.

Although Cole's series seems to represent the pagan Roman Empire, contemporaries were also inclined to interpret the imagery with reference to Jerusalem and other biblical cities that fell victim to pride and decadence.

5.43 George Catlin Buffalo Bull's Back Fat, Head Chief, Blood Tribe (Blackfoot), 1832. Oil on canvas, 29×24 in (73.7 imes 60.9 cm). National Museum of American Art. Washington, p.c.

Possessing a powerful square iaw and thick neck, the chief stares directly at the beholder. His red-painted face, head feathers, and colorfully ornamented costume and pipe are sketched with free, often wispy brushstrokes. Set against a contrasting, cloudy blue sky, the warrior's portrait possesses almost visionary intensity.

George Catlin (1796-1872) claimed that in his pictures of "the noble races of red men" he had "flown to their rescue—not of their lives or of their race (for they are "doomed" and must perish), but to the rescue of their looks and their modes" (cited in McCoubrey, pp. 94-95). Catlin was saving the memory of Indians, though doomed in the real world, for his white patrons: "phoenix-like, they may rise from the 'stain on a painter's palette' and live again upon canvas, and stand forth for centuries yet to come, the living monuments of a noble race" (cited in McCoubrey, p. 95). In travels to the western frontier, Catlin painted several hundred portraits of subjects belonging to approximately fifty different tribes (fig. 5.43). The exhibition of his "Indian Gallery" throughout America and Europe began in 1837. In London, at the Egyptian Hall in Piccadilly, Catlin's pictures were accompanied by a living group of Iowa Indians. The Egyptian-Revival building implicitly suggested the belief held by many of Catlin's contemporaries that Native Americans were descendants of the ancient Egyptians or were, perhaps, one of the lost tribes of Israel.

Cole viewed American imperial expansion with a jaundiced eye, for it posed a threat to traditional values of civic virtue and self-sacrifice. The land rush westward and the commercialization of American life signified the danger that material selfishness and consumer luxuries would dissipate public morals. For Cole, the decadent architectural wilderness of The Course of Empire: The Consummation of Empire (see fig. 5.42) was far more worrisome than the vibrant energy of the Savage State.

> In his earlier painting of Kaaterskill Falls (see fig. 5.37), he nostalgically included a tiny Native American standing upon a precipice in the center of the picture.

> Cole died in 1848 after seeing the United States triumph in a war against Mexico that he adamantly opposed. The Treaty of Guadalupe-Hidalgo ended the war that had begun in 1846. Under its terms, the United States became a continental power, acquiring all of California as well as New Mexico. Annexation of Texas, which had contributed to the outbreak of hostilities, was reconfirmed by Mexico's recognition of the Rio Grande as the southern border of the United

> In the wake of the United States' victory over Mexico and its new identity as a Pacific power, Congress voted in 1850 to expand the Capitol building in Washington to accommodate the growing number of senators and representatives from the new states. The Philadelphia architect Thomas Ustick Walter (1804-87) offered a plan for two additional north and south wings that would blend with the neoclassical appearance of the old building (fig. 5.44). Walter also proposed to replace the old dome with a much higher and more elaborately

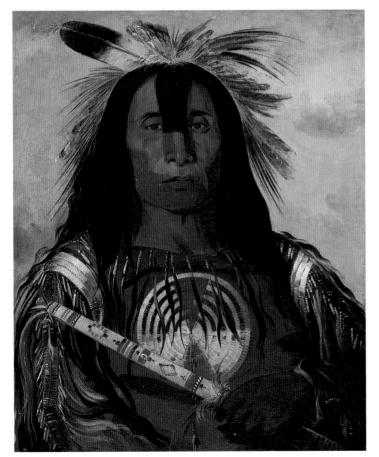

decorated cast-iron dome, similar in profile to St. Peter's basilica in the Vatican or to St. Paul's Cathedral in London.

Construction of the Capitol expansion necessitated new paintings and sculptures to decorate the building's interior and exterior. During the 1830s and 1840s, painters already were working on murals for the remaining panels of the Rotunda. finishing the job that John Trumbull had begun in 1817. Unlike Trumbull's relatively secular subjects of Revolutionary War scenes (see Chapter 4), the artists Robert W. Weir (1803-89) and John Gadsby Chapman (1808-89) represented the colonial founders of Massachusetts and Virginia in explicitly religious terms (figs. 5.45–5.46). Weir's New England Pilgrims kneel in prayer to form a covenant with God. Chapman's Virginians piously convert the Indian princess Pocahontas to Christianity. Both pictures contributed to the mid-nineteenth-century ideology of Manifest Destiny, a term employed by politicians, clergymen, and newspaper editors to justify the war against Mexico and the confiscation of Indian territories as a holy mission to bring the western wilderness under enlightened Christian rule.

Thomas Crawford's pedimental sculpture for the east facade of the new Senate wing, The Progress of Civilization, represents an Indian family defeated by white settlers and the superiority of Western civilization (fig. 5.47). In Crawford's words, an Indian boy is returning from a hunting trip: "His looks are directed to the pioneer, whose advance he regards with surprise" (cited in Fryd, pp. 114-115). The Indian boy's father personifies fatalistic resignation. A critic for the journal The Crayon wrote of the Indian: "His Tribe has disappeared, he is left alone, the solitary offshoot

5.44 Thomas U. Walter United States Capitol, Senate, and House Wings, Washington, D.C., 1855-65. Architect of the Capitol, Washington, D.C.

of a mighty race; like the tree stump beside him he is old and withered, already the ax of the backwoodsman disturbs his last hours; civilization and Art, and agriculture ... have desecrated his home" (cited in Fryd, p. 119). Crawford's portrayal seems relatively sympathetic, compared with Horatio Greenough's contemporaneous (now dismantled) sculptural group for the east facade of the Capitol (fig. 5.48), representing a gigantic pioneer rescuing a white woman and her baby from a bloodthirsty Indian.

5.45 Robert W. Weir Embarkation of the Pilgrims at Delft Haven, Holland, 22 July 1620, 1836-43. Oil on canvas, 12 imes 18 ft (3.65 imes5.48 m). Architect of the Capitol, Washington, D.C.

Representing the Old World, a group of Pilgrims is seen departing from Delft Haven in the Netherlands toward religious asylum in America. Kneeling on the deck of the Speedwell, the Pilgrims are led in prayer by the Reverend John Robinson, who gazes upward and, with open hands, asks God's blessing. The Dutch town is visible at the right, while a rainbow at the left beckons toward the American future.

5.46 John Chapman Baptism of Pocahontas at Jamestown, Virginia, 1613, 1836-40. Oil on canvas. 12 \times 18 ft (3.65 \times 5.48 m). Architect of the Capitol, Washington, D.C.

Dressed in white, the Indian princess Pocahontas (see fig. 1.16) kneels before the Reverend Alexander Whiteaker, who dips one hand into an octagonal baptismal font, preparing to administer the sacrament of purification. The maiden's betrothed, John Rolfe, stands behind her, while a group of five unconverted Indians at the right represents family from her former tribal life.

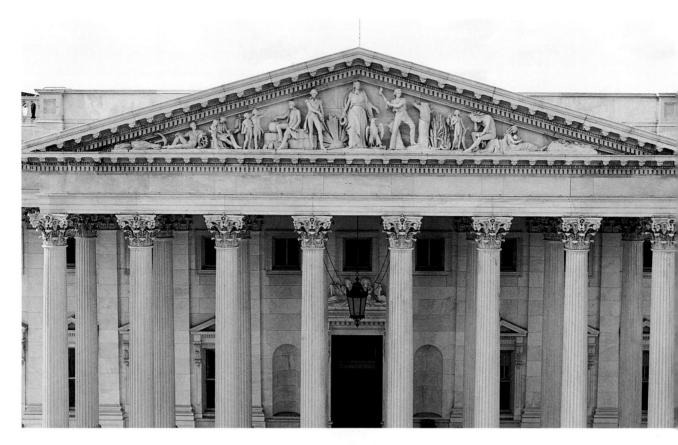

5.47 Thomas Crawford *Progress of Civilization* (detail),
1855–63. Architect of the
Capitol, Washington, p.c.

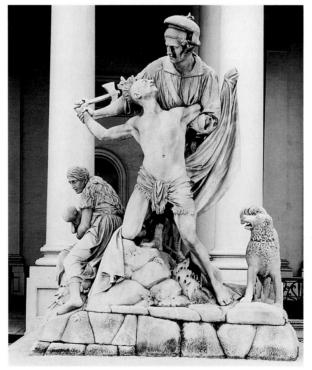

5.48 Horatio Greenough Rescue, 1837–53. Marble, 11 ft 9 in \times 10 ft 2 in (3.5 \times 3 m). Architect of the Capitol, Washington, D.C.

In contrast to the menacing Indians in John Vanderlyn's The Death of Jane McCrea (see fig. 4.47), here the Native American warrior is overpowered by a formidable white settler. The conquering rescuer of the white woman and child is dressed in academic, Renaissance-style costume to symbolize the triumph of enlightened Anglo-Saxon values. The figure's flat hat and robe resemble those worn by humanists at the court of Henry VIII, as depicted in the portraits of Hans Holbein (1497/8-1543).

George Caleb Bingham

Many admirers of the *Rescue* interpreted Greenough's conquering pioneer as a representation of the Indian fighter Daniel Boone, who, in 1775 at the beginning of the American Revolution, had led a group of frontiersmen westward into Kentucky through the Allegheny Mountains. While Greenough was finishing his sculpture, the Missouri painter George Caleb Bingham (1811–79) unsuccessfully proposed a mural for the U.S. Capitol commemorating Boone's daring accomplishment. Bingham had painted a widely reproduced painting, Daniel Boone Escorting Settlers through the Cumberland Gap, which represents Boone and his wife as if they were Mary and Joseph, Christ's holy family (fig. 5.49). Like Cole, whom he deeply admired, Bingham represented a wilderness redeemed by religious symbolism. The pyramidal group of settlers also evokes associations with the children of Israel's forty years of wandering in the wilderness before they entered the Promised Land. As Boone leads his wife's white horse forward into the light, they are flanked on either side by rough emblems of Christ's cross in the intersecting dead tree branches at the left and in a horizontal root and vertical branch in the painting's lower right.

A native of Virginia, Bingham had moved with his parents to Franklin, Missouri, where his father ran the Square and the Compass, an inn that probably doubled as a Masonic lodge. Bingham's career began when he became a studio assistant to the itinerant portraitist Chester Harding (1792–1866). Harding gained fame by painting portraits of the aging Boone, who lived sixty miles south of Franklin on the Missouri River. Initially following Harding as a portraitist, Bingham turned toward

5.49 George Caleb **Bingham**

Daniel Boone Escorting Settlers Through the Cumberland Gap, 1851-2. Oil on canvas, $36\% \times 50\%$ in $(92.7 \times 127.6 \text{ cm}).$ Washington University Gallery of Art, St. Louis, Missouri. Gift of Nathaniel Phillips, 1890.

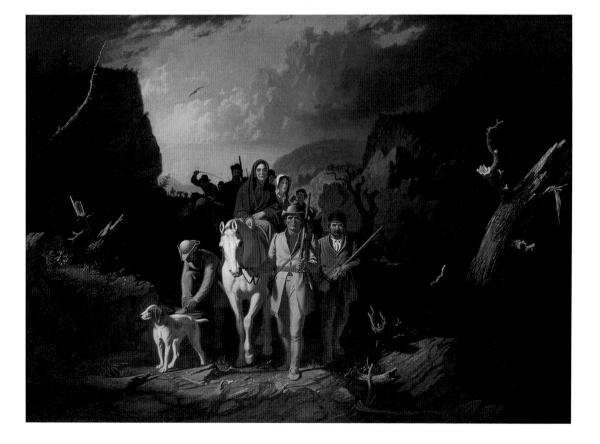

One of Bingham's most famous paintings of river life capitalized upon the popularity of John Banvard's (1815–91) *Panorama of the Mississippi River*, a moving panorama that was advertised as "three miles of canvas" exhibiting 1200 miles of countryside "from the mouth of the Missouri River to the City of New Orleans" (cited in Oettermann, p. 328). Banvard's moving panorama was exhibited over a period of hours on a stage displaying changing scenery to narrative commentary and musical accompaniment. Experiencing the mammoth work was akin to a steamboat river tour. When the panorama first opened in Louisville, Kentucky, Banvard gave away free tickets to riverboatmen, who testified to the accuracy of the panorama's scenery.

An 1847 review of Banvard's "Great Picture" was illustrated by an engraved reproduction of Bingham's *Jolly Flatboatmen*. Painted for the American Art-Union, Bingham's painting reassuringly represented eight muscular, working-class riverboatmen as a happy group listening and dancing to music (fig. 5.50). The artist's stable, pyramidal composition orders the play of workers whose reputation for rowdy, immoral behavior ordinarily generated middle- and upper-class fears of social violence. Illuminated by the rising morning sun, the bright pyramid of figures denies the reality of hard labor. Despite realistic, still-life details in the foreground cabin of the flatboat, Bingham's dreamlike picture is a nostalgic memory of pre-industrial harmony. By the late 1840s, steamboats largely had displaced the manual labor of flatboatmen in transporting cargoes for markets downstream.

5.50 George Caleb Bingham

Jolly Flatboatmen, 1846. Oil on canvas, $38\% \times 48\%$ in $(96.9 \times 123.2 \text{ cm})$. National Gallery of Art, Washington D.c. Loan, Manoogian Foundation, New York.

Bingham's pyramid of sculpturesque workmen may be compared to the Egyptian pyramid decorating the Great Seal of the United States (see fig. 4.14). The implied apex of Bingham's triangular composition is the radiant solar light against which the dancing flatboatman is silhouetted. Often the sun was interpreted as a symbol of the all-seeing eye of God.

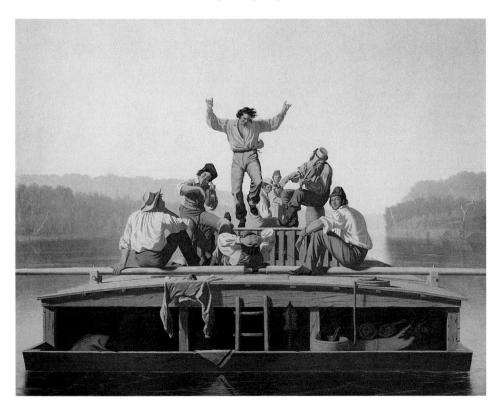

Visions of Millennial Progress and Religious Conflict

Unlike Cole, other American painters mostly celebrated America's imperial expansion and prosperity. Yet they, too, expressed doubts or ambivalence about national progress. Five years older than Cole, Asher B. Durand (1796-1886) was one of Cole's principal disciples and lived twice as long as his mentor to become a president of the National Academy of Design. Differing from Cole's preference for wilderness scenes, Durand devoted most of his career as a landscapist to themes of pastoral harmony. In the words of an unfriendly critic for the New York Daily Tribune, Durand was "always soothing, never inspiring—sure to please, equally sure not to surprise a careful and loving student and imitator of the placid aspect of nature, and a genius that breathes pastoral peace over all his works" (cited in J. Durand, p. 218).

Durand startled the expectations of critics when he exhibited God's Judgment upon Gog at the National Academy in 1852 (fig. 5.51). Based on the Old Testament text from Ezekiel, Chapter 39, this unusually violent picture of divine retribution was painted for Jonathan Sturges, a New York financier for various railroad companies and an admirer of Thomas Cole's cataclysmic The Course of Empire. However, unlike that pessimistic series for Sturges's business partner, Luman Reed, Durand's biblical subject expressed nationalists' faith that America had succeeded ancient Israel as God's chosen nation. Gog, the pagan ruler of the land of Magog, had invited God's violent punishment because of his aggression against the Hebrews. As described by Daniel Huntington, a fellow academician, Durand's painting:

represents a scene of darkness and desolation in the valley of graves. The hosts of Gog are scattered and falling in terror, while the blackened air is horrid with the ominous flight of birds of prey snuffing the blood of the slain oppressors of Israel. Out of a cavernous gap in the mountains rush forth hordes of wild beasts—tigers and leopards, swift and stealthy, thirsting for blood. There is something of an awful and demoniac spirit about this scene, the widest departure from Durand's favourite themes. (cited in J Durand, pp. 174–175)

The art historian Gail Husch has found that while most contemporary reviews of Durand's painting were positive, others lamented the violent character of the picture. One reviewer argued that the cruelty of God's punishment unfortunately made one sympathetic to Gog and the enemies of Israel. The artist painted the sensational subject with unusually vigorous brushwork, which reduced the forces of Gog in the middle ground to virtual illegibility. Within the cavernous abyss, human figures and animals swirl about in a chaotic frenzy of destruction. Meanwhile, Ezekiel stands upon a rock pulpit. Like a powerful magician, hands raised and cloak blowing in the wind, the prophet appears to orchestrate nature's destructive powers. The bright red of his cloak visually links him with the lightning and the fiery, volcanic explosion overhead.

Sturges, the patron, orginally suggested the Old Testament subject to Durand. A deeply religious man, Sturges was an abolitionist. In 1850, just before Durand's painting, Congress had passed the Fugitive Slave Act, which made it easier for Southern slave owners to recapture former and runaway slaves who had fled to the North. Fiery abolitionist clergymen promised that an angry Old Testament Jehovah would punish the United States with "an earthquake voice through the land" (cited

5.51 Asher B. Durand
God's Judgment upon Gog,
c 1852. Oil on canvas, 60¾ ×
50½ in (154.3 × 128.3 cm).
Chrysler Museum of Art,
Norfolk, Virginia. Gift of
Walter P. Chrysler, Jr.

in Zinn, p. 177). Sturges and others who saw the painting at the 1852 academy exhibition may have interpreted *God's Judgment upon Gog* in relation to the angry rhetoric of anti-slavery.

However, far from being an entirely violent, gloomy painting, Durand's picture draws the viewer inward toward a distant background of blue sky, white clouds, and sunbathed fields of green. The artist appears to promise an era of peace and prosperity once the cataclysmic storms of the present have passed. Durand and Sturges were both liberal Protestants who believed in a future millennium—the utopian, thousand-year reign of Christian harmony before God's final judgment of humankind.

Whether Durand intended it or not, *God's Judgment upon Gog* could arouse associations with more extreme forms of political radicalism and religious zealotry. Durand affiliated himself with the Unitarian Church, a liberal Protestant denomination whose clergy criticized revivalist camp meetings by comparing them to natural catastrophes that overwhelmed audiences (see fig. 5.40). Inundated by a flood of emotion, individual souls lost their free will. They became "machines" manipu-

lated by artful demagogues or tyrants. During the 1840s, the Baptist preacher William Miller (1782–1849) had created a wave of national hysteria by forecasting the Second Coming of Christ. Throughout the country, thousands of people were motivated by Miller and fellow revivalists to abandon their homes and possessions, dress in white robes, and meet on hilltops for this supernatural, millennial event. Christ's failure to appear as prophesied resulted in the collapse of the Millerite movement in 1844.

Millennial dreams of Christ's return or of a heavenly "New Jerusalem" literally descending to earth continued to generate and sustain new religious sects, contributing to national conflict rather than peaceful harmony. In 1846, the Mormons, or members of the Church of Jesus Christ of Latter-Day Saints, completed construction of a temple that towered over their quasi-independent city-state Nauvoo, Illinois, on the banks of the Mississippi River. The Mormon religion originated from the visions of Joseph Smith (1805-44) from western upstate New York, where myriad religious sects arose in response to social dislocations caused by capitalist development. Steeped in the occult search for buried treasures and the Masonic delight in secret rituals, Smith announced that he had dug up a set of golden tablets, inscribed with "reformed Egyptian" hieroglyphics. Translating the mysterious text with a magical set of "seer stones," he claimed to reveal the history of ancient American Indian tribes, who had migrated from Egypt and the Holy Land. Smith's Book of Mormon prophesied the establishment of God's heavenly kingdom in the American West. Incurring charges of blasphemy and sexual immorality, Mormon "saints" practiced polygamy, conducted secret rituals in their temples, and chose to

5.52 Asher B. Durand Progress (The Advance of Civilization), 1853. Oil on canvas, 4×6 ft (1.22 \times 1.83 m). Warner Collection of Gulf States Paper Corporation, Tuscaloosa, Alabama.

live communally apart from the American mainstream. At Nauvoo, they established a virtually autonomous theocracy, a divinely guided government or city-state administered by the church fathers. However, on June 27, 1844, a mob of Illinois state militiamen, motivated by religious bigotry and fears of political separatism, lynched Smith, leaving plans for a Mormon empire in the Far West to his successor, Brigham Young.

Liberal Protestants did not believe in the imminent return of Christ to earth. Rather, they put their faith in the notion of human perfectibility. Unitarians rejected the divinity of Christ. Durand admired the Boston Unitarian clergyman William Ellery Channing, who argued that Jesus Christ represented a human ideal toward which all humankind must strive. Unitarians and other liberal Protestants assumed that the Christian millennium was achievable through human agency. Human progress toward Christ's perfection was especially promising in America. For Channing, the cyclical rise and fall of empires would be broken in the free and open society of the New World.

In Boston, Sunday-school teachers at Channing's Federal Street Church voted not to teach children the Old Testament. They believed that the Hebraic stories of human depravity and God's angry judgment were too demoralizing and frightening for the very young. Certainly Durand's painting of *God's Judgment upon Gog* may have been thought unsuitable for innocent young eyes or for individuals with sensitive temperaments. However, Durand's next major painting more clearly expressed a millennial optimism in the nation's future.

Commissioned by Charles Gould, a financier for the Ohio and Mississippi Railroad, Durand's *Progress (The Advance of Civilization)* celebrates the transformative power of American industry and technology (fig. 5.52). Durand visually rejects Cole's pessimistic *The Course of Empire*, with its central image of human depravity in *The Consummation of Empire* (see fig. 5.42). By combining the stages of civilization into a single painting, Durand marginalized a group of diminutive Indians to a remnant of wilderness located far left on the canvas. From their shaded space, the Native Americans gaze in apparent wonder at the luminous vision of civilization in the valley below. The shade trees in the wilderness are tinged by the golden light of the rising sun, symbolizing the new millennial age of Christian striving toward perfection. The tree that rises highest into the light blue sky bends toward the sun in deference to its divine potency.

From the picture's lower-right corner, telegraph wires lead the eye past the pastoral space of cattle and a horse-drawn wagon toward a canal and river, transportation arteries for a commercial, industrialized civilization. The telegraph poles would have triggered contemporary associations with Durand's fellow painter Samuel F. B. Morse, the inventor of the telegraph. During the 1830s and 1840s, experimentation with electromagnetism had reportedly, according to a friend, led Morse, the president of the National Academy of Design, to believe that:

God had created the great forces of Nature not only as manifestations of his own infinite power, but as expressions of good-will to man, to do him good, and that every one of God's great forces could yet be utilized for man's welfare; that modern science was constantly evolving from the hitherto hidden secrets of Nature some new development promotive of human welfare, and . . . that analogically magnetism would do in the advancement of human welfare what the Spirit of God would do in the moral renovation of man's nature; that it would educate and enlarge the forces of the world. (cited in Prime, p. 305)

5.53 Jasper Francis Cropsey

Starrucca Viaduct, Pennsylvania, 1865. Oil on canvas, $22\% \times 36\%$ in $(56.9 \times 92.5 \text{ cm})$. Toledo Museum of Art, Toledo, Ohio.

Even more than Thomas Cole and other artists of the Hudson River School, Cropsey liked to paint autumnal landscapes for their rich contrasts of colorful foliage. Painted toward the end of the Civil War, this panoramic view of bounty and progress celebrates the benefits of peaceful pursuits.

For both Morse and Durand, scientific and technological progress went hand in hand with moral and spiritual enlightenment. In antebellum America, the Christian God of the Bible was being reconceived as a deity defined by nature's energy forces, which were being harnessed for the welfare of humankind. Unlike Cole's stultifying, overdeveloped empire in Consummation, Durand's optimistic vision of America's technological progress is providentially blessed by the elemental flux of air, water, and radiant sunlight bathing and softening gently rolling hills. The artist represents factories, steamboats, and a railroad train puffing a thin trail of white steam that emulates in miniature the golden grandeur of nature's clouds. In contrast to Cole's critique of railroad magnates' destruction of the wilderness, Durand's inoffensive train is scarcely visible, constituting no threat to the divine beauty of the panoramic landscape. Durand's painting served the ideological purposes of Charles Gould, who financially supported train excursions by painters into the wilderness. Seeking to unify the nation through transportation and communication technology, railroad entrepreneurs wished to alleviate environmental concerns and encourage tourist travel by commissioning inspiring landscapes that harmonized nature with industry.

Other Cole disciples emulated Durand's more optimistic view of railroads as engines of progress. In Starrucca Viaduct, Pennsylvania, Jasper Francis Cropsey (1823-1900) represented the distant view of a newly constructed railroad bridge that itself had become a tourist attraction (fig. 5.53). The stone viaduct was regarded as an engineering miracle, rising one hundred feet high to cross over one thousand feet of the Starrucca creek and Starrucca valley near Lanesboro, Pennsylvania. Cropsey chose this scenic viewpoint because it recorded a popular tourist train stop

along the Erie Railroad. A contemporary newspaper described the site in terms parallel to Cropsey's panoramic composition:

From the summit of the hill, just before you descend to Lanesboro, as perfect a picture lies before you as the eye ever longed for. The landscape is skirted by thickly-wooded hills—the mirror-like Susquehanna sleeps through the midst of green meadows. Over it you see an old rural bridge, contrasting, pleasingly, with the elegant Tressel Bridge near by. . . . The solid masonry of the Starrucca Viaduct, with its regular arches, is seen in the distance, blending with the scenery, the grandeur, and dignity of art, like the effect of a piece of colossal statuary in a green park. (cited in Howat, p. 211)

Both the newspaper account and Cropsey's painting encouraged beholders to identify technology and engineering projects with the fine arts of painting and sculpture. Displacing Durand's Native Americans in *Progress*, Cropsey's internal beholders are tourists, whose relaxed presence reinforces the composition's easy, sweeping continuity between foreground wilderness and the background's artful, industrialized garden. Cropsey's distant, atmospheric view of the viaduct allows it to blend seamlessly with the surrounding topography. An architect as well as a painter, Cropsey eventually designed train station stops for the Gilbert Elevated Railroad on Sixth Avenue in New York (fig. 5.54). Cropsey's designs explored the decorative possibilities of iron, a modern industrial material.

Transcendentalism, Spiritualism, and American Art

Economic depressions periodically shook confidence in national progress. From 1837 until 1843, the United States experienced its first major economic depression. Bankruptcies and high unemployment led many to question the magic of free markets, the growing disparity of wealth between rich and poor, and America's very identity as a Christian nation. In Boston, the former Unitarian clergyman Ralph Waldo Emerson challenged the nation's social and religious establishment by abandoning the Christian faith and its fragmentation into separate denominations and sects. He urged a new Transcendentalist philosophy, which rejected established

5.54 Jasper Francis Cropsey

Design for elevation of Gilbert Elevated Railroad, New York, New York, c. 1878. Pencil. Museum of Fine Arts, Boston, Massachusetts. Mr. and Mrs. Karolik Collection. institutions and traditional authority figures in favor of self-reliant individuals communing with the natural, vitalistic energies of God's universe.

Transcendentalist philosophers and their followers looked for commonalities rather than differences among religious faiths, including Buddhism and other non-Christian religions. They hoped to "transcend" human conflict through social as well as religious reforms. While Emerson emphasized individual self-reliance, other Transcendentalists founded socialist communes as experimental alternatives to capitalist greed and competition. Participants in the Brook Farm commune established in 1841 at West Roxbury, Massachusetts, later founded the American or Religious Union of Associationists. Also known as the First Church of Humanity, this Boston organization advocated socialist principles and a union of diverse faiths under a broad theological umbrella.

Services of the Religious Union of Associationists centered upon an empty chair "symbolizing the Invisible Presence" (cited in Ellis, p. 89). On the nearby altar, a candelabrum with three candles signified members' tripartite unity with God, nature, and humanity. During meetings, Associationists discussed a range of issues from labor abuses and communist political theory to phrenology and Spiritualist séances. Several members of the group were Spiritualist mediums.

Joining Transcendentalism in opposition to the social and religious establishment, the Spiritualist movement developed during the late 1840s as a radical alternative to the denominational sectarianism of Christian churches. In 1848, two young sisters, Margaret and Kate Fox, from upstate New York, gained national attention for their reputed ability to communicate with the dead. Spiritualist mediums and their supporters argued in quasi-scientific terms that just as the recently invented telegraph could transmit messages across vast distances, so could spirits from a higher life beyond the grave communicate through encoded rappings analogous to the Morse code.

By the early 1860s, the notion of a "Spiritual Telegraph" had gripped the national imagination, while attracting approximately 1 million followers. The Poughkeepsie, New York, seer Andrew Jackson Davis helped to legitimize Spiritualist rappings and séances by framing them within a "Harmonial Philosophy." Dispensing entirely with the existence of Hell, Davis interpreted the earth as a lower sphere of Heaven. After death, individual souls would continue to develop in spiritual harmony, beauty, and wisdom.

Many artists and writers were attracted by the Transcendentalist and Spiritualist movements. The Gloucester, Massachusetts, painter Fitz Hugh Lane (1804-65) was a member of the Religious Union of Associationists as were other Boston-area artists who attempted to synthesize Spiritualist and socialist principles to create a heaven upon earth. Lane's early topographical views represented and promoted Gloucester's development as a fishing and tourist community north of Boston on the Atlantic coast. However, later pictures that he painted in Boston and Maine as well as Gloucester are luminous and geometric distillations of real life, suggesting a spiritual transcendence of materialist, economic interests. Boston Harbor at Sunset nostalgically celebrates Boston's seafaring history, while relegating the presence of a modern steamboat to the distant background (fig. 5.55). Recalling Horatio Greenough's admiration for the organic, functional beauty of American sailing ships, Lane carefully depicts the sleek, linear architecture of masts, rigging, and hulls against multicolored sky and mirrorlike water. Receding into the colorful distance from a darkened foreground, his great ships appear as silent, ghostly witnesses to the sun's slow descent into the underworld. With darkened white sails ascending

like church spires or towers into the glowing twilight, they inevitably evoked moral associations with life's spiritual voyage and quest for perfection. The crystallized stillness of the picture contrasts with Durand's animated painting of *Progress*. Lane's sunset view seems to have more in common with the spiritual atmosphere of Mount Auburn Cemetery than with the activist ideology of westward expansionism and industrial modernization.

Lane worked in relative isolation from Hudson River School artists, but a number of New York-based landscapists also tended toward a more quiet, "luminist" style that depicted simplified scenes of the Atlantic coast. John Frederick Kensett (1816–72) had a particularly successful career highlighted by a series of austerely elemental, light-filled seascapes of Newport, Rhode Island, and Long Island (fig. 5.56). Kensett's friend, the Reverend Samuel Osgood, characterized the artist's paintings of Long Island Sound by comparing them to the stark, funereal landscape of ancient Egypt: "Under his touch we see the marvel of the Egyptian sands reappearing in the shore of our great Sound, and that stone looks upon you with the face of the Sphinx. That rock whispers to you the secret of earth, and sea, and sky" (cited in Roque, pp. 148–149). Unlike Cole's dramatic, often violent landscapes and Durand's and Cropsey's tributes to national progress, Kensett's abstractly minimal views of air, water, light, and earth are virtually silent, sphinxlike meditations on nature's hidden truths. Even Protestant clergymen such as Osgood were turning away from denominational dogmatism and biblical revelation toward the individual soul's direct communications with divine mysteries. No longer able to agree upon specific theological doctrines, many Protestants joined Transcendentalists and Spiritualists in banking their faith on signs for the orderly design of the universe.

5.55 Fitz Hugh Lane Boston Harbor at Sunset, 1850–55. Oil on canvas, 26½ × 42 in (66.8 × 106.6 cm). Museum of Fine Arts, Boston, Massachusetts. Gift of Maxim Karolik for the Mr. and Mrs. Karolik Collection of American Paintings, 1815–1865.

The yellow light of sunset forms a great arc across the horizon, contrasting with the cool blue of the evening sky above. The strong color note of a red-shirted oarsman calls attention to the small central boat that draws us toward the water's reflected glory of golden light.

5.56 John F. Kensett Eaton's Neck, Long Island, 1872. Oil on canvas, $18 \times 36 \text{ in } (45.7 \times 91.4 \text{ cm}).$ Metropolitan Museum of Art, New York.

5.57 Frederic Church Niagara Falls, 1857. Oil on canvas, 42½ imes 90½ in (108 imes229.9 cm). The Corcoran Gallery of Art, Washington, D.C.

Frederic Church

Frederic Edwin Church (1826-1900) emerged from a traditional Protestant background to become a painter who catalogued nature's cosmic wonders from infinitesimal details to grand panoramic views. Following his teacher, Thomas Cole, Church, during the late 1840s and early 1850s, painted biblical landscapes and American historical landscapes that strongly expressed nationalist identification with Old Testament Israel.

Church's most famous work, Niagara Falls, may also be interpreted as a painting that stirred nationalist feeling for America's Manifest Destiny (fig. 5.57). Yet the

picture was also designed to generate a degree of fear and anxiety, testing viewers' faith in God's orderly, benign universe. *Niagara Falls* thrillingly transported beholders to the dangerous edge of Niagara's Horseshoe Falls, forcing them to confront its sheer, physical power. At the lower left a dead tree branch or snag, awash with the flow of white-capped waves, points toward the fatal abyss. Commentators praised the elongated composition, which daringly eliminated a safe foreground:

The spectator stands looking directly upon the troubled waters, flowing at the very base line of the canvas, . . . the eye naturally travels with the current until it reaches the brink of the invisible abyss into which the water tumbles. . . . (cited in Kelly, p. 51)

When the painting was exhibited at a private New York art gallery during the spring of 1857, thousands of spectators rushed to see the work before it left for a tour through England and Scotland.

Ever since John Trumbull and other artists had begun painting views of Niagara Falls (see fig. 5.36), the sublime site had become an icon of national pride. The nearly perpetual rainbow that appeared through the prismatic mist over the Falls conjured forth the rainbow that followed the Flood in the Old Testament book of Genesis. For American tourists, the Niagara Falls' rainbow signified the nation's special identity as a chosen land and people. Church's sweeping, panoramic painting interlinks the powerful arch of the Falls with the relatively tenuous, broken arch of a rainbow. The fractured rainbow descends from left to right through a wall of white mist before disappearing beyond the edge of the Falls.

Church's desire to accurately record physical phenomena competed with his opposing inclination to incorporate biblical symbols into landscapes. Church admired the German natural historian Alexander von Humboldt's (1769–1859) treatise *Cosmos: A Sketch of a Physical Description of the Universe*, published in four volumes beginning during the 1840s. Having traveled extensively throughout North and South America, Humboldt sought to summarize his life's work in an encyclopedic "portrait" of the entire universe. Of particular interest to Church and other artists, Humboldt advocated the art of landscape painting and geological panoramic drawings as a means for exploring and mapping the earth.

In *Niagara Falls*, Church visually replicates Humboldt's cosmic ambition by combining into a single picture views of both the near and far sides of Horseshoe Falls. This panoramic, "all-seeing" perspective expanded the normal power and range of the human eye. Furthermore, by slightly curving the long horizon line, Church suggested the curvature of the earth, the spherical shape of the planet. Moving from the macroscopic to the microscopic, he obsessively studied and sketched the movement of water in preparation for his careful, detailed rendering of its cascading, swirling flow and its misting upward into the atmosphere.

Like Humboldt, Church traveled widely throughout the western hemisphere, recording nature as if he were the original Adam naming the flora and fauna in the Garden of Eden. In 1859, Church exhibited one of his largest and most celebrated paintings, *The Heart of the Andes*, which he had finished after a second trip to Ecuador (fig. 5.58). He imaginatively harmonized into one panoramic canvas a variety of geographical regions and meteorological phenomena ranging from snow-capped mountain peaks to a tropical forest and waterfall in the foreground.

Church ordered a specially built wooden frame for *The Heart of the Andes* that appeared to transform the picture into an upper-story palatial window overlooking

5.58 Frederic Church

The Heart of the Andes, 1859. Oil on canvas, $66\% \times 119\%$ in $(168.1 \times 302.9 \text{ cm}).$ Metropolitan Museum of Art, New York. Bequest of Margaret E. Dows, 1909.

The lofty Andes Mountains are powerful presences in the background, but their rounded, softened peaks do not aspire beyond the picture frame and the strongly horizontal format of Church's panorama. Despite his imaginative juxtaposition of contrasting weather conditions and types of terrain, Church emphasized the seamless harmony of nature, expressed by the foaming, misty waterfall at the right, bearing the water of melted snow from the higher elevations.

a paradisiacal space. The gallery exhibition space was darkened except for the brightly lit and theatrically draped picture window. Visitors were supplied opera glasses for viewing the landscape's myriad details, which were itemized in gallery guides that read like travelogues. Perhaps the most prominent detail is a small cross in the left foreground, which attracts pious pilgrims.

For Church and his traveling companion Cyrus Field, who financed the transatlantic telegraph cable, South America seemed a natural extension of the United States, an untapped area of the New World ripe for economic development and aesthetic appropriation. Church was not the only artist from the United States to explore South America's natural resources or to be captivated by its popular association with the biblical Garden of Eden. The Indian painter George Catlin and the landscape painter Martin Johnson Heade (1819-1904) were among those who also toured South America. After years of painting atmospheric Atlantic coastal scenes similar in mood and style to Fitz Hugh Lane's, Heade embarked upon a series of paintings representing Brazilian tropical flowers and hummingbirds. Though the project was never finished, he had intended to transform the paintings into an illustrated book on hummingbirds. The book project's title, Gems of Brazil, and the vividly colored, lush paintings suggested the rich, paradisiacal treasures that awaited North American scientists and entrepreneurs (fig. 5.59).

Abolitionist and Feminist Art

Though he did not travel to South America, the African-American artist Robert S. Duncanson (1821-72) deeply admired Church's The Heart of the Andes when it was exhibited in Cincinnati, Ohio. Duncanson's The Land of the Lotus Eaters (1861) emu-

5.59 Martin Johnson Heade

Two "Sun Gems" and a "Crimson Topaz", 1866. Oil on canvas, 14×13 in $(35.6 \times 33$ cm). Shelburne Museum, Vermont.

Heade's detailed encyclopedic paintings of hummingbirds continued the tradition of mixing art and natural history, as seen in Charles Willson Peale's museum displays of stuffed birds (see fig. 4.43). However, Heade was more directly following in the footsteps of John James Audubon (1785-1851). who published The Birds of America (1826-1838), a collection of 435 handcolored prints based on his own original watercolors of more than a thousand different birds.

lated Church's tropical landscape. However, the Cincinnati artist already had been painting Edenic pastoral landscapes before witnessing Church's South American masterpiece.

A light-skinned mulatto who was the son of a free African-American carpenter-house painter, Duncanson was born in upstate New York but began his career in Cincinnati as a largely self-taught landscapist working in the Hudson River School style. Located on the Ohio River, across from the slave state of Kentucky, Cincinnati was divided over the issue of slavery. A sizable community of free blacks and white abolitionists confronted the institutional racism of the city's discriminatory "Black Laws" as well as anti-abolitionist mob violence that frequently targeted the black neighborhood of Bucktown.

Duncanson's racially mixed ancestry and lighter skin color facilitated his career, since white patrons tended to regard mulattoes as intellectually and emotionally superior to dark-skinned African Americans. Ambiguously situated between black and white, Duncanson angrily rejected accusations that he sometimes attempted to pass as white. He contributed to activities sponsored by the abolitionist movement and painted the portraits of Cincinnati's leading abolitionists. Yet, for the most part, he avoided explicit anti-slavery themes in his paintings, undoubtedly fearing that he might alienate his white clientele with overt, politically volatile subject matter.

Duncanson's *Uncle Tom and Little Eva* is the singular exception to the artist's avoidance of the slave controversy (fig. 5.60). Painted on commission for an aboli-

tionist newspaper editor from Detroit, the picture represents a scene from the celebrated anti-slavery novel Uncle Tom's Cabin (1852) by Harriet Beecher Stowe, a former Cincinnati resident. Depicting an Edenic, tropical landscape, Duncanson focuses upon the Christlike, otherworldly figures of Little Eva, the dying daughter of a Louisiana plantation owner, and Uncle Tom, an aging, loval slave for Eva's ungrateful father. Gesturing toward a colorful sunset, Duncanson's angelic Eva, dressed in white, links arms with the seated Tom, who listens intently to her vision of the heavenly afterlife, where all souls are free and equal. The painting suggests that the reconciliation of black and white and the liberation from slave labor may have to wait for another world spiritually superior to the imperfect present. The painting's gardenlike setting and statuesque little girl bear resemblance to the pastoral environments of rural cemeteries with their white marble sculptures promising the continued spiritual presence of the deceased. Duncanson was a follower of the Spiritualist movement, as were many abolitionists. They, like the artist, harshly judged the institution of slavery against the higher moral standards of the spirit world. Later in his career, Duncanson reportedly told friends that a spirit was assisting him in paintings of paradisiacal landscapes.

5.60 Robert Duncanson Uncle Tom and Little Eva, 1853. Oil on canvas, 27% imes38% in (69.2 \times 97.1 cm). Detroit Institute of Art. Gift of Mrs. Jefferson Butler and Miss Grace R. Conover.

Such claims were not unique to Duncanson nor were they necessarily signs of mental derangement. Other Spiritualist artists also were inspired by visions of spirits. During the same year that he finished Uncle Tom and Little Eva, Duncanson traveled to Italy and visited the studio in Florence of Hiram Powers, whose sculpture The

Greek Slave he had long admired (fig. 5.61). Powers had begun his career in Cincinnati and shared abolitionist sympathies with Duncanson. Belonging to the Swedenborgian Church, named after the Swedish mystic Emanuel Swedenborg (1688–1772), Powers also transformed his Florentine home into a meeting place for Spiritualist séances. Possibly Powers encouraged Duncanson's inclination toward communication with the souls of the spirit world.

In his general avoidance of overt references to African-American slavery, Duncanson took a lesson from Powers, whose *The Greek Slave* symbolized the early-nineteenth-century Greek struggle for independence against the Muslim Turks of the Ottoman Empire. In hope of gaining greater sympathy for slavery's abolition in the United States, American abolitionists publicized horrific stories of Turkish "infidels" enslaving white-skinned Caucasians. The Scottish artist Sir William Allan's painting *Sale of Circassian Captives in a Turkish Bashaw* (1818) was favorably reviewed by the abolitionist press. Although Allan's picture may have influenced Powers's decision to sculpt the *The Greek Slave*, Powers apparently feared that abolitionist zeal would destroy the national union.

Powers attributed the origins of this erotic nude sculpture not to political concerns over slavery but to a recurrent boyhood dream. In 1851, he wrote his cousin:

I used to see in my sleep, when a child, a white female figure across the river. . . . It stood upon a pillar, or pedestal, was naked and to my eyes very beautiful. But the water was between me and it, too deep to ford. I had a strong desire to see it nearer, but was always prevented by the river, which was always high. This dream ceased years after, when I began to model. Altogether, one may conclude that the dream was not entirely a phantom. At that time I had no wakeful thought of sculpture, nor had I ever seen anything likely to excite such a dream. (cited in Wunder, I. p. 181)

The Greek Slave was just one of many female nudes that materialized Powers's libidinal desire to cross the river into manhood. But the manacled figure is particularly charged with sadomasochistic overtones. Anticipating hostile reviews from prudish critics, Powers attempted to "clothe" his idealized nude with morality and chastity. When the sculpture was exhibited to enthusiastic crowds in London in 1845 and then American cities beginning in 1847, visitors were given catalogues with Powers's narrative, explaining the reason and meaning of the figure's nudity. With a crucifix dangling at her side, the victimized woman attempts to deflect the corrupt, sexual gaze of her Turkish captors. She stares at them with dignified defiance while modestly covering her pubic region with one hand.

So popular was *The Greek Slave*'s synthesis of eroticism and Christian moralism that Powers finished six different versions of the figure. Choosing to ignore possible, if unintended, allusions to African-American slavery, Southerners also flocked to see the controversial, world-famous sculpture. As a personification of female virtue and Protestant opposition to paganism, the statue won over numerous clergymen, although some insisted upon separate viewing hours for women and

5.61 Hiram Powers
The Greek Slave, 1843.
Marble, 65 in (165.1 cm) high.
Yale University Art Gallery,
New Haven, Connecticut.
Olive L. Dann Fund.

5.62 Harriet Hosmer Zenobia, 1857-59. Marble, 88 in (223.5 cm) high. Wadsworth Atheneum, Hartford, Connecticut.

Hosmer may have been inspired by the English author Anna Jameson's popular Memoirs of Celebrated Female Sovereigns (1831).

children. Ironically, however, in Cincinnati, where Powers began his career, The Greek Slave received a barrage of negative criticism from religious journals. The Western Christian Advocate implicitly equated the sculpture and other nude statuary with prostitutes "traveling from city to city, and from town to town, exhibiting themselves for money; and strange to say, they draw large audiences even among the ladies!" (cited in Wunder, I. p. 233).

To counter the danger of sexual voyeurism in the appreciation of sculptures, art advocates recommended that beholders stand at a distance from the work. Close-up views were discouraged because they emphasized

> the marble or the material representation of flesh. The superior distant view, by contrast, was "poetic" because it invited viewers to meditate upon the spiritual whole and moral meaning of the piece rather than its seductive, physical parts. From this poetic point of view, The Greek Slave's message of victimization and chaste defiance appealed to American women, who clothed the figure with their own narratives. Feminist and abolitionist associations coalesced in the minds of some women. One woman writer imagined the white slave's "capture, her exposure in the market place; the freezing of every drop of her young blood beneath the libidinous gaze of shameless traffickers in beauty" (cited in Kasson, p. 63).

As the art historian Charles Colbert has demonstrated, Powers's sculpture also seemed to express the concerns of middle-class women involved in health and clothing reform. Groups such as the Ladies' Physiological Institute, founded in Boston in 1848, studied ways to improve the well-being and development of the female body within an increasingly urbanized environment. Resisting the male-dictated fashion industry's promotion of corsets, girdles, and other articles of tight-fitting clothing that constricted the natural contours and movements of the female body, reform-minded women could admire the beauty of The Greek Slave as a healthful and liberated image of ideal womanhood.

The financial success of The Greek Slave encouraged other sculptors to emulate or compete with the celebrated statue. In Rome, the Massachusetts-born sculptor Harriet Hosmer (1830-1908) responded to Powers's image of female powerlessness with her fully clothed historical figure of Zenobia (fig. 5.62). Zenobia, Queen of Palmyra in Syria during the third century C.E., had defied Roman domination of the Middle East but was captured by the Emperor

Aurelian, who paraded her in chains through the streets of Rome.

While perpetuating the stereotypical image of female captivity, Hosmer's Zenobia, like Margaret Foley's Cleopatra (see fig. 5.13), commemorated a woman who had wielded governmental authority against powerful men and military forces. Hosmer was not active in the struggle for women's suffrage until the end of the century, but her dignified sculpture expressed feminists' resistance to political powerlessness. In an 1859 letter to the Cosmopolitan Art Journal, Hosmer characterized her Zenobia as an unsentimental personification of strength: "I have tried to make her too proud to exhibit passion or emotion of any kind; not subdued, though a prisoner; but calm, grand, and strong within herself" (cited in Kasson, p. 155).

Hosmer's later political portrait of the United States Senator Thomas Hart Benton was clothed and posed in a manner closely resembling the Zenobia. Hosmer had herself photographed standing next to the clay model of the colossal statue (fig. 5.63), which had been commissioned by the state of Missouri. Cloaking Benton in a Roman togalike costume that hangs like the Palmyran queen's, Hosmer wore masculine "Zouave trousers" beneath her skirt rather than petticoats, which enabled her to move more freely on the scaffolding surrounding the sculpture. When the final bronze sculpture was unveiled in St. Louis in 1868, her detractors criticized the cloak for being in conflict with Senator Benton's ruggedly masculine character.

Hosmer's sculptures implicitly suggested the fluidity or interchangeability of gender roles. Her own unconventional life as an unmarried woman who dressed and behaved in masculine ways also challenged stereotypes. In addition to pursuing a professional career overwhelmingly dominated by men, Hosmer identified herself as a Spiritualist medium. As an artist, she confronted the common male prejudice that women could not create original works of art. Perhaps for this reason, Hosmer openly discussed her experiences as a Spiritualist medium and, early in her career, chose to represent sprites or playful spirit-children, who had appeared to her in personal visions.

More powerfully, photography served Hosmer's purpose in proving herself an accomplished artist. The photograph of Hosmer touching the Benton

statue with one hand while holding a sculpting instrument with the other documented her creativity, refuting charges that her statues were conceived by Italian male assistants. Nevertheless, later in the century, the American novelist Henry James dismissively referred to Hosmer and other American women sculptors in Rome as the "white marmorean flock" (cited in Kasson, p. 11). The phrase derided the group's collective preference for the traditional, non-classical medium of marble rather than bronze, the malleable material favored by more naturalistic sculptors after the Civil War.

5.63 Anonymous Harriet Hosmer at Work on her Statue of Senator Benton, c. 1861. Albumen print. Schlesinger Library, Radcliffe College, Cambridge, Massachusetts.

Photography and the Democratization of Art

Unlike the idealizing medium of white marble, the photographic process appeared inherently realistic and objective when introduced to the American public in 1839. Literally translated as "writing with light," photography seemed to exclude the fallible hand of an artist. Piercing through a camera's lens, sunlight "drew" nature's image upon a chemically sensitized plate or film. Nature, a New York critic claimed, "shall paint herself . . . by virtue of the sun's patent, all nature, animate and inanimate, shall be henceforth its own painter, engraver, printer, and publisher" (cited in Foresta and Wood, p. 224). Yet the photographer seemed to possess magical, occult powers in recording phenomena that the human eye misses or overlooks. In The House of Seven Gables (1851) the New England novelist Nathaniel Hawthorne (1804–64) featured a "daguerreotypist," or photographer, who enigmatically states: "There is a wonderful insight in heaven's broad and simple sunshine. While we give it credit only for depicting the merest surface, it actually brings out the secret character with a truth that no painter would ever venture upon, even could he detect it" (p. 68).

Samuel F. B. Morse led American artists in embracing the optical and chemical process that could "fix the image of the camera obscura" (cited in Kloss, p. 143). Ever since the Renaissance, artists had known of this "darkened chamber" or box, which could project exterior images onto a surface interior. But, until the nineteenth century, artists could preserve the naturalistic image only by tracing over it manually. Morse recalled that during his youth, while a student at Yale University, he had experimented with camera images, attempting to make them permanent through use of paper that had been made light-sensitive by being "dipped into a solution of nitrate of silver" (cited in Kloss, p. 146). But he discovered to his frustration that the tonal areas were reversed in the final result: "light produced dark, and dark light" (cited in Kloss, p. 146). Morse had produced a negative image but did not yet know that negative film could be used to make positive photographic prints.

Later in his career, after he had become President of the National Academy of Design, Morse met the Parisian artist-inventor Louis Jacques Mandé Daguerre (1787–1851), whose daguerreotype process employed polished, light-sensitized metal plates for producing positive images that did not invert light and dark areas. Using the vapors given off by heated mercury, Daguerre developed the film plate to "bring out" the latent image, fixed it by washing away the remaining photosensitive salts, and then toned the plate with gold chloride to heighten the light-dark contrast and the image's durability. Because of its fragility and the tendency of the silver plate to tarnish, the daguerreotype had to be protected further by a glass covering. Nevertheless, Daguerre had created clear, detailed pictures that amazed Morse.

When Morse returned from his visit to Paris in 1839, he experimented with the daguerreotype process and publicized it as an important advance in the democratization of art. He announced to his former painting teacher, Washington Allston:

Art is to be wonderfully enriched by this discovery. How narrow and foolish the idea which some express that it will be the ruin of art, or rather artists, for every one will be his own painter. One effect, I think, will undoubtedly be to banish the sketchy, slovenly daubs that pass for spirited and learned: those works which possess mere general effect without detail, because, forsooth, detail destroys general effect. Nature in the results of Daguerre's process, has taken the pencil into her own hands, and she shows that the minutest detail disturbs not the general repose. Artists will learn how to paint, and amateurs, or rather connoisseurs, how to criticise, how to look at Nature, and, therefore, how to estimate the value of true art. Our studies will now be enriched with sketches from nature which we can store up during the summer, as the bee gathers her sweets for winter, and we shall thus have rich materials for composition and an exhaustless store for the imagination to feed upon. (cited in Kloss, p. 146) For Morse, photography was a teaching tool that could visually educate the public, enabling every American to become an artist or informed art critic. Following his advice, many American painters minimized sketchlike brushwork to produce detailed, quasi-photographic pictures. Engraved reproductions of daguerreotypes began appearing in popular magazines, competing with illustrations of artists' paintings. Since there was no negative, the daguerreotype print was a unique image that could be reproduced only by taking another picture of it with a camera or by manual printing methods. The daguerreotype was also laterally reversed like a mirror image. The reversal was particularly noticeable in city views, where store signs read backward. By attaching a mirror to the camera lens, daguerreotypists later rectified the error. Engraved reproductions or rephotographing the original daguerreotype also corrected the mirror reversal although copies inevitably lacked the original's clarity.

Lengthy exposure times made it impossible to record figures in motion and initially made portraits an uncomfortable ordeal for sitters, who had to remain motionless, held in place by iron headrests for long minutes while being blinded by lights from windows and mirrors. However, by the 1840s American daguerreotypists had made technical improvements that reduced exposure times to a few minutes and finally to less than half a minute. Throughout America, daguerreotypists, many of them former painters, established photographic studios and galleries that displayed rows of framed portraits.

In Cincinnati alone, by 1851, there were thirty-seven daguerreotype studios. During the mid-1850s, Robert Duncanson worked for the African-American daguerreotypist James Presley Ball (1825–1904), whose lavishly decorated gallery was patronized by Cincinnati's leading citizens. To elevate the photographic medium to the level of high art, Ball displayed Duncanson's painted landscapes on the wall above his daguerreotypes and entertained visitors with music. Ball also asked Duncanson to hand-color photographs to make them look more like paintings.

However, even in their black-and-white state, daguerreotypes often mimicked painterly qualities. In Boston, the photographic team of Albert Sands Southworth (1811–94) and Josiah Johnson Hawes (1808–1901) dramatically portrayed Chief Justice Lemuel Shaw of the Massachusetts Supreme Court in a classical oratorical pose (fig. 5.64). Sunlight cascades over his jowly face and corpulent body, creating impressionistic contrasts of light and dark. Despite Shaw's stiff pose, the picture seems animated by a luminous, spiritual energy. Similarly, the series of photographs that Southworth and Hawes made of Mount Auburn Cemetery contrasts ghostly white tombstones and mausoleums with the surrounding darkness of trees and landscape (see fig. 5.27). Art historians have compared the tonal qualities of these photographs to the luminist paintings of Fitz Hugh Lane (see fig. 5.55).

On the eve of the Civil War, the popularity of the daguerreotype had declined in favor of a negative-positive process first invented by the English photographer William Henry Fox Talbot (1800–77). During the late 1830s, Talbot had demonstrated that a negative image on paper film could be transferred to another surface, creating a positive paper print with both light and dark areas and lateral directions corresponding to the appearance of the subject. Owing to the granular quality of the chemically treated paper film, Talbot's photographs lacked the crisp clarity of the daguerreotype's metal-plate images. However, after 1851, the collodion process displaced paper with grainless glass negatives, enabling the reproduction of finely detailed photographic prints.

5.64 Albert Sands Southworth and Josiah **Johnson Hawes** Lemuel Shaw, 1851. Daguerreotype, $5\% \times 4$ in $(13.3 \times 10.1 \text{ cm})$. Metropolitan

Museum of Art, New York.

The stark contrasts of light and dark in this daguerreotype were reputedly a stroke of luck. When Shaw walked into the photographic studio for his sitting, he apparently just happened to step into a spot where a sunbeam suddenly highlighted his rugged features. Working as quickly as possible, Southworth and Hawes attempted to capture this fleeting moment of time. This story underscores the important role of nature in "painting" the image.

positive process facilitated the mobility of documentary photographers. Once Confederate forces began firing on Union troops at Fort Sumter, South Carolina, on April 12, 1861, photographers took to the field with wagons filled with equipment and chemicals to record history in the making. Hampered by their cumbersome equipment and technical difficulties in recording figures in motion, the 1,500 photographers who produced tens of thousands of images documenting the war and its participants could not capture actual battle scenes. Nor could photographers travel to many battlefields distant from urban centers. Because of a Union naval blockade of the South, few photographers had the necessary supplies to record Confederate military life. Despite its limitations, the modern

Technical improvements in the negative-

mechanical process of photography provided an unprecedented visual record of warfare's increasingly mechanized, devastating effects. During four years, nearly 10,500 military actions occurring over eighteen states and territories took a toll of over 1 million casualties and at least 623,000 deaths of Union and Confederate troops. Virtually every family in both the North and the South was affected by the loss of relatives and friends. For the United States president, Abraham Lincoln, the primary

goal was not to abolish slavery but to preserve the Union and defeat the Confederacy as a separate nation.

Photographers brought Civil War battlefields into American consciousness in a manner that seemed to surpass the communicative power of history painting. Civil War photographs of corpses on the battlefield transfixed beholders (fig. 5.65). Civilians in the North flocked to the New York gallery of Mathew Brady (1823–96). Brady employed a team of photographers to follow Union troops. On October 20, 1862, the New York Times reviewed an exhibition at Brady's gallery, following the Union victory at the Battle of Antietam:

Mr. Brady has done something to bring home to us the terrible reality and earnestness of war. If he has not brought bodies and laid them in our dooryards and long the streets, he has done something very like it. At the door of his gallery hangs a little placard, "The Dead of Antietam." Crowds of people are constantly going up the stairs; follow them and you find them bending over photographic views of that fearful battle-field, taken immediately after the action. Of all objects of horror one would think the battlefield should stand pre-eminent, that it should bear away the palm of repulsiveness. But, on the contrary, there is a terrible fascination about it that draws one near these pictures, and makes him loth [sic] to leave them. You will see hushed, reverend groups standing around these weird copies of carnage, bending down to

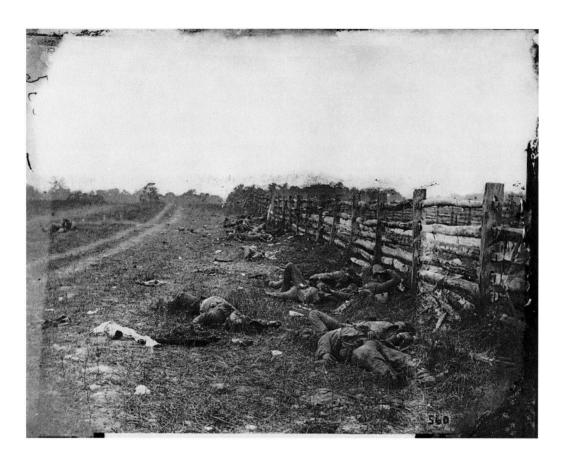

look in the pale faces of the dead, chained by the strange spell that dwells in dead men's eyes \dots

The ground whereon they lie is torn by shot and shell, the grass is trampled down by the tread of hot, hurrying feet, and little rivulets that can scarcely be of water are trickling along the earth like tears over a mother's face. It is a bleak, barren plain and above it bends an ashen, sullen sky. . . .

These pictures have a terrible distinctness. By the aid of the magnifying glass, the very features of the slain may be distinguished. (cited in Davis, pp. 150–152)

Contradicting the poetic, distant gaze recommended for marble sculptures, photographs invited close, magnified viewing of details that the unaided eye could not hope to notice. The photograph's optical realism created an uncanny, hallucinatory effect that forced viewers to make verbal sense of the blank, mute faces of the dead. As if to comfort visitors to Brady's exhibit, the *Times* critic poetically buries the dead within the tearful, blood-stained embrace of Mother Earth. "Hushed, reverend" beholders add to the impression that Brady's gallery has been transformed into a funeral parlor or wake for the dead.

Battlefield photographs not only laid soldiers' corpses in dooryards and city streets, but they brought them into the parlors of private homes. One of Brady's best photographers, Alexander Gardner (1821–82), established his own studio by 1863 with the intention of publishing a photographic album of the war. Juxtaposing word and image, he attempted to give poetic, nationalist meaning to the fratricidal conflict. His most famous photograph, *A Harvest of Death, Gettysburg, Pennsylvania,*

5.65 Mathew B. BradyOn the Antietam Battlefield,
1862. Library of Congress,
Washington, D.C.

1863, metaphorically transforms the specific horror of the Battle of Gettysburg into an allegory of the cycles of life (fig. 5.66). The seeds of discord sown in previous decades are now being harvested by Death. Receding from the foreground toward the misty horizon, Gardner's corpses become less corporeal, more ethereal, as if their souls are being drawn heavenward by the sun's light.

Through poetic titles and moralizing commentary, Gardner's Photographic Sketchbook of the Civil War created ideological, aesthetic distance from the war's carnage. Verbally framed by the themes of sacrifice and renewal, Gardner's corpses become living sculptures anticipating the restoration of the Union and its memorialization in marble and bronze. However, photography's relative realism dealt a powerful blow to the cultural prestige of history painting, which traditionally represented important heroes performing virtuous or ennobling deeds, as exemplified by John Trumbull's Revolutionary War paintings (see fig. 4.30) or Benjamin West's The Death of General Wolfe (see fig. 4.21). The seemingly matter-of-fact photographs of Civil War battlefields seriously deflated the dramatic and grandiose visual rhetoric normally employed for representing history subjects. During the decades that followed the war between the states, many artists responded to the accelerated pace of urbanization and economic modernization by turning inward toward more private and spiritual forms of aesthetic communication. Supported by a growing number of critics, art dealers, and wealthy patrons, American artists also functioned as canny entrepreneurs in marketing their work and promoting themselves as the arbiters of taste and fashion. In the chapter that follows, we shall examine how post-Civil War artists attempted to reconstruct national unity and purpose through the healing, therapeutic powers of art.

5.66 Alexander Gardner and Timothy O'Sullivan A Harvest of Death, Gettysburg, Pennsylvania, 1863, from Gardner's Photographic Sketchbook of the War by A. Gardner, 1865. Wet plate, albumen. New York Public Library, New York.

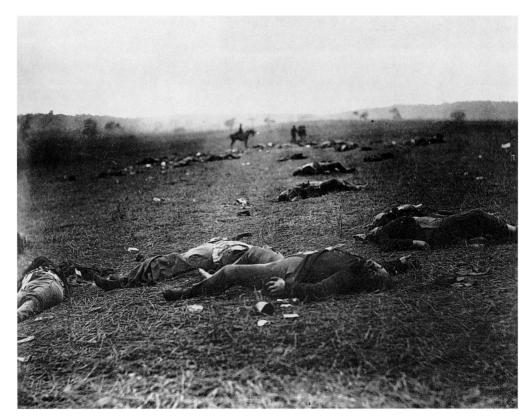

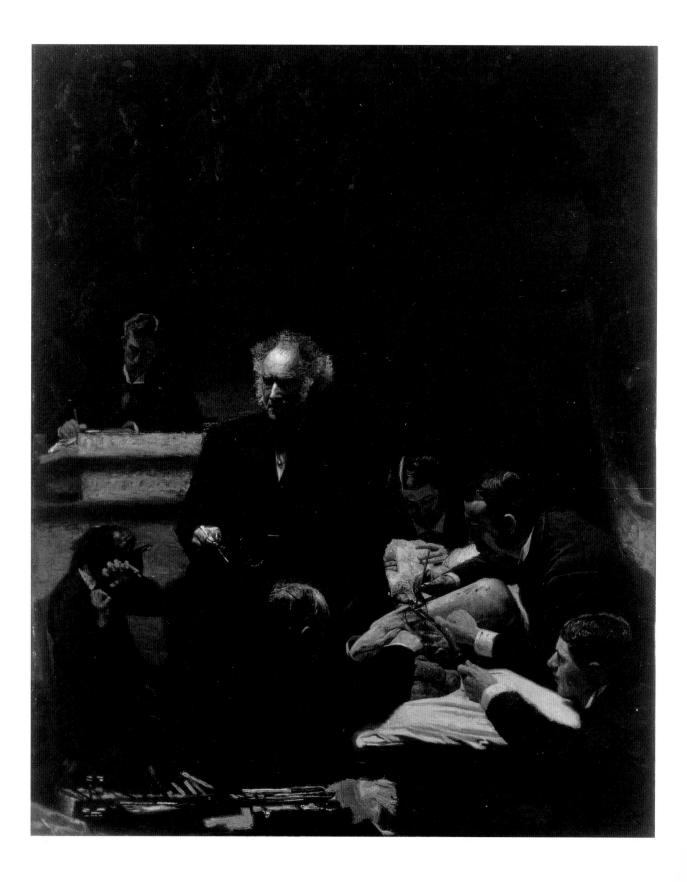

CHAPTER 6

Art and Commerce in the Gilded Age

1865-1905

he four decades from 1865 to 1905 comprise America's Gilded Age, in which the nation resurrected itself from the ashes of the Civil War and became the world's leading industrial power. The country's most prominent industrialists and financiers, including Andrew Carnegie in steel manufacturing, John D. Rockefeller in oil, and Cornelius Vanderbilt in railroads, became multimillionaires. Unencumbered by personal income taxes, they ostentatiously spent their wealth by living like European aristocrats. Commissioning American architects and artists to build and decorate palatial mansions, they also collected European Old Master paintings and sculptures as well as Japanese and other Oriental decorative arts. Interest in non-Western art was abetted by American foreign policy. During the early 1850s, Commodore Matthew C. Perry had led U.S. diplomatic expeditions to persuade Japanese officials to permit the business ventures of American merchants. By the time that World War I began in Europe in 1914, the United States had become an imperial power in Asia and Latin America.

In 1867, just two years after the end of the Civil War, Secretary of State William H. Seward successfully negotiated the purchase of Alaska from Russia for just over \$7 million in gold. Approved by Congress the following year, the acquisition of the new territory of Alaska, twice the size of Texas, pushed Americans further westward toward the coast of Siberia and the continent of Asia. In 1893, as Americans continued to celebrate the four-hundredth anniversary of Christopher Columbus's 1492 voyage of discovery, the Hawaiian Islands in the Pacific Ocean became a U.S. protectorate. A few years earlier, an invading force of United States Marines had installed a new Hawaiian government friendly to American commercial investments in the sugar industry. In 1898, the United States declared war against Spain and asserted authority over Latin America by expelling Spanish colonial forces from Cuba and acquiring the colony of Puerto Rico. The Spanish-American War also extended to the Pacific Ocean as the United States pushed further westward to take possession of the Philippine Islands and Samoa. Finally, during the early twentieth century, the United States forcibly appropriated a ten-mile-wide strip of land from Panama in Central America to build a canal that would facilitate naval and commercial ship traffic between the Atlantic and Pacific Oceans. Begun in 1906, the Panama Canal was completed in August of 1914 just as World War I was beginning in Europe.

The Gilded Age visually manifested America's economic and imperial power with spectacular social and cultural displays. Believing that the United States could not surpass Europe unless it appropriated cultural capital or masterpieces and symbols of high art, American men of wealth, beginning during the 1870s, founded major city art museums such as the Museum of Fine Arts in Boston, the Metropolitan Museum of Art in New York, the Art Institute of Chicago, and the

Thomas Eakins

The Gross Clinic, 1875. Oil on canvas, 96×78 in (243.8 \times 198.1 cm). Jefferson Medical College of Thomas Jefferson University, Philadelphia.

Eakins's heroic portrait of Dr. Samuel Gross has often been compared to Rembrandt van Rijn's The Anatomy Lesson of Dr. Nicolaas Tulp (1632). However, the Dutch painter's graphic painting represents the dissection of a cadaver rather than a surgical act of healing. Eakins depicts the modern advancement of medical practice for the direct benefit of patients. Dr. Gross's removal of a dead bone for the treatment of osteomyelitis, a bone disease, superseded the past practice of amputating entire limbs.

Philadelphia Museum of Art. Members of the corporate elite dominated museum boards of trustees. They envisioned the building of art museums, libraries, and other cultural institutions as a means of competing with European nations in claiming the legacy of Western civilization as descended from Greco-Roman antiquity and the Italian Renaissance. Multimillionaires such as the banker J. Pierpont Morgan and the coal and steel magnate Henry Clay Frick filled newly built New York mansions with vast collections of European art objects, manuscripts, and rare books.

Descendants of the railroad magnate Cornelius Vanderbilt were particularly prolific in building and furnishing lavish new mansions. More than any other family, the Vanderbilts emulated the famous Medici banking family of the Italian Renaissance in their extensive art patronage. From 1876 to 1917, Vanderbilt family members constructed and furnished seventeen large mansions, significantly contributing to an American Renaissance of art and architecture. The Vanderbilt family's favorite architect, Richard Morris Hunt (1827–95), designed their most spectacular estate, "Biltmore," near Asheville, North Carolina (fig. 6.1). Intended as the principal residence for George Washington Vanderbilt, grandson of Cornelius, the 255-room mansion on 125,000 acres of forest and landscaped woodland cost \$5 million and was designed in the aristocratic style of a French château. The largest private home in the United States, Biltmore housed a vast collection of European art objects and a large library of rare books (fig. 6.2). George W. Vanderbilt's father, William H. Vanderbilt, owned a Fifth Avenue, New York City, mansion that became the subject of a ten-volume description of its art collec-

6.1 Richard Morris HuntBiltmore, Asheville, North
Carolina, 1895. Biltmore
Estate, Asheville, North
Carolina.

Conceived in an early French Renaissance style, the threestory limestone mansion features two lateral projecting wings balanced on either side of an entrance pavilion. Recessed courts connect the wings to the central pavilion, from which a grand staircase projects on the left side. The essentially symmetrical arrangement of the building masses is picturesquely complicated by a wealth of decorative detail. The ornamented dormer windows piercing the steeply pitched roof contribute Gothic, vertical accents to the building facade.

6.2 Richard Morris Hunt Biltmore Library, Asheville, North Carolina, 1895. Biltmore Estate, Asheville, North Carolina.

The library was the most richly decorated room in the Biltmore mansion. Hunt sought the assistance of the Viennese-born sculptor Karl Bitter (1867-1915) to decorate the Italian black marble fireplace. On the overmantel, above the fireplace, Bitter carved two wooden standing female figures to flank a seventeenth-century tapestry. To the fireplace's andirons, Bitter attached small, polished steel representations of the Roman gods Vulcan and Venus. In addition to Biltmore, Bitter helped ornament other Huntdesigned mansions.

tion and interior decoration. An American decorator, Christian Herter (1840-83), was responsible for designing and supervising work on all the ornamental details, creating an eclectic mélange of Japanese, Italian Renaissance, and other cultural styles (fig. 6.3). Having been removed from their original sites or historical contexts, the art objects collected by American industrialists lost their traditional symbolic, moral, or religious meanings. Judged by supposedly universal standards of aesthetic quality, decontextualized objects of Western and non-Western art became interchangeable and more precisely measurable in monetary terms as marketable commodities and precious investments.

Bolstering America's international standing, a series of spectacular world's fairs, held at home and abroad, celebrated the latest advances in science and modern technology such as the telephone, the electric light bulb, and the latest industrial machinery. They also attracted crowds with extensive cultural exhibitions that showcased participating nations' contributions to architecture and the decorative and fine arts. Visited by many affluent, cosmopolitan Americans, the Exposition Universelle held in Paris in 1867 created a fashion for French art in the United

States, leading many younger artists to abandon provincial or uniquely American subject matter in favor of more generalized, non-narrative themes and more personal, sketchlike techniques. In 1876, nearly ten years later, Philadelphia's Centennial Exposition, celebrating the one-hundredth anniversary of the Declaration of Independence, nostalgically revived interest in the arts and crafts of colonial America. At the same time, however, the Japanese pavilion became one of the most widely praised exhibitions at the fair, with its rich display of porcelain vases, bronze objects, painted silks, embroidered fabrics, and lacquered ware. Inspired by the Centennial Exposition, the architects Charles Follen McKim (1847-1909), William Rutherford Mead (1846-1928), and Stanford White (1853–1906) designed a casino, or entertainment pavilion, in the fashionable ocean resort community of Newport, Rhode Island, that featured a Japanese-style interior of continuous open spaces interwoven with skeletal, light wooden screens and moldings (fig. 6.4).

The 1876 Centennial Exposition stimulated the Aesthetic movement in the United States, as middle- and upper-class Americans, concerned over the quality of mass-produced industrial goods, applied aesthetic principles to a wide array of household and consumer goods, including furniture, textiles, wallpaper, ceramics, metalwork, glassware, and books. Beginning with the Great Exhibition of 1851, held in London's Crystal Palace, which made evident the poor design of most manufactured objects, British reformers established industrial training programs, design schools, and, in 1857, the South Kensington Museum (today the Victoria and Albert Museum), a national museum of design.

These developments were widely praised by American art critics. Just before the end of the Civil War, James Jackson Jarves (1818-88), an art collector and son of a glass manufacturer, published The Art-Idea (1864), in which he called upon American industrialists to surpass their British rivals:

England preserves her preeminence by schooling her artisans in matters of refined taste and perfect workmanship. Under similar advantages, there is no reason why our people, with more cosmopolitan brains, acuter sensibilities, readier impressibility, and quicker inventive faculties, should not excel her in these respects, as we do already in some of the industrial arts. We have a continent of fast-multiplying millions to supply with all the fabrics into which aesthetic enjoyment may enter, as well as with absolute works of art. And what utensil is there with which we may not, as did the Greeks, connect beauty of form and color, and which we may not make suggestive of hidden meaning, pointing a moral or narrating a tale? (p. 266)

During the next four decades, American artists and architects directly and indirectly addressed public anxieties over the effects of industrialization and urbanization. Most were influenced by the Aesthetic movement's emphasis on the decorative arts and by the development of an Arts and Crafts movement, which promoted the handmade, nonmechanized products of artisans and their small workshops over factory labor. Even architects of steel-framed skyscrapers conceived their designs in terms of natural, organic growth and ornamented the buildings with historical and vegetal motifs (see fig. 6.9). In response to the new, corporate age of assembly-line production, advertising, and illustrated magazines and newspapers, artists and critics increasingly placed a high value on originality and irreproducible signs of artistic creativity. With its voluntary societies, professional design firms, magazines, and educational classes, the Arts and Crafts movement extended the Aesthetic movement's campaign to beautify the home into the 1890s and early twentieth century. While there was a considerable overlap between the two movements, with each drawing upon medieval and Oriental stylistic sources, and the talents of numerous women as well as men, Arts and Crafts reformers more readily espoused a democratic, progressive ideology devoted to the improvement of working-class life. Politically, however, the Arts and Crafts movement's emphasis on handicrafts and fine artisanship did little to challenge the capitalist mode of factory production, as the ranks of industrial labor mushroomed with millions of new immigrants.

6.3 The Japanese Room

from a plate in Edward Strahan (Earl Shinn), Mr. Vanderbilt's House and Collection (New York, 1883-4), Morris Library, University of Delaware, Newark, Delaware.

Bearing comparison with James Abbott McNeill Whistler's earlier Peacock Room for Frederick Leyland (see fig. 6.51), Herter's Japanese Parlor had its goldbrocaded walls lined with lacquered shelves and cabinets to hold Vanderbilt's collection of Japaneseimported art objects. The upper walls and ceiling were lined with bamboo to accentuate the oriental character of this jewelboxlike space.

As the national population more than doubled between 1860 and 1900 from 31 million to approximately 76 million, some 15 million immigrants crowded into the nation's rapidly growing cities. Initially, most of these immigrants came from Britain, Ireland, Germany, and Scandinavia. However, after 1890, immigrants from eastern and southern Europe-Poles, Russian Jews, Ukrainians, Italians, Greeks, Slovaks, Hungarians, and others—outnumbered those from northwestern Europe. Thousands of Chinese immigrants joined Irish laborers and Civil War veterans in completing, by 1869, the transcontinental railway for the Union Pacific and Central Pacific railroads. Expressing the prejudices of many white, Anglo-Saxon Protestant Americans, popular magazines and newspapers routinely published cartoons filled with demeaning racial caricatures or ethnic stereotypes, warning that the tide of poor immigrants threatened American liberties and institutions.

The Aesthetic and Arts and Crafts movements had little to offer these new immigrants, who scarcely fit James Jackson Jarves's ideal image of the Anglo-American artisan. Even national trade unions such as the American Federation of Labor (founded in 1886) excluded from membership Asian and Eastern European immigrants as well as African Americans and women. Unions largely refrained from organizing unskilled workers in iron and steel manufacturing and other industries. Though the American workforce grew with cheap immigrant labor, manufacturing actually became more dependent upon heavy investments in machinery and new technologies. Money invested in low-wage workers paled in comparison, as mechanized, assembly-line factories grew ever larger. To keep labor costs low, capitalist

6.4 McKim, Mead, & White Casino, Newport, Rhode Island (1879-80). Paper print. Newport Historical Society,

Newport, Rhode Island.

entrepreneurs hired teams of managers to monitor workers' efficiency. Industrialists such as Andrew Carnegie and Henry Clay Frick, who became renowned for their philanthropy and art collecting, readily employed strikebreakers and private, armed security forces to destroy unions and drive down workers' wages. Furthermore, to protect themselves against competition and the unpredictable fluctuations of market supply and demand, bureaucratic corporations combined to form large trusts or monopolies in the production and distribution of agricultural and manufactured goods.

Though historical-revival styles may have evoked a certain nostalgia for preindustrial social and cultural values, they also became expressions of America's modern economic power and corporate energy. Most spectacularly, the Gilded Age produced the American Renaissance. Soon after the Civil War, American architects, sculptors, and painters actively collaborated in commissions to beautify growing cities with civic monuments and murals and sculptures for new public buildings and private homes. American artists and architects freely borrowed figures and forms from Italian Renaissance art, hoping to demonstrate that the course of history had moved westward from Europe and that human culture now was attaining its evolutionary zenith in the New World.

At the beginning of this period in American art, James Jackson Jarves agreed with the English art critic John Ruskin (1819–1900) that the beautification of even the humblest utensil could point toward an uplifting moral value. However, by the end of the period, a number of artists and writers were criticizing the artificiality and aesthetic illusions created by the leisured classes. In her novel *The House of Mirth* (1905), the New York author Edith Wharton (1862–1937) created the tragic heroine Lily Bart, who uses her physical beauty to enter New York City's elite social circles. One evening, Lily triumphantly participates in a lavish high-society entertainment, *tableaux vivants*, or Old Master paintings that are brought to life in staged performances. Following several other *tableaux vivants*, Lily impresses her audience with a living representation of a portrait by the eighteenth-century English painter Sir Joshua Reynolds:

... the unanimous 'Oh!' of the spectators was a tribute, not to the brushwork of Reynolds's "Mrs. Lloyd" but to the flesh and blood loveliness of Lily Bart. She had shown her artistic intelligence in selecting a type so like her own that she could embody the person represented without ceasing to be herself. It was as though she had stepped, not out of, but into, Reynolds's canvas, banishing the phantom of his dead beauty by the beams of her living grace. The impulse to show herself in a splendid setting—she had thought for a moment of representing Tiepolo's Cleopatra—had yielded to the truer instinct of trusting to her unassisted beauty, and she had purposely chosen a picture without distracting accessories of dress or surroundings. Her pale draperies, and the background of foliage against which she stood, served only to relieve the long dryad-like curves that swept upward from her poised foot to her lifted arm. (p. 106)

To the novel's aesthete Lawrence Seldon, this was "the real Lily Bart, divested of the trivialities of her little world, and catching for a moment a note of that eternal harmony of which her beauty was a part." Transfixed by Lily as an aesthetic object, Selden later stands idly by while she falls into debt and is forced into a working-class existence before ultimately committing suicide. During the Gilded Age, art more than ever became immersed in an amoral economy of conspicuous consumption and elite entertainments.

Commercialization and the Uninterrupted Progress of Art

Already at the beginning of this period, critics were acutely conscious that the spiritual and moral content of American art was threatened by art's inescapable status as a marketable commodity. In 1867, two years after the end of the Civil War, the New York art historian and critic Henry Tuckerman (1813–71) published Book of the Artists: American Artist Life, a survey of American art. He concluded that the Civil War had done little or no damage to the production and dissemination of the visual arts in the United States, even in the defeated South. He observed that exhibitions of American art were now held frequently throughout the country from Chicago, Illinois, and Buffalo, New York, southward to Baltimore, Maryland, and Charleston, South Carolina. It seemed that Americans everywhere were, at the very least, commissioning portraits from hundreds of artists. Particularly in New York, the nation's financial and cultural capital, new galleries, art dealerships, and other art organizations appeared to be flourishing:

In fact, the entire relation of Art to the public has changed within the last ten years: its products are a more familiar commodity; studio-buildings, artist-receptions, auction sales of special productions, the influence of the press, constant exhibitions, and the popularity of certain foreign and native painters, to say nothing of the multiplication of copies, the brisk trade in 'old masters', the increase of travel securing a vast interchange of artistic products—these and many other circumstances have greatly increased the mercantile and social importance of Art. (p. 22)

New York's Tenth Street Studio Building (fig. 6.5) had become one of the centers of the city's artistic life. Designed in 1857 by Richard Morris Hunt, it was intended specifically for the use of artists and architects, providing studios, living quarters, and gallery space all under one roof. During the post-Civil War era, painters' studios became art markets for middle- and upper-class patrons. Tuckerman was already worried that American art was being aesthetically victimized by its own

6.5 Richard Morris Hunt Studio Building, 15 West Tenth Street, New York City, 1857. City of New York Museum.

Trained at the Ecole des Beaux-Arts in Paris, Hunt designed his first major project in terms of the French rationalist style of Pierre-François-Henri Labrouste (1801-75). Constructed from red brick with brown sandstone trim, the Studio Building's symmetrically balanced facade featured large recessed windows. The generous fenestration and a skylight over the building's interior courtvard provided artists' studios and exhibition spaces with ample illumination.

6.6 Peter B. WightNational Academy of Design,
New York City, 1862–5.
National Academy of Design.

Modeled after the Doge's Palace (1345-1438) in Venice, Wight's building was constructed with bands of gray and white marble. bluestone trim, and red Vermont marble columns. The upper story featured a diamond pattern made from buff and red brick. Approached by a two-winged staircase, the entranceway reached the ornamental frieze, providing a vertical contrast to the building's horizontal bands and stringcourses. Windows repeated on a smaller scale the entranceway's arch.

popularity. It was "too dependent on the market" and artists' eagerness for financial success. In Tuckerman's view, art that was produced for purely materialistic reasons lacked the necessary imprint of individual and national character, which could only be expressed apart from selfish, commercial interests. The critic bemoaned the fact that in order to make a comfortable living, American artists simply repeated popular motifs and conventions. Under these circumstances, art became monotonous, superficial, and mechanical. While Tuckerman praised America's "atmosphere of Freedom" (p. 28) and prosperity for animating the "manly artist" (p. 28), he also expressed admiration for the more traditional, refined atmosphere of Europe, where beauty and art appeared rooted in an idealized Renaissance past that seemed to transcend the crass world of commerce. Conceiving the artist in masculine terms, Tuckerman warned that pandering to the whims of the marketplace risked an artist's creative potency or manhood. When, on the other hand, "a painter really expresses what is in him, and not what the public fiat approves," he is no longer a passive imitator but finally may generate the life-giving "spark of artistic genius" (p. 27). Contrarily, as the art historian Sarah Burns has demonstrated, artists' and critics' emphasis on godlike powers of genius was itself a marketing strategy for promoting public interest in specific personalities and their incomparable works.

By the end of the Civil War, New York artists could celebrate the opening of a spacious new building for the National Academy of Design, one of the nation's leading art academies (fig. 6.6). Tuckerman praised this new "Temple of Art," designed after "the famed Ducal palace at Venice," as "one of the finest buildings in the city" (p. 19). Standing on the corner of 23rd Street and 4th Avenue, the handsome building consisted of three stories and cost \$200,000. Tuckerman dutifully noted that most of this money had been "contributed by our wealthy citizens, lovers of art" (p. 19). The architect, Peter B. Wight (1838–1925), chose an historical-revival, Venetian Gothic style. The richly ornamented facade features a pointed-arch entrance and polychromatic masonry with alternating courses of light and dark stones for the main story's pillars and arched openings. Wight's selection of Venetian Gothic was

undoubtedly influenced by the English critic John Ruskin, whose books The Seven Lamps of Architecture (1849) and The Stones of Venice (1851-3) nostalgically associated medieval art and architecture with truth and nature. Contradicting earlier associations of Gothic architecture with primitive barbarism (see p. 86), Ruskin valued the organic variety and ornamental richness of the medieval style. Unlike the more austere classical tradition, Gothic decorativeness permitted designers and craftsmen a greater freedom for creative expression. For Ruskin, the handiwork of individual stonemasons and craftsmen was, by definition, honest and natural in contrast to the shoddy, machine-made products of the industrial age.

However, American architects saw no necessary contradiction in employing medieval or other historical-revival styles for modern commercial buildings or engineering projects. In 1870-71, Wight published a translation of the lectures of Eugène-Emanuel Viollet-le-Duc (1814–79), who taught at the prestigious École des Beaux-Arts in Paris. The French scholar compared the structural skeleton of a Gothic cathedral to the iron skeletons of contemporary nineteenth-century buildings. He argued that Gothic construction methods were a rational foundation for modern principles of design.

Economic Modernization and the Appropriation of European Architecture

No monument more dramatically symbolized the new age of modern technology than the Brooklyn Bridge (fig. 6.7), and yet its designer, John Augustus Roebling (1806-69), also looked backward toward an ennobling Gothic-Revival style.

> Alleviating ferry traffic on the East River, the bridge connected Manhattan to Brooklyn and ultimately inspired the 1898 consolidation of the five boroughs-Manhattan, Brooklyn, Queens, the Bronx, and Staten Island—into the greater city of New York. Begun in 1869, the engineering project was completed in 1883 by Roebling's son, Washington Augustus Roebling (1837–1926). Through the use of twisted steel wires suspended from monumental masonry towers, the Roeblings were able to support a high, 1600-foot span of roadway without intermediate supports from below. River traffic could continue to flow freely beneath the bridge deck, while streetcars shuttled back and forth through pointed-arch tower openings designed to resemble the windows of a Gothic cathedral. Called the "eighth wonder of the world" and "the 19th Century Wonder" (cited in McNamara, pp. 140–41) when it was publicly dedicated on May 24, 1883, the Brooklyn Bridge became a symbol of American ambition and ingenuity.

6.7 John A. Roebling Brooklyn Bridge, New York City, 1869-83. @ Collection of The New York Historical Society.

The bridge's sweeping roadway suspended from a web of steel cables essentially marked the beginning in America of modern architectural ideas regarding the construction of continuous, grand-scale urban spaces. The horizontal vault across the river contrasts with the vertical, Gothic towers, which foreshadowed the triumph of the modern skyscraper.

Skyscrapers, the building type most closely associated with modern industry and corporate power, also were designed in terms of traditional, historical styles. While the new bridge was under construction, improvements in metal framing, foundation work, fireproofing, power equipment, elevator service, and other technologies allowed architects to plan office buildings that rose far higher than four or five stories. In 1873, Richard Morris Hunt (1827–95), the architect of the Studio Building (see fig. 6.5), designed one of the nation's first skyscrapers—a description accurate at least regarding its great height if not its new materials or means of construction (fig. 6.8). New York's eightstory Tribune Building, housing the offices and printing presses of the Tribune newspaper, had a two-story attic and rose 260 feet from the sidewalk level to the top of its clock tower. Supported by massive brick piers and thick masonry walls, the blocklike heaviness of the building evokes traditional associations with Italian Renaissance architecture. Nevertheless, Hunt's office spaces were generously illuminated by natural light, as the architect designed every room with at least one window to the outside. When the building opened in 1875, people in the upper stories marveled over the superior quality of light and air high above the noise and dust of street-level traffic.

As a writer for *Building News* concluded in 1883, building vertically made practical, economic sense:

The present . . . is likely to be known in the history of New York as the High-Building Epoch. Seven or eight years ago, after struggling in vain to pack the lower or business end of the city more closely with buildings, in order to supply the insatiable demand for office room, real estate capitalists suddenly discovered that there was plenty of room in the air, and that by doubling the height of its buildings the same result would be reached as if the island had been stretched to twice its present width. (cited in Landau and Condit, p. 111)

By the 1880s, architects were beginning to use steel-skeleton frames to support floors and exterior walls. Earlier, a number of high-rise buildings had been constructed with iron frames; but iron, unlike steel, proved unreliable in fires, wilting rapidly when the temperature increased. Louis Sullivan (1856–1924), a partner in the Chicago firm of Adler & Sullivan, designed the Wainwright Building, a speculative office building in St. Louis, as a nine-story, steel-framed skyscraper sheathed in brick masonry and terra-cotta panels (fig. 6.9). Sullivan conceived the building in organic terms, believing that its aesthetic form should express its internal functions and social purposes. Although Sullivan adapted and incorporated historical references into his architecture, he did not believe that historical styles should be reproduced unmodified without regard to the contemporary socioeconomic environment. More than any other material, steel symbolized for Sullivan the progress and efficiency of a new entrepreneurial, industrial culture. Therefore, it

6.8 Richard Morris Hunt Tribune Building, New York City, 1875. © Collection of The New York Historical Society, New York.

seemed contradictory to the organic evolution of architecture to design banks like Greek temples or business buildings like Gothic cathedrals, as other architects would do on into the twentieth century (see fig. 7.19).

The Wainwright Building is divided functionally and visually into three parts. The two-story base, with its large display windows at ground level, housed spacious shops and their offices. The next seven stories of smaller office units rise dramatically upward to form the main body of the building. Narrow windows and terracotta panels are set back from the narrow brick piers so that there is a strong, uninterrupted vertical thrust. As Sullivan wrote, the repetitious grid of windows transparently reveals the interior arrangement of individual office cells and they "look all alike because they are all alike" (cited in Upton, p. 212). Sullivan actually doubled the number of thin vertical piers between the windows, since only every other one sheathes a steel structural column. The multiplication of piers not only expressed the interior division of office cells but also accentuated the essentially vertical character of skyscraper design.

Nevertheless, the building's attic floor with crowning cornice provides a strong horizontal cap to the whole structure's upward movement. Housing essential mechanical services for plumbing and heating, the corniced attic is covered by terra-cotta panels decorated with organic, foliate forms expressing the presence of the building's internal organs and arteries. The Wainwright Building thus rises like a tree from its foundational roots, through its main trunk, to terminate in a leafy

6.9 Louis Sullivan Wainwright Building, St. Louis, Missouri, 1890-91. Art Institute of Chicago, Chicago, Illinois.

canopy. However, its tripartite division also subtly mimics the elements of a classical column—base, shaft, and foliated capital. Sullivan was still drawing on classical Greco-Roman and Renaissance traditions. More immediately, he was influenced by Henry Hobson Richardson's (1838–86) dynamic Marshall Field Warehouse (fig. 6.10). Richardson designed this Chicago department-store warehouse entirely in ashlar masonry like a modern-day Renaissance palazzo with high arches that encompass several stories of windows. Meanwhile the building's generously fenestrated exterior seems horizontally stretched to express its continuous interior space. Adapted to modern commercial needs, European historical styles lent an aura of cultural dignity to the American urban environment. Symbolizing the New World

6.10 Henry Hobson Richardson

Marshall Field Warehouse, Chicago, Illinois, 1885–7. Chicago Historical Society.

Built around a central court, this massive, seven-story building had minimal decorative detail. Variations in fenestration and the size and arrangement of the masonry stones constituted the primary ornamentation for the boxlike warehouse's otherwise flat, planar surfaces. As they decreased in size, the number of windows doubled and quadrupled in the upper stories. The building's corners were defined by broad, powerful piers, while narrower but still substantial piers vertically divided the windows into a regular sequence of bays.

6.11 World's Columbian Exposition

looking south to South Canal, Chicago, Illinois, 1893. Chicago Historical Society, Chicago, Illinois. energy of ambitious, restless Americans, skyscrapers simultaneously looked backward and forward, evoking associations with the historical monuments of the Old World while implicitly challenging Europe's economic and cultural domination.

Led by Daniel Hudson Burnham (1846–1912), a group of architects planned the 1893 World's Columbian Exposition in Chicago as a modern urban utopia. Commemorating the four-hundredth anniversary of Christopher Columbus's 1492 voyage of discovery, the architects' temporary "White City" featured spectacular exhibition buildings with classical, Roman-style facades symmetrically arranged around Venetian-style lagoons or waterways (fig. 6.11). The White City's ancient Roman and Renaissance-Revival architecture was criticized by Louis Sullivan for its apparent lack of modernity. Yet the participating architects agreed that neoclassicism, based on a modular system of design, was suitable for modern American architecture and urban planning. The overall uniformity and rationality of the White City expressed the values of American business interests, the corporate desire for social harmony and political consensus. Anticipating Disneyland and the elaborate theme parks of the twentieth century (see fig. 8.68), this controlled environment on the shores of Lake Michigan seemed entirely free of the cacophony, congestion, and social problems of Chicago's nearby downtown. Employing the latest technology in sewage and water-filtration systems, the White City hired street cleaners for the daily removal of litter. Professionally trained guards or policemen kept the social order, while acting in a polite, solicitous manner. One commentator, writing for Cosmopolitan magazine, marveled that out of a crowd of more than 300,000 fairgoers, he was unable to find "one ill-tempered face, one drunken man" (cited in Lovell, p. 47, n. 23). At night, the White City became a fantasyland of colored lights, illuminated fountains, and shimmering waterways bearing passengers in elegant Venetian gondolas (fig. 6.12).

6.12 Charles C. Curran Machinery Hall, Administration Building, and MacMonnies Fountain: World's Columbian Exposition of 1893. 1893. Oil on canvas. $18\% \times 22\%$ in (46 × 57.1 cm). Chicago Historical Society, Chicago, Illinois.

Curran's representation of the White City at night focuses on Richard Morris Hunt's domed Administration Building, located at one end of the Fair's Court of Honor that overlooked the Grand Basin, a lagoon designed by the landscape architect Frederic Law Olmsted. In front of Hunt's neoclassical structure floats The Triumph of Columbia, a plaster sculpture by Frederic MacMonnies (1863-1937) that honored Christopher Columbus's voyage. Allegorical figures symbolizing Father Time, Fame, and various arts and industries decorated this "barge of state."

The architect of several major skyscrapers, Burnham had helped Chicago rebuild after a disastrous 1871 fire that destroyed over 1,600 acres of downtown property. He now intended the White City as a model for the city's future urban development. Burnham was a member of the Swedenborgian Church, which was founded on the visionary writings of the eighteenth-century Swedish mystic Emanuel Swedenborg. Burnham equated the White City with Swedenborg's detailed personal visions of the heavenly New Jerusalem, which he described in his book Heaven and its Wonders, and Hell from Things Heard and Seen (1758). Claiming to have visited the heavenly city on numerous occasions, Swedenborg outlined an urban paradise that Burnham and his late Chicago partner, John Wellborn Root (1850-91), had found inspirational. Swedenborg's celestial citizens walk through spacious avenues, public squares, and landscaped parks. They enjoy impressive civic, commercial, and cultural buildings, including colleges, museums, libraries, and auditoriums. Influenced, in part, by Swedenborg's dynamic urban vision, Burnham's Chicago City Center Plan (fig. 6.13) features a central civic core as a point of gravitational convergence and radiating energy. A symmetrical system of ten arterial avenues or boulevards fans out through the city from a domed city hall, which Burnham apparently intended as a civic cathedral, the worldly manifestation of a heavenly prototype.

Burnham's plan was a major contribution to the City Beautiful movement, in which late-nineteenth- and early-twentieth-century architects and urban planners attempted to control the rapid growth of American cities by designing public parks,

amenities, and ennobling civic buildings. Chicago adopted many of the ideas in Burnham's proposal, including the expansion of parks along the lakefront and formation of the Cook County Forest Preserve beyond the city's center. Though a domed city hall was never constructed, the city's major cultural institutions, including the Art Institute of Chicago and the Field Museum of Natural History, formed an urban core around Grant Park on Lake Michigan.

Meanwhile, the Wisconsin-born architect Frank Lloyd Wright (1869-1959) was also in Chicago and its suburbs, working to revolutionize the modern home. Influenced by the domestic architecture of H. H. Richardson and sharing many of the views of Louis Sullivan, for whom he initially worked, Wright also viewed architecture more in organic than historical terms. Rejecting the arbitrary reproduction of historical-revival styles, he equated buildings with the natural growth of a plant, with every form functionally necessary to the life of the entire organism. Working within the American Midwest's characteristic geography of flat plains and prairies, Wright developed what he called the Prairie style of domestic architecture. As seen in the Ward W. Willitts House (fig. 6.14), Wright's Prairie homes were

6.13 Daniel H. Burnham City Center Plan, Chicago, 1909. Chicago Historical Society, Chicago, Illinois.

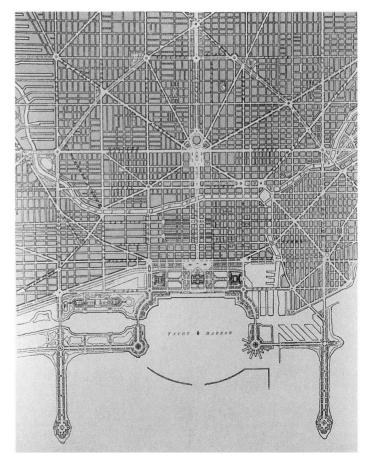

6.14 Frank Lloyd Wright Ward W. Willitts House, Highland Park, Illinois, 1900-02.

During the period in which he was working on this home, Wright published a drawing of the prototypical Prairie-style house in the February 1901 issue of the Ladies Home Journal. Wright's advertisement for the virtues of his expansive, horizontal structures demonstrates his desire to reach a relatively wide, middle-class clientele.

defined by overlapping, low-pitched, or horizontal roofs and porches, which clustered around the building's chimney core or central hearth (heart). The house seems to hug the land by repeating the flattened ground plane. The overhanging horizontal planes protect or shade long ribbons of windows, which illuminate and open the interior space to the outside world. Wright rejected the idea that rooms and houses were enclosed boxes with fixed walls, favoring instead movable panels and screens. Though he avoided copying traditional historical styles, he was strongly influenced by Japanese domestic architecture, which he was able to study at the official Japanese pavilion for the 1893 Columbian Exposition. An admirer of John Ruskin, Wright identified with the anti-industrial aesthetic of the Arts and Crafts movement. The architect was also an interior decorator and designer of furniture and household objects. Like other exponents of the Arts and Crafts aesthetic, Wright believed in the power of art to transform and vitalize family life during an increasingly mechanized age. Nevertheless, though Wright's Prairie houses were far more modestly scaled than Richard Morris Hunt's mansions for the Vanderbilts and other elite clients, working-class families, who suffered the most from factory machinery, certainly could not afford Wright's services or most Arts and Crafts home furnishings.

Images of Renewal and the Family in the Aftermath of War

In the aftermath of the Civil War, painters and sculptors addressed the problems of modern family life and the need to heal the racial and geopolitical divisions within American society. John Rogers (1829-1904), a New York sculptor, specialized in small, inexpensive plaster figural groups that represented genre subjects, or scenes of ordinary daily life. During the Civil War, Rogers's sculptures of common Union soldiers and victims of war and slavery garnered considerable public attention. Day after day, crowds of people reportedly gathered in front of the storefront windows of Rogers's art dealer on Broadway to admire the latest statuettes from the artist's studio. After the war, Rogers continued to represent his sentimental war themes. In The Fugitive's Story (fig. 6.15), an African-American woman holding a child in her arms stands before three white abolitionists and social reformers: the poet John Greenleaf Whittier, the Protestant clergyman Henry Ward Beecher, and the leading anti-slavery spokesman, William Lloyd Garrison. As editor of the abolitionist journal The Liberator, Garrison possesses the greatest air of authority. He sits at his writing desk while gazing at the young woman as she relates the story of how she became a fugitive from slavery. The small, makeshift sack of earthly possessions resting at her feet poignantly expresses the woman's plight and her dependence on the protection of these sympathetic, well-dressed men, who clearly are represented as her social superiors. Apparently, Rogers's rejection of the austere neoclassicism of Hiram Powers's The Greek Slave (see fig. 5.61) in favor of a detailed sculptural realism appeared original to the critic Henry Tuckerman's eyes. Nevertheless, Rogers's studio virtually became an assembly-line factory. Over the course of his career, he produced approximately 80,000 replicas representing around eighty fig-

ural groups. Reaching a broad middle-class audience, Rogers's \$10–15 plaster statuettes were displayed in thousands of home parlors

during the second half of the nineteenth century.

Anti-slavery and Civil War themes became popular during the twelve-year Reconstruction period (1865–77) that followed the Civil War. Once the war had ended, the victorious North struggled to formulate a policy for reconstructing the South, or readmitting the Southern states back into the Union. After the assassination of President Abraham Lincoln in 1865, President Andrew Johnson adopted a more lenient attitude toward the defeated South. Johnson's administration initially enabled the unrepentant white plantation elite to return to political power. Southern state legislatures agreed to the abolition of slavery, but they soon passed "Black Codes," which forced African Americans to sign yearly labor contracts. The codes declared jobless and landless blacks vagrants, who could be arrested and hired out as laborers to plantation owners. In 1867, however, the United States Congress, dominated by Radical Republicans from the North, passed a strict set of Reconstruction policies, which divided the South into military districts and forced Southern states to recognize the civil and political rights of black citizens. Aided by numerous "carpetbaggers," or newly arriving teachers, businessmen, and retired Union soldiers from the North, former African-American slaves finally were able to vote in elections, initiating a liberalization of the South's political life. During the next ten years, sixteen African Americans from the South served in the United States Congress, while hundreds

6.15 John RogersThe Fugitive's Story, 1869.
Plaster, 22 in (55.8 cm) high.
New York Historical Society,
New York.

6.16 Edmonia Lewis Forever Free, 1867. Howard University Art Gallery, Washington, D.C.

Lewis originally named this sculptural group The Morning of Liberty, but she changed the title and inscribed the words "Forever Free" from Lincoln's Emancipation Proclamation on the sculpture's base. The male figure's physique was carefully softened by Lewis into smooth, gentle planes of marble flesh. She thereby made the grateful figures a non-threatening presence for white audiences, who feared violent. black male anger and revenge as the legacy of American

slavery.

more were elected to state legislatures and to local offices. By 1870, the Fifteenth Amendment to the U.S. Constitution prohibited states from discriminating against voters because of their race or previous state of servitude. However, this amendment did not apply to African-American women, since women in general were not given the right to vote until after World War I. Furthermore, after Reconstruction ended in 1877, the United States government withdrew oversight of Southern states' political affairs, thereby allowing the return of a racist legal system and giving free rein to white terrorist organizations such as the Ku Klux Klan.

The tenuous expansion of civil and political rights for African Americans inspired some artists to celebrate their new constitutional status. In contrast to John Rogers with his realistic, small-scale plaster figures, other sculptors represented

> the demise of slavery in more idealized terms, evoking traditional associations with ancient Greco-Roman art. Working in Rome, Edmonia Lewis (1845-?), daughter of an African-American father and a Chippewa Indian mother, commemorated President Abraham Lincoln's famous 1863 Emancipation

Proclamation, which declared slaves "forever free." Her marble sculptural group Forever Free features an African-American couple celebrating the proclamation (fig. 6.16). With one foot resting on a broken ball and chain, the pow-

erful male figure raises an arm in triumph. The ineffectual manacle still on his wrist now becomes an emblem of the vic-

tory over slavery. With his other arm, the man places a protective hand on the kneeling woman, whose hands are clasped in a prayer of thanks. Conceived as a unified, married pair, rather than two separate figures, Forever Free symbolically expressed the restoration of the black family. With the abolition of slavery, African-American families could remain intact. Husbands could now protect their wives from physical abuse and sexual exploitation, allowing them to live as virtuous mothers of children born into freedom.

Although Lewis herself lived an unconventional life as a single woman working in a male-dominated profession, Forever Free expressed the conventional attitude of most Americans regarding inequality between men and women. Lewis's white, middle-class patrons were primarily abolitionists, not feminists. On October 18, 1869, the sculpture was dedicated at Tremont Temple, a Baptist church in Boston, in a public ceremony attended by numerous abolitionists, including William Lloyd Garrison (see fig. 6.15) and the Reverend Leonard A. Grimes, who formally accepted the marble group. Writing for a religious journal, the Christian Register, the Boston critic Elizabeth Palmer Peabody described the abolitionist audience's "profound emotion" in viewing Forever Free. Asserting that the sculpture was "poetry" in stone, she imagined hearing its two figures sing "Praise de Lord" (cited in Buick, p. 194).

By using the definite article "de" instead of "the," Peabody, a schoolteacher as well as critic, condescendingly attributed to the African-American figures an illiterate black dialect. Curiously, however, Edmonia

Lewis's representation of the kneeling woman is free of ethnic attributes. In contrast to the clearly African character of the husband, the wife's hair and facial features appear more white or European than African. The art historian Kirsten P. Buick has speculated that Lewis avoided representing the female figure with strong, African features because she didn't wish her white audience to interpret the work in autobiographical terms. In their reviews of Lewis's sculptures, critics tended to focus more on the novelty of a part-African, part-Indian woman artist rather than the actual art work. Henry Tuckerman, in his *Book of Artists*, quoted at length a letter from a correspondent in Rome, who wrote that Lewis herself was the object of that city's curiosity. The correspondent proceeded to describe the physical appearance of this "little American girl," which clearly confirmed her "Indian and negro parentage" (cited in Tuckerman, p. 603). By expunging signs of African ethnicity in the kneeling wife, Lewis sought to shift the critical focus from herself to her creative work. The white marble medium, neoclassical style, and ethnic "whitening" of the female figure enabled Lewis to claim the aesthetic objectivity and professional credibility that most of her fellow artists could take for granted.

The cool, neoclassical style, with its austere reduction of realistic detail, was particularly associated with the life of the mind or noble feelings and universal ideas. By choosing to work in this traditional Greco-Roman manner, Lewis could more convincingly establish her artistic legitimacy before a primarily white audience. Indeed, when the Museum of Fine Arts in Boston and other major city museums first opened their doors during the 1870s, curators initially filled the galleries with plaster copies or reproductions of Greek and Roman antiquities.

6.17 Thomas Satterwhite Noble

The Price of Blood, 1868. Oil on canvas, $39\% \times 49\%$ in $(99.6 \times 125.7 \text{ cm})$. Morris Museum of Art, Augusta, Georgia.

6.18 Winslow Homer The Veteran in a New Field. 1865. Oil on canvas, $24\% \times 38\%$ in (61.3 \times 96.8 cm). The Metropolitan Museum of Art, New York. Beguest of Adelaide Milton de Groot, 1967.

Soon after the Civil War, tour books guided American readers through northern and southern battlefields. Authors meditated over the soil sanctified by the blood of so many young men, who were compared to harvested sheaves reaped by the scythewielding figure of Death. Homer's solitary veteran similarly evokes associations with Death and somberly recalls the lost lives of countless fellow soldiers.

The familial meaning of Lewis's sculpture appears in greater relief when contrasted with a virtually contemporaneous painting by the Kentucky artist Thomas Satterwhite Noble (1835–1907). Though personally opposed to slavery, Noble had been a supporter of Southern states' right to secede from the Union and had served in the Confederate army. After the Civil War, however, he painted a series of pictures with anti-slavery themes. In The Price of Blood, he represented a heartless plantation owner who sells his own slave-son to a slave dealer (fig. 6.17). Examining the bill of sale, the dealer stands in the middle of the picture, physically and symbolically dividing it into two halves, separating the seated father from the barefoot, defiant son at the left side of the painting. The youth's only slightly dark complexion identifies him as mulatto, or part African. His African mother, also the father's slave, is absent from this cruel scene, but she is implicitly present, as viewers are left to imagine the coercive and illegitimate sexual relationship between master and slave. Noble's bifurcated composition strongly suggests that slavery tore at the moral fabric of white as well as black family life.

The Boston-born painter Winslow Homer (1836–1910) first gained fame with his simplified and unsentimental pictures of the Civil War. During the war, Homer worked as an artist-illustrator for Harper's Weekly, a New York magazine. Competing with the army of Civil War photographers, Homer sketched unheroic, matter-of-fact scenes of military life, which were then reproduced as wood engravings for the popular periodical. Homer continued to paint Civil War themes after the Union's victory. Perhaps the most poignant of his post-Civil War paintings is The Veteran in a New Field (fig. 6.18), which was finished just a few months after the South's

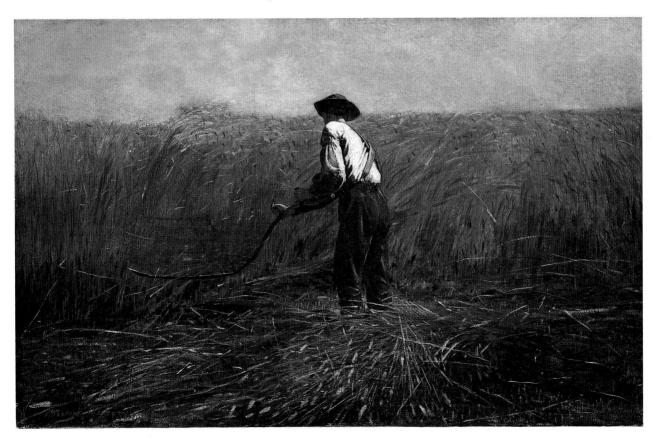

surrender and Lincoln's assassination at the hands of a Southern sympathizer. In this starkly simple and sketchily painted composition, the artist represented a former Union soldier returning to the peaceful pursuit of agriculture after years of military service. As seen in the picture's lower-right corner, the soldier's military jacket and canteen have been set aside. Harvested stalks of wheat, represented by slashing strokes of paint, are beginning to shroud the well-worn emblems of war. The critic for the New York Weekly Tribune suggested that Homer's painting recalled the ancient story of Cincinnatus, the Roman general who preferred a life of farming to military and political power. Similarly, George Washington, the American Cincinnatus, had abandoned his military command for rural retirement at his Mount Vernon plantation, following the Revolutionary War (see figs. 4.37–4.39). For the New York critic, Homer's The Veteran in a New Field expressed the post-war necessity for productive, economic renewal: "we must now take our soldiers from the camp and make them farmers" (cited in Cikovsky, Jr., and Kelly, p. 25). Couching the need for national regeneration in religious terms, the sympathetic critic also alluded to the well-known Old Testament passage, which metaphorically expressed in agricultural terms the transition from war to peace: "they shall beat their swords into plowshares and their spears into pruning hooks" (Isaiah 2:4).

However, Homer's painting also has a darker symbolism that compares with Alexander Gardner's battlefield photograph *A Harvest of Death* (see fig. 5.66). In wielding his scythe, the anonymous Union soldier evokes associations with Death or the Grim Reaper, harvester of souls. As the art historian Nikolai Cikovsky, Jr., has observed, sheaves of wheat were funerary symbols and often were placed on coffins before burial. Despite its vigorous brushwork and bright, sun-drenched colors, Homer's quiet painting somberly mourns the martyrdom of the nation's soldiers and its assassinated president, Abraham Lincoln.

For this and other pictures during the 1860s and 1870s, Homer was often criticized for his sketchlike technique. Critics who were used to smoothly finished painting surfaces claimed that Homer's compositions were mere blotches or smears of paint applied in a relatively slapdash manner. Contemporaneously in Paris, art critics also ridiculed a number of French painters for exhibiting pictures that appeared unfinished or sloppily executed. Homer visited Paris toward the end of 1866, staying almost a year, and may have seen the brilliantly colored, sketchlike paintings of Édouard Manet (1832–83), the most important precursor of the Impressionist movement, which formally organized itself into an independently exhibiting group of artists during the next decade. Often painting outdoors, young French painters such as Claude Monet (1840–1926) and Pierre Auguste Renoir (1841–1919) sought to record the effects of natural light and their own fleeting impressions of nature and modern life.

However, Homer was already sketching outdoors and painting in a loose, sunlit style before his Paris trip. His war experience as an artist-illustrator contributed to his preference for working up compositions quickly in the open air. As Homer continued to paint scenes of American life, including nostalgic pictures of rural New England schoolchildren (fig. 6.20), critics soon began praising his relatively crude painting technique for its distinctively American, nationalist character. Awkwardness and roughness in paint application became a virtue for many, as Homer's pictures seemed to emerge organically from American soil, free from the taint of foreign influence. For an American public in mourning for its Civil War dead, his representation of healthy, apple-cheeked boys at play in *Snap the Whip* expressed hope and confidence in the nation's future. The boys in the foreground

6.19 Eastman Johnson The Brown Family, 1869. Oil on canvas, 38 $\% \times$ 32 % in (97.7 \times 82.3 cm). Fine Arts Museums of San Francisco, San Francisco, California. Gift of Mr. and Mrs. John D. Rockefeller 3rd.

Johnson's painting is as much a portrait of a room as it is of a family. Contemporary critics denounced the picture for its portrayal of the parlor's oldfashioned, Renaissancerevival style designed by a French interior decorator during the 1840s. Clarence Cook, propagandist for simpler, Asian-influenced designs, particularly ridiculed the Browns' ornately carved woodwork and furnishings, and he compared the chandelier's crystals to the tears of the artist forced to paint such tasteless ornamentation.

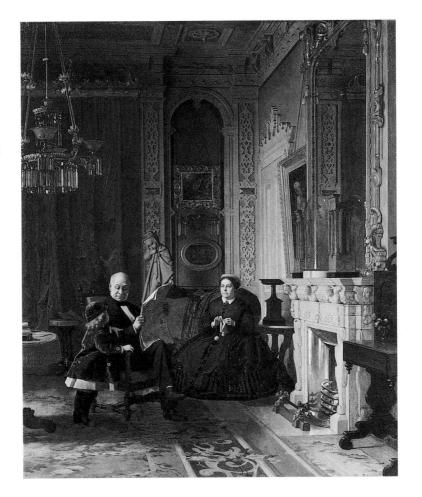

seem to form a tenuous unit as they hold hands and run barefoot through the flowering field outside the wooden red schoolhouse. One might imagine that a number of these boys, born during the Civil War, had lost fathers, older brothers, or uncles in battle. The line of boys mimics the wartime struggle to hang together. However, just as the war has ended and soldiers have returned home to productive employment, so must the playful solidarity of boyhood ultimately give way to the manly responsibilities of adulthood.

In the middle distance, two boys, who can no longer hang on to the others, fall to the ground in the direction of two girls and a waving husband-wife couple among other figures in the distant background. Homer's dynamic composition thus pulls the viewer inward, away from an isolated brotherhood of young boys toward a marriage of the sexes and a renewal of family life designed to replenish post-Civil War America.

Images of family life were especially popular during the years immediately following the war. Group portraits of children with their parents and grandparents reassuringly expressed generational continuity after the violent disruption of the Civil War and during an age when medical science still had no defense against many deadly diseases. Beginning in 1865, Eastman Johnson (1824–1906) painted several detailed group portraits of wealthy New York families. One of the most intimate was The Brown Family (fig. 6.19), which focuses on young William Brown, grandson and

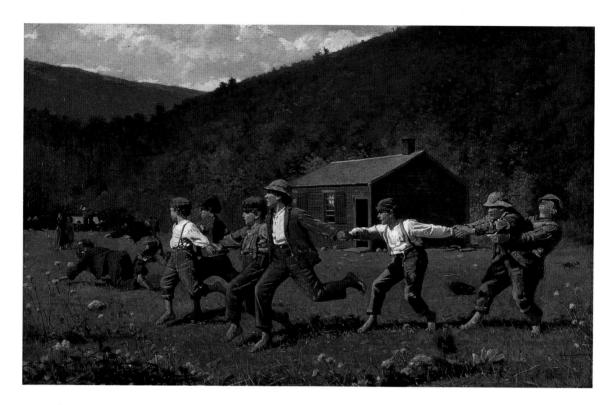

future heir of banker James Brown, who sits with his second wife, Eliza, in the lavishly decorated parlor of their mansion at Park Avenue and 37th Street. Although the middle generation between grandson and grandfather is not visibly represented, Johnson's picture was commissioned and owned by William's father and James's son, John Crosby Brown, who was taking over management of the family's extensive banking business. In strongly gripping his grandfather's arm and crossing his legs in the same manner as James Brown, little William seems to demonstrate that one day he, too, will manage the family business. By 1869, James Brown had already lost six children and nine grandchildren in premature or unexpected deaths. Another grandchild, Eliza Coe Brown, William's sister, was still alive. However, the granddaughter is absent from the group portrait, probably because, as a girl, she was deemed inessential to preservation of the family business. Certainly, Johnson expressed this gender bias more explicitly by marginalizing William's grandmother. As she sits in a corner performing a domestic task, she is virtually ignored by grandfather and grandson, who seem to communicate secretly with each other behind the screen of James's open newspaper, itself an emblem of the male-dominated world of finance.

Snap the Whip, 1872. Oil on canvas, 22 \times 36 in (55.9 \times 91.4 cm). The Butler Institute of American Art, Youngstown, Ohio.

6.20 Winslow Homer

Science, Capitalism, and Masculine Identity

American capitalists often spoke of business in martial terms. According to the English naturalist Charles Darwin (1809–92), whose scientific treatise *On the Origin of Species* (1859) haunted late-nineteenth-century American thought, the evolution of all earthly life was itself a deadly struggle of "natural selection," whereby only the fittest species survive while the weak disappear into extinction. By the 1880s, Winslow Homer began to specialize in painting powerful seascapes and hunting

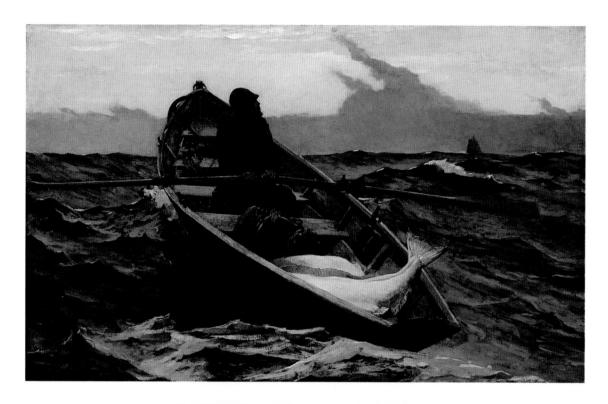

6.21 (top) Winslow Homer The Fog Warning, 1885. Oil on canvas, $30\% \times 48\%$ in $(76.8 \times 123.2 \text{ cm}).$ Museum of Fine Arts, Boston, Massachusetts. Otis Norcross Fund.

Homer represents only a single fisherman in a dory looking over his shoulder toward a sailing vessel. However, in fishing for halibut in the deep waters of the Grand Banks, schooners usually transported a fleet of small rowboats, each manned by a pair of fishermen, who set and tended trawl lines. Homer's focus on a lonely, isolated figure intensifies the dramatic impact of the picture and its allegorical implications about the human struggle against nature's chaotic forces.

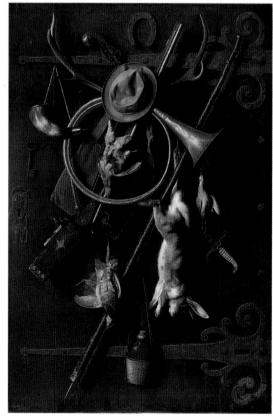

6.22 William Michael Harnett

After the Hunt, 1885. Oil on canvas, $71\% \times 48\%$ in (181.6 \times 123.2 cm). Fine Arts Museums of San Francisco. San Francisco, California. Mildred Anna Williams Collection.

pictures that represented the harshness of nature and suggested the Darwinian struggle for survival. In 1881, Homer spent several months living near Tynemouth, northeast England, a small fishing village on the North Sea, where he painted the statuesque wives of fishermen waiting patiently on storm-tossed shores for the safe return of the fishing boats. After 1883, when his well-to-do family built a house and made real-estate investments at Prout's Neck on the coast of Maine, Homer continued to depict seascapes with heroic figures contending with the powerful forces of nature. Apparently inspired by a trip with a fishing fleet to the Grand Banks off the coast of Nova Scotia, The Fog Warning (fig. 6.21) was painted at Prout's Neck. A local fisherman agreed to pose for Homer, who had set up a dory, a flat-bottomed rowboat, on a large sand dune outside his studio. After initially naming the painting Halibut Fishing, Homer changed the title before exhibiting it at a private Boston gallery in 1886. The new title called attention to the danger that Homer's lone fisherman was facing from an approaching bank of fog that could prevent him from finding his way back to the sailing ship on the distant horizon. The ocean-swells and the weight of the large fish appear to work against the fisherman, who pauses to look over his shoulder while calculating the great distance he must row before the obscuring fog rolls in. Homer's broad masses of pigment in both water and sky convey nature's raw physical power, while the more tightly painted architecture of the dory suggests human ingenuity in overcoming nature and navigating the perils of life. Significantly, Homer failed to sell *The Fog Warning* until years later. The art historian Sarah Burns suggests that American businessmen were not inclined to buy the work and similar pictures because it reminded them all too well of the financial risks and uncertainties they confronted as the American economy unpredictably ebbed and flowed, frequently hitting periods of depression.

More popular with American capitalists were the *trompe l'oeil* (fool-the-eye) still-life paintings of William Michael Harnett (1848–92). Illusionistic pictures such as his *After the Hunt* (fig. 6.22) appealed to New York City businessmen, many of whom fished and hunted at expensive resorts and lodges in upstate New York and parts of New England. Harnett's images of dead game and hunting paraphernalia, rendered life size and with uncanny attention to textures and material surfaces, represented the literal and pictorial conquest of nature. Harnett could have expected affluent patrons to draw parallels between his trophy pictures and the predatory practices of capitalism, notably the competition with arch-rivals in the pursuit of new markets and clients. For many years, *After the Hunt* contributed to the masculine atmosphere of Stewart saloon on Warren Street in Lower Manhattan, a well-known bar patronized by successful New York businessmen.

Thomas Eakins's Circle and the Human Figure

Like Homer and Harnett, the Philadelphia artist Thomas Eakins (1844–1916) painted numerous pictures with pronounced masculine themes. Undoubtedly influenced by his father, who taught penmanship, Eakins was a careful draftsman and, in 1876, became a drawing instructor at the Pennsylvania Academy of the Fine Arts after several years of art study in Paris (1866–9) and classes in human anatomy at Philadelphia's Jefferson Medical College. That same year, the members of the Pennsylvania Academy, the nation's oldest existing art academy (founded in 1805), dedicated their new building on the corner of Broad and Cherry Streets (fig. 6.23). The primary architect, Frank Furness (1839–1912), designed an eclectic mixture of

6.23 Frank Furness and George W. Hewitt

Pennsylvania Academy of the Fine Arts, Philadelphia, 1871-6.

A student of Richard Morris Hunt, Furness shared his teacher's interest in the contemporary French neoclassical style known as "Neo-Grec." Furness lined the academy's facade on the upper story with square panels of relief sculptures stacked above grooved triglyph blocks, like the frieze of a Greek temple. However, like Wight's National Academy of Design (see fig. 6.6), Furness's polychromatic building with its pointed arch windows was also indebted to the Gothic revivalism of Ruskin and English architecture.

historical styles, drawing ornamental details from both the classical and medieval traditions. However, despite the decorative richness of the facade, with its polychromatic brickwork and Gothic rose window, the building's symmetrical longitudinal plan borrowed from the contemporary commercial architecture of shopping arcades.

The opening of the new Pennsylvania Academy was timed for the celebration of the nation's 1876 Centennial. The building's dedication mixed art, religion, and nationalism as the architect's father, the Reverend William H. Furness, announced the dawn of a new day for the arts and the moral refinement of American society. After the clergyman's inspirational address, officials unveiled two marble statues representing biblical subjects. G. B. Lombardi's sculpture of Deborah depicted an Old Testament woman prophet and songstress of ancient Israel's victories, while Jerusalem (fig. 6.24) by William Wetmore Story (1819–95) ideally personified the Hebrews' holy city. Both sculptures patriotically reaffirmed the nation's traditional identification with the ancient Jews, as white, Anglo-Saxon Protestant Americans continued to think of themselves as God's new chosen people.

The relatively realistic modern paintings of Thomas Eakins fit uneasily within this moral atmosphere of genteel refinement. While he assumed his new post as a drawing instructor at the Pennsylvania Academy, his most famous painting, The Gross Clinic (see p. 226), was rejected by a jury for exhibition in the art galleries at the Philadelphia Centennial Exposition. Modeled after a series of European world's

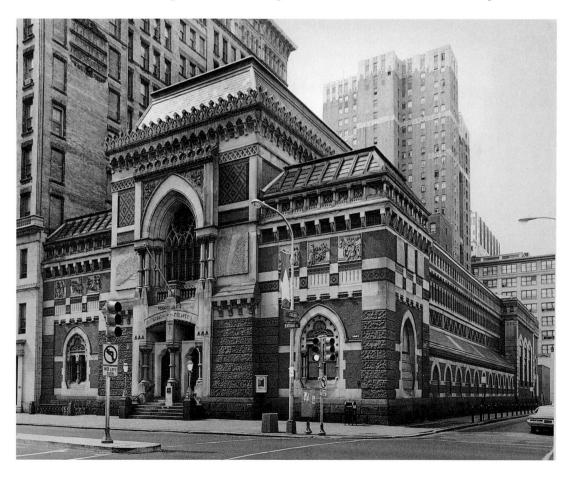

fairs, beginning with London's Great Exhibition of 1851, the 1876 Centennial Exposition was designed to celebrate American economic and cultural progress within the competitive context of an international display of art and industry. Eakins's painting represents a contemporary historical portrait of Dr. Samuel David Gross (1805–84), professor and surgeon at Philadelphia's Jefferson Medical College, where Eakins attended anatomy classes as a young student in 1864–5 and later, again, in 1873–4.

Through the course of his long career, Dr. Gross had published important treatises on anatomy, surgery, and the treatment of various diseases. In this portrait, the doctor stands in a crowded amphitheater performing a lecture-demonstration on the subject of the bone disease osteomyelitis. Following procedures that he had published in his Elements of Surgery (1859), Dr. Gross is operating to remove a dead bone from the thigh of a young boy. The youth lies on the surgeon's table at the right and is only partially visible. By representing this figure in strict perspective sharply receding backward into space, Eakins forced viewers' attention on the boy's lower body: his feet, thigh, and buttocks. A team of surgeons directs our gaze to the open surgical wound, while an anesthesiologist hovers over the patient's hidden face, waiting to apply more chloroform if the boy should start to awaken. Blood-soaked gauze and more sharp surgical instruments in the immediate foreground form the base of a compositional pyramid that has its apex in the gleaming forehead of Gross. Eakins signifies through geometry and light the preeminence of the professor's intellect. Surrounding Gross's luminous head, a halo of gray hair appears almost electric with mental energy. The aging doctor has temporarily turned away from the operation and seems lost in profound thought, his eyes furrowed and darkened to suggest introspection and the powers of reason. At the same time, the heroic surgeon is a man of action. His right hand glistens with bright red blood as he holds a scalpel, also tinged with red.

Eakins juxtaposed the bloody hand next to the only female figure in the painting. In contrast to the man of reason and his skillful handling of a scalpel, the woman, probably the patient's mother, displays ineffectual, contorted hands that screen her eyes from the operation. While the male student body intently observes the operation and a male secretary coolly records Gross's lecture, the woman sits below in an apparent fit of hysteria, unable to control her body and emotions. So complete is the woman's painful identification with the patient that she, too, seems in need of the doctor's care.

The painting's stereotypical division between rational males and irrational female accentuates its controlled violence, as the dark-suited surgeons earnestly strive to cure the maladies of the body or the imperfections of nature. Beholders have responded to *The Gross Clinic* with the same kind of polarized views expressed by the male-female figures represented in the amphitheater. One critic later compared the boy to a blackboard and suggested that Gross was merely a classroom lecturer, who was inscribing the day's lesson on the board with a piece of chalk. Similarly, Gross has often been compared to a painter who holds a brush dripping with red paint. The boy's thigh then becomes a canvas for the expression of the doctor's creative genius. Such interpretations have tended to sanitize

6.24 William Wetmore Story *Jerusalem,* 1876. Marble, $71 \times 40 \times 44$ in (180.3 \times 101.6 \times 111.8 cm). Pennsylvania Academy of the Fine Arts. Gift of Arthur Klein.

This brooding personification of Jerusalem was inspired by the Old Testament's Lamentations of Jeremiah, in which the biblical prophet mourns over the Babylonians' destruction of the Jewish holy city: "How doth the city sit solitary, that was full of people! how is she become a widow! she that was great among the nations, and princess among the provinces. . . . She weepeth sore in the night, and her tears are on her cheeks. . . . " (Lamentations I: 1-2).

the painting, defusing the violent impact of the bloody incision, the picture's compositional focus and vagina-like symbol of nature's torturous penetration by masculine science and realist art.

However, the more common response when the painting was first exhibited was revulsion over the gory, frank subject matter. Though the art jury for the Centennial Exposition refused to exhibit the picture, Gross apparently intervened on Eakins's behalf so that the portrait did appear in the U.S. Army Post Hospital, displayed with the latest developments in medical technology. The medical setting undoubtedly intensified the public impression that The Gross Clinic was a relatively crude and unpleasant slice of real life rather than an ennobling work of high art in the tradition of Rembrandt and other Old Masters.

Throughout his career, Eakins offended the genteel sensibilities of Philadelphia's social elite. Despite his reputation for realism, the artist possessed an almost mystical faith in the physical beauty and purity of the human body. As drawing instructor at the Pennsylvania Academy, Eakins urged students to move quickly beyond copying antique sculptures or plaster casts. He insisted that all students, both male and female, participate in life-drawing classes, using both female and male nude models. Furthermore, he petitioned the academy's board of directors to hire amateurs or respectable society women rather than "professional models," a euphemism for prostitutes, to work as models. For Eakins, the traditional practice of employing prostitutes unjustly tainted academic art classes with an atmosphere of sexual immorality.

Controversy over The Gross Clinic had scarcely passed when Eakins completed another contentious picture, William Rush Carving His Allegorical Figure of the Schuylkill River (fig. 6.25), which forcefully addressed the issue of nude female models. The painting pays homage to William Rush (see pp. 172), an original founder of the Pennsylvania Academy and a sculptor of idealized wooden figures.

Toward the end of his career. Eakins returned to the subject of William Rush and the use of a nude model for carving his famous personification of the Schuylkill River. However, in an austere, simplified painting entitled William Rush and His Model (1908), Eakins essentially represented himself as Rush gallantly assisting the nude model as she steps down from her wooden posing stand.

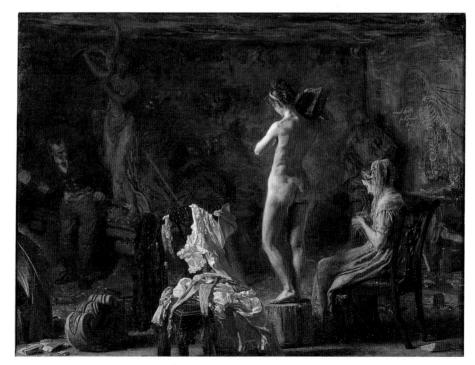

However, the primary subject is not Rush but the fleshy, strongly illuminated nude model who stands on a tree-stump platform in the foreground. In a written statement, Eakins identified Rush's model as Louisa Vanuxem, daughter of James Vanuxem, a prominent merchant who had served on a city committee responsible for providing Philadelphians with pure drinking water.

In the shadowy background, Rush, who also served on the water committee, hammers away with mallet and chisel to sculpt his most famous work, *Water Nymph and Bittern* (1809), a female personification of the Schuylkill River intended for a fountain outside the city's new water-pumping station. Contradicting any suggestion of sexual immorality, Eakins represents Rush as the epitome of civic pride, artistic professionalism, and moral respectability. Though working in a studio littered with wood chips and sawdust, Rush wears his Sunday-best clothing. He does not leer at the model but looks down in absorption at the task of perfecting the wooden sculpture. Meanwhile, seated in the right foreground, an older woman serves as a chaperone for the model. This matronly woman apparently has little cause for moral anxiety as she looks down at her knitting rather than keeping a watchful eye on the propriety of Rush's behavior. The only figure who gazes at the nude model is Rush's lifelike sculpture of George Washington standing amid the shadows in the right background. Eakins's witty inclusion of this figure suggests that the "Father" of the nation was also expressing his approval of this particular artistic practice.

There is no historical evidence that Louisa Vanuxem posed nude in 1809 or that William Rush ever worked from a nude model. In fact, it was not until the 1850s that life-drawing classes with nude models became the norm at both the National Academy of Design and the Pennsylvania Academy. As the art historian Elizabeth Johns has argued, Eakins's deliberate historical fiction was inspired by his own belief that respectable women from good Philadelphia families had little to fear in posing for professional artists and aspiring art students. Eakins represents the artist's studio as a cluttered workplace ill-suited for sexual liaisons. The model herself is working hard as she rests a heavy book on her right shoulder and holds the desired pose for long and boring periods of time. Nevertheless, Eakins titillated the sexual imagination of beholders by draping the model's discarded clothing over a chair in the immediate foreground. These richly painted objects are so brightly highlighted and are pushed so close to the picture plane that they seem to invite viewers to reach into the fictive space. The fine lace and ruffled articles of clothing identify the model's elevated social status. They also inevitably evoke the image of the model's act of disrobing before the male artist. Rather than representing an ideal nude figure who seems to exist outside of any specific time and place, Eakins represents a particular nineteenth-century woman who has just removed her clothing and displays her less-than-perfect naked body as a symbol of sincerity and truth to nature.

Eakins rejected middle-class American prudery, strongly arguing that no shame or embarrassment should be felt in admiring the physical sensuality of the nude form. Eakins shared many of the views of the National Liberal League, founded in Philadelphia in 1876 to oppose a growing right-wing movement against free speech, women's equality, and sexual freedom. After the Civil War, organizations like the New England Society for the Suppression of Vice and the Young Men's Christian Association (YMCA) supported moral purity campaigns for the eradication of "obscene" books, pictures, and contraceptive devices. In Philadelphia during the Centennial celebration, moral reformers attacked lewd entertainments such as cancan dancing in variety halls. Later, during the 1880s, a Philadelphia clergyman, the Reverend J. Gray Bolton, founded a group known as the Moral Committee of One

Hundred, while another leading moralist, Josiah W. Leeds, questioned the moral wisdom of representing nudes in art. In 1886, Eakins resigned from his teaching post at the Pennsylvania Academy apparently because members of the board of directors had criticized his use of nude male models in a class that mixed both male and female students.

In fact, Eakins had become preoccupied with study of the nude figure, and he took up photography as a useful technology for examining the human body in motion. His famous painting The Swimming Hole (fig. 6.27) was composed from photographic studies of the artist and his male students (fig. 6.26). In 1882 or 1883, they had taken an outing together to a secluded creek near Bryn Mawr, just outside of Philadelphia. The group was chaperoned by an older man, who remained fully clothed, while Eakins and his students swam and posed for the camera. In the photograph, Eakins can be seen at the right climbing out of the water and onto the rocky ledge. In the painting, he is further isolated from the group as he swims toward the others from the lower-right corner of the picture. As is evident from both the photographs and the painting, the outing became a self-conscious attempt to re-create the ancient Greek ideal of male beauty and camaraderie. As much as the

6.26 Circle of Eakins Thomas Eakins and Students Swimming Nude, c. 1883. Platinum print, $8^{15}/_{6} \times 11\%$ in $(22.6 \times 28.1 \text{ cm}).$ Pennsylvania Academy of the Fine Arts. Charles Bregler's Thomas Eakins Collection.

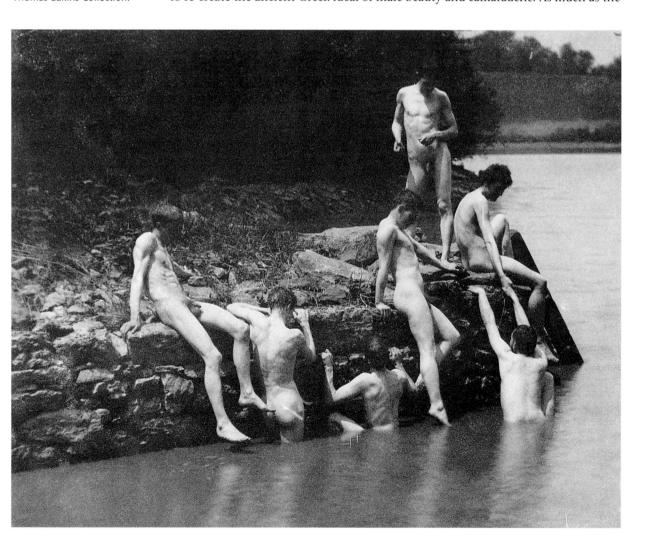

painting, the photograph appears artfully composed. The young men display their bodies as if they were modern re-creations of classical sculptures. As the United States became increasingly urbanized and industrialized, Eakins and other American artists produced works that expressed a nostalgia for simpler, less complicated modes of living, closer to the regenerative energies of nature. In the painting, Eakins set the figures further back into space, more clearly integrating them with the lush, surrounding landscape. Furthermore, he arranged the composition to suggest an energetic circle of figures moving into and out of the cool, revivifying water.

Eakins's interest in recording physically active bodies was further stimulated by the English-born photographer Eadweard Muybridge (1830–1904), who, while living in California, had become a pioneer in the development of motion photography. By using banks of cameras closely placed together, Muybridge was able to make a rapid succession of photographs that captured the split-second movements of animals and humans as they moved through space (fig. 6.28). After meeting Muybridge in 1884 at the University of Pennsylvania and assisting him in his photographic experiments, Eakins began to shoot his own motion photographs. But instead of following Muybridge's technique, he adopted the methods of the Frenchman Étienne-Jules Marey (1830–1904), who was able to record motion on a single photographic negative. By spinning a disc before an open camera lens, admitting light through a single

6.27 Thomas Eakins The Swimming Hole, c. 1885. Oil on canvas, $27\% \times 36\%$ in $(69.6 \times 92.5 \text{ cm})$. Amon Carter Museum, Fort Worth, Texas.

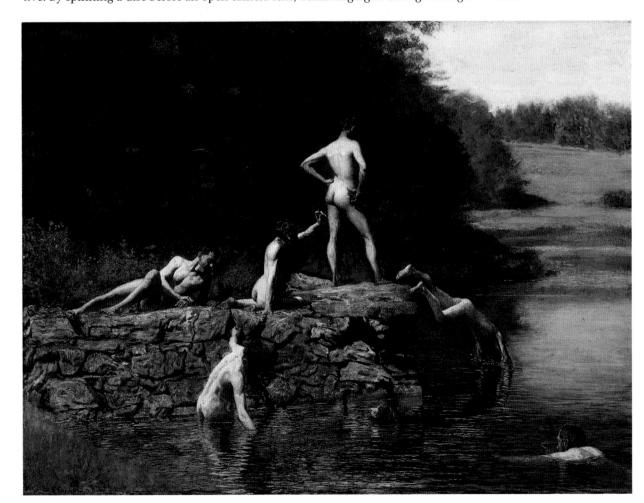

6.28 Eadweard Muybridge Twisting Summersault, from The Attitudes of Animals in Motion, 1881, plate 106. Albumen print. Addison Gallery of American Art, Phillips Academy, Andover, Massachusetts. Partial gift of

the Beinecke Foundation, Inc.

Muybridge had gained fame during the 1870s, when his photographic technique captured a racehorse in motion. The sequential photographs demonstrated the inaccuracy of painters' traditional flying "hobbyhorse" convention for depicting a speeding horse, whereby the horse's front leas were extended entirely forward off the ground and the hind legs entirely backward off the ground. Muybridge advanced the reputation of photography as a scientific instrument.

point, Eakins could make quick, successive exposures, thereby recording on one plate the transit of the body as it ran, walked, or jumped (fig. 6.29).

Eakins taught many younger artists to focus on the human body as a site of truth. One of his students, Thomas Pollock Anshutz (1851–1912), painted a rare industrial subject, The Ironworkers' Noontime (fig. 6.30), which represents a group of working-class men washing up, relaxing, and posing outside an iron factory during the heat of the day. Anshutz came from a family that had owned and operated iron mills earlier in the century, and he had grown up in Wheeling, West Virginia, where iron mills lined the banks of the Ohio River. As an adult, Anshutz frequently visited relatives in Wheeling, and, in 1880, he began to sketch its workers and iron factories. Most artists avoided such subjects because American factory laborers were commonly represented in the popular media as animalistic or primitive beings. Unlike the romanticized artisans of the pre-industrial past, modern wage-laborers were viewed as human cogs within the vast and ingenious machinery of factory production. The fact that many workers were foreign immigrants, African Americans and union members (and some were political radicals), made them even less desirable as subjects for high art. Certainly, few capitalists or businessmen wished to be reminded of their exploited workers while relaxing in their homes and private clubs.

Understandably enough, Thomas Anshutz had difficulty selling The Ironworkers' Noontime. Though the painting is not explicitly political and does not necessarily foreshadow the artist's later conversion to socialism, the picture represents strong and independent-looking workers. Temporarily freed from the factory machinery, they are not a unified group but are relaxing as individuals—many standing,

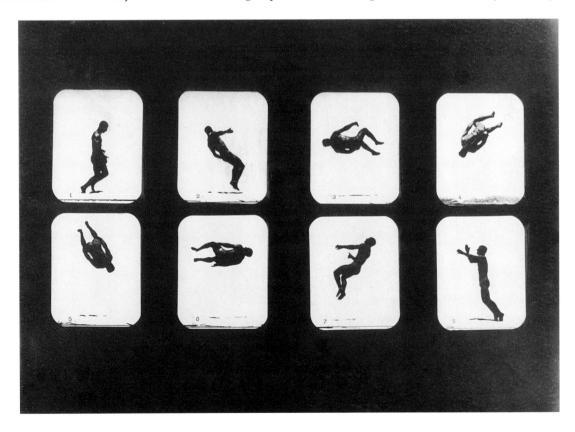

walking, or sitting alone, some lost in thought. While the figure closest to the picture plane self-consciously poses for the artist, others seem to express a certain class antagonism or distrust toward the affluent producers and consumers of fine arts as they suspiciously stare outward, looking directly at us, the viewers/outsiders. Unlike Eakins's later The Swimming Hole, Anshutz's unsentimental painting lacks any romantic nostalgia for an ideal world of pastoral harmony. The younger artist's hot and dusty realism may not be overtly political, but for many contemporaries it must have appeared unusually frank and confrontational. On the other hand, much to Anshutz's embarrassment, his composition was copied or pirated by corporate America soon after the painting's exhibition. Inspired by the picture's group of figures who wash and clean themselves at a water pump, the Proctor & Gamble Company transformed the image into an advertisement for Ivory Soap (fig. 6.31). With the growth of American advertising and the simultaneous expansion of the art market, this type of commercial appropriation became increasingly commonplace and also eventually worked in reverse, as artists began to borrow images from advertisers.

The masculine visions of Homer, Eakins, and Anshutz implicitly expressed the notion, argued by many artists and art critics, that the art profession should be the preserve of men. Though he taught many young women at the Pennsylvania Academy, Eakins wrote to a friend in 1886 that he did not believe a woman could ever produce art works that were truly great. According to the art historian Randall C. Griffin, Anshutz's *The Ironworkers' Noontime* and Eakins's many paintings of athletic young men masked contemporary anxieties that modern culture was becoming feminized and even emasculated not only by the proliferation of ladies' magazines and the genteel decorative arts, but also by the increased demand for mental rather than physical labor among the middle and upper classes. Cultural critics informed men who worked in business offices or had intellectual careers that they were especially in danger of losing their manly will. Remedies for this

6.29 (below) Thomas Eakins

Motion Study: George Reynolds nude, pole-vaulting, 1885. Dry-plate negative, $3\% \times 4\%$ in $(9.6 \times 12.4 \text{ cm})$. Pennsylvania Academy of the Fine Arts. Charles Bregler's Thomas Eakins Collection.

6.30 (right, above) **Thomas Pollock Anshutz**

The Ironworkers' Noontime, 1880. Oil on canvas, 17 × 23% in (43.2 × 60.7 cm). Fine Arts Museums of San Francisco, San Francisco, California. Gift of Mr. and Mrs. John D. Rockefeller 3rd.

The dark factory building behind the workers and the overlapping lines of wheel ruts beginning in the foreground create a strong diagonal movement. The shadowed factory and the gritty gray ground dust contrast with the freshly washed white flesh of the workers. Polluting smoke belches from chimneys and smokestacks. Ironically, this painting was ultimately purchased by descendants of oil baron John D. Rockefeller, the personification of Gilded Age capitalism's anti-labor practices.

6.31 (right, below) Poster by Proctor & Gamble to introduce Ivory Soap c. 1883. Lithograph on paper,

c. 1883. Lithograph on pape 8 ft 4 in \times 13 ft 4 in (2.5 \times 4 m).

The Proctor & Gamble advertisement represents Anshutz's workers washing themselves, while supplying them with washcloths, clean towels, and large tubs of water. Even the background factory appears neater and cleaner than in Anshutz's original work.

6.32 Daniel H. Burnham Masonic Temple, Chicago, 1890–92. Chicago Historical Society, Chicago, Illinois.

Together with his partner John Wellborn Root, Burnham created one of Chicago's most distinguished skyscrapers. Located downtown at the corner of State and Randolph streets, this grand steel-frame structure, faced with brick and terra-cotta, was demolished in 1939. Between its sturdy, arcaded base and its lofty, steeply gabled roof, the building's main shaft featured narrow continuous piers that accentuated the skyscraper's vertical character.

dissipation of male energy included strenuous recreational activities and the development of organized sports. Furthermore, membership in private men's clubs and ritualistic fraternal orders such as Freemasonry mushroomed during the post–Civil War era. For many years, Daniel Burnham's twenty-two-story Masonic Temple in Chicago was the tallest building in the world (fig. 6.32). Not to be outdone, the Odd Fellows, an organizational spin-off from Freemasonry, commissioned Louis Sullivan to design an even higher, thirty-six-story Fraternity Temple Building, although the project never left the planning stage.

War Memorials and the Heroic White Male

While photographers had undercut the traditional masculine heroism of history painting, American sculptors answered the post–Civil War demand for public memorials of military officers, soldiers, and statesmen. The 1876 Centennial cele-

bration also inspired commissions that nostalgically glorified America's colonial settlers and revolutionary founding fathers. In 1872, in anticipation of the nation's one-hundredth birthday, the town of Concord, Massachusetts, commissioned a young local sculptor, Daniel Chester French (1850–1931), to create a Revolutionary War sculpture commemorating the April 19, 1775, battle of Concord, one of the war's opening skirmishes. Working in his Boston studio, French designed plaster and clay models for the Minute Man, a seven-foot statue that was then cast into bronze at a nearby foundry (fig. 6.33). French's anonymous noble figure represents an eighteenth-century farmer, who, at a moment's notice, voluntarily joins his fellow citizens to form a militia against the British in defense of political freedom. Though the sculptor clothed the figure in realistic, revolutionary-period costume, its striding pose led contemporaries to recognize the young artist's debt to ancient Greece and the ever-popular Apollo Belvedere (see fig. 4.33). Furthermore, as in Homer's painting The Veteran in a New Field (see fig. 6.18), French's inclusion of a plow next to the militiaman evoked associations with the ancient Roman general Cincinnatus and his American counterpart, George Washington (see fig. 4.39). Significantly, in casting the bronze sculpture, the Ames Foundry in Chicopee, Massachusetts, melted down discarded Civil War cannons donated by the United States government. Thus, the Minute Man symbolically celebrated the end of the Civil War and the return of American unity, while idealizing the masculine strength and valor of the nation's founders.

Shortly after the nation's Centennial, a committee of eminent New York City businessmen and state leaders commissioned another young sculptor, Augustus

6.33 Daniel Chester French Minute Man, 1873-5, Concord, Massachusetts. Bronze and stone, height 84 in (213.3 cm).

Saint-Gaudens (1848-1907), to create a memorial for Admiral David Glasgow Farragut, a naval hero during the Civil War (fig. 6.34). The bronze statue, over eight feet high, stands in New York's Madison Square Park on a Hudson River bluestone pedestal designed by Saint-Gaudens's collaborator, the architect Stanford White. Favoring bronze over white marble for its greater malleability and potential for realistic detail, Saint-Gaudens endowed Farragut with a naturalistic aura of masculine vigor and resolute will as he seems to stand on the deck of his ship, his coat flapping open in the ocean breeze. By contrast, Saint-Gaudens created two rather bloodless female personifications of Loyalty and Courage, carved in low relief, for the semicircular sandstone base. These idealized yet relatively listless, funereal women blend with nature and the stylized waves of the sea. The placid, horizontal arrangement of their elongated arms and legs provides a counterpoint to the vertical Farragut, who stands straight as an arrow, ready for action. In memorializing the admiral, Saint-Gaudens implicitly reinforced the stereotypical notion that women could not be active creators or conquerors of nature because they themselves were immersed like mermaids within nature's watery ebb and flow.

However, for Saint-Gaudens, who shared the elitist views of his wealthy patrons, not all men were created equal. In 1884, the sculptor received a commission for another Civil War memorial, this one from a group of Boston citizens who wished to honor Captain Robert G. Shaw (1837-63). The only son of a genteel Boston family, Shaw had commanded the Massachusetts 54th Regiment, composed primarily of African-American volunteers. Shaw and most members of the regiment were killed during a suicidal attack on the Confederate Army at Fort Wagner, South Carolina, on July 16, 1863.

6.34 Augustus Saint-Gaudens

The Admiral David Farragut Memorial, New York City. 1881 (base designed by Stanford White). Bronze and stone. Collection of the City of New York, Madison Square, Manhattan, New York.

Below the figure of Farragut, Saint-Gaudens sculpted the admiral's long sword in low relief on the central pedestal block. The sword's strong vertical line, symbolizing masculine strength, continues that of the bronze scabbard hanging from the naval hero's waist. Later, Saint-Gaudens created for New York's Central Park the more grandiose Civil War memorial (1892-1903) dedicated to General William Tecumseh Sherman.

6.35 Augustus Saint-Gaudens

The Robert Gould Shaw Memorial, Boston, Massachusetts, 1884–97. Massachusetts Historical Society, Boston, Massachusetts.

Saint-Gaudens' Civil War memorial directly faces Charles Bulfinch's Massachusetts State House on Boston's Beacon Hill (see fig. 4.12). At the far right, the sculpture's bronze surface bears the Latin inscription Omnia Relinquit Servare Republicam ("He forsook all to preserve the public weal"). These words are the motto of the Society of the Cincinnati, to which Shaw belonged as the descendant of a Revolutionary War officer. The Shaw Memorial thus establishes a link with the nation's Founding Fathers.

Taking almost fourteen years to complete the monumental bronze sculpture, Saint-Gaudens again contrasted male and female figures (fig. 6.35). Set within a stone framework designed by the architect Charles Follen McKim, an ethereal female figure sculpted in low relief floats over the parade of men. Like an angel of death, she holds poppies and an olive branch, traditional symbols of eternal sleep and peace or victory, respectively. By contrast, the naturalistically rendered regiment of men below stands out in high relief. While most scholars have praised Saint-Gaudens for his sympathetic portrayal of African-American foot soldiers, the art historian Albert Boime argues that the Shaw Memorial implicitly expressed a racist dichotomy between white and black. Saint-Gaudens's sculpture reinforced the conventional military wisdom that no African-American could be relied on to command an all-black regiment. While Shaw, the noble white officer, sits erect astride a powerful horse, his black troops appear more tired and bedraggled than heroic. Far from being energized by the prospect of fighting for their own freedom, they appear weighed down by the heavy burden of warfare.

One can certainly attribute the black soldiers' appearance to the influence of non-heroic photographic journalism and Saint-Gaudens's desire for objective truth. However, the sculptor clearly represented Shaw upon a higher, ideal plane, as the equestrian figure was designed to evoke associations with ancient Roman and Italian Renaissance prototypes. The image of African-American men carrying rifles in heroic fashion would have been too disturbing and threatening for a white audience. Saint-Gaudens employed African-American models to create individualized black soldiers, but none stands out from the group and a number are obscured by Shaw's monumental horse. Indeed, the legs of the troops blend with those of the

horse, the symbol of Shaw's strict control over animal nature. Saint-Gaudens's correspondence amply demonstrates his belief that African Americans, or "darkeys" as he repeatedly called them, were inherently slavish beings in need of strong discipline. In his *American Masters of Sculpture* (1913), the critic Charles Caffin applauded the sculpture's racial distinctions:

He [Saint-Gaudens] portrays the humble soldiers with varying characteristics of pathetic devotion, and from the halting uniformity of their movement, even from the uncouthness of their ill-fitting uniforms, from such details as the water-bottles and rifles, secures an impressiveness of decorative composition, distinguished by virile contrasts and repetitions of line and by vigorous handsomeness of light and shade. Mingled with our enjoyment of these qualities is the emotion aroused by the intent and steadfast onward movement of the troops, whose doglike trustfulness is contrasted with the serene elevation of their white leader. (cited in Boime, p. 209)

By 1898, when Saint-Gaudens had completed the Shaw Memorial, the United States Supreme Court had ruled in the case of *Plessy v. Ferguson* (1896) that "if one race be inferior to the other socially, the Constitution of the United States cannot put them upon the same plane" (cited in Boime, p. 39). The decision officially authorized the segregationist doctrine of "separate but equal accommodations" for whites and blacks. However, equality could hardly have been the court's goal given the justices' presumption of black inferiority. The landmark ruling essentially nullified the political and civil rights that African Americans had gained during Reconstruction.

Henry Ossawa Tanner and the Expression of African-American Creativity

Many white Americans borrowed from Charles Darwin's evolutionary theory that only the fittest species survive to insist that the inherently inferior black race was destined, like the American Indian, for ultimate extinction. Contrary to Edmonia Lewis's affirmation of African-American creativity and dignity (see fig. 6.16), influential white American artists and critics continued to argue well into the twentieth century that women and blacks were incapable of producing significant art. Just before his death, the printmaker Joseph Pennell (1857–1926) wrote a memoir that implicitly scorned the painting career of the black artist Henry Ossawa Tanner (1859–1937), who had been Pennell's fellow student at the Pennsylvania Academy during the early 1880s. Though Thomas Eakins welcomed Tanner into his drawing class and later painted a sympathetic portrait of his former student (fig. 6.36), he apparently was unaware that Pennell and

6.36 Thomas Eakins Portrait of Henry O. Tanner, 1900. Oil on canvas, $24\% \times 20\%$ in (61.6 \times 51.4 cm). The Hyde Collection, Glen Falls, New York.

This somber, meditative painting typifies Eakins's portraits of family, friends, and former students. Against an empty, sketchily painted background, the seated Tanner is turned away from the viewer, his spectacled gaze cast downward to suggest a contemplative, melancholic mood. The welldressed painter sports a fashionable goatee and moustache. Eakins brightly illuminated Tanner's forehead in contrast to the heavily shaded right side of the face, thereby conveying the artist's intelligence and poetic, introspective character.

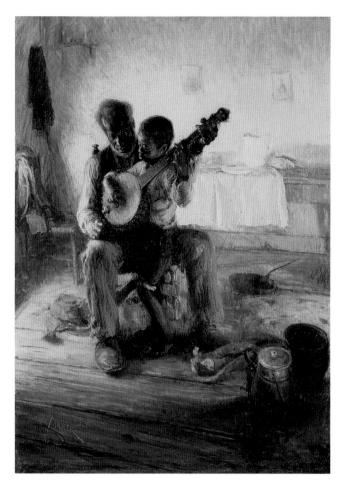

6.37 Henry Ossawa Tanner The Banjo Lesson, 1893. Oil on canvas, $49 \times 35\%$ in (124.4 \times 90.2 cm). Hampton University Museum. Hampton, Virginia.

Tanner shared Thomas Eakins's admiration for the painterly, golden tonalities of Rembrandt van Rijn's compositions. However, the evocative blue and bluegreen colors of Tanner's painting differ from both Eakins's and Rembrandt's palettes and suggest the influence of French Post-Impressionist art.

other students were victimizing Tanner with an intense campaign of racial harassment. In his account entitled "The Advent of the Nigger," Pennell recalled that "One night his [Tanner's] easel was carried out in the middle of Broad Street and, though not painfully crucified, he was firmly tied to it and left there" (cited in Bearden and Henderson, p. 82). While not identifying Tanner by name, Pennell concluded with the assertion that "There has never been a great Negro or a great Jew artist" (cited in Bearden and Henderson, p. 82).

Despite these hateful remarks, Tanner achieved artistic fame by leaving the racially hostile environment of Post-Reconstruction America for the more tolerant atmosphere of Paris. The son of a bishop in the African Methodist Episcopal Church, Tanner ultimately specialized in painting biblical subjects bathed in atmospheric tones of color. Earlier, however, he painted scenes of African-American life. One of his best-known works. The Banjo Lesson (fig. 6.37), seems to represent a conventional subject in its portrayal of an old African American man teaching a barefoot boy, probably his grandson, how to play a musical instrument. However, Tanner's picture, with its theme of education, contradicted the racial stereotype that blacks were inherently musical. Tanner celebrates the image of African-American self-cultivation and creative development as transmitted from one generation to the next. Like Eakins, he worked from a

photograph in composing the picture and he gave his figures a sculptural solidity and weight reminiscent of his former teacher's painterly realism. However, The Banjo Lesson possesses a blurring atmospheric haze that suggests a more spiritualized strand of American painting.

Cosmopolitanism and the Lure of French Art

Before the Civil War, Rome had been the most popular destination on the European continent for Americans studying the arts. Rome, the "eternal city," was like an arthistorical museum of ruins and artifacts from antiquity through the Renaissance. After the war, however, cosmopolitan American artists who wished to break with tradition flocked to Paris, where they found a number of artists representing modern subjects in fresh, innovative ways. Unlike Homer and Eakins, who studied in Paris for relatively brief periods of time, other Americans became long-term residents in this foreign capital of contemporary art. It has been estimated that over 1,800 American artists studied in Paris during the later nineteenth century. As the novelist Henry James observed in the 1880s, "When we look for 'American art' we find it mainly in Paris. When we find it out of Paris, we at least find a great deal of Paris in it" (cited in Pollock, p. 76).

6.38 Mary Cassatt At the Opera (In the Loge), 1879. Oil on canvas, 32×26 in (81.3 \times 66 cm). Museum of Fine Arts. Boston. Massachusetts. The Hayden Collection.

This picture began a series of theater paintings by Cassatt that focused on young women variously situated alone or in pairs in balcony spaces. Appropriating the Impressionist techniques of Edgar Degas, Cassatt experimented with different angles of vision and the cropping of images to draw viewers' attention dynamically away from the compositional center toward the periphery and the spaces beyond the picture frame. Cassatt thus expressed the Impressionist tendency to merge art with modern life.

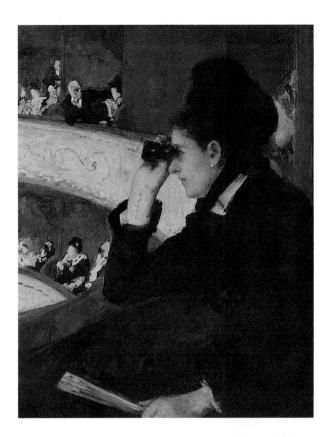

6.39 (below) Mary Cassatt Reading "Le Figaro," 1877-78. Oil on canvas, 393/4 \times 32 in (101 \times 81.2 cm). Private Collection, Washington, D.C.

The daughter of an investment broker and merchant from Allegheny City, Pennsylvania, Mary Cassatt (1844-1926) first studied painting at the Pennsylvania Academy from 1861 to 1865 before traveling extensively in Europe and then settling in Paris by the 1870s. Unable to study at the École des Beaux-Arts because of her sex, Cassatt drifted away from traditional academic styles and joined the circle of French Impressionists, who were the leading avantgarde painters in Paris. Originally a military term for an advanced guard that precedes the main force of troops, during the nineteenth century the "avant-garde" in art came to refer to modern, forward-looking artists who broke with past, conventional styles and challenged the perceptual habits of the public with innovative means of expression. The Impressionists, led by Monet, Renoir, and Edgar Degas (1834–1917), had generally stopped sending works to the Paris Salon, the annual state-supported exhibition juried by conservative French academic artists. Instead, in 1874, they began exhibiting independently as a group, startling the public with their sketchily painted, spontaneous impressions of modern Paris and its surrounding suburbs.

Invited by Degas, Cassatt joined the Impressionists in 1877 and exhibited with them from 1879 to 1886, when the group broke up. As a single woman, Cassatt was unable to

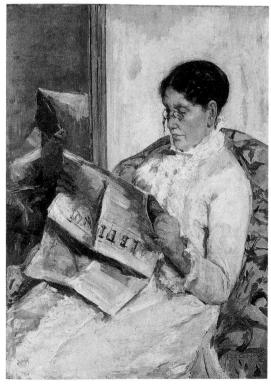

frequent many of the café and entertainment sites that her male counterparts depicted in their paintings. Cassatt's At the Opera (fig. 6.38) represents a strong feminist point of view, as it depicts a lone woman attending a theatrical event. The young woman is turned away from us, while our gaze is mirrored in the background by a sketchily painted man with opera glasses who also intently directs his attention toward the attractive foreground figure. Cassatt's woman is not a beautiful seductress or passive object of voyeuristic pleasure. She has her own independence as she, too, actively looks beyond the picture frame with a small pair of opera glasses. Emulating other Impressionists, Cassatt composed the picture as a kind of photographic snapshot, or slice of life, but she employed the Impressionist emphasis on the act of seeing to assert the principle of sexual equality with men. The painter primarily produced images of mothers and their children but, in general, without the cloying sentimentality normally associated with the theme of motherhood. Significantly, Cassatt's portrait of her own mother represents the visiting parent as she reads a Paris newspaper (fig. 6.39). Traditionally in American and European art, reading women were absorbed in novels or romances, works of fiction rather than newspapers. As we saw with Eastman Johnson's portrait of The Brown Family (see fig. 6.19) and Richard Caton Woodville's War News from Mexico (see fig. 5.28), newspapers were conventionally read by men, since the news was dominated by the masculine realm of politics and business. Once again, the older woman is absorbed by her own intellectual activity and ignores our obtrusive gaze. A mirror next to the mother might have allowed us to see the news story that she is reading. but Cassatt's liquid brushstrokes render illegible such niggling narrative details, thereby preserving her mother's privacy.

In stark contrast to Cassatt, John Singer Sargent (1856–1925), another American in Paris, created a scandal with his Salon exhibition portrait Madame X (fig. 6.40), representing Virginie Gautreau, the American-born wife of a wealthy French businessman. Born in Florence, Italy, to wealthy parents, Sargent was educated abroad and spent most of his career traveling and living in Europe, especially in Paris and London. Influenced by Édouard Manet's sexually charged pictures of the female nude, Sargent collaborated with Virginie Gautreau to create a frank and icily sexual image of a professional beauty. Contemporary critics employed the term to refer to women who used their professional beauty and personal manners and skills to advance themselves into elite social circles. Unlike the young woman in Cassatt's At the Opera, Gautreau is fully aware of our presence and presents herself as a beautifully composed body or visual object. Her provocative, deeply cut gown reveals unblemished, porcelain-white flesh and a fashion-plate figure with swelling breasts and slim waist. Sargent originally painted Gautreau with a shoulder strap slipped down along her arm, but he later reworked the picture and returned the strap to its proper position. In her classical-Greek-style hair, Gautreau wears a diamond crescent, symbol of the moon goddess Diana, patroness of the hunt. Like a modern-day goddess, the celebrated beauty proudly turns away from the beholder. Her sharp, linear profile contributes to the impression of a tightly coiled sexual energy that can be admired safely only from a distance. Though the painting was exhibited with an anonymous title, critics immediately recognized the identity of the sitter and denounced both Sargent and Gautreau for collaborating in a sexually suggestive, immoral painting.

Sargent soon escaped the scandal by moving to London in 1886, followed by a brief working visit to America in 1887-88, which established his reputation as the leading, most fashionable portraitist of the American social elite. Controversy over

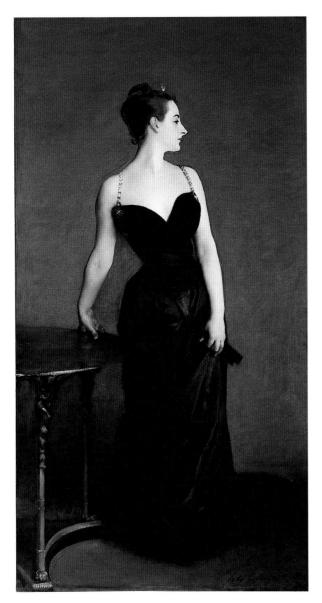

6.40 (left) John Singer Sargent Madame X, 1883-84. Oil on canvas, $82\% \times 43\%$ in $(208.6 \times 109.9 \text{ cm})$. The Metropolitan Museum of Art, New York. Arthur Hoppock Hearn Fund, 1916.

Madame X had served to publicize the artist's fame and aesthetic daring. Sargent's success as a portraitist led in 1890 to a major mural commission for Boston's new public library designed by the New York architects Charles Follen McKim and Stanford White (fig. 6.41). For the next three decades, much of Sargent's career was occupied by the task of decorating the large, third-floor vaulted gallery at the top of the library's main staircase. Eager to demonstrate that he was intellectually and artistically capable of Renaissance-style history paintings, Sargent chose to represent the evolutionary progress of Western civilization as manifested in the history of religion. Although his Triumph of Religion was never entirely completed, the artist, beginning in 1895, made four major installments of panels representing some sixteen subjects that traced the development of religion from the ancient pagan gods to the advent of Christianity (fig. 6.42).

6.41 McKim, Mead, & White

Boston Public Library, 1887-95. Special Collections Hall, looking north toward John Singer Sargent's Israelites Oppressed (north wall lunette, installed 1895) and Frieze of the Prophets (north wall, below lunette, installed 1895). The Trustees of the Public Library of the City of Boston, Massachusetts.

This photograph of the thirdfloor Special Collections Hall focuses on the north wall of Sargent's religious history cycle. The wall's large lunette painting, Israelites Oppressed, represented the Jews' persecution at the hands of an Egyptian pharaoh and an Assyrian king, Sargent appropriated the flattened, hieratic styles of ancient Egyptian and Assyrian art to represent the picture's dominant figures.

6.42 John Singer Sargent Frieze of the Prophets, north wall, 1895. Trustees of the Public Library of the City of Boston, Massachusetts.

Immediately below Israelites Oppressed, Sargent painted this group of Old Testament figures. At the center is a highly stylized representation of Moses holding the stone tablets bearing the Ten Commandments. As the oldest historical figure, Moses is surrounded by the wings of a divine presence. Sargent painted the remaining frieze figures in more naturalistic terms to suggest religion's progress toward individuality and freedom.

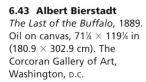

Bierstadt specialized in painting grandiose pictures of the American West. Based on sketches that he made in Wyoming in 1863 and 1871-3, Bierstadt created this fictive work, which attributed the decimation of American buffalo herds entirely to avaricious, warring Indians. In fact, the United States government itself significantly contributed to the declining buffalo population by strategically encouraging their slaughter so as to deprive rebellious Native tribes of their food supply. Bierstadt's last standing buffalo seems to prophesy the ultimate defeat or extinction of the Indian race.

The Society of American Artists: Art as Religion

While Frederic Church, Albert Bierstadt (1830–1902), and other painters continued to produce panoramic landscapes of the disappearing American wilderness and western frontier (fig. 6.43), other artists and critics increasingly expressed dissatisfaction with their illusionistic detail and almost mechanistic precision. With the accelerated pace of urbanization and economic modernization threatening to overwhelm American culture in a sea of mass-produced goods and popular entertainments, elite critics sought out artists who expressed higher, more poetic truths than the unimaginative imitation of nature. Many post-Civil War painters turned toward subjects and techniques that expressed spiritual and introspective moods in contrast to the naturalism or photographic details of Church's paintings.

In 1878, the newly founded Society of American Artists challenged the National Academy of Design by offering New Yorkers a rival exhibition of contemporary art devoted to the expression of inner feelings. Led by the painter Helena de Kay Gilder (1848–1916), most artists who joined the Society came from patrician, socially connected New York and Massachusetts families. Many of the artists had just returned from extensive study abroad and had become dissatisfied with what they perceived as the provincial, narrow-minded nature of National Academy exhibitions. In 1874,

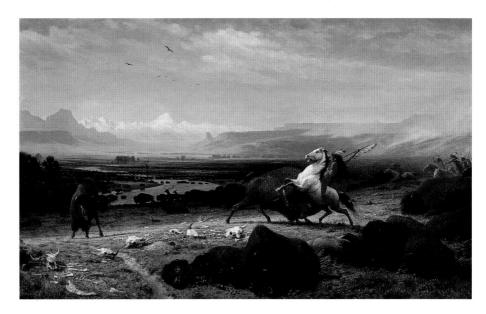

the academy jury had rejected all of the submissions offered by the painter John La Farge (1835–1910), who was also an art theorist and a lecturer on aesthetics at Harvard University. Born in New York to a French émigré family, La Farge developed an international, cosmopolitan perspective, which led him to an interest in Japanese as well as European art. La Farge was one of the first American artists to intensively study Japanese prints, admiring their flexible distortions of form and illusionistic space as well as their sensuous, expressive use of color. Drawing on his wide knowledge of Western and non-Western art, La Farge concluded that the visual arts, the formal properties of color, line, and perspective, were governed by divinely inspired, universal laws. Rejecting the need for narrative subject matter, La Farge painted a number of flower pictures during the 1860s and 1870s which synthesized naturalistic observation with jewel-like colors and stylized compositions influenced by Japanese as well as English and French art (fig. 6.45).

Though La Farge was a member of the National Academy, his paintings appeared too foreign or unconventional for the Academy jury. Martyred by the Academy, La Farge came to personify the new, more individual and stylistically innovative art advocated by the Society of American Artists. Though he had difficulty in selling his paintings and was often in financial straits, he helped to launch the American Renaissance movement when, in 1876, he received a commission to decorate the interior of Henry Hobson Richardson's Trinity Church in Boston's Copley Square (fig. 6.44). Richardson, who supported the decorative aesthetic principles of the Arts and Crafts movement, chose a monumental Romanesque, rather than a Gothic, style for this episcopal church. Unlike Gothic cathedral architecture, the earlier medieval Romanesque style allowed for greater, uninterrupted wall space that could more easily be decorated with murals and mosaics. Indeed, a rich coloristic effect for the worship space was essential to Richardson's conception of the church. Therefore, he plastered over the granite piers and arches to create continuity between these structural elements and the plastered wall surfaces. The architect provided a clear field for La Farge, who, with a number of assistants, including Augustus Saint-Gaudens, created a golden, jewel-like interior glowing with colorful murals, stained-glass windows, and mosaics of sparkling colored glass.

The decoration of Trinity Church exemplified the American Renaissance collaboration of architects and artists and expressed the late-nineteenth-century tendency to view art or aesthetic beauty as a virtual religion, or spiritual end in itself. Throughout his career, La Farge received commissions to decorate Protestant churches with painted murals, stained-glass windows, and other media. Even Congregationalists and Presbyterians, theologically descended from the iconoclastic, Puritan tradition, now sought solace in art. During a scientific age, when Darwinian theories of evolution were undermining the Christian story of creation and the literal truth of biblical history, many American Protestants from the northeastern elite found it more reasonable to interpret the Bible in poetic terms and to view the transcendent experience of art as a spiritual substitute for traditional religious doctrines. In arranging Trinity Church's Old and New Testament scenes, La Farge was not guided by any particular theological or doctrinal program. The artist, instead, based his decorative scheme on aesthetic principles, or the compositional harmonization of colors and formal patterns.

For La Farge and the genteel members of the Society of American Artists, art functioned as a guide for ascending toward a higher state of civilization and spiritual refinement. Another artist affiliated with the Society was the landscapist George Inness (1825–94), who began his career before the Civil War by emulating

6.44 Henry Hobson Richardson with John La Farge Trinity Church, Boston, c 1875. Interior view toward the chancel.

the Hudson River School style of Thomas Cole and Asher B. Durand (see Chapter 5). However, by the 1860s, Inness was seeking to evoke inward religious feelings inspired by the visionary writings of Swedenborg. To that end, he adopted a less detailed, more atmospheric, and more tonal style borrowed from a group of midnineteenth-century French landscapists known collectively as the Barbizon School. Named after a French village and art colony in the Forest of Fontainebleau near Paris, this group of artists also influenced the art of La Farge and many other American painters.

Inness's painting of Niagara exemplifies his mature style (fig. 6.46). Unlike Frederic Church's antebellum interpretation of the subject (see fig. 5.57), Inness blurs details and mutes the light with misty and smoky veils of paint. In contrast with Church's dramatic diagonal sweep into space, Inness's dissolution of sharp lines and forms stills movement to create a quiet space for spiritual reverie. On the other hand, Inness does not allow the viewer to escape the reality of modern American industrial life. As the most pronounced vertical element in the entire picture, a distant factory smokestack strongly calls attention to itself as it emits a great plume of pinkish-orange smoke in contrast to the greenish blue of the Falls. Though Inness appropriated a style of painting derived from French landscapists such as Jean Baptiste Camille Corot (1796-1875) and Théodore Rousseau (1812-67), his continued choice of primarily American subjects enabled friendly critics to couple him with Winslow Homer as a self-reliant painter of national themes and values. Through the thin glazes of paint, Niagara Falls still emerges as a recognizable symbol of American nationhood.

Following in the footsteps of La Farge and Inness, Albert Pinkham Ryder (1847–1917) found a more sympathetic audience for his sketchily painted canvases when he left the National Academy of Design and began exhibiting with the Society of American Artists in 1878. Early in his career, Ryder had abandoned the realistic imitation of nature. Rather than painting detailed, illusionistic deceptions, he chose to paint his private visions and dreams. While admirers often noted the awkwardness of Ryder's drawing technique and the naive, almost childlike simplicity of his forms, they interpreted these oddities as signs of individual sincerity, or the artist's struggle to express his soul.

Ryder's small painting *The Dead Bird* (fig. 6.47) strongly contrasts with the *trompe l'oeil* still lifes of William Michael Harnett (see fig. 6.22), whose pictures of dead game were hung in saloons and hunting lodges. Far from expressing masculine bravado, Ryder's modest image of a pale-yellow canary represents a poignant meditation on death. Thinly painted on wood panel, the songbird's frail form is surrounded by a ghostly shroud. The artist used the butt-end of his brush to scratch in lines for the bird's feathers, while building up paint to accentuate its contorted, skeletal legs. As the art historian Elizabeth Brown observes, the canary's half-opened beak underscores the tragic stilling of its voice. Within the harsh Darwinian struggle for survival, Ryder clearly sympathizes with life's vulnerable creatures. Born to a poor, working-class family from New Bedford, Massachusetts, he tended to identify with society's outsiders and eccentrics.

Inspired in part by New Bedford's history as a whaling and fishing community, Ryder painted numerous seascapes that symbolically suggested the individual's perilous voyage through life. But unlike Winslow Homer with his relatively realistic narrative paintings of man against the sea (see fig. 6.21), Ryder tended to subordinate narrative

6.45 (top) John La Farge Magnolia Grandiflora, c. 1863. Oil on panel, 36 × 171% in (91.4 × 45 cm). Williams College Museum of Art, Williams, Massachusetts. Gift of Mrs. John W. Field in memory of her husband.

6.46 George Inness *Niagara*, 1889. National
Museum of American Art,
Smithsonian Institution,
Washington, D.C.

Inness frequently painted Niagara Falls. Rebelling against the Hudson River School's descriptive specificity, Inness emphasized the distilling role of memory rather than the quasiscientific role of the observational eye.

6.47 Albert Pinkham Ryder

The Dead Bird (The Dead Canary), c. late 1870s. Oil on wood, 4 $\% \times$ 9 % in (10.7 \times 25.1 cm). The Phillips Collection, Washington, D.C.

almost entirely to the drama of paint. In his painting of Jonah (fig. 6.48), the Old Testament story is almost entirely overwhelmed by his gestural brushwork and visionary representation of oceanic fury. Tossed overboard by his fellow mariners for incurring God's wrath, Jonah is virtually immersed within the sea of swirling paint. He cries out and raises his arms in the air in front of a flimsy boat crowded with barely legible, huddled human figures. From the far right, an enormous whale emerges from the vortex of ocean waves, its open mouth preparing to swallow Jonah alive. Meanwhile, overhead, a bearded God, the Old Testament Jehovah, floats between two elongated, winglike clouds. Holding a globe in one hand, Jehovah gives a sign of blessing with the other. The symmetrical arrangement of the heavenly sphere promises the triumph of order over chaos and Jonah's ultimate Christlike resurrection from entombment in the whale's stomach.

Fiercely independent, Ryder did not adhere to any particular religious doctrine or faith. But, like his mentor La Farge, the younger painter identified art with spirituality. In some reminiscences that he published in New York's Broadway Magazine

6.48 Albert Pinkham Ryder

Jonah, c. 1885, Canvas mounted on fiberboard, 271/4 \times 34% in (69.2 \times 87.3 cm). National Museum of American Art, Smithsonian Institution, Washington, D.C. Gift of John Gellatly.

Although painted in an entirely different style and historical context, Ryder's painting thematically recalls the death and resurrection imagery of John Singleton Copley's Watson and the Shark (see fig. 4.26). Ryder was a great admirer of the elemental seascapes of J.M.W. Turner (1775-1851). The English painter's Slavers Throwing Overboard the Dead and Dying - Typhoon Coming On (1840), exhibited in the United States and purchased by the Boston Museum of Fine Arts, was an inspiration for Ryder's biblical sea disaster.

in 1905, Ryder described the discovery of his painting method as if it had been a religious conversionary experience. After futilely attempting to imitate nature's colors, he suddenly began to see nature as a framed picture, subordinate to his art and to his own godlike creative powers:

The old scene presented itself one day before my eyes framed in an opening between two trees. It stood out like a painted canvas—the deep blue of a midday sky—a solitary tree, brilliant with the green of early summer, a foundation of brown earth and gnarled roots. There was no detail to vex the eye. Three solid masses of form and color—sky, foliage and earth—the whole bathed in an atmosphere of golden luminosity. I threw my brushes aside; they were too small for the work at hand. I squeezed out big chunks of pure, moist color and taking my palette knife, I laid on blue, green, white and brown in great sweeping strokes. As I worked I saw that it was good and clean and strong. I saw nature springing into life upon my dead canvas. It was better than nature, for it was vibrating with the thrill of a new creation. Exultantly I painted until the sun sank below the horizon, then I raced around the fields like a colt let loose, and literally bellowed for joy. (cited in McCoubrey, pp. 187–188)

More than other artists, Ryder developed a reputation for being a hermitlike loner who cared little for the practical necessities of selling his art. In fact, Ryder had appreciative patrons, but he tended to return to or hang on to many of his paintings, adding layer after layer of color glazing until the thick surfaces were as glowing as Japanese lacquerwork. Ryder painted *Jonah* around 1885 and reworked it at some point before 1895, even though the picture's first owner, a New York stockbroker, had lent it to the New York Athletic Club for an 1890 exhibition. Because Ryder did not allow earlier layers of paint to dry properly before adding new glazes, his paint surfaces have tended to crack and slip over time. Continually experimenting with painting materials, the artist also employed bituminous varnishes that have caused his colors to fade into powerful light-dark contrasts.

Whistler and the Triumph of Aestheticism

Ryder's anti-commercial attitude was inspired, in part, by the cosmopolitan painter James Abbott McNeill Whistler (1834–1903), a Lowell, Massachusetts, native who spent most of his career abroad in Paris and London after dropping out of the U.S. Military Academy at West Point. In Paris, Whistler quickly rejected traditional academic art and soon associated himself with stylistically innovative artists such as Manet and Gustave Courbet (1819-77), who were challenging the traditional academic rule that the highest art must possess a high degree of finish and illusionistic detail at the same time as conveying moral narratives or ennobling ideas. Whistler readily adopted the controversial credo of the French poet and art critic Théophile Gautier (1811–72), who had argued already during the 1830s that art was an end in itself and, therefore, had no need to tell an uplifting story or serve any particular moral purpose. In London, Whistler allied himself with the classical scholar and art historian Walter Pater (1839–94) and the playwright and poet Oscar Wilde (1854–1900) in becoming a leading spokesman for the Aesthetic movement, which rejected the distinction between the fine and decorative arts. As Wilde argued during a well-publicized lecture tour of the United States in 1882–3, an easel painting was no more spiritual than a well-crafted painted vase or a decorative tile from

Damascus. Each "is a beautifully-coloured surface, nothing more, and affects us by no suggestion stolen from philosophy, no pathos pilfered from literature, no feeling filched from a poet, but by its own incommunicable artistic essence" (cited in Stein, pp. 25-26).

Similarly, Whistler regarded his paintings as decoratively arranged surfaces. Though his portrait of his mother, Anne Matilda McNeill Whistler, has become a popular symbol of American motherhood appropriated by mass-media advertising and entertainment, the artist's title for the painting, Arrangement in Gray and Black (Portrait of the Artist's Mother) (fig. 6.49), subordinates the maternal figure, with all of its moral and psychological associations, to the purely aesthetic or formal arrangement of tones. Unlike Thomas Eakins, whose portraits were intense studies of human character and emotion (see p. 226), Whistler chose a strict profile view to minimize beholders' inclination to decipher an internal state of mind from facial features and expression. Whistler's flatly painted mother also contrasts with the more lively, flesh-and-blood naturalism of Mary Cassatt's mother (see fig. 6.39).

Nevertheless, despite Whistler's stated belief that the public could not have much interest in the personal identity of his mother, the picture's formal arrangement does suggest her sober New England moral character. Forming a relatively strict right angle, the seated figure adheres to the rectilinear geometry of the shallow pictorial space. The floor and background wall create a decorative grid of rectangular and oblong shapes painted with thin washes of mostly colorless gray and black oil pigments with only touches of yellow and pink.

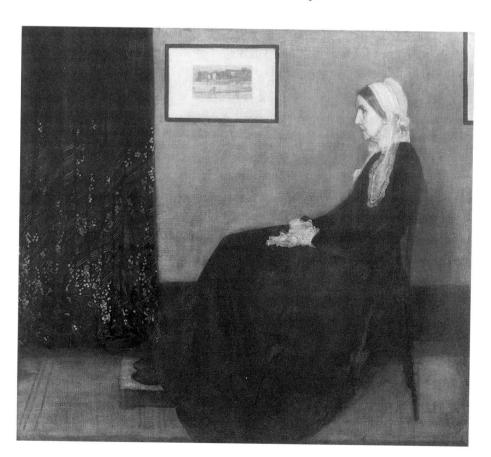

6.49 James Abbott McNeill Whistler Arrangement in Gray and Black (Portrait of the Artist's Mother), 1871. Oil on canvas, $57 \times 64 \%$ in (144.8 \times 163.8 cm). Musée d'Orsay, Paris.

Despite his loyalty to the Aesthetic movement, which divorced art from overt moral themes, Whistler, in a 1867 letter to the French painter Henri Fantin-Latour (1836–1904) characterized the formal means of expression in strongly moral terms:

Color—color is the vice. Certainly it can be and has the right to be one of the finest virtues. Grasped with a strong hand, controlled by her master, drawing, color then is a splendid girl with a husband worthy of her—her lover, but her master too—the most magnificent mistress in the world, and the result is to be seen in all the lovely things produced from their union. But coupled with indecision, with a weak, timid, vicious drawing, easily satisfied, color becomes a filthy whore. . . . (cited in Pyne, pp. 110–111)

Whistler's attitude toward the painter's technique derives from a long tradition of academic criticism which cast the dichotomy between color and drawing in terms of gender. Because of its fluid sensuosity and rich visual appearance, color was a feminine quality in need of formal discipline from the austere, manly rigor of drawing. Whistler favored arrangements of light and dark tones and muted atmospheric canvases because they evoked associations with the immaterial tonal harmonies of music. The feminine beauty of color was thereby spiritualized or elevated beyond vulgar physical desire.

In his controversial painting Nocturne in Black and Gold (The Falling Rocket) (fig. 6.50), Whistler abandoned rational geometric rigor. The highly abstract picture of a fireworks display over London's Cremorne Gardens was one of a series of atmospheric "nocturnes," the pictorial equivalent of piano nocturnes with their contemplative musical tones. When Whistler exhibited his nocturnes at a London gallery in 1877, the English art critic John Ruskin accused the artist of "flinging a pot of paint in the public's face" (cited in McCoubrey, p. 181). For Ruskin, who thought paintings should provide some edifying moral message or legible narrative content, Nocturne in Black and Gold: The Falling Rocket was simply an unreadable, sloppily executed painting with no redeeming social value. In retaliation, Whistler sued Ruskin for libel and during the highly publicized trial argued that the value of art did not reside in the imitation of nature or in the representation of any particular story or subject. Under cross-examination, the painter denied that his representation of the fireworks was an actual view of Cremorne Gardens: "If it were called a view of Cremorne, it would certainly bring about nothing but disappointment on the part of the beholders. . . . It is an artistic arrangement" (cited in McCoubrey, p. 182). The formal arrangement of tones and colors defined painting's autonomy from external reality. Though Whistler won the lawsuit, he was awarded only one farthing in damages and was forced into bankruptcy over the court costs.

Nevertheless, Whistler used the trial's publicity to establish his European and American reputation as a self-proclaimed "preacher" for the new religion of art. In a May 22, 1878, article for *The World*, a London newspaper, Whistler asserted that "Art should be independent of all claptrap—should stand alone, and appeal to the artistic sense of eye or ear, without confounding this with emotions entirely foreign to it, as devotion, pity, love, patriotism, and the like" (cited in Bendix, p. 33). The artist later argued in biblical terms that true art was intended only for the initiated or elect few, who could rise above the middle-class materialism of the majority to experience a higher, spiritual consciousness. Whistler's aestheticism merged with his interest in Spiritualist séances. As a Spiritualist medium, the artist claimed the ability to communicate beyond the grave with the more refined realm of spiritual

6.50 James Abbott McNeill Whistler Nocturne in Black and Gold

(The Falling Rocket), c.1875. Oil on oak panel, $23\% \times 18\%$ in (60 \times 47 cm). Detroit Institute of Art. Dexter M. Ferry Jr. Fund.

Whistler employed a minimal amount of black in this picture. His night sky was formed through thin veils of dark blue-green pigments. In the left background, he depicted the twin-towered fireworks platform encircled by lights. Overhead, a variety of hues create the shower of lights from exploding rockets: salmon pink, beige, lemon yellow, and blue-green. Down below, where spectral figures watch the fireworks, traces of red create a warm counterpoint to the painting's cool, dark blue

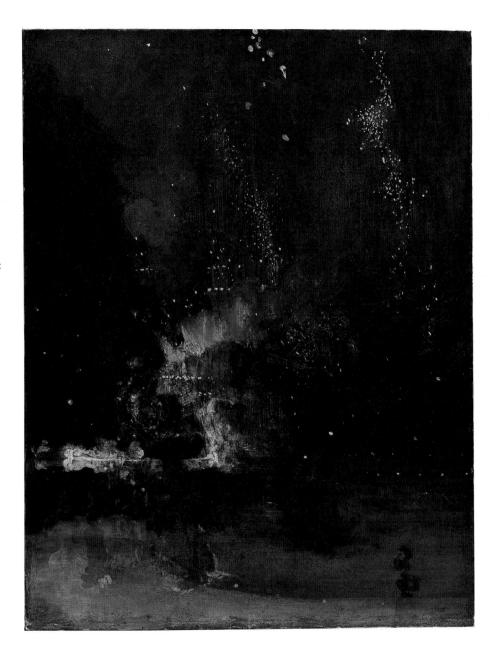

beings. Similarly, the reveries produced by beauty and art could elevate individuals toward an ethereal, transcendent state. More than a religion of art, Whistler pursued a religion of life whereby, ideally, the entire human environment would become transformed into aestheticized spaces conducive to higher forms of spiritual communication. Thus, Nocturne in Black and Gold (The Falling Rocket) and the other London nocturnes can be interpreted as Whistler's attempt to reimagine the city according to the harmonic principles of art and beauty.

Whistler's nocturnes and arrangements were informed by his love of the decorative arts, particularly the arts and crafts of Japan and the Orient. Just before his libel suit against Ruskin, the artist decorated the dining room of a London house

owned by Frederick R. Leyland, a shipowner from Liverpool, England (fig. 6.51). Originally inspired by a desire to have the room's decor harmonize with his Orientalist painting The Princess from the Land of Porcelain, which hung over the fireplace, Whistler produced an aestheticized environment that was also intended to showcase Leyland's valuable collection of blue-and-white Chinese porcelain. Ironically, the painter's Harmony in Blue and Gold: The Peacock Room features a frankly discordant mural of fighting peacocks, which he bitterly referred to as "Art and Money; or The Story of The Room." The battling peacocks represented an assaulted Whistler and an angry Leyland, who had refused to pay Whistler's asking price of 2,000 guineas for an interior decoration that exceeded his original order and expectations. Silver coins lie at the feet of the aggressive, right-hand peacock. The coins signified Whistler's opinion that Leyland had a miserly personality. Elsewhere in the room, Whistler painted three pairs of window shutters with four additional peacocks and further decorated the walls and ceiling with overlapping peacock feathers. Leyland's collection of Oriental vases, placed on gilded shelves along the walls, was overwhelmed by Whistler's lavish decoration. Painted in the patron's absence, the Peacock Room, with its contentious, insulting mural, nevertheless remained intact. Over a decade after Leyland's death in 1892, the room was purchased by an American industrialist, Charles Lang Freer, who had it reinstalled in his Detroit, Michigan, home and later bequeathed it to a new Washington, D.C., museum that would house his extensive collection of Asian and American art.

6.51 James McNeill Whistler

Harmony in Blue and Gold: The Peacock Room, 1876–77. Oil on leather and wood, 13 ft 11% in \times 33 ft 2 in \times 19 ft 11% in $(4.26 \times 10.11 \times 6.08$ m). Freer Gallery of Art, Smithsonian Institution, Washington, p.c.

6.52 William Merritt Chase

James A. M. Whistler, 1885. Oil on canvas, $74\% \times 36\%$ in $(188.9 \times 92 \text{ cm}).$ Metropolitan Museum of Art. New York. Bequest of William H. Walker, 1918.

Freer, a manufacturer of railroad cars and investor in pharmaceuticals, gradually retired from the cares of business to pursue the aesthetic cult of beauty. In addition to collecting Oriental art and works by Whistler, Freer commissioned paintings from Dwight William Tryon (1849–1925) and Thomas Wilmer Dewing (1851–1938). both of whom had fallen under the spell of the Aesthetic movement and the tonalist technique of Whistler. Dewing's After Sunset (Summer Evening) (fig. 6.53) represents two richly gowned women in an amorphous landscape of thinly painted

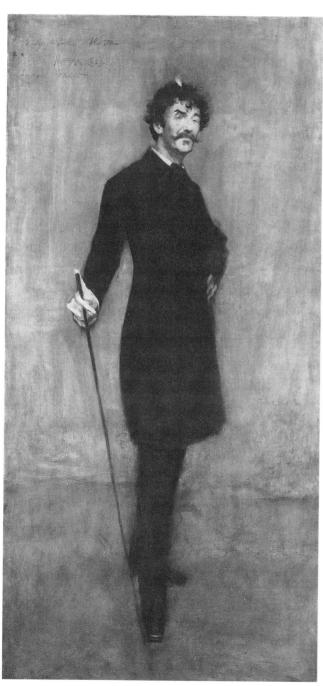

blue-green tones. This quiet, non-narrative painting evokes the aestheticized environment of Cornish, New Hampshire, where Dewing and his artist-wife Maria Oakey Dewing (1845–1927) were part of an artists' colony far from the social problems of modern urban life. Rather than imitating the natural landscape of Cornish, Dewing sought to express its restorative cosmic energy as an antidote for the overwrought nerves of wealthy businessmen and art patrons like Freer. Frequently engaging in theatrical performances and ritualized costume parties, the Dewings and other artists of the Cornish colony attempted to extend Whistler's aestheticism into the fabric of their daily lives. Most famously, in 1905, at the Cornish residence of the sculptor Augustus Saint-Gaudens, the Boston Symphony Orchestra joined a cast of 200 in the performance of an outdoor theatrical ritual entitled Masque of the Ours, the Gods and the Golden Bowl. Before a small Greek temple and altar, seventy of the players impersonated Greek gods and goddesses to present Saint-Gaudens with an honorific golden bowl.

Concentrating much of their wrath on the figure of Oscar Wilde, many American critics denounced the hedonistic amorality of the Aesthetic movement. In caricatures that were published in both England and America during the 1880s and 1890s, Wilde and male aesthetes in general were represented as effeminate dandies who appeared primarily in the company of admiring society women. Aestheticism thus seemed to threaten American manhood by promoting the feminization of culture and the worship of sensuous beauty divorced from moral truth. Whistler managed to avoid most of the venom directed against Wilde, partly because he stressed the spiritual dimension of his art, but also because he did not share Wilde's socialist politics and displayed an intimidating, masculine aggressiveness in attacking his critics and enemies. In 1885, the New York artist William Merritt Chase (1849–1916) portrayed Whistler in relatively caricatured terms as a hyper-refined aesthete (fig. 6.52). Whistler

publicly denounced the painting as a mocking lampoon and accused Chase of an act of betrayal. However, as the admiring Chase recalled, Whistler was an immaculately dressed and groomed man, a dandy who had virtually transformed himself into a work of art. Whistler's trademark lock of white hair appears like a spiritual flame of inspiration atop his head. Whistler, too, had included this characteristic tuft of white hair to identify himself as one of the battling peacocks in Leyland's Peacock Room.

Chase adopted the art-for-art's-sake credo of the Aesthetic movement. Unlike Whistler and Dewing, however, he cultivated an aesthetic that was more earthbound, less abstract, and oriented toward a more colorful palette under the influence of French Impressionism. Before meeting Whistler, he represented his own studio, located in Richard Morris Hunt's Studio Building (see fig. 6.5), as an elegantly furnished space filled with his own collection of beautiful, rare, and exotic art objects (fig. 6.55). In marked contrast to Thomas Eakins's portrayal of William Rush's studio (see fig. 6.25), Chase's lavishly decorated chamber appears as a place for the consumption of art rather than its messy production. As the art historian Sarah Burns has observed, Chase's studio with its fashionably dressed female customer compares closely with contemporary department-store displays. By the 1880s, newly established large-scale stores such as Wanamaker's in Philadelphia and Macy's in New York were selling paintings as well as expensive, exotic art

6.53 Thomas Dewing After Sunset (Summer Evening), 1892. Oil on canvas $42\% \times 54\%$ in $(107 \times 137.4 \text{ cm})$. Freer Gallery of Art, Smithsonian Institution, Washington, D.C.

This painting was partially inspired by the English painter and poet Dante Gabriel Rossetti (1828-82), whose sonnet "The One Hope" from The House of Life, a cycle of sonnets, asked the question of what awaited the individual soul after death. Rossetti's poem searches for answers to the unknown terrain of life beyond the grave.

6.54 John Twachtman Argues-la-Bataille, 1885. Oil on canvas, $60 \times 78\%$ in $(152.4 \times 200.3 \text{ cm}).$

Metropolitan Museum of Art, New York. Morris K. Jesup Fund, 1968.

For Twachtman, art was to provide a quiet, contemplative refuge from the tensions of modern urban-industrial life. Emphasizing relaxation, the artist's broad horizontal bands of tone and delicate feathery brushwork were influenced by Japanese prints, Whistler's tonalism, and French Impressionist paintings. Twachtman regarded Japanese art as a tasteful antidote to the crass vulgarity of American mass culture.

objects in addition to the usual underwear, socks, and other dry goods. If the Aesthetic movement had transformed art into a substitute religion, it also served to commercialize art objects, transforming them into expensive commodities for an anonymous art market.

Chase, who painted Impressionist seascapes at his summer studio at Shinnecock, Long Island, later joined Thomas Dewing in exhibitions of The Ten or Ten American Painters, a group of New York and Boston artists who resigned from the Society of American Artists to exhibit as a small group without the intrusion of exhibition juries or Society officers. The group formed in 1898 and was active until 1919, but Chase did not join until 1902, when he replaced John Henry Twachtman (1853–1902), who died that year. Though most members of the group were influenced by French Impressionism, they tended to work in a more poetic style that suggested dissatisfaction with the materialism or naturalism of the Impressionistic aesthetic. When, for instance, the Cincinnati-born Twachtman studied in Paris from 1883 to 1885, he adopted a contemplative, tonal style that was far closer in mood and technique to Whistler's nocturnes than to the bright colors of French Impressionism (fig. 6.54).

When, in 1886, the first major American exhibition of French Impressionist paintings took place in New York, a number of critics attacked the ugly, vulgar

subject matter and associated the bright, clashing colors of the Impressionist palette with revolutionary politics or the red flag of Communism. That same year, in fact, labor strikes and protests had culminated in the infamous Haymarket Square bombing and riots in Chicago, which left a number of workers and policemen dead and many more injured.

One of The Ten, (Frederick) Childe Hassam (1859–1935), worked in an Impressionist style but, like other members of the group, he carefully avoided views of overcrowded urban environments and lower-class subjects. Hassam's pictures of New York depicted the spacious and light-filled ambience of Fifth Avenue, the city's most aesthetic and architecturally fashionable thoroughfare. In his painting of Washington Arch, Spring (fig. 6.56), Hassam represents the monumental arch that marks the terminus of the avenue in Greenwich Village. The brightly lit, sketchily painted scene is inhabited not only by horse-drawn carriages and well-dressed society women, but also by a street cleaner clothed in white, who dutifully keeps this urban paradise free from debris. The painting seems to anticipate Daniel Burnham's immaculate and utopian White City for the 1893 Columbian Exposition (see fig. 6.11). Indeed, Hassam later painted a small sketch of the White City in a more detailed, less Impressionist rendering of the classical architecture and pristine Venetian waterways.

During the Gilded Age, art tended to appeal to the genteel taste for beauty, harmony, and refined subject matter. By the early twentieth century, however,

6.55 William Merritt Chase

In the Studio, c. 1880. Oil on canvas, $28\% \times 40\%$ in (71.8 \times 101.6 cm). Brooklyn Museum of Art, New York. Gift of Mrs. Carl H. De Silver.

Chase's representation of his studio's opulent furnishings seems a manifesto for aestheticism. A customer leafs through a heavy book resting on an expensive Turkish rug. Oriental fabrics, Japanese fans, musical instruments, and gold-framed paintings line the walls. An elaborately carved Renaissance chest displays vases, sculptures, and other objects, including a model ship. A reproduction of Frans Hals's Malle Babbe (c.1650) suggests Chase's indebtedness to the Dutch painter.

socialist and progressive reformers were forcefully challenging the monopolistic and anti-labor practices of American capitalists. Concurrently, as we shall see, many American artists began to view themselves as avant-garde challengers of the cultural and political status quo. This new generation of artists sought to move beyond Aestheticism by arguing that art's purpose was not to beautify but to radically transform or revolutionize life.

6.56 Childe Hassam Washington Arch, Spring, 1890. Oil on canvas, 27\% imes22½ in (68.9 \times 57.1 cm). The Phillips Collection, Washington, D.C.

CHAPTER 7

Modernist Art and Politics

1905-41

rom 1905 until America's entrance into World War II in 1941, culturally and politically radical new subjects, forms, media, and experimental concepts challenged academic styles. During this period, many American artists and architects continued to work in a conservative, historicist manner. Particularly in Washington, D.C., ancient, classical styles remained revered symbols of national prestige and political stability, as architects designed Greek and Roman temple fronts for government buildings. The muralist Kenyon Cox (1856–1919) defended Italian Renaissance masters as the academic ideal in painting and insisted on the existence of immutable commandments for art equivalent to the laws of physics. But, by the early twentieth century, economic modernization and scientific and intellectual developments were helping to displace the moral certitudes and conventional assumptions of the Gilded Age with a Modernist culture that reshaped reality in more fluid, relativistic, and dynamic terms. In addition to the automobile, other inventions such as the airplane, telephone, radio, motion picture, and photo magazine dramatically shrank spatial and temporal distances between both places and people. Using cinematic editing, film directors could represent an action or scene from different perspectives, thereby demonstrating the relativism of vision. Meanwhile, from high airplane altitudes, earth's landscapes could be quickly reduced into flattened geometric patterns and grids.

Scientists and mathematicians complicated the mapping of the universe, which had been explained by the predictable, mechanistic physics of Sir Isaac Newton and the ancient geometric axioms of the Greek philosopher Euclid. The French mathematician Henri Poincaré argued in 1902 that Euclid's geometry and all other competing geometries were arbitrarily grounded on convention or convenience rather than objective truth. Scientific "truths" were now acknowledged as relative rather than absolute, being dependent on the position of the observing scientist in relation to the observed object of investigation. In studying both the macrocosmic and microcosmic universes, twentieth-century scientists learned the fallacy of drawing firm distinctions between space and time or energy and matter. Atomic physicists proved that matter was far from solid as its orbiting particles could be transformed into radioactive energy. Meanwhile, in expounding his theory of relativity, Albert Einstein employed non-Euclidean geometry to prove that space and time are not separate categories, as previously assumed, but coexist as a dynamic continuum shaped and slowed by the presence of matter. The discoveries or new hypotheses of geometers and physicists fueled the speculations of visionary thinkers and artists that there existed a fourth dimension beyond the perceptible three-dimensional spaces and forms of everyday experience. For twentieth-century painters, the traditional, three-dimensional illusionism of landscapes, still lifes, and portraits seemed increasingly arbitrary and old fashioned. Many artists distorted or fragmented objects and figures to suggest new physics theories of space, time, and matter.

Following upon the evolutionary theories of Charles Darwin, which came to public attention during the 1860s and 1870s, anthropologists and philosophers

Morgan Russell

Cosmic Synchromy, 1913–14. Oil on canvas, $16\% \times 13\%$ in $(41.2 \times 33.3 \text{ cm})$. Munson-Williams-Proctor Institute, Museum of Art, Utica, New York.

Although Synchromists tended to reject traditional, illustrative forms of representation, they were influenced by the formal rhythms of figural works by Michelangelo (1475–1564) and Peter Paul Rubens (1577-1640). Preparatory drawings suggest that Russell conceived these spiraling, polychromatic discs from the circular motion of two nude figures interlocked in a yinyang configuration, an oriental symbol signifying the cosmic balance of opposing principles such as malefemale and active-passive. Russell's warm-cool, advancing-receding colors expressed a universal spiritual harmony.

increasingly questioned the traditional, pre-modern thinking that elevated humans to a special, ideal realm beyond the animal kingdom. While clergymen and educators since the Colonial period had constructed strict moral codes of behavior based on sharp distinctions between man and animal or civilization and savagery, the American philosopher William James (1842–1910) argued that humans existed on an evolutionary continuum with other animals. For James, the human brain, as a biological organ, made the so-called "higher" intellectual faculty dependent on the body's raw sensory experiences and passions. Believing that intellectual constructs were at a further remove from truth than an active pursuit of new experiences and discoveries, James played a key role in shaping America's Modernist culture of perpetual experimentation and innovation.

Modernist art may be defined by its self-conscious interest in experimentation with the materials and creative processes of each individual medium. Freed from the obligation of representing "objective" reality, Modernist artists have tended to stress the subjective uniqueness of their own particular visions. They willfully manipulated subjects, colors, shapes, and forms in new, expressive ways and thereby called attention to the relativity of vision and the contradictions, ambiguities, and uncertainties of modern urban life. From rebellious European painters and sculptors, American Modernists learned to identify themselves as an avant-garde of forward-looking individuals. As such, they sought to create works that not only redefined the conventions and institutions of art but also critically challenged repressive political and social conditions.

If nineteenth-century artists had appealed primarily to genteel upper- and middle-class tastes, those who now gained prominence in the art world shocked the American public with works that were intentionally unrefined or in rebellion against academic standards and conventional ideals. Doubting the primacy of abstract reason, Modernist artists dissented from the traditional moral wisdom of repressing sexual desires and sensual pleasures. For many, the creative act of selfexpression became a powerful metaphor for political freedom and social regeneration. To varying degrees, avant-garde artists tended to empathize with the plight of immigrants and the struggles of workers, political reformers, and social radicals against capitalist, corporate power. Conservative critics frequently likened experimental Modernist artists' defiance of Renaissance traditions and academic rules to the acts of bomb-throwing anarchists and political revolutionaries. On the other hand, American corporations eventually learned to value the dynamic visual forms and rhythms of Modern art for advertising, public relations, industrial design, and functional, sleek commercial architecture. Furthermore, though Modernist critics frequently ridiculed corporate-sponsored mass culture, the artists of Modernism borrowed extensively from popular media such as the cinema and illustrated newspapers and magazines.

Modernization and Architecture as Imperial Symbols

The original Pennsylvania Station in New York was the world's largest railroad station when it was built in 1905–10 (fig. 7.1). In its synthesis of modern urban functionalism and ancient, classical grandeur, the station bears comparison with the Roman and Renaissance-Revival architecture of the White City for the 1893 World's

7.1 (top) Mckim, Mead, & White

Pennsylvania Station, New York City, 1905-1910 (demolished). New York Historical Society, New York.

Pennsylvania Station's Seventh Avenue facade expressed its monumentality with unfluted Doric order columns, austere symbols of masculine strength. The massive columns supported an almost continuous cornice, interrupted only for the slightly projecting central entrance and two pedimented bays at the 31st and 33rd Street ends of the facade. From a distance, the exterior of the station's huge waiting room, with its semicircular thermal windows, could be seen projecting upward behind the facade.

7.2 McKim, Mead, & White

Pennsylvania Station, New York City, 1905-1910, original view of concourse (demolished). Avery Architectural and Fine Arts Library, Columbia University, New York.

Columbian Exposition in Chicago (see fig. 6.11). Designed by the architectural firm of McKim, Mead, & White, the vast, temple-like building boasted an impressive facade colonnade: a row of thirty-two freestanding columns, each towering sixtyeight feet high. However, while the interior waiting room recalled the ancient Roman Baths of Caracalla, the architects also employed every modern technological convenience to move people efficiently in and out of the station. The terminal was fed by a system of river and land tunnels and a maze of electrified rail lines that arrived well below ground. Passenger luggage and freight were guided through a multilevel network of ramps and overpasses. For the concourse leading from the waiting room to the trains, a steel skeleton of columns and arches supported intersecting glass vaults illuminating a free flow of open space (fig. 7.2).

The building of Pennsylvania Station had necessitated the demolition of approximately 400 homes and stores bordered by 31st and 33rd Streets and Seventh and Ninth Avenues. Newspapers and magazines carried photographs and drawings representing the excavation site dramatically emptied by blasting and wrecking machinery, while headlines and articles compared the engineering feat to the contemporaneous, U.S. government-sponsored construction of the Panama Canal in Central America. Despite its classical, historical-revival style, Pennsylvania Station signified the progress of economic modernization. Indeed, the architects argued that only by building in the style of the ancient Roman Empire could they express the new imperial ambitions of a United States taking its place as a dominant force in the world economy.

New York Realists and Modern Urban Life

From 1907 to 1909, the young Ohio-born artist George Bellows (1882–1925) painted a series of pictures representing the gaping excavation and construction site for Pennsylvania Station. Unlike the genteel urban views of Childe Hassam (see fig. 6. 56) and other Gilded Age Impressionists, Bellows's *Pennsylvania Excavation* (fig. 7.3) represents a dirty, wintry scene with sketchily painted workers and steam-driven digging machinery within a vast urban canyon. The dense cluster of tall buildings on the far horizon accentuates the subterranean depths that dominate the

7.3 George Bellows
Pennsylvania Excavation, c.
1907–09. Oil on canvas, 31½
× 38½ in (104 × 121.3 cm).
Brooklyn Museum of Art,
New York. A. Augustus Healy
Fund.

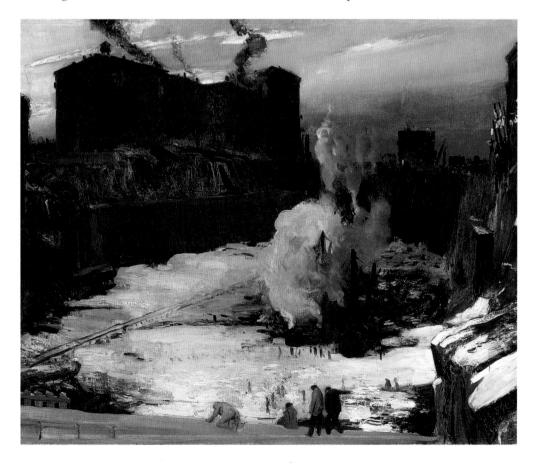

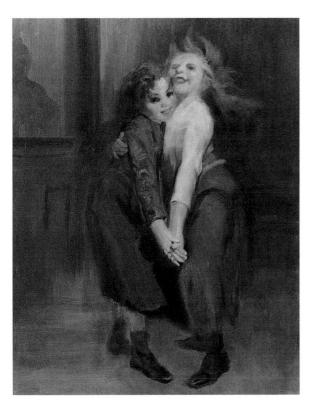

7.4 George Benjamin Luks The Spielers, 1905. Oil on canvas, 36×26 in $(91.4 \times 66 \text{ cm})$. Addison Gallery of American Art, Phillips Academy, Andover, Massachusetts. Gift of anonymous donor.

picture. While Hassam painted his upper-class urban scenes with light, pastel hues and feathery brushwork, Bellows emphasized the working-class, industrial nature of his subject with thick brushstrokes and a somber palette of grays, browns, and off-whites, contrasting with a blue and gold sky.

Arriving in New York in 1904 from Columbus, where he had attended Ohio State University, Bellows fell under the influence of Robert Henri (1865–1929), who taught painting at the New York School of Art. An admirer of Thomas Eakins and a former student of Thomas Anshutz at the Pennsylvania Academy of the Fine Arts, Henri was the leader of a group of New York realist painters who were rebelling against the conventional, elevated styles of the National Academy of Design and the refined, art-for-art's-sake aestheticism of artists such as Whistler and Thomas Dewing. Promoting the credo of an art for life's sake, Henri had inspired a small band of painters who had once worked as illustrators or artist-reporters for various Philadelphia newspapers. The group included George B. Luks (1866-1933), John Sloan (1871–1951), Everett Shinn (1876–1953), and William Glackens (1870–1938). By the turn of the century, when a screen halftone, or photomechanical, process was invented for reproducing photographs on the printed

page, these newspaper artists lost their jobs and moved to New York to pursue painting careers. Having been trained as journalists to sketch subjects quickly outside the controlled studio environment, these Philadelphia émigrés drew inspiration from Henri, who insisted that artists must search for subjects like perpetual hunters:

The sketch hunter has delightful days of drifting about among people, in and out of the city, going anywhere, everywhere, stopping as long as he likes—no need to reach any point, moving in any direction following the call of interests. He moves through life as he finds it, not passing negligently the things he loves, but stopping to know them, and to note them down in the shorthand of his sketchbook. . . . Like any hunter he hits or misses. He is looking for what he loves, he tries to capture it. It's found anywhere, everywhere. Those who are not hunters do not see these things. The hunter is learning to see and to understand—to enjoy. (p. 17)

In its emphasis upon the artist-hunter's intense love for subjects, Henri's modern realist aesthetic was emotionally expressive and individualistic. Henri and his protégés were less social reformers than enthusiastic sportsmen seeking novel, exotic experiences from the noisy, crowded spectacle of lower-class urban life. In 1907, while Bellows was working on Pennsylvania Excavation, his teacher encountered a young African-American girl named Eva Green from one of New York's poorer neighborhoods. Employing quick, broad brushstrokes, Henri painted an energetic portrait that expresses a magnetic bond with the smiling girl (fig. 7.5). Henri and his circle of artist-disciples painted numerous pictures of poor or immigrant children, whose youthful exuberance seemed to typify the new century's urban diversity and dynamism. In George Luks's The Spielers (fig. 7.4), two immigrant girls, probably of German origin, dance closely together in a manner known as "spieling." This German type of dancing, also called "pivoting," was popular among the working class around the turn of the century. In contrast to the upper-class waltz, which involved elegant, graceful movements, spieling brought couples into close physical contact as they swirled wildly across the dance floor. Cultural moralists were critical of spieling for its potential to stimulate sexual desire. In his painting, Luks defused this concern by depicting innocent, fun-loving girls rather than adults. Situated within an ambiguous, relatively bare gray space, the girls' motion is suggested by a sketchlike blurring of their bodies. The right-hand figure's wispy blonde hair particularly creates the breezy illusion of twirling in space.

More controversial were Luks's and Bellows's representations of brutal wrestling and boxing matches. Though public prizefights were then illegal, private clubs were formed to stage fights exclusively for their members. Appealing initially to a lower-class male underworld, these private athletic clubs soon attracted an increasing number of middle- and upperclass men, whose patronage helped to

transform successful fighters from social outcasts into popular, newsworthy celebrities. In contrast to Thomas Eakins's ideal male nudes in *The Swimming Hole* (see fig. 6.27) or Thomas Anshutz's relatively sedate, seminude figures in *The Ironworkers'* Noontime (see fig. 6.30), Bellows's Both Members of this Club (fig. 7.6) startled audiences with the raw, animal brutality of its muscular figures. The artist places us at ringside amid a demonic, bloodthirsty, group of fans transfixed by the bloodied head and torso of a white boxer, recoiling from the powerful onslaught of a lunging black fighter. After originally titling the picture A Nigger and a White Man, Bellows soon renamed it Both Members of This Club. The new title alluded to the popular strategy for circumventing the law against public prizefighting. Saloon owners frequently staged backroom fights by transforming their bars into private athletic clubs which offered one-night memberships to ticket buyers and to black and white fighters alike. In representing the powerful black fighter as the dominant force, Bellows implicitly expressed the anxiety of America's white majority over its presumed racial superiority. Though Both Members of This Club represents anonymous fighters, it indirectly referred to the African-American heavyweight boxing champion Jack Johnson, who first won the championship title in 1908. Bellows's unflattering representation of the boxing audience suggests that he shared middleclass moralists' objections to prizefighting. Yet he was also a member of Sharkey's athletic club, where he could freely observe and sketch virtually nude males under

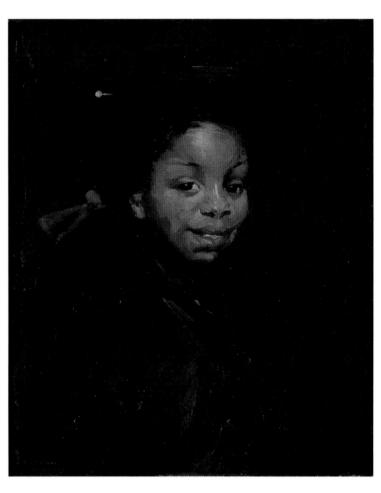

7.5 Robert Henri Eva Green, 1907. Oil on canvas, $24 \times 20\%$ in $(60.9 \times 51.4 \text{ cm})$. Wichita Art Museum, Wichita, Kansas. Roland P. Murdock Collection.

Fancily dressed with a large black hat, Eva Green smiles warmly as she gazes directly toward us. Her chocolatebrown face is luminous against the inky background and contrasts with her broadly painted dark costume. The energetic sparkle in her eyes and face is echoed by a small ivorycolored hat pin and a brightred hair ribbon. Henri's vivid likeness recalls the painterly style of the seventeenthcentury Dutch artist Frans Hals (c. 1580-1666).

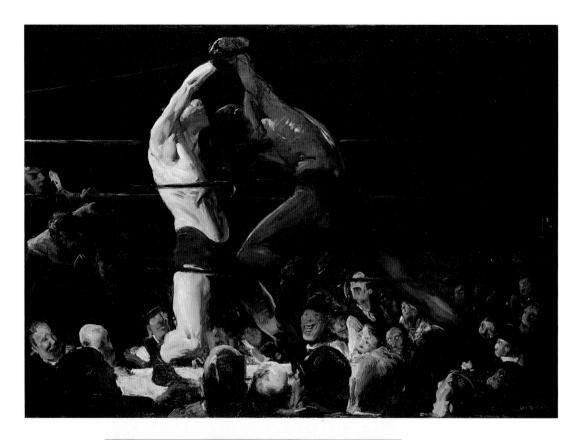

7.6 (top) George Bellows Both Members of This Club, 1909. Oil on canvas, 45 % \times 63 $\frac{1}{2}$ in (114.9 \times 160 cm). National Gallery of Art, Washington, D.C. Chester Dale Collection.

Although New York realists prided themselves on the direct observation of modern urban life, they appropriated visual ideas from a number of past European masters. Bellows's boxing pictures, with their grotesque array of spectators, seem particularly indebted to prints and paintings by the Spanish artist Francisco Goya (1746-1828). Goya's many images of bull-fighting scenes especially may have been a source of inspiration for Bellows.

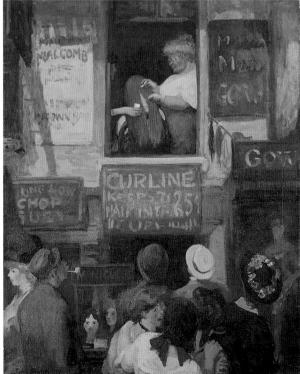

7.7 John Sloan Hairdresser's Window, 1907. Oil on canvas, 31% \times 26 in (81 imes 66 cm). Wadsworth Atheneum, Hartford, Connecticut. The Ella Gallup Sumner and Mary Catlin Sumner Collection.

non-studio, "real-life" conditions. Amid the blood and gore, Bellows implicitly conveys the inherent homoerotic and sadistic content of the sport as the all-male audience leers in delight at the tortured physiques of the combatants. Having led a sheltered life in the Midwest, the artist also thrilled to the exotic spectacles of New York's underworld.

The New York realists challenged traditional notions of beauty by choosing subjects that were considered vulgar and ugly by genteel, Gilded Age standards. In his book The Story of American Art (1907), the influential critic Charles Caffin especially credited John Sloan for expanding the conventional repertoire of images to include the congested, transient life of street traffic, working-class or immigrant tenements, and popular entertainments. In June of 1907, while walking to Henri's studio, Sloan directed his journalistic eye toward the second-story window of a shabby commercial building, where, according to his diary, a hairdresser was bleaching the hair of a customer. What made the scene humorous and aesthetically compelling was that a group of spectators was standing about gazing at the public display of private grooming. Shortly afterward, Sloan reproduced this piece of street theater in a colorful picture filled with gawking onlookers and a hairdresser's window surrounded by shop and restaurant signs (fig. 7.7). The scene through the window also serves as a sign advertising the skills of the hairdresser. Undoubtedly hoping to attract more business, the matronly woman purposefully exhibits her client's lush red hair, flowing over the back of a chair. Meanwhile, two female mannequin heads visible in the display window below apparently demonstrate the beautiful results of the hairstylist's art, even in this lower-class environment. Sloan painted numerous pictures of women cleaning, laundering, and self-grooming. For him, these simple, daily cleansing rituals suggested the hopeful theme of social renewal and regeneration amid the filthy squalor of urban slums.

More than most of the New York realists, Sloan actively involved himself in radical, working-class political causes. In 1909, he published several prints of New York City life for *The Craftsman*. The editor of this Arts and Crafts journal, the furniture designer Gustav Stickley (1848–1942), had argued in a 1907 issue that:

Social unrest is, without question, the distinguishing characteristic of this age. Especially is this true in America, where greed and arrogance on the one hand and class hatred and jealousy on the other seem to have arrayed the people into two great factions, represented by the terms Capital and Labor. The prevailing feeling is that a relatively small class has possessed itself of the land and its treasures: that a few great corporations of the same men, control the main arteries of the nation's industry and commerce. (cited in Hills, p. 313)

Historians have estimated that in 1900, approximately 40 percent of all Americans were living in poverty. President Theodore Roosevelt's antitrust lawsuits against banking and corporate monopolies and the passage of such progressive reforms as the graduated income tax helped to stabilize the nation's economy, but they did not halt labor unrest nor lower-class demands for higher wages and better working and living conditions.

During the summer of 1905, a "Continental Congress of the Working Class," comprising 200 delegates from thirty-four different American labor organizations, met in Chicago to form a single large union or "union of unions" called the Industrial Workers of the World (IWW). In its constitution the IWW explicitly dedicated itself to the radical principle of class struggle and the workers' overthrow of the capitalist elite's ownership of the means of production. Unlike the older, exclu-

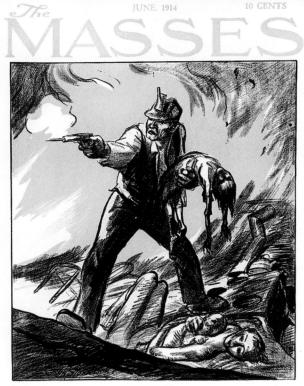

IN THIS ISSUE CLASS WAR IN COLORADO --- Max Eastman WHAT ABOUT MEXICO ?- John Reed

7.8 John Sloan

Class War in Colorado, cover for The Masses, June 1914. Delaware Art Museum, Wilmington, Delaware. Gift of Helen Farr Sloan.

Against a bright wall of fiery orange flames, Sloan represented a lone Ludlow, Colorado, mineworker holding the limp body of a child in one hand. With the other he fires a gun at an unseen National Guardsman or security agent for the Rockefellers, the capitalist mine owners. Sloan sympathetically portrays the worker as a family man who avenges the apparent massacre of his wife and children. Lying beneath the striking miner are the bodies of a mother and child.

sionary American Federation of Labor (AFL), the "Wobblies," or IWW members, included unskilled workers, immigrants from all ethnic backgrounds, African-Americans, and women.

John Sloan became an active member of the Socialist Party in 1909. In political cartoons published in left-wing journals, the artist expressed sympathy for the IWW and its dedication to the uncompromising pursuit of class warfare. His cover illustration for the June 1914 issue of The Masses, entitled Class War in Colorado (fig. 7.8), dramatically imagines a scene from the "Ludlow Massacre" of April 1914, in which striking miners in Ludlow, Colorado, defended themselves against National Guard troops and the strikebreaking agents of the Rockefellers, the wealthy New York family who owned the powerful Colorado Fuel & Iron Corporation.

Sloan sharply distinguished his political cartoons from his paintings, which remained free of overt socialist or anti-capitalist messages. Robert Henri, who favored the anarchistic position of a libertarian, stateless society, encouraged Sloan's inclination to employ the painting medium for the non-doctrinaire expression of individual feeling. Nevertheless, many contemporary friends and critics associated the New York realists' preference for lower-class subjects with socialism and radical

political ideas. In organizing, in 1908, an independent exhibition of eight painters at New York's Macbeth Gallery at 450 Fifth Avenue, Henri was consciously rebelling against established cultural authority as symbolized by the conservative National Academy of Design. The exhibition of "The Eight" included Henri, Luks, Sloan, Glackens, and Shinn, the five original members of the Philadelphia realist circle, but not the younger Bellows, who was just beginning his career. These six painters later became known as the "Ashcan School," a term that referred to the group's gritty urban subjects, general preference for a dark palette, and roughly sketched painting style. Ashcan realists rebelled against feminine prettiness and academic correctness to express a masculine, virile energy, primarily symbolized by the teeming humanity of an increasingly urbanized America.

The Modernist Turn from Realism

The Eight included three other artists, whose works diverged from the Ashcan School's realist aesthetic: the Impressionist Ernest Lawson (1873–1939), the symbolist figure painter Arthur B. Davies (1862-1928), and Maurice Prendergast (1859–1924), an innovative painter of highly decorative, non-narrative pictures of parks and beach resorts. Influenced by the French artists Paul Cézanne (1839-1906), Henri Matisse (1869-1954), and others who went beyond Impressionism toward more abstract and non-naturalistic styles, Prendergast exhibited colorful pictures

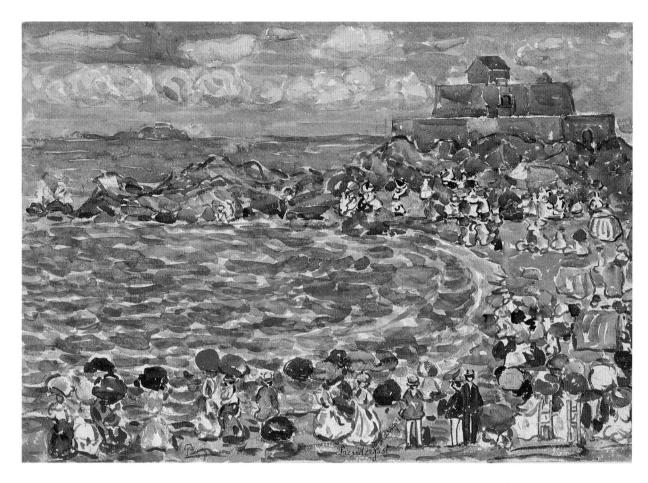

that differed significantly from the relatively conservative, illustrational painting techniques of the New York realists (fig. 7.9). Arthur Hoeber, a hostile critic for the *New York Globe*, wrote that the artist had sent to the Macbeth Gallery:

nearly a score of modest sized canvases, full of spots of color, with many people mainly on the beach at the French St. Malo, obviously a place where the sun shines in a curious manner, where color is made wonderfully manifest, where the people are careless about their drawing and construction, and where everything is a jumble of riotous pigment, such as one does not see elsewhere. Hung in a group, these canvases of Mr. Prendergast look for all the world like an explosion in a color factory. (cited in Wattenmaker, p. 95)

On the other hand, James Huneker, a critic who was more familiar with Modernist art in Paris, declared that, on the whole, the exhibition of the Eight at the Macbeth Gallery was "decidedly reactionary," "provincial," and "far from revolutionary" (cited in Wattenmaker, p. 96) when compared with the works of such avant-garde Europeans as Cézanne, Paul Gauguin (1848–1903), and Vincent van Gogh (1853–90). Yet Huneker's comparison was itself out of date, since all three of these Post-Impressionist painters had died and were being superseded by a new, even more stylistically radical generation of European artists working in Paris, Munich, and elsewhere.

7.9 Maurice Prendergast St. Malo Beach, c. 1907. Watercolor on paper, 13% × 19% in (34.9 × 50.6 cm). Cleveland Museum of Art, Cleveland, Ohio. Gift of William Mathewson Millikin in memory of H. Oothout Millikin.

Alfred Stieglitz, Photography, and the 291 Gallery

7.10 Edward Steichen Self-Portrait with Palette and Brush, 1902. Gum-bichromate print, 10½ \times 7 % in (26.7 \times 20 cm). Art Institute of Chicago, Chicago, Illinois. Alfred Stieglitz Collection.

Steichen's atmospheric selfrepresentation was strongly influenced by his deep admiration for the Symbolist paintings of the French artist Eugène Carrière (1849-1906). As an art of nuance and spiritual suggestion, Symbolism sought to transcend the materialism of everyday life.

Even as The Eight's exhibition was creating a sensation with extensive newspaper publicity and crowds of visitors at the Macbeth Gallery, the photographer Alfred Stieglitz (1864–1946) was quietly operating a small gallery further downtown at 291 Fifth Avenue. Originally opened in 1905 as an exhibition space for fine-arts photographers, by 1907, Stieglitz's Little Galleries of the Photo-Secession, which came to be known as the 291 Gallery, was exhibiting the art of European and American painters and sculptors who had adopted various non-realist, individually expressive styles. Pamela Colman Smith (1877?-c. 1950), an American painter of decorative, visionary pictures symbolically representing mystical states of mind, was the first non-photographer to have a show at the gallery. Employing evocative analogies with the invisible tones and harmonies of music, Smith's anti-materialistic aesthetic appealed to Stieglitz, who ridiculed the paintings of Henri and the Ashcan School as illustrational, colored photographs.

Like other fine-arts photographers of the late nineteenth and early twentieth centuries. Stieglitz had favored an atmospheric, soft-focus Pictorialist style (see fig. 7.13) that enabled photography to compete with the evocative, spiritual effects

signified rebellion against the cultural status quo and conventional, illustrational art. Having first studied photography in Berlin, he borrowed the term from German and Austrian avant-garde artists, who formed secessionist groups during the 1890s in opposition to established academies and exhibition societies. Stieglitz's Little Galleries of the Photo-Secession was originally intended as a permanent exhibition space for those fine-arts photographers who wished to secede from large exhibitions that indiscriminately displayed amateur and journalistic photographs without regard for aesthetic quality or formal stylistic values.

During the late nineteenth century, George Eastman's invention of the Kodak hand-held camera, loaded with its small roll of film, had created a national mania for photography. This invention had been made possible by the new dry-plate process of the 1880s. Unlike the earlier, cumbersome wet-plate process, photographic dry plates could be prepared in advance with a more effective light-sensitive emulsion. Civil War photographers had been forced to transport heavy wagons filled with chemicals and equipment onto battlefields. The wet-plate process had required that glass plates, carefully hand-coated with an emulsion just before shooting, remain wet throughout the camera exposure and darkroom development. The mechanical simplification of photography allowed millions of individual amateurs to take their own family pictures. Influencing the paintings of the Ashcan School and encouraging progressive social reforms, a number of documentary photographers, led by Jacob August Riis (1849–1914) and Lewis Hine (1874–1940), utilized the new portability of the camera to capture stark scenes of urban blight, child labor, and immigrant and working-class poverty (fig. 7.11).

Stieglitz's most famous photograph, *The Steerage* (fig. 7.12), shares the same type of subject matter as represented by Hine and the Ashcan School of painters. Stieglitz took the picture on the spur of the moment, while sailing to Europe on a fashionable new German ocean liner. Having left his first-class accommodations, he wandered toward the steerage, or lower levels of the ship, where he saw the poorer passengers crowded together. Stieglitz found himself energized by this scene of migratory European workers, who were returning home after temporary employment in America. However, unlike documentary photographers, he recalled how the formal values of the subject, rather than its specific social content, excited his interest:

A round straw hat, the funnel leaning left, the stairway leaning right, the white drawbridge with its railings made of circular chains, white suspenders crossing on the back

7.11 Lewis Hine

Breaker Boys Working in Ewen Breaker, South Pittston, Pennsylvania, 1911. Records of the Children's Bureau, National Archives, Washington, D.C.

Having earned a degree in sociology from Columbia University, Hine became an investigative photographer for the National Child Labor Committee. He documented the exploitation of child labor in southern cotton mills, northern coal mines, and elsewhere. This group portrait is one of a series representing young boys who worked in breakers, the mechanical plants for breaking up coal. Probably the sons of immigrants, the stiffly posed children look toward the camera with somber, coal-smudged faces. Huddled within the rail tracks, they seem embarked upon, and trapped within, a journey through life without

of a man in the steerage below, round shapes of iron machinery, a mast cutting into the sky, making a triangular shape. . . . I saw a picture of shapes and underlying that the feeling I had about life. (cited in Newhall, p. 111)

7.12 Alfred Stieglitz The Steerage, 1907. Library of Congress, Washington, D.C.

Stieglitz regarded this photograph as an abstract study in mathematical lines and light-dark contrasts. Through his friend Marius de Zayas (a Mexican-born caricaturist and critic for Stieglitz's journal Camera Work), he learned that Pablo Picasso greatly admired the photograph and regarded its dynamic grid of geometric patterns as a creative act of self-expression. Stieglitz later developed a theory of equivalents, in which he argued that all of his photographs, no matter what the subject, were symbolic equivalents or representations of his own individual self and unique vision

Stieglitz later regarded The Steerage as the most important photograph of his career. Its sharply focused forms marked a break with the painterly, nuanced effects of the Pictorialist style as seen in his earlier Spring Showers, an atmospheric New York City street scene (fig. 7.13). By 1910, Stieglitz was becoming an advocate of straight photography. This style rejected the artificial manipulation of photographic images in favor of a sharper lens focus that underscored the inherent formal values found within nature or everyday modern life. Stieglitz eventually believed that each medium should explore and emphasize its own particular qualities and formal characteristics. While the mechanical art of photography should not compete with painting or sculpture for handmade effects, neither should these more traditional media attempt to replicate the realism of the camera. In a 1910 article published in Camera Work, his own fine-arts journal, Stieglitz argued that photography's reproductive accuracy had made realist painting and drawing styles virtually obsolete.

After 1910, Stieglitz's refusal to promote Pictorialist photography alienated such fine-arts photographers as Clarence White (1871-1925) and Gertrude Kasebier (1852-1934). In any case, as director of the 291 Gallery, Stieglitz was devoting himself to exhibitions of European and American Modernist painters and sculptors. Assisted by Edward Steichen, who kept him abreast of artistic developments in Paris, Stieglitz did not adhere to an exhibition schedule that favored any single visual style. But in introducing to American audiences the works of such major French artists as Cézanne, Matisse, and Auguste Rodin (1840-1917), the 291 Gallery became a haven for anti-academic painters and sculptors asserting their independ-

> tual religion, a spiritual alternative to Gilded Age materialism and the Protestant, middle-class repression of the senses. Thanks to his first wife's steady income from a family brewery in Brooklyn, Stieglitz had the luxury of operating the 291 Gallery as a highminded aesthetic calling rather than a crassly commercial enterprise. But his cause was not the art for art's sake of an apolitical aesthete. Although not associated with socialist or communist political organizations, the gallery director always regarded himself as a revolutionary, who broadly believed that radical, individualized artistic expression possessed the power to

For Stieglitz, innovative avant-garde art was a vir-

ence from the slavish imitation of nature.

As his recollection of *The Steerage* suggests, Stieglitz did not reject twentieth-century technology and machinery, but rather sought to reconcile its rational structure and functionalism with the arbitrary, accidental movements and shifting, spontaneous percepimmediate non-rational, experience. Significantly, Stieglitz boasted that this photograph

liberate society from the repressive, dead weight of economic utilitarianism and outmoded cultural con-

ventions, traditions, and habits.

elicited words of praise from Pablo Picasso (1881–1973), the Spanish-born Parisian artist who promoted Cubism, the abstract geometric style that most vividly expressed the Modernist desire to integrate the diverse perspectives and fluctuating experiences of modern life. Beginning with his famous 1907 painting *Les Demoiselles d'Avignon*, Picasso launched the Cubist assault on Renaissance tradition by fracturing and merging the human figure with the flat, two-dimensional space of the picture plane. In fragmenting forms and destroying the Renaissance illusion of three-dimensional space, Picasso and other Cubist painters denied the existence of a fixed, objective reality. Influenced by developments in geometry, philosophy, and science which demonstrated that truth was not absolute but relative and a matter of pragmatic usefulness, Cubists rebelled against the supposed objectivity and universality of academic rules and conventions.

Stieglitz played a major role in introducing Cubist art into the United States by giving Picasso his first American one-man show at the 291 Gallery in 1911 and by juxtaposing reproductions of the Spaniard's abstract drawings next to his own photographs in *Camera Work*. Picasso's drawing of a female nude (fig. 7.14) particularly pleased Stieglitz, who purchased the work and noted its formal resemblance to his photograph *Spring Showers* (see fig. 7.13), taken seven years before the beginning of the Cubist revolution.

Stieglitz's education in Cubist aesthetics was facilitated by Max Weber (1881–1961), a Russian-born, Jewish immigrant whose devoutly religious family had settled in Brooklyn, New York, in 1891. At Brooklyn's Pratt Institute of Art from 1898 to 1900, Weber studied under Arthur Wesley Dow (1857–1922), a devotee of

7.13 (left) Alfred Stieglitz Spring Showers—New York, 1900. Photogravure, 12½ × 5 in (31.1 × 12.7 cm), from Camera Work, no. 36, October 1911. Metropolitan Museum of Art. Alfred Stieglitz Collection, 1949.

7.14 (middle) **Pablo Picasso** Drawing, 1910. Photogravure, $19\frac{1}{6} \times 12\frac{5}{6}$ in (48.5 \times 31.2 cm), from Camera Work, no. 36, October 1911. Metropolitan Museum of Art. Alfred Stieglitz Collection, 1949.

7.15 (p. 298, right) Max Weber

Composition with Three Figures, 1910. Gouache and watercolor over black crayon on cardboard, 47×23 in (119.4 \times 58.4 cm). Ackland Art Museum, University of North Carolina, Chapel Hill. Ackland Fund.

Weber's adoption of a Cubist figural style coincided with an article on "The Wild Men of Paris" published in the May 1910 issue of the Architectural Record and illustrated with reproductions of Picasso's Cubist paintings. Weber's figures possess sharply defined geometric features borrowed from the simplified shapes of African masks and sculptures.

Oriental art, who taught students the radical principle that art developed from a consciousness of abstract formal relationships rather than any impulse or obligation to imitate nature. Dow's instruction prepared Weber for his eventual encounter with Matisse, Picasso, and other European Modernist artists, whom he met during his residence in Paris from 1906 to 1909. Together with other American expatriate painters such as Alfred Henry Maurer (1868-1932), John Marin (1870-1953), and Patrick Henry Bruce (1881-1936), Weber became a founding member of the New Society of American Artists in Paris, organized by Edward Steichen, Stieglitz's overseas talent scout for the 291 Gallery.

Upon returning to New York in 1909, Weber had long conversations with Stieglitz about the meaning of the Cubist revolution, but it was not until 1910 that Weber began to assimilate the abstract new style into his own work. At first, he painted large female nudes (fig. 7.15) whose crystalline geometry and African, mask-like faces resembled early Cubist figurative works by Picasso and Georges Braque (1882–1963), the French inventor of Cubism. However, like Stieglitz, Weber soon began to compare the fractured, interpenetrating planes of Cubism to the

7.16 Max Weber New York, 1913. Oil on canvas, 40% imes 32% in (103.1 imes82.5 cm). Thyssen-Bornemisza Collection, Lugano, Switzerland.

The English critic and art theorist Roger Fry included this Weber painting in an exhibition of English Modernist art in 1913. An art review for The London Times, entitled "Artist Cult of the Horrible: Exhibition of Wild Eccentricities," ridiculed Weber's picture by comparing its forms to a concertina or accordion that had become fatally ensnarled with the stars and stripes of the American flag and a serpent playing hide and seek.

dynamic abstract geometry of the urban landscape as captured by Modernist photography. The painter became a close friend of Alvin Langdon Coburn (1882-1966), who shared Stieglitz's interest in taking futuristic photographs of New York City streets and skyscrapers. Coburn's most famous photograph, The Octopus, New York (fig. 7.17), was taken from the top of the Metropolitan Life Insurance Company Tower, a 700-foot, fifty-story structure that was for a brief time the tallest skyscraper in the world. Coburn aimed his camera downward at Madison Square, with its pattern of radiating paths resembling the eight-armed sea creature. In the photograph's left half, the monumental tower casts its shadow over the snow-covered park and dwarfs the diminutive trees and street traffic below. For Coburn, the modern, mechanical art of photography was the medium most suited for recording skyscrapers and the new age of science and steel.

Max Weber, however, disagreed with his friend by arguing that the eye of the painter was more flexible and sensitive than the camera lens. Guided by the mind rather than a mechanical device, the painter's body is immersed more immediately and completely in the sensory experience of the moment, spiritually and physically stimulated by the city's kaleidoscopic sounds, motions, colors,

lights, and forms. In New York (fig. 7.16), one of his first cityscapes, Weber attempts to induce in the beholder a dizzying reverie with a maze of tall architectural forms tilted at odd angles with one another. Disengaged from any firm ground or space below, the flat, light skyscraper forms seem to float toward the top of the canvas. Meanwhile, recalling Coburn's Octopus, Weber weaves a serpentine line throughout the picture. This urban boa constrictor represents New York's elevated trains and mass transportation system. Plunging into and emerging out of gaping earthen holes, the circulating, snakelike form also suggests the new subway system, which recently had been inaugurated in 1904.

The Influence of Futurism

Stieglitz first exhibited Weber's paintings in 1910 in a group show of "Younger American Artists," which also included works by John Marin, Alfred Maurer, Arthur Dove (1880-1946), Marsden Hartley (1877-1943), and Arthur B. Carles (1882–1952), who were all adopting anti-realist painting styles. Like Weber, Marin had studied in Paris for several years, from 1905 to 1910, but he did not adopt a futuristic abstract style until after Picasso's one-man show at the 291 Gallery in 1911. In a series of watercolors representing the newly constructed Woolworth Building in Lower Manhattan, Marin abandoned his earlier more meditative and Whistlerian technique of paint application in favor of an explosive style that

7.17 Alvin Langdon Coburn The Octopus, New York, 1912. International Museum of Photography and Film, George Eastman House, Rochester, New York.

Influenced by the art educator Arthur Wesley Dow (1857-1922), Coburn was attracted to the abstract, two-dimensional designs of Japanese art. Favoring an atmospheric, Pictorialist aesthetic, Coburn immersed himself in Symbolist, mystical thought and became involved in the occult, ritualistic lore of Freemasonry. This is one of a series of photographs that resulted from the camera lens being directed downward from the dizzying heights atop New York skyscrapers. The resulting images expressed the enigmatic, vitalistic spirit of modern life.

suggests not only the influence of Cubism but also the paintings of the Italian Futurists (fig. 7.18). This group of artists, which included Giacomo Balla (1871-1958), Umberto Boccioni (1882-1916), Carlo Carrà (1881-1966), and Gino Severini (1883-1966), adopted Cubist fragmentation and interpenetration of forms to suggest lines of force, motion, and the dynamism of the machine age. Originating as a movement in Milan, the Italian Futurists opened their first group show in Paris in 1912 by dramatically proclaiming in their catalogue manifesto "we are young and our art is violently revolutionary" in its opposition to academicism and classical, Renaissance "traditionalism" (cited in Chipp, p. 294).

While the architect Cass Gilbert (1859-1934) designed the decorative details of the Woolworth Building in a historical-revival, Gothic style (fig. 7.19), Marin's spontaneous brushwork obliterates all references to European medieval tradition. Far from recalling the lofty but massive cathedrals of a distant past, Marin's Woolworth Building, No. 31 expresses a futuristic world in which the world's tallest skyscraper appears to shudder with motion like a rocket ship preparing to take off from a collapsing launch pad. Despite the heavy masonry and steel structure of the actual building, Marin emphasizes its glassy transparency and anti-gravitational verticality as the architecture merges with the watery brushstrokes defining the luminous sky.

Outside the Stieglitz circle of painters, the Italian-American immigrant Joseph Stella (1877-1946) was more directly affected by the Italian Futurists, since he was in Paris for their widely publicized show. Having arrived in the United States from Naples in 1896, Stella identified closely with the immigrant community in New York and remained homesick for his native Italy, which he revisited in 1909 just as the Futurist movement was announced by the Milanese poet Filippo Tommaso Marinetti (1876–1944). Before his trip to Italy, Stella made numerous detailed drawings of hard-working laborers and impoverished immigrants, whose somber, anxious moods contrast starkly with the generally optimistic portraits of the poor by Ashcan School realists. However, a year after returning to New York, he underwent an enthusiastic, quasi-religious conversion to the Futuristic aesthetic when he visited the amusement parks of New York's Coney Island. As he later recalled, the oldfashioned harmonies of Renaissance Old Master painters seemed remote or dead in contrast to the dazzling, conflicting riot of swirling forms and light rays which excited Coney Island crowds during the annual Mardi Gras celebration. Stella's Battle of Lights, Coney Island (fig. 7.20) represents the hedonistic, carnivalesque frenzy created by dizzying rides, popular games, side shows, colorful electric lights, and exotic, decorative architecture. Unlike the sedate, classical idealism of the White City at the World's Columbian Exposition in 1893 (see fig. 6.11), Coney Island's environment had no reformist, morally didactic purpose. Attempting to revitalize high art, Stella created a kaleidoscopic painting that implicitly endorsed commercialized mass culture's rejection of the refined, genteel tradition in favor of irrational, bodily pleasures.

Nevertheless, lower-class commercial amusements actually served to reinforce the social status quo by restricting bizarre, raucous behavior within a controlled environment for a brief period of leisure time. By contrast, leaders of the Modernist art movement in America hoped to radically transform society with forms and images that liberated the senses and human imagination from the stifling dictates of conventional morality and materialism. A few months before Stella's Coney Island conversion to anti-realist abstraction, the American public had responded with excitement and bewilderment to the International Exhibition of Modern Art

7.18 (top) **John Marin** Woolworth Building, No. 31, 1912. Watercolor over graphite, $18\% \times 15\%$ in (46.9 \times 39.9 cm). National Gallery of Art, Washington, D.C. Gift of Eugene and Agnes E. Meyer.

7.19 Cass GilbertWoolworth Building, New
York City, 1911–13. New York
Historical Society, New York.

7.20 Joseph Stella Battle of Lights, Coney Island, Mardi Gras, 1913-14. Oil on canvas, 75 $\frac{3}{4}$ \times 84 in $(192.4 \times 213.3 \text{ cm})$. Yale University Art Gallery, New Haven, Connecticut. Gift of Collection Société Anonyme.

American popular culture is celebrated in the cacophony of electric lights, honky-tonk signs, exotic dancers, confetti, and the radiating steel girders of amusement rides.

held at the 69th Infantry Regiment Armory in New York City. The poster for this mammoth show of some 1,300 paintings, sculptures, and prints by both European and American artists featured a Revolutionary War pine-tree flag, thereby associating the Modernist rebellion against academic art with the American War for Independence. Ironically, the Association of American Painters and Sculptors, which sponsored the so-called Armory Show, had a membership that overlapped with that of the conservative National Academy of Design. But the organization's president, Arthur B. Davies, had earlier exhibited with the rebellious Robert Henri and The Eight. Davies's controversial conception of the Armory Show as a survey of modern art from its early-nineteenth-century European roots in the art of Eugène Delacroix (1798-1863) and Jean-Auguste-Dominique Ingres (1780-1867) to its twentieth-century culmination in Picasso and the Cubist revolution inevitably alienated more tradition-bound artists.

Modernism and Political Radicalism

Although the Armory Show did not include works by the Italian Futurists, the participating Stella and other American artists were stirred by the generally hostile rhetoric of newspaper critics, which described Cubism as a distorted, futuristic style. Newspapers particularly lampooned the exhibition's most talked-about painting, Nude Descending a Staircase No. 2 (fig. 7.21), by the French Cubist Marcel Duchamp (1887–1968). One cartoonist for the New York Evening Sun very wittily satirized Duchamp's canvas with a frenzied contemporary scene of The Rude Descending the Staircase (Rush Hour at the Subway) (fig. 7.22). Duchamp's painting may be compared to the visual multiplication of the human form as recorded in motion photography, a realist medium (see fig. 6.29). Like motion photography, his montage, or juxtaposition of diverse forms, parallels the pictorial flux of cinema, a new medium admired by Modernist artists.

The satirical cartoon of Duchamp's painting visually underscores the equation that academic artists and critics made between Cubism and anarchism. As the American Renaissance painter Kenyon Cox declared in the March 15th, 1913 issue of Harper's Weekly:

. . . the real meaning of this Cubist movement is nothing else than the total destruction of the art of painting. . . . The important question is what it is proposed to substitute for this art of painting which the world has cherished since there were men definitely differentiated from beasts. They have abolished the representation of nature and all forms of recognized and traditional decoration; what will they give us instead?... In some strange way they [the French Cubists] have made their work revolting and defiling. To have looked at it is to have passed through a pathological museum where the layman has no right to go. One feels that one has not seen an exhibition, but an exposure.

... The lack of discipline and the exaltation of the individual have been the destructive forces of modern art, and they began their work long ago. For a time the persistence of earlier ideals and the possession by the revolutionaries of the very training which they attacked as unnecessary saved the art from entire dissolution. Now all discipline has disappeared. . . . (cited in McCoubrey, pp. 194–195)

When the Armory Show opened in February, 1913, its identification with the American revolutionary tradition was reinforced by a contemporaneous strike of textile workers led by the Industrial Workers of the World (see p. 292) in nearby Paterson, New Jersey. Big Bill Haywood, the union's leader, recruited the support of New York political activists as well as Modernist artists and writers, who lived and socialized primarily in Manhattan's Greenwich Village. Shortly after the Armory Show closed

7.21 Marcel Duchamp Nude Descending a Staircase, No. 2, 1912. Oil on canvas, 58 imes 35 in 147.3 imes 88.9 cm). Philadelphia Museum of Art, Philadelphia, Pennsylvania. Arensberg Collection.

Duchamp's painting was exhibited in the Cubist Room, which became popularly designated as the Chamber of Horrors. Nevertheless, the work attracted long lines of visitors. One critic suggested that the painting be renamed "Profit" for its role in attracting paying, if bemused, customers.

in March, Hutchins Hapsgood, a leftist critic for the New York Globe, likened Modernist art to the IWW and claimed that both Haywood and Stieglitz possessed a common revolutionary desire to "dynamite the baked and hardened earth so that fresh flowers can grow" (cited in Abrahams, p. 166). Contemporary cultural critics saw a connection between the Modernist revolt against academic art and the working class's rebellion against the capitalist system of wage labor and factory discipline. Both were opposed to the status quo and aspired to transcend the limitations of exploitative social relationships and deadening cultural habits. In their different spheres, both Modernist art and socialist politics seemed to promise a future state of individual creative freedom and communal harmony.

On June 7, 1913, a manifestation of this alliance occurred when 1,200 textile workers from Paterson represented a history of their strike in a pageant organized by a group of radical Greenwich Village intellectuals and artists, who had earlier championed the Armory Show. Performing at New York's Madison Square Garden before an enormous crowd of 16,000 spectators, the striking workers and IWW members recreated dramatic scenes of their struggle against textile company owners. The Fifth Avenue socialite Mabel Dodge, who actively supported Modernist artists and wrote a favorable article on the Armory Show for Camera Work, assisted the radical political writer John Reed in rehearsing and directing the pageant. An exhibitor at the Armory Show, the Ashcan School realist John Sloan painted for the

7.22 J. F. Griswold The Rude Descending the Staircase (Rush Hour at the Subway). Cartoon, New York Evening Sun, March 20, 1913.

pageant a 200-foot theatrical backdrop representing a textile mill. A poster advertising the performance featured a youthful, virile worker boldly climbing upward and forward against a dark prison-house background of factory buildings and smokestacks (fig. 7.23). Despite this remarkable fusion of art and politics and an overflow audience of supporters, the pageant lost money and created divisions among the textile workers, who were soon forced to capitulate to the company's terms. In the process, thousands of strikers were arrested and replaced by strikebreakers, while the IWW declined as a force in the American labor movement.

Modernist Art and World War I

By the end of 1913, the optimistic spirit of collaboration between American artists and workers had suffered from the disillusioning failure to transform America's socioeconomic and cultural life. When World War I began in Europe in August of 1914, socialists at home and abroad were placed on the defensive as governments called upon workers to abandon class warfare in favor of an imperial war patriotically pursued for the advancement of national interests. When the United States entered the war against Germany in 1917, socialist and IWW leaders were arrested for arguing against the sacrifice of workers' lives for the benefit of America's economic or corporate expansion abroad.

By contrast, the Modernist artist Marsden Hartley, who had exhibited at the 291 Gallery and the Armory Show, traveled to Berlin in 1913, where he painted a series of pictures celebrating the pageantry of German military parades, uniforms, flags, and medals. An avid reader of mystical occult texts and a participant in the German Expressionist art movement, Hartley associated Germany with its tradition of idealist philosophy and Romantic art, music, and poetry. While Cubist artists in Paris seemed preoccupied by technical, formal problems of pictorial representation, Berlin Expressionists appeared to Hartley more concerned with expressing an inner spiritual content by means of vivid colors and mysterious abstract signs. Led by the Russian painter Wassily Kandinsky (1866-1944), these artists had organized themselves into the Blaue Reiter (Blue Rider) group, a name that clearly conjured forth in Hartley's mind images of gallant, chivalrous knights or warriors willing to sacrifice themselves for a noble cause (fig. 7.24). Hartley's most famous military painting, Portrait of a German Officer (fig. 7.25), memorializes his friend and lover Karl von Freyburg, who was killed early in World War I. Rather than painting a traditional likeness, Hartley evokes his friend's spiritual presence with a funereal shroud of colorful flags, badges, and military paraphernalia set against a melancholic black background. The initials K.V.F. in the lower-left corner identify the deceased, while a twisting letter E inscribed upon an epaulet refers to Hartley himself, whose original, given name was Edmund. During a period when homosexuality was not only illegal but still condemned by most doctors and intellectuals, Hartley declared his love for Freyburg in a private code of letters, numbers, and signs, and then only after his friend's death.

7.23 Robert Edmond Jones

Program cover for the Paterson Strike Pageant, 1913. Poster. Tamiment Library, New York University, New York.

Despite his German sympathies, Hartley was forced to leave war-torn Berlin, where he found it impossible to find buyers for his paintings. The market in the United States for abstract, Modernist art was little better. While a number of new galleries displaying avant-garde art opened after 1913, the Armory Show had actually cast the works of young American artists in the shadows of leading European painters and sculptors. Typifying the contrast from a negative perspective, the conservative academic artist-critic Kenyon Cox had directed his bitter attack on the Armory Show at the wild, foreign productions of Picasso and the Parisian Cubists. At the same time, he dismissively referred to a pair of Hartley's drawings as "purely nugatory," or of no consequence.

Synchromism

In 1916, Hartley participated in the Forum Exhibition of Modern American Painters, which attempted to stimulate market demand by demonstrating the independent, consequential meaning of a national movement toward Modernist abstraction. Organized by the art critic and anti-war pacifist Willard Huntington Wright, the Forum Exhibition of sixteen artists' paintings at the Anderson Galleries in New York was publicized as an anti-commercial venture, representing a diversity of individual styles. Acknowledging that "many charlatans have allied themselves with the [modern art] movement," the Forum Exhibition Catalogue blamed "the commercial element" for confusing the American buying public, which had been, until now, "unable to differentiate between the sincere and insincere" (Anderson Galleries, p. 6). Nevertheless, Wright obviously designed the show to promote primarily the "Synchromist" paintings of his brother Stanton Macdonald-Wright (1890–1973) and friend Morgan Russell (1886–1953). The two artists, working among the Cubists in Paris, had founded the Synchromist movement in 1913 to reassert the prominence of strong color contrasts as an integral, rhythmic dimension of abstract art. In explaining such works as Abstraction on Spectrum (Organization No.5) (fig. 7.26), which was reproduced in the Forum Exhibition catalogue, Stanton Macdonald-Wright wrote that he strove to divest his colorfully pulsating art "of all anecdote and illustration, and to purify it to the point where the emotions of the spectator will be wholly aesthetic, as when listening to good music" (Anderson Galleries, p. 56). By stressing the aesthetic transcendence of daily existence, the artist implicitly underscored the anti-commercial, quasi-religious emotional content of Modernist art. Similarly, Morgan Russell described his exhibition painting Cosmic Synchromy (see p. 284) as a modern-day version of medieval cathedral music.

Nevertheless, these co-founders of Synchromism were necessarily motivated by financial self-interest. As Macdonald-Wright confided to Russell in a revealing letter about the Forum Exhibition dating from early 1916:

Here goes to invite you to a big show . . . which will for once and all establish you as a selling factor in this country. Willard is getting it up in conjunction with Kennerley, the president of the Anderson Galleries (the biggest selling gallery in the world, and by the way, the most sumptuous and whose patrons are the Rockefellers, the Yerkes, Harrimans, the Morgans and the rest of the rich ones). . . . These galleries when they lend their name to a show are as good as cash. . . . You and I, because of our reputation will sell every thing. (cited in Agee, p. 89)

7.24 Marsden Hartley Warriors, 1913. Oil on canvas, $41\% \times 47\%$ in $(106 \times 119.8$ cm). Curtis Galleries Inc., Minneapolis, Minnesota.

Hartley's painting commemorates a military parade in Berlin celebrating the marriage of Kaiser Wilhelm II's daughter. The implicitly homoerotic representation of the equestrian guards' military comradery centers upon a tiered, phallic-shaped mountain rising to the top of the canvas as a symbol of valorous, manly striving.

7.25 *(below)* **Marsden Hartley**

Portrait of a German Officer, 1914. Oil on canvas, 68½ x 41½ in (173.4 x 104.9 cm). Metropolitan Museum of Art, New York. Alfred Stieglitz Collection, 1949.

Modernism for the Masses

Expressing political distance from the Modernist pre-war alliance with socialism, Macdonald-Wright unabashedly encouraged Russell to imagine the possible patronage of America's leading capitalist entrepreneurs. Ironically, John Weichsel (1870-1946), a Jewish socialist intellectual and advocate of introducing Modernist art to lower-class, immigrant communities, was on the organizing committee for the Forum Exhibition and wrote an exhibition catalogue statement criticizing American men of wealth for supporting reactionary classical art. Despite Macdonald-Wright's hopes, the Forum Exhibition did not result in significant sales for the participating painters. Eight years earlier, at the Macbeth Gallery, the more conservative realist paintings of The Eight had garnered \$4,000 in sales, which John Sloan regarded as a great success. However, the American art public was far less attracted to Modernist abstraction. By 1918, Macdonald-Wright's impoverished circumstances forced him to leave New York City for California. Similarly, Morgan Russell and Patrick Henry Bruce, the two other leading Synchromists in the Forum Exhibition, suffered financially from meager sales of their work. When Stieglitz suspended publication of Camera Work in 1917, this important Modernist art journal, which promoted avant-garde painting and sculpture, had a subscription list of only thirty-six names.

7.26 Stanton **Macdonald-Wright** Abstraction on Spectrum (Organization No. 5), 1914. Oil on canvas, $30\% \times 24\%$ in $(76.5 \times 61.5 \text{ cm})$. Des Moines Art Center, Des Moines, Iowa. Purchased with funds from the Coffin Fine Arts Trust. Nathan Emory Coffin

Collection.

Macdonald-Wright did not purport to represent any recognizable object in this work. Sharing much in common with the French Orphist paintings of Robert Delaunay (1855-1941) and Sonia Delaunay (1884-1979), Macdonald-Wright's color abstraction focused on the expressive power of the painting medium itself.

In contrast to Stieglitz, who refused to commercially advertise Modernist art exhibitions at the 291 Gallery, John Weichsel systematically attempted to popularize avant-garde art. During 1915-17, Weichsel established the People's Art Guild, which sponsored modern art exhibitions in the restaurants, theaters, schools, and immigrant settlement houses of poor New York neighborhoods. Although his socialistic goal of democratizing the audience for Modernist painting and sculpture was dismissed as naive by Stieglitz and Willard Wright, most of the artists who exhibited in Wright's Forum Exhibition, including Macdonald-Wright, later exhibited in 1917 at Weichsel's large, eighty-nine-person "Lower East Side Exhibition" at the Jewish Daily Forward Building on East Broadway, a down-market, downtown-Manhattan venue. The People's Art Guild's most popular exhibition, this event, known as the Forward Show, reportedly attracted numerous working-class visitors. They viewed not only familiar scenes of Lower East Side life by Ashcan School realists but also the challenging abstract cityscapes of immigrant artists such as Joseph Stella (see fig. 7.20) and the Russian-born Abraham Walkowitz (1878–1965) (fig. 7.27). Walkowitz assisted in the founding of Weichsel's socialist-inspired project.

Nevertheless, sales from the People's Art Guild exhibitions were negligible and, by 1919, Weichsel's organization had disappeared from the New York art scene.

7.27 Abraham Walkowitz New York, 1917. Watercolor, ink, and graphite on paper, $30\% \times 21\%$ in (77.8 \times 55.2 cm). Whitney Museum of American Art, New York. Gift of the artist in memory of Juliana Force.

Marcel Duchamp and New York Dada

The 1917 Forward Show was overshadowed by the far more glamorous and highly publicized first Exhibition of the Society of Independent Artists, the largest art show ever held in New York, comprising over 2,500 paintings and sculptures by more than 1,000 artists. Financially supported by a group of wealthy New York patrons, the independent exhibition was organized by realist artists but had no jury and was open to anyone who paid the Society's small initiation fee and modest annual dues. Joseph Stella and other Modernists from the Forward Show also participated in the independent exhibition. Despite its non-exclusionary policy, however, the Society's 1917 exhibition became famous for what its board of directors chose not to exhibit. Having already created a public sensation at the Armory Show (see fig. 7.21), Marcel Duchamp instigated yet another storm of controversy when he submitted a white porcelain urinal bearing the ironic title Fountain and signed with

Now Mr. Mutt's fountain is not immoral, that is absurd, no more than a bath tub is immoral. It is a fixture that you see every day in plumbers' show windows.

Whether Mr. Mutt with his own hands made the fountain or not has no importance. He *CHOSE* it. He took an ordinary article of life, placed it so that its useful significance disappeared under the new title and point of view—created a new thought for that object. (cited in Naumann, p. 185)

Escaping the war in Europe, Duchamp had arrived in New York in 1915. Together with the Parisian artist Francis Picabia (1879–1953), he helped to import an iconoclastic, anti-art movement into New York known as Dada. Named after a childish French term for a rocking horse, Dada originated in war-torn Europe, as poets and artists in Zurich, Paris, Berlin, Hanover, and Cologne ridiculed patriotism, militarism, and all established political and cultural values. Blaming the cold rationalism of modern technology and the hypocrisy of middle-class morality for the senseless loss of millions of lives, Dadaists embraced the irrational by disrupting theatrical performances and concerts, engaging in street protests, and creating nonsensical, anti-art works. They nihilistically attacked all notions of aesthetic beauty and original genius for elevating art into a stultifying religion that only reinforced

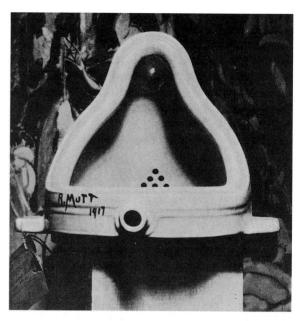

7.28 Marcel DuchampFountain (original lost), 1917.
Gelatin silver print, 9½ × 7 in (23.4 × 17.7 cm), by Alfred Stieglitz, reproduced in *The Blind Man*, No. 2 (May 1917).
Philadelphia Museum of Art. Louise and Walter Arensberg Archives.

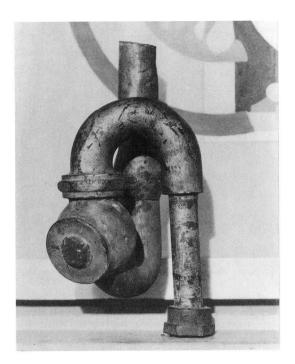

7.29 Elsa von Freytag-Loringhoven and Morton Schamberg

God, c. 1917. Gelatin silver print, $9\% \times 7\%$ in (24.1 \times 19.2 cm). Metropolitan Museum of Art, New York. Elisha Whittelsey Collection and Fund, 1973.

Since Dada constituted an anti-art rebellion against traditional notions of authorship and originality, it is unsurprising that an iconoclastic woman like this German baroness made little apparent effort to claim this work as hers. On the other hand, Schamberg acted more conventionally by photographing God in front of one of his own signed machinist paintings. The plumbing trap appears here without a wooden miter box that the baroness used as an ironic, protective pedestal for the detumescent phallic form. the status quo. Rejecting traditional fine-arts techniques and materials, Duchamp and other Dadaists sought to demolish the barrier between art and life, declaring that anyone could be an artist and anything could become a work of art. For Duchamp, art was more an act of finding than making or crafting, depending upon conceptual more than purely visual qualities.

Duchamp's Fountain was a "readymade," an object that he had found or purchased already made from a store or factory. In appropriating this utilitarian, manufactured object and then resituating it, signed and titled, within a gallery or exhibition space, the artist magically gave the object a new life and identity as a work of art. Significantly, given Dada's abhorrence of the war, Stieglitz chose to photograph Fountain against the backdrop of Marsden Hartley's Warriors (see fig. 7.24), though this was doubtless partly because the shape of the urinal echoed the painting's abstract mountain ceremonially ascended by German cavalrymen. Although born to a German-Jewish immigrant family and educated in Berlin, Stieglitz, like Duchamp, felt no patriotic allegiance to any particular national government. By 1917, as America was preparing to

enter the war against Germany, he gloomily viewed the prospect as a social and cultural catastrophe. Intentionally or not, Stieglitz's juxtaposition of Hartley's militaristic painting with Duchamp's scandalous Buddha or Madonna-shaped urinal seems itself a Dadaist critique of pre-war optimism and patriotic fervor.

Playing upon the concept of a changeable artistic identity, Duchamp's assumption of alternative personalities such as R. Mutt demonstrates that the former Cubist painter regarded art as a fluid process of self-transformation without fixed rules or boundaries. His most notorious adopted persona was Rose Selavy, whose name became connected with a number of enigmatic readymades. The New York Dada artist Man Ray (1890–1976) publicized the birth of this female alter ego by photographing Duchamp wearing a wig, pearl necklace, and lavish feathered hat.

Contradicting Dada's anti-art subversion of formal beauty, Stieglitz's photograph of Fountain makes the urinal aesthetic, or visually interesting. By contrast, in apparent response to Duchamp's infamous work, Baroness Elsa von Freytag-Loringhoven (1874–1927), who most epitomized New York Dada's anarchistic ethos, chose an unaesthetic found object, a cast-iron plumbing trap, to create a sacrilegious, sexually suggestive readymade entitled God (fig. 7.29). The German baroness had arrived in New York in 1913, only to live in abject poverty after her aristocratic husband, Baron Leopold von Freytag-Loringhoven, returned to Germany and committed suicide during the war. While Duchamp enjoyed the hospitality and financial support of affluent patrons, the baroness scraped by in a cheap, two-room, Greenwich Village tenement filled with pieces of junk that she found in the streets or shoplifted. Frequently arrested for petty theft, she sometimes earned money as an artist's model and published Dadaist poetry in avant-garde journals. More than a creator of readymades, the baroness dressed and lived Dada in a nearly continuous performance of shocking, outrageous behavior, such as parading half-naked through Greenwich Village in bizarre costumes that she had crafted from various pieces of cloth and decorative bric-a-brac. She once shaved her head bald and painted it with a bright red lacquer, explaining that the act of shaving one's head was like making love.

Emulating Duchamp's *Fountain*, the baroness's *God* treated American plumbing fixtures as ironic icons of divinity. In an essay that she later published in defense of James Joyce's Modernist novel *Ulysses* (1922), she sarcastically wrote that puritanical Americans were so preoccupied by the external machinery of sanitation facilities that they forgot about their own bodily functions or internal plumbing. For the baroness, iron plumbing was America's God.

Romancing the Machine in Art and Architecture

Traditionally, Morton Livingston Schamberg (1881–1918), a painter of sleek, abstract pictures of machines (fig. 7.30), has been credited with the creation of *God*. Certainly, he photographed the readymade and may have assisted in its assembly, but recent art historians have reattributed primary authorship to the irreverent baroness. The ironic, dark humor and crude, sexual appearance of *God* is not in character with Schamberg's elegant machine aesthetic. Though Schamberg admired the New York Dadaists, he did not share their anti-art tendencies. Originally trained as an architect, he employed a precise, linear drawing style to celebrate the machine's formal beauty and rational geometry.

Schamberg died prematurely, but many other painters also shed the Dadaist nihilism of the war years to portray with more optimism than skepticism the sublime power of the machine and the industrialized American landscape. Charles Demuth (1883–1935), who wrote a poem defending "Richard Mutt" and his Fountain, then later employed Duchampian humor in comparing American factories, warehouses, and grain elevators to the sacred architectural forms of ancient and medieval history. A native of Lancaster. Pennsylvania, Demuth chose the ironic title Incense of a New Church to represent the stylized smokestacks and swirls of polluting smoke from a nearby industrial complex (fig. 7.31). Yet the somber humor of the title loses its critical punch, since Demuth's colorful suggestion of a precious, stained-glass church window clearly idealizes the subject. The artist encourages beholders to imagine the smokestacks as the pipes for a monumental organ, while the industrial plumes of smoke curve about in seductive serpentine lines that induce an otherworldly state of reverie. In contrast to the far more fragmented Cubist cityscapes of Max Weber (see fig. 7.16), Demuth's composition serenely harmonizes the cacophony and dislocations of economic modernization to create a relatively calm and stable order of industrial forms.

America's romance with the machine was especially expressed in architecture and the decorative arts. In 1925, a major international exhibition on the decorative arts was held in Paris. The Exposition Internationale des Arts

7.30 Morton Schamberg *Mechanical Abstraction*, 1916.
Oil on canvas, 30 ×
20½ in (76.2 × 51.4 cm).
Philadelphia Museum of Art.
Louise and Walter Arensberg
Collection.

Inspired by both Duchamp and Francis Picabia (1879-1953), Schamberg began exhibiting machine paintings in 1916. But he did so without any apparent Dadaist irony or humor. Scholars have argued that this work, one of Schamberg's most refined images, was actually abstracted from a sewing machine or from an automated stitcher used in bookbinding. Painted with nuanced color harmonies, Schamberg's abstractions express an almost religious devotion to finely crafted mechanisms.

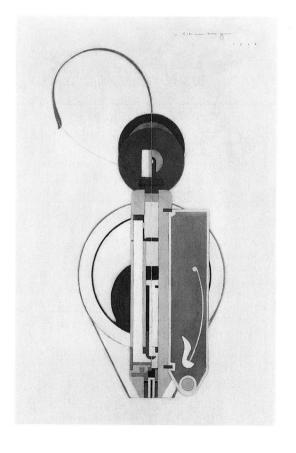

7.31 Charles Demuth Incense of a New Church, 1921. Oil on canvas. $26 \times 20\%$ in (66×50.8 cm). Columbus Museum of Art, Columbus, Ohio, Gift of Ferdinand Howald.

Representing the Lukens Steel yards of Lancaster, Pennsylvania, Demuth's painting incorporates a large chalice-shaped form amidst the swirling incense of industrial smoke. The chalice equates the alchemical, transformative powers of industry with the sacramental symbolism of Holy Communion and the transubstantiation of wine into the blood of Christ. During the pre-Depression optimism of the 1920s, numerous Americans, led by President Calvin Coolidge, equated factories with temples or churches.

Décoratifs et Industriels Modernes spawned the Art Deco movement, which popularized a modern, machine-age style for buildings and everyday utilitarian objects. One of the most eye-catching examples of streamlined Art Deco design in the United States was the 185-foot-high spire of glistening stainless steel that capped the Chrysler Building in New York City (fig. 7.32). Commissioned by the car manufacturer Walter P. Chrysler, the architect William van Alen (1883-1954) ornamented the skyscraper with automotive decorative motifs.

Like giant wheels or hubcaps, overlapping circles of silvery metal ascend toward the top of this commercial cathedral. Within each sleek parabolic curve of the spire, triangular windows create a radiant, sunburst pattern that equates industrial

production with a godlike creative energy. In addition to machine forms, Art Deco designers also borrowed sleek, modern-appearing motifs from nature and ancient historical styles. Thus, the elevator doors of the Chrysler Building were adorned with metal and wood veneers of Egyptian-Revival floral designs. For a few months, the Chrysler Building was the tallest in the world, but it was

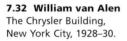

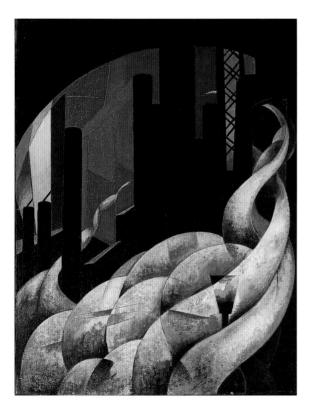

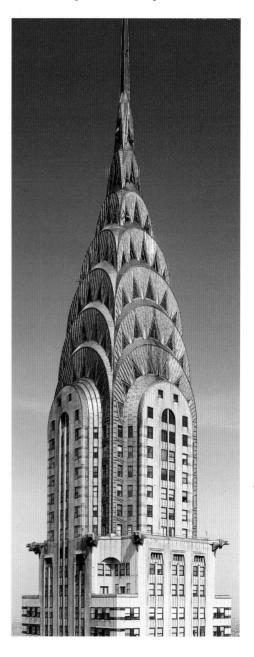

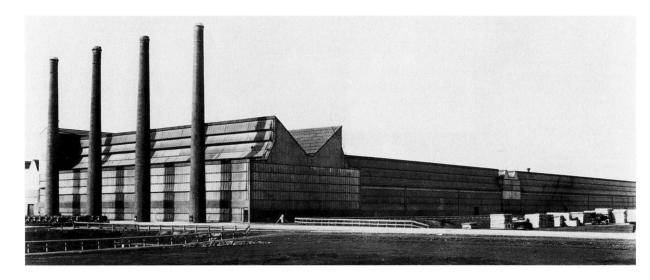

soon surpassed by the eighty-five-story Empire State Building further downtown. Like its competitor, the Empire State Building was crowned by a lofty spire, but its Art Deco design was less distinctive than Chrysler's automobile motifs.

Fordism

Architects also invented a purely functional industrial building style. During the 1920s, Fordism, or the scientifically managed production techniques of the automobile manufacturer Henry Ford, captured the imagination of European and American artists and architects, who believed that industrial technology was the best means for rebuilding a new world after the devastation of war. Before the war, Ford had hired the German-Jewish immigrant Albert Kahn (1869–1942) to design factory buildings in Highland Park, Michigan, a suburb of Detroit. Kahn's task was to accommodate the demands of assembly-line production: the continuous flow of raw materials and parts through the work space and their incorporation into the final, assembled automobile exiting at the opposite end of the factory. Hiring unskilled workers to fit into the separate steps of the assembly-line process, Ford followed Frederick Taylor's *Principles of Scientific Management* (1911), which recommended the division of labor into a seamless series of repetitive, routine motions timed to maximize productivity.

Though he designed the private, suburban homes of Detroit auto manufacturers in nostalgic historical-revival styles, Albert Kahn shaped his minimalist factory designs to the practical needs of factory management. At Highland Park and later, after the war, at Ford's River Rouge Plant in Dearborn, Michigan (fig. 7.33), he employed the modern industrial materials of steel and reinforced concrete to create vast, open factory spaces uninterrupted by cumbersome interior supports and brightly illuminated by long ribbons of windows and skylights. Whereas earlier American factories had been multi-story, small-span buildings, Kahn's assembly-line factories were horizontal, single-story structures that covered acres of land. Each structure in the self-sufficient River Rouge complex was designed for the production of a specific component, subassembly, or auxiliary activity in transforming raw materials into modestly priced automobiles. The plant's buildings were connected

7.33 Albert Kahn

Ford Motor Company, Glass Plant, River Rouge Plant, Dearborn, Michigan, 1922. Albert Kahn Associates, Inc., Architects and Engineers, Detroit, Michigan.

7.34 (p. 315, top) Charles Sheeler

Criss-Crossed Conveyors, Ford Plant, 1927. Gelatin silver print, $10\% \times 9\%$ in $(26.6 \times 23.8 \text{ cm})$. From the Collections of Henry Ford Museum and Greenfield Village, Dearborn, Michigan.

When Vanity Fair reproduced this photograph, the caption not only quoted from Matthew 7:16 but also praised Henry Ford as a virtually divine mastermind. Ford's new River Rouge Plant was an American Mecca or holy site. Behind the crisscrossing coke and coal conveyers, eight enormous smokestacks from one of the plant's powerhouses loom overhead. Sheeler's composition, with its low viewpoint, is meant to instill feelings of reverential awe before this sublime image of god-like industrial power.

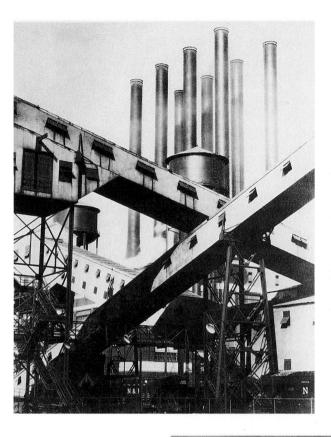

by miles of railroad tracks, conveyer belts, and roads to create a giant assembly chain.

In 1927, the Ford Motor Company, working through the N. W. Ayer advertising agency, hired the American painter and photographer Charles Sheeler (1883–1965) to photograph its River Rouge Plant. An admirer of Duchamp's detached, unemotional, and mechanical images, Sheeler, along with the photographer Paul Strand (1890-1976), in 1920 had created Manhatta, a short, silent film of New York City architectural and engineering landmarks, which was shown at a Dada festival in Paris. However, Sheeler was more a devotee of Fordism than Dadaist nihilism. His most famous River Rouge photograph, Criss-Crossed Conveyors (fig. 7.34), was reproduced in Vanity Fair magazine with the biblically inspired caption "By Their Works Ye Shall Know Them." Indeed, Sheeler employed this dynamic shot of elevated conveyor belts for the centerpiece of a photographic triptych equivalent to a medieval or Renaissance altarpiece. Even after the stock market crash of 1929 and the advent of the Great Depression, Sheeler paid homage to Ford's capitalist venture in a series of paintings that associated the industrial landscape with the rational grandeur of the classical past (fig. 7.35). Painting

7.35 (right) Charles Sheeler

Classic Landscape, 1931. Oil on canvas, $25 \times 32\%$ in $(63.5 \times 81.9 \text{ cm})$. Collection Mr. and Mrs. Barney A. Ebsworth Foundation.

Sheeler synthesized photographic realism with classical order in this view of a cement plant in Ford's River Rouge complex. Distant silos and smokestacks evoke associations with classical columns. The sharply receding railroad tracks continue the rational, spatial constructions of Renaissance linear perspective. The painting possesses an eerie, airless emptiness. The industrial landscape seems strangely inert and expressive of the Depression, despite billowing factory smoke from the tall smokestack.

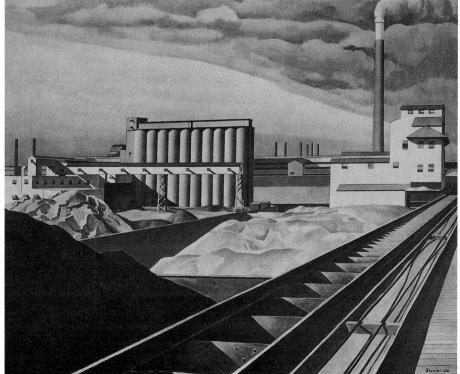

in a precise, quasi-photographic style, Sheeler, even more than his friend Demuth, abandoned the confusion of Cubist fragmentation, while adopting the simplified, relatively abstract geometry of American machinery and functional factory architecture.

The Aesthetics of the Hole

Critics employed the terms "immaculate" and "precisionist" to characterize the crisp, linear, urban-industrial imagery of Schamberg, Demuth, Sheeler, and other American painters. Though she is most famous for her sensuous, sexually suggestive pictures of flowers, the painter Georgia O'Keeffe (1887-1986) also completed a series of Precisionist cityscapes when, from 1926 to 1929, she lived in New York with Alfred Stieglitz. Stieglitz had given the Wisconsin-born artist her first solo exhibition as the 291 Gallery's finale before it closed for financial reasons in 1917. Though he had assisted O'Keeffe's career and married her in 1924, Stieglitz also attempted to discourage some of her innovative artistic choices. He particularly assumed that phallic, masculine skyscraper shapes were unsuitable subjects for a woman artist. However, as the art historian Anna C. Chave has observed, in pictures such as City Night, O'Keeffe emphasized the canyon-like space between towering architectural forms (fig. 7.36). Partially illuminated by a full moon, a traditional feminine symbol, O'Keeffe's nocturnal opening to the sky represents an androgynous marriage of male and female forms. The artist's frequent representations

of canyons, crevices, and holes suggest associations with the womb or the creative power of female sexuality.

However, the aesthetic of the void had already been popularized in Modernist sculpture by the Russian Cubist Alexander Archipenko (1887–1964), who emigrated to New York in 1923. In 1913, Stieglitz had purchased five drawings by the then Paris-based sculptor. With its geometric interplay of voids and convex and concave shapes, Archipenko's *Seated Woman* (fig. 7.37) employs empty spaces as positive design elements. Critics reviewing his aesthetics of the hole speculated upon its cosmic, spiritual significance or how the figural representation of being could be expressed by apparent absence, or non-being. Just as Cubist painters had merged abstract figures and objects with the pictorial background, so did Archipenko integrate mass with ambient, activated space.

Attuned to modern architectural spaces, O'Keeffe's aesthetic emphasis upon womb-like openings also parallels the organic, prairie-style homes of her fellow Midwesterner Frank Lloyd Wright. Already at the turn of the century, Wright had

7.36 Georgia O'KeeffeCity Night, 1926. Oil on canvas, 48 × 30 in (121.9 × 76.2 cm). Minneapolis Institute of Arts, Minnesota. Gift of Regis Corporation, W. John Driscoll, and the Beim Foundation; the Larsen Fund; and by public subscription.

7.37 Alexander Archipenko

Seated Woman (Geometric Figure Seated), 1920. Painted plaster, 22½ in (57 cm) high. The Tel Aviv Museum, Israel.

After settling in the United States, Archipenko spent much of his time teaching art and art theory in schools throughout the nation. Building on his Cubist sculptures of interlocking positive-negative spaces and convex-concave forms, the Russian-born artist played a significant role in gaining public acceptance for sculpture as a non-narrative, abstract medium for studying tectonics, or formal structures.

7.38 Frank Lloyd Wright Fallingwater, or The Kaufmann House, Bear Run, Pennsylvania, 1937.

employed overhanging roofs and balconies that protected long ribbons of windows and established a dynamic interplay between interior and exterior spaces, while simultaneously creating a sheltered, cave-like sense of privacy (see fig. 6.14). Decades later, in Fallingwater, a country retreat designed for a Pittsburgh department-store owner, Wright fully realized his vision of creating a home that appears not only to imitate, but also to originate from, the earth's porous, underground network of caves, tunnels, and springs (fig. 7.38). Built over Bear Run and an actual waterfall, Fallingwater has deeply recessed interiors that mimic nature's cavernous spaces. Glass-wall openings or ribbon windows are shielded by roof overhangs and cantilevered or projecting reinforced concrete balconies. At the heart of this shaded refuge, an enormous fireplace offers the comfort of warmth and additional light in cold, damp weather.

The Société Anonyme

While O'Keeffe's focus on the void may be compared to Archipenko's perforated sculptures and the cave-like homes of Wright, the phallic, sleek towers of her City Night resemble a series of visionary skyscraper sculptures that John Storrs (1885–1956), the son of a Chicago architect and real-estate developer, created in the mid-1920s (fig. 7.39). Storrs thought of buildings in elemental, naturalistic terms. He attributed religious meaning to the ancient human quest to control the elements of earth, water, air, and fire through art and architecture. An avid collector of American Indian artifacts, Storrs equated skyscrapers with Northwest Indian totem poles and houseposts, which symbolized unity between earth and sky. Looking beyond the purely functional, economic rationale for the construction of skyscrapers, he

associated their verticality with an infinite spiritual growth toward the illumination of sun and sky. By contrast, for Storrs, horizontality signified all that was heavy, brutal, or purely materialistic. His simplified sculptures foreshadowed Modernist American skyscrapers, which eventually eliminated all decorative, historical details in favor of starkly cubical geometric towers and Precisionist slabs (see figs. 8.8–8.9). Cast with steel, the industrial metal of skyscraper construction, Storrs's *New York* was reproduced in 1926 for the cover of an exhibition catalogue of international art published by the Société Anonyme, the nation's first modern art museum.

Founded in 1920 by the New York painter and Dadaist art patron Katherine Dreier (1877–1952), the Société Anonyme was named after the French business term for an incorporated company. However, like Storrs, Dreier interpreted modern art forms in spiritualized terms. She admired Duchamp and other Dadaists for their apparent lack of concern for material gain in the production of anti-art readymades. But she also adhered to the religious beliefs of Rudolf Steiner (1861–1925), founder of the Anthroposophical Society in Germany in 1912, who argued that artists, more than ordinary humans, were especially able to create visionary "thought-pictures," or colors and forms that communicated the ideas and feelings of a higher, spiritual world.

A determined social activist, Dreier especially favored the work of the Russian Constructivists, a group of artists led by Vladimir Tatlin (1885–1953?), who allied themselves with the 1917 communist revolution in Russia and the establishment of the Soviet Union. As explained by Louis Lozowick (1892–1973) a Russian-born American Precisionist painter who visited Constructivists in Moscow in 1922, construction was the "new Gospel" of art. Unlike the traditional aesthetic notion of composition, which Lozowick associated with illusion, art for art's sake, and mere decoration, Constructivisim was an activist art dedicated to life or the construction of a vigorous, new society through industry, machinery, and science. Constructivists valued industrial machine forms and engineering technology for promising a higher new reality that would transcend the accidents of nature and the limitations of indi-

that would transcend the accidents of nature and the limitations of individual caprice or idiosyncratic creativity. In addition to exhibiting the futuristic works of Archipenko, Storrs, and the American Precisionists, the Société Anonyme held an exhibition of Russian Constructivist Art in 1924 and featured it again in an International Exhibition of Modern Art in 1926. Dreier's introduction of the Russian avant-garde to the American public encouraged the young Alexander Calder (1898–1976), whose metal and wire mobiles of the 1930s went much further than Archipenko in liberating sculpture from the tyranny of gravity and heavy, massive forms (fig. 7.40). Calder borrowed the term "mobile" for his motorized and wind-driven constructions from Duchamp, who assembled a kinetic,

or moving, sculpture with his 1920 motorized *Rotary Glass Plates*, acquired by the Société Anonyme.

Regionalism Versus Social Realism

The internationalist, Constructivist aesthetic of Société Anonyme exhibitions struggled against the dominant American trend toward political and cultural nationalism after World War I. In 1919, in the wake of numerous anarchist bombings and

7.39 John Storrs New York, c.1925. Brass and steel on black marble base, $25\% \times 5\% \times 3\%$ in (65.8 \times 14 \times 8.9 cm). Indianapolis Museum of Art, Indiana. Discretionary Fund.

the Soviet Union's establishment of the Communist Third International, which fostered revolutionary politics abroad, the United States government began rounding up thousands of working-class immigrants suspected of being communists. That same year, the Senate expressed support for an isolationist foreign policy by rejecting President Woodrow Wilson's proposal for an international League of Nations. During the 1920s and 1930s, the industrialists John D. Rockefeller and Henry Ford collected American folk art and antiques and nostalgically re-created America's premodern past in the living museums of Colonial Williamsburg, Virginia, and Greenfield Village, Michigan.

By contrast, Modernist artists appropriated folk art for more radical ends: they employed the style's simplified forms to suggest that Americans possessed an instinctive taste for anti-academic art and abstraction. The Polish-American sculptor Elie Nadelman (1882-1946), who had a solo exhibition at Stieglitz's 291 Gallery in 1915, became an avid collector of American folk art and adapted its naive, self-taught appearance for many of his elegant, stylish sculptures (fig. 7.41). Meanwhile, American painters represented nationalist historical narratives and regional customs and folkways that had survived the forces of economic modernization. Indicative of the growth of Protestant fundamentalism during the 1920s, the Kansas painter John

7.40 Alexander Calder A Universe, 1934. Motordriven mobile. Painted iron pipe, wire, and wood with string, 40½ in (102.9 cm) high. Museum of Modern Art, New York, Gift of Abby Aldrich Rockefeller.

Like other American Modernists, Calder used abstraction to express spiritual ideas of cosmic harmony and dynamism. His sculpture of moving spheres recalls the long-popular orrery, or scientific model of the solar system's orbiting planets. Accompanied by a mechanical device placed alongside it, Calder's delicate construction features just two spheres, a small red one and larger white orb, each representing a star or planet moving at different speeds along separate curved paths within the wire construction's large open sphere.

7.41 Elie Nadelman Tango, 1919. Painted cherry wood and gesso, 3 units, $35\% \times 26 \times 13\%$ in (91.1 \times 66 imes 35.2 cm). Whitney Museum of American Art, New York.

These delicate, doll-like wooden figures are fashionably dressed and dancing the Argentine tango. Despite its Argentine folk origins, Nadelman's Tango expresses the sophistication of the modern hotel ballroom. The crisscrossed arms and interlocked gazes of the two figures sexually magnetize the "empty" space between them.

7.42 John Steuart Curry

Baptism in Kansas, 1928. Oil on canvas, 40×50 in $(101.6 \times 127 \text{ cm}).$ Whitney Museum of American Art, New York.

This painting represents a baptism conducted by the Campbellites, a Christian fundamentalist sect. The scene is located on a farm neighboring Curry's own home. Standing in the middle of a water tank, a blacksuited minister is about to immerse a female convert dressed in white. Other white-robed figures wait their turn for baptism.

7.43 (below) Thomas **Hart Benton** The History of New York: New York Today, 1927. Oil on canvas, 70 imes 36 in (177.8 imes91.5 cm). Courtesy Hirschl-Adler Galleries, New York.

Steuart Curry (1897–1946) first gained public recognition with his painting Baptism in Kansas (fig.7.42) and a series of other pictures representing rural American religious piety.

Earlier, however, in 1919, Thomas Hart Benton (1889–1975), great-nephew of a famed United States Senator from Missouri (see p. 220), essentially launched the Regionalist painting movement when he began a series of mural-size pictures entitled The American Historical Epic. In 1916, Benton had exhibited with the Synchromists at the Forum Exhibition of Modern American Painters, but, unlike Stanton Macdonald-Wright and Morgan Russell, he was unwilling to give up recognizable subject matter. Far from being a reactionary anti-Modernist, Benton was attracted to John Weichsel's People's Art Guild and its attempt to make modern art more socially and politically connected to progressive, democratic reforms. Seeking to reach a broader audience, he synthesized the bold colors and rhythms of Synchromist compositional techniques with the modern medium of cinema to create a dynamic, popular visual history of the United States beginning with the Spanish discovery and conquest. Having worked as a set designer for numerous westerns and two-reel movies from 1913 to 1918, Benton appropriated the stereotypical cast of characters from cinema to create immediately recognizable, action-filled narrative paintings. Though Regionalist artists tended to focus upon rural themes of farming and small-town settlements, Benton did not hesitate to paint urban scenes. Following the western, pioneering picture Over the Mountains, his 1927—New York Today (fig. 7.43) represented the futuristic culmination of The American Historical Epic. This painting's verticality and towering background skyscrapers recall the architectural forms of John Storrs and the machine aesthetic of the Precisionists. However, as

7.44 Grant Wood American Gothic, 1930. Oil on beaver board, $29\% \times 24\%$ in (76 \times 63.2 cm). Art Institute

of Chicago, Chicago, Illinois. Friends of American Art Collection.

With its vertical board-andbatten construction and pointed arch window, Wood's Iowa farmhouse echoes the Gothic Revival architecture of Alexander Jackson Davis (see fig. 5.17). Although the couple may be interpreted as personifications of Midwestern moral virtue, both figures have frowning expressions. Perhaps expressing a stereotypical rural suspicion of strangers. the couple's apparent lack of hospitality is reinforced by the pitchfork held tightly by the farmer as a possible weapon.

focus upon people rather than buildings. Suggesting a political desire for humane, democratic control of the urban-industrial environment, Benton portrays a team of muscular construction workers, heroic, curvilinear forms dominate the picture space. During the 1920s, the Ku Klux Klan, the white supremacist terrorist organization, grew phenomenally to a nationwide membership of several million and dominated local and state politics not only in the South but also in many parts of the Midwest and West. Nevertheless, in The American Historical Epic, Benton represented the brutality of slavery and also depicted blacks and whites working harmoniously together to settle and build the nation. During the Depression of the 1930s, he painted numerous similar public murals that supported President Franklin Delano Roosevelt's "New Deal" social policies for stimulating the economy and providing welfare and work projects for millions who had lost jobs from bankrupt companies and closed factories. Opposed to the communist belief in class struggle, Benton shared the viewpoint of the American commentator on social issues

Erika Doss has observed, Benton preferred to

Lewis Mumford, who defined Regionalism as a progressive, liberal synthesis of modern industrial efficiency and pre-industrial communal values.

In 1930, a year after the stock market crash, the Iowa painter Grant Wood (1892-1942) produced American Gothic (fig. 7.44), the most famous picture of Midwestern Regionalism. Wood studied in Paris and Munich during the 1920s and attended Iowa State University, but he enjoyed posing for photographs dressed as a country farmer. Similarly, Wood's sister and the local Cedar Rapids dentist posed as the painting's fictive farming couple. While many critics and art historians have interpreted American Gothic as a humorous satire, the painting's representation of sturdy individualism, religious piety, and rural labor was also reassuring for a nation experiencing numerous farm foreclosures, bank failures, and a sharp decline in economic production.

Wood's portrait of Midwestern types is actually a history painting inspired by his discovery of a nineteenth-century farmhouse that had a distinctive Gothic-arch window, a form borrowed from church architecture and a symbol of religious piety. The painting nostalgically depicts 1880s Iowans, who may be imagined as the original occupants of the house. Wood studied nineteenth-century photographs and had his models stiffly pose with old-fashioned costumes and props. Wishing to demonstrate how the Midwestern rural environment was shaped by virtuous, hardworking settlers, he framed the Gothic window with human figures that reiterate the building's upright, vertical architecture. Symbolizing masculine work and strength, the pitchfork mimics the rectilinear patterns of the man's bib overalls and

shirt as well as the house's wooden siding. By contrast, a circular pattern in the woman's dress, together with her oval, egg-shaped head and ivory cameo, accentuates the feminine gender and associates her with the domestic fertility of the potted plants resting upon the porch in the background.

During the 1930s, dust storms, floods, and other natural disasters aggravated the national economic crisis. The Farm Security Administration (FSA), an agency of Roosevelt's New Deal, hired a team of photographers to document the destitute living conditions of America's farmers. In contrast to the prosperity and stability of Wood's Midwestern couple, Dorothea Lange's (1895–1965) photograph of a pair of migrant workers walking down the middle of a dusty California road underscores the rootless plight of contemporary agricultural labor (fig. 7.45). By juxtaposing the two men with the cruelly ironic message of a Southern Pacific Railroad billboard, Lange contradicts corporate advertising's images of upper- and middle-class affluence, which totally ignored the realities of the Depression. The billboard's representation of a comfortable, sleeping passenger particularly emphasizes this willful blindness toward the hardships of the unemployed and working poor.

The painter Ben Shahn (1898–1969) also traveled the countryside working for the FSA, not only taking photographs but also painting murals for small, working-class communities. Shahn used his photographs as material for many of his paintings. However, his snapshot of a Morgantown, West Virginia, sheriff during a coal

7.45 Dorothea Lange Southern Pacific Railroad Billboard near Los Angeles, California, 1937. Library of Congress, Washington, D.C.

7.46 Ben Shahn Sheriff During Strike, Morgantown, West Virginia, 1935. Gelatin silver print. $7\% \times 9\%$ in (18.4 × 24.1 cm). Hallmark Photographic Collection, Hallmark Cards, Inc., Kansas City, Missouri.

7.47 Edward Weston Dante's View. Death Valley. 1938. Gelatin silver print, $7\% \times 9\%$ in (19 \times 24 cm). Collection Center for Creative Photography, Arizona Board of Regents, University of Arizona, Tucson.

From Dante's View, 6000 feet above sea level, Weston aimed his camera downward toward the salt beds of the valley floor, which continually changed depending upon the amount of water that flowed into curving stream and lake shapes. Always shooting within inches of the same spot, he created photographs representing the different ghostly patterns of the valley's black, white, gray, and brown tones.

miners' strike stands on its own as a powerful political statement against government repression of labor-union activities (fig. 7.46). By cropping the sheriff's head and concentrating upon his holstered gun and ample backside, Shahn creates the generic image of an authoritarian local policeman serving the interests of company owners and mine managers.

Photographers working outside of New Deal agencies also managed to capture the depressed national mood even if they did not direct their cameras toward the human figure. Primarily known for his sharply focused close-up shots of peppers, seashells, and other organic forms, Edward Weston (1886-1958) traveled throughout the western United States during the late 1930s. Published in a photographic travelogue, California and the West (1940), Weston's picture of

Dante's View, Death Valley (fig. 7.47) represents a desolate California landscape that evokes an association with the Inferno, an epic vision of hell from the Divine Comedy (1313–14), by the Italian poet Dante Alighieri.

7.48 Moses Soyer *Artists on WPA,* 1935.
National Museum of
American Art, Washington,

Although no style of art was proscribed by the WPA, some government administrators were hostile to Modernist abstraction. Furthermore, participating artists sought to communicate with a broad public and, therefore, tended to favor easily recognizable subjects. As Moses Sover recalled, Depression-era artists were excited by the sense that they had a social mission and were needed by a public hungry for visually uplifting images such as those being finished by this workshop of painters.

During the 1930s, the art market was also a casualty of the Depression. With most artists unable to sell their work, President Roosevelt in 1935 established the Works Progress Administration (WPA) and Federal Arts Project (FAP). Within a year the WPA-FAP was employing over 5,000 artists and eventually sponsored the production of over 2,500 public murals, 108,000 easel paintings, and thousands of prints and posters for post offices, public employment and welfare agencies, and other government offices. In addition, the U.S. Treasury Department created in 1934 the Section of Painting and Sculpture, which commissioned over 1,100 murals and 300 sculptures for new federal buildings.

In his painting of Artists on WPA (fig. 7.48), the Russian-born, New York artist Moses Soyer (1899-1975) represents the collective nature of artistic production under the WPA's Portable Murals Project. From his chair in the lower-right corner, the portly, plainly dressed Soyer draws a sketch, while a female model casually sits in front of him smoking a cigarette. Soyer's assistants, two women and three men, are all absorbed by their work for Children at Play, a multi-panel mural for the children's ward of a New York hospital. Soyer, like Ben Shahn, was a Social Realist painter who was critical of the nostalgic provincialism and nationalism of the Regionalist or "American Scene" paintings that chauvinistically celebrated America. As suggested by the workmanlike, production-line character of Sover's studio, Social Realists identified themselves with the working class. They sought to represent the devastating social effects of the Depression in a popular realist style. In Reading from Left to Right (fig. 7.51), Raphael Soyer (1899–1987), Moses's twin brother, does not glorify Main Street America but borrows from Shahn's photograph of a cheap restaurant in the impoverished Bowery district of Lower Manhattan. The painting's title ironically associates the gaunt, haunted portraits of these anonymous, unemployed men with the captions of society-page newspaper photographs, which normally identified socially prominent figures or celebrities by beginning with the words "reading from left to right." Soyer's highly political interplay between the verbal and visual closely compares with Dorothea Lange's photographic criticism of corporate advertising (see fig. 7.45).

7.49 Aaron Douglas Aspects of Negro Life: Song of the Towers, 1934. Oil on canvas, 9×9 ft $(2.74 \times 2.74 \text{ m})$. Art and Artifacts Division, Schomburg Center for Research in Black Culture, New York Public Library, New York. Astor, Lenox, and Tilden Foundations.

Douglas's critical interpretation of American urbanism and industrialization expressed his socialist political views and strong support for labor unions. The plumes of smoke and towering urbanindustrial forms create the demonic characteristics of a hellish underworld.

The mural paintings of Aaron Douglas (1898–1979), an African-American artist, demonstrate that Social Realism also could encompass a more Modernist, abstract vocabulary of forms. His Song of the Towers (fig. 7.49) is one of a series of FAP murals on Aspects of Negro Life for a branch of the New York Public Library that serves Harlem, the center of New York's African-American life in Upper Manhattan. Douglas was one of the leading figures in the Harlem Renaissance of the 1920s and 1930s, when black writers and artists created a vital culture of musical, visual, theatrical, and literary arts inspired by African art and African-American folk traditions.

7.50 Stuart Davis

Hot Still-scape for 6 Colors — 7th Avenue Style, 1940. Oil on canvas, $36 \times 44\%$ in (91.4 \times 114 cm). Museum of Fine Arts, Boston, Massachusetts. Gift of the William H. Lane Foundation and the Mr. and Mrs Karolik Collection, by exchange.

The Harlem Renaissance blossomed through the migration of Southern blacks into major Northern cities. In New York City, the area of northern Manhattan called Harlem soon was described as the national capital of African-American life. As we shall see, the painter Jacob Lawrence (b. 1917) poignantly documented this epic Great Migration in a series of narrative history paintings (see fig. 8.3). During the 1920s, Alain Locke, the leading critic and spokesman for the Harlem Renaissance, promoted the idea of racial equality by highlighting distinctively African-American contributions to the arts. In *The New Negro: An Interpretation* (1925), an anthology of African-American literature, Locke, as editor, asked black writers and artists to draw inspiration from their African heritage and racial origins.

Aaron Douglas became closely identified with Locke's notion of a Negro Renaissance or New Negro Movement, since he provided illustrations for *The New Negro*. In book jackets designed for the poet Langston Hughes and other major African-American authors, Douglas borrowed from the African-influenced style of Cubism and stylized Egyptian art, made popular through Art Deco, which evoked ancient African civilizations.

Painted after the optimistic height of the Harlem Renaissance during the 1920s, Douglas's Depression-era

Public Library mural decoration expressed the new cultural pessimism caused by mass unemployment and poverty. His mural represents the silhouettes of several African-American men within a nightmarish urban-industrial landscape of mechanical wheel cogs, skyscrapers, and polluting smokestacks. At the center stands a jazz saxophonist juxtaposed with New York harbor's Statue of Liberty in the far background. However, the distant promise of African-American freedom appears overwhelmed by an inhuman socio-economic environment. In the lower-left corner, an exhausted, muscular figure holds his head in despair as serpentine and clawlike clouds of smoke threaten to imprison him, sapping his strength.

7.51 Raphael Soyer Reading from Left to Right, 1938. Oil on canvas, $26\% \times 20\%$ in $(66.6 \times 51.4 \text{ cm})$. Whitney Museum of American Art, New York. Gift of Mrs. Emil J. Arnold.

Modernism and the Defense of Democracy

In 1934, Douglas and many other artists formed the Artists' Union, a labor union that sought to create better working conditions and economic security for visual artists struggling against the decline in the private art market. A year later, most of these same artists joined the American Artists' Congress, which was supported by the American Communist Party as part of the larger Popular Front movement of labor unions, New Deal liberals, socialist political organizations, and leftist cultural groups committed to defending democracy and freedom from the militaristic and totalitarian policies of Benito Mussolini's fascist dictatorship in Italy and Adolf Hitler's Nazi Party state in Germany. The Depression had caused mass unemployment and unrest in Europe as well as in America. Appealing to the German capitalist and middle-class desire for order and promising revenge for Germany's defeat in

World War I, Hitler gained power in 1933 by attacking Jews, communists, and the alleged decadence of Modernist culture, while promoting Germans as a master race descended from blond, blue-eyed Aryan peoples. Having begun his career as a minor painter, Hitler conservatively adopted academic neoclassicism as the official Nazi style in art and architecture and condemned as degenerate modern, abstract art, which he associated with communism, Judaism, and African primitivism.

Hitler's denunciation of Modernist art served to strengthen the perception that abstract painting and sculpture possessed a strong, anti-fascist political content. Stuart Davis (1894–1964), the national chairman of the American Artists' Congress from 1936 to 1940, was a Cubist-inspired painter who believed that abstract, modern art was an antidote to fascism. It could stimulate positive and radical political changes in America and the world, because such art interpreted reality not in terms of absolutes or static, unchanging truths but rather as a material state of conflicting processes, dynamic individual relationships, and temporary negotiated solutions. Though he identified with socialist and working-class causes and had once worked in an Ashcan School style, Davis rejected Social Realist art as endorsed by the American Communist Party. Like Regionalist painting, which he despised as a reactionary form of nationalism, Davis regarded Social Realism as a backward, propagandistic style that failed to express the modern reality of change and motion. His Hot Still-scape for 6 Colors—7th Avenue Style (fig. 7.50) is, therefore, an implicitly political painting. As a "still-scape," completed in his Seventh Avenue studio, it combines forms from two different art traditions, still life and landscape painting. Davis draws upon the Cubist tradition of overlapping geometric forms to replicate in paint the colorful, "hot" rhythms and improvisational riffs of American jazz, which he frequently listened to in all-night jazz sessions at New York nightclubs. Jazz musicians who are "hot" are so thoroughly absorbed by their art that they freely experiment with melodies and rhythms, spontaneously expressing intense feelings. Within his jigsaw puzzle of hot- and cool-colored shapes, Davis creates doodling, twisting lines and shapes that suggest improvisational jazz techniques. These arbitrary doodles also recall European Surrealist painters such as Joan Miró (1893-1983), who developed relatively spontaneous, "automatic" drawing styles as a means for exploring the unconscious and releasing repressed feelings and desires. However, unlike the Surrealists and the Abstract Expressionists, whom we shall discuss in the next chapter, Davis created an abstract art that was primarily inspired by the urban-industrial environment of street signs, traffic, commercial advertising, cafés, clubs, radio, and other forms of mass communication.

By 1940, when he painted Hot Still-scape, Davis, like most other leftist American artists, had become disillusioned by the failure of the Popular Front. In August of 1939, Joseph Stalin, the communist dictator of the Soviet Union, had signed a nonaggression pact with Hitler, which enabled Nazi Germany to invade Poland the following month, marking the beginning of World War II. By April 1940, after the Soviet Union had invaded Finland, Davis quit the American Artists' Congress and condemned both communism and Nazism as totalitarian systems opposed to democracy. The United States finally entered the war only after the Japanese, allies of Germany and Italy, bombed the Hawaiian U.S. naval base of Pearl Harbor on December 7, 1941.

In the next chapter, we shall see how World War II contributed to the international dominance of American art. Assisted by the arrival of numerous immigrants, American artists and architects would emerge from the war as leading, avant-garde inheritors of the European Modernist tradition.

CHAPTER 8

Modernism, Postmodernism, and the Survival of a Critical Vision

1941-2000

hile New Deal art patronage collapsed during World War II, the immigration of European artists into the United States made New York City the international refuge for avant-garde, Modernist art. The war's violent conclusion in 1945 did nothing to alleviate the sense of crisis experienced by most Americans, who were soon caught up in the Cold War rivalry with the Soviet Union and the frightening prospect that another world war could trigger a devastating nuclear holocaust. At the same time, spurred by rapid economic growth and the expansion of U.S. government and corporate interests abroad, American art flourished during the second half of the twentieth century. The burgeoning art market contributed to an affluent consumerist culture even as the Soviet Empire declined and eventually collapsed by the early 1990s. Nevertheless, at the dawn of a new millennium, a globalized economy of multinational corporations, free markets, and cybernetic communications has made it impossible to speak of a uniquely American vision or the nationalist "triumph" of American art.

Since the late 1950s, artists and critics have seriously questioned Modernism's faith in individual originality and an artistic avant-garde in heroic opposition to mass culture. As a result, American art production has expanded with a notable pluralism of forms and techniques that has often been labeled Postmodernist, a broad and imprecise term. Definitions of Postmodernism have varied, depending on the particular artistic medium in question and on differing definitions of Modernism. If Modernist critics during the 1950s and 1960s tended to stress the formal, abstract purity of painting and sculpture, Postmodernist artists have embraced narrative subject matter and appropriated popular imagery from the mass media and commercial art. Many have rejected the notion of autonomous, self-contained art objects in favor of theatrical happenings, performances, videos, and films.

The term Postmodernism did not become current until the 1970s, but critics have traced its origins to the Pop Art movement of the 1960s and earlier to the revival of Dadaist readymade imagery and other anti-formalist practices during the 1950s. Although they borrowed from popular culture, Modernist artists during the first half of the twentieth century could easily think of themselves as an embattled avant-garde at cultural odds with the vast majority of the American public. Artists during the latter half of the century, however, have become increasingly integrated into middle-class life. A growing market for art works in almost any style or medium has made it difficult for artists to shock the public with novel forms of expression. Many Postmodernists have celebrated the death of a Modernist avant-garde as an inherently elitist concept.

Willem de Kooning Woman I, 1950–2. Oil on canvas, 6 ft 3% in \times 4 ft 10 in (1.92 \times 1.47 m). Museum of Modern Art, New York.

Compared to a vampire as well as a modern, secular Madonna, this enthroned, fleshy Woman, like Leonardo da Vinci's Mona Lisa (1503-05), has elicited a number of conflicting interpretations regarding her oracular, sphinx-like presence. Exaggeratedly summarizing the entire history of female idolatry, de Kooning referred to the comic, hilarious nature of the Women series, suggesting that he was lampooning traditional female stereotypes. Indeed, the figure's grin was inspired by a smiling model in a magazine advertisement for Camel cigarettes.

Subverting Modernist demands for originality, Postmodernist photographers have called attention to the immersion of "high" art into mass, consumer culture by imitating or reproducing the stereotypical imagery of advertising and the entertainment industry. Similarly, Postmodernist architects have derived inspiration from the garish, commercial-strip landscapes of Las Vegas, Nevada, and other hotel, motel, and leisure-resort sites. Breaking with the austere, functionalist aesthetic of Modernist architecture, Postmodernist architects have decorated buildings with historical-revival motifs and contemporary symbols of American consumerism and popular culture.

After World War II, expansive growth in the art market and number of professional artists fueled this artistic pluralism. From 1949 to 1977, New York City art galleries that handled twentieth-century American art increased from ninety to 290. Meanwhile, one-artist exhibitions grew from 800 during the 1949-50 season to 1,900 in 1984-5. Nationwide, over 1 million individuals identified themselves as artists in the 1980 United States census. This professional category includes designers, musicians, authors, dancers, actors, and art teachers, as well as painters, sculptors, photographers, and architects. By the 1990 census, the number had risen to nearly 1.7 million artists, a 127 percent increase from 1970. From 1970 to 1990, the subgroup of painters, sculptors, craft-artists, and artist-printmakers more than doubled from 86,849 to 212,762, as did photographers from 67,588 to 143,520. The ranks of architects almost tripled from 53,670 to 156,874. Government and corporate funding stimulated the professional expansion. Established by an act of Congress in 1965 as the chief federal arts agency, the National Endowment for the Arts has awarded millions of dollars for the arts. However, as we shall see, federal funding has aroused intense opposition from religious and political conservatives, who have long viewed artists as social subversives. Meanwhile, American corporations have not only supported the establishment of new museums, a sixty-seven percent increase between 1940 and 1980, but have also hired curators to develop their own collections of contemporary art. Amid this wealth and expansion of art as leisure entertainment and investment opportunity, artists have struggled to maintain a critical vision. Indeed, many have embraced the commodity status of art and adopted novel strategies for marketing their work.

Art and Propaganda During World War II

During the 1940s, as the United States battled the Japanese Empire in the Pacific and the German and Italian dictatorships in Europe, American corporations, working closely with government agencies, managed to rehabilitate their public image after industrial capitalism nearly collapsed during the Depression. In retooling factories for military production, American companies represented themselves as patriotic organizations dedicated to the defeat of Nazi tyranny. For example, the Chicago-based Container Corporation of America produced many public relations advertisements that identified the company with the Allied campaign to defeat Hitler (fig. 8.1). In fact, the company employed numerous artists who had formerly worked for the Bauhaus, an enormously influential German school of Modernist design closed by the Nazis in 1933. This nationalist renewal of corporate reputations occurred despite Henry Ford and other major American industrialists, who had openly admired and supported the Nazi regime in its early years and initially resisted converting factories for the manufacture of armaments.

8.1 Jean Carlu Gift Packages for Hitler, 1942. Gouache and gelatin silver print collage on paper, 25 × 19 in (63.5 \times 48.3 cm). National Museum of American Art, Washington, D.C.

World War II brought the United States out of the Depression as the nation's one hundred largest corporations benefited from \$117 billion in federal government contracts. Unemployment fell dramatically when able-bodied men joined the armed forces and women took over many jobs in factory assembly lines. During the war years, the democratic idealism, leftist politics, and labor activism of New Deal social programs were displaced by a far more conservative government alliance of business and military leaders. While Congress passed anti-labor legislation to prevent wartime strikes and to limit unions' financial contributions to political campaigns, the Roosevelt administration organized the Office of War Information (OWI) to galvanize working-class patriotism and discourage antinationalist radicalism. During the war, New Deal programs for the arts were dismantled. By 1943 the Works Progress Administration (WPA), which had employed thousands of artists, was shut down, as were the art projects of the Treasury Department. Although disillusioned by Joseph Stalin's brutal Soviet dictatorship and its temporary alliance with Nazi Germany, leftist American artists, without official government support, founded Artists for Victory shortly after the German invasion of the Soviet

Union in 1941. Uniting communists and non-communists, Artists for Victory was a nonprofit umbrella organization for nearly thirty smaller arts societies. Receiving commissions from various government and military agencies, its members designed propaganda posters, paintings, and advertisements for interest-bearing war bonds to finance the anti-fascist cause.

The government directly employed some artists to produce war posters. Nevertheless, these artists had little latitude for independent political expression since the government strictly controlled the posters' content. As head of the graphics division for OWI during 1942-3, the New Deal photographer and Social Realist painter Ben Shahn (see fig. 7.46) was frequently censored by his superiors over the imagery he chose. For example, they rejected his poster, originally entitled "A Need for All in Time of War, a Place for All in Time of Peace," which represented an African-American and a white welder. The poster was published later by the Political Action Committee for the Congress of Industrial Organizations (CIO), the leading umbrella organization for activist labor unions demanding full employment (fig. 8.2). In addition to the controversial fact that the white welder bore too close a resemblance to President Franklin Delano Roosevelt, OWI officials apparently regarded the image of solidarity between black and white workers as too politically radical for a racially segregated nation. Influenced in part by earlier Shahn paintings, the African-American artist Jacob Lawrence (b.1917) vividly underscored the problem of race relations at the beginning of World War II. In a series of sixty paintings entitled The Migration of the Negro, the Harlem artist employed a Modernist synthesis of narrative realism and dynamic abstract design to represent the Great Migration of poor, rural Southern African-Americans to the industrial cities of the

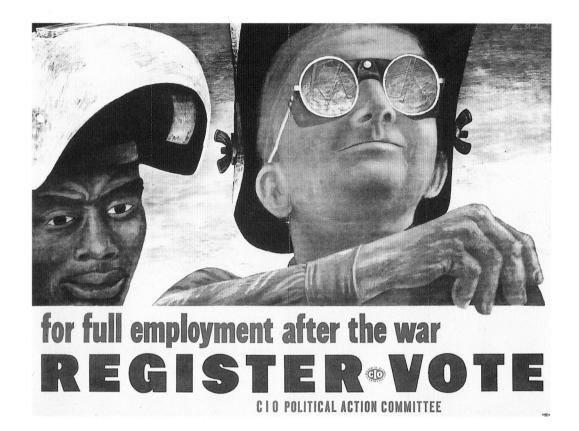

North (fig. 8.3). Industrialists employed African-Americans as low-wage strikebreakers. This tactic contributed to white workers' resentments and triggered deadly antiblack race riots. Shahn's later poster optimistically suggests that unionization and full employment would foster racial harmony. Nevertheless, his white welder clearly is the dominant figure in the working-class brotherhood.

Modernism and Post-war Architecture

As African-American veterans learned after returning from the war against the racist Nazi dictatorship, American racism would persist in poor-quality segregated housing and public accommodations. Real-estate developer William J. Levitt (1907–94) marketed inexpensive suburban housing to the families of war veterans. Applying the assembly-line methods of Henry Ford, he used prefabricated materials and employed 15,000 non-unionized laborers to build the 17,447 standardized, single-family homes of Levittown, New York, on Long Island, twenty-five miles east of Manhattan (fig. 8.4). Levitt's company associated racial integration with communist, left-wing rabble-rousing. With official support from the Federal Housing Administration, the company legally barred African-Americans from buying property and living in Levittown until 1960. Well before that year, the development had sold out. Most postwar suburban developers were allowed to exclude black settlement. This first Levittown project met with such success that two more Levittowns were constructed during the 1950s and 1960s, one in Pennsylvania and the other in New Jersey.

8.2 Ben Shahn

For Full Employment after the War: Register/Vote, 1944. Lithograph in colors, 29¾ × 39¾ in (75.5 × 100 cm). New Jersey State Museum Collection, Trenton, New Jersey.

The white welder's large goggles, upward gaze, determined expression and outstretched hand distinguish him from the secondary, relatively deferential African-American worker. The visionary appearance of the white figure seemed for many to suggest the leadership qualities of President Roosevelt, who, in 1944, was running for reelection to an unprecedented fourth term.

8.3 Jacob Lawrence

Migration of the Negro, The Migration Series, Panel 50: Race Riots were very Numerous all over the North, 1940-41. Tempera on gesso on composition board, 18 imes12 in (45.7 \times 30.5 cm). Museum of Modern Art, New York. Gift of Mrs. David M. Levy.

Lawrence's family had migrated from South Carolina to northern industrial cities. In this panel from the Migration series, Lawrence depicted several club and knife-wielding rioters in flattened, distorted patterns of violence directed against unseen victims beyond the picture frame. Although his abstract, simplified style recalls American folk art, Lawrence assimilated Cubist painting techniques and admired Aaron Douglas's fusion of realism and Modernist abstraction (see fig. 7.49). He also studied the art of Mexican muralists such as Diego Rivera.

8.4 (below) Levittown, New York, 1954.

Though suburban homes provided more space, privacy, and pride for new owners, the Levittown developments also became negative symbols of white, middle-class escapism and cultural uniformity. In 1962, Malvina Reynolds (1900–78), a leftist political activist and songwriter from San Francisco, composed "Little Boxes" after she witnessed a similar suburban development in nearby Daly City. As performed on college campuses and at Vietnam War protests during the 1960s and 1970s, the song's ridicule of "ticky-tacky" suburban tract housing led to other critical verses. These lyrics satirically attacked the social and cultural conformism represented by thoroughly insulated and homogeneous suburban lives.

To support the sprawling new suburban culture, car manufacturers successfully lobbied the United States government to redirect federal funds from public masstransit projects to build new highways and roads. These thoroughfares would serve suburban families, who required at least one, often two, cars for commuting to work and shopping. Regional malls steadily displaced urban downtowns as active commercial hubs. Surrounded by parking lots, suburban shopping malls seemed to be constructed on the commercial theory that only people who could afford to travel by private car need be accommodated as desirable customers (fig. 8.5). More recently, with the aid of creative architects such as Frank Gehry (b.1929), corporate mall developers have managed to establish a highly sanitized substitute for the sense of community formerly offered by most downtown centers. Gehry's design for Santa Monica Place outside Los Angeles typifies mall design throughout the United States. In 1979-81, he recreated a pedestrian-friendly interior that nostalgically recalls busy city sidewalks and parks (fig. 8.6). Sky-lit trees visually unite tiered storefronts. Street benches, small vendor carts, and open food courts help to establish a more intimate social space. Yet unlike public streets in city downtowns, privately owned malls can employ security forces to exclude commercially undesirable activities, including panhandling, political leafleting, and sidewalk speechmaking.

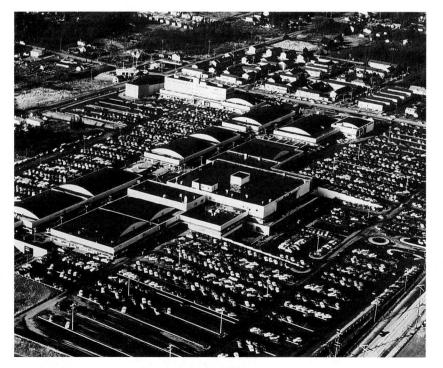

8.5 John Graham and Company

Northgate Regional Shopping Center, Seattle, 1947–50. DLR Group (formerly John Graham and Company), Seattle, Washington.

This aerial view shows two rows of stores situated along a pedestrian mall. Large department stores functioned as anchors or magnets for attracting mall customers, who could also then visit the smaller specialty shops. Located near main highway arteries, the complex is surrounded by acres of parking space.

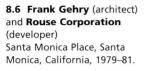

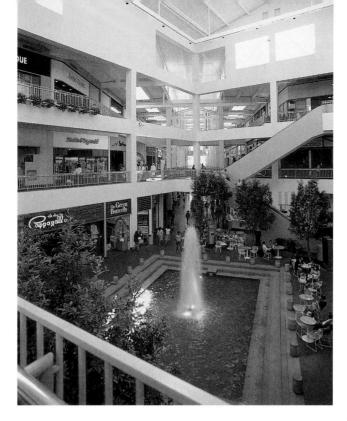

8.7 Kleinweber, Yamasaki, & HellmuthPruitt-Igoe Houses, St. Louis, Missouri, 1955. Photograph by Ted McCrea, 1955.

Emptied of shoppers by suburban malls, most American cities also were damaged by the construction of interstate freeways, which divided downtowns and destroyed established, mostly African-American and lower-class neighborhoods. Immediately after World War II, city governments confronted overcrowded housing, homelessness, and racial tension. With the return of war veterans and the continued Great Migration of African-Americans from the rural South, officials in Northern industrial cities tore down old, decaying neighborhoods. They relocated displaced, poor residents in high-rise public housing projects at sites distantly isolated from city centers and more desirable white enclaves (fig. 8.7)

A German émigré, Ludwig Mies van der Rohe (1886–1969), who settled in Chicago just before World War II, established the precedent for Modernist high-rise apartments in his luxurious, but starkly geometric twin towers along the city's prestigious and scenic North Lake Shore Drive overlooking Lake Michigan (fig. 8.8). Mies eliminated all architectural ornamentation and pared down the skyscraper design to a steel cage and an outer curtain wall of glass. The former director of the German Bauhaus school created an elegant, functionalist architecture that appealed to a machine-age corporate taste for rationality, homogeneity, and order. During the early 1930s, the American architect Philip Johnson (b.1906) and the architectural historian Henry-Russell Hitchcock coined the term "International Style." Their designation referred to the virtually styleless, pristine geometric forms of Mies and other European Modernists, whose functional building designs seemed essentially universal or transcendent of any particular national tradition. Once Mies had relocated to the United States, Johnson collaborated with him in designing New York City's Seagram Office Building (fig. 8.9), dominated by a clean, rectilinear skyscraper slab with a steel frame sheathed in dark amber glass that becomes luminously golden at night. Supported by a large service block in back, the tower is elevated by slender columns and set back from Park Avenue traffic. With a terrace plaza and fountain in front, the Seagram Building stands as a sleek icon of corporate power and sophistication.

American businessmen, real-estate developers, and public-housing authorities saw something more than the sleek elegance of similar skyscrapers. They recognized that the austere functionalism of International Style architecture, which employed

8.8 Ludwig Mies van der Rohe

Apartment houses at 860–880 North Lake Shore Drive, Chicago, Illinois, 1951. Chicago Historical Society.

Mies van der Rohe placed these two identical rectangular towers perpendicular to one another so that they would both fit within their trapezoidally shaped lot. Each stands on freestanding columns with a recessed glass-enclosed entrance lobby on the ground floor. The glass towers thus seem to hover lightly in space, while each column leads upward to the thin piers that divide the building into regular fourwindow bays.

8.9 Ludwig Mies van der **Rohe and Philip Johnson** Seagram Building, New York City, 1954-58.

standardized, repeatable building elements, was a practical model for economic efficiency and construction cost reductions. Thus, for the low-income Pruitt-Igoe housing project in St. Louis, Missouri (see fig. 8.7), federal government officials rejected the architects' suggestion for low- and midsize apartment buildings in favor of thirty-three high-rise towers constructed from substandard materials. Urban renewal projects such as the Pruitt-Igoe apartments effectively segregated African-Americans, Built on an inhuman scale without regard for parks, landscaping, or the surrounding environment, the projects housed residents within islands of inferior real estate and in monotonous structures that rapidly deteriorated owing to negligible expenditure on maintenance.

American Realism's Darker Visions

Already in the 1920s, the realist painter Edward Hopper (1882–1967) was producing disquieting images of the modern urban landscape that depicted isolated, lonely

figures imprisoned within cold, comfortless architectural spaces. During World War II, Hopper's Nighthawks (fig. 8.10), representing a desolate city street corner, powerfully expressed the nation's darkened mood. This painting anticipates the ominous lighting, urban set designs, and predatory, fatalistic themes of many film noir motion pictures that Hollywood directors and writers produced after the war. Though the neighborhood in Nighthawks appears seedy and derelict, the large, plate-glass windows of the all-night diner signify the sleek geometry and transparency of modern architecture. Yet far from contributing to a liberating sense of spatial openness, Hopper's glass-encased, harshly lit diner merely exposes its lonely and hard-bitten nocturnal characters to our voyeuristic surveillance. The artist obscures our view of the darkened, apparently empty street around the corner of the diner, thereby stimulating feelings of anxiety over city crime. Hopper's disturbing vision of an impersonal, alienated urban culture was shared by George Tooker and other realist painters. Tooker's later, nightmarish representation of the New York subway system (fig. 8.11) contrasts markedly with the optimistic Futurism of Modernists in the early twentieth century (see fig. 7.16).

In 1959, the Swiss-born photographer Robert Frank (b.1924) published *The Americans*, a book of photographs that undermined America's rose-colored image of affluence. Shot during a cross-country tour of the United States, his stark, black-and-white photographs contrasted images of cocktail parties, college commencements, and political rallies with disturbing pictures of urban blight, racial segregation, car accidents, and desolate parks and back roads. Frank's photograph *U.S. 285, New Mexico* (fig. 8.12) captures the lonely emptiness of an apparently endless highway to nowhere. In his introduction to *The Americans*, the novelist Jack Kerouac (1922–69) wrote poetically of Frank's "Long shot of night road arrowing forlorn into immensities and flat of impossible-to-believe America in New Mexico under the

8.10 Edward Hopper *Nighthawks*, 1942. Oil on canvas, 33½ × 60 in (84.1 × 152.4 cm). Art Institute of Chicago, Chicago, Illinois. Friends of American Art Collection.

Hopper had been a student of Robert Henri from 1900 to 1906, but he did not share his teacher's optimistic view of modern urban life. Paintings such as this one were probably informed, in part, by the writings of Lewis Mumford, a leading sociocultural critic, who argued that a genuine avant-garde architecture would not be devoted to corporatefinanced skyscrapers but rather to communal projects built on a smaller, more human scale.

8.11 (top) George Tooker The Subway, 1950. Egg tempera on composition board, 18½ \times 36½ in (46 \times 91.8 cm). Whitney Museum of American Art, New York. Purchase, with funds from the Juliana Force Purchase Award.

8.12 Robert Frank

U.S. 285, New Mexico, from The Americans, 1958. Silvergelatin print, $11\% \times 7\%$ in (29.1 \times 19.2 cm). Art Institute of Chicago, Illinois. Restricted gift of the Photography Gallery.

Prior to publication in New York, Frank's Les Américains was published in Paris in 1958. His photographs of denim- and leather-clad motorcyclists, gambling tables, juke boxes, and drivein movies followed upon Hollywood films such as Rebel Without a Cause (1955) starring James Dean, who represented the youthful, alienated, dark side of American material affluence.

prisoner's moon—under the whang whang guitar star" (p. 6). Kerouac's restless "Beat" movement novel *On the Road* (1957) portrayed, in part, a delinquent, alienated teenager just released from a New Mexico reform school. The youth dedicates his life to fast cars and the coast-to-coast search for a woman at the end of the road. Beat-generation authors of the late 1950s and early 1960s included Kerouac, Allen Ginsberg, William S. Burroughs, and Lawrence Ferlinghetti. These writers represented a bohemian counterculture, based primarily in San Francisco and New York's Greenwich Village, which rejected conventional, middle-class culture as materialistically crass and corrupt. The Beat authors helped develop an alternative culture of spontaneous, "hip" prose, free-form poetry, improvised jazz, and Buddhist philosophy mixed with sexual experimentation and the use of mind-altering drugs.

Frank shot his photographs for *The Americans* before entering Beat circles. Nevertheless, Kerouac clearly saw a kindred spirit in the photographer's highly personal, unidealized pictures of urban cowboys, factory workers, railroad station men's rooms, and coffee shops. Frank's photographs also share an emotional kinship with Edward Hopper's troubling paintings of modern loneliness and human despair (see fig. 8.10).

Cultural Crisis and the Emergence of Abstract Expressionism

While many artists produced realist, narrative works during the 1940s and 1950s, an increasing number of painters and sculptors adopted abstract, spontaneous imagery to address universal themes on individual, creative freedom and the internal, psychic conflicts of the human condition. Shortly after the war, this loosely connected group of artists was labeled Abstract Expressionist by a New York critic seeking to categorize their highly individualized styles. In contrast to Regionalist and Social Realist painters, who supported the American war effort with optimistic representations of nationalist myths and folk heroes, these rebellious artists alluded to the world crisis with raw, violent images inspired by primitive art and ancient myths and rituals. During the late 1930s, the New York painter Mark Rothko (1903–70), a Jewish-Russian immigrant, had been representing relatively serene pictures of the city's subway system. However, his Antigone (fig. 8.13) strongly diverges from the expressive realism of the subway series. Having turned toward classical Greek mythology for parallels to the contemporary traumatic events abroad, Rothko here refers to the rebellious, tragic heroine Antigone. According to the ancient Greek playwright Sophocles, Antigone, the daughter of Oedipus, committed suicide after the Theban king Creon had imprisoned her for illegally performing funeral rites for her brother Polynices, a declared traitor to the Theban city-state.

Rothko does not conventionally illustrate Antigone's disobedience and violent death, but reinterprets it in purely visual terms with several layers of sketchily rendered dismembered heads and body parts spread across the picture surface in shallow, atmospheric space. The picture's mutilated bodies, male and female, are arranged schematically in registers similar to flattened, anti-illusionistic ancient Egyptian wall paintings.

American writers during the 1940s often made implicit analogies between World War II and the gruesome, seemingly universal, human tragedies of Greek myth.

8.13 Mark Rothko Antigone, c. 1941. Oil on canvas, 34 imes 45 $^{3}\!\!\!/$ in (86.4 imes116.2 cm). National Gallery of Art, Washington, D.C. Gift of the Mark Rothko Foundation.

Rothko, a political leftist and self-declared anarchist, identified with Antigone's libertarian spirit and her willful disobedience of the inhuman King Creon, who personified for many American intellectuals the contemporary tyranny of Adolf Hitler. Conversely, the Greek heroine's suicide also suggested the fatalistic despair that had pervaded American intellectual circles. Other New York artists, such as Adolph Gottlieb (1903-74), shared Rothko's dark vision. Gottlieb's enigmatic Hands of Oedipus (fig. 8.14) refers to the violent mythic story of Antigone's father. Oedipus purposely blinded himself after learning that he had unwittingly both married his mother and killed his father. Dividing his canvas into a grid of animal and body parts, Gottlieb created what he called a "pictograph." The work features a primitive, hieroglyphic picture language of schematically drawn signs to evoke the myth's emotional, symbolic content. Believing that these mysterious signs expressed more than mere words or narrative details, Gottlieb, like Rothko, emphasized the flat surface of the picture plane, the better to confront viewers with the psychological power of imaginative figures and abstract visual forms.

Sigmund Freud, the Viennese founder of psychoanalysis, had transformed the Oedipus myth into the psychological paradigm of what he called the Oedipus Complex. Freud's archetype symbolized in universal terms the sexual fixation or incestuous attachment male children have for their mothers. However, Gottlieb focusses on Oedipal guilt and self-mutilation rather than illicit desire. Throughout the painting, Oedipus's murderous hands, responsible for the death of his father, point ominously to floating eyes, foreshadowing the imminent act of self-blinding. In addition, the artist eerily contrasts opened eyes with closed or faded ocular forms. At the upper left, a dark, sharp-beaked bird menacingly sits above a pair of vulnerable, opened eyes.

Abstract Expressionism and the Surrealist Unconscious

Rothko, Gottlieb, and many other American artists rejected the technocratic, optimistic machine aesthetic of early Modernism. Instead, they were influenced by a group of European artists who had turned toward Freudian psychoanalytical theory and inward for revelations of unconscious thoughts and hidden, repressed desires. Emerging in 1924 from the Dadaist, anti-art movement of World War I, the Parisian poet and critic André Breton (1896–1966) announced the birth of Surrealism, a movement that sought to employ the visual and verbal arts to explore

the subconscious mind and its profound, irrational contents. Breton linked the psychoanalytical interests of Surrealism with communist politics. He believed that bringing repressed thoughts and images to full conscious awareness could reform civilization to accommodate and more productively direct natural human desires and needs.

The self-taught New York sculptor Joseph Cornell (1903–73) had helped to introduce Surrealist art into the United States during the 1930s. Influenced by the Dadaist or Duchampian practice of appropriating found objects, Cornell specialized in assembling wooden and glass-encased boxes. These works were filled with small, ordinary objects, whose juxtaposition in the various compartments or spaces of the box could trigger private memories or emotional associations previously buried within the unconscious. Although the intimate, magical boxes tended to avoid explicit political content, his Habitat Group for a Shooting Gallery (fig. 8.15) clearly alludes to World War II. Behind a bullet-cracked pane of glass, found images of colorful, exotic birds are poised as targets amid splatters of paint and pasted pieces of paper carrying references to France, the birthplace of the Surrealist movement. Following the German conquest of France in 1940, Breton and other Parisian Surrealists had fled to New York. In 1942, the Pierre Matisse Gallery and Peggy Guggenheim's Art of the Century gallery held group exhibitions for exiled Surrealists and other European artists. Guggenheim, a wealthy American collector and niece of the copper tycoon Solomon Guggenheim, had married the Germanborn Surrealist Max Ernst (1891–1976), whose bizarre collages of found images had inspired Cornell's boxed assemblages. Guggenheim's gallery exhibited the works of European Surrealist exiles such as André Masson (1896-1987), Joan Miró, and Jean

8.14 Adolph Gottlieb Hands of Oedipus, 1943. Oil on linen, $40 \times 35\%$ in (101.6

× 91.1 cm). © 1979 Adolph and Esther Gottlieb Foundation, Inc., New York.

Eyes as well as hands play a prominent role in this compositional grid of pictographs. Pointed to by a large centrally located hand, two profile heads are joined at the back and face in opposite directions. The left face has an open eye in contrast to the closed eye of its opposing twin. These eyes may allude to the role of the artist, who remains open to the world and yet transforms sense impressions according to an inner vision.

8.15 Joseph Cornell Habitat Group for a Shooting Gallery, 1943, Wood, paper, glass, $15\% \times 11\% \times 4\%$ in $(39.4 \times 28.3 \times 10.8 \text{ cm})$. Des Moines Art Center, Illinois. Purchased with funds from the Coffin Fine Arts Trust. Nathan Emory Collection.

Cornell situated the mock bullet hole immediately over the bending central bird's head and splattered bloodred paint to mark the spot. This assemblage may have been Cornell's response to a particularly harsh review in The New York Times, which criticized the artist's work as escapist and irrelevant to the contemporary war-torn state of the world.

Arp (1887–1966). The gallery also became an important venue for Rothko, Gottlieb, and other American artists who became identified with the Abstract Expressionist movement.

Abstract Expressionist artists borrowed ideas, techniques, and visual forms from the Surrealists but rejected the hyper-illusionistic dreamscapes of Salvador Dalí (1904–89) and other Europeans. They also were skeptical of Surrealism's insistence on the primacy of the unconscious over conscious design, as evident in its relatively passive, anti-art technique of finding objects or accidental shapes that suddenly, unexpectedly aroused visionary thoughts. In his 1924 "Surrealist Manifesto," Breton particularly advocated automatism, or the technique of automatic drawing. Seated with a drawing instrument before a blank writing surface, practitioners of automatism were to place themselves in an entirely passive frame of mind. Within this receptive, trancelike state, beyond the repressive power of reason, unconscious desires would ideally surface and reveal themselves by spontaneously guiding the drawing hand and dictating the visual interplay of lines.

Dissenting from the apparent passivity of the Surrealists, Rothko, Gottlieb, and other Abstract Expressionists stressed the active, heroic making of art, originating from primitive man's confrontation with the infinite wonders and terrors of the cosmos. Barnett Newman (1905-70) painted simplified, abstract compositions that often alluded to ancient Greek myths and Judeo-Christian religious beliefs (see

> fig. 8.22). After the war, in a 1947 exhibition statement on "The Ideographic Picture," Newman expressed a masculine bias in comparing the profound spiritual content of Abstract Expressionist art with the ritualistic imagery of Native American hide painting:

> The Kwakiutl artist painting on a hide did not concern himself with the inconsequentials that made up the opulent social rivalries of the Northwest Coast Indian scene, nor did he, in the name of a higher purity, renounce the living world for the meaningless materialism of design. The abstract shape he used, his entire plastic language, was directed by a ritualistic will towards metaphysical understanding. The everyday realities he left to the toymakers; the pleasant play of non-objective pattern to the women basket weavers. To him a shape was a living thing, a vehicle for an abstract thought-complex, a carrier of the awesome feelings he felt before the terror of the unknowable. (cited in Chipp, p. 550)

> Newman's dismissal of women basket weavers and ordinary material objects might appear to marginalize Cornell's magical boxes, with their humble, found imagery. Nevertheless, Newman's insistence that an abstract shape could serve as a living, real vehicle for thoughts and feelings had been suggested by Surrealist painters and sculptors, who used biomorphic forms (bio meaning life and morphe meaning form).

> Arshile Gorky (1904–48) bridged the gap between Surrealism and Abstract Expressionism. By the early

1940s, this Armenian-born painter abandoned the geometric abstraction of Cubism for abstract organic shapes expressing sexual desires and childhood memories. Foremost in his remembrance was his father's garden, named "the Garden of Wish Fulfillment," which grew in the family's small native village of Khorkom. As Gorky painted *The Liver is the Cock's Comb* (fig. 8.16), he wrote his sister that an ancient Armenian spirit seemed to guide his hand to re-create the lush, natural shapes of their garden and orchards. During World War I, Gorky's family had been forced to leave the country when Islamic Turks had pursued a genocidal campaign against Christian Armenians. The painting's biomorphic Surrealist imagery evokes these deeply personal memories. The fecund shapes further suggest male and female genitalia and the key organ of the liver, which, in ancient and medieval legends, was the repository of all human passions.

Yet Gorky distrusted the automatic drawing and painting techniques favored by Surrealists. Automatism was a means of escaping the strictures of academic learning and conventional conscious thought. According to the theory espoused by Surrealist practitioners, the unpremeditated, spontaneous gestures of automatic drawing could generate dynamic new images of unconscious thoughts and desires through a psychic process of free association. However, Gorky rejected automatism's anti-art passivity and lack of conscious control. Meticulously detailed studies for *The Liver is the Cock's Comb* and his other paintings suggest that he carefully guided the spontaneous flow of line and juicy application of pigments.

While Surrealists praised the unconscious as the wellspring of a higher reality,

8.16 Arshile Gorky The Liver Is the Cock's Comb, 1944. Oil on canvas, 6 ft 1% in \times 8 ft 2 in (1.86 \times 2.49 m). Albright-Knox Art Gallery, Buffalo, New York. Gift of Seymour H. Knox, 1956.

Abstract Expressionist artists warned that the mind's darker recesses also harbored dangerous impulses, as evidenced by Nazi Germany's collective madness. The source of previously unthinkable possibilities, the unconscious had to be integrated with conscious thought. Only then could it contribute to social and cultural progress by reconciling rational, civilized needs with the irrational pleasures of human sensuousness and emotions.

If Abstract Expressionist painters were skeptical of André Breton's belief in the supremacy of the unconscious, they readily endorsed his conviction that artistic freedom was a critical weapon against totalitarian societies. In 1938, the Partisan Review, an influential New York cultural journal, published a manifesto co-authored by Breton, the pro-communist Mexican muralist Diego Rivera (1886–1957), and the anti-Stalinist Soviet communist Leon Trotsky, who lived in exile in Mexico. Filled with references to both Surrealist theory and the nineteenth-century, anti-capitalist writings of Karl Marx, founder of modern communism, this "Manifesto: Towards a Free Revolutionary Art" audaciously advocated an alliance between socialist political goals and an absolute freedom of artistic expression.

Abstract Expressionism and Cold War Politics

Some critics and art historians have characterized Abstract Expressionism as a retreat from social and political life. Others, however, led by the Marxist art historian Meyer Schapiro (1904–96), have claimed that this movement helped to maintain a radical critical spirit in America. After World War II, the Cold War between the United States and the Soviet Union began and grew. Meanwhile, Abstract Expressionist artists developed innovative imagery that implicitly criticized both Stalinist communism and the nationalistic anti-communism of American liberals and right-wing conservatives. Responding to U.S. government policies that served corporate interests but repressed union activism and leftist dissent, Schapiro, during the 1950s, praised Abstract Expressionism. He admired its aesthetic form of free, creative labor that opposed the dehumanized, mechanistic division of labor fostered by American capitalism.

Robert Motherwell (1915–91), a college-educated Abstract Expressionist painter, had taken Schapiro's art history courses at New York's Columbia University. According to Motherwell, modern artists should reaffirm the wholeness of individual life in a severely fragmented world. Writing in 1944, he explained that his works attempted to synthesize the duality between unconscious and conscious thought or between body and mind, senses and reason. Motherwell and other Abstract Expressionist painters strove to accomplish this synthesis by assimilating their automatic gestures and spontaneous forms within flat, two-dimensional Cubist space, which they associated with aesthetic reality and anti-illusionistic honesty. Far from advocating an apolitical, socially escapist art for art's sake, Motherwell employed an abstract style that expressed opposition to many repressive political forces. His targets included not only fascism and Stalinism but also the subtler totalitarianism of modern capitalist consumerism, which subordinated human labor to the private interests of a property-owning elite. As World War II raged, Motherwell painted a sequence of somber works that referred to the tragic Spanish Civil War of 1936–9. The United States government and European democracies had stood idly by during the Spanish conflict, while the Nazi-supported military dictator Francisco Franco overthrew Spain's democratically elected socialist government. Several years after the war, Motherwell returned to the subject again in a mural-size painting entitled *At Five in the Afternoon* (fig. 8.17). The title refers to a poem by Federico García Lorca (1899–1936), a Spanish author executed by Franco's fascist regime, about the death of a great Spanish bullfighter (Ignacio Sánchez Mejías) in the bull ring. Motherwell's visual idea for the painting originated from an automatist, pen-and-ink drawing. He transformed the image into a dramatic black-and-white open format of confining, oppressive bars or pillars and resisting, egg-shaped life forms. This was the first of many works in the *Spanish Elegy* series. During the 1950s, Motherwell insistently returned to the series, even as John Foster Dulles, the U.S. Secretary of State under President Eisenhower, openly embraced the Franco regime as part of America's Cold War strategy.

From 1945 to the early 1950s, Abstract Expressionism emerged as a relatively cohesive and highly visible movement in New York galleries and in art journals, newspapers, and popular magazines. Writing for the New Yorker magazine in March 1946, the art critic Robert Coates formally coined the term Abstract Expressionist to refer to those painters who seemed uncompromising in their pursuit of spontaneous, abstract techniques. New York artist Jackson Pollock (1912-56), a former student of Thomas Hart Benton (see fig. 7.43), soon became the movement's leading figure. The fifth son of a farming family in Cody, Wyoming, Pollock was attracted to the democratic ethos and rhythmic forms of Benton's populist paintings. Yet the young artist's more radical, leftist politics led him away from the Regionalist imagery of his teacher. During the mid-1930s, he joined the New York workshop of the Mexican muralist David Alfaro Siqueiros (1896–1974), who was active in communist, working-class politics. Influenced by Surrealist automatism, Siqueiros taught Pollock to experiment with various spraying, splattering, and dripping techniques for applying non-traditional, industrial paints to figurative murals. Furthermore, the Mexican artist's belief in the revolutionary potential of Native

8.17 Robert Motherwell At Five in the Afternoon, 1949. Casein on composition board, 15 × 20 in (38.1 × 50.8 cm). Photograph by Peter. A. Juley & Son, Smithsonian Institution, New York. Collection, Helen Frankenthaler, New York.

Lorca's poem about a fatally gored bullfighter symbolically contrasts the harsh white sunlight of the bullring with the shadows and blackness of death. Motherwell conceived his black-white elegy, or funeral lament, as a painted temple consecrated to the Spanish poet's unjust execution. The artist's gestural, dripping paint expressed the freedom of individual creativity and cultural resistance to political repression.

8.18 Jackson Pollock Guardians of the Secret, 1943. Oil on canvas, $48\% \times$ 75% in (122.9 \times 191.5 cm). San Francisco Museum of Modern Art, San Francisco. California. Albert M. Bender Collection. Albert M. Bender Bequest.

American tribal art appealed to Pollock's western-frontier sensibility and psychoanalytical interests.

John Graham (1881–1961) was a Russian-born painter who befriended Pollock, Gorky, and other Abstract Expressionists. In a 1937 article on "Primitive Art and Picasso," he had argued that primitive peoples learned about the unconscious mind by creating images that visualized tribal taboos and sacred, totemic kinships with the animal world. This notion was borrowed from the mystical psychoanalytical theories of Carl Jung, a disciple of Freud. Jung claimed that artistic exploration of individual unconscious thoughts would give modern man contact with a collective unconscious, which appears in archetypal symbols that have existed since the human race began. He hoped that modern culture, by assimilating the psychic impulses and instinctual insights evoked by these universal symbols, could achieve a greater equilibrium between conscious thought and nature's realm of unconscious life forces. According to Jung, the centuries-old repression of unconscious desires in Western civilization had erupted in the volcanic, self-destructive madness of fascism. Ideally, humans would prevent future catastrophic outbursts of collective state violence by integrating emotional, irrational needs with reason, science, and technology.

Like other Abstract Expressionists, Jackson Pollock tended to equate the social problems of the world crisis with his own insecurity and alienation. Suffering from alcoholism and violent temper tantrums, he sought help from Jungian psychoanalysts. They encouraged him to explore archetypal symbols and the energetic, spontaneous release of unconscious impulses through drawing and painting. Works with animistic, ritualistic symbols such as Guardians of the Secret (fig. 8.18) possess a Cubist geometry overlaid with hieroglyphic scrawls and roughly painted, gestural forms. Apparently influenced by an 1894 photograph of Native American guardians

of a secret knife society, the painting's mysterious figures include a bright red rooster sitting atop the guarded central rectangle, with a dog lying below. Convinced that his primitive imagery and spontaneous picture-writing surpassed words or realistic illusions, Pollock intended the painting's indecipherable energy as an expressive alternative to the technocratic rationalism of modern culture. Lee Krasner (1908–84), who married Pollock, also painted hieroglyphic paintings that seem written in an enigmatic, secretive code that defies facile, rational interpretation (fig. 8.19). However, Krasner's dense, linear calligraphy of pictorial signs appears far more orderly than Pollock's disparate hieroglyphs.

Three years after Guardians of the Secret, Pollock eliminated archetypal symbols and figurative imagery. Instead, he concentrated on painterly, physical traces that recorded a spontaneous, virtually continuous flow of psychic energy through the body. Pollock and Lee Krasner retreated to a ramshackle farmhouse on Long Island, where Pollock soon abandoned easel painting in favor of mural-size canvases laid on the studio floor. Moving his body around and inside the picture space, he employed sticks, hardened brushes, and paint cans to drip, fling, and pour pigments into dense, weblike energy fields. Pollock's drip painting technique obliterated the illusionistic, hierarchical distinction between figure and

background. As we scan paintings such as Number 1 (Lavender Mist) (fig. 8.20), particular linear strokes temporarily appear to coalesce into figures only to dissolve back into the ground once our attention shifts to another area of the picture field. Many art historians have compared Lavender Mist and similar works to the waterlily paintings of Claude Monet. But Pollock went further than the French Impressionist in collapsing any objective distance from nature, and once declared that he was nature. Widely publicized photographs of Pollock crucially documented the manner in which the artist's entire body was present in the energetic interlacings of paint (fig. 8.21). In Lavender Mist, he impressed numerous handprints into the wet pigment toward the top edge of the painting. The artist's handprints graphically demonstrate an active participation or immersion in nature's rich flux of fluid, dynamic forces. These physical signs recall the pre-Columbian handprint designs that Native Americans spray-painted on rocks or sculpted from thin mica sheets and other materials as symbols of creative potency (see fig. 1.8). Pollock's drip paintings also echo the ancient technique of Native American sandpainting. As practiced for centuries by Navajo Indian wise men in the American southwest, sandpainting was a ritualistic healing process that drew on the earth's ancestral spiritual powers. The artist wise man designed elaborate patterns by pouring dry, granular pigments onto

8.19 Lee Krasner

Composition, 1949. Oil on canvas, 38% × 271% in (96.6 × 70.5 cm). Philadelphia Museum of Art, Philadelphia, Pennsylvania. Gift of the Aaron E. Norman Fund, Inc.

Krasner's pictorial language of abstract signs is densely packed and impossible to decode in verbal terms. Her hieroglyphs have been compared to the Hebraic script that she had once studied as a child. From this Jewish perspective, her mysterious signs may be interpreted as indirect, subliminal meditations upon World War II and the Holocaust.

8.20 Jackson Pollock Lavender Mist (Number 1), 1950. Oil, enamel, and aluminum on canvas, 87 imes118 in (221 imes 299 cm). National Gallery of Art, Washington, D.C. Ailsa Mellon Bruce Fund.

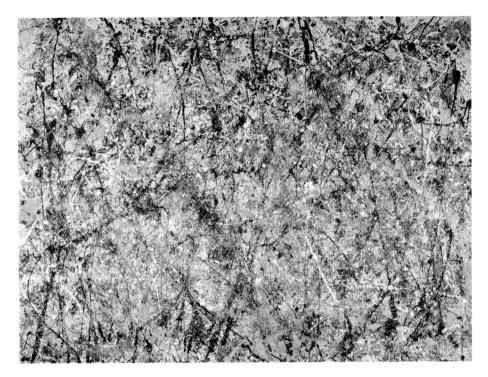

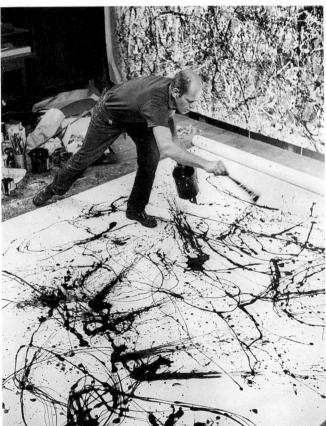

8.21 Hans Namuth Jackson Pollock at work. Pollock-Krasner House and Study Center, East Hampton, New York. © 1990 Estate of Hans Namuth.

the ground. A sick patient could then sit or lie within the painting to absorb nature's healing, harmonizing forces. These temporary works, which were destroyed immediately after the healing, suggested for Pollock the therapeutic importance of the artist's creative dialogue with paints and craft materials.

In 1952, the critic Harold Rosenberg (1906–78) coined the term "action painting" to characterize the work of Pollock and other Abstract Expressionists, who conceived the canvas as "an arena in which to act—rather than as a space in which to reproduce, re-design, analyze, or 'express' an object, actual or imagined" (cited in Chipp, p. 569). He argued that action painters had made the creative act inseparable from their own biographies or life experiences. Like many other postwar American intellectuals, this influential critic borrowed ideas from the contemporary French thinker Jean-Paul Sartre, whose Existentialist philosophy taught that human values and meanings do not derive from some preexisting deity or universal essence. Rather, meaning is created only through daily existence and the subjective choices and actions individuals take in a harsh, unsympathetic world.

Far from asserting an egoistic control over nature's forces, Pollock's performances in the drip technique seemed to open his body and mind to the new experiential possibilities offered by the canvas. However, his openness to nature did not mean that he lacked control or that his unconscious took over in an act of pure automatism. Insisting that there were no accidents in his work, Pollock composed paintings that possess linear delicacy as well as an overall unity of tone and color. In *Lavender Mist*, he did not create a shimmering, unitary color effect by using lavender pigment. Instead, he carefully interwove aluminum- and salmon-colored paints. Pollock suggested in a 1951 radio interview that his paintings were not simply private, individualistic expressions: they alluded to the modern age of airplanes, radio, and the atomic bomb. The art historian Serge Guibault contends that two of Pollock's earliest drip paintings from 1946 actually referred to the apocalyptic destructiveness of the atomic bomb, which the United States, in August of 1945, had twice devastatingly used in Hiroshima and Nagasaki, Japan.

The haunting specter of nuclear annihilation had intensified by the late 1940s as the United States and the Soviet Union began to wage a Cold War that soon divided the world into competing spheres of influence. The ideological and imperial rivalry between the two powers stopped just short of "hot," military conflict. Nonetheless, U.S. government officials ominously raised the possibility of again resorting to atomic weapons to prevent the spread of communism in Europe and Asia. The Soviet Union's first test explosion of an atomic bomb in 1949 particularly spurred President Harry Truman's decision to develop the even deadlier hydrogen bomb.

For most Abstract Expressionists, the catastrophic tragedy of contemporary history, especially the revelation of the Nazi concentration camps and the devastation of Hiroshima and Nagasaki, defied description or representation. Realistic narratives of these horrific events seemed unacceptably finite or limited. According to the painter Barnett Newman, modern painters and sculptors, like primitive artists, required abstract forms of thought and feeling to confront the chaos of existence. Rather than empathy for natural, organic forms, Newman came to believe that a hostile world environment demanded geometric abstraction. Rectilinear, geometric forms symbolized the human power to think and to spiritually transcend the terrifying, unconscious flux of nature. Nonetheless, Newman equally abhorred the celebratory machine aesthetic. A political anarchist, he developed an austere, elemental style that expressed his alienation from contemporary culture and his

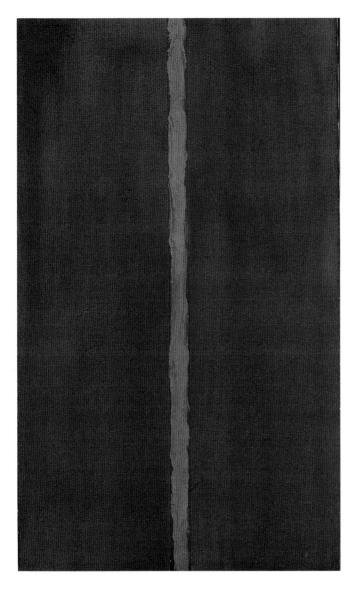

8.22 Barnett Newman Onement I, 1948. Oil on canvas, $27\% \times 16\%$ in $(69.2 \times 41.2 \text{ cm})$. Museum of Modern Art, New York City. Gift of Annalee Newman.

This painting's bilateral symmetry signifies perfect oneness with God. Although Newman had experimented with Surrealist automatism during the early 1940s, he was more interested in expressing cosmic themes of creation than exploring his individual psyche.

assertion of absolute artistic freedom against totalitarianism, capitalist greed, and consumerism. In 1948, Newman began his trademark series of "zip" paintings that equated straight, vertical stripes or zips with the Creator's original act of bringing order from chaos. Newman's Onement I (fig. 8.22) alludes to the Jewish book of Genesis and God's primordial separation of light from darkness. With its russet colors, the painting further symbolizes the creation of the earth and of Adam, the first man, from mere clay. According to cabalistic or Jewish mystical thought, the concept of onement also encompassed Eve, the first woman. The perfection of creation was conceived as a unification of opposites, such as male-female and light-dark.

Newman found spiritual strength in his own Jewish heritage. In addition to the book of Genesis, Onement I metaphorically refers to the sacred Jewish festival of Yom Kippur, or Day of Atonement, which celebrates the cleansing, healing act of forgiveness and becoming one with God. In his later zip paintings, Newman increased their scale to mural size so that viewers would feel themselves absorbed by the luminous, spiritualized color fields.

Closely associated with Newman's meditative, religious imagery, Mark Rothko, by the late 1940s, was also creating simplified color fields and abstract forms that appeared more universal in mythic, spiritual content than his earlier figurative paintings (see fig. 8.13). His mature paintings from the late 1940s and early 1950s were variations on a large, compositional format of vertically stacked, cloud-like, rectangular blocks and blurred, horizontal color bands. In Green and

Maroon (fig. 8.23), the large areas of dark forest green and maroon seem to float over a blue ground to create a quiet space for meditation and reflection. Rothko wrote that he painted very large pictures not as grandiose statements but as intimate environments into which beholders could enter for private contemplation. Although stylistically different from the energetic color fields of Pollock, Rothko's far more thinly painted canvases were also performances in which the fluid development of tone, color, and form could not be fully anticipated or plotted out in advance. The somber, irregularly toned colors and hazy forms of Green and Maroon create a mysterious atmosphere that expresses Rothko's obsession with mortality and the tragic fate of humanity.

Far from transcending the vulgarity of American commercialism or rejecting the figurative tradition in art, the Dutch-born New York action painter Willem de Kooning (1904–97) created vigorous Abstract Expressionist works that were primarily inspired by the female figure. Yet, in a long series of Woman paintings, de

Kooning expressed the Cold War mood of anxiety and crisis by violently attacking the fleshy, big-breasted figures with slashing, razor-sharp brushstrokes composed of strongly contrasting, clashing pigments (see p. 328). The artist employed brushes and a traditional easel rather than dripping or pouring paint onto the canvascovered studio floor. Yet, like Pollock, he also seemed to regard the picture space as an arena for action and perpetual self-expression. Rejecting the finished look of perfection, de Kooning created nervous, spontaneous compositions that appear unpremeditated or open to change and revision.

De Kooning's inspiration for Women came from prehistoric sculptures of fertility goddesses and the toothy smiles of modern, commercial sex goddesses. His frightening women lack the natural beauty of traditional academic art. The figure in Woman I glares from the web of thick brushstrokes, embodying a nature that refuses to comfort or nurture beholders. At the same time, Elaine de Kooning (1918-89), Willem's fellow artist and spouse, was painting a parallel series of defaced or faceless portraits of men fragmented and absorbed into the tense, gestural brushwork (fig. 8.24). While Willem's female figures seem aggressively threatening, Elaine's eyeless, vulnerable men lack identity or any power to return our gaze.

8.23 Mark Rothko Green and Maroon, 1953. Oil on canvas, $91\frac{1}{4} \times 54\frac{3}{4}$ in (231.8 × 139.1 cm). The Phillips Collection, Washington, D.C.

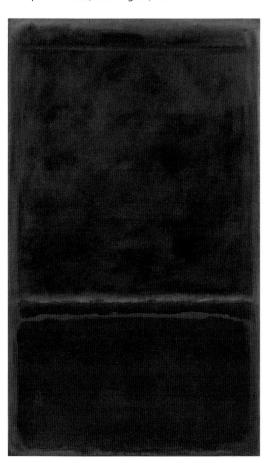

8.24 Elaine de Kooning Conrad, 1950. Oil on canvas, 58×34 in (147.3 \times 86.4 cm). Courtesy of the Elaine de Kooning Estate. Photograph courtesy Salander-O'Reilly Gallery, New York.

Elaine de Kooning explained that even from a distance, when faces cannot be clearly seen, familiar figures can still be identified by the nature of their physical build, movements, and characteristic presence. The bodily presence here is made evident in the painting's spontaneous, gestural brushwork.

The Masculine Bias of Abstract Expressionism

Women artists had considerable difficulty in gaining recognition as Abstract Expressionists. The movement tended to be defined in heroic, hypermasculine terms. Harold Rosenberg compared these American avant-garde painters to the character of Ishmael in Herman Melville's great American novel Moby Dick (1851). Like the young hero who joined the adventurous quest for a great white whale, Rosenberg's action painters daringly launched themselves on a vast sea of white canvas to prove their mettle in creating pioneering, original art works. As a disciple of Willem de Kooning, the artist Franz Kline (1910-62) created large blackand-white action paintings from thick, rough slabs of pigment applied with a house painter's broad brush. Later, the second-generation Abstract Expressionist Mark di Suvero (b.1933) adapted Kline's masculine, physical style to construct rugged, dynamic sculptures of found wooden beams and steel chains (fig. 8.25). With its manly title, thick lumber, and monumental forms suggesting heroic struggle, Hankchampion derives not only from di Suvero's earlier career as a carpenter: it also seems connected to his immigrant Italian father's labor in a San Francisco shipvard.

In contrast to di Suvero's early success, Louise Nevelson (1899-1988) had to wait until her sixties to receive recognition for her Surrealist-influenced assemblages. Like Joseph Cornell, the Russian-born Nevelson collected found objects in small wooden boxes. Working exclusively with pieces of wooden junk, she painted all the

8.25 Mark di Suvero Hankchampion, 1960. Wood (nine pieces) and chains, 6 ft 5% in \times 12 ft 5 in \times 8 ft 9 in $(1.97 \times 3.79 \times .67 \text{ m}).$ Whitney Museum of American Art, New York. Gift of Mr. and Mrs. Robert Scull.

8.26 Louise Nevelson *Sky Cathedral,* 1958. Wood, 135 in (342.9 cm) high. Museum of Modern Art, New York. Gift of Mr. and Mrs. Ben Mildwoff.

Each modular unit is filled with wooden bric-à-brac, such as rolling pins, furniture remnants, and even toilet seats. By carefully painting, housing, and stacking these found pieces of debris, she assembled modern monuments that magically transformed the ordinary into an extraordinary experience of personal memory and meaning.

8.27 David Smith The Hero, 1952. Steel, 6 ft $1\frac{11}{6}$ in \times 2 ft $1\frac{11}{6}$ in \times 11 $\frac{11}{4}$ in (1.87 \times .64 \times 2.98 m). Brooklyn Museum of Art, New York. Dick S. Ramsay Fund.

boxes and objects in black or some other unifying color such as gold or white. She then stacked the boxes together to create large, grid-like wall reliefs that enveloped beholders within a mysterious, spiritual space, as suggested by the title of a key work, *Sky Cathedral* (fig. 8.26).

Most Abstract Expressionist sculptors experimented with welding techniques, which associated their constructions with the gritty world of working-class men. During the same period as Elaine de Kooning's portraits of faceless men, the sculptor David Smith (1906-65), a former auto worker, represented himself as a blinded hero, who becomes the receptive object of the beholder's gaze (fig. 8.27). Steeped in the literature of ancient mythology and psychoanalytic theory, Smith believed that the modern artist was a heroic seer, who helped others to see and understand themselves. Yet in representing the image of himself as a blind, faceless man, he makes it clear that the material image doesn't dictate our vision. The artist represents himself as a mere object, which cannot lead or act as a moral guide for others. As the art historian Ann Gibson has argued, Smith's self-image ultimately deflects the power of sight and decision-making back toward the viewer. Adhering to libertarian, existentialist principles, Smith created oracular, enigmatic sculptures of welded steel that remain open to beholders' interpretations. In exercising their moral, critical faculties, viewers act heroically and help to create a world of free individuals opposed to totalitarianism and capitalist consumerism. For Smith, whose industrial welding knowledge was derived from working-class experience, individual freedom could only occur within a truly egalitarian socialist society.

Abstract Expressionism and Right-wing Attacks on Modernist Art

While Abstract Expressionist artists were gaining press notoriety, Midwestern Congressman George A. Dondero expressed the views of many American conservatives when he denounced Modernist art as a foreign conspiracy to support the communist overthrow of American capitalism. In an August 16, 1949, speech in the House of Representatives, Dondero listed Pablo Picasso, Marcel Duchamp, and several other European Modernists as dangerous subversives. He also named four American Abstract Expressionists as participants in the communist conspiracy, including Robert Motherwell and Jackson Pollock. The same year that Dondero delivered his public attack on Modernist art, the Paris-born American Surrealist Louise Bourgeois (b.1911) was called to testify before the House Un-American Activities Committee, which was investigating communist influence in the arts and Hollywood movie industry. In response, Bourgeois entitled a series of wooden sculptures The Blind Leading the Blind (fig. 8.29), after Christ's biblical characterization of his vain and blindly ignorant opponents (Matthew 15:14). The sculpture was originally constructed to represent her loneliness in America. But the artist's pointedly chosen title transformed the image of headless, regimented figures into a critical satire of right-wing American demagogues and inquisitors who wished to suppress freedom of expression.

Dondero's 1949 speech established a pattern of conservative criticism that linked Modernist artists with communist subversion. Anti-communist denunciations of Pollock and Motherwell were repeated by other congressmen during the 1950s, even after Dondero's retirement and Pollock's death in a car crash in 1956. Congressional attacks on Modernist art were quoted almost verbatim by agents for the Federal Bureau of Investigation (FBI), who kept extensive files on numerous

> European and American artists suspected of communist or other left-wing affiliations. These suspicions of subversion were supported by the aesthetic judgments of politically conservative art critics. American liberals, meanwhile, ignored the socialist and radical libertarian views of Pollock, Rothko, Motherwell, and others and embraced Modernist, Abstract Expressionist art as a nationalist expression of American freedom in the face of Soviet communist totalitarianism. Working through the Museum of Modern Art and a Paris-based organization called the Congress for Cultural Freedom, the U.S. Central Intelligence Agency (CIA) adopted this liberal interpretation of Abstract Expressionism and avidly promoted New York art in international exhibitions as a symbol of individual liberty. Nevertheless, during the late 1940s and 1950s, right-wing conservatives succeeded in canceling several government-sponsored exhibitions of modern art scheduled to travel abroad.

> Of all the painters associated with Abstract Expressionism, Ad Reinhardt (1913-67) was the

8.28 Ad Reinhardt Abstract Painting No. 5, 1962. Oil on canvas, 5 ft \times 5 ft $(1.5 \times 1.5 \text{ m})$. Tate Gallery, London.

Despite his harsh criticism of Barnett Newman, Reinhardt himself couldn't resist philosophizing about his art and the relation of blackness to the mysterious, nonassertive mysticism of Chinese Taoism as taught by the sixthcentury-B.C.E. philosopher Lao-Tzu. Reinhardt's square, black paintings are never entirely blank or even black. Cross shapes often optically emerge from overlapping tonal bands, which reveal blue, red, green, or other blackened layers of colored underpainting.

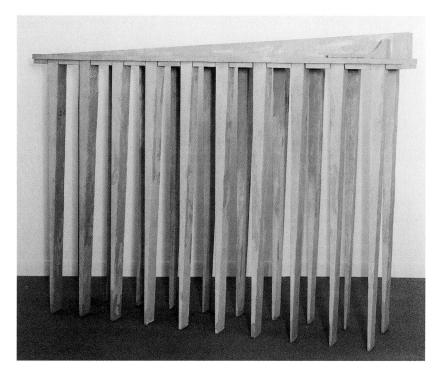

most politically active. Next to Picasso and the Social Realist Ben Shahn (see fig. 8.2), Reinhardt had the largest FBI surveillance file (123 pages) of any modern artist. Having been a member of the American Communist Party and active in many causes to advance civil rights, peace, and labor unions, Reinhardt, nevertheless, rejected explicitly political art works as compromising free expression. During the 1950s and 1960s, influenced by oriental Buddhist art, he painted a series of blackon-black, square paintings that asserted an absolute negation of the external world and of moralizing, propagandistic messages (fig. 8.28).

Though these black-square paintings bear similarity to Newman's and Rothko's more somber color field paintings, Reinhardt rejected the Abstract Expressionist tendency to attribute philosophical, spiritual content to the art object. He particularly ridiculed Newman for emphasizing the intellectual content of art over its physical presence. The cultural critic Susan Sontag later wrote in a 1964 essay:

In most modern instances, interpretation amounts to the philistine refusal to leave the work of art alone. Real art has the capacity to make us nervous. By reducing the work of art to its content and then interpreting that, one tames the work of art. Interpretation makes art manageable, conformable. (p. 8)

For Reinhardt and Sontag, interpretation also made art more marketable, more subject to the world of fashion and mass-media entertainment. Thus, popular magazines such as Life and Time quoted artists' statements and critics' explanations of Abstract Expressionism within articles that essentially trivialized the actual art works as faddish commodities and transformed artists into media celebrities. Called "Jack the Dripper" by a reporter for *Life*, Pollock especially was compared to movie stars such as Marlon Brando and James Dean, whose film roles portrayed existential social rebels against middle-class values and conventions.

8.29 Louise Bourgeois The Blind Leading the Blind, c. 1947-49. Painted wood, 70% imes 96% imes 17% in (178.7 imes 246.1×44.1 cm). Hirshhorn Museum and Sculpture Garden, Smithsonian Institution, Washington, D.C. Regents Collection Acquisition Program with Matching Funds from the Jerome L. Green, Agnes Gund, Sydney and Frances Lewis, and Leonard C. Yaseen Purchase Fund, 1989.

Like Louise Nevelson, Bourgeois sought to create sculptures in relation to real space. These two wooden rows of figures are without pedestals and appear actively to occupy the room in which they march or stand in place. Despite her work's implicit affirmation of individual creative freedom, Bourgeois' fragile, anti-heroic sculptures were often coolly received by a male-dominated New York avant-garde that favored the grand heroic gesture.

Formalist Criticism and the Objectivity of Abstract Art

Meanwhile, "high-brow" critics such as Clement Greenberg (1909–94) engaged in detailed formal analyses of Abstract Expressionist paintings and sculptures. These critiques interpreted the objects as art for art's sake rather than as acts that merged art and life. Making the works palatable to wealthy American art patrons and museum directors. Greenberg's formalist interpretations examined how individual artists worked within the inherent logic of the flat, two-dimensional painting medium or, alternatively, the sculptural realm of three-dimensional space and mass. Greenberg opposed expressionist content, which he associated with the chaos of life. Instead, he praised those Abstract Expressionist painters who most distilled and disciplined anarchic life forces by rigorously subordinating them to the aesthetic unity of the picture surface. He tended to ignore artists' philosophical intentions or the literary, mythological associations that many of them alluded to in their art. Instead, he wished to establish a set of rational, objective criteria for making aesthetic judgments. As an editor from 1945 to 1957 for Commentary, a New York journal of conservative thought, Greenberg defended congressional tactics in hunting down communists and communist sympathizers. Meanwhile, ignoring the leftist political sympathies of most Abstract Expressionists, he claimed that the images they produced were apolitical and free of subversive ideological content. As a critic, he normalized and aesthetically canonized their works by situating them within the stylistic, historical evolution of Modernist art. He argued that Abstract Expressionists were fulfilling the formalist goals of earlier Modernist painters such as Cézanne and Picasso, whose abstract pictures had dramatically furthered the inevitable progression toward the two-dimensionality of pure painting. For Greenberg, the flatness of paintings by Rothko, Pollock, and Newman seemed much newer or more stylistically advanced than the figurative imagery and expressionistic savagery of Willem de Kooning's Woman series.

Greenberg's formalist criticism greatly influenced the next generation of Abstract Expressionist painters. During the early 1950s, the critic befriended Helen Frankenthaler (b.1928), a recent graduate of Bennington College in Vermont and the daughter of a New York Supreme Court Justice. Greenberg introduced Frankenthaler to members of the Abstract Expressionist group and accompanied her to Pollock's studio in Long Island, where she became excited by the older artist's technique of dancing around and inside his drip paintings.

In 1952, Frankenthaler executed a large, nature-inspired work, Mountains and Sea (fig. 8.30), that satisfied Greenberg's insistence that painters frankly acknowledge the two-dimensional nature of their medium. The artist's seminal picture affirmed an inherent flatness. Its diaphanous, transparent forms are non-sculptural. Virtually intangible washes of color appeal to purely optical sensations rather than the sense of touch or imagined grasp of three-dimensional objects. Frankenthaler created thin veils of lyrical colors by soaking or staining the unprimed canvas with highly diluted oil pigments. Her technique fused the gestural image with the twodimensional canvas, leaving its weave entirely visible through the washes of paint. Despite Frankenthaler's adaptation of Pollock's spontaneous method, Harold Rosenberg refused to recognize her as an action painter. In contrast to Greenberg, his primary rival in the world of Modernist criticism, he emphasized energetic expressionist content and found it lacking in Frankenthaler's pictures. To Rosenberg, the artist's work seemed more passive than willfully active, more content to allow the poured pigments to flow of their own accord. Yet Frankenthaler

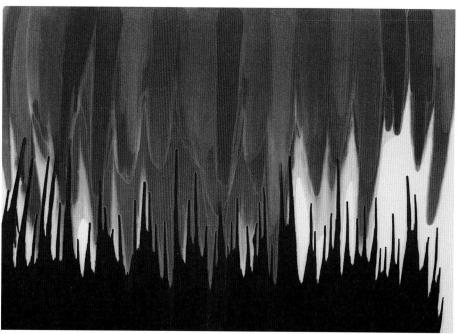

8.30 (top) Helen Frankenthaler Mountains and Sea, 1952. Oil on canvas, 86% × 117% in (2.2 × 2.98 m). Collection of the artist, on loan to the National Gallery of Art, Washington, D.C.

8.31 Morris Louis Ambi II, 1959. Acrylic on canvas, 98×142 in (248.9 \times 360.7 cm). National Gallery of Art, Washington, D.C. The Nancy Lee and Perry Bass Fund.

Rather than employing a brush, Louis often used a stick to guide the gravitational flow of pigments or folded and pleated the canvas to create rivulets of paint. 8.32 Robert Rauschenberg Bed, 1955. Combine painting: oil and pencil on pillow, quilt, and sheet on wood supports, $75\% \times 31\% \times 8$ in (191.1 \times 80 \times 20.3 cm). Museum of Modern Art, New York. Gift of Leo Castelli.

Rauschenberg's spontaneous pairings of objects lack programmatic coherence or fixed meanings. His combine paintings compare with the prose of William Burroughs, whose Naked Lunch (1959) captured the immediacy of experience without a continuous storyline.

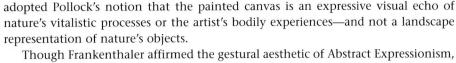

her staining technique influenced a group of abstract, color field painters, who turned away from spontaneous, expressionist content toward a formalist preoccupation with the painting medium. In 1953, Greenberg brought Morris Louis (1912–62), a young Washington, D.C., painter, to Frankenthaler's New York studio. Louis's admiration for the unabashedly beautiful and harmonic optical forms of Mountains and Sea led him to adopt a staining or pouring technique. Employing liquid acrylics, a new, synthetic, water-based medium, Louis eliminated all brushwork and individualistic handwriting. He created large works that were more decorative than expressive. Louis's Ambi II (fig. 8.31) derives its optical illusion of deep space from the contrast between the lower foreground's flow of dark pigments and the more colorful red, orange, blue, and green tones that gush upward from a foun-

> tain of reds in the background. Yet the woven texture of the unprimed canvas is visible throughout and even fully exposed in areas to affirm the painting medium's essential flatness. Together with Kenneth Noland (b.1924) and other colorists, Louis directed abstract painting away from expressionism toward formalist experimentation with color's optical effects.

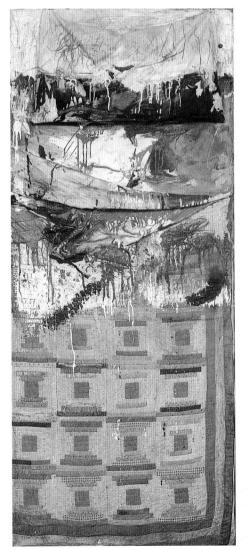

The Return of Dadaist Dissent: Happenings, Performances, and Readymade Assemblages

During the 1950s and 1960s, artists reacted against both the heroic individualism of Abstract Expressionism and Modernist formalism. The Texas-born artist Robert Rauschenberg (b.1925) particularly dissented from the psychological emotionalism and introspective philosophizing of the older generation. During the late 1940s, while a student at the experimental Black Mountain College near Asheville, North Carolina, he befriended the avant-garde composer John Cage (1912-92), who taught students a Zen Buddhist openness toward their immediate surroundings. Stemming from the Dadaist tradition, Cage's musical compositions incorporated accidental noises, long silences, and sounds not normally associated with music. In 1951, Rauschenberg finished White Painting, a series of plain white panels, which served as a stage backdrop for Cage's Theater Piece #1 (1952), performed at Black Mountain College, a prototype of the "happenings" that became popular during the late 1950s and 1960s. Lacking any fixed structure, Cage's "event" invited poets, dancers, musicians, and artists to engage in parallel but unrelated activities, thereby evading a rational sequence of cause-and-effect actions. Rauschenberg himself played phonograph records, while the musician David Tudor (1926-96) played a piano. Charles Olson (1910-70) recited poetry and the dancer Merce Cunningham

(b.1919), chased by a barking dog, moved around members of the audience. Unlike Ad Reinhardt's non-referential black paintings (see fig. 8.28), the blank, visual silence of Rauschenberg's *White Painting* was equivalent to Cage's musical pieces, in which environmental, non-art noises and sounds constitute found music. The painting's white panels passively reflect randomly passing shadows of figures and objects moving in front of them. Cage described these panels as "airports" or runways for various lights, shadows, and particles.

As defined by the artist Allan Kaprow (b.1927), who was much influenced both by Cage and by Pollock's painting performances, happenings were an open-ended assemblage of theatrical events with no clear beginning, middle, or ending. Orchestrators of happenings rejected formalist art and the notion of art as a discrete object made by a lonely, creative genius. They purposely mingled art and life in transient, unpredictable fashion. Sometimes transforming viewers into participants, happenings were generally scripted but open to improvisational gestures and unplanned human interactions. The objective was to affirm the spontaneity of experience and to challenge conventional middle-class behavior and social inhibitions (fig. 8.33). Happenings emerged from an anti-conformist counterculture that included San Francisco and Greenwich Village Beat poets and writers such as Allen Ginsberg and Jack Kerouac. Beat poetry readings were relatively spontaneous vocal perform-

ances that paralleled the theatrical environments of Rauschenberg, Kaprow, and other visual artists. Happenings could be performed in the streets as well as in art galleries and studios. According to Kaprow, such events ought not be performed more than once, since repetition was boring and detrimental to originality and aesthetic immediacy. Nevertheless, photographs of these ephemeral occurrences became important for documenting the creativity of artist-directors and for preserving images of happenings as collectible art objects. Happenings evolved into the more controlled and focused realm of performance art, in which the artist's own body became the medium. Whether directly performed before an audience or not, the action was generally recorded with film, video, or still photography. Inspired by a 1963 retrospective of Marcel Duchamp's paintings and readymades in Pasadena, California, Bruce Nauman (b.1941) paid homage to the French Dadaist's infamous Fountain (see fig. 7.28) by representing himself as a living fountain spitting a stream of water into the air (fig. 8.34). His Self-portrait as a Fountain was one of several works in which he used his own body as a readymade medium.

Besides participating in happenings and performances, Rauschenberg became an energetic assembler of found objects and materials. Calling his assemblages "combine" paintings, the artist parodied the art of Abstract Expressionism in *Bed* (fig. 8.32), which incorporated the pillow, quilt, and sheet from his own bed as support for Pollock-like drips of paint, striped toothpaste, and fingernail polish. Rauschenberg's *Bed* humorously alludes to action painters' desire to get inside and move around within their canvases. Whereas Abstract Expressionists wished to plumb the depths of their unconscious being, Rauschenberg literalized their psy-

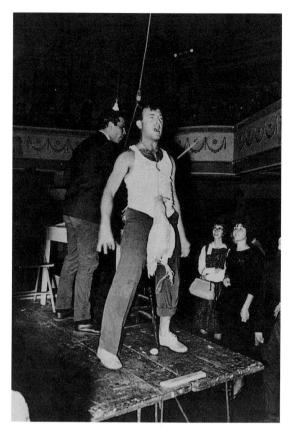

8.33 Allan Kaprow *Chicken,* 1962. Photograph by Edwin Sobol.

This photograph represents the performance of "Chicken man," who displays a dead chicken dangling from his neck and crows like a rooster. Suggesting a confusion of gender roles, he triumphantly stands over a chicken egg. In an anthology documenting his Happenings, Kaprow offered no explanation for the bizarre scene but did provide additional photographs of Chicken's anarchic scenario of events, including a group of rioters overturning a cage and a policeman spraying a gas canister.

8.34 Bruce Nauman Self-portrait as a Fountain, 1966. Photograph, 20 $\%6 \times$ $23^{1}\%$ in (51 × 60.8 cm). Whitney Museum of American Art, New York. Purchase.

Nauman's witty performance actually reverses the implied ejaculatory content of Duchamp's Fountain. The French Dadaist's arid, inert object was originally fabricated as a passive receptacle for urine. In contrast, the youthful, barechested Nauman spits forth a sparkling, clear stream of water, suggesting creative energy rather than bodily waste.

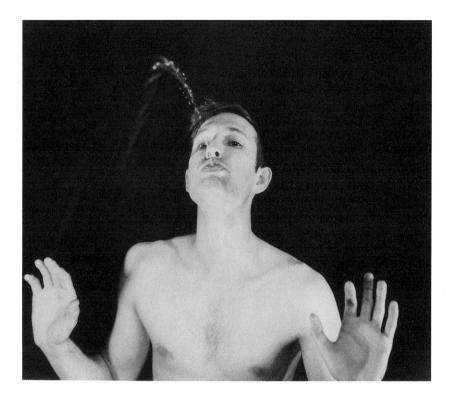

choanalytical, personal obsessions by using his own bedding materials within which he had slept, dreamt, and presumably had sexual experiences. Indeed, the artist's messy rivulets of pigment conjure forth associations with semen spilled during erotic fantasies, thereby parodying the expressionist notion of art as a creative force that emerges volcanically from within the bodily self.

Readymade Signs, Minimalist Objects, and Real Space

Rauschenberg developed a close friendship with Jasper Johns (b.1930), who had arrived in New York in 1952 from South Carolina. After meeting Rauschenberg and Cage in 1954, Johns soon began creating collages and assemblages that also subverted the traditions of expressionist and formalist art. Inspired by Duchampian Dadaism, he chose to work with readymade signs that could be found in everyday material culture. These included targets, American flags, and printed maps of the United States. Being inherently flat, these signs ironically satisfied the strictures of Greenbergian formalism, which demanded that paintings affirm the flat picture plane. Yet Johns's series of flags and targets (see fig. 8.36) so closely imitated the real objects or signs that they made nonsensical any formal, stylistic analysis or psychological interpretation of the artist. Johns's target paintings particularly inspired the painters Kenneth Noland and Frank Stella (b.1936), whose starkly simplified canvases contributed to the Minimalist art movement of the 1960s. Minimalism emphasized art as a physical object and suppressed internal, formal relationships. By altering the shapes and eliminating the frames of paintings, Stella accentuated their identity as non-referential objects that do not mirror external reality or interior, psychological content. Thus, the internal pattern of symmetrical lines within

his *Pagosa Springs* (fig. 8.35) repeats the H-shape of the canvas as a whole. A single horizontal axis between the copper bands of paint extends across the entire length of the picture, dividing it into two equal halves, each merely the mirror reflection of the other. Although the arbitrary title may suggest a landscape, Stella's painting does not provide an illusionistic window onto another, absent reality. By refusing to represent external, distant realities, Minimalist painters hoped to stimulate the beholder's immediate experience of the art object's physical presence.

Though scarcely minimal in its assemblage of diverse material and images, Johns's Target with Plaster Casts (fig. 8.36) invites beholders to focus on the essentially flat but relatively lumpy surface of the painting. Accentuating its material physicality, he employed encaustic paints, a thick, wax-based medium, which he laid over a collage of newspapers. Atop this mute, inexpressive surface, he attached a row of small, lidded boxes. When opened, the boxes reveal painted plaster casts of such body parts as an eyeless face, a flat, nippled breast, and a penis luridly covered with green paint. Unlike Joseph Cornell's or Louise Nevelson's boxes (see figs. 8.15 and 8.26), which are filled with found objects that evoke personal associations, Johns's plaster body parts possess an emotionally cool, almost clinical impersonality, reinforced by the inert, banal surface of the target below. The bull's-eye image is a passive receptor for arrows, bullets, and darts. As a work of art, its traditionally feminine, circular forms invite the phallic, penetrating gaze of a beholder. Yet the newspaper print, legible just below the thick coat of paint, yields no intelligible meaning. The open boxes, with their otherwise hidden, private content, literalize and thus parody the psychic depth of Abstract Expressionist art. Considered from the perspective of Johns's homosexuality, Target with Plaster Casts may bear some comparison with Marsden Hartley's emblem- and sign-filled Portrait of a German Officer, which memorialized the painter's deceased lover (see fig. 7.25). However, Hartley's highly personal numbers, letters, badges, and epaulets help to create an emotional, deeply contemplative space that differs markedly from Johns's

8.35 Frank Stella
Pagosa Springs, 1960. Copper
metallic enamel and pencil
on canvas, 99% × 99% in
(252.4 × 252 cm). Hirshhorn
Museum and Sculpture
Garden, Smithsonian
Institution, Washington, D.C.
Gift of Joseph H. Hirshhorn,
1972.

unromantic, anti-expressionist assemblage of signs and anatomy. With its secretive placement of anonymous sexual organs and body parts, Target with Plaster Casts may be interpreted as an implicit if unintentional critique of the sexually repressive and conformist atmosphere of the 1950s, when homosexuals were routinely targeted or hounded out of jobs and positions of public trust. It would not be until the gay and lesbian liberation movement of the 1960s and 1970s that homosexuals would begin to emerge from closeted, hidden spaces.

Johns's restraint markedly contrasts with a later, rather ebullient parody of Abstract Expressionism by the sculptor Robert Morris (b.1931), whose small I-Box, when opened, revealed a photograph of the grinning heterosexual artist standing proudly naked behind a large I-shaped door (fig. 8.37). The first-person-singular pronoun directly connects with the heroic presence of the individual, male creator. Though far smaller than most Minimalist sculptures and more complex in its humorous, parodic content, Morris's I-Box expresses the Minimalists' aesthetic opposition to the dramatically gestural sculptures of Mark di Suvero and other Abstract Expressionists (see fig. 8.25).

8.36 (top) Jasper Johns Target with Plaster Casts, 1955. Collection David Geffen, Courtesy of the Leo Castelli Gallery, New York.

The sexual, homoerotic imagery of this early Johns work was later repeated in Painting with Two Balls (1960), in which two small, sexually suggestive, plastercast balls insinuate themselves within a fissure dividing the lushly painted canvas. Unlike those of the Minimalists, Johns's paint surfaces possess a handcrafted sensual richness descended from Abstract Expressionism.

8.37 Robert Morris I-Box (open), 1962. Mixed media, approx. 12×18 in $(30.4 \times 45.7 \text{ cm})$. Leo Castelli Gallery, New York.

8.38 Tony Smith

Die, 1962. Steel, edition of three, $6\times6\times6$ ft (1.83 \times 1.83 \times 1.83 m). Whitney Museum of American Art. Photograph by Ivan Dalla Tana.

Though industrially made without the intervention of the artist's hand or personal touch, this sculpture's dark cube shape, human scale, and poetic title were designed to evoke private, emotional feelings. Smith appropriated Barnett Newman's notion of a holistic image or a form seen at a glance as a single, indivisible whole.

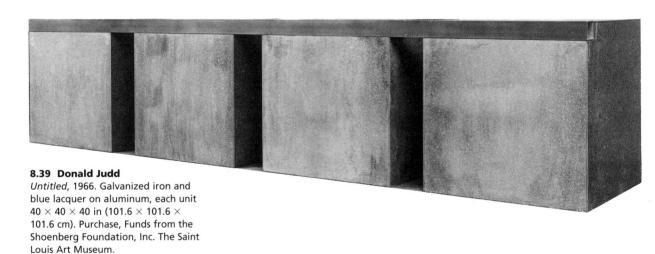

8.40 Carl Andre

Steel Magnesium Plain, New York, 1969. Steel and magnesium, 36 units, 12×12 in (30.5×30.5 cm). Private collection, Switzerland. Photograph courtesy Paula Cooper Gallery.

Andre's art was influenced by his sympathy with leftist politics. He argued that horizontal sculptures running across the ground signified a political engagement with lived space and the real world.

Minimalist sculptors such as Tony Smith (1912-81) and Donald Judd (1928-94) created large-scale, industrially crafted boxes that confronted viewers as literal, physical objects rather than referring to some fictive, illusionistic truth (figs. 8.38–8.39). Smith credited the styleless sameness and artificial, but non-artistic, geometry of the New Jersey Turnpike for eventually inspiring his Minimalist sculptures. Many Minimalists rejected the painting medium entirely. No matter how empty or minimal-appearing, paintings were too pictorial or composed and, therefore, no substitute for the direct, immediate experience of real, three-dimensional space.

Greenbergian formalist critics objected that Minimalist artists had gone too far in the anti-art eradication of internal formal relationships and the aesthetic distance between object and beholder. Meanwhile, defenders of the movement argued that it represented a new realism and artistic engagement with real space and materials. Sculptors like Judd stressed the literalness rather than the formal expressiveness of objects, which were not handcrafted but industrially manufactured according to the artist's specifications. Yet some Minimalists, more interested in space than mass, created sculptures that were virtually invisible. Carl Andre (b.1935) designed floor pieces from metallic square plates, which could be walked on by people who did not realize they were in the middle of an art work (fig. 8.40). In their absolute flatness and inexpressiveness, Andre's "rugs" seem to squeeze out internal meanings or spiritual content. His floor pieces became aesthetically perceptible only for beholders who are actively looking for them. Their awareness of the art work enlivens the surrounding space, creating an interactive, immediate experience between the viewer's body and an art environment that seems virtually continuous with the fabric of everyday life. Minimalism contributed to the notion of sculpture as installation art. Andre's floor pieces, composed of individual, modular units, could be altered or rearranged to adapt to different sites or exhibition spaces.

Artists working with lighting techniques created installations that explored perception as a complex interplay between visual fact and illusion. During the mid-1960s, the Los Angeles artist Robert Irwin (b.1928) fashioned mirage-like environments of light and shadow. A 1969 installation features a luminous white acrylic disk attached to, but floating in front of, a white wall (fig. 8.41). Illuminated by four spotlights, the translucent, convex circle casts four circular shadows that overlap within a square wall space. The disk's frosted glassiness, divided by a horizontal silver bar, seems to dematerialize into the insubstantial shadows through subtle tonal variations. From an apparently minimal, circular object, Irwin creates a perceptually complex arrangement of lights and shadows that challenges the eye's ability to distinguish visual reality from reflected, illusionistic forms.

By the late 1960s, many artists ignored formal concerns to focus on the fluid processes and materials of art. Eva Hesse (1936-70), a German-born sculptor, exemplified Process art by rejecting the hard steel boxes of Donald Judd's industrial works to fabricate soft, malleable fiberglass, latex, and wire pieces that lack precise form (fig. 8.42). Hesse's rectangular or square wall panels appear to be a hybrid of painting and sculpture. Though blank and apparently non-representational, the luminous fiberglass and latex surfaces possess a malleable, skin-like translucency. Each box shape also has two long wire appendages that dangle limply on the floor. Unlike the gestural lines of an Abstract Expressionist sculpture, Hesse's loose wires have no fixed formal qualities that express an inner psychic center. She tended to regard the irregular, organic-appearing materials of her art works as parallel to her own physical being, particularly after she became mortally ill with brain cancer in 1969.

8.41 Robert Irwin *Untitled*, 1969. Acrylic paint on cast acrylic disk, and light. Disk 54 in (137.2 cm) in diameter. Hirshhorn Museum and Sculpture Garden, Smithsonian Institution, Washington, D.C. Joseph H. Hirshhorn Purchase Fund, 1986.

8.42 Eva Hesse Untitled, 1970. Fiberglass over wire mesh, latex overcloth and wire, 7 ft 6½ in × 12 ft 3½ in × 3 ft 6½ in (2.31 × 3.75 × 1.08 m) overall. Des Moines Art Center, lowa. Nathan Emory Coffin Collection. © Estate of Eve Hesse.

Process art or Postminimalism was an open, anti-formalist art that rejected the rigid, rectilinear forms of Minimalism. It was characterized as feminine, since softness and fluidity are stereotypically female attributes. Hesse's loose, hanging appendages and rubbery latex materials typified Postminimalists' irregular, scattered installations of diverse industrial and nonindustrial media.

Pop Art and the Culture of Mass Consumerism

If Minimalists and Process artists like Hesse stressed materials and real space, other artists reacted against Abstract Expressionism by returning to representational realist imagery appropriated from popular culture. The San Francisco artist Burgess Collins (b.1923), who simply identified himself as "Jess," had been a student of the Abstract Expressionist painter Clyfford Still (1904–80). However, Jess reacted against his teacher's disdain for the everyday imagery of mass culture. He adopted the Dadaist technique of appropriating found images to create works with subversive, sometimes homoerotic, content. Together with his partner, the poet Robert Duncan (1919–88), Jess opened a short-lived, non-commercial exhibition space in San Francisco that also became a venue for Beat poetry readings and other performances. In a series of collages from the 1950s, he took images from the popular newspaper comic strip Dick Tracy. He rearranged the hyper-masculine, detective-story narratives and the letters of the hero's name to create *Tricky Cad* (fig. 8.43), featuring unflattering variations on the Dick Tracy persona. Jess's chaotic reconfigurations subverted the conservatively moralizing, conformist messages normally pronounced by this all-American, crime-fighting hero. Jess began the eight Tricky Cad collages in 1954, shortly after the United States had first tested the hydrogen bomb. As a former nuclear scientist, the artist had worked on the secret Manhattan and Hanford projects, which had produced plutonium for the atomic bombs that had devastated Hiroshima and Nagasaki. By 1949, deeply disturbed by the terrible destructive force of nuclear technology, he had abandoned his science career. Jess's Tricky Cad series is an absurdist satire of America's Cold War faith in technology, rationalism, and absolute moral distinctions between good and evil. His attempt to confuse the law-and-order certitude

8.43 Burgess Collins ("Jess")

Tricky Cad—Case 1, 1954. Collage, $9\% \times 7\% \times \%$ in (24.1 x 19 x 1.1 cm). Odyssia Gallery, New York.

In Jess's nonsensical. reconfigured comic collages. confusion reigns as the legendary detective futilely searches for rational resolutions to life's chaotic, anarchic forces. The Tricky Cad series shares the nonconformist, energetic spirit of Beat poems such as Allen Ginsberg's Howl (1956).

of Dick Tracy as a symbol of American justice also probably alluded to Vice-President Richard Nixon. The future U.S. president had made his earlier congressional political career as an investigator and prosecutor of communist nuclear spies. However, in 1952, during his vice-presidential campaign, Nixon had become known as "Tricky Dick" after evading a scandal over misused political campaign funds.

Jess's *Tricky Cad* collages preceded the commercial advent of the 1960s Pop Art movement in the United States, but the term had already been coined in Great Britain. During the early 1950s, several London artists transformed the artifacts and mass-media imagery of American popular culture into critical, satirical art works. They were responding to a flood of American postwar exports of consumer goods, movies, magazines, comics, and advertising. British artists such as Richard Hamilton (b.1922) and Peter Blake (b.1932) contributed works to several highly publicized exhibitions, representing a materialist utopia of American media images and consumer goods.

The birth of Pop Art in the United States coincided with the maturation of mass-media advertising and the proliferation of television, a luxury that soon became a necessity for every American home. Exponentially multiplying the media and advertising images that barraged the public, television made Abstract Expressionist artists seem quaintly out of touch in their persistent evasion of mass culture's vulgar taint. In 1962, after New York's well-established Sidney Janis Gallery held a block-buster exhibition of the "New Realists," which promoted the new Pop Art movement, several Abstract Expressionist artists abandoned their association with the gallery in protest. Roy Lichtenstein (1923–97), who exhibited in the New Realists show and became a leading Pop artist, retaliated by parodying Abstract Expressionist action painting in a series of works that impersonally imitated their supposedly individualized brushstrokes. He used a commercial silkscreen-printing

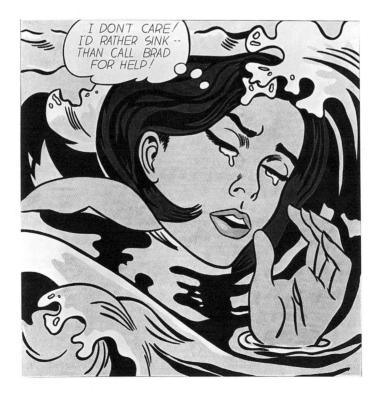

8.44 Roy Lichtenstein *Drowning Girl*, 1963. Oil and synthetic polymer paint on canvas, $67\% \times 66\%$ in (171.6 \times 169.5 cm). Museum of Modern Art, New York. Philip Johnson Fund and gift of Mr. and Mrs. Bagley Wright.

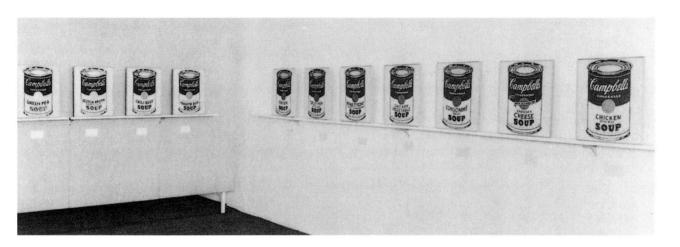

8.45 Andy Warhol Installation of Campbells Soup Cans, Ferus Gallery, Los Angeles, 1962. Each painting synthetic polymer on canvas, $20 \times 16 \text{ in } (50.8 \times 40.6 \text{ cm}).$

technique, squeezing paint through a stenciled screen to create the regularized, mechanical appearance of a comic-strip cartoon. During the early 1960s, Lichtenstein became famous for his silkscreened enlargements and croppings of single comic-strip panels. He rejected the mysterious, contemplative environments of Abstract Expressionism, arguing that the commercial terrain of media imagery now constituted the natural landscape experienced by most Americans. As a manmade, industrial form of nature, commercial art represented a fertile source of subjects for painters and sculptors in the fine arts. In a 1963 interview, Lichtenstein commented that "the meaning of my work is that it's industrial, it's what all the world will soon become. Europe will be the same way soon, so it won't be American; it will be universal" (cited in Stiles and Selz, p. 339). The artist admired the way that popular cartoonists had created a vivid, pictorial vocabulary adapted to the processes of industrial or mechanical reproduction. He borrowed the visual shorthand of commercial art to compose pictures unified by bold, simplified shapes and flat planes of strongly contrasting colors. Although he employed a mechanical technique, Lichtenstein purposely chose extremely violent or emotionally overwrought subjects from war comics or melodramatic romances (fig. 8.44). By presenting a single action frame, his pictures avoided the easy narrative resolutions and moral certitudes of the original comic sources, which generally affirmed the eventual triumph of good over evil or love over faithlessness.

In 1959, during his famous "kitchen debate" with the visiting Soviet leader Nikita Khrushchev, Vice-President Nixon argued capitalism's superiority over communism by pointing to the labor-saving, push-button conveniences of American household appliances. Shortly thereafter, Andy Warhol (1928–87) became the Pop Art personification for the consumerist world of mass-produced fast foods filling the cupboards and refrigerators of American kitchens. Though New York-based, Warhol, a former commercial artist, had his first major fine-art exhibition in 1962 in a Los Angeles art gallery. There he installed thirty-two paintings of individual Campbell's Soup cans (fig. 8.45). Ironically mimicking a grocery store shelf, the artist placed the paintings, each representing a different soup, on a narrow shelf encircling the gallery. Campbell's Soup, in business since 1897, had helped to pioneer the convenience-food industry with its simple cooking instruction to "just add water." Sporting a distinctive, bright red label, Campbell's Soup had become a familiar icon of American affluence. The company was a sponsor of family-oriented television shows, and its advertisements were designed to ensure that consumers

would associate the eye-catching product label with moral as well as nutritional wholesomeness. Warhol flattened the three-dimensional cans to subordinate their interior contents to the repetitive, uniform images of modern advertising and product design. Although he hand-painted the first series of Soup Cans, he soon switched to the silkscreen stencil process of comics and advertising. This process allowed him to reproduce Soup Cans, Coca-Cola Bottles, and other images hundreds of times, thereby imitating the assembly-line production techniques used in American factories. Explicitly rejecting the heroic individualism of Abstract Expressionism, Warhol called his own New York studio "The Factory," and here the artist and his assistants produced as many as eighty silkscreen paintings per day in addition to filming underground movies about New York's gay and drug subcultures. The Factory soon became a social and cultural mecca for drag queens, rock musicians, fashion designers, and radically chic socialites. Warhol became a celebrity and performance artist, whose sphinxlike presence attracted admiring patrons. He even replicated himself by hiring a look-alike to deliver lectures in his stead. For about four months during 1967, the deception fooled college audiences.

In an early 1963 interview for *Art News*, Warhol blithely dismissed patriotic, Cold War rhetoric that championed the myth of American individualism over the social conformism of Soviet communism. Citing the German playwright Bertolt Brecht (1898–1956), he observed with ironic, deadpan seriousness:

Someone said that Brecht wanted everybody to think alike. I want everybody to think alike. But Brecht wanted to do it through Communism, in a way. Russia is doing it under government. It's happening here all by itself without being under a strict government: so if it's working without trying, why can't it work without being Communist? Everybody looks alike and acts alike, and we're getting more and more that way.

I think everybody should be a machine. (cited in Stich, pp. 91–2)

8.46 Andy Warhol

Marilyn Monroe's Lips, 1962. Synthetic polymer, enamel, and pencil on canvas, panel A 82% × 80% in (210.1 × 205.1 cm), panel B 82% × 82% in (210.1 × 209.2 cm). Hirshhorn Museum and Sculpture Garden, Smithsonian Institution, Washington, D.C. Gift of Joseph H. Hirshhorn, 1972.

Warhol originally appropriated these lips by cropping them from a film publicity photograph for Marilyn Monroe's role in Niagara (1953). The toothy smile of the movie star recalls Willem de Kooning's Woman I (see page 328), which had also been inspired by popular culture. Warhol's Monroe series foreshadowed the launching of his own career as a director of more than fifty improvisational, underground films. Emulating Hollywood, he created stars out of New York drag queens, hustlers, and Greenwich Village eccentrics.

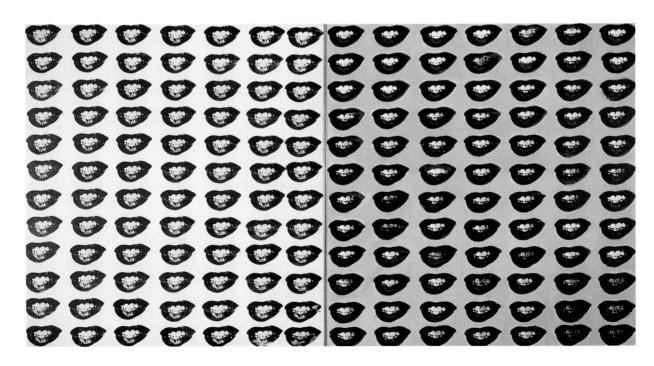

8.47 (top) Andy Warhol Orange Disaster, 1963. Acrylic and silkscreen enamel on canvas, 106 imes 81½ in (269.2 imes207 cm). Solomon R. Guggenheim Museum, New York. Gift of Harry N. Abrams Family Collection, 1974.

The lifelessness of the death chamber takes on an eerie quality due to Warhol's orange tinting of the grainy black-andwhite photograph. A sign at the upper right calls for SILENCE. Presumably directed at the witnesses to executions, the message is also directed at beholders of this nightmarish series.

As a gay man who had grown up in a Catholic, working-class family of Czech immigrants, Warhol knew that most Americans had little tolerance for individualistic behavior that deviated from established, heterosexual social norms. His appropriation of images from glossy movie and celebrity magazines underscored the mass media's transformation of film actors into marketable commodities. After the tragic suicide in 1962 of Hollywood's leading sex goddess, Marilyn Monroe, Warhol produced a series of often garishly colored silkscreen portraits taken from a glitzy publicity photograph. In Marilyn Monroe's Lips (fig. 8.46), the artist's fetishistic, assembly-line repetition of the star's toothy grin suggests the dehumanizing emptiness of American mass culture.

Though Warhol assumed a public persona of political naiveté and impassivity, his early 1960s Disasters series, which included sensational tabloid newspaper photographs of gruesome airplane and car crashes, graphically demonstrated the violence at the heart of American life. In one of the most critical images from the Disaster series. Warhol reproduced eerily colored, multiple images of a lone electric chair symbolizing the government-sanctioned technology of death (fig. 8.47).

Emerging from the realist, Pop Art aesthetic, the Minnesota artist Duane Hanson (1925-96) shared Warhol's dark vision of an affluent but violent American culture. Working with fiberglass cast molds taken from living human bodies, Hanson created uncannily realistic sculptures by painting the figures with convincing flesh tones and dressing them in appropriate clothing. He then installed the figures with accompanying props so that they could mimic the banal, but sometimes horrific, incidents of everyday life. His grisly Motorcycle Accident (fig. 8.48) recalls Warhol's Disasters series and the photographs of car

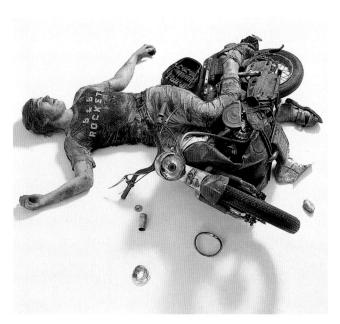

8.48 Duane Hanson

Motorcycle Accident, 1969. Fiberglass, polychromed in oil, lifesize figure with motorcycle. © 1999 Sotheby's, Inc., New York.

Hanson created this remarkably realistic sculpture by taking a fiberglass cast mold from a human body, painting it, and then dressing it in clothing suitable for a teenage motorcyclist. Like the photographer Robert Frank's unsettling representations of America's endless highways (see fig. 8.12), Hanson's violent assemblage of a mangled roadside victim and a wrecked motorcycle questions American prosperity and its restless culture of high-speed living.

accidents that typically attract readers or viewers to the sensational tabloid media. Hanson became associated with the Super Realist movement, which included photo-realist painters such as Richard Estes (b.1936) and Chuck Close (b.1940). Like Hanson, John de Andrea (b.1941) used fiberglass and painted vinyl to create trompe l'oeil figures that surpass the realism of Patience Wright (see fig. 4.7) and the early Anglo-American waxworks tradition.

Pop Art and Postmodernist Architecture

Pop Art's transgression against the purity of abstract formalism inspired architects to design buildings that subverted the Modernist functionalism of the International Style. Countering Mies van der Rohe's anti-decorative maxim that "less is more," the architect Robert Venturi (b.1925) advocated a return of ornamental signs and historical references. Guided by the alternative notion that "less is a bore" (cited in Klotz, p. 142), Venturi's design for Philadelphia's Guild House, a Quaker retirement home, has been called the first significant example of Postmodern architecture (fig. 8.49). Although the term did not gain currency until the 1970s, Venturi's buildings and theoretical writings helped to define the Postmodern movement's rejection of the austere geometry of Modernist architecture. In his treatise Complexity and Contradiction in Architecture (1966), Venturi denounced the puritanical simplicity and functionalism of the International Style. Modernists such as Mies van der Rohe had tended to regard their box-like, steel-frame skeletons sheathed in glass (see figs. 8.8–8.9) as a universal, geometric vocabulary adaptable to virtually any social or cultural function and building site. International Style architects often ignored the local, historic character of the urban neighborhoods or downtowns in which they constructed their sleek, skyscraper towers. Postmodernist architects have defined their movement, in part, by the principle of "contextualism" or the recognition that a building cannot be composed like a universal language of forms without any regard to the surrounding environment or to the vernacular, local building traditions of particular communities. Rejecting Modernist austerity for ornamental allusions, Postmodernists have playfully decorated buildings with historical-revival motifs and contemporary, popular signs to suggest various symbolic meanings and

8.49 Robert Venturi and John Rauch

Guild House, Philadelphia, Pennsylvania, 1960-63.

Despite its relatively unpretentious appearance and visual similarity to entirely anonymous examples of inexpensive housing complexes, Venturi's Guild House possesses an architectural playfulness and inventiveness that some have compared to sixteenthcentury Italian Mannerist architecture. Just as Venturi willfully contradicted the need for a massive, granite entrance column, so did Mannerist architects such as Giulio Romano (1492/9-1546) purposely employ architectural elements in opposition to their original purpose or meaning.

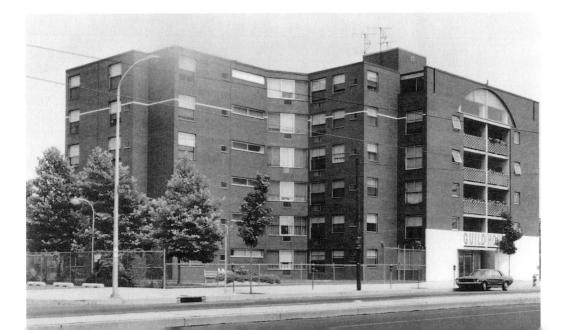

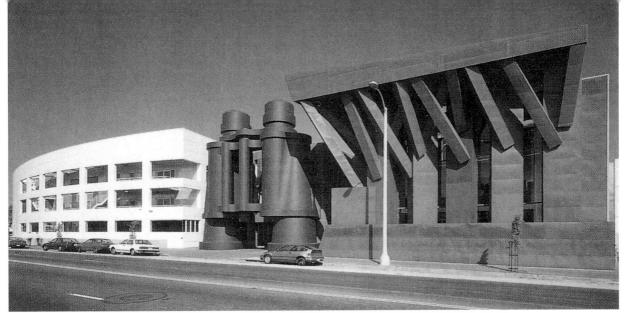

8.50 Frank O. Gehry & AssociatesChiat Day Mojo Offices,
Venice, California, 1985–91.

contextual associations. In his controversial book *Learning from Las Vegas* (1972), Venturi challenged the avant-garde elitism of Modernist art and architecture. He sided with Pop artists in praising the messy but eye-catching communicative power of the garish commercial "Strip" in Las Vegas, Nevada, lined by gaudy gambling casinos, resort hotels, billboards, and monumental electronic advertising signs.

Borrowing from the commercial-strip landscapes characterizing most American cities and suburbs, Venturi conceived the facade of the unpretentious, low-cost Guild House as a gigantic billboard with the name of the building emblazoned over a recessed entrance divided by a granite column. Contradicting the functional need for its massiveness, the column supports seemingly weightless forms: a flat sign, light balconies with perforated sheet-metal railings, and a crowning arched window. The top-floor window illuminates a communal TV lounge. Originally, Venturi had capped the building with a decorative golden television antenna to signify the residents' primary recreational activity. Though the architect had intended the symbol as a humorously ironic substitute for the Virgin Mary sculptures that often decorated Catholic retirement homes, critics accused him of being insensitive and demeaning to the elderly residents. The building's Quaker owners soon removed the offending, ornamental sign derived from Pop Art, leaving only the more inconspicuous functional antenna to project from the roof.

Later Postmodernist architects have continued to produce expressive designs in response to popular, consumerist culture. The California architect Frank Gehry (see fig. 8.6) even collaborated with the sculptor Claes Oldenburg (b.1929) and Oldenburg's wife Coosje Van Bruggen (b.1942) to shape the facade of a Venice, California, advertising agency into a giant pair of binoculars (fig. 8.50). During the 1960s, Oldenburg had gained fame as a Pop artist, thanks to his large-scale sculptures of common consumer products, such as hamburgers, clothespins, and typewriters. Famous for its former nude beach and oceanside culture of beefy bodybuilders, the Los Angeles metropolitan community of Venice has long been a mecca for voyeurs, a cultural fact alluded to by this gigantic pair of binoculars that now decorates Main Street.

Postmodernist architectural critics have claimed Frank Lloyd Wright as a forerunner of the movement. They have praised his synthesis of modern technology and building functions with traditional historical symbols and organic forms. Philip Johnson, spokesman for the International Style, had once sarcastically referred to Wright as the greatest architect of the nineteenth century. Yet, by the 1950s, the aging inventor of the Prairie house (see fig. 6.14) had become an even more powerful presence in American architecture. Among Wright's many commissions, none was more famous or spectacular than his design for the Solomon Guggenheim Museum on New York's Fifth Avenue. The circular building, a repository for the Guggenheim family's collection of non-representational Modern art, was modeled after a round, upside-down ziggurat. An ancient stepped tower or pyramid form dating from early civilization in the Middle East, the ziggurat is associated with the biblical tower of Babel (Genesis 11:1-9). In the Bible, this towering building form became a negative symbol of human pride. But Wright obviously interpreted the pyramidal ziggurat far more generously as a positive, hopeful form that signified humanity's godlike, progressive pursuit of knowledge and spiritual enlightenment. From this optimistic perspective, the ziggurat was symbolically suitable for an art museum. Since the eighteenth century, most architects had conceived art museums as public temples for celebrating human creativity and cultural refinement. For Wright, the ziggurat design was a means for creating a dynamic, spiraling space that suggested progress and human aspiration. The space of the Guggenheim's interior (fig. 8.51) spirals upward and outward toward a brilliant, virtually circular glass dome. Constructed from reinforced concrete and painted entirely in cream white, the building's spiral has been compared to seashell forms. An elevator takes visitors to the top floor so that they may comfortably view exhibitions as they descend gradually along an inclined ramp. The vast, womblike space at the interior's core facilitates a view of this human procession from all levels, thanks to the low rise of the sweeping ramp balconies. Understandably, many exhibiting painters and sculptors have complained that Wright's architecture overwhelms the art it is supposed to showcase.

8.51 Frank Lloyd Wright Solomon R. Guggenheim Museum, New York. 1956–59. Robert E. Mates/Guggenheim Museum, New York.

8.52 Hans Haacke

Shapolosky et al. Manhattan Real Estate Holdings, a Real-Time Social System, as of May 1, 1971 (detail), 1971. Photograph 10×8 in $(25.4 \times 20.3 \text{ cm})$ and typewritten data sheet 10×8 in (25.4 × 20.3 cm).

8.53 Christo and Jeanne-Claude

Valley Curtain, Grand Hogback, Rifle Gap, Colorado, 1970-72. Nylon polyamide and steel cables. Copyright © 1972 Christo.

Photographs of the fullyinstalled Valley Curtain evoke strong visual associations with the panoramic paintings of nineteenth-century **Hudson River School artists** such as Frederic Church (see figs. 5.57-58) and Jasper Cropsey (see fig. 5.53). Particularly in this rugged Colorado site, the colorful, theatrical curtain continues the tradition of Americans' romance with the western frontier.

Conceptual and Earth Art as Cultural Criticism

In 1971, the German-born artist Hans Haacke (b.1936) attempted to exhibit in the Guggenheim a photographic series documenting the Manhattan real-estate holdings of the museum's board of trustees (fig. 8.52). Rather than visually competing with the grandeur of Wright's architecture, Haacke's architectural record of derelict slum buildings would have been a subversive display of the trustees' hypocrisy in funding a temple of art, in part, from the rent and lease payments of lowincome tenants living in substandard housing. When the museum's director discovered what Haacke intended to exhibit, he canceled the artist's show, which then moved to a less prestigious venue. In his combination of photographs and real estate records, Haacke was creating a work of conceptual art. Echoing the Dadaist tradition of Marcel Duchamp, the Conceptual Art movement of the late 1960s and early 1970s stressed artists' ideas rather than the making of material objects.

Escaping the physical confines of art studios, galleries, and museums, several Conceptual artists launched the Earth Art movement during the late 1960s. Because their projects were often grandiose and impractical. many Earth Art works never went past the conceptual planning stages of

maps, charts, sketches, and verbal instructions. Yet these documents were displayed and sold by galleries as art works. The New Jersey artist Robert Smithson (1938–73) became one of the most successful Earth artists before his career was cut short by an airplane crash near one of his projects in Amarillo, Texas. Critical of the quasireligious aura of museum architecture, Smithson ridiculed the Guggenheim's organic, spiral design as an "inverse digestive tract" (cited in Shapiro, p. 168). Unlike later Postmodernist critics, he situated Wright's Guggenheim entirely within Modernism's optimistic faith in historical progress and the artist's godlike genius.

Smithson's most famous work, *Spiral Jetty* (fig. 8.54) was, in part, a response to Wright's transcendent, light-filled spiral.

Consisting of a coil of earth 1,500 feet long and fifteen feet wide, Smithson's flat, horizontal ramp spirals into the deadened western environment of Utah's inland sea, the Great Salt Lake. With financial support from the New York gallery owner Virginia Dwan and a Canadian art gallery in Vancouver, British Columbia, Smithson supervised the moving of some 6,650 tons of material into the relatively inaccessible desert lake site. Influenced by Minimalist sculpture, Smithson's spiral ramp could once be entered and walked on by any adventurous person determined to make a long and difficult art pilgrimage. However, the ramp has been submerged by the lake's rising water level. Thus, as a work of art, Spiral Jetty is best known through aerial photographs, a film documenting the ramp's construction, and conceptual writings and sketches. Unlike the Guggenheim Museum's optimistic ascent skyward, Smithson's spiral leads nowhere. Moving in a counterclockwise direction, the visitor or beholder is directed to a point of entropy or dissipation of energy into disorder and chaotic nothingness. As Smithson explained, "Following the spiral steps we return to our origins, back to some pulpy protoplasm, a floating eye adrift in an antediluvian ocean" (cited in Shapiro, p. 137). The ramp's eventual submersion beneath the lake's surface only underscored the principle of entropy and decay. Within a post-industrial wasteland of abandoned oil rigs and machinery, which the artist compared to dinosaurs, Spiral Jetty critiques America's environmentally destructive romance with technology and science. Significantly, Smithson began the Spiral Jetty project in 1969, the hundredth anniversary of the completion of the transcontinental railway. The artist's ramp to nowhere is, in fact, located near the Golden Spike national monument, which patriotically commemorates this

8.54 Robert Smithson
Spiral Jetty, Great Salt Lake,
Utah, 1969–70. Black basalt
and limestone rocks and
earth, 1,500 ft (457.2 m) long,
15 ft (4½ m) wide.
Photograph courtesy of the
Dawn Gallery, New York.

Dependent upon meteorological conditions, Spiral Jetty has once again resurfaced into visibility with the recently receded water levels of the Great Salt Lake. Smithson began work on this monumental earthwork in 1969, the same year that the United States first landed astronauts on the moon. That event helped accelerate the environmental movement's campaign to increase public awareness of the earth and its fragile ecology, a theme forcefully addressed by Smithson's entropic work.

transportation conquest of the American West. In contrast to the Spike Monument's celebration of national unity and economic modernization, Spiral Jetty may be interpreted as an allusion to the political chaos and disunity of the late 1960s, when violent anti-Vietnam War protests and urban riots in black ghettos shook confidence in the nation's future. Smithson's Spiral Jetty and his last work, Amarillo Ramp, both recall the ancient uroboros, or circular serpent biting its own tail. The uroboros was a popular symbol for cyclical regeneration during the American Revolution of the eighteenth century (see fig. 4.27). Even earlier, the uroboros had signified the dawn of the new age that followed the European discovery of America (see fig. 1.10). Smithson's fascination with entropy, decay, and dissolution implicitly contains the apocalyptic hope for future social renewal. Smithson and other Earth artists consciously drew parallels with Native American earthworks, which expressed the desire to harmonize with the vitalistic, cyclical forces of nature (see fig. 1.7).

Numerous other artists have conceived of grand-scale projects that have called attention to rural and urban spaces. Christo Javacheff (b.1935), known simply as Christo, a Bulgarian-born artist, and the French-born artist Jeanne-Claude de Guillebon (b.1935) have created a series of particularly ambitious outdoor projects. Influenced by Dadaist and Surrealist readymades, Christo in 1958 began his art career by wrapping objects in fabric or plastic. In 1964 he created actual storefronts and wrapped buildings and landscapes, including, in 1969, 1 million square feet of the Australian coast near Sydney. Christo and Jeanne-Claude have decorated various sites in the United States with, for example, a vast curtain, a fence, and objects made from synthetic fabric, steel, and aluminum. From 1970 to 1972, they planned and completed Valley Curtain (fig. 8.53) at Rifle Gap, Colorado. Composed of 200,000 square feet of translucent, bright orange, nylon fabric, the curtain, over 1.300 feet wide, was hung from 110,000 pounds of steel cable and anchored by 800 tons of concrete. Installed by a crew of workers, Valley Curtain lasted for only twenty-eight hours, since a powerful gale tore the work and forced its dismantling. From the artists' perspective, the physical realization of Valley Curtain constituted only one part of the art work. Christo and Jeanne-Claude regard both the conceptual planning and the completion of projects as examples of artistic expression. They established a company, the Valley Curtain Corporation, which sold Christo's sketches and scale models to finance the construction of Valley Curtain. Even the legal petitions, government hearings, and local debates over the work's public authorization became part of the artistic process. To preserve the memory of the project, the artists engaged professional film crews to film the curtain's installation and established a photographic record of its dramatic, scenic realization. Forming a vivid contrast with the blue sky and ochre, muted colors of the rugged mountainous terrain, the artists' bright orange canvas temporarily drew together nature's elements to create a spacious, outdoor panorama of the western landscape.

Art and the Vietnam War: from Protest to Commemoration

While Abstract Expressionists had avoided explicit political content, many artists produced works critical of American intervention in the civil war between communist North Vietnam and the pro-Western government in South Vietnam. The California artist Edward Kienholz (b.1927) paralleled Robert Rauschenberg as a prolific assemblage artist. However, unlike Rauschenberg, Kienholz created installations with a strong political and social content. In *The Portable War Memorial* (fig. 8.55), he produced a darkly ironic tableau that juxtaposed a copy of a World War II memorial celebrating America's victory over Japan with the image of a fast-food diner and other consumer or leisure-time furnishings. By recycling the war monument as a portable commodity, the artist deflates the heroic pretensions of the Southeast Asian war, which Kienholz thought served the imperial, economic interests of the United States.

The sculptural tableau also satirizes the jingoistic patriotism that the war generated on the home front. At the far left of the assemblage, Kienholz represents the portly singer Kate Smith, who became nationally renowned for her stirring rendition of "God Bless America." The obese figure, whose body resembles an upsidedown garbage can, stands next to a World War I army recruiting poster with an image of Uncle Sam, the fabled personification of American nationalism, pointing outward to exclaim "I WANT YOU." Kienholz employed an audio recording of Smith's performance of the patriotic anthem to accentuate the eerie, ironic atmosphere of the work. Sandwiched between the war memorial sculpture and the image of oblivious fast-food consumers, a gigantic blackboard looms like a tombstone, bearing the names of 475 nations extinguished by past wars.

The Chicago-born artist Leon Golub (b.1922) revived the art of politically charged history painting in works protesting American atrocities in Vietnam. In a 1969 series entitled *Napalm*, he had represented classical gladiator figures, whose bare flesh seems burned by some corrosive, acidic chemical such as napalm, the notorious anti-personnel weapon manufactured by the Dow Chemical Company and employed in Vietnam. Later, between 1972 and 1974, Golub produced *Vietnam*, a series of mural-size paintings originally entitled *Assassins* that more specifically represents an American military massacre of Vietnamese civilians. The series alludes to the 1968 My Lai massacre and the 1971 U.S. military trial of several army officers held responsible for the killing at the village of some 500 Vietnamese, most of them

8.55 Edward Kienholz
The Portable War Memorial,
1968. Mixed-media
installation, 9 ft 6 in \times 32 ft \times 8 ft (2.89 \times 9.75 \times 2.43 m).
Museum Ludwig, Cologne.

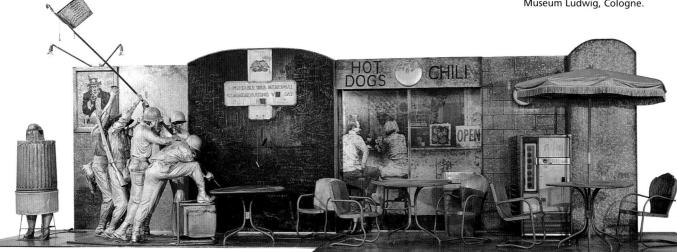

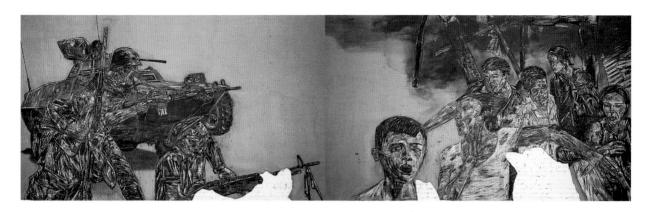

8.56 Leon Golub

Vietnam II, 1973. Acrylic on canvas, 10 ft imes 40 ft (3.04 imes12.1 m). Rhona Hoffman Gallery, Chicago, Illinois.

Golub's brutal painting technique was partially inspired by the French artist Jean Dubuffet (1901-1985). an advocate of art brut or "raw art," encompassing graffiti and the uncultivated art of children and the insane. Golub's wife, the feminist artist Nancy Spero (1926-), has worked on a smaller scale, employing a graffiti-like technique. During the Vietnam War she, too, created numerous political works protesting American involvement.

defenseless women, children, and old men. In Vietnam II (fig. 8.56), frightened peasants rush toward us, away from a torched hut, while armed American soldiers and a tank take aim from the far left side of the composition. Golub accentuates the violence by tearing away sections of the canvas, which hangs unstretched on the wall like flayed skin. Employing an expressionistic technique, the artist roughly scraped the paint surface with a knife or cleaver to convey the raw, brutal nature of the subject. Golub's large work recalls the Spanish painter Francisco de Goya's famous The Third of May, 1808 (1814-1815), which represents occupying French Napoleonic troops mechanistically executing a group of pleading Spanish civilians outside the city of Madrid.

In 1975, the war ended when North Vietnamese troops triumphantly marched into Saigon, South Vietnam. Since then, America's defeat in Vietnam has been a recurrent source of bitter political debate. No artist created more controversy over the meaning of the war than the Korean-American Maya Ying Lin (b.1959). Her quiet, abstract design for the Vietnam Veterans Memorial in Washington, p.c., stemmed from the 1960s Earth Art movement (fig. 8.57). The design contrasts dramatically with the nearby Iwo Jima monument of World War II soldiers triumphally raising the American Flag, the work mockingly copied by Edward Kienholz (see fig. 8.55). Instead of triumph, Maya Lin's funereal work memorializes military defeat and the tragic loss of over 58,000 American lives from 1959 to 1975. Situated within eyesight of the Washington Monument, a lofty Egyptian-style obelisk, the Vietnam Veterans Memorial emphasizes the horizontal and earthbound. Its two long, triangular wedges of polished black granite panels slope below the surface of the earth. Chronologically arranged, the names of those American men and women who died in the war have been inscribed on the mirror-like panels, which reflect the surrounding space of the site and the stream of visitors placing flowers and mementos before the memorial's embracing arms.

Lin's design aroused intense opposition from right-wing politicians, who complained that its intentionally anti-heroic profile constitutes an anti-war critique of U.S. intervention in Vietnam. Dissenters succeeded in placing a rival, more traditional sculpture of American soldiers in close proximity to Lin's strongly feminist memorial. As she recalled in 1983, a year after completing the project, her abstract design is not explicitly political, but it was meant to contrast with the vertical, phallic symbols of power that visually dominate the national capital's cultural landscape. Far from offending former participants in the war, Lin's memorial has become a pilgrimage site for friends and relatives of the deceased and for surviving war veterans.

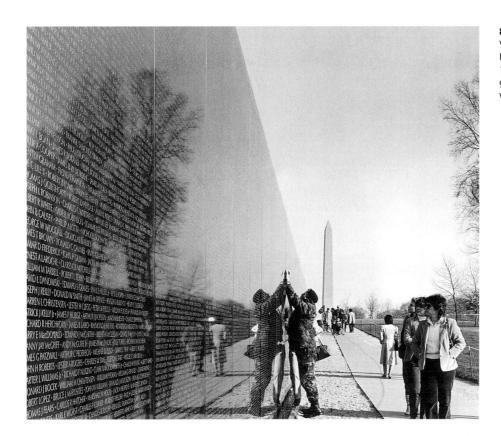

8.57 Maya Lin
Vietnam Veterans' War
Memorial, Washington, D.C.,
1981–84. Black polished
granite wall; two wings, each
wing 246 ft (75 m).

Feminist Art and Politics

During the 1970s, a number of women collectively and individually challenged the dominance of male artists in gallery and museum exhibitions. In New York, Women Artists in Revolution (WAR) was founded to protest the Whitney Museum of American Art's 1969 annual exhibition of contemporary art, which included only eight women out of 143 participating artists. Over a decade later, a collective of women artists known as the Guerilla Girls organized to protest the sexual bias of major New York museums, which continued to favor exhibitions of male artists. To protect their anonymity, group members wore gorilla masks while picketing, leafleting, and plastering city streets with posters that sarcastically asked, among other things, "Do women have to be naked to get into the Metropolitan Museum?" Closely connected with the anti-war and black civil rights movements, women's liberation organizations had begun to proliferate with the founding of the National Organization for Women (NOW) in 1966. Local and national organizations of women artists were founded not only to combat the male monopoly in the art world but also to focus on broader issues of social and political justice.

In Los Angeles, the African-American artist Betye Saar (b.1926) subversively reconfigured the popular racist imagery of American advertising and kitchenware in *The Liberation of Aunt Jemima* (fig. 8.58), a box construction that recalls the assemblage technique of Joseph Cornell (see fig. 8.15). Set against a background papered with the advertising logo for Aunt Jemima pancakes, a large Aunt Jemima cookie jar dominates the intimate space. Saar transforms the grossly caricatured figurine from

a humble, happy servant into a proud, triumphant black militant who holds a broom and a pistol in one hand and a rifle in the other. Furthermore, emerging from the bottom of the cookie jar, between the rifle and broom, a large clenched fist symbolizes black power, apparently frightening a white baby held by another grinning Jemima figure. While the United States Congress had passed civil rights and voting rights laws during the 1960s, many African-American leaders noted their lax enforcement and called attention to the growing economic plight of impoverished blacks. Dissenting from the non-violent protests used by the Reverend Martin Luther King, Jr., the leading opponent of racial segregation, other black leaders employed the slogan "black power," with its image of a raised fist, to suggest the willingness to use more militant means to defend the interests of African Americans. As a symbol of black power, Saar's armed Jemima liberates herself not only from a history of white oppression as symbolized by the crying baby but also from traditional gender roles that had once relegated her to the passive role of a happy domestic laborer or black mammy.

Substantially encouraged by feminist artists, Postmodernist ideas gained currency outside of architectural criticism. Following in the path of Pop artists' appropriations from mass culture, Postmodern artists rebelled against the Modernist cult of original genius, which almost invariably had elevated men over women. Unlike the Abstract Expressionist painter Barnett Newman, who had belittled Native American basket weaving and the decorative arts, Postmodern, feminist artists and critics denounced Modernism's "high art" disdain for women's craft traditions. They also supported newer popular media such as video and performance to escape the arcane, formalist analysis that characterized the writings of Clement Greenberg and other Modernist critics. Reacting against Modernist formalism, feminist artists appropriated the decorative art tradition of women's crafts. They also returned to representational subject matter and historical narratives to make personal political statements.

Judy Chicago (b.1939), a leading feminist artist of the 1970s, created a major, room-size work in The Dinner Party (fig. 8.59), a triangular table composed of thirtynine place settings for mythical and historical women throughout the ages, including a prehistoric goddess and the artist Georgia O'Keeffe. Each setting was composed of embroidered cloth placemats, napkins, painted and carved ceramic plates, utensils, and a porcelain chalice. With thirteen settings for each of its three sides, The Dinner Party purposely recalled the Last Supper of Christ and his twelve disciples, thereby suggesting the equivalent martyrdom of women heroes. But, according to Chicago, it also subversively referred to the thirteen members of a witches' coven, a traditional symbol of female occult powers. The triangular table was an act of "herstory," or historical resurrection for women swallowed up or ignored by the brotherhood of historians. An additional 999 names have been painted in gold on the white porcelain floor tiles below the table. Each of the glaze plates possesses a butterfly or an organic, vagina-like form as an emblem of feminine identity and women's liberation. The Dinner Party was a collaborative project that involved the anonymous labor of some 400 people over a five-year period. Chicago does not credit by name these individuals because the needlepoint workers, ceramicists, and other participants were not co-equal creators. The artist maintained control over the final design of every place setting. In contributing toward a more inclusive record of women's achievements in the face of Western civilization's repressive, patriarchal history, Chicago also challenged the masculine bias of art by reviving such traditional women's crafts as weaving, embroidery, and ceramics.

While The Dinner Party attracted thousands of enthusiastic visitors to exhibition spaces nationwide, Chicago's work also aroused considerable criticism from some feminists. They argued that the artist's sexual imagery and celebration of prehistoric goddess worship tended to make the differences between men and women essentially a function of biology. Influenced by French "deconstructionist" or "poststructuralist" literary theory, these feminists rejected nature-based "essentialism." In deconstructing the supposedly essential, objective nature of social relationships, they argued that gender roles are artificial, cultural constructs that have no necessary grounding in biological, sexual difference. During the late 1970s and 1980s, responding to the deconstructionist critique of fixed meanings and social identities, a number of feminist artists turned away from mythological fertility goddesses and biological symbols of femininity. Instead they explored the ways photography and the mass media have created cultural stereotypes that arbitrarily limit women and their relationships with men. The photographer-performance artist Cindy Sherman (b.1954) has undermined the supposed journalistic objectivity of photography. By shooting pictures of herself in different disguises and in various melodramatic poses and narrative contexts, Sherman portrays a large cast of stereotypical female characters (fig. 8.60). The artist's "directorial" mode ironically mimics the craft of film directors. Sherman gives the illusion that her photographs are

excerpted from a movie that she not only scripts and directs but also stars in, using exaggerated gestures and expressions. Each photograph appears to be a still shot taken from a cinematic narrative of changing scenes and intriguing situations. Sherman's fictional images subvert the factual basis of the photographic medium and critically parody mass-media stereotypes. Her chameleon-like performances suggest that the individual self has no fixed identity but is an imaginative construct always in a state of flux, dependent on social interaction with others.

In work closely related to Sherman's critique of media imagery, the photographer Richard Prince (b.1949) has employed his camera to rephotograph and, thereby, appropriate readymade pictures of female fashion models from chic advertisements (fig. 8.61). By isolating the heads of three women looking in the same direction and then displaying them in a series, he demonstrates how the supposedly meaningful expressions of each individual figure are mass-media poses or impersonal, conventional signs for creating consumer desires. Like other Postmodernist artists, Prince has questioned the Modernist premise that the individual artist-genius is the primary author of an art work. Arguing, instead, that "the audience has always been the author of an artist's work" (cited in Fineberg, p. 456), he conceived his acts of appropriation from the relatively passive perspective of the consumer

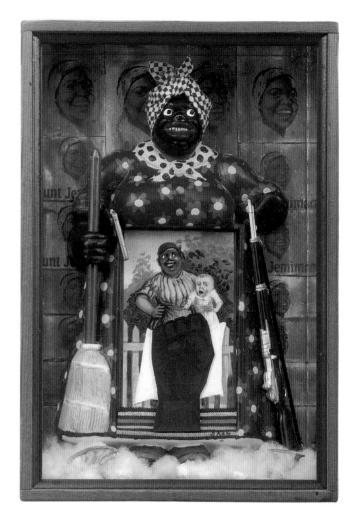

8.58 Betye Saar The Liberation of Aunt Jemima, 1972. Mixed media, $11\% \times 8 \times 2\%$ in $(29.8 \times 20.3 \times 7 \text{ cm})$. Berkeley Art Museum, University of California. Purchased with the aid of funds from the National Endowment for the Arts.

In a contemporaneous variation on the same stereotype, *The Liberation of Aunt Jemima: Measure for Measure*, Saar comically but pointedly supplied the normally benevolent figure of Jemima with two measuring cups, one carrying pancake mix, the other explosives.

8.59 (top) Judy Chicago The Dinner Party, 1979. Mixed media, 48 \times 42 \times 3 ft (17.6 \times 12.8 \times 0.9 m). Courtesy Through the Flower.

8.60 Cindy Sherman

Untitled Film Still no. 3, 1977. Blackand-white photograph, 8×10 in $(20.3 \times 25.4 \text{ cm})$. Photograph courtesy of Metro Pictures, New York.

Sherman stands over a kitchen sink but does not have her mind focused on household duties. Wearing tightfitting clothing, she looks seductively over her shoulder away from the dish rack and liquid soap toward some unseen presence beyond the cropped image. In this melodramatic tableau, a dark, blurred pot handle in the immediate foreground also points in the direction of Sherman's vixen-like gaze. The photograph thus parodies stereotypical soap-opera imagery.

audience targeted by Madison Avenue advertisers. Fittingly or unsurprisingly, his rephotographed corporate images have been purchased, or reappropriated, by corporate art patrons. By Prince's own logic the circle becomes complete, in that these corporate patrons become not simply the audience but the very authors of the images attributed to the artist.

As opposed to Prince's subtle immersion into stereotypical advertising imagery, the feminist artist Barbara Kruger (b.1945) appropriates emotionally evocative photographic readymades and emblazons them with dramatic verbal headlines to virtually shout her opposition to male dominance (fig. 8.62). In *Your Comfort is My Silence*, the ominous, black-and-white cinematic image of a man gesturing for silence floats in an ambiguous dark space. Meanwhile, the words, attributable either

to the aggressive man or his implicitly female antagonist, suggest a conventionalized sexual psychodrama akin to a pulp-fiction melodrama.

Kruger's billboard-like images never express comfort or endorse silence. For the artist, visual and verbal languages are the conflicted means through which individuals perpetually redefine themselves. Women must challenge or "deconstruct" the cultural stereotype of female passivity and obedience to liberate themselves from masculine control. Having worked as a commercial artist and graphic designer for *Mademoiselle*, *Vogue*, and other fashion magazines, Kruger unabashedly markets her confrontational images and messages through various consumer goods, including T-shirts, matchbooks, and tote bags.

Similarly, the conceptual artist Jenny Holzer (b.1950), who appropriated ideas from both corporate advertising and New York City street graffiti, created verbal art works that she disseminated outside restrictive gallery and museum spaces by using posters, leaflets, and T-shirts. More dramatically, Holzer's *Truisms*, a sequence of impersonal, broadly moral cultural messages, were flashed on an electrical sign overlooking Times Square in midtown Manhattan (fig. 8.63). Such cautionary admonitions as "abuse of power comes as no surprise" were designed to arrest the attention of busy pedestrians and motorists. The easily read *Truisms* temporarily altered the strictly commercial, functional character

8.61 Richard PrinceUntitled (Three Women
Looking in the Same
Direction), 1980. Set of three
Ektacolor prints, edition of
ten, 3 ft 4 in × 5 ft (1.01 ×
1.52 m) each. Collection of
Chase Manhattan Bank, New
York

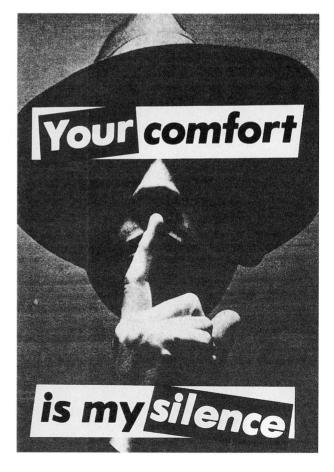

8.63 Jenny Holzer

Truisms, 1977-79: Abuse of Power Comes As No Surprise, 1982. Spectacolor Board, $20 \times 40 \text{ ft } (6.1 \times 12.2 \text{ m}).$ Times Square, New York. Courtesy the artist and Cheim and Reid Gallery, New York.

Holzer's Truisms questioned power and authority with a series of messages advising passersby that "Private property created crime" and "Money creates taste." Flashed on a Spectacolor signboard overlooking Times Square in the world's financial capital, these maxims were intended as controversial challenges to conventional American capitalist thought.

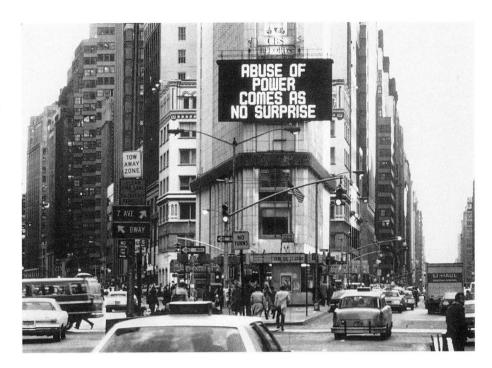

of the architectural site. Although employing an electronic advertising medium, the artist composed political, often feminist maxims more akin to graffiti than to corporate consumerist messages.

Neo-Expressionism and the Revival of Painting

During the early 1980s, stimulated by international art exhibitions in London, Venice, and Berlin, new movements in figurative and expressionist painting in Europe and America challenged conceptual and media appropriation techniques. German artists Anselm Kiefer (b.1945) and Georg Baselitz (b.1938) drew on their own rich tradition of expressionist art movements developed during the early twentieth century. These artists especially affirmed individual authorial presence through gestural brushstrokes and evocative, personal subject matter. In part, Neo-Expressionism, or the expressionist revival, initiated an overdue critical recognition of older figural painters such as Leon Golub (see fig. 8.56). In the late 1970s and 1980s, Golub became a leading figure in the New York art world. He created vividly colored, mural-size works alluding to the support of the United States military and Central Intelligence Agency for anti-communist dictatorships and mercenaries in Latin America and elsewhere.

Few critics have questioned Golub's artistic sincerity in continuing the expressionist manner or in reviving the tradition of history painting. However, the vounger Neo-Expressionist painter Julian Schnabel (b.1951) was harshly attacked as a commercial opportunist for cynically recycling the masculine, action-painting persona of the heroic artist-genius. After selling out his first one-person show in New York before it even opened in 1979 at the Mary Boone Gallery, Schnabel also

8.62 (left) Barbara Kruger Untitled (Your Comfort Is My Silence), 1981. Photograph with added text, 4 ft 8 in imes3 ft 4 in (1.4 \times 1 m). Private collection.

Kruger's confrontational photomontages typically consist of rediscovered blackand-white photographs that are enlarged and overlaid by banners of accusatory words in bold type. Her poster-like style is partially indebted to the propaganda imagery and typography of politically engaged Russian Constructivists such as El Lissitzky (1890-1941) who were active during the early years of the Soviet Union.

signed on with the prestigious Leo Castelli Gallery. Transformed into a media celebrity, Schnabel had himself photographed working directly on the studio floor, walking inside and around his canvases, just like a latter-day Jackson Pollock (see fig. 8.21). Nevertheless, Schnabel's use of broken dishes, ceramic shards, antlers, and black velvet surfaces recalls the combine paintings of Robert Rauschenberg (see fig. 8.32) and the Dada and Pop Art traditions of employing vulgar or popular materials. In his large, somber Portrait of Andy Warhol (fig. 8.64), Schnabel painted on black velvet, a fabric widely used in garish, mass-produced paintings sold in souvenir stores. However, there is none of Pop Art's ironic humor in the

of the Pop artist Andy Warhol implies an art-historical progression from past mas-

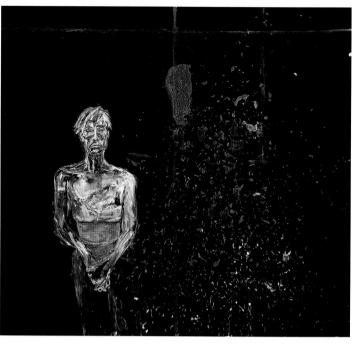

8.64 Julian Schnabel
Portrait of Andy Warhol,
1982. Oil on velvet, 107% ×
120% in (273.6 × 305.1 cm).
Hirshhorn Museum and
Sculpture Garden,
Smithsonian Institution,
Washington, D.C. Joseph H.
Hirshhorn Purchase Fund and
Regents Collections
Acquisition Program.

Postmodernist Meditations on Death

ters to a new generation of celebrity artists.

Unlike Schnabel's reverent tribute to the Abstract Expressionist and Pop Art traditions, the Postmodernist painter Ross Bleckner (b.1949) has chosen to reexamine the history of modern art by exploring its failed or short-lived movements such as Op Art of the mid-1960s. Denounced by critics as a vulgarization of formalist geometric abstraction, paintings by Op artists created dizzying optical effects and vibrating retinal sensations. Their work used densely packed shapes, swirling stripes, wavy lines, and intense, contrasting colors. Quickly assimilated into product designs for rock album covers and the psychedelic posters of the anti-rationalist drug culture, Op Art came to signify the failure of Modernist abstraction. Unlike Pop Art's ironic ridicule of Abstract Expressionism, Bleckner's paintings seek to salvage

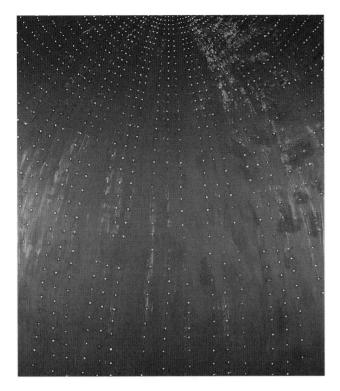

8.65 Ross Bleckner Architecture of the Sky III, 1988. Oil on canvas, 8 ft 10 in \times 7 ft 8 in (2.7 \times 2.3 m). Collection Reinhard Onnasch, Berlin. Photograph courtesy of the Mary Boone Gallery, New York.

Bleckner's Whistler-like dots of light against a dark, nocturnal sky allude to the interiors of church domes, which traditionally symbolized the sacred dome of heaven.

something valuable from Modernism's historical devolution into hedonistic consumerism. As suggested by the metallic glow of Architecture of the Sky III (fig. 8.65), with its flickering lines of gold dots illuminating a dark, shiny surface, Bleckner admired and sought to preserve the faded memory of Op Art's intensely electric light effects. However, his shiny, spiritually evocative surface also evokes associations with Pictorialist photographs of the late nineteenth and early twentieth centuries. These works mimicked the atmospheric, hazy effects of tonalist pictures by Whistler (see fig. 6.50) and other Gilded Age painters. Pictorialism became a casualty of Modernist criticism, which insisted that each medium should define its own inherent nature. As seen in the contrast between Stieglitz's Pictorialist Spring Showers (see fig. 7.13) and his later The Steerage (see fig. 7.12), photography abandoned painterly effects for the clear realism and mechanical precision that only the camera could produce. The art historian Thomas Crow argues that Bleckner's morbid allusions to the "history of bypassed modernisms" ought to be interpreted within the context of the AIDS pandemic of the 1980s (p. 126). AIDS killed thousands of young

and middle-aged gay men and devastated the artistic and cultural communities of American cities. Like Pictorialist photographers, whose pictures often conveyed spiritualist communications from beyond the grave, Bleckner characterized his luminous, glossy surfaces as meditations on death. He observed that "I think things shine with their maximum brilliance just at that point that they're about to die" (cited in Crow, p. 121). Unlike Schnabel's celebrity portrait of Warhol, Bleckner's Architecture of the Sky III expresses life's fragility by evoking memories of forgotten or reviled artists and art movements.

During the 1990s, the Connecticut-born sculptor Robert Gober (b.1954) also made works that indirectly allude to the AIDS crisis. Borrowing from the popular American tradition of wax figures, Gober created a series of eerily realistic sculptures of body fragments. The first in the series, a wax copy of his own left leg, replete with body hair, was dressed in trousers, sock, and shoe (fig. 8.66). Placed directly against

8.66 Robert Gober Untitled, 1990. Wax, cotton, wood, leather shoe, and human hair, $10\% \times 20\% \times 5\%$ in $(27.2 \times 52 \times 14.2 \text{ cm})$. Hirshhorn Museum and Sculpture Garden, Smithsonian Institution, Washington, D.C. Joseph H. Hirshhorn Purchase Fund, 1990.

a wall, the leg fragment seems severed by the partition, suggesting an act of mutilation akin to Brook Watson's famous lost limb in John Singleton Copley's *Watson and the Shark* (see fig. 4.26). Gober recalled from childhood his mother's stories about working as a hospital nurse and holding amputated limbs after surgery. Yet, just as Copley's visual tale of Brook Watson evoked associations with Christ's martyrdom, so Gober's wax body fragments refer to his own Catholic upbringing and the church's cult of body relics honoring martyrs to the faith. Gober's own sense of fragmented being and martyrdom as a gay man arises in large measure from the Vatican's condemnation of homosexuality and established religion's tendency to interpret the AIDS plague as divine punishment for illicit sexual desire. However, as the critic Hal Foster has observed, Gober's amputated limbs and missing body parts also more broadly dissent from the technology of cybernetic space, which falsely promises a totally integrated system of digitalized images. Ironically, Gober uses wax sculpture, the popular medium that enraptured pre-industrial audiences, as an illusionist virtual reality.

Sexual Politics, Family Values, and Contemporary Art

Whether homosexual or heterosexual, American artists in general have felt besieged or persecuted by Christian conservatives. The religious right's clout markedly increased during the 1980s and 1990s, thanks to a cultural and political backlash against the leftist radicalism of the 1960s and 1970s. Conservatives successfully pressured the United States Congress in 1990 to prohibit the National Endowment for the Arts from funding projects that might be deemed obscene. This included but was "not limited to depictions of sadomasochism, homoeroticism, the sexual exploitation of children, or individuals engaged in sex acts and which, when taken as a whole, do not have serious literary, artistic, political, or scientific value" (cited in Stiles and Selz, p. 274). Of course, the problem of defining artistic worth is itself a political issue: Is it right that those in power should set aesthetic standards? Thus, in 1990, when Judy Chicago attempted to donate The Dinner Party (see fig. 8.59) to the University of the District of Columbia, a school that serves primarily African Americans, conservative U.S. congressmen, led by Republicans Robert K. Dornan and Dana Rohrabacher of California, denounced the art work as pornography or as a "weird" sexual display of female genitalia. Dornan condemned the National Endowment for the Arts for having awarded The Dinner Party project a grant of \$39,500 in the late 1970s. Congress even threatened to punish the financially strapped university for daring to accept Chicago's gift as a means for elevating the school's academic and cultural profile. Having hoped for a permanent exhibition space for The Dinner Party, Chicago regretfully withdrew her donation. She denounced the anti-intellectual, religious fanaticism of right-wing politicians, who suppress freedom of expression by demonizing feminists, gays and lesbians, and minority, outsider groups. After the collapse of the Soviet Union in 1991, America's victory in the Cold War encouraged right-wing Christian conservatives to redirect their focus from anti-communism toward an intensified moral campaign for "family values." This campaign has coupled attacks on "immoral" art and the feminist and gay rights movements with a legislative agenda to promote school prayer and government funding of private religious schools and church activities.

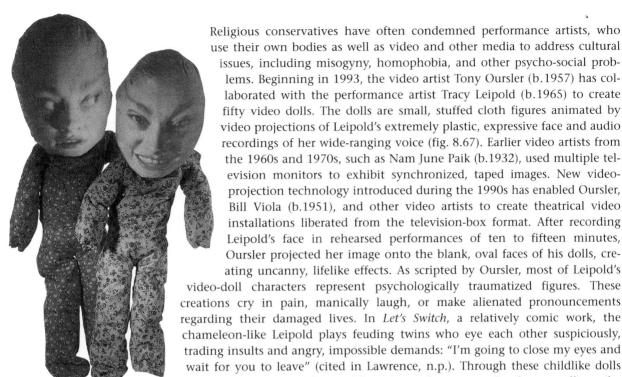

8.67 Tony Oursler Let's Switch, 1996. Mixed media with video projection, and performance by Tracy Leipold, $17 \times 11 \times 14$ in (43.2 imes 27.9 imes 35.6 cm). The Broad Art Foundation. Courtesy the artist and Metro Pictures.

The technologically sophisticated quality of this work seems belied by the childlike simplicity of the soft, flannel-covered dolls, one dressed in red, the other in green. Here these complementary colors suggest conflict rather than harmony. Elevated high on a pedestal, the small figures assume an eerie, larger-thanlife adult presence when animated by the video projection of Leipold's expressive face.

use their own bodies as well as video and other media to address cultural issues, including misogyny, homophobia, and other psycho-social problems. Beginning in 1993, the video artist Tony Oursler (b.1957) has collaborated with the performance artist Tracy Leipold (b.1965) to create fifty video dolls. The dolls are small, stuffed cloth figures animated by video projections of Leipold's extremely plastic, expressive face and audio recordings of her wide-ranging voice (fig. 8.67). Earlier video artists from the 1960s and 1970s, such as Nam June Paik (b.1932), used multiple tel-

evision monitors to exhibit synchronized, taped images. New videoprojection technology introduced during the 1990s has enabled Oursler, Bill Viola (b.1951), and other video artists to create theatrical video installations liberated from the television-box format. After recording Leipold's face in rehearsed performances of ten to fifteen minutes, Oursler projected her image onto the blank, oval faces of his dolls, creating uncanny, lifelike effects. As scripted by Oursler, most of Leipold's video-doll characters represent psychologically traumatized figures. These

creations cry in pain, manically laugh, or make alienated pronouncements regarding their damaged lives. In Let's Switch, a relatively comic work, the chameleon-like Leipold plays feuding twins who eye each other suspiciously, trading insults and angry, impossible demands: "I'm going to close my eyes and wait for you to leave" (cited in Lawrence, n.p.). Through these childlike dolls and careful editing of Leipold's twin performances, Oursler crystallizes the image of an entirely dysfunctional family relationship. In doing so, he implicitly casts doubt on the conservative faith in traditional family values as a social panacea for America's moral and cultural ills.

Contemporary Art and Architecture and the Disney Vision

Toward the end of the twentieth century, video artists fostered a tendency to make the exhibition space an entertaining spectacle. For anyone who has visited America's leading amusement parks, Disneyland in Anaheim, California, and Walt Disney World Resort near Orlando, Florida, Oursler's video dolls may perversely recall the thematic boat ride "It's a Small World," which features a multinational army of singing "Audio-Animatronics dolls" dressed in native costumes.

However, Disney's smiling, mechanized dolls unflaggingly accentuate laughter and hopes rather than Oursler's darkly disturbed world of tears and fears. As the creator of popular animated cartoons during the 1930s, Walt Disney (1901-66) became a major force in American culture after 1945, when he created children's television programs and first opened Disneyland in 1955. An ardent anti-communist hostile to unions and social welfare programs, Disney especially focussed on the "imagineering" of Main Street, U.S.A. (fig. 8.68). As the arterial heart of Disneyland and the Magic Kingdom, Main Street, U.S.A. was conceived as the idealized, nostalgic re-creation of Disney's Midwestern hometown. Dominated by pedestrians and historical-revival architecture, the litter-free, tree-lined street incongruously leads to a soaring medieval castle and a host of other "Magic Kingdom" attractions. Disney amusements reinforce the guiding cultural themes of social harmony and historical,

technological progress as culminating in the futuristic Tomorrowland.

Significantly, since 1984, when Michael Eisner became chairman of The Walt Disney Company's media and entertainment empire, several major architects have been hired for building projects. These ventures include hotels, restaurants, and a Team Disney corporate headquarters (1990) in Burbank, California.

Most notably, however, the architectural historians Vincent Scully and Beth Dunlop have praised Disney corporate executives for attempting to build Main Street, U.S.A., in real American towns and cities. While speculating that future Disney theme parks might help to revitalize otherwise depressed urban areas, these historians have especially praised Disney's development of Celebration, Florida, a new town south of Walt Disney World. Designed by New York architect Robert A. M. Stern (b.1939), a member of the company's board of directors, Celebration opened in 1996 as a traditional, pedestrian-friendly town. Cohesively arranged streets and squares, as well as homes with spacious porches and verandas in six different historical-revival styles, are intended to encourage old-fashioned neighborliness, according to the Celebration Company. The current real-estate prospectus by this Disney subsidiary adds that the development of over 700 homes with 2,000 residents is surrounded by a 4,700-acre greenbelt with walking paths and public golf course. Celebration is not a company town for Disney employees, since only a few, chosen by lottery, have been allowed to live in this carefully designed community, which plans to expand to a maximum population of 20,000. With prices for residential homes presently starting at \$195,000 it is difficult, in any case, to see how most Disney employees could afford to live in Celebration. Although not a private gated community with its own security police, Celebration is an Americana theme town and enclave for affluent citizens. Since the end of the Cold War, Disney's

8.68 Main Street, U.S.A. Walt Disney World Resort. © Disney Enterprises, Inc.

8.69 Jeff Koons Art Magazine Ads, 1989. Portfolio of four color lithographs, $74\% \times 45$ in $(188.6 \times 114.3 \text{ cm}).$ © Jeff Koons.

In this advertisement announcing a new exhibition of his work in New York, Chicago, and Cologne, Germany, Koons stands in the company of two women dressed only in bikinis. In a later series of works entitled Made in Heaven he posed with his wife (a pornographic film star) in a series of sexually explicit photographs that proclaimed their identities as the contemporary, media-created incarnation of Adam and Eve. vision of "It's a Small World" seems to have been realized economically and technologically by the triumph of global capitalism and the computerized advent of the Internet. However, at the community level, the notion that the socially exclusive Celebration, Florida, can serve as a model for a new urbanism seems as naively optimistic as the town's corporately conceived name. Like the interiors of American shopping malls, this small real-estate development is a relatively controlled, sanitized island surrounded by a regional sea of car-clogged highways and commercial strips. With the United States entering a new millennium, the problems of urban decay and suburban sprawl, as well as class, race, and gender relationships, will have to be politically negotiated in public, democratic institutions rather than in private, corporate boardrooms. As the frequent beneficiaries of corporate patrons, including Disney and other media giants, American artists and architects will have an especially difficult time ahead in developing critical, creative visions that challenge the private monopolization of culture and the social environment.

Even more than Warhol and other Pop artists, recent Postmodernists have underscored the commodity status of art by appropriating mass-produced consumer goods and manipulating corporate media imagery. As a former Wall Street commodities broker and an exhibitor of Duchampian, readymade objects, the New York artist leff Koons (b.1955) has especially personified the commodification of the visual arts. Koons has stated that his high-finance job as a salesman of commodity futures initially subsidized his art work and helped him "to remain independent from the commercial art world system" (p. 7). Yet he has also identified his artistic

career with the commercial world of the hard sell: "Salesmen are today's great communicators. They are out there pushing cars, real estate, advertising. That is where the real morality is played out in society today" (p.

Koons has unabashedly sold his art work through glossy art-magazine advertisements and commercial billboards depicting himself with scantily clad, voluptuous women (fig. 8.69). Critics from various positions on the political spectrum have condemned his commercial hucksterism and use of sexual, playboy imagery. Yet Koons's appropriations from America's corporate culture and his undisguised salesmanship seem brutally frank and honest when compared with the nostalgic urbanism of Disney's Main Street, U.S.A., and other multinational corporations' attempts to burnish their public, civic-minded images through the patronage of art and architecture. Furthermore, intentionally or not, Postmodernist artists such as Koons have compelled many critics and art historians to become more self-conscious about their own relationship to the art market and the economic processes that contribute to the production and consumption of culture.

DATE	POLITICS AND RELIGION	SCIENCE AND CULTURE
Pre- 1600	 Treaty of Tordesillas divides New World between Spain and Portugal, 1494 Walter Raleigh founds colony of Virginia on Roanoke Island, 1584–87 John White appointed governor of Roanoke Island colony, 1587 	 Christopher Columbus's first landfall in Western Hemisphere, 1492 John Cabot's voyages to North America, 1497–98 Martin Waldseemüller coins the name "America" for map of the New World, 1507
1600	 Jamestown colony founded, 1607 Mayflower pilgrims found Plymouth colony; John Carver first governor, 1620 Maryland founded by Lord Baltimore, 1632 Rhode Island founded by Roger Williams, 1636 	 John Rolfe introduces tobacco cultivation in the colony of Virginia, 1612 Harvard College founded, 1636 Roger Williams's A Key to the Languages of America, 1643
1650	 Duke of York seizes New Amsterdam (renamed New York), 1664 Pennsylvania founded by William Penn, 1681 Salem witch trials, 1692 	 First slave plantations established in the Carolinas, 1670 Anne Bradstreet's The Tenth Muse Lately Sprung up in America, 1678
1700	 Queen Anne's War between Britain and France over control of North American territories, 1702–13 New Orleans, LA, founded by French settlers, 1718 Spanish mission established, San Antonio, TX, 1718 	 Yale College founded, 1701 The Boston News-Letter, first colonial weekly paper, established, 1704
1720	 North and South Carolina become Crown Colonies, 1729 George Washington born, 1732 Georgia becomes 13th colony, 1733 Clergyman Jonathan Edwards preaches "The Great Awakening," fueling religious revivalism in New England, 1733 First Moravian (United Brethren) community established at Savannah, GA, 1735 William Byrd II founds the city of Richmond, VA, 1737 	 William Byrd II's surveying expedition, 1728 Boston physician Zabdiel Boylston becomes first American to inoculate patients against smallpox, 1721 Benjamin Franklin founds Junto, a scientific, philosophical society and predecessor to the American Philosophical Society, Philadelphia, 1727 New York newspaper publisher John Peter Zenger acquitted of seditious libel charges in a major victory for freedom of the press, 1735
1740	 King George's War between British and French colonies, 1744–48 Ohio Company formed to extend English colonial settlements westward, 1747 French construct Fort Duquesne (Pittsburgh) at the forks of the Ohio river, 1754 Seven Years' War (French and Indian War), 1756–63 	 Tuesday Club founded by Dr Alexander Hamilton in Annapolis, MD, 1745 Benjamin Franklin invents lightning conductor, 1752 First American Masonic Hall inaugurated in Philadelphia, 1755
1760	 British Parliament enacts Stamp Act, forcing anti-tax protests in colonies, 1765 British Parliament repeals Stamp Act, passes Declaratory Act, asserting the right to legislate laws in the colonies, 1766 British Parliament passes Townshend Acts requiring colonists to pay duties on tea and other imports, 1767 Boston Massacre, 1770 Boston Tea Party, 1773 British Parliament passes "Intolerable Acts," closing Boston's port, forcing Bostonians to quarter British troops, 1774 First Continental Congress meets, Philadelphia, 1774 War of Independence, 1775–83 Declaration of Independence, 1776 	 Harvard professor John Winthrop leads Newfoundland expedition to observe the transit of Venus across the sun, 1761 The St. Cecilia Society, the first musical society in America, founded in Charleston, SC, 1761 First American medical school established at the College of Philadelphia, 1765 Mastodon bones discovered at Big Bone Lick along the Ohio river, 1766 Phillis Wheatley, an African-American from Boston, publishes <i>Poems on Various Subjects</i>, 1773 "Yankee Doodle" becomes a popular revolutionary song for taunting British troops, 1775 Tom Paine's <i>Common Sense</i>, 1776

FINE ART AND PHOTOGRAPHY	ARCHITECTURE AND EARTH ART
 Map Rock, Givens Hot Springs, ID, c. 1400 c.e. (?) (1.1) Hand shape, Hopewell culture, OH, c. 200 B.C.E.—400 c.e. (1.8) Gorget or neck pendant, Spiro Site, OK, c. 1200–1350 c.e. (1.9) 	 Great Serpent Mound, Locust Grove, OH, c. 1070 C.E. (1.7) Monk's Mound, Cahokia, IL, c. 900–1200 C.E. (1.6) Pueblo, Taos, NM, pre-1400 (1.2) Kiva, Chaco Canyon, NM, pre-1400 (1.4) Cliff Palace, Mesa Verde, CO, pre-1400 (1.5)
 Anon., La Conquistadora, early 17th century (2.9) Seal of the Massachusetts Bay Company, 1629 (1.17) Boundary marker, Newbury, MA, 1636–50 (2.4) Indian fort, from News from America, 1638 (1.18) 	• San Estevan, Acoma, NM, 1629–42 (2.6–2.8)
 John Foster, Richard Mather, c. 1670 (2.26) Anon., John Freake, Elizabeth Freake, Baby Mary, c. 1671–74 (2.29, 2.30) John Foster, "The Dominion of the Moon in Man's Body," 1678 (2.5) City Hall, New Amsterdam (New York), 1679 (3.14) Thomas Smith, Self-Portrait, c. 1680–90 (2.28) Joseph Lamson (attrib.), Gravestone of Timothy Cutler, 1694 (2.31) 	 St. Luke's, Smithfield, VA, c. 1680 (2.14, 2.15) Old Ship Meetinghouse, Hingham, MA, 1681–1755 (2.20, 2.21) Parson Capen House, Topsfield, MA, 1683 (2.22, 2.23) Wren Building, Williamsburg, VA, 1695–8 (3.6)
 Justus Engelhardt Kühn, Henry Darnall III, c. 1710 (p. 76) John Simon after John Verelst, Etow Oh Koam and Ho Nee Yeath Taw No Row, 1710 (1.19, 1.20) Mohawk Indian king's mural, Macpheadris-Warner House, c. 1716 (1.21) 	• St. James's Church, Goose Creek, SC, 1708–19 (2.18)
 • John Potwine, Silver flagon, c. 1720–30 (2.19) • William Burgis (attrib.), A North East View of Boston, c. 1723 (2.25) • John Senex, A Front View of the Temple of Solomon, 1725 (3.7) • John Smibert, The Bermuda Group, 1729 (3.21) • John Smibert, Daniel, Peter, and Andrew Oliver, 1732 (3.24) • John Smibert, William Browne, 1734 (3.23) • John Faber, Governor Jonathan Belcher, 1734 (3.20) • Peter Pelham, The Reverend Benjamin Colman, 1735 (3.22) • Gustavus Hesselius, Tishcohan and Lapowinsa, 1735 (1.22, 1.23) • Elizabeth Hudson, Sampler, 1737 (2.16) 	 Dr. John Kearsley, Christ Church, PA, 1727–54 (2.1) Robert Twelves, Old South Meetinghouse, Boston, MA, 1729–30 (2.24) Westover, Charles City County, VA, 1730–34 (3.10, 3.11) Isaac Royall House, Medford, MA, 1733–37 (3.17, 3.18) Drayton Hall, Ashley River, SC, 1738–42 (3.12, 3.13)
 Robert Feke, Isaac Royall and His Family, 1741 (3.19) Anon., Belshazzar's Feast, c. 1742 (2.13) Robert Feke, James Bowdoin II and Mrs James Bowdoin, 1748 (3.3, 3.4) Fray Andrés Garcia, El Santo Entierro, 18th century (2.11) Alexander Hamilton, "Mr. Neilson's Anger," c. 1750 (3.5) John Singleton Copley, Mars, Venus, and Vulcan, c. 1754 (3.27) Benjamin Franklin, "Join or Die," 1754 (4.23) John Greenwood, Sea Captains Carousing in Surinam, c. 1758 (3.1) 	 Hexangular pulpit, 1750 (2.17) Peter Harrison, Touro Synagogue, Newport, RI, 1759–63 (2.33)
 John Valentine Haidt, Lamentation over Christ's Body, c. 1760 (2.12) Benjamin West, The Savage Chief (The Indian Family), c. 1761 (1.24) John Singleton Copley, Mrs. Samuel Quincy, c. 1761 (3.26) John Stevens II (attrib.), Gravestone of Rebecca Polock, c. 1764 (2.32) John Singleton Copley, Boy with a Squirrel, 1765 (3.28) Matthew Pratt, The American School, 1765 (4.20) William Williams, Deborah Hall, 1766 (3.25) Benjamin Franklin, Magna Britannia, c. 1766 (4.2) John Singleton Copley, Portrait of Paul Revere, 1768 (3.29) Paul Revere, Masonic Lodge 169, late 1760s (3.30) Benjamin West, The Departure of Regulus from Rome, 1769 (4.22) Benjamin West, The Death of General Wolfe, 1770 (4.21) Paul Revere, Bloody Massacre, 1770 (4.25) Samuel King, Portrait of the Reverend Ezra Stiles, 1771 (p. 38) Paul Revere, The Able Doctor, 1774 (4.3) John Singleton Copley, Watson and the Shark, 1778 (4.26) 	 Quaker Meetinghouse, Stony Brook, NJ, 1760 (2.2) William Buckland, Samuel Chase–Edward Lloyd House, Annapolis, MD, 1769–73 (3.15, 3.16) Pedro Huizar, San José y San Miguel de Aguayo portal, San Antonio, TX, c. 1770–75 (2.10) Thomas Jefferson, Monticello, Charlottesville, VA, 1770–1809 (4.16)

DATE	POLITICS AND RELIGION	SCIENCE AND CULTURE
1780	 Shays's Rebellion, a revolt by debt-ridden Massachusetts farmers, suppressed by government forces, 1786–87 Constitution of the U.S. ratified, 1789 George Washington 1st president of the U.S., 1789–97 American Bill of Rights, 1791 Fugitive Slave Act passed, making it illegal to aid runaway African-American slaves, 1793 Washington declares neutrality in British war against French revolutionary government, 1793 Naturalization Act passed requiring five-year residency for U.S. citizenship, 1795 Washington's "Farewell Address" warns against U.S. entanglements in foreign affairs, 1796 John Adams 2nd president of the U.S., 1797–1801 Alien and Sedition Acts passed amid fears that radical French Revolutionary politics were threatening the U.S., 1798 	 Great Seal of the United States adopted, 1782 Pennsylvania Evening Post, first daily paper in the U.S., begins publication, 1783 Thomas Jefferson's Notes on the State of Virginia, 1784–85 Peale's Museum (later Philadelphia Museum) opened in Philadelphia, 1786 John Fitch launches first American steamboat on Delaware river, 1787 Federalist papers published in support of U.S. Constitution, 1788 William Hill Brown publishes The Power of Sympathy, reputedly the first American novel, 1789 Benjamin Franklin's Autobiography posthumously published in Paris, 1791 Organized by Charles Willson Peale, the short-lived Columbianum or American Academy of the Fine Arts holds an art exhibition in Philadelphia's Philosophical Hall, 1795
1800	 Washington, DC, becomes the new national capital, as the government moves out of Philadelphia, 1800 Thomas Jefferson 3rd president of the U.S., 1801–9 Alien and Sedition Acts allowed to expire, 1802 Louisiana Purchase, 1803 War of 1812, 1812–15 American Bible Society founded in New York City, 1816 Spain cedes Florida to U.S., 1819 	 Library of Congress founded, 1800 American Academy of the Fine Arts founded, 1802 Lewis and Clark's expedition, 1804–6 Pennsylvania Academy of Fine Arts founded, 1805 Noah Webster's Compendious Dictionary of the English Language, 1806 Boston Athenaeum founded, 1807 Henry Wadsworth Longfellow born, 1807 (d. 1882) Francis C. Lowell opens first completely mechanized textile factory, Massachusetts, 1814
1820	 Missouri Compromise, 1820 Slave rebellion suppressed in Charleston, SC, 1822 Bureau of Indian Affairs established, 1824 House of Representatives chooses John Quincy Adams as president, 1825 John Adams and Thomas Jefferson both die July 4th, the 50th anniversary of the Declaration of Independence, 1826 Anti-Masonic movement, 1826–40 Democratic Party formed, Andrew Jackson elected first Democratic U.S. president, 1828 Workingmen's Party formed in New York, 1829 Joseph Smith founds first community of the Church of Jesus Christ of Latter-Day Saints (Mormons), 1830 Indian Removal Act, 1830 Nat Turner leads unsuccessful revolt of African-American slaves in Southampton County, VA, 1831 Anti-Slavery Society founded, 1833 Samuel F.B. Morse writes a series of nativist, anti-Catholic newspaper articles for the New York Observer, 1834 Anti-abolition riots break out in New York City and Philadelphia, 1834 Seminole Indian War, 1835–42 Texas becomes an independent republic after defeating Mexican troops at San Jacinto, 1836 U.S. troops force the removal of Cherokee Indians westward from Georgia, 1838 Ralph Waldo Emerson gives Harvard Divinity School Address, 1838 	 Washington Irving publishes The Sketch Book, a collection of stories featuring "Rip van Winkle" and "The Legend of Sleepy Hollow," 1820 Emma Willard founds the Troy Female Seminary, the first women's college-level school, Troy, NY, 1821 America's first school of science and engineering, later named the Rensselaer Polytechnic Institute, opens, 1824 The Marquis de Lafayette's grand tour of the U.S., 1824–25 Erie Canal opened, 1825 National Academy of Design founded, 1825 James Fenimore Cooper's Last of the Mohicans, 1826 Freedom's Journal, the first African-American paper, begins publication in New York City, 1827 John James Audubon's Birds of America, 1827–38 Noah Webster's An American Dictionary of the English Language, 1828 The Trumbull Gallery at Yale, the nation's first university art gallery, founded, 1831 William Lloyd Garrison founds The Liberator, an abolitionist periodical, 1831 Ralph Waldo Emerson's Nature, 1836 Samuel Morse develops electric telegraph, 1837 Nathaniel Hawthorne's Twice-Told Tales, 1837 American Art-Union founded, 1839 Retrospective exhibition of the paintings of Washington Allston at Chester Harding's Gallery in Boston, 1839

FINE ART AND PHOTOGRAPHY

ARCHITECTURE AND EARTH ART

- Anon., Master Mason's apron, c. 1780 (3.8)
- John Singleton Copley, Portrait of Elkanah Watson, 1782 (4.28)
- Benjamin West, American Commissioners, 1783-84 (4.29)
- Mather Brown, Portrait of Thomas Jefferson, 1786 (4.6)
- John Trumbull, The Death of General Joseph Warren, 1775, 1786 (4.30)
- John Trumbull, *The Declaration of Independence*, 1787–1820 (4.31)
- Jean-Antoine Houdon, George Washington, 1788 (4.39)
- Charles Willson Peale, William Smith and His Grandson. 1788 (4.40)
- Amos Doolittle, "View of the Federal Edifice in New York," 1789 (4.15)
- Charles Willson Peale, Benjamin Franklin, 1789 (4.41)
- Samuel Hill, View of the Triumphal Arch and Colonnade, 1790 (4.10)
- Samuel Jennings, Liberty Displaying the Arts and Sciences, 1790–92 (4.5)
- Anon., Liberty, c. 1790–1800 (p. 114)
- John Trumbull, General George Washington, Battle of Trenton, 1792 (4.32)
- Gilbert Stuart, George Washington, 1795-96 (4.36)
- Gilbert Stuart, George Washington (Lansdowne portrait), 1796 (4.38)

- Pierre Charles L'Enfant, plan of the City of Washington, 1791 (4.13)
- Charles Bulfinch, Massachusetts State House, Boston, MA, 1795-98 (4.12)

- Benjamin Henry Latrobe, Washington Mausoleum, c. 1800 (4.34)
- Washington Allston, Tragic Figure in Chains, 1800 (4.48)
- John Vanderlyn, The Death of Jane McCrea, 1804 (4.47)
- John Vanderlyn, Marius amid the Ruins of Carthage, 1807 (4.49)
- John Trumbull, View of the Falls of Niagara, c. 1808 (5.36)
- John Vanderlyn, Ariadne Asleep on the Island of Naxos, 1809–14 (4.50)
- Rembrandt Peale, The Roman Daughter, 1811 (4.45)
- Charles Robert Leslie, John Quincy Adams, 1816 (4.54)
- Washington Allston, Elijah in the Desert, 1817–18 (4.52)
- Washington Allston, Belshazzar's Feast, 1817-43 (4.51)

- Benjamin Henry Latrobe, Corn capital vestibule to the Supreme Court, 1808 (4.18)
- Benjamin Henry Latrobe, Tobacco-leaf capital, c. 1815 (4.19)
- Thomas Jefferson, University of Virginia plan, Charlottesville, VA, 1817–26 (4.44)

- Rembrandt Peale, The Court of Death, 1820 (4.46)
- Raphaelle Peale, Still Life, c. 1820-22 (5.30)
- Charles Willson Peale, The Artist in His Museum, 1822 (4.43)
- Samuel Morse, The Old House of Representatives, 1822 (4.53)
- John Trumbull, The Resignation of General Washington, 1822–24 (4.37)
- Gilbert Stuart, Portrait of Josiah Quincy, 1824 (5.6)
- William Rush, Wisdom, 1824 (4.4)
- Thomas Fletcher, Sidney Gardiner, DeWitt Clinton vase, 1824 (5.9)
- William Rush, The Schuylkill Enchained and Freed, 1825 (5.10, 5.11)
- Jeremiah Paul, Evangelist Campmeeting, c. 1826 (5.40)
- Thomas Cole, Kaaterskill Falls, 1826 (5.37)
- Thomas Cole, St. John in the Wilderness, 1827 (5.38)
- John Rubens Smith, View of the East Front of the Capitol, c. 1828 (4.17)
- Charles Bird King, The Anatomy of Art Appreciation, 1830 (5.29)
- Samuel Morse, Chapel of the Virgin at Subiaco, 1830 (5.32)
- John Quidor, Money Diggers, 1832 (5.15)
- George Catlin, Buffalo Bull's Back Fat, Blood Tribe, 1832 (5.43)
- Thomas Doughty, Mill Pond, Lowell, Massachusetts, c. 1833 (5.12)
- Thomas Cole, The Course of Empire: The Savage State, 1834 (5.41)
- Thomas Cole, The Course of Empire: Consummation, 1835–36 (5.42)
- Thomas Cole, View from Mount Holyoke (The Oxbow), 1836 (5.39)
- William Sidney Mount, Farmers Nooning, 1836 (5.2)
- John Chapman, Baptism of Pocahontas, 1613, 1836–40 (5.46)
- Hiram Powers, Daniel Webster, 1836-41 (5.21)
- Robert W. Weir, Embarkation of the Pilgrims, 1620, 1836-43 (5.45)
- Horatio Greenough, Rescue, 1837–53 (5.48)
- William Sidney Mount, The Painter's Triumph, 1838 (5.4)
- Thomas Crawford, Orpheus, 1839-43 (5.3)

- John Haviland, Eastern Penitentiary, Philadelphia, PA, 1821–37 (5.7)
- Alexander Parris, Quincy Market, Boston, MA, 1825-26 (5.5)
- Bunker Hill Monument, Charlestown, MA, 1825-43 (p. 162)
- · Jacob Bigelow, Gateway, Mount Auburn Cemetery, Cambridge, MA, 1831 (5.25)
- Campbell-Whittlesey House, Rochester, NY, 1835–36 (5.14)

DATE	POLITICS AND RELIGION	SCIENCE AND CULTURE
1840	 Dorr's Rebellion in Rhode Island forces liberalization of voting requirements in the state, 1842 Florida becomes 27th state, 1845 Texas annexed by the U.S. and becomes 28th state, 1845 Mexican War, 1846–48 Mormons found Salt Lake City, UT, 1847 Seneca Falls convention on universal suffrage, 1848 Free Soil Party organized in opposition to slavery's territorial expansion, 1848 Compromise of 1850 strengthens Fugitive Slave Act while admitting California as a free state and abolishing slave trade in the District of Columbia, 1850 First American chapter of the Young Men's Christian Association (YMCA) opens in Boston, 1851 Sioux Indians give up land in Iowa and Minnesota to U.S. government, 1851 Commodore Matthew C. Perry leads U.S. fleet to Japan, seeking to open up trade, 1853 Gadsden Purchase, 1853 Kansas-Nebraska Act repeals Missouri Compromise of 1820 and allows all territories to permit or prohibit slavery, 1854 	 Edgar Allen Poe's Tales of the Grotesque and Arabesque, 1840 George Catlin's Letters and Notes on the Manners, Customs, and Condition of the North American Indians, 1841 New York Philharmonic founded, 1842 P.T. Barnum's American Museum opens in New York City, 1842 Migration to Oregon Territory over Oregon Trail begins, 1843 Smithsonian Institution established, 1846 American Medical Association founded, 1847 American Association for the Advancement of Science (AAAS) founded, 1848 California Gold Rush, 1849 Nathaniel Hawthorne's The Scarlet Letter, 1850 Herman Melville's Moby Dick, 1851 Harriet Beecher Stowe's Uncle Tom's Cabin, 1852 Henry David Thoreau's Walden, 1854 Walt Whitman's Leaves of Grass, 1855 Frank Leslie's Illustrated Newspaper begins publication in New York City, 1855 American Institute of Architects founded, 1857
1860	 U.S. Secret Service established, 1860 Abraham Lincoln 16th president of the U.S., 1861–65 Confederate States of America formed, 1861 Seventh-Day Adventists founded, 1861 American Civil War, 1861–65 Homestead Act, 1862 Emancipation Act, 1863 Thirteenth Amendment to U.S. Constitution ratified, abolishing slavery, 1865 President Lincoln assassinated, 1865 Ku Klux Klan formed, 1866 First Young Women's Christian Association (YWCA) opens in Boston, 1866 Reconstruction Acts, passed over President Andrew Johnson's vetoes, divide South into five military districts, 1867 Purchase of Alaska from Russia, 1867 Impeached by the House of Representatives, President Johnson is tried and acquitted by the Senate, 1868 Susan B. Anthony and Elizabeth Cady Stanton organize the National American Woman Suffrage Association, 1869 Reform Rabbi Isaac Meyer Wise organizes Union of Hebrew Congregations in Cincinnati, 1873 National Women's Christian Temperance Union founded, 1874 U.SHawaii commercial treaty, 1875 National Liberal League founded, 1876 Battle of Little Bighorn ("Custer's Last Stand"), 1876 Reconstruction ends as federal occupying troops leave the South, 1877 U.SSamoa treaty establishes a coaling station for U.S. Navy, 1878 Mary Baker Eddy founds First Church of Christ, Scientist, 1879 	 Elisha Otis patents a steam-powered elevator, 1861 Transcontinental telegraph service established between New York and San Francisco, 1861 National Academy of Sciences founded, 1863 New York engineer Alexander Holley acquires American rights to the Bessemer steelmaking process, 1863 Abraham Lincoln's Gettysburg Address, 1863 Massachusetts Institute of Technology (MIT) opens in Cambridge, MA, 1865 First elevated railroad begins service in New York City, 1867 Howard University chartered, 1867 Horatio Alger's Ragged Dick; or Street Life in New York, 1867 Christopher L. Sholes patents the first practical typewriter, 1868 Louisa May Alcott's Little Women, 1868 Union Pacific and Central Pacific railroads meet at Promontory Point, UT, 1869 John D. Rockefeller forms the Standard Oil Company of Ohio, 1870 Fire destroys large portions of Chicago, 1871 Yellowstone National Park established, 1872 Bethlehem Steel begins manufacturing in Pittsburgh, PA, 1873 Louis Comfort Tiffany opens a factory for producing artistic glass household objects, 1874 Mark Twain's The Adventures of Tom Sawyer, 1876 Thomas Edison establishes the nation's first industrial research laboratory, Menlo Park, NJ, 1876 Centennial Exposition, Philadelphia, 1876 Alexander Graham Bell invents the telephone, 1876 Society of American Artists founded, 1878 Edison patents the phonograph, 1878

FINE ART AND PHOTOGRAPHY

- Horatio Greenough, George Washington, 1840 (4.35)
- Jeremiah Pearson Hardy, Catherine Wheeler Hardy and Her Daughter, 1842 (5.33)
- Hiram Powers, The Greek Slave, 1843 (5.61)
- Henry F. Darby, Portrait of Reverend John Atwood and His Family, 1845 (5.34)
- George Caleb Bingham, Jolly Flatboatmen, 1846 (5.50)
- Asa Ames, Phrenological Head, 1847–50 (5.20)
- Richard Caton Woodville, War News from Mexico, 1848 (5.28)
- Thomas Chambers, Mount Auburn Cemetery, c. 1850 (5.24)
- Rafael Aragón, The Flight into Egypt, c. 1850 (5.31)
- Albert S. Southworth and Josiah J. Hawes, Mount Auburn Cemetery, c. 1850 (5.27)
- Fitz Hugh Lane, Boston Harbor at Sunset, 1850-55 (5.55)
- Albert S. Southworth and Josiah J. Hawes, Lemuel Shaw, 1851 (5.64)
- George Caleb Bingham, Daniel Boone Escorting Settlers Through the Cumberland Gap, 1851–52 (5.49)
- Asher B. Durand, God's Judgment upon Gog, c. 1852 (5.51)
- Asher B. Durand, Progress (The Advance of Civilization), 1853 (5.52)
- Robert Duncanson, Uncle Tom and Little Eva, 1853 (5.60)
- Lilly Martin Spencer, Shake Hands?, 1854 (5.35)
- Frederic Church, Niagara Falls, 1857 (5.57)
- Harriet Hosmer, Zenobia, 1857–59 (5.62)
- Frederic Church, The Heart of the Andes, 1859 (5.58)

- ARCHITECTURE AND EARTH ART
- Gaineswood, Demopolis, AL, 1843–59 (5.16)
 Alexander Jackson Davis, Gatehouse,
- Alexander Jackson Davis, Gatenouse, Llewellyn Park, Orange, NJ, 1853 (5.19) • John Richards, Watertown, WI, 1854–56
- Thomas Crawford, *Progress of Civilization*, Capitol, Washington, DC, 1855–63 (**5.47**)
- Thomas U. Walter, United States Capitol, Senate and House Wings, Washington, DC, 1855–65 (5.44)
- Richard Morris Hunt, Studio Building, 15 West Tenth Street, New York City, 1857 (6.5)
- Alexander Jackson Davis, Edward W. Nicholls House, Llewellyn Park, Orange, NJ, 1858–59 (5.17)

- Anon., Harriet Hosmer at work on her Statue of Senator Benton,
 ε. 1861 (5.63)
- Emanuel Leutze, Westward the Course of Empire Takes Its Way, 1861–62 (5.1)
- Matthew B. Brady, On the Antietam Battlefield, 1862 (5.65)
- Alexander Gardner and Timothy O'Sullivan, A Harvest of Death, Gettysburg, Pennsylvania, 1863 (5.66)
- John La Farge, Magnolia Grandiflora, c. 1863 (6.45)
- Jasper Francis Cropsey, Starrucca Viaduct, Pennsylvania, 1865 (5.53)
- Winslow Homer, The Veteran in a New Field, 1865 (6.18)
- Martin Johnson Heade, Two "Sun Gems" and a "Crimson Topaz," 1866 (5.59)
- Edmonia Lewis, Forever Free, 1867 (6.16)
- Thomas Satterwhite Noble, The Price of Blood, 1868 (6.17)
- William Henry Rinehart, Sleeping Children, 1869 (5.26)
- John Rogers, The Fugitive's Story, 1869 (6.15)
- Eastman Johnson, The Brown Family, 1869 (6.19)
- James McNeill Whistler, Arrangement in Gray and Black (Portrait of the Artist's Mother), 1871 (6.49)
- John F. Kensett, Eaton's Neck, Long Island, 1872 (5.56)
- Winslow Homer, Snap the Whip, 1872 (6.20)
- Timothy O'Sullivan, Ancient Ruins in the Canyon de Chelly, New Mexico, 1873 (1.3)
- Daniel Chester French, Minute Man, 1873-75 (6.33)
- Thomas Eakins, The Gross Clinic, 1875 (p. 226)
- James McNeill Whistler, Nocturne in Black and Gold, c. 1875 (6.50)
- Margaret Foley, Cleopatra, 1876 (5.13)
- William Wetmore Story, Jerusalem, 1876 (6.24)
- James McNeill Whistler, Harmony in Blue and Gold, 1876-77 (6.51)
- Thomas Eakins, William Rush Carving his Allegorical Figure of the Schuylkill River, 1876–77 (6.25)
- Mary Cassatt, Reading "Le Figaro," 1877–78 (6.39)
- Jasper Francis Cropsey, Design for elevation of Gilbert Elevated Railroad, c. 1878 (5.54)
- Mary Cassatt, At the Opera (In the Loge), 1879 (6.38)
- Albert Pinkham Ryder, The Dead Bird, c. late 1870s (6.47)

- Samuel Sloan, Longwood, Natchez, Mississippi, begun 1860 (5.23)
- Peter B. Wight, National Academy of Design, New York City, 1862–65 (6.6)
- John A. Roebling, Brooklyn Bridge, New York City, 1869–83 (6.7)
- Frank Furness and George W. Hewitt, Pennsylvania Academy of Fine Arts, Philadelphia, PA, 1871–76 (6.23)
- Richard Morris Hunt, Tribune Building, New York City, 1875 (6.8)
- Henry Hobson Richardson with John La Farge, Trinity Church, Boston, MA, c. 1875 (6.44)
- McKim, Mead, and White, Casino interior, Newport, RI, 1879–80 (6.4)

DATE	POLITICS AND RELIGION	SCIENCE AND CULTURE
1880	 President James Garfield assassinated, 1881 Chinese Exclusion Act, 1882 American Federation of Labor launched, 1886 Pan-American Union formed, 1890 Massacre of Wounded Knee, South Dakota, 1890 National American Woman Suffrage Association founded, 1890 Immigration center established on Ellis Island, New York City, 1892 Hawaii becomes a U.S. Protectorate, 1893 Spanish-American War, 1898 	 American Red Cross founded, 1881 Mark Twain's Adventures of Huckleberry Finn, 1884 Ezra Pound born, 1885 (d. 1972) Coca-Cola invented, 1886 Charlie Chaplin born, 1889 (d. 1977) Daughters of the American Revolution founded, 1890 World Columbian Exposition, Chicago, 1893 Klondike Gold Rush, 1896 Ernest Hemingway born, 1899 (d. 1961)
1900	 President William McKinley assassinated, 1901 Theodore Roosevelt 26th president of the U.S., 1901–09 International Workers of the World union founded, 1905 Paterson Strike Pageant, 1913 Woodrow Wilson 28th president of the U.S., 1913–21 World War I begins in Europe, 1914 U.S. enters World War I, 1917 Russian Revolution, 1917 U.S. acquires Virgin Islands from Denmark, 1917 World War I ends, 1918 Eighteenth Amendment to the Constitution (Prohibition), 1919 (repealed 1933) 	 Walt Disney born, 1901 (d. 1966) First radio broadcast, from Plymouth, MA, 1906 Orville and Wilbur Wright achieve first powered flight, Kitty Hawk, NC, 1908 Exhibition of "The Eight," New York, 1908 Ford Model T goes into production, 1908 Leo Baekeland develops Bakelite, the first synthetic polymer, 1909 First movie studio opens in Hollywood, 1911 Armory Show, New York City, 1913 Henry Ford builds first moving assembly line, Detroit, 1913 Panama Canal opened, 1914 D.W. Griffith's Birth of a Nation, 1915 H.L. Mencken's The American Language, 1919
1920	 Nineteenth Amendment to the Constitution (women's suffrage), 1920 Immigration controls introduced, 1921 Calvin Coolidge 30th president of the U.S., 1923–29 "Monkey Trial," Dayton, TN, 1925 Wall Street Crash begins Great Depression, 1929 Nation of Islam founded, 1930 Franklin D. Roosevelt 32nd president of the U.S., 1933–45 Roosevelt launches New Deal, 1933 World War II begins in Europe, 1939 	 Margaret Sanger founds American Birth Control League, 1921 First talking picture, <i>The Jazz Singer</i>, 1927 Charles Lindbergh's solo flight of the Atlantic, 1927 First television broadcast in the U.S., 1928 Technicolor introduces full color film, 1930 Maiden flight of first modern airliner, the Boeing 247, 1933 Artists' Union founded, 1934 Works Progress Administration and Federal Arts Project established, 1935 Wallace Carothers invents nylon, 1935 First feature-length cartoon, <i>Snow White and the Seven Dwarfs</i>, 1937

ARCHITECTURE AND EARTH ART FINE ART AND PHOTOGRAPHY • Henry Hobson Richardson, Marshall Field • William Merritt Chase, In the Studio, c. 1880 (6.55) • Thomas Pollock Anshutz, The Ironworkers' Noontime, 1880 (6.30) Warehouse, Chicago, IL, 1885–87 (6.10) • Augustus Saint-Gaudens, David Farragut Memorial, New York, 1881 (6.34) • McKim, Mead, & White, Boston Public Library, Boston, MA, 1887-95 (6.41) • John Singer Sargent, Madame X, 1883–84 (6.40) • Louis Sullivan, Wainwright Building, • Augustus Saint-Gaudens, Shaw Memorial, Boston, 1884–97 (6.35) • Albert Pinkham Ryder, Jonah, c. 1885 (6.48) St. Louis, MO, 1890-91 (6.9) • Thomas Eakins, The Swimming Hole, c. 1885 (6.27) • Daniel H. Burnham, Masonic Temple, Chicago, IL, 1890-92 (6.32) • Thomas Eakins, Motion Study, 1885 (6.29) • World's Columbian Exposition, Chicago, IL, • Winslow Homer, The Fog Warning, 1885 (6.21) • William Michael Harnett, After the Hunt, 1885 (6.22) 1893 (6.11) • Richard Morris Hunt, Biltmore and library, • William Merritt Chase, James A.M. Whistler, 1885 (6.52) • John Twachtman, Arques-la-Bataille, 1885 (6.54) Asheville, NC, 1895 (6.1, 6.2) • Albert Bierstadt. The Last of the Buffalo. 1889 (6.43) • George Inness, Niagara, 1889 (6.46) • Childe Hassam, Washington Arch, Spring, 1890 (6.56) • Thomas Dewing, After Sunset (Summer Evening), 1892 (6.53) • Henry Ossawa Tanner, The Banjo Lesson, 1893 (6.37) • Charles C. Curran, World's Columbian Exposition of 1893, 1893 (6.12) • John Singer Sargent, Frieze of the Prophets, 1895 (6.42) • Thomas Eakins, Portrait of Henry O. Tanner, 1900 (6.36) • Frank Lloyd Wright, Ward W. Willitt's House, Highland Park, IL, 1900-02 (6.14) • Alfred Stieglitz, Spring Showers—New York, 1900 (7.13) • McKim, Mead, & White, Pennsylvania • Edward Steichen, Self-Portrait with Palette and Brush, 1902 (7.10) • George Benjamin Luks, The Spielers, 1905 (7.4) Station, New York City, 1906–10 (7.1, 7.2) • Cass Gilbert, Woolworth Building, New York • Robert Henri, Eva Green, 1907 (7.5) • Alfred Stieglitz, The Steerage, 1907 (7.12) City, 1911-13 (7.19) • John Sloan, Hairdresser's Window, 1907 (7.7) • Maurice Prendergast, St. Malo, c. 1907 (7.9) • George Bellows, Pennsylvania Excavation, c. 1907–09 (7.3) • George Bellows, Both Members of This Club, 1909 (7.6) • Max Weber, Composition with Three Figures, 1910 (7.15) • Lewis Hine, Breaker Boys, 1911 (7.11) • Alvin Langdon Coburn, The Octopus, 1912 (7.17) • John Marin, Woolworth Building, No. 31, 1912 (7.18) • Max Weber, New York, 1913 (7.16) • I.F. Griswold. The Rude Descending the Staircase, 1913 (7.22) • Robert Edmond Jones, Paterson Strike Pageant cover, 1913 (7.23) • Marsden Hartley, Warriors, 1913 (7.24) • Joseph Stella, Battle of Lights, Coney Island, Mardi Gras, 1913-14 (7.20) • Morgan Russell, Cosmic Synchromy, 1913–14 (p. 284) • Marsden Hartley, Portrait of a German Officer, 1914 (7.25) • John Sloan, Class War in Colorado, 1914 (7.8) • Morton Schamberg, Mechanical Abstraction, 1916 (7.30) • Abraham Walkowitz, New York, 1917 (7.27) • Elie Nadelman, Tango, 1919 (7.41) • Charles Demuth, Incense of a New Church, 1921 (7.31) • Albert Kahn, Ford Motor Company, Glass • John Storrs, New York, c. 1925 (7.39) Plant, Dearborn, MI, 1922 (7.33) • William van Alen, The Chrysler Building, • Georgia O'Keeffe, City Night, 1926 (7.36) • Thomas Hart Benton, 1927-New York Today, 1927 (7.43) New York City, 1928-30 (7.32)

- Charles Sheeler, Criss-Crossed Conveyors, Ford Plant, 1927 (7.34)
- John Steuart Curry, Baptism in Kansas, 1928 (7.42)
- Grant Wood, American Gothic, 1930 (7.44)
- Charles Sheeler, Classic Landscape, 1931 (7.35)
- Alexander Calder, A Universe, 1934 (7.40)
- Aaron Douglas, Aspects of Negro Life: Song of the Towers, 1934 (7.49)
- Moses Sover, Artists on WPA, 1935 (7.48)
- Dorothea Lange, Southern Pacific Railroad Billboard, 1937 (7.45)
- Edward Weston, Dante's View, Death Valley, 1938 (7.47)
- Raphael Sover, Reading from Left to Right, 1938 (7.51)

• Frank Lloyd Wright, Fallingwater, Bear Run, PA, 1937 (7.38)

DATE	POLITICS AND RELIGION	SCIENCE AND CULTURE
1940	 Atlantic Charter issued by Roosevelt and Winston Churchill, 1941 Japanese attack on Pearl Harbor brings U.S. into World War II, 1941 American troops land in Normandy, 1944 Conference between Roosevelt, Churchill, and Stalin, Yalta, 1945 Harry Truman 33rd president of the U.S., 1945–53 U.S. drops atomic bombs on Hiroshima and Nagasaki, 1945 World War II ends, 1945 United Nations established, 1945 CIA established, 1947 NATO established, 1949 Korean War, 1950–53 Dwight D. Eisenhower 34th president of the U.S., 1953–61 Heyday of McCarthyism, 1953–54 Racial segregation in schools banned, 1954 Bus boycott, Montgomery, Alabama, 1955 	 Orson Welles's Citizen Kane, 1941 Pan-Am begins round-the-world commercial flights, 1947 Invention of transistor, 1947 William Faulkner receives Nobel Prize for Literature, 1949 John Cage's Theater Piece #2, 1952 Color television becomes available in the U.S., 1952 Arthur Miller's The Crucible, 1953 First credit card, the Diners' Club, launched, 1955 First transatlantic telephone cable laid, 1956 Jack Kerouac's On the Road, 1957
1960	 John Kennedy 35th president of the U.S., 1961–63 Berlin Wall erected, 1961 Cuban Missile Crisis, 1962 President Kennedy assassinated, 1963; Lyndon Johnson 36th president of the U.S., 1963–69 Civil Rights Act, 1964 Vietnam War, 1964–75 Martin Luther King, Jr., assassinated, 1968 Richard Nixon 37th president of the U.S., 1969–74 Watergate scandal, 1972–74 President Nixon resigns, 1974; Gerald Ford 38th president of the U.S., 1974–77 Jimmy Carter 39th president of the U.S., 1977–81 Camp David Accords between Israel and Egypt, negotiated by President Carter, 1978 Moral Majority founded, 1979 Iran Hostage Crisis, 1979–81 	 Oral contraceptive pill goes on sale in the U.S., 1960 Joseph Heller's Catch-22, 1961 Rachel Carson's The Silent Spring, 1962 Martin Luther King, Jr., receives Nobel Peace Prize, 1964 Peace Corps founded, 1966 First moon landing, 1969 Gilbert Hyatt invents microprocessor, 1970 Boeing introduces first jumbo jet, 1970 Bill Gates and Paul Allen form Microsoft company, 1975 Apollo-Soyuz project, 1975
1980	 Ronald Reagan 40th president of the U.S., 1981–89 George Bush 41st president of the U.S., 1989–93 Destruction of Berlin Wall ends Cold War, 1989 Gulf War, 1990–91 Bill Clinton 42nd president of the U.S., 1993– Welfare Reform Act, 1996 President Clinton acquitted by the U.S. Senate of impeachment charges, 1999 U.S. turns over Panama Canal to Panama, 1999 	 Space shuttle <i>Columbia</i> launched, 1981 Apple launches first graphics-based Macintosh, 1984 Hubble space telescope goes into orbit, 1990 Toni Morrison, Nobel Prize for Literature, 1993 New York Mayor Giuliani threatens to close Brooklyn Museum of Art over controversial British art exhibition, 1999 Entire genetic code of a human chromosome is mapped, 1999

FINE ART AND PHOTOGRAPHY

- Stuart Davis, Hot Still-scape for 6 Colors—7th Avenue Style, 1940 (7.50)
- Jacob Lawrence, Migration of the Negro, Panel 50, 1940–41 (8.3)
- Mark Rothko, Antigone, 1941 (8.13)
- Edward Hopper, Nighthawks, 1942 (8.10)
- Jean Carlu, Gift Packages for Hitler, 1942 (8.1)
- Joseph Cornell, Habitat Group for a Shooting Gallery, 1943 (8.15)
- Adolph Gottlieb, Hands of Oedipus, 1943 (8.14)
- Jackson Pollock, Guardians of the Secret, 1943 (8.18)
- Arshile Gorky, The Liver Is the Cock's Comb, 1944 (8.16)
- Ben Shahn, For Full Employment after the War: Register/Vote, 1944 (8.2)
- Louise Bourgeois, The Blind Leading the Blind, c. 1947–49 (8.29)
- Barnett Newman, Onement I, 1948 (8.22)
- Robert Motherwell, At Five in the Afternoon, 1949 (8.17)
- Lee Krasner, Composition, 1949 (8.19)
- Jackson Pollock, Lavender Mist, Number I, 1950 (8.20)
- Hans Namuth, Jackson Pollock at work, 1950 (8.21)
- George Tooker, The Subway, 1950 (8.11)
- Elaine de Kooning, Conrad, Number 2, 1950 (8.24)
- Willem de Kooning. *Woman I.* 1950–52 (p. 328)
- Helen Frankenthaler, Mountains and Sea, 1952 (8.30)
- David Smith, The Hero, 1952 (8.27)
- Mark Rothko, Green and Maroon, 1953 (8.23)
- Burgess Collins ("Jess"), Tricky Cad—Case I, 1954 (8.43)
- Robert Rauschenberg, Bed, 1955 (8.32)
- Jasper Johns, Target with Plaster Casts, 1955 (8.36)
- Louise Nevelson, Sky Cathedral, 1958 (8.26)
- Robert Frank, U.S. 285, New Mexico, 1958 (8.12)
- Morris Louis, Ambi II, 1959 (8.31)
- Mark di Suvero, Hankchampion, 1960 (8.25)
- Frank Stella, Pagosa Springs, 1960 (8.35)
- Allan Kaprow, Chicken, 1962 (8.33)
- Ad Reinhardt, Abstract Painting No. 5, 1962 (8.28)
- Andy Warhol, Installation of Campbell's Soup Cans, 1962 (8.45)
- Andy Warhol, Marilyn Monroe's Lips, 1962 (8.46)
- Robert Morris, I-Box (open), 1962 (8.37)
- Tony Smith, Die, 1962 (8.38)
- Andy Warhol, Orange Disaster, 1963 (8.47)
- Roy Lichtenstein, Drowning Girl, 1963 (8.44)
- Bruce Nauman, Self-Portrait as a Fountain, 1966 (8.34)
- Edward Kienholz, The Portable War Memorial, 1968 (8.55)
- Donald Judd, Untitled, 1969 (8.39)
- Carl Andre, Steel Magnesium Plain, 1969 (8.40)
- Robert Irwin, Untitled, 1969 (8.41)
- Duane Hanson, Motorcycle Accident, 1969 (8.48)
- Eva Hesse, Untitled, 1970 (8.42)
- Hans Haacke, Shapolsky et al. Manhattan Real Estate Holdings, 1971 (8.52)
- Betye Saar, The Liberation of Aunt Jemima, 1972 (8.58)
- Leon Golub, Vietnam II, 1973 (8.56)
- Cindy Sherman, Untitled Film Still No. 3, 1977 (8.60)
- Judy Chicago, The Dinner Party, 1979 (8.59)
- Richard Prince, Untitled, 1980 (8.61)
- Barbara Kruger, Your Comfort Is My Silence, 1981 (8.62)
- Maya Lin, Vietnam Memorial, Washington, DC, 1981-84 (8.57)
- Jenny Holzer, Truisms, 1977–79, 1982 (8.63)
- Julian Schnabel, Portrait of Andy Warhol, 1982 (8.64)
- Ross Bleckner, Architecture of the Sky III, 1988 (8.65)
- Jeff Koons, Art Magazine Ads, 1988 (8.69)
- Robert Gober, Untitled, 1990 (8.66)
- Tony Oursler, Let's Switch, 1996 (8.67)

- ARCHITECTURE AND EARTH ART
- John Graham & Co., Northgate Regional Shopping Center, Seattle, WA, 1947–50 (8.5)
- Ludwig Mies van der Rohe, Lake Shore Drive Apartments, Chicago, IL, 1951 (8.8)
- Levittown, NY, 1954 (8.4)
- Ludwig Mies van der Rohe and Philip Johnson, Seagram Building, New York City, 1954–58 (8.9)
- Kleinweber, Yamasaki, & Hellmuth,
- Pruitt-Igoe Houses, St. Louis, MO, 1955 (8.7)
 Frank Lloyd Wright, Solomon R. Guggenheim Museum, New York City, 1956–59 (8.51)

- Robert Venturi and John Rauch, Guild House, Philadelphia, PA, 1960–63 (8.49)
- Robert Smithson, *Spiral Jetty*, Great Salt Lake, UT. 1969–70 (8.54)
- Christo and Jeanne-Claude, Valley Curtain, Rifle Gap, CO, 1970–72 (8.53)
- Frank Gehry, Santa Monica Place, Santa Monica, CA, 1979–81 (8.6)

- Frank Gehry & Associates, Chiat Day Mojo Offices, Venice, CA, 1985–91 (8.50)
- Richard Meier, Getty Center, Los Angeles, CA, 1997
- I.M. Pei, Rock and Roll Hall of Fame, Cleveland, OH, 1998

Bibliography

GENERAL WORKS, SURVEYS, ANTHOLOGIES

- Baigell, Matthew. A Concise History of American Painting and Sculpture. Rev. edn. New York: HarperCollins; Icon Editions, 1996.
- Baigell, Matthew. Dictionary of American Art. New York: Harper & Row; Icon Editions, 1979.
- Brown, Milton W., et al. American Art: Painting, Sculpture, Architecture, Decorative Arts, Photography. Englewood Cliffs, NJ, and New York: Prentice-Hall and Harry N. Abrams, 1979.
- Burnham, Patricia M. and Lucretia Hoover Giese. *Redefining American History Painting*. Cambridge, MA, and New York: Cambridge University Press, 1995.
- Calo, Mary Ann, ed. *Critical Issues in American* Art. Boulder, CO: Westview Press, 1998.
- Craven, Wayne. American Art: History and Culture. Madison, WI: Brown & Benchmark, 1994.
- Craven, Wayne. *Sculpture in America*. New York: Thomas Y. Crowell, 1968.
- Doezema, Marianne and Elizabeth Milroy, eds. Reading American Art. New Haven, CT: Yale University Press, 1998.
- Gowans, Alan. Images of American Living: Four Centuries of Architecture and Furniture as Cultural Expression. New York: Harper & Row; Icon Editions, 1976.
- Greenough, Sarah, et al. On the Art of Fixing a Shadow: One Hundred and Fifty Years of Photography. Washington, DC: National Gallery of Art, 1989.
- Greenthal, Kathryn, et al. American Figurative Sculpture in the Museum of Fine Arts, Boston. Boston, MA: Museum of Fine Arts, 1986
- Handlin, David P. American Architecture. London: Thames & Hudson, 1985.
- Harris, Neil. *The Artist in American Society: The Formative Years, 1790–1860.* New York: G. Braziller, 1966.
- Hughes, Robert. American Visions: The Epic History of Art in America. New York: Alfred A. Knopf, 1997.
- James-Gadzinski, Susan and Mary Mullen Cunningham. American Sculpture in the Museum of American Art of the Pennsylvania Academy of the Fine Arts. Philadelphia, PA: Museum of American Art of the Pennsylvania Academy of the Fine Arts, 1997.
- McCoubrey, John W., ed. *American Art,* 1700–1960: Sources and Documents. Englewood Cliffs, NJ: Prentice-Hall, 1965.
- Miller, David C., ed. American Iconology: New Approaches to Nineteenth-Century Art and Literature. New Haven, CT: Yale University Press, 1993.
- Patton, Sharon F. African American Art. Oxford and New York: Oxford University Press, 1998.
- Powell, Richard J. *Black Art and Culture in the* 20th Century. London: Thames & Hudson, 1997.
- Rubinstein, Charlotte Streifer. American Women Artists from Early Indian Times to the Present. New York: Avon Books, 1982.
- Rubinstein, Charlotte Streifer. American Women Sculptors: A History of Women Working in Three Dimensions. Boston, MA: G.K. Hall, 1990.
- Scully, Vincent Jr. American Architecture and Urbanism. New York: Henry Holt, 1988.

- Spencer, Harold, ed. *American Art: Readings from* the Colonial Era to the Present. New York: Charles Scribner's Sons, 1980.
- Taylor, Joshua C. *America as Art*. New York: Harper & Row; Icon Editions, 1976.
- Taylor, Joshua C. The Fine Arts in America. Chicago, IL: University of Chicago Press, 1979
- Trachtenberg, Alan. Reading American
 Photographs: Images as History, Matthew Brady
 to Walker Evans. New York: Hill & Wang,
 1989.
- Turner, Jane, ed. *Encyclopedia of American Art* before 1914. New York: Grove's Dictionaries, 1999
- Upton, Dell. Architecture in the United States. Oxford and New York: Oxford University Press, 1998.
- Wallach, Alan. Exhibiting Contradiction: Essays on the Art Museum in the United States. Amherst, MA: University of Massachusetts Press, 1998.
- Whiffen, Marcus, and Frederick Koeper. *American Architecture, 1607–1976*. Cambridge, MA: MIT Press, 1981.
- Whitney Museum of American Art, New York. 200 Years of American Sculpture. New York: David R. Godine in assoc. with Whitney Museum of American Art, 1976.
- Wilmerding, John. *American Art*. Pelican History of Art. Harmondsworth, England: Penguin Books, 1976.

CHAPTER ONE

Works Cited

- Alberts, Robert C. Benjamin West: A Biography. Boston, MA: Houghton Mifflin, 1978.
- Bond, Richmond P. Queen Anne's American Kings. New York: Octagon Books, 1974. Calloway, Colin G. New Worlds for All: Indians,
- Calloway, Colin G. New Worlds for All: Indians, Europeans, and the Remaking of Early America. Baltimore, MD: Johns Hopkins University Press, 1997.
- Galt, John. *The Life and Studies of Benjamin West, Esq.* 2nd edn. London: T. Cadell & W. Davies and T. & G. Underwood, 1817.
- W. Davies and T. & G. Underwood, 1817. Gunn, Giles, ed. *Early American Writing*. New York: Penguin Books, 1994.
- Kibbey, Ann. The Interpretation of Material Shapes in Puritanism: A Study of Rhetoric, Prejudice, and Violence. Cambridge, England: Cambridge University Press, 1986.
- Lorant, Stefan, ed. The New World: The First Pictures of America Made by John White and Jacques Le Moyne and Engraved by Theodore de Bry with Contemporary Narratives of the Huguenot Settlement in Florida, 1562–1565, and the Virginia Colony, 1585–1590. New York: Duell, Sloan & Pearce, 1946.
- McCoubrey, John W., ed. *American Art,* 1700–1960: Sources and Documents. Englewood Cliffs, NJ: Prentice-Hall, 1965.
- Middleton, Richard. *Colonial America: A History*, 1585–1776. 2nd edn. Oxford: Blackwell,
- Myers, John Kenneth. "On the Cultural Construction of Landscape Experience: Contact to 1830," in *American Iconology*, ed. David C. Miller. New Haven, CT: Yale University Press, 1993, 58–79.
- Nabakov, Peter and Robert Easton. *Native American Architecture*. Oxford and New York: Oxford University Press, 1989.
- Sale, Kirkpatrick. The Conquest of Paradise: Christopher Columbus and the Columbian Legacy. New York: Alfred A. Knopf, 1991.
- Sanders, Ronald. Lost Tribes and Promised Lands: The Origins of American Racism. 1978. Rprt. New York: HarperCollins; Harper Perennial, 1992.
- Warhus, Mark. Another America: Native American Maps and the History of Our Land. New York: St. Martin's Press, 1997.

Works Consulted

- Berlo, Janet C., and Ruth B. Phillips. *Native North American Art*. Oxford and New York: Oxford University Press, 1998.
- Bunting, Bainbridge. Early Architecture in New Mexico. Albuquerque, NM: University of New Mexico Press, 1976.
- Erffa, Helmut von and Allen Staley. *The Paintings of Benjamin West*. New Haven, CT: Yale University Press, 1986.
- Fagan, Brian M. Ancient North America: The Archaeology of a Continent. Rev. edn. London: Thames & Hudson, 1995.
- Fairbanks, Jonathan, Robert Trent, et al. New England Begins: The Seventeenth Century. 3 vols. Boston, MA: Museum of Fine Arts, 1982.
- Feest, Christian F. *Native Arts of North America*. Rev. edn. London: Thames & Hudson, 1992.
- Fleischer, Roland E. *Gustavus Hesselius: Face Painter to the Middle Colonies*. Trenton, NJ: New Jersey State Museum, 1988.
- Grant, Campbell. Canyon de Chelly: Its People and Rock Art. Tuscon, AZ: University of Arizona Press, 1978.
- Greene, Jack P. The Intellectual Construction of America: Exceptionalism and Identity from 1492 to 1800. Chapel Hill, NC: University of North Carolina Press, 1993.
- Honour, Hugh. The New Golden Land: European Images of America from the Discoveries to the Present Time. New York: Pantheon Books, 1975.
- Hulton, Paul. America 1585: The Complete Drawings of John White. Chapel Hill, NC: University of North Carolina Press, 1984.
- King, Jonathan C. H. First Peoples, First Contacts: Native Peoples of North America. Cambridge, MA: Harvard University Press, 1999.
- Maurer, Evan M. Visions of the People: A Pictorial History of Plains Indian Life. Minneapolis, MN: Minneapolis Institute of Arts, 1992.
- St. Louis Museum of Art. Made in America: Ten Centuries of American Art. New York: Hudson Hills Press, 1995.
- Saunders, Richard H. and Ellen G. Miles. American Colonial Portraits, 1700–1776. Washington, DC: Smithsonian Institution Press for National Portrait Gallery, 1987.

CHAPTER TWO

Works Cited

- Butler, John. Awash in a Sea of Faith: Christianizing the American People. Cambridge, MA: Harvard University Press, 1990.
- Dillenberger, John. The Visual Arts and Christianity in America: From the Colonial Period to the Present. Rev. edn. New York: Crossroad Publishing, 1989.
- Dominguez, Fray Francisco Atanasio. *The Missions of New Mexico, 1776*. Trans. and annot. Eleanor B. Adams and Fray Angelico Chavez. Albuquerque, NM: University of New Mexico Press, 1956.
- Espinoza, José E. Saints in the Valleys: Christian Sacred Images in the History, Life and Folk Art of Spanish New Mexico. Rev. edn. Albuquerque, NM: University of New Mexico Press, 1967.
- Hall, David D. Worlds of Wonder; Days of Judgment: Popular Religious Belief in Early New England. Cambridge, MA: Harvard University Press, 1990.
- Horner, George F. and Robert A. Bain, eds. *Colonial and Federalist American Writing*. New York: Odyssey Press, 1966.
- Jeffrey, David Lyle, ed. A Dictionary of Biblical Tradition in English Literature. Grand Rapids, MI: William B. Eerdmans, 1992.
- Kubler, George. The Religious Architecture of New Mexico: In the Colonial Period and Since the

- American Occupation. 4th edn. Albuquerque, NM: University of New Mexico Press, 1972.
- McCoubrey, John W., ed. American Art, 1700-1960: Sources and Documents. Englewood Cliffs, NJ: Prentice-Hall, 1965. Philadelphia Museum of Art. Philadelphia: Three
- Centuries of American Art. Philadelphia, PA: Philadelphia Museum of Art, 1976. Piwonka, Ruth, and Roderic H. Blackburn. A
- Remnant in the Wilderness: New York Dutch Scripture History Paintings of the Early Eighteenth Century. Albany, NY: Albany Institute of History and Art, 1980.
- Pointon, Marcia. "Quakerism and Visual Culture 1650-1800." Art History, vol.20
- (Sept. 1997), 397–431. Stein, Roger B. "Thomas Smith's Self-Portrait: Image/Text as Artifact." *Art Journal*, vol.44 (Winter 1984), 316-27
- Touro Synagogue of Congregation Jeshuat Israel, Newport, Rhode Island. Newport, RI: Society of Friends of Touro Synagogue National Historic Shrine, 1948.
- Upton, Dell. Holy Things and Profane: Anglican Parish Churches in Colonial Virginia. New Haven, CT: Yale University Press,
- Weber, David J. The Spanish Frontier in North America. New Haven, CT: Yale University Press. 1992.

Works Consulted

- Benes, Peter, and Philip D. Zimmerman. New England Meeting House and Church: 1630-1850. Boston, MA, and Manchester, NH: Boston University Scholarly Publications and Currier Gallery of Art, 1979
- Boyd, E. Popular Arts of Spanish New Mexico. Santa Fe: Museum of New Mexico Press,
- Buhler, Kathryn C., and Graham Hood. American Silver: Garvan and Other Collections in the Yale University Art Gallery, vol.1: New England. New Haven, CT: Yale University Press, 1970.
- Dillenberger, Jane, and Joshua C. Taylor. The Hand and the Spirit: Religious Art in America, 1700-1900. Berkeley, CA: University Art Museum, 1972.
- Egbert, Donald Drew. "Religious Expression in American Architecture," in Modern Perspectives in Western Art History: An Anthology of 20th Century Writings on the Visual Arts, ed. W. Eugene Kleinbauer. New York: Holt, Rinehart & Winston, 1971, 312-38.
- Fairbanks, Jonathan, Robert Trent, et. al. New England Begins: The Seventeenth Century. 3 vols. Boston, MA: Museum of Fine Arts, 1982
- Garfinkel, Susan. "Letting in 'The World': (Re)interpretive Tensions in the Quaker Meeting House," in *Gender, Class, and Shelter:* Perspectives in Vernacular Architecture, ed. Elizabeth Collins Cromley and Carter L. Hudgins. Knoxville, TN: University of Tennessee Press, 1995
- Jewish Museum, New York. The Jewish Heritage in American Folk Art. New York: Universe Books, 1984.
- Kennedy, Rick. "Thomas Brattle, Mathematician-Architect in the Transition of the New England Mind, 1690-1700. Winterthur Portfolio, vol.24 (Winter 1989),
- Morgan, David. Visual Piety: A History and Theory of Popular Religious Images. Berkeley and Los Angeles, CA: University of California Press, 1998.
- Nelson, Vernon. John Valentine Haidt. Williamsburg, VA: Abby Aldrich Rockefeller Folk Art Collection, 1966.

- Patton, Sharon F. African-American Art. Oxford History of Art. New York: Oxford University Press, 1998.
- Sweeney, Kevin M. "Meetinghouses, Town Houses, and Churches: Changing Perceptions of Sacred and Secular Space in Southern New England, 1720-1850. Winterthur Portfolio, vol.28, no.1 (1993), 59-94
- Tashjian, Dickran and Anne. Memorials for Children: The Art of Early New England Stonecarving, Middletown, CT: Wesleyan University Press, 1974.
- Treib, Marc. Sanctuaries of Spanish New Mexico. Los Angeles, CA: University of California Press, 1993.
- Ward, Barbara Mclean. "'In a Feasting Posture': Communion Vessels and Community Values in Seventeenth- and Eighteenth-Century New England." Winterthur Portfolio, vol.23 (Spring 1988), 1–24.
- Williams, Peter W. Houses of God: Region, Religion, and Architecture in the United States. Urbana, IL: University of Illinois Press, 1997.
- Wroth, William. Images of Penance, Images of Mercy: Southwestern Santos in the Late Nineteenth Century, Norman, OK: University of Oklahoma Press, 1991.

CHAPTER THREE

Works Cited

- Bailyn, Bernard. The Peopling of British North America: An Introduction. New York: Vintage Books, 1988.
- Bullock, Steven C. Revolutionary Brotherhood: Freemasonry and the Transformation of the American Social Order, 1730-1840. Chapel Hill, NC: University of North Carolina Press,
- Fischer, David Hackett. Albion's Seed: Four British Folkways in America. New York: Oxford
- University Press, 1989. Fleischer, Roland E. "Emblems and Colonial American Painting." American Art Journal, vol.20, no.3 (1988), 3-35.
- Hamilton, Dr. Alexander. The Tuesday Club: A Shorter Edition of 'The History of the Ancient and Honorable Tuesday Club, 'ed. Robert Micklus. Baltimore, MD: Johns Hopkins University Press, 1995.
- Horner, George F. and Robert A. Bain, eds. Colonial and Federalist American Writing. New York: Odyssey Press, 1966.
- Kasson, John, Rudeness and Civility: Manners in Nineteenth-Century America. New York: Hill & Wang, 1990.
- Lockridge, Kenneth A. The Diary, and Life, of William Byrd II of Virginia, 1674-1744. Chapel Hill, NC: University of North Carolina Press, 1987.
- McCoubrey, John W., ed. American Art, 1700–1960: Sources and Documents. Englewood Cliffs, NJ: Prentice-Hall, 1965.
- Pierson, William H., Jr. American Buildings and Their Architects: The Colonial and Neoclassical Styles. Garden City, NY: Doubleday,
- Sadik, Marvin S. Colonial and Federal Portraits at Bowdoin College. Brunswick, ME: Bowdoin College Museum of Art, 1966.
- Sandoz, Ellis, ed. Political Sermons of the American Founding Era: 1730-1805. Indianapolis, IN: Liberty Press, 1991.
- Saunders, Richard H. John Smibert: Colonial America's First Portrait Painter. New Haven, CT: Yale University Press, 1995.
- Saunders, Richard H., and Ellen G. Miles. American Colonial Portraits: 1700-1776. Washington, DC: Smithsonian Institution Press, 1987.
- Silverman, Kenneth. A Cultural History of the American Revolution. New York: Thomas Y. Crowell Company, 1976.

Works Consulted

- Brand, Barbara Allston, "William Buckland, Architect in Annapolis," in Palladian Studies in America: Building by the Book. No.2, ed. Mario di Valmarana. Charlottesville, VA: University Press of Virginia, 1986,
- Breen, T.H. "The Meaning of 'Likeness': American Portrait Painting in an Eighteenth-Century Consumer Society." Word & Image 6 (Oct.-Dec. 1990), 325-50.
- Bushman, Richard L. The Refinement of America: Persons, Houses, Cities. New York: Alfred A. Knopf, 1992.
- Carson, Cary, Ronald Hoffman, and Peter J. Albert. Of Consuming Interests: The Style of Life in the Eighteenth Century. Charlottesville, VA: University Press of Virginia, 1994.
- Finney, Arthur L. "The Royall House in Medford: A Re-Evaluation of the Structural and Documentary Evidence," in Architecture in Colonial Massachusetts: A Conference Held by the Colonial Society of Massachusetts, September 19 and 20, 1974. Boston, MA: Colonial Society of Massachusetts, 1979, 23-41.
- Gowans, Alan. "Freemasonry and the Neoclassic Style in America." Antiques (Feb. 1960), 172-75.
- Hamilton, John D. Material Culture of the American Freemasons. Lexington, MA: Museum of our National Heritage, 1994.
- Lovell, Margaretta M. "Reading Eighteenth-Century American Family Portraits: Social Images and Self-Images," in Critical Issues in American Art: A Book of Readings, ed. Mary Ann Calo. Boulder, CO: Westview Press, 1998, 35-45.
- Miles, Ellen G., ed. The Portrait in Eighteenth-Century America. Newark, NJ: University of Delaware Press, 1993.
- Schimmelman, Janice G. Architectural Treatises and Building Handbooks Available in American Libraries and Bookstores through 1800. Worcester, MA: American Antiquarian Society, 1986.

CHAPTER FOUR

Works Cited

- Alberts, Robert C. Benjamin West: A Biography. Boston, MA: Houghton Mifflin, 1978.
- Berens, John F. Providence and Patriotism in Early America, 1640-1815. Charlottesville, VA: University Press of Virginia, 1978.
- Bielajac, David. Millennial Desire and the Apocalyptic Vision of Washington Allston. Washington, DC: Smithsonian Institution Press, 1988
- Bjelajac, David. Washington Allston, Secret Societies and the Alchemy of Anglo-American Painting. Cambridge, England, and New York: Cambridge University Press, 1997
- Conger, Clement E., and Alexandra W. Rollins. Treasures of State: Fine and Decorative Arts in the Diplomatic Reception Rooms of the U.S. State Department. New York: Harry N. Abrams, 1991.
- Cooper, Helen A., ed. John Trumbull: The Hand and the Spirit of a Painter. New Haven, CT: Yale University Press, 1982.
- Dunlap, William. A History of the Rise and Progress of the Arts of Design in the United States. 2 vols. 1834. Rprt. New York: Dover Publications, 1969.
- Fliegelman, Jay. Declaring Independence: Jefferson, Natural Language and the Culture of Performance. Stanford, CA: Stanford University Press, 1993.
- Fortune, Brandon Brame. "'From the World Escaped': Peale's Portrait of William Smith and His Grandson." Eighteenth-Century Studies 25 (Summer 1992), 587-615.

- Kaplan, Sidney, and Emma Nogrady Kaplan. The Black Presence in the Era of the American Revolution. Rev. edn. Amherst, MA: University of Massachusetts Press, 1989.
- Lubin, David M. Picturing a Nation: Art and Social Change in Nineteenth-Century America. New Haven, CT: Yale University Press, 1994.
- McCoubrey, John W., ed. American Art, 1700–1960: Sources and Documents. Englewood Cliffs, NJ: Prentice-Hall, 1965.
- Miles, Ellen G. American Paintings of the Eighteenth Century. Collections of National Gallery of Art Systematic Catalogue. Washington, DC: National Gallery of Art, 1995.
- Miller, Lillian B. *In Pursuit of Fame: Rembrandt Peale, 1778–1860.* Washington, DC: National Portrait Gallery, Smithsonian Institution, 1992.
- Neff, Emily Ballew. *John Singleton Copley in England*. Houston, TX: Museum of Fine Arts, 1995.
- Prown, Jules David. *John Singleton Copley.* 2 vols. Cambridge, MA: Harvard University Press, 1996.
- Prown, Jules David. "John Trumbull as History Painter," in *John Trumbull: The Hand and Spirit of a Painter*, ed. Helen A. Cooper. New Haven, CT: Yale University Art Gallery, 1982, 22–41.
- Roth, Leland M. A Concise History of American Architecture. New York: Harper & Row; Icon Editions, 1979.
- Scott, Pamela. Temple of Liberty: Building the Capitol for a New Nation. Oxford, England, and New York: Oxford University Press, 1995.
- Sellers, Charles Colman. *Benjamin Franklin in Portraiture*. New Haven, CT: Yale University Press, 1962.
- Sellers, Charles Colman. Patience Wright: American Artist and Spy in George III's London. Middletown, CT: Wesleyan University Press, 1976.
- Simpson, Marc, Sally Mills, and Jennifer Saville. The American Canvas: Paintings from the Collection of the Fine Arts Museums of San Francisco. New York: Hudson Hill Press, 1989
- Trumbull, John. *The Autobiography of Colonel John Trumbull, Patriot-Artist, 1756–1843*, ed. Theodore Sizer. New Haven, CT: Yale University Press, 1953.

Works Consulted

- Abrams, Ann Uhry. *The Valiant Hero: Benjamin West and Grand-Style History Painting*. Washington, DC: Smithsonian Institution Press. 1985.
- Boston (Museum of Fine Arts). Paul Revere's Boston: 1735–1818. Boston, MA: Museum of Fine Arts, 1975.
- Brigham, Clarence S. *Paul Revere's Engravings*. New York: Atheneum, 1969.
- Brigham, David. *Public Culture in the Early Republic: Peale's Museum and Its Audience*. Washington, DC: Smithsonian Institution Press, 1995.
- Burnham, Patricia M. "John Trumbull, Historian: The Case of the Battle of Bunker's Hill," in *Redefining American History Painting*, ed. Patricia M. Burnham and Lucretia Hoover Giese. Cambridge, England, and New York: Cambridge University Press, 1995, 37–53.
- Evans, Dorinda. *Mather Brown: Early American Artist in England*. Middletown, CT: Wesleyan University Press, 1982.
- Fortune, Brandon Brame, and Deborah J. Warner. Franklin & His Friends: Portraying the Man of Science in Eighteenth-Century America. Washington, DC: National Portrait Gallery, Smithsonian Institution, 1999.

- Fryd, Vivien Green. "Rereading the Indian in Benjamin West's *Death of General Wolfe."* American Art 9 (Spring 1995), 73–85.
- Marks, Arthur S. "The Statue of King George III in New York and the Iconology of Regicide." *American Art Journal* 13 (Summer 1981), 61–82.
- Montgomery, Charles F., and Patricia E. Kane, eds. American Art: 1750–1800, Towards Independence. Boston, MA: New York Graphic Society for Yale University Art Gallery and Victoria and Albert Museum, 1976.
- Olson, Lester C. Emblems of American Community in the Revolutionary Era: A Study in Rhetorical Iconology. Washington, DC: Smithsonian Institution Press, 1991.
- Rebora, Carrie, Paul Staiti, Erika E. Hirshler, et al. *John Singleton Copley in America*. New York: Metropolitan Museum of Art,
- Savage, Kirk. "The Self-made Monument: George Washington and the Fight to Erect a National Memorial," in Critical Issues in Public Art: Content, Context, and Controversy, ed. Harriet F. Senie and Sally Webster. New York: HarperCollins; Icon Editions, 1992, 5–43.
- Staiti, Paul. Samuel F.B. Morse. Cambridge: Cambridge University Press, 1989.
- Stein, Roger B. "Charles Willson Peale's Expressive Design: *The Artist in His Museum." Prospects*, 6 (1981), 139–85.

CHAPTER FIVE

Works Cited

- Bjelajac, David. Washington Allston, Secret Societies and the Alchemy of Anglo-American Painting. Cambridge, England, and New York: Cambridge University Press, 1997.
- Butler, Jon. Awash in a Sea of Faith: Christianizing the American People. Cambridge, MA: Harvard University Press, 1990.
- Cayton, Andrew R.L. "The Fragmentation of 'A Great Family': The Panic of 1819 and the Rise of the Middling Interest in Boston, 1818–1822." Journal of the Early Republic 2 (Summer 1982), 143–67.
- Colbert, Charles. A Measure of Perfection: Phrenology and the Fine Arts in America. Chapel Hill, NC: University of North Carolina Press, 1997.
- Cole, Thomas. *The Collected Essays and Prose Sketches*. Ed. Marshall Tymn. St. Paul, MN: John Colet Press, 1980.
- Cremin, Lawrence A. American Education: The National Experience, 1783–1876. New York: Harper & Row; Harper Torchbooks, 1980.
- Davis, Keith F. "'A Terrible Distinctness': Photography of the Civil War Era," in Photography in Nineteenth-Century America, ed. Martha A. Sandweiss. Fort Worth, TX, and New York: Amon Carter Museum and Harry N. Abrams, 1991, 131–79.
- Dimmick, Lauretta. "Thomas Crawford's Orpheus: The American Apollo Belvedere." American Art Journal, vol.19 (1987), 47–84.
- Dunlap, William. A History of the Rise and Progress of the Arts of Design in the United States. 2 vols. 1834. Rprt. New York: Dover Publications, 1969.
- Durand, John. *The Life and Times of A.B. Durand*. 1894. Rprt. New York: Kennedy Graphics and Da Capo Press, 1970.
- Graphics and Da Capo Press, 1970. Ellis, Elizabeth Garrity. "Fitz Hugh Lane and the American Union of Associationists." American Art Journal 17 (Spring 1985), 89.
- Foresta, Merry A., and John Wood. Secrets of the Dark Chamber: The Art of the American Daguerreotype. Washington, DC: Smithsonian Institution Press. 1995.

- Fowler, Orson S. *The Octagon House: A Home for All*. 1853. Rprt. with new intro. by Madeline B. Stern. New York: Dover Publications, 1973.
- Fryd, Vivien Green. Art and Empire: The Politics of Ethnicity in the United States Capitol, 1815–1860. New Haven, CT: Yale University Press. 1992
- Greenough, Horatio. Form and Function: Remarks on Art, Design, and Architecture, ed. Harold A. Small. Berkeley and Los Angeles, CA: University of California Press, 1958.
- Hawthorne, Nathaniel. *The House of the Seven Gables*. New York: Bantam Books; Bantam Classics, 1981.
- Howat, John K., ed. American Paradise: The World of the Hudson River School. New York: Metropolitan Museum of Art and Harry N. Abrams, 1987.
- Husch, Gail E. Something Coming: Apocalyptic Expectation and Mid-Nineteenth-Century American Painting. Hanover, NH: University Press of New England, 2000.
- Johns, Elizabeth. American Genre Painting: The Politics of Everyday Life. New Haven, CT: Yale University Press, 1991.
- Josephson, Hannah. *The Golden Threads: New England's Mill Girls and Magnates*. New York: Duell, Sloan & Pearce, 1949.
- Kasson, Joy. Marble Queens and Captives: Women in Nineteenth-Century American Sculpture. New Haven, CT: Yale University Press, 1990.
- Kelly, Franklin. Frederic Edwin Church. Washington, DC: National Gallery of Art, 1989.
- Kerr, Howard. Mediums and Spirit-Rappers, and Roaring Radicals: Spiritualism in American Literature, 1850–1900. Urbana, IL: University of Illinois Press, 1972.
- Kloss, William. Samuel F.B. Morse. New York: Harry N. Abrams, 1988.
- Lubin, David. Picturing a Nation: Art and Social Change in Nineteenth-Century America. New Haven, CT: Yale University Press, 1994.
- Mabee, Carleton. The American Leonardo: A Life of Samuel F.B. Morse. New York: Alfred A. Knopf, 1944.
- McCoubrey, John W., ed. *American Art,* 1700–1960: Sources and Documents.
 Englewood Cliffs, NJ: Prentice-Hall, 1965.
- Miller, Angela. "Thomas Cole and Jacksonian America: The Course of Empire as Political Allegory." Prospects: An Annual of American Cultural Studies 14 (1989), 65–92.
- Miller, Lillian B. Patrons and Patriotism: The Encouragement of the Fine Arts in the United States, 1790–1860. Chicago, IL: University of Chicago Press, 1966.
- Oettermann, Stephan. *The Panorama: History of a Mass Medium*. Trans. Deborah Lucas Schneider. New York: Zone Books, 1997.
- Parry, Ellwood C. III. *The Art of Thomas Cole: Ambition and Imagination*. Newark, NJ: University of Delaware Press, 1988.
- Peabody, Elizabeth Palmer. Reminiscences of Rev. Wm. Ellery Channing. Boston, MA: Roberts Brothers, 1880.
- Poesch, Jessie. The Art of the Old South: Painting, Sculpture, Architecture and the Products of Craftsmen, 1560–1860. New York: Harrison House, 1989.
- Prime, Samuel Irenaeus. *The Life of Samuel F.B. Morse*. 1875. Rprt. New York: Arno Press, 1974.
- Roque, Oswaldo Rodriguez. "The Last Summer's Work," in John Frederick Kensett: An American Master, ed. John Paul Driscoll and John K. Howat. New York: W.W. Norton, 1985, 137–61.
- Schuyler, David. *Apostle of Taste: Andrew Jackson Downing, 1815–1852*. Baltimore, MD: Johns Hopkins University Press, 1996.

- Taylor, Alan. "The Early Republic's Supernatural Economy: Treasure Seeking in the American Northeast, 1780-1830." American Quarterly 38 (Spring 1986), 6–33.
- Wallach, Alan. "Making a Picture of the View from Mount Holyoke," in American Iconology: New Approaches to Nineteenth-Century Art and Literature, ed. David C. Miller. New Haven, CT: Yale University Press, 1993.
- Wallach, Alan. "Thomas Cole: Landscape and the Course of American Empire," in *Thomas* Cole: Landscape into History, ed. William H. Truettner and Alan Wallach. Washington, DC: National Museum of American Art. 1974, 23-111.
- Wunder, Richard P. Hiram Powers, Vermont Sculptor, 1805-1873. 2 vols. Newark, NJ: University of Delaware Press,
- Zinn, Howard. A People's History of the United States, 1492-Present. Rev. edn. New York: HarperCollins; Harper Perennial, 1995.

Works Consulted

- Burns, Sarah, Pastoral Inventions: Rural Life in Nineteenth-Century American Art and Culture. Philadelphia, PA: Temple University Press, 1989.
- Davis, John. The Landscape of Belief: Encountering the Holy Land in Nineteenth-Century American Art and Culture. Princeton, NI: Princeton University Press, 1996.
- Jackson, Kenneth T. Crabgrass Frontier: The Suburbanization of the United States. Oxford. England, and New York: Oxford University Press, 1985.
- Ketner, Joseph D. The Emergence of the African-American Artist: Robert S. Duncanson, 1821-1872. Columbia, MO: University of Missouri Press, 1993.
- Manthorne, Katherine Emma. Tropical Renaissance: North American Artists Exploring Latin America, 1839-1879. Washington, DC: Smithsonian Institution Press,
- McLanathan, Richard. Gilbert Stuart. New York: Harry N. Abrams, 1986.
- Miller, Angela. The Empire of the Eye: Landscape Representation and American Cultural Politics, 1825-1875. Ithaca, NY: Cornell University Press, 1993.
- Novak, Barbara, Nature and Culture: American Landscape Painting. Rev. ed. Oxford, England, and New York: Oxford University Press, 1995.
- Nygren, Edward J. Views and Visions: American Landscape before 1830. Washington, DC: Corcoran Gallery of Art, 1986.
- Pohl, Frances K. "Old World, New World: The Encounter of Cultures on the American Frontier," in Nineteenth Century Art: A Critical History, ed. Stephen F. Eisenman. London: Thames & Hudson, 1994, 144-62
- Rothman, David J. The Discovery of the Asylum: Social Order and Disorder in the New Republic. Boston, MA: Little, Brown, 1971.
- Stern, Madeline B. Heads and Headlines: The Phrenological Fowlers. Norman, OK: University of Oklahoma Press, 1971
- Sweeney, J. Gray. The Columbus of the Woods: Daniel Boone and the Typology of Manifest Destiny. St. Louis, MO: Washington University Gallery of Art, 1992.
- Sweeney, J. Gray. "The Nude of Landscape Painting: Emblematic Personification in the Art of the Hudson River School." Smithsonian Studies in American Art 3 (Fall 1989),
- Trachtenberg, Alan. "Albums of War; On Reading Civil War Photographs," in Critical Issues in American Art: A Book of Readings, ed. Mary Ann Calo. Boulder, CO: Westview Press, 1998, 135-54.

- Truettner, William H., ed. The West as America: Reinterpreting Images of the Frontier, 1820-1920. Washington, DC: Smithsonian Institution Press, 1991.
- Wichita Art Museum. John Quidor: Painter of American Legend. Essay by David M. Sokol. Wichita, KS: Wichita Art Museum,
- Wolf, Bryan. "All the World's a Code: Art and Ideology in Nineteenth Century American Painting." Art Journal 44 (Winter 1984), 328-37.
- Wolf, Bryan Jay. Romantic Re-Vision: Culture and Consciousness in Nineteenth-Century American Painting and Literature. Chicago, IL: University of Chicago Press, 1982
- Wroth, William. "New Mexican Santos and the Preservation of Religious Traditions," in Critical Issues in American Art: A Book of Readings, ed. Mary Ann Calo. Boulder, CO: Westview Press, 1998, 125–33.

CHAPTER SIX

Works Cited

- Bearden, Romare, and Harry Henderson. A History of African-American Artists: From 1792 to the Present. New York: Pantheon Books, 1993.
- Bendix, Deanna Marohn. Diabolical Designs: Paintings, Interiors, and Exhibitions of James McNeill Whistler. Washington, DC: Smithsonian Institution Press,
- Boime, Albert. The Art of Exclusion: Representing Blacks in the Nineteenth Century. London: Thames & Hudson, 1990.
- Broun, Elizabeth. Albert Pinkham Ryder. Washington, DC: National Museum of American Art, Smithsonian Institution,
- Buick, Kirsten P. "The Ideal Works of Edmonia Lewis: Invoking and Inverting Autobiography," in Reading American Art, ed. Marianne Doezema and Elizabeth Milroy. New Haven, CT: Yale University Press, 1998, 190-207
- Burns, Sarah. Inventing the Modern Artist: Art & Culture in Gilded Age America. New Haven, CT: Yale University Press, 1996.
- Cikovsky, Nicolai, Jr. "The School of War," in Winslow Homer, ed. Nicolai Cikovsky, Jr. and Franklin Kelly. Washington, DC: National Gallery of Art, 1995, 17-37.
- Griffin, Randall C. Thomas Anshutz: Artist and Teacher. Seattle, WA: Heckscher Museum in association with University of Washington Press, 1994.
- Jarves, James Jackson. The Art-Idea. 1864. Rprt. ed. Benjamin Rowland, Jr. Cambridge, MA: Harvard University Press, Belknap Press 1960.
- Johns, Elizabeth. Thomas Eakins: The Heroism of Modern Life. Princeton, NJ: Princeton University Press, 1983.
- Landau, Sarah Bradford and Carl W. Condit. Rise of the New York Skyscraper: 1865-1913. New Haven, CT: Yale University Press,
- Lovell, Margaretta. "Picturing 'A City for a Single Summer': Paintings of the World's Columbian Exposition." Art Bulletin, vol.78 (March 1996), 40-55.
- McCoubrey, John W., ed. American Art, 1700–1960: Sources and Documents. Englewood Cliffs, NJ: Prentice-Hall, 1965.
- McNamara, Brooks. Day of Jubilee: The Great Age of Public Celebrations in New York, 1788-1909. New Brunswick, NJ: Rutgers University Press, 1997.
- Pollock, Griselda. Mary Cassatt: Painter of Modern Women. London: Thames & Hudson,

- Pyne, Kathleen. Art and the Higher Life: Painting and Evolutionary Thought in Late Nineteenth-Century America. Austin, TX: University of Texas Press, 1996.
- Stein, Roger B. "Artifact as Ideology: The Aesthetic Movement in its American Cultural Context," in *In Pursuit of Beauty:* Americans and the Aesthetic Movement, by Doreen Bolger et al. New York: Rizzoli for Metropolitan Museum of New York, 1986,
- Tuckerman, Henry T. Book of the Artists: American Artist Life Comprising Biographical and Critical Sketches of American Artists: Preceded by an Historical Account of the Rise and Progress of Art in America. 1867. Rprt. New York: James F. Carr, 1967
- Upton, Dell. Architecture in the United States. Oxford History of Art. Oxford, England: Oxford University Press, 1998.
- Wharton, Edith, The House of Mirth, Ed. Elizabeth Ammons. New York: W.W. Norton,

Works Consulted

- Baker, Paul R. Richard Morris Hunt. Cambridge, MA: MIT Press, 1980.
- Brooklyn Museum. The American Renaissance, 1876–1917. New York: Brooklyn Museum, 1979
- Condit, Charles. The Chicago School of Architecture: A History of Commercial and Public Building in the Chicago Area, 1875-1925. Chicago, IL: University of Chicago Press, 1964.
- Danly, Susan and Cheryl Leibold. Eakins and the Photograph: Works by Thomas Eakins and His Circle in the Collection of the Pennsylvania Academy of the Fine Arts. Washington, DC: Smithsonian Institution Press for Pennsylvania Academy of the Fine Arts, 1994
- Davis, John. "Children in the Parlor: Eastman Johnson's Brown Family and the Post-Civil War Interior." American Art, vol.10 (Summer 1996), 50-77.
- Detroit Institute of Arts Founders Society, Detroit, MI. American Paintings in the Detroit Institute of Arts, vol.2: Works by Artists Born 1816–1847. New York: Hudson Hills Press in association with Detroit Institute of Arts Founders Society, 1997.
- Fink, Lois Marie. American Art at the Nineteenth-Century Paris Salons. Washington, DC, and Cambridge, England: Smithsonian Institution and Cambridge University Press, 1990.
- Fisher, Irving D. "An Iconography of City Planning: The Chicago City Plan," in Emmanuel Swedenborg: A Continuing Vision, ed. Robin Larsen et al. New York: Swedenborg Foundation, 1988, 245-62.
- Harris, Neil. Cultural Excursions: Marketing Appetites and Cultural Tastes in Modern America. Chicago, IL: University of Chicago Press, 1990.
- Lears, T.J. Jackson. No Place of Grace: Antimodernism and the Transformation of American Culture, 1880–1920. New York: Pantheon Books, 1981.
- Neff, Emily Ballew and George T.M. Shackelford. American Painters in the Age of Impressionism. Houston, TX: Museum of Fine Arts, 1994.
- Prettejohn, Elizabeth. Interpreting Sargent. New York: Stewart, Tabori & Chang, 1999.
- Promey, Sally M. "Sargent's Truncated Triumph: Art and Religion at the Boston Public Library, 1890-1925." Art Bulletin, vol.79 (June 1997), 217–50.
- Riley, Terence, ed. Frank Lloyd Wright, Architect. New York: Museum of Modern Art, 1994.

CHAPTER SEVEN

Works Cited

- Abrahams, Edward. The Lyrical Left: Randolph Bourne, Alfred Stieglitz and the Origins of Cultural Radicalism in America. Charlotteville, VA: University Press of Virginia,
- Agee, William C. "Willard Huntington Wright and the Synchromists: Notes on the Forum Exhibition." *Archives of American Art Journal*, vol.30, nos.1–4 (1990), 88–93.
- Anderson Galleries [New York]. *The Forum Exhibition of Modern American Painters*. 1916. Rprt. New York: Arno Press, 1968.
- Chave, Anna C. "O'Keeffe and the Masculine Gaze," in *Reading American Art*, ed. Marianne Doezema and Elizabeth Milroy. New Haven, CT: Yale University Press, 1998, 350–70.
- Doezema, Marianne. *George Bellows and Urban America*. New Haven, CT: Yale University Press, 1992.
- Doss, Erika. Benton, Pollock, and the Politics of Modernism: From Regionalism to Abstract Expressionism. Chicago, IL: University of Chicago Press, 1991.
- Henri, Robert. *The Art Spirit*. 1923. Rprt. Boulder, CO: Westview Press; Icon Editions, 1984.
- Hills, Patricia. "John Sloan's Images of Working-Class Women: A Case Study of the Roles and Interrelationships of Politics, Personality, and Patrons in the Development of Sloan's Art, 1905–16," in *Reading American Art*, ed. Marianne Doezema and Elizabeth Milroy. New Haven, CT: Yale University Press, 1998, 311–49.
- McCoubrey, John W., ed. *American Art,* 1700–1960: Sources and Documents.
 Englewood Cliffs, NJ: Prentice-Hall, 1965.
 Naumann, Francis M. *New York Dada, 1915–23*.
 New York: Harry N. Abrams, 1994.
- Newhall, Beaumont. *The History of Photography* from 1839 to the Present Day. Rev. and enlarged edn. New York: Museum of Modern Art. 1964.
- Wattenmaker, Richard J. Maurice Prendergast. New York: Harry N. Abrams in association with National Museum of American Art, Smithsonian Institution, 1994.

Works Consulted

- Altshuler, Bruce. *The Avant-Garde in Exhibition:* New Art in the 20th Century. New York: Harry N. Abrams, 1994.
- Conger, Amy. Edward Weston: Photographs from the Collection of the Center for Creative Photography. Tucson, AZ: Center for Creative Photography, University of Arizona, 1992.
- Corn, Wanda. "The Birth of a National Icon: Grant Wood's American Gothic," in Reading American Art, ed. Marianne Doezema and Elizabeth Milroy. New Haven, CT: Yale University Press, 1998, 387–408.
- Davis, Keith F. An American Century of Photography: The Hallmark Photographic Collection. Kansas City, MO: Hallmark Cards, 1995.
- Dennis, James M. *Grant Wood: A Study in American Art and Culture*. Columbia, MO: University of Missouri Press, 1986.
- Fine, Ruth E. *John Marin*. Washington, DC: National Gallery of Art, 1990.

- Frackman, Noel. John Storrs. New York: Whitney Museum of Art, 1986.
- Gambone, Robert L. *Art and Popular Religion in Evangelical America*, 1915–1940. Knoxville, TN: University of Tennessee Press, 1989
- Green, Martin. New York 1913: The Armory Show and the Paterson Strike Pageant. New York: Charles Scribner's Sons, 1988.
- Guimond, James. American Photography and the American Dream. Chapel Hill, NC: University of North Carolina Press, 1991.
- Haskell, Barbara. The American Century: Art and Culture, 1900–1950. New York: Whitney Museum of American Art, 1999.
- Haskell, Barbara. Charles Demuth. New York: Whitney Museum of American Art in association with Harry N. Abrams, 1987.
- Haskell, Barbara. *Joseph Stella*. New York: Whitney Museum of American Art, 1994.
- High Museum of Art. *Max Weber: The Cubist Decade, 1910–1920.* Atlanta, GA: High Museum of Art, 1991.
- Hildebrand, Grant. *The Wright Space: Pattern and Meaning in Frank Lloyd Wright's Houses*. Seattle, WA: University of Washington Press, 1991.
- Hills, Patricia, and Roberta K. Tarbell. The Figurative Tradition and the Whitney Museum of American Art. New York: Whitney Museum of American Art, 1980.
- Hills, Patricia. *Stuart Davis*. New York: Harry N. Abrams in association with National Museum of American Art, Smithsonian Institution, 1996.
- Kalaidjian, Walter. American Culture Between the Wars: Revisionary Modernism and Postmodern Critique. New York: Columbia University Press, 1993.
- Kirstein, Lincoln. *Elie Nadelman*. New York: Eakins Press, 1973.
- Kushner, Marilyn S. *Morgan Russell*. New York: Hudson Hills Press, 1990.
- Levin, Gail. *Synchromism and American Color Abstraction, 1910–1925*. New York: G. Braziller, 1978.
- Longwell, Dennis. *Steichen: The Master Prints,* 1895–1914; *The Symbolist Period.* New York: Museum of Modern Art, 1978.
- Marter, Joan M. *Alexander Calder*. Cambridge: Cambridge University Press, 1991.
- Montclair Art Museum, Montclair, NJ. Precisionism in America, 1915–1941: Reordering Reality. New York: Harry N. Abrams in association with Montclair Art Museum, 1994.
- Robertson, Bruce. *Marsden Hartley*. New York: Harry N. Abrams, 1995.
- Sawelson-Gorse, Naomi, ed. Women in Dada: Essays on Sex, Gender, and Identity. Cambridge, MA: MIT Press, 1998.
- Singal, Daniel Joseph. "Toward a Definition of American Modernism." *American Quarterly* 39 (Spring 1987), 7–26.
- Stavitsky, Gail. "John Weichsel and the People's Art Guild." Archives of American Art Journal 31, no.4 (1991), 12–19.
- Weinberg, H. Barbara, Doreen Bolger, and David Park Curry. American Impressionism and Realism: The Painting of Modern Life, 1885–1915. New York: Metropolitan Museum of Art, 1994.
- Whiting, Cecile. Antifascism in American Art. New Haven, CT: Yale University Press, 1989.

CHAPTER EIGHT

Works Cited

Chipp, Herschel B., ed. Theories of Modern Art: A Sourcebook by Artists and Critics. Berkeley and Los Angeles, CA: University of California Press, 1968.

- Crow, Thomas. *Modern Art in the Common Culture*. New Haven, CT: Yale University Press, 1996.
- Dunlop, Beth. *Building a Dream: The Art of Disney Architecture*. Foreword by Vincent Scully. New York: Harry N. Abrams, 1996.
- Fineberg, Jonathan. Art Since 1940: Strategies of Being. New York: Harry N. Abrams, 1995.
- Foster, Hal. "The Art of the Missing Part," in Robert Gober, ed. Paul Schimmel. Los Angeles, CA: Museum of Contemporary Art, 1997, 57–68.
- Gibson, Ann Eden. Abstract Expressionism: Other Politics. New Haven, CT: Yale University Press, 1997.
- Guibault, Serge. How New York Stole the Idea of Modern Art: Abstract Expressionism, Freedom and the Cold War. Trans. Arthur Goldhammer. Chicago, IL: University of Chicago Press, 1983.
- Kerouac, Jack. Introduction to *The Americans*, by Robert Frank. 1959. Rprt. New York: SCALO Publishers with National Gallery of Art, Washington, DC, 1994.
- Klotz, Heinrich. *The History of Postmodern Architecture*. Trans. Radka Donnell. Cambridge, MA: MIT Press, 1988.
- Koons, Jeff. *The Jeff Koons Handbook*. New York: Rizzoli International, 1992
- Lawrence, Sidney. *Directions: Tony Oursler: Video Dolls with Tracy Leipold*. July 2–Sept. 7, 1998 exhibition. Washington, DC: Hirshhorn Museum and Sculpture Garden, 1998.
- Shapiro, Gary. Earthwards: Robert Smithson and Art after Babel. Berkeley and Los Angeles, CA: University of California Press, 1995.
- Sontag, Susan. Against Interpretation and Other Essays. New York: Dell Publishing, 1961.
- Stich, Sidra. Made in U.S.A.: An Americanization in Modern Art, the '50s & '60s. Berkeley and Los Angeles, CA: University of California Press, 1987.
- Stiles, Kristine and Peter Selz. Theories and Documents of Contemporary Art: A Sourcebook of Artists' Writings. Berkeley and Los Angeles, CA: University of California Press, 1996.

Works Consulted

- Alloway, Lawrence, et al. *The Pictographs of Adolph Gottlieb*. New York: Hudson Hills Press in association with Adolph and Esther Gottlieb Foundation, 1994.
- Anfam, David. Abstract Expressionism. London: Thames & Hudson, 1990.
- Belgrad, Daniel. *The Culture of Spontaneity: Improvisation and the Arts in Postwar America*.
 Chicago: University of Chicago Press, 1998.
- Bertens, Hans. The Idea of the Postmodern: A History. London and New York: Routledge, 1995.
- Bogart, Michele H. Artists, Advertising, and the Borders of Art. Chicago, IL: University of Chicago Press, 1995.
- Broude, Norma and Mary D. Garrard. The Power of Feminist Art: The American Movement of the 1970s, History and Impact. New York: Harry N. Abrams, 1994.
- Cox, Anette. Art-as-Politics: The Abstract Expressionist Avant-Garde and Society. Ann Arbor, MI: UMI Research Press, 1982.
- Crane, Diana. *The Transformation of the Avant-Garde: The New York Art World, 1940–1985.* Chicago, IL: University of Chicago Press,
- Craven, David. Abstract Expressionism as Cultural Critique: Dissent during the McCarthy Period. Cambridge, England, and New York: Cambridge University Press, 1999.
- Crow, Thomas. The Rise of the Sixties: American and European Art in the Era of Dissent. New York: Harry N. Abrams, 1996.
- Dennison, Lisa, ed. *Ross Bleckner*. New York: Solomon R. Guggenheim Foundation, 1995.

- Ellis, Diane C., and John C. Beresford. Trends in Artist Occupations: 1970-1990. Research Division Report #29. Washington, DC: National Endowment for the Arts, 1994.
- Gottdiener, Mark. The Theming of America: Dreams, Visions, and Commercial Spaces. Boulder, CO: Westview Press, 1997
- Greenberg, Clement. Art and Culture: Critical Essays. Boston, MA: Beacon Press, 1961.
- Hertz, Richard. Theories of Contemporary Art. Englewood Cliffs, NJ: Prentice-Hall, 1985.
- Hobbs, Robert. Lee Krasner. New York: Abbeville Press, 1993.
- Jencks, Charles. Kings of Infinite Space: Frank Lloyd Wright & Michael Graves. New York: St. Martin's Press, 1983.
- Johnson, Ellen H. American Artists on Art from 1940 to 1980. New York: Harper & Row,
- Kaprow, Allan. Assemblage, Environments, and Happenings. New York: Harry N. Abrams,
- Kienholz, Edward, and Nancy Reddin Kienholz. Kienholz: A Retrospective. New York: Whitney Museum of American Art, 1996.
- Krauss, Rosiland E. The Originality of the Avant-Garde and Other Modernist Myths. 1985. Rprt. Cambridge, MA: MIT Press, 1994.

- Krauss, Rosiland E. Passages in Modern Sculpture. Cambridge, MA: MIT Press; pbk. edn.,
- Kuspit, Donald B. Clement Greenberg. Madison, WI: University of Wisconsin Press, 1979. Kuspit, Donald B. Leon Golub:
- Existentialist/Activist Painter. New Brunswick, NI: Rutgers University Press, 1985.
- Lears, T.J. Jackson. Fables of Abundance: A Cultural History of Advertising in America. New York: Basic Books, 1994.
- Lippard, Lucy R. Ad Reinhardt. New York: Harry N. Abrams, 1981.
- Moos, Stanislaus von. Venturi, Rauch & Scott Brown. New York: Rizzoli, 1987
- Owens, Craig. Beyond Recognition: Representation, Power and Culture. Berkeley and Los Angeles, CA: University of California Press,
- Phillips, Lisa. The American Century: Art and Culture, 1950-2000. New York: Whitney Museum of American Art, 1999.
- Pohl, Frances K. Ben Shahn: New Deal Artist in a Cold War Climate, 1947-1954. Austin, TX: University of Texas Press, 1989.
- Robins, Corinne. The Pluralist Era: American Art, 1968–1981. New York: Harper & Row; Icon Editions, 1984.

- Ross, Andrew. The Celebration Chronicles: Life, Liberty and the Pursuit of Property Value in Disney's New Town. New York: Ballantine Books, 1999.
- Sandler, Irving. Art of the Postmodern Era: From the Late 1960s to the Early 1990s. New York: HarperCollins; Icon Editions, 1996.
- Saunders, Frances Stonor, Who Paid the Piper?: The CIA and the Cultural Cold War. London: Granta, 1999.
- Schellmann, Jörg, and Joséphine Benecke, eds. Christo and Jeanne-Claude: Prints and Objects 1963-95, A Catalogue Raisonné. New York: Edition Schellmann, 1995.
- Solomon, Deborah, Utopia Parkway: The Life and Work of Joseph Cornell. New York: Farrar, Straus & Giroux, 1997.
- Taylor, Brandon. Avant-Garde and After: Rethinking Art Now. New York: Harry N. Abrams, 1995.
- Varnedoe, Kirk. Jackson Pollock. New York: Museum of Modern Art, 1998.
- Whitaker, Craig. Architecture and the American Dream. New York: Three Rivers Press, 1998.
- Wood, Paul, et al. Modernism in Dispute: Art Since the Forties. New Haven, CT: Yale University Press in association with Open University, 1993.

Picture Credits

The author, Calmann & King Ltd, and Prentice Hall wish to thank the institutions and individuals who have kindly provided photographic materials for use in this book. In all cases, every effort has been made to contact the copyright holders, but should there be any errors or omissions the publishers would be pleased to insert the appropriate acknowledgment in any subsequent edition of this book.

CHAPTER 1

Frontispiece and 1.24 Reproduced by kind permission of the President and Council of the Royal College of Surgeons of England; page 12, 1.13 © British Museum; 1.4 Robert Harding Picture Library, London.

CHAPTER 2

2.10 Photo: G.E. Kidder-Smith, New York.

3.12, 3.13 Courtesy of Drayton Hall, Charleston, South Carolina, a property of the National Trust for Historic Preservation; 3.22, 3.24, 3.26, 3.28, 3.29 Courtesy Museum of Fine Arts, Boston. Reproduced with permission. © 1999 Museum of Fine Arts, Boston. All rights reserved.

CHAPTER 4

Page 114, 4.52 Courtesy Museum of Fine Arts, Boston, Reproduced with permission. © 1999 Museum of Fine Arts, Boston. All rights reserved; 4.7 © Dean and Chapter of Westminster; 4.8, 4.9 © British Museum; 4.35, 4.45 Art Resource, New York.

CHAPTER 5

5.6, 5.33, 5.34, 5.54, 5.55 Courtesy Museum

of Fine Arts, Boston. Reproduced with permission. © 1999 Museum of Fine Arts, Boston. All rights reserved; 5.13, 5.26, 5.43 Art Resource, New York; 5.14 Photo: Hans Padelt.

CHAPTER 6

Page 226 Bridgeman Art Library, London; 6.1, 6.2 Used with permission from Biltmore Estate, Asheville, North Carolina; 6.9 Photo: Emil Boehl; 6.14 @ ARS New York and DACS London 2000. Photo: Esto Photographics, New York; 6.21, 6.38 Courtesy Museum of Fine Arts, Boston. Reproduced with permission. © 1999 Museum of Fine Arts, Boston. All rights reserved; 6.31 Peter Newark's American Pictures, Bath, England; 6.36 Photo: Joseph Levy; 6.46, 6.48 Art Resource, New York City; 6.49 RMN-Reversement Orsay.

CHAPTER 7

7.14 © Succession Picasso/DACS 2000; 7.21, 7.28 © Succession Marcel Duchamp/ADAGP Paris/DACS London 2000; 7.26 Photo: Michael Tropea, Chicago; 7.32 Esto Photographics, New York; 7.36, 7.37 © ARS New York and DACS London 2000; 7.38 © ARS New York and DACS London 2000. Photo: Ralph Liebermann; 7.40 © ADAGP Paris and DACS London 2000; 7.43 © T.H. Benton and R.P. Benton Testamentary Trusts/VAGA New York/DACS London 2000; 7.46 © Ben Shahn Estate/VAGA New York/DACS London 2000; 7.47 © 1981 Center for Creative Photography, Arizona Board of Regents. Collection, Center for Creative Photography, The University of Arizona; 7.48 © Moses Sover Estate/VAGA New York/DACS London 2000. Photo: Art Resource, New York; 7.50 Courtesy Museum of Fine Arts, Boston. Reproduced with permission. ©1999 Museum of Fine Arts, Boston. All rights reserved. © Stuart Davis Estate/VAGA New York/DACS London 2000.

CHAPTER 8

Page 328 © Willem de Kooning, Revocable Trust/ARS New York/DACS London 2000; 8.1 © ADAGP Paris and DACS London 2000. Photo: Art Resource, New York; 8.2 © Ben Shahn Estate/VAGA New York/DACS London 2000; 8.6, 8.49, 8.57 Esto Photographics, New York.; 8.7 Photo: Ted McCrea; 8.8, 8.9, 8.52 © DACS 2000; 8.12 © Robert Frank, Courtesy Pace/MacGill Gallery, New York; 8.13, 8.23 © Kate Rothko Prizel & Christopher Rothko/DACS 2000; 8.14 © Adolph and Esther Gottlieb Foundation/VAGA New York/DACS London 2000; 8.15 Photo: Michael Tropea, Chicago; 8.16 © ADAGP Paris and DACS London 2000; 8.17 © Dedalus Foundation Inc./VAGA New York/DACS London 2000; 8.18, 8.19, 8.20, 8.22, 8.26, 8.28, 8.34, 8.35, 8.37, 8.38, 8.41, 8.51 © ARS New York and DACS London 2000; 8.27 © David Smith Estate/VAGA New York/DACS London 2000; 8.29 © Louise Bourgeois/VAGA New York/DACS London 2000; 8.32 © Untitled Press Inc./VAGA New York/DACS London 2000; 8.36 © Jasper Johns/VAGA New York/DACS London 2000; 8.39 © Donald Judd Estate/VAGA New York/DACS London 2000; 8.40 © Carl Andre/VAGA New York/DACS London 2000; 8.42, 8.46 Photo: Lee Stalsworth: 8.44 © Estate of Roy Lichtenstein/DACS 2000; 8.45 Photo: Seymour Rosen-1991, Los Angeles/© The Andy Warhol Foundation/DACS 2000; 8.46 © The Andy Warhol Foundation/DACS 2000; 8.47 Photo: Robert E. Mates ©The Solomon R. Guggenheim Foundation, New York/© The Andy Warhol Foundation/DACS 2000; 8.54 © Robert Smithson Estate/VAGA New York/DACS London 2000; 8.55 Photo: Rheinisches Bildarchiv, Cologne; 8.56 Photo: David Reynolds; 8.59 Collection: The Dinner Party Trust. Photo © Donald Woodman; 8.64 Photo: Ricardo Blanc.

Index

Able Doctor, or American Swallowing the Bitter Draught, The (Revere) 118-19, 4.3 abolition movement 166, 205-6, 216-17, 218, 219, 242, 245 Abstract Expressionism 327, 340, 342-8, 350–6, 357, 359, 377 Abstract Painting No. 5 (Reinhardt) 356, 8.28 Abstraction on Spectrum (Macdonald-Wright) 307, 7.26 Acoma, New Mexico: San Estevan 46-8. 2.6-2.8 Action painting 350 Adams, Abigail 122 Adams, John, President 133–4, 136, 138, 142, 4.29 Adams, John Quincy, President 122, 157; portrait (Leslie) 159-60, 4.54 Adena culture 20 adobe construction 17, 1.2 Advance of Civilization, The (Durand) see Progress Aesthetic movement 229-30, 231, 274-5, 276, 279, 280, 281, 283 African-Americans: artists and craftsmen 177, 215-18, 264-5, 325-6, 380-1; and Boston Massacre 133-4; and civil and political rights 117, 185, 231, 242-3, 264, 293, 337, 380, 381; and Civil War 141, 262, 263-4; as slaves see slaves, African; in World War II 331-2 After the Hunt (Harnett) 250, 6.22 After Sunset (Dewing) 279, 6.53 AIDS 387, 388 Alaska 227 Albany, New York 171; Dutch population 54-6, 93-5 alchemy 44-5 Alexander VI, Pope 40 Alexandria, Virginia 124; wrought-iron figure 43, 2.3 Algonquin tribes 16, 28, 29, 30, 31 Alien and Sedition Acts (1798) 153 Allan, Sir William: Sale of Circassian Captives in a Turkish Bashaw 218 Allen, William 85 Allston, Washington 117, 149, 152, 153, 155, 158, 187, 221; Belshazzar's Feast 155–8, **4.51**; Elijah in the Desert 158–9, 4.52; Tragic Figure in Chains 152, 4.48 almanacs 44, 2.5 Ambi II (Louis) 359, 8.31 American Academy of the Fine Arts 149, 185 American Art-Union 192, 204 American Artists' Congress 326, 327 American Civil War (1861-5) 163, 223-5, 233, 241-2, 245, 247, 296, 5.65, 5.66 American Commissioners of the Preliminary Peace Negotiations with Great Britain (West) 138, 4.29 American Federation of Labor 231, 293 American Gothic (Wood) 321-2, 7.44 American Historical Epic, The (Benton) 320, American Philosophical Society 146, 147 American Revolution (War for Independence) (1775-83) 37, 110, 113, 115, 116, 117, 136, 138, 140-1, 142, 152 American School, The (Pratt) 130, 4.20 American War for Independence, Second (1812-15) 153 Americans, The (Frank) 338, 340, 8.12 Ames, Asa: Phrenological Head 180, 5.20

the Artist's Dream' (C. King) 186-7, 5.29 Ancient Ruins in the Canyon de Chelly, New Mexico (O'Sullivan) 18, 1.3 Anderson, James: Constitutions of Freemasons Andre, Carl 365; Steel Magnesium Plain 365, 8.40 Anglican Church/churches 41, 42, 58-63, 65, 74, 2.1, 2.14, 2.15, 2.18 Annapolis, Maryland: Samuel Chase-Edward Lloyd House (Buckland) 95-7, 3.15, 3.16; Tuesday Club 82, 83, 95, 3.5 Anshutz, Thomas Pollock 257, 289; The Ironworkers' Noontime 257-8, 6.30 Antietam, battle of 223-4, 5.65 Antigone (Rothko) 340-1, 8.13 Apaches, the 16 Apollo Belvedere 37, 142, 166, 186, 261, 4.33 Aragón, Rafael 188; The Flight into Egypt 188, 5.31 Archipenko, Alexander 316, 318; Seated Woman (Geometric Figure Seated) 316, 7.37 architecture: churches and synagogues 39, 46-9, 58-63, 67, 73-4; classical and Greek Revival 85-6, 90-3, 122-7, 149, 167-8, 175, 176-7; Colonial Dutch 93-5; and Freemasonry 85-7, 91; Gothic and Gothic Revival 86, 98, 178-9, 234-5, 301; meetinghouses 39, 57, 63, 65, 67; Native American pueblo 17-19; 19th-century 169-71 (functionalist), 180-2 (octagonal), 228-9 (mansions), 233-5, 238, 251 (commercial), 230, 236-9, 240, 260 (skyscrapers); Palladian 93, 95-7; 20th-century 286-8, 301 (historical-revival), 312-14 (Art Deco), 332, 334-5 (suburban), 336-7, 372, 373 (International Style), 330, 372-3 (Postmodernist); see also Wright, Frank Lloyd Architecture of the Sky III (Bleckner) 387, 8.65 Ariadne Asleep on the Island of Naxos (Vanderlyn) 153-4, 4.50 Armory Show (1913) 301, 303, 304-5, 306, 307, 310 Arp, Jean 342-3 Arques-la-Bataille (Twachtman) 281, 6.54 Arrangement in Gray and Black (Whistler) 275, 6.49 Art Deco movement 312-14 Art Magazine Ads (Koons) 391, 8.69 Artist in his Museum, The (C. Peale) 148, 4.43 Artists for Victory 331 Artists on WPA (M. Soyer) 324, 7.48 Artists' Union 326 Arts and Crafts movement 230, 231, 241, "Ashcan" School 293, 295, 296, 301, 305, Asheville, N. Carolina: Biltmore (Hunt) 228, 6.1, 6.2 Aspects of Negro Life (Douglas) 325, 7.49 assemblages 353-4, 360, 361 Association of American Painters and Sculptors 303 At Five in the Afternoon (Motherwell) 346, 8.17 At the Opera (Cassatt) 267, 6.38 Athore, Chief 25-6 atomic bombs 350, 367 Attucks, Crispus 134 Atwood, Reverend John: portrait (Darby) 190. 5.34 automatism, Surrealist 343, 344, 346 Ball, James Presley 222

Anasazi Indians 17

Anatomy of Art Appreciation, 'The Vanity of

Balla, Giacomo 301 Baltimore, Cecil Calvert, 2nd Baron 79, 83 Baltimore, Charles Calvert, 3rd Baron 80 Baltimore, 4th Baron 83-4 Bamana, the 43 Banjo Lesson, The (Tanner) 265, 6.37 Banvard, John: Panorama of the Mississippi River 204 Baptism in Kansas (Curry) 319-20, 7.42 Baptism of Pocahontas at Jamestown, Virginia (Chapman) 200, 5.46 Baptists 42, 57, 65, 207 Barbizon School 271 Barlow, Ioel: The Columbiad 152 Bartol, C.A. 157 Baselitz, Georg 385 Battle of Lights, Coney Island, Mardi Gras (J. Stella) 301, 7.20 Bauhaus 330, 336 Bear Run, Pennsylvania: Fallingwater (F.L. Wright) 317, 7.38 "Beat" movement 340, 360, 367, 8.43 Bed (Rauschenberg) 360-1, 8.32 Beecher, Henry Ward 242 Belcher, Jonathan 99-100, 101, 104, 105, 106; mezzotint portrait (Faber) 99, 3.20 Bellows, George 289, 293; Both Members of This Club 290, 292, 7.6; Pennsylvania Excavation 288-9, 7.3 Belshazzar's Feast (Allston) 155-8, 4.51 Belshazzar's Feast (anon.) 55-6, 2.13 Benavides, Friar Alonso 49 Benton, Thomas Hart 320, 346; The American Historical Epic (series) 320, 321; The History of New York: New York Today 320-1, **7.43** Benton, Senator Thomas Hart: statue (Hosmer) 220, 5.63 Berkeley, Dean George 101; The Bermuda Group: Dean George Berkeley and his Family (Smibert) 101–4, 3.21; "Verses on the Prospect of Planting Arts and Learning in America" 103, 119 Berkeley, Henry 104 Berkeley, Sir William 79 Bermuda Group, The (Smibert) 101-4, 3.21 Bethlehem, Pennsylvania 36, 52 Bible, King James 69, 2.27 Bierstadt, Albert 269; The Last of the Buffalo Bigelow, Jacob: Gateway, Mount Auburn Cemetery, Cambridge 182, 5.25 Biltmore, Asheville, N. Carolina (Hunt) 228, 6.1. 6.2 Bingham, George Caleb 203-4; Daniel Boone Escorting Settlers Through the Cumberland Gap 203, 5.49; Jolly Flatboatmen 204, 5.50 Blackfoot (Catlin) 199, 5.43 Blake, Peter 368 Blaue Reiter (Blue Rider) group 306 Bleckner, Ross 386-7; Architecture of the Sky III 387, 8.65 Blind Leading the Blind, The (Bourgeois) 355, 8.29 Bloody Massacre, The (Revere) 133, 136, 4.25 Blue Rider group 306 Boccioni, Umberto 301 Bolton, Reverend J. Gray 254 Boone, Daniel 203; *Daniel Boone Escorting* Settlers Through the Cumberland Gap (Bingham) 203, 5.49 Boston, Massachusetts 31, 67, 77, 99, 105, 106, 157, 168, 2.25; Channing's Federal Street Church 208; Faneuil Hall 168; Freemasonry 83, 107, 124, 4.11; King's Chapel (Harrison) 74; Ladies' Physiological Institute 219; Massachusetts State House (Bulfinch) 124, 4.12;

Massacre (1770) 133-4, 4.25; Museum of Fine Arts 227, 244; Old South Meetinghouse (Twelves) 65, 67, 2.24; Public Library (McKim, Mead, & White) 268, 6.41; Quincy Market (Parris) 167, 192, 5.5; Shaw Memorial (Saint-Gaudens) 262-4, 6.35; Tea Party (1773) 118, 134; Trinity Church 270, 6.44; triumphal arch (Bulfinch) 123-4, 4.10 Boston Harbor at Sunset (Lane) 211-12, 5.55 Both Members of This Club (Bellows) 290, 292, 7.6

Boullée, Étienne-Louis 143

Bourgeois, Louise 355; The Blind Leading the Blind 355, 8.29

Bowdoin, James, II 81; portrait (Feke) 81,

Bowdoin, Mrs. James (née Elizabeth Erving): portrait (Feke) 81, 3.4

Boy with a Squirrel (Copley) 110, 112, 3.28 Brady. Matthew B.: On the Antietam Battlefield 223-4, 5.65

Braque, Georges 299

Breaker Boys Working in Ewen Breaker (Hine) 296, 7.11

Brecht, Bertolt 370

Breton, André 342, 345

Broadway Magazine 273-4

Brooklyn Bridge, New York City (Roebling) 235, 6.7

Brotherhood of Our Father Jesus Nazarene 188 Brown, Mather: Portrait of Thomas Jefferson

120, 4.6 Brown Family, The (E. Johnson) 247-8, 267,

6.19

Browne, William: portrait (Smibert) 104, 3.23

Bruce, Patrick Henry 299, 308

Bry, Theodore de 27, 28

Buckland, William 95; Samuel Chase-Edward Lloyd House 95-7, 3.15,

Buffalo Bull's Back Fat... (Catlin) 199, 5.43 **Building News 236**

Bulfinch, Charles: Capitol, Washington 126; Massachusetts State House 124, 4.12; triumphal arch 123-4, 4.10

Bunker Hill, battle of 140-1, 4.30; Monument, Charlestown 157, 163, 167,

Burgis, William (attrib.): A North East View of the Great Town of Boston 67, 2.25 burial mounds, Native American 19-21

Burlington, Richard Boyle, 3rd Earl of 93 Burnham, Daniel Hudson 239; Chicago City Center Plan 240, 6.13; Masonic Temple, Chicago 260, 6.32; "White City" (World's Columbian Exposition) 239-40, 282, 286, 301, 6.11

Burr, Aaron 153

Burroughs, William S. 340 Byles, Mather 106

Byrd, William II 90, 91, 92-3; History of the Dividing Line 90-1

Caffin, Charles: American Masters of Sculpture 264; The Story of American Art 292 Cage, John 359, 360; Theater Piece #1 359 Cahokia, Illinois 19; Monk's Mound 19-20, 1.6

Calder, Alexander 318; A Universe 318, 7.40 California 52, 188, 199

Calvinism 41, 54, 63, 70

Cambridge, Massachusetts 178; Mount Auburn Cemetery 182, 184, 222, 5.24, 5.25, 5.27

Cambridge Platform 42

Camera Work (journal) 297, 305, 308 Campbell, Benjamin: House, Rochester, New York 175, 5.14

Campbell's Soup Cans (Warhol) 369-70, 8.45 canal construction 163, see also Erie Canal; Panama Canal

Canyon de Chelly, Arizona 17-18, 1.3 Cape Cod, Massachusetts 29, 30 Cape Fear, N. Carolina 83

Capen, Reverend Joseph 65

capitalism 163, 230, 231-2, 248, 250 Capitol, The see Washington, DC Carles, Arthur B. 300

Carlu, Jean: Gift Packages for Hitler 330, 8.1 Carnegie, Andrew 227, 232

Carolinas, The 16; see North Carolina; South Carolina "carpetbaggers" 242

Carrà, Carlo 301 Carrière, Eugène 7.10

Cassatt, Mary 266-7; At the Opera (In the Loge) 267, 6.38; Reading "Le Figaro" 267,

Catholic Church 30-1, 39-40, 52, 157, 187-8, 189; Bible 69; missions 45-52

Catlin, George 199, 215; Buffalo Bull's Back Fat... (Blackfoot) 199, 5.43 Celebration, Florida 390-1

cemeteries 73-5, 182-4, 2.33; see also

gravestones Central Intelligence Agency (CIA) 355, 385

ceramics: pearlware mug (anon.) 133, 4.24; punch bowls 78, 3.2 Cézanne, Paul 293, 294, 297, 357

Chaco Canyon, New Mexico: Great Kiva 18,

Chambers, Thomas: Mount Auburn Cemetery 182, 5.24

Chambers, William: Somerset House, London 4.12

Channing, William Ellery 208 Chapel of the Virgin at Subiaco (Morse) 189, 5 32

Chapman, John Gadsby: Baptism of Pocahontas at Jamestown, Virginia 200, 5.46

Charles I, King 29, 58, 79

Charles II, King 58

Charles City County, Virginia: Westover 91-3, 3.10, 3.11

Charleston, S. Carolina 142, 177; Drayton Hall 93, 3.12, 3.13

Charlestown, Massachusetts: battle of Bunker Hill 140–1, 4.30; Bunker Hill Monument 157, 163, 167, 182

Charlottesville, Virginia: Monticello (Jefferson) 125-6, 4.16

Chase, Samuel 95

Chase, William Merritt 280-1; In the Studio 280, 6.55; James A.M. Whistler 279-80, 6.52

Cherokee Indians 197

Chesterfield, Philip Stanhope, 4th Earl 82 Chicago, Illinois 240, 282; Art Institute 227, 240; City Center Plan (Burnham) 240, 6.13; Marshall Field Warehouse (Richardson) 238, 6.10; Masonic Temple (Burnham) 260, 6.32; North Lake Shore Drive apartment houses (Mies van der Rohe) 336, 8.8; see also World's Columbian Exposition

Chicago, Judy: The Dinner Party 381-2, 388, 8.59

Chicken (Kaprow) 360, 8.33 Christian Register 243

Christo and Jeanne-Claude 377; Valley Curtain 377, 8.53

Chrysler Building, New York City (Van Alen) 313-14, 7.32

Church, Frederic Edwin 213, 269; The Heart of the Andes 214-15, 5.58; Niagara Falls 213-14, 271, 5.57

Church of Jesus Christ of Latter-Day Saints see Mormons

CIA see Central Intelligence Agency Cincinnati, Ohio: daguerreotype studios 222 cinema 285, 338, 356, 8.12

City Night (O'Keeffe) 316, 317, 7.36 civil rights see abolition movement; African-Americans

Clarke, Richard 134

Class War in Colorado (Sloan) 293, 7.8 Classic Landscape (Sheeler) 315-16, 7.35 Cleopatra (Foley) 174, 219, 5.13

Clinton, DeWitt 171

Close, Chuck 372

clubs, 18th-century social 82-3 Coates, Robert 346

Coburn, Alvin Langdon 300; The Octopus 300. 7.17

Cold War 329, 345, 346, 350, 367, 370, 388 Cole, Thomas 193, 194-5, 199, 203, 213; The Course of Empire: The Consummation of Empire 197, 199, 205, 208, 209, 5.42; The Course of Empire: The Savage State 197, 198, 205, 5.41; Kaaterskill Falls 193, 194, 199, 5.37; St. John in the Wilderness 194-5, 5.38; View from Mount Holyoke...

(The Oxbow) 196-7, 5.39

Collins, Burgess see "Jess" Colman, Reverend Benjamin: Government the Pillar of the Earth 100-1; portrait (Pelham, after Smibert) 105-6, 3.22

Colman, William 193

color field painters 359

Columbus, Christopher 13-14, 22, 24, 40 Commentary (journal) 357

communism/American Communist Party 318-19, 326, 327, 331, 342, 345, 350, 355, 356, 368

Composition (Krasner) 348, 8.19 Composition with Three Figures (Weber) 299,

7.15 Conceptual Art 375, 384

Concord, Massachusetts: battle 113, 115. 261; Minute Man (French) 261, 6.33

Congregationalists 42, 44, 63, 65, 68, 105-6, 270

Congress for Cultural Freedom 355 Congress of Industrial Organizations (CIO): poster (Shahn) 331, 8.2 Conquistadora, La (anon.) 49-51, 2.9

Conrad (E. de Kooning) 352, 8.24 Constitution, United States 117, 120

Constructivists, Russian 318, 8.62 consumerism, 18th-century 77-8, 108, 109,

Copley, John Singleton 109, 116, 133, 137-8; Boy with a Squirrel 110, 112, 3.28; Mars, Venus, and Vulcan: The Forge of Vulcan 109, 3.27; Portrait of Mrs. Samuel Quincy 109-10, 3.26; Portrait of Paul Revere 112-13, 3.29; Portrait of Elkanah Watson 137, 4.28; Watson and the Shark 134-7, 388, 4.26

Cornell, Joseph 342, 362; Habitat Group for a Shooting Gallery 342, 8.15 Cornish, New Hampshire 279

Corot, Jean-Baptiste Camille 271 Cosmic Synchromy (Russell) 285, 307

Cosmopolitan Art Association 191 Cosmopolitan magazine 239

Courbet, Gustave 274

Course of Empire, The (Cole) 197-9, 205, 208, 209, 5.41, 5.42

Court of Death, The (R. Peale) 150, 161, 4.46

Cox, Kenyon 285, 304, 307

Coypel, Charles-Antoine 3.27 Crawford, Thomas: Orpheus 164-5, 5.3; The Progress of Civilization 200-1, 5.47 Crayon, The (journal) 191, 200-1 Criss-Crossed Conveyors, Ford Plant (Sheeler) 315, 7.34 Cropsey, Jasper Francis: Gilbert Elevated Railroad Station 210, 5.54; Starrucca Viaduct, Pennsylvania 209-10, 5.53 Cubism 298-9, 301, 304, 306, 307, 316, 327 Cunningham, Merce 359-60 Curran, Charles C.: Machinery Hall, World's Columbian Exposition 239, 6.12 Curry, John Steuart: Baptism in Kansas 319-20, 7.42 Dadaists 310-11, 312, 329, 359 Daguerre, Louis-Jacques Mandé 221 daguerreotypes 221-2, 5.27 Dalí, Salvador 343 Dante's View (Weston) 323, 7.47 Darby, Henry F.: Portrait of Reverend John Atwood and His Family 190, 5.34 Dare, Virginia 27 Darnall, Henry, II 80 Darnall, Henry, III: portrait (Kühn) 77, 80 Darwin, Charles 264, 285; The Origin of Species 248 David, Jacques-Louis 4.45, 4.49 Davies, Arthur B. 293, 303 Davis, Alexander Jackson 178; Gatehouse, Llewellyn Park 179, 5.19; Edward W. Nicholls House 178, 5.17 Davis, Andrew Jackson 211 Davis, Stuart 327; Hot Still-scape for 6 Colors—7th Avenue Style 327, 7.50

Bunker's Hill, The (Trumbull) 140–1, 4.30 Death of General Wolfe, The (West) 116, 130–3, 4.21 Death of Jane McCrea, The (Vanderlyn) 150, 152, 4.47 Deborah (Lombardi) 251 Declaration of Independence 115, 120 Declaration of Independence, The (Trumbull) 141–2, 4.31

Death of General Joseph Warren at the Battle of

Dead Bird, The (Ryder) 272, 6.47

deconstructionist theories 382

Dean, James 356, 8.12

de Andrea, John 372

Degas, Edgar 266 de Kooning, Elaine 352; Conrad 352, 8.24 de Kooning, Willem 351, 353; Woman series 351–2, 357; Woman I 329, 352 Delacroix, Eugène 303 Delaunay, Robert and Sonia 7.26

Delaware tribes 35, 36, 37, 1.22, 1.23
Demopolis, Alabama: Gaineswood 176–7, 5.16

Demuth, Charles 312, 316; Incense of a New Church 312, 7.31 Departure of Regulus from Rome, The (West)

130, **4.22** Depression, Great 315, 321, 322–4, 326,

330–1
Desaguliers, Theophilus 3.29
Destruction de la Statue Royale à Normalle

Desaguliers, Theophilus 3.29
Destruction de la Statue Royale à Nouvelle
York, La (Habermann) 115, 4.1
Dewing, Maria Oakey 279
Dewing, Thomas Wilmer 279, 281, 289;

Dewing, Thomas Wilmer 2/9, 281, 289; After Sunset (Summer Evening) 279, 6.53 Die (T. Smith) 365, 8.38

Dillenberger, John 52
Dinner Party, The (Chicago) 381–2, 388, **8.59**

Disasters series (Warhol) 371, 8.47
Disney, Walt 389; Disneylands 389–91, 8.68
di Suvero, Mark 363; Hankchampion 353, 8.25

Dodge, Mabel 305

Dominguez, Fr. Francisco Atanasio 46–7 Doolittle, Amos: "View of the Federal Edifice in New York" 126, **4.15** Dornan, Robert K. 388

Doughty, Thomas: Mill Pond and Mills, Lowell, Massachusetts 173, 5.12

Douglas, Aaron 325, 326; Aspects of Negro Life: Song of the Towers 325, **7.49**

Dove, Arthur 300 Dow, Arthur Wesley 299, 7.17

Downing, Andrew Jackson 177–8 Downman, John: *Patience Wright* 122, **4.8**

Drake, Sir Francis 26 Drawing (Picasso) 298, 7.14

Drayton Hall, Charleston, S. Carolina 93, 3.12, 3.13

Dreier, Katherine 318 drip paintings 346, 348, 357 Drowning Girl (Lichtenstein) 369, **8.44**

Dubuffet, Jean **8.56**Duchamp, Marcel 310, 355, 360, 375;

Fountain 310, 311, 312, 7.28; Nude Descending a Staircase, No. 2 304, 7.21; Rotary Glass Plates 318

Dulles, John Foster 346 Duncan, Robert 367

Duncanson, Robert S. 215–16, 217–18, 222; The Land of the Lotus Eaters 216; Uncle Tom and Little Eva 216–17, 5.60

Dunlap, William 137, 175, 193; A History of the Rise and Progress of the Arts of Design in the United States 175, 185–6

Durand, Asher B. 205, 206, 208, 209; *God's Judgment upon Gog* 205–6, **5.51**; *Progress (Advance of Civilization*) 208–9, 212, **5.52** Dutch, the 29, 54, 56, 70, 93–5; artists 54–6

Eakins, Thomas 250, 254–5, 258, 264, 275, 289; Gross Clinic 227, 251–3; Motion Study 256–7, 6.29; Portrait of Henry O. Tanner 264, 6.36; William Rush Carving His Allegorical Figure of the Schuylkill River 253–4, 6.25; The Swimming Hole 255–6, 258, 6.26, 6.27

Earth Art 375–7

earthworks, Native American 19–21 Eastman, George 296

Eaton's Neck, Long Island (Kensett) 212, 5.56 economy and trade: 18th-century 58,

77–81, 115–16, 118; 19th-century 163–4, 177, 210, 227, 230–2; 20th-century 285, 286, 314, 315, 321, 322, 326, 329, 330–1 "Eight. The" 293–4, 295, 303, 308

Einstein, Albert 285 Eisner, Michael 390

Elijah in the Desert (Allston) 158–9, **4.52** Elizabeth I, Queen 26, 41

Embarkation of the Pilgrims at Delft Haven, Holland (Weir) 200, **5.45** Emerson, Ralph Waldo 210–11

English Civil War 58, 60, 62, 79 Erie Canal 161, 163, 171, 174, 189, 342 Estes, Richard 372

Etow Oh Koam, King of the River Nation (Simon, after Verelst) 33–4, 1.19 Evangelist Campmeeting (Paul) 194, 5.40 Evelyn, John 98

Existentialism 350

Expressionism see Abstract Expressionism; Neo-Expressionism

Faber, John: *Governor Jonathan Belcher* 99, 3.20
"Factory, The" 370 *Falling Rocket, The* (Whistler) 276–7, 6.50
Fallingwater, Bear Run, Pennsylvania (F.L. Wright) 317, 7.38

Farm Security Administration (FSA) 322
Farmers Nooning (Mount) 165–6, 5.2
Farragut Memorial (Saint-Gaudens) 261–2,
6.34

Federal Arts Project (FAP) 324, 325 Federal Bureau of Investigation (FBI) 355 Feke, Robert 81, 87, 104, 109; James Bowdoin II 81, 3.3; Mrs. James Bowdoin 81, 3.4; Judgment of Hercules 89; Isaac Royall and His Family 97–8, 3.19

feminist art 219–20, 380–2, 384–5 Ferdinand, King, and Isabella, Queen 13, 40 Ferlinghetti, Lawrence 340

Field, Cyrus 215

Flavius Amalfitanus *1.10*Fletcher, Thomas (and Sidney Gardiner):
DeWitt vase 171–2, *5.9*

Flight into Egypt, The (Aragón) 188, 5.31 Flyer, The (White) 27, 29, 1.13 Fog Warning, The (Homer) 250, 6.21 Foley, Margaret 173–4; Cleopatra 174, 219, 5.13

Ford, Henry 314, 319 Ford Motor Company 314–15, **7.33**, **7.34** Forever Free (Lewis) 243–5, **6.16** Forge of Vulcan, The (Copley) 109, **3.27** formalist painting 357, 359

Forum Exhibition of Modern American Painters (1916) 307, 308, 320 Forward Show (1917) 309, 310

Foster, John: "The Dominion of the Moon in Man's Body" 44, 2.5; Richard Mather 68–9, 2.26

Fountain (Duchamp) 310, 311, 312, 7.28 Fowler, Orson S.: The Octagon House: A Home for All 180, 181, 182

Fox, George 57 Fox, Kate 211

Fox, Margaret 211

France/the French 24–6, 29, 33, 34, 37, 135–6, 150–153; French Revolution 150, 152-3, 156; Seven Years' War 116, 118-119, 130–3; *see also* Impressionism; Paris Franciscan order 45–6, 49, 51–2

Franco, General Francisco 345, 346 Frank, Robert: *The Americans* 338, 340, **8.12** Frankenthaler, Helen 357; *Mountains and Sea* 357, 359, **8.30**

Franklin, Benjamin 108, 122, 124, 138, 142, 147, 4.29; *Magna Britannia: her Colonies Reduc'd* 118, 135, 4.2; portrait (C. Peale) 146–7, 4.41

Fraser, Charles: St. James's Church, Goose Creek, S. Carolina **2.18**

Freake, Elizabeth: Elizabeth Freake and Baby Mary (anon.) 71, 2.30 Freake, John: portrait (anon.) 71, 2.29

Frederick Louis, Prince of Wales 84 Frederick Treemasons 45, 74, 83–7, 89, 101, 105, 107, 109, 112, 113, 124–5, 12

101, 105, 107, 109, 112, 113, 124–5, 126, 129, 136, 143, 157, 160, 168, 192, 193–5, 203, 260; aprons 87, 89, 112, 3.8; armchairs 124, 4.11; Masonic Lodge notification (Revere) 112, 3.30

Freer, Charles Lang 278–9
French, Daniel Chester: *Minute Man* 261, 6.33

Fe.d, Sigmund 341, 347 Freytag-Loringhoven, Elsa von 311–12; *God* 311, 312, **7.29**

Frick, Henry Clay 228, 232 Frieze of the Prophets (Sargent) 268, 6.41, 6.42

Fugitive's Story, The (Rogers) 242, 6.15 Furness, Frank: Pennsylvania Academy of the Fine Arts 250–1, 6.23 Furness, Reverend William H. 251 Futurists, Italian 301, 304 Gaineswood, Demopolis, Alabama 176-7, García, Fray Andrés 51; El Santo Entierro 51, Gardiner, Sidney see Fletcher, Thomas Gardner, Alexander 224, 225; (with O'Sullivan) A Harvest of Death, Gettysburg... 224-5, 5.66 Garrison, William Lloyd 242, 243 Gauguin, Paul 294 Gautier, Théodore 274 Gautreau, Virginie 267 Gehry, Frank 334; Chiat Day Mojo Offices, Venice, California 373, 8.50; Santa Monica Place, California 334, 8.6 Geometric Figure Seated (Archipenko) 316, George III, King 84, 115, 130, 133, 4.21 Gettysburg, battle of 224-5, 5.66 Gibbs, James 85, 2.1 Gift Packages for Hitler (Carlu) 330, 8.1 Gilbert, Cass: Woolworth Building, New York City 301, 7.19 Gilbert, Sir Humphrey 26 Gilder, Helena de Kay 269 Ginsberg, Allen 340, 360; Howl 8.43 Glackens, William 289, 293, 310 "Glorious Revolution" (1688-9) 58, 83 Gober, Robert 387; Untitled 387-8, 8.66 God (Freytag-Loringhoven and Schamberg) 311, 312, **7.29** God's Judgment upon Gog (Durand) 205-6, 5.51 Gogh, Vincent van 294 Golub, Leon 385; Napalm 378; Vietnam (series) 378-9, 8.56 Goose Creek, S. Carolina: St. James's Church 61-3, 65, 2.18 Gorky, Arshile 343-4, 347; The Liver is the Cock's Comb 344, 8.16 Gottlieb, Adolph 341, 343; Hands of Oedipus 341-2, 8.14 Gould, Charles 208, 209 Goya, Francisco de 7.6; The Third of May, 1808 379 Graham, John 347 Graham, John, and company: Seattle shopping center 334, 8.5 gravestones 71-3, 2.31, 2.32 Great Seal of the United States 126, 142, 4.14 Great Serpent Mound, nr. Locust Grove, Ohio 20, 1.7 Greek Slave, The (Powers) 217-19, 5.61 Green, Eva: portrait (Henri) 289, 7.5 Green and Maroon (Rothko) 351, 8.23 Greenberg, Clement 357, 359, 381 Greenfield Village, Michigan 319 Greenough, Horatio 169, 180, 211; Bunker Hill Monument 163, 167; Rescue 201, 203, 5.48; George Washington 143, 144, 4.35 Greenwood, John 81; Sea Captains Carousing in Surinam 78, 3.1 Gribelin, Simon: The Judgment of Hercules 89, 3.9

Staircase (Rush Hour at the Subway) 304, 7.22
Gross, Dr. Samuel David 252, 253
Gross Clinic, The (Eakins) 227, 251–3
Guadalupe-Hidalgo, Treaty of 199
Guardians of the Secret (Pollock) 347–8, 8.18
Guerrilla Girls 380
Guggenheim, Peggy 342; Art of the Century gallery 342–3
Guggenheim Museum, New York City (F.L.

Grimes, Reverend Leonard A. 243

Griswold, J.F.: The Rude Descending the

Wright) 374, 375, **8.51** Guibault, Serge 350

Guibault, Serge 350 Haacke, Hans: Shapolosky et al. Manhattan Real Estate Holdings 375, 8.52 Habermann, Franz Xaver: La Destruction de la Statue Royale à Nouvelle York 115, 4.1 Habitat Group for a Shooting Gallery (Cornell) 342, 8.15 Haidt, John Valentine 52, 53; Lamentation over Christ's Body 53, 2.12 Hairdresser's Window (Sloan) 292, 7.7 Hall, David 107, 108 Hall, Deborah: portrait (Williams) 107-8, Hamilton, Alexander (Treasury Secretary) 153 Hamilton, Dr. Alexander 39, 42, 43, 45, 54, 74, 82, 83, 86, 87, 89, 93–5, 101; Mr. Neilson's Anger Restrained by Philosophy 82, Hamilton, James 85 Hamilton, Richard 368 Hancock, John 142 Hands of Oedipus (Gottlieb) 341-2, 8.14 Hankchampion (di Suvero) 353, 8.25 Hanson, Duane 371, 372; Motorcycle Accident 371-2, 8.48 "happenings" 359, 360 Hapsgood, Hutchins 305 Harding, Chester 203 Hardy, Anne Eliza 190 Hardy, Jeremiah Pearson 190; Catherine Wheeler Hardy and Her Daughter 190, 5.33 Hariot, Thomas 27; A Brief and True Report of the New Found Land of Virginia 27-8 Harlem Renaissance 325-6 Harmony in Blue and Gold: The Peacock Room (Whistler) 277-8, 6.51 Harnett, William Michael 250, 272; After the Hunt 250, 6.22 Harper's Weekly 245, 304 Harrison, Peter: Touro Synagogue 73-5, 2.33 Hartley, Marsden 300, 306–7; Portrait of a German Officer 306, 362, 7.25; Warriors 306, 311, **7.24** Harvard College, Cambridge, MA 69 Harvest of Death, Gettysburg..., A (Gardner and O'Sullivan) 224-5, 5.66 Haskell, Llewellyn 178 Hassam, (Frederick) Childe 282, 288, 289; Washington Arch, Spring 282, 6.56 Haviland, John: Eastern Penitentiary, Philadelphia 170, 5.7, 5.8 Hawaiian Islands 227, 327 Hawes, Josiah Johnson see Southworth, Albert Sands Hawkins, John 26 Hawthorne, Nathaniel 143; The House of Seven Gables 221 Haywood, Bill 304 Heade, Martin Johnson 215; Two "Sun Gems" and a "Crimson Topaz" 215, 5.59 Heart of the Andes, (Church) 214-15, 5.58 Henri, Robert 289, 292, 293, 295, 303; Eva Green 289, 7.5 Henry VIII, King 41 Hero, The (D. Smith) 354, 8.27 Herring, James 192 Herter, Christian 229 Hesse, Eva 365; Untitled 365, 8.42 Hesselius, Gustavus 35-6; Lapowinsa 35, 36, 1.23: Tishcohan 35, 36, 1.22 Highland Park, Illinois: Ward W. Willitts House (F. L. Wright) 240-1, 6.14 Hill, Samuel (after Bulfinch): View of the

Triumphal Arch and Colonnade 123-4, 4.10

Hine, Lewis 296; Breaker Boys Working in

Ewen Breaker 7.11 Hingham, Massachusetts: Old Ship Meetinghouse 63, 65, 2.20, 2.21 Hiroshima, bombing of 350, 367 History of New York: New York Today (Benton) 320-1, 7.43 Hitchcock, Henry-Russell 336 Hitler, Adolf 326–7, 341 Ho Nee Yeath Taw No Row, King of the Generethgarich (Simon, after Verelst) 33-4, Hoeber, Arthur 294 Hogarth, William: A Midnight Modern Conversation 78, 3.2 Holzer, Jenny 384; Truisms 384-5, 8.63 Homer, Winslow 245, 246, 248, 250, 258, 265, 271, 272; The Fog Warning 250, 6.21; Snap the Whip 246-7, 6.20; The Veteran in a New Field 245-6, 261, 6.18 homosexuality 306, 363, 371, 387, 388 Hopewell culture 20; hand shape 21, 1.8 Hopi, the 17 Hopkins, Stephen 3.1 Hopper, Edward 337-8, 340; Nighthawks 338, 8.10 Hosmer, Harriet 220; Senator Thomas Hart Benton 220, 5.63; Zenobia 219, 5.62 Hot Still-scape for 6 Colors—7th Avenue Style (Davis) 327, 7.50 Houdon, Jean-Antoine: George Washington 145, 4.39 House Un-American Activities Committee 355 Hudson, Elizabeth: sampler 58, 2.16 Hudson River School 192, 193, 212, 216 Hughes, Langston 326 Huizar, Pedro: San José y San Miguel de Aguayo portal sculptures 50, 2.10 Humboldt, Alexander von: Cosmos: A Sketch of a Physical Description of the Universe 214 Huneker, James 294 Hunt, Richard Morris: Biltmore, Asheville, N. Carolina 228, 6.1, 6.2; Studio Building, West Tenth St., New York City 233, 280, 6.5; Tribune Building, New York City 236, 6.8 Huntington, Daniel 205 I-Box (Morris) 363, 8.37

immigrants 80-1, 133, 164, 230-1, 329 Impressionism 246, 266-7, 280, 281-2, 293 In the Loge (Cassatt) 267, 6.38 In the Studio (Chase) 280, 6.55 Incense of a New Church (Demuth) 312, 7.31 Indian Family, The (West) 37, 1.24 Indian Village of Secoton (White) 13, 16, 27, 28-9 Industrial Workers of the World (IWW) 292-3, 304-5, 306 Ingres, Jean-Auguste-Dominique 303 Inness, George 270-1; Niagara 271, 6.46 installations 365, 378 International Style 336-7, 372, 373 Ironworkers' Noontime, The (Anshutz) 257-8, 6.30 Iroquois, the 34 Irving, Washington 155 Irwin, Robert 365; Untitled 365, 8.41

Jackson, Andrew, U.S President 197 James I, King 29, 69 James II, King 58, 83 James, Henry 220, 265 James, William 286 Jamestown, Virginia 28, 29 Jarves, J. Jackson: *The Art-Idea* 230, 231, 232 Jay, John 4.29 Jeanne-Claude *see* Christo

Jefferson, Thomas 122, 125, 142, 147, 149, 152, 153; Declaration of Independence 115; Monticello 125-6, 4.16; portrait 120, 4.6; University of Virginia 149, 4.44 Jennings, Samuel: Liberty Displaying the Arts and Sciences 119-20, 4.5 Jerusalem 56; King Solomon's Temple 74, 86–7, 100, 101, 113, 156, 157, **3.7** Jerusalem (Story) 251, 6.24 "Jess" (Burgess Collins) 367; Tricky Cad series 367-8, 8.43 Jews 42, 44, 45, 195, 251; see also Jerusalem; Touro Synagogue Johns, Jasper 361; Painting with Two Balls 8.36; Target with Plaster Casts 361, 362-3, Johnson, Andrew, President 242 Johnson, Eastman 247; The Brown Family 247-8, 267, 6.19 Johnson, Philip 336, 373; Seagram Building, New York City 336, 8.9 Johnson, William 132-3 "Join or Die" 133, 4.23 Jolly Flatboatmen (Bingham) 204, 5.50 Jonah (Ryder) 273, 274, 6.48 Jones, Inigo 86, 93 Jones, Robert Edmond: Paterson Strike Pageant program cover 306, 7.23 journals see newspapers Joyce, James: Ulysses 312 Judd, Donald: Untitled 365, 8.39 Judgment of Hercules, The (Gribelin) 89, 3.9 Jung, Carl 347

Kaaterskill Falls (Cole) 193, 194, 199, 5.37 Kahn, Albert: Ford Motors 314, 7.33 Kandinsky, Wassily 306 Kaprow, Allan 360; Chicken 360, **8.33** Kasebier, Gertrude 297 Kaufmann House, Bear Run, Pennsylvania (F.L. Wright) 317, 7.38 Kearsley, Dr. John: Christ Church, Philadelphia 39, 2.1 Kensett, John F. 212; Eaton's Neck, Long Island 212, 5.56 Kerouac, Jack 360; On the Road 340 Khrushchev, Nikita 369 Kiefer, Anselm 385 Kienholz, Edward 378; The Portable War Memorial 378, 379, 8.55 King, Charles Bird 187; The Anatomy of Art Appreciation, "The Vanity of the Artist's Dream" 186–7, **5.29** King, Martin Luther, Jr. 381 King, Samuel: Portrait of the Reverend Ezra Stiles 39, 45 kivas 18-19, 1.4 Kleinweber, Yamasaki, & Hellmuth: Pruitt-Igoe Houses, St. Louis 335, 337, 8.7 Kline, Franz 353 Kneller, Sir Godfrey 101

Krasner, Lee 348; Composition 348, 8.19 Kruger, Barbara 384; Your Comfort is My Silence 384, 8.62 Ku Klux Klan 321 Kühn, Justus Engelhardt 81; Henry Darnall III 77, 80

Koons, Jeff 391; Art Magazine Ads 391, 8.69

labor relations see unions, labor La Farge, John 270; Magnolia Grandiflora 270, 6.45; Trinity Church, Boston 270, 6.44 Lafayette, Marie-Joseph, Marquis de 157,

167, 168 Lafever, Minard: design book 175, 176 Lamentation over Christ's Body (Haidt) 53,

Lamson, Joseph 72; (attrib.) gravestone of Timothy Cutler 72, 2.31 Land of the Lotus Eaters (Duncanson) 216 landscape painting 173, 189, 192, 193, 194-7, 208-9, 212, 213-15, 269 Lane, Fitz Hugh 211, 222; Boston Harbor at Sunset 211-12, 5.55 Lange, Dorothea: Southern Pacific Railroad Billboard near Los Angeles 322, 324, 7.45 Langley, Batty 85; Ancient geometry... 85; The Builder's Jewel 85; City and Country Builder's and Workman's Treasury of Designs 97, 2.17 Lapowinsa (Hesselius) 35, 36, 1.23

Last of the Buffalo, The (Bierstadt) 269, 6.43 Latrobe, Benjamin Henry: Capitol 126, 127, 4.18, 4.19; Proposal for a Washington Mausoleum 142-3, 4.34

Laudonnière. René Goulaine de 24-5: Laudonnière and the Indian Chief Athore Visit Ribaut's Column (Le Moyne de Morgues) 25-6, 1.12

Laurens, Henry 4.29 Lavender Mist (Pollock) 348, 350, 8.20 Lawrence, Jacob 326; The Migration of the Negro 331-2, 8.3

Lawson, Ernest 293 Leeds, Josiah W. 255 Leipold, Tracy: Let's Switch 389, 8.67 Le Moyne de Morgues, Jacques 24-26; Laudonnière and the Indian Chief Athore

Visit Ribaut's Column 25-6, 1.12 L'Enfant, Pierre Charles: plan of Washington 125, **4.13**

Leslie, Charles Robert: John Quincy Adams 159-60, 4.54

Let's Switch (Oursler and Leipold) 389, 8.67 Leutze, Emanuel Gottlieb: Westward the Course of Empire Takes Its Way 163, 5.1 Levittown, New York 332, 334, 8.4

Lewis, Edmonia 243; Forever Free 243-5, 6.16 Lexington, battle of 113, 115 Leyland, Frederick R. 278

Liberation of Aunt Jemima, The (Saar) 380-1, 8.58

Liberty (anon. sculpture) 115 Liberty Displaying the Arts and Sciences (Jennings) 119-20, 4.5

Lichtenstein, Roy 368-9; Drowning Girl 369, 8.44

Life magazine 356 Lin, Maya Ying: Vietnam Veterans' War Memorial 379, 8.57 Lincoln, Abraham, President 242, 243

Lissitzky, El 8.62 Liver is the Cock's Comb, The (Gorky) 344,

8.16 Llewellyn Park, Orange, NJ 178-9, 5.18,

Lloyd, Edward 95

Locke, Alain: The New Negro: An Interpretation 326 Logan, James 36

Lombardi, G. B.: Deborah 251 London 82, 121, 129; Freemasonry 83; Great Exhibition (1851) 229; Rose and Crown 101; Royal Academy of Art 37, 123, 129; Royal Society 90; Society of Antiquaries 101; Society of Artists 110; Somerset House (Chambers) 4.12

Longwood, Natchez, Mississippi (S. Sloan) 181–2, *5.23*

Lorca, Federico García 346 Louis, Morris 359; Ambi II 359, 8.31 "Louisiana Purchase" 152 Lowell, Massachusetts 173-4, 274, 5.12 Lozowick, Louis 318 "Ludlow Massacre", Colorado 293

Luks, George Benjamin 289, 293; The Spielers 289-90, 7.4

Macdonald-Wright, Stanton 307, 308, 309; Abstraction on Spectrum (Organization No. 5) 307, **7.26**

McKim, Charles Follen 229, 263, see McKim, Mead, & White

McKim, Mead, & White: Boston Public Library 268, 6.41; Casino, Newport, Rhode Island 229, 6.4; Pennsylvania Station, New York City 286-8, 7.1, 7.2

MacMonnies, Frederic: The Triumph of Columbia 6.12 Madame X (Sargent) 267-8, 6.40

Magna Britannia: her Colonies Reduc'd (Franklin) 118, 135, 4.2 Magnolia Grandiflora (La Farge) 270, 6.45 Manet, Édouard 246, 267, 274 Manhatta (Sheeler and Strand) 315 "Manifest Destiny" 200, 213

Map Rock (Native American petroglyph) 15-16, **1.1**

Marin, John 299, 300; Woolworth Building, No. 31 301, 7.18 Marinetti, Filippo Tommaso 301

Marius amid the Ruins of Carthage (Vanderlyn) 153, 154, 4.49

Mars, Venus, and Vulcan: The Forge of Vulcan (Copley) 109, 3.27

Marshall, John, Supreme Court Justice 197 Marshall Field Warehouse, Chicago (Richardson) 238, 6.10

Mary, Virgin: cult 50

Maryland 41, 43, 52, 77, 78, 79-80, 83, see also Annapolis

Mason, George 95

Mason, Captain John 31, 32 Masonic order see Freemasonry

Massachusetts 16, 29, 30-1, 42, 44, 63, 65, 97, 117, 196; Treasury Note 136, 4.27; see also Boston; Cambridge; Charlestown; Concord; Lowell

Massachusetts Bay Colony 57, 169; anniversary of founding 99, 106 Massachusetts Bay Company 30; 1.17 Masson, André 342 Mather, Increase 68

Mather, Richard: Foster's woodcut 68-9, 2.26

Matisse, Henri 293, 297, 299 Matisse (Pierre) Gallery, New York City 342 Maurer, Alfred Henry 299, 300

Mead, William Rutherford 229, see McKim, Mead, & White

Mechanical Abstraction (Schamberg) 312, 7.30

Medford, Massachusetts: Isaac Royall House 97, 3.17, 3.18

meetinghouses: Puritan 57, 63, 65, 67, 2.20, 2.21, 2.24; Quaker 39, 57-8, 2.2

Melville, Herman: Moby Dick 353 Mesa Verde, Colorado 17; Cliff Palace 18-19, 1.5

Mexican muralists 345, 346-7 Mexican War 199, 200 mezzotints 99, 105, 3.20, 3.22

Michelangelo Buonarroti 22, 285 Midnight Modern Conversation, A (Hogarth)

78, 3.2 Mies van der Rohe, Ludwig 336, 372; North Lake Shore Drive apartment houses.

Chicago 336, 8.8; Ŝeagram Building, New York City (with P. Johnson) 336, 8.9 Migration of the Negro, The (Lawrence) 331-2, 8.3

Mill Pond and Mills, Lowell, Massachusetts (Doughty) 173, 5.12

Miller, William 207 Minimalist art 361-2, 363, 365 Minute Man (French) 261, 6.33 Miró, Joan 327, 342 mission churches 46-8 "Missouri Compromise" 161 mobiles 318, 7.40 Modernist art 286, 319, 327 Mohawk Indians 34, 37, 132-3, 1.20 Monet, Claude 246, 266, 348 Money Diggers (Quidor) 174, 5.15 Monk's Mound, Cahokia, Illinois 19-20, 1.6 Monroe, James, President 161 Monroe, Marilyn: Marilyn Monroe's Lips (Warhol) 371, 8.46 Monticello, nr. Charlottesville, Virginia (Jefferson) 125-6, 4.16 Moral Committee of One Hundred 254-5 Moravian Church 36, 52-4 Morgan, John Pierpont 228 Mormons 207-8 Morris, Robert: I-Box 363, 8.37 Morris, Robert Hunter 85 Morse, Samuel F.B. 157, 160, 161, 187-8, 190, 208-9, 221-2; Chapel of the Virgin at Subiaco 189, 5.32; The Old House of Representatives 160-1, 4.53 Motherwell, Robert 345, 355; At Five in the Afternoon 346, 8.17 Motion Study: George Reynolds Nude, Pole-vaulting (Eakins) 256-7, 6.29 Motorcycle Accident (Hanson) 371-2, 8.48 Mount, William Sidney 165, 166-7; Farmers Nooning 165-6, 5.2; The Painter's Triumph 166, 5.4 Mount Auburn Cemetery, Cambridge, MA, 182, 184, 222, 5,24, 5,25, 5,27 Mountains and Sea (Frankenthaler) 357, 359,

8.30 Mr. Neilson's Anger Restrained by Philosophy (Hamilton) 82, 3.5 mug, pearlware (anon.) 133, 4.24 multinational corporations 329 Mumford, Lewis 321 Muybridge, Eadweard 256; Twisting Summersault 6.28 My Lai massacre 378-9 Nadelman, Elie 319; Tango 319, 7.41

Namuth, Hans: Jackson Pollock 8.21 Napalm (Golub) 378 Napoleon Bonaparte 152, 153, 156 Narragansetts, the 31, 32 Natchez, Mississippi: Longwood (S. Sloan) 181-2, 5.23 National Academy of Design 157, 161, 185, 187, 189, 196, 205, 234-5, 254, 269-70, 289, 6.6 National Endowment for the Arts 330, 388

National Organization for Women (NOW)

National Liberal League 254

Native Americans: ancestry 14-15; and Anglo-French rivalry 32-3, 37, 116; artifacts 21; and disease 30, 31, 49; earthworks and burial mounds 19-21; and European settlers 14, 16-17, 22-32, 49; expulsion from lands 197; hide painting 343; mapping 15-16; and Moravians 36, 52; portraits 33-6, 198-9; pueblo architecture 17-19; sandpainting 348, 350; and the Spanish 45-52; white colonists as 36-7; wigwams 16

Nauman, Bruce: Self-Portrait as a Fountain 360, 8.34

Nauvoo, Illinois 207, 208 Navajo sandpainting 348, 350 Nazareth, Pennsylvania 53, 2.12 Neo-Expressionism 385-6 Nevelson, Louise 353-4, 362; Sky Cathedral 354, 8.26 "New Deal", the 321, 322, 329 New England 29-32, 42, 1.15; "spirit stones" 43-4; see also Puritans New Hampshire 42, 279; see also Portsmouth New Jersey see Orange; Paterson; Stony Brook New Mexico 188, 199; mission churches 46-8 New York (Storrs) 318, 7.39 New York (Walkowitz) 309, 7.27 New York (Weber) 300, 7.16 New York City 83, 115, 174, 233, 330; American Academy of the Fine Arts 149, 185; Art of the Century Gallery 342-3; Brooklyn Bridge (Roebling) 235, 6.7; Chrysler Building (Van Alen) 313-14, 7.32: Empire State Building 314; and Erie Canal 161, 171, 185; Farragut Memorial (Saint-Gaudens) 261-2, 6.34; Federal Hall 126, 4.15; Gilbert Elevated Railroad station (Cropsey) 210, 5.54; Guggenheim Museum (F. L. Wright) 374, 375, 8.51; Sidney Janis Gallery 368; Macbeth Gallery 293, 294, 295; Pierre Matisse Gallery 342; Metropolitan Museum of Art 227: Museum of Modern Art 355: National Academy of Design (P. B. Wright) 234-5, 6.6, see also National Academy of Design; Pennsylvania Station (McKim, Mead, & White) 286-8, 7.1, 7.2; population 77, 178; Public Library 325, 326, **7.49**; Realist painters 289–90, 292; Seagram Building (Mies van der Rohe and P. Johnson) 336, **8.9**; Stadt Huys (New Amsterdam) 95, **3.14**; Studio Building, West Tenth St. (Hunt) 233, 280, 6.5; Tribune Building (Hunt) 236, **6.8**; 291 Gallery 295, 297, 298, 306, 309, 310, 319; Woolworth Building 301, 7.18, 7.19 New York Daily Tribune 205 New York Evening Post 193 New York Globe 294, 305 New York State 41; Levittown 332, 334, 8.4;

see also Albany; Rochester New York Weekly Tribune 246

New Yorker magazine 346 Newbury, Massachusetts: boundary marker

44, 2.4 Newman, Barnett 343, 350-1, 356, 357, 381; Onement 1 351, 8.22

Newport, Rhode Island 87; Casino (McKim, Mead, & White) 229, 6.4; Touro Synagogue (Harrison) 73-5, 2.32, 2.33

newspapers, journals, and magazines 118, 119, 185, 191, 192, 193, 200-1, 205, 222, 239, 246, 273–4, 289, 294, 297, 305, 308, 314, 345, 346, 356, 357

Newton, Sir Isaac 74, 85; The Chronology of Ancient Kingdoms Amended 86-7

Niagara (Inness) 271, 6.46

Niagara Falls 192, 214

Niagara Falls (Church) 213-14, 271, 5.57 Nicholls, Edward W.: Llewellyn Park house 178, 5.17

Nighthawks (Hopper) 338, 8.10 Nixon, Richard 368, 369

Noble, Thomas Satterwhite 245; The Price of Blood 245, 6.17

Nocturne in Black and Gold (Whistler) 276-7,

Noland, Kenneth 359, 361 North Carolina 16, 26-7, 41, 52, 80, 83, 90-1, 92; see also Asheville Nova Reperta (Stradanus) 22-24, 1.10, 1.11 NOW see National Organization for Women Nude Descending a Staircase, No. 2 (Duchamp) 304, 7.21 Number 1 (Pollock) 348, 350, 8.20

occult, the 43-5, see also Freemasonry

Octopus, The (Coburn) 300, 7.17 Office of War Information (OWI) 331 Ohio: burial mounds and artifacts 20-1, 1.7, 1.8; see also Cincinnati Ohio and Mississippi Railroad 208 O'Keeffe, Georgia 316, 381; City Night 316, 317, 7.36 Old House of Representatives, The (Morse) 160-1, 4.53 Old Ship Meetinghouse, Hingham, Mass. 63, 65, 2.20, 2.21 Oldenburg, Claes 373 Oliver, Daniel, Peter, and Andrew: portrait (Smibert) 106-7, 3.24 Olmsted, Frederic Law: lagoon 6.12 Olson, Charles 359 On the Antietam Battlefield (Brady) 223-4, 5.65 Oñate, Juan de 47 one-artist exhibitions 330 Onement 1 (Newman) 351, 8.22 Op Art 386-7 Orange, New Jersey: Llewellyn Park 178-9, 5.18, 5.19; Edward W. Nicholls House (Davis) 178, 5.17 Orange Disaster (Warhol) 371, 8.47 Organization No. 5 (Macdonald-Wright) 307, 7.26 Orpheus (Crawford) 164-5, 5.3

Orphism 7.26 Osgood, Reverend Samuel 212 O'Sullivan, Timothy: Ancient Ruins in the Canvon de Chelly, New Mexico 18, 1.3; see also Gardner, Alexander "Ould Virginia" (Vaughan) 28-9, 1.14 Oursler, Tony: Let's Switch 389, 8.67 Oxbow, The (Cole) 196-7, 5.39

Pagosa Springs (F. Stella) 361-2, 8.35 Paik, Nam June 389 Painter's Triumph, The (Mount) 166, 5.4 Palladianism 93, 95-7, 2.1 Palladio, Andrea 93 Panama Canal 227, 288 Panorama of the Mississippi River (Banvard) Paris 265-7; Exposition Universelle (1867)

Parris, Alexander: Quincy Market, Boston

167, 192, 5.5 Parson Capen House, Topsfield, Massachusetts 65, 2.22, 2.23

Partisan Review (journal) 345 Passe, Simon van de: map of New England

29, 1.15; Pocahontas 29-30, 1.16 Pater, Walter 274

Paterson, New Jersey: strike and pageant 304, 305-6, 7.23

Paul, Jeremiah: Evangelist Campmeeting 194,

Peabody, Elizabeth Palmer 243 Peacock Room, The (Whistler) 277-8, 280, 6.51

Peale, Charles Willson 117, 138, 143, 145-6, 147-8, 149, **4.45**; The Artist in his Museum 148, 4.43; Benjamin Franklin 146-7, 4.41; William Smith and His Grandson 145, 4.40 Peale, Raphaelle: Still Life with Raisins, Yellow and Red Apples in Porcelain Basket 186,

5.30 Peale, Rembrandt 117, 149; The Court of Death 150, 161, 4.46; The Roman Daughter

Potwine, John: silver flagon 62, 2.19

149-50, 4.45 Powers, Hiram 180; Daniel Webster 180-1. Ribaut, Captain Jean 25, 26 Pelham, Henry 133; portrait (Boy with a 5.21; The Greek Slave 217-19, 5.61 Richards, John: Watertown, Wisconsin 181, Squirrel) (Copley) 110, 112, 3.28 Powhatan, Chief 16, 28-9 Pelham, Peter 109, 3.29; The Reverend Pratt, Matthew: The American School 130, Richardson, Henry Hobson 240: Marshall Benjamin Colman 105-6, 3.22 Field Warehouse, Chicago 238, 6.10; Penn, John 35, 36 Precisionism 316, 318, 321 Trinity Church, Boston 270, 6.44 Penn, William 35, 36, 42, 58; The Great Case Rifle Gap, Colorado: Valley Curtain (Christo Prendergast, Maurice 293-4; St. Malo Beach of Liberty of Conscience 42 294, 7.9 and Jeanne-Claude) 377, 8.53 Pennell, Joseph 264-5 Presbyterians 270 'Right" Situation, The (J. Williams) 122, 4.9 Pennsylvania 35, 42, 57, 209-10; Moravians Price of Blood, The (Noble) 245, 6.17 Riis, Jacob August 296 36, 52-4; see also Bear Run; Philadelphia Prince, Richard: Untitled (Three Women Rinehart, William Henry: Sleeping Children Pennsylvania Academy of the Fine Arts 149. Looking in the Same Direction) 382, 384, 183-4, 5.26 172, 250-1, 253, 254, 255, 258, 264-5, Rivera, Diego 345 289, 6.23 Proctor & Gamble: poster 258, 6.31 Roanoke Island, N. Carolina 26-7 Progress (Durand) 208–9, 212, 5.52 Pennsylvania Excavation (Bellows) 288-9, 7.3 Rochester, New York 175, 189; Pennsylvania Station, New York City Campbell-Whittlesey House 175, 5.14 Progress of Civilization, The (Crawford) (McKim, Mead, & White) 286-8, 7.1, 7.2 200-1, 5.47 Rockefeller, John D. 227, 293, 319 People's Art Guild 309, 320 Protestants 39, 41-42, 54, 69, 71-2, 86, Rodin, Auguste 297 Pequots, massacre of the 31-2, 1.18 188-189, 197, 319-20; see also Anglican Roebling, John Augustus, and Roebling, Perry, Commodore Matthew C. 227 Church; Calvinism; Congregationalists; Washington Augustus: Brooklyn Bridge Phi Beta Kappa Society 160 Moravian Church; Puritans Philadelphia, Pennsylvania 35, 39, 42, 77, psychoanalytical theories 341, 342, 347 Rogers, John 241-2; The Fugitive's Story 242, 107, 254; art academy 143-4, see also pueblo architecture 17-19, 1.2 6.15 Pennsylvania Academy of Fine Arts: Pueblo Revolt (1680) 48-50 Rohrabacher, Dana 388 Centennial Exposition (1876) 229, 251-2; pulpits, 18th-century 61, 2.17 Rolfe, John 29 Christ Church (Kearsley) 39, 2.1; Eastern punch bowls, ceramic 78, 3.2 Roman Daughter, The (Rembrandt Peale) Penitentiary (Haviland) 170, 5.7, 5.8; Puritans 30-2, 41, 42, 57, 58, 63, 65, 68, 149-50, 4.45 Freemasons 83, 85, 108; Governor's Club Roosevelt, Franklin D., President 324, 331; 105 82; Guild House (Venturi-Rauch) 372. "New Deal" 321, 322, 329 373, 8.49; museums 147-9, 228, 4.42 Quakers 39, 42, 57-8, 130 Roosevelt, Theodore, President 292 Philips, Richard: Governor Jonathan Belcher Quebec, battle of (1759) 116, 130-3 Root, John Wellborn 240; Masonic Temple, 99, 3.20 Quidor, John 174-5, 180; Money Diggers 174, Chicago 260, 6.32 photography: 19th-century 18, 220-5, 5.15 Rosenberg, Harold 350, 353, 357 255-7; 20th-century 189, 295-8, 300, Quincy, Josiah (father) 169 Rotary Glass Plates (Duchamp) 318 310, 322-3, 330, 338, 340, 382, 384, 387 Quincy, Josiah 168; portrait (Stuart) 168-9, Rothko, Mark 340, 342, 343, 351, 355, 356, Phrenological Head (Ames) 180, 5.20 357; Antigone 340-1, **8.13**; Green and phrenology 180, 211 Quincy, Samuel 109, 110, 168 Maroon 351, 8.23 Picabia, Francis 310, 7.30 Quincy, Mrs. Samuel (née Hannah Hill): Rousseau, Théodore 271 Picasso, Pablo 298, 299, 303, 307, 355, 356, portrait (Copley) 109-10, 3.26 Royal Academy of Art, London 37, 123, 129 357; Drawing 298, 7.14 Royal Society, London 90 Pictorialist photography 295, 297, 387, 7.10 railroads 163, 177, 197, 208, 209-10, 227, Royall, Isaac 97; Isaac Royall and His Family Pietism 52 231, 5.54 (Feke) 97–98, 3.19; Isaac Royall House, Pilgrims 30, 42 Raleigh, Sir Walter 26 Medford, Massachusetts 97, 3.17, 3.18 Pitt, William, Earl of Chatham: wax effigy Ramirez, Fr. Juan 48 Rubens, Peter Paul 109, 285; Jonah and the (Wright) 121, 4.7 Rauch, John: Guild House, Philadelphia Whale 4.26 plantations 52, 79-80, 92-3, 176-7 372, 373, 8.49 Rude Descending the Staircase, The (Griswold) Plymouth, Massachusetts 30 Rauschenberg, Robert 359, 360, 361; Bed 304, 7.22 360-1, 8.32; White Painting 359, 360 Pocahontas 29, 30, 200, 5.46; portrait Rush, Benjamin 171 29-30, 1.16 Ray, Man 311 Rush, William 253, 254; William Rush Poincaré, Henri 285 Carving His Allegorical Figure of the Reading from Left to Right (R. Soyer) 324, Pollock, Jackson 346, 347, 348, 355, 356, 7.51 Schuylkill River (Eakins) 253-4, 6.25; The 357, 359, 8.21; Guardians of the Secret Reading "Le Figaro" (Cassatt) 267, 275, 6.39 Schuykill Enchained 172, 5.10; The 347-8, 8.18; Lavender Mist (Number 1) Schuykill Freed 172, 5.11; Wisdom 119, 4.4 readymades 311, 312, 329 348, 350, 8.20 Realist painters: New York 289-90, 292; Ruskin, John 232, 235, 276 Poor, Salem 141 see also Social Realism Russell, Morgan 307, 308; Cosmic Synchromy Pop Art 329, 367-71, 372, 386 Reed, John 305 285, 307 Popé (Indian leader) 48-49 Reed, Luman 197, 205 Ryder, Albert Pinkham 272, 273-4; The Dead pornography 388 Reformation, Protestant 39 Bird (The Dead Canary) 272, 6.47; Jonah Portable War Memorial, The (Kienholz) 378, Regionalism 319-22, 324, 340 273, 274, 6.48 379, 8.55 Reinhardt, Ad 355-6, 360; Abstract Painting Portrait of the Artist's Mother (Whistler) 275, No. 5 356, 8.28 Saar, Betye: The Liberation of Aunt Jemima 6.49 Religious Union of Associationists 211 380-1, 8.58 Portrait of a German Officer (Hartley) 306, Rembrandt van Rijn: The Anatomy Lesson of Saint-Gaudens, Augustus 270, 279; The 362, 7.25 Dr. Nicolas Tulp 2.27 Admiral David Farragut Memorial 261-2, Portrait of Andy Warhol (Schnabel) 386, 8.64 Renaissance, The 22, 86, 123, 127, 285 6.34; The Robert Gould Shaw Memorial portraits: of Native Americans 33-6, 198-9; Renoir, Pierre Auguste 246, 266 262-4, 6.35 17th-century 68–71; 18th-century 39, 80, Rescue (Greenough) 201, 203, 5.48 St. James's Church, Goose Creek, S. Carolina Resignation of General Washington, The 81, 97-8, 99-108, 109-10, 112-13, 137, 61-3, 65, **2.18** 142–7; 19th-century 160, 168, 190, 264, 267–8, 275, 279–80; 20th-century 289, (Trumbull) 144-5, 4.37 St. John in the Wilderness (Cole) 194-5, 5.38 Revere, Paul 116, 124, 134; The Able Doctor, St. Louis, Missouri: Pruitt-Igoe Houses 352, 386; see also photography; sculpture or America Swallowing the Bitter Draught (Kleinweber, Yamasaki, & Hellmuth) 335, Portsmouth, New Hampshire: 118-19, 4.3; The Bloody Massacre 133, 337, 8.7; Wainwright Building (Sullivan) Macphreadis-Warner House (murals) 136, 4.25; Masonic lodge notification 236-8.6.9 33-4, 35, **1.21** 112, 113, 124, 3.30; portrait (Copley) St. Luke's Church, Isle of Wight, Virginia Post-Impressionists 293, 294 112-13, 3.29 59-61, 2.14, 2.15 Postmodernism 329-30, 381, 382, 386-7, Reynolds, Sir Joshua 110, 122, 123, 130-1, St. Malo Beach (Prendergast) 294, 7.9

Rhode Island 42, 57; see also Newport

Sale of Circassian Captives in a Turkish

Bashaw (Allan) 218

sampler, Quaker 58, 2.16 San Antonio, Texas: San José y San Miguel de Aguayo (portal sculptures) 50, 2.10 San Estevan, Acoma, New Mexico 46-8, sandpainting, Navajo 348, 350 Santa Fe, New Mexico 50–1 Santa Monica, California: Santa Monica Place (Gehry) 334, 8.6 Santo Entierro, El (García) 51, 2.11 Sargent, John Singer 267; Frieze of the Prophets 268, 6.42; Madame X 267-8, 6.40 Sartre, Jean-Paul 350 Savage Chief, The (West) 37, 1.24 Schaack, Peter van 56 Schamberg, Morton Livingston 312, 316; God 311, 312, 7.29; Mechanical Abstraction 312. 7.30 Schapiro, Meyer 345 Schnabel, Julian 385-6; Portrait of Andy Warhol 386, 8.64 Schott, Gerhard 3.7 Schuykill Enchained, The (W. Rush) 172, 5.10 Schuykill Freed, The (W. Rush) 172, 5.11 science, 20th-century 285 Scots Charitable Society 101 sculpture: African-American 43; early Spanish 49; 18th-century 115, 117, 119; 19th-century 119, 143-5, 162, 163, 164-5, 172, 174, 180-3, 200-1, 217-20, 241-4, 253-4; 20th-century 316, 317-18, 319, 354, 363, 365, 371-2; see also Apollo Belvedere; war memorials; wax sculptures Sea Captains Carousing in Surinam (Greenwood) 78, 3.1 Seagram Building, New York City (Mies van der Rohe and P. Johnson) 336, 8.9 Seated Woman (Archipenko) 316, 7.37 Seattle, Washington: Northgate Regional Shopping Center (Graham) 334, 8.5 Secoton, North Carolina 13, 16, 27 Self-Portrait (T. Smith) 69-71, 2.28 Self-Portrait as a Fountain (Nauman) 360, Self-Portrait with Palette and Brush (Steichen) 295, 7.10 Seven Years' War (1756-63) 116, 119, 130-3 Severini, Gino 301 Seward, William H. 227 Shahn, Ben 322, 331, 356; poster 331, 8.2; Sheriff During Strike, Morgantown, West Virginia 322-3, 7.46 Shake Hands? (Spencer) 190-1, 5.35 Shapolosky et al. Manhattan Real Estate Holdings (Haacke) 375, 8.52 Shaw, Chief Justice Lemuel: portrait (Southworth and Hawes) 222, 5.64 Shaw Memorial, Boston (Saint-Gaudens) 262-4, 6.35 Shays's Rebellion 117 Sheeler, Charles 315; Classic Landscape 315–16, 7.35; Criss-Crossed Conveyors, Ford Plant 315, 7.34; (with Strand) Manhatta 315 Sheriff During Strike, Morgantown, West Virginia (Shahn) 322-3, 7.46 Sherman, Cindy 382; Untitled Film Still no. 3 382, 8.60 Shinn, Everett 289, 293 Shippen, Colonel Joseph 37 silverwork: flagon 62, 2.19; vase 171-2, 5.9 Simon, John: Etow Oh Koam, King of the River Nation 33-34, 1.19; Ho Nee Yeath Taw No Row, King of the Generethgarich 33-34, 1.20

Salem, Massachusetts: witch-hunting 44

Salem, Peter 141

Salmon, Robert 192

Siqueiros, David Alfaro 346-7 Sky Cathedral (Nevelson) 354, 8.26 skyscrapers 230, 236-9, 240, 260, 317-18, 336-7 slaves, African 43, 52, 77, 79, 80, 92-3, 321; abolition movement 166, 205-6, 216-17, 218, 219, 242, 245 Sleeping Children (Rinehart) 183-4, 5.26 Sloan, John 289, 292, 293, 305-6, 308; Class War in Colorado 293, 7.8; Hairdresser's Window 292, 7.7 Sloan, Samuel: Longwood, Natchez, Mississippi 181-2, 5.23 Small, Colonel John 140 Smibert, John 98, 101, 104-5, 109; Jonathan Belcher 104: The Bermuda Group 101-4, 3.21; William Browne 104, 3.23; The Reverend Benjamin Colman 105, 3.22; Daniel, Peter, and Andrew Oliver 106-7, 3.24 Smith, David 354; The Hero 354, 8.27 Smith, Captain John 28, 29, 30; The Generall Historie of Virginia... 28, 29, 1.14, 1.15 Smith, John Rubens: View of the East Front of the Capitol 4.17 Smith, Joseph 207, 208 Smith, Kate 378 Smith, Pamela Colman 295 Smith, Captain Thomas 69; Self-Portrait 69-71, **2.28** Smith, Tony 363, 365; Die 365, 8.38 Smith, Reverend William 129 Smith, William: portrait (C. Peale) 145, 4.40 Smithfield, Isle of Wight County, Virginia: St. Luke's Church 59-61, 2.14, 2.15 Smithson, Robert 375; Spiral Jetty 376-7, Snap the Whip (Homer) 246-7, 6.20 Social Realism 324, 327, 340, 337-8, 340 Société Anonyme 318 Society for the Propagation of the Gospel (SPG) 61, 62 Society of American Artists 269, 270, 272, 281 Society of the Cincinnati 144, 6.35 Society of Independent Artists: 1917 Exhibition 310 Solomon's Temple see Jerusalem Somerset House, London (Chambers) 4.12 Song of the Towers (Douglas) 325, 7.49 Sontag, Susan 356 Sorcerer, The (White) 27, 29, 1.13 South Carolina 16, 25, 41, 43; see also Charleston; Goose Creek Southern Pacific Railroad Billboard near Los Angeles (Lange) 322, 324, 7.45 Southworth, Albert Sands (and Josiah Johnson Hawes): Lemuel Shaw 222, 5.64; Mount Auburn Cemetery 184, 5.27 Sover, Moses: Artists on WPA 324, 7.48 Soyer, Raphael: Reading from Left to Right 324, 7.51 Spanish, the: explorers and conquistadores 26, 40, 47-8; missionaries and settlers 45-52 Spanish-American War (1898) 227 Spanish Civil War 345–6 Spencer, Lilly Martin 190, 191; Shake Hands? 190-1, 5.35 Spero, Nancy 8.56 SPG see Society for the Propagation of the Gospel Spielers, The (Luks) 289-90, 7.4 Spiral Jetty (Smithson) 376-7, 8.54 Spiritualists 211, 212, 217, 218, 220, 276 Spiro Site, Oklahoma: gorget 21, 1.9 Spring Showers (Stieglitz) 298, 387, 7.13

Stalin, Joseph 327, 331, 345

Stamp Act (1765) 115–16 Starrucca Viaduct, Pennsylvania (Cropsey) 209-10, 5.53 Steel Magnesium Plain (Andre) 365, 8.40 Steerage, The (Stieglitz) 296–8, 387, **7.12** Steichen, Edward 295, 297, 299; Self-Portrait with Palette and Brush 295, 7.10 Steiner, Rudolf 318 Stella, Frank 361; Pagosa Springs 361-2, 8.35 Stella, Joseph 301, 309; Battle of Lights, Coney Island, Mardi Gras 301, 7.20 Stern, Robert A.M. 390 Stevens, John, II 73; (attrib.) gravestone of Rebecca Polock 73, 2.32 Stickley, Gustav 292 Stieglitz, Alfred 295, 297, 298-9, 300, 308, 316; Duchamp's Fountain 311, 7.28; Spring Showers 298, 387, 7.13; The Steerage 296–8, 387, **7.12**; 291 Gallery, New York City 295, 297, 298, 306, 309, 310, 319 Stiles, Reverend Ezra 44-5, 85; portrait (S. King) 39, 45 Still, Clyfford 367 Still Life with Raisins, Yellow and Red Apples in Porcelain Basket (Raphaelle Peale) 186, Stony Brook, New Jersey: Quaker Meetinghouse 39, 57, 2.2 Storrs, John 317-18; New York 318, 7.39 Story, William Wetmore: Jerusalem 251, 6.24 Stowe, Harriet Beecher: Uncle Tom's Cabin Stradanus, Johannes (Jan van der Straet): Nova Reperta 22-24, 1.10, 1.11 Stuart, Gilbert 117, 146, 157; George Washington 144, 4.36 ("Vaughan"), 144, 4.38 ("Lansdowne"); Portrait of Josiah Quincy 168-9, 5.6 suburban development 164, 181, 332, 334 Subway, The (Tooker) 338, 8.11 Sullivan, Louis 236, 239, 240, 260; Wainwright Building, St. Louis, Missouri 236-8, 6.9 Summer Evening (Dewing) 279, 6.53 Super Realism 371-2 Surrealism 327, 342-3, 344-5, 346, 355 Swedenborg, Emanuel 218, 271; Heaven and its Wonders... 240 Swedenborgian Church 218, 240 Swimming Hole, The (Eakins) 255-6, 258, 6.26, 6.27 Symbolist painting 7.10 Synchromism 285, 307, 320 Talbot, William Henry Fox 222 Tango (Nadelman) 319, 7.41 Tanner, Henry Ossawa 264–5; The Banjo Lesson 265, 6.37; portrait (Eakins) 264, 6.36 Taos, New Mexico: pueblo 17, 1.2 Tardieu, Nicolas-Henry 3.27 Target with Plaster Casts (Johns) 361, 362-3, 8.36 Tatlin, Vladimir 318 Taylor, Frederick: Principles of Scientific Management 314 "Ten, The"/"Ten American Painters" 281, 282 Theater Piece #1 (Cage) 359 Three Women Looking in the Same Direction (Prince) 382, 384, 8.61 Tishcohan (Hesselius) 35, 36, 1.22

Tooker, George 338; The Subway 338, 8.11

Touro Synagogue, Newport, Rhode Island (Harrison) 73–5, 2.32, 2.33

Topsfield, Massachusetts: Parson Capen

House 65, 2.22, 2.23

Townshend Acts (1767) 116

Tragic Figure in Chains (Allston) 152, 4.48 Transcendentalists 210-11, 212 Tribune Building, New York City (Hunt) 236, 6.8 Tricky Cad series ("Jess") 367-8, 8.43 Truisms (Holzer) 384-5, 8.63 Truman, Harry, President 350 Trumbull, John 117, 138, 193; The Death of General Joseph Warren at the Battle of Bunker's Hill 140-1, 4.30; The Declaration of Independence 141-2, 4.31; General George Washington at the Battle of Trenton 142, 4.32; The Resignation of General Washington 144-5, 4.37; View of the Falls of Niagara From Under Table Rock 192, 5.36

Tuckerman, Henry: Book of the Artists... 233, 234, 242, 244

Tuesday Club, Annapolis, Maryland 82, 83, 95, 3.5

Twachtman, John Henry 281; Arques-la-Bataille 6.54

Twelves, Robert: Old South Meetinghouse, Boston 65, 67, 2.24

Twisting Summersault (Muybridge) 256, 6.28 Two "Sun Gems" and a "Crimson Topaz" (Heade) 215, 5.59

Uncle Tom and Little Eva (Duncanson) 216–17, 5.60 Underhill, Captain John 31–2; Indian Fort 31, 32, 1.18

unions, labor 231, 232, 292–3, 326, 331 Unitarian Church 206, 208, 210 Universe, A (Calder) 318, 7.40 Unitiled (Gober) 387–8, 8.66 Untilled (Hesse) 365, 8.42 Untilled (Irwin) 365, 8.41

Untitled (Judd) 365, **8.39** Untitled (Prince) 382, 384, **8.61**

Untitled Film Still no. 3 (Sherman) 382, 8.60 uroboros 136, 377, 4.27 U.S. 285, New Mexico (Frank) 338, 8.12

Valley Curtain (Christo and Jeanne-Claude) 377, 8.53

377, **8.53** Van Alen, William: Chrysler Building, New York City 313–14, **7.32**

Van Bruggen, Coosje 373 Vanderbilt, Cornelius 227, 228

Vanderbilt, George Washington 228 Vanderbilt, William H.: Fifth Avenue

Vanderbilt, William H.: Fifth Avenue mansion, New York City 228–9, 6.3 Vanderlyn, John 117, 149, 150, 152; Ariadne Asleep on the Island of Naxos 153–4, 4.50;

The Death of Jane McCrea 150, 152, 4.47; Marius amid the Ruins of Carthage 153, 154, 4.49

Vanity Fair 314

Vaughan, Robert: "Ould Virginia" 28–9, 1.14

Venice, California: Chiat Day Mojo Offices (Gehry) 373, **8.50**

Venturi, Robert 372; Guild House, Philadelphia 372, 373, **8.49**

Verelst, John: Etow Oh Koam, King of the River Nation 33–4, 1.19; Ho Nee Yeath Taw No Row, King of the Generethgarich 33–4, 1.20

Vespucci, Amerigo 14; Mundus Novus 24; Amerigo Vespucci Awakens a Sleeping America (Stradanus) 23–4, 1.11

Veteran in a New Field, The (Homer) 245–6, 261, 6.18

video art 389

Vietnam series (Golub) 378–9, **8.56** Vietnam Veterans' War Memorial, Washington, DC (Lin) 379, **8.57** Vietnam War 377–9

View from Mount Holyoke, Massachusetts (Cole) 196–7, 5.39

View of the Falls of Niagara From Under Table Rock (Trumbull) 192, 5.36

Viola, Bill 389

Virginia 27–9, 41, 43, 44, 77, 78–9, 90, 91–3, 124, 257, 322–3, 1.14; Anglican Church 59–61, 2.14, 2.15; University (Jefferson) 149, 4.44; see also Charles City County; Charlottesville; Williamsburg

Wainwright, John 101, 102, 104 Wainwright Building, St. Louis (Sullivan) 236–8, *6.9*

Waldseemüller, Martin 14 Walkowitz, Abraham 309; *New York 7.27* Walter, Thomas Ustick: U.S Capitol, Washington, DC 199–200, *5.44*

Wanton, Jonas 3.1

WAR see Women Artists in Revolution war memorials 260–4, 379, 6.33–6.35, 8.57 War News from Mexico (Woodville) 185, 267, 5.28

Warhol, Andy 369, 370–1; Campbell's Soup Cans 369–70, **8.45**; Disasters series 371, **8.47**; Marilyn Monroe's Lips 371, **8.46**; portrait (Schnabel) 386, **8.64**

Warren, General Joseph 140, 4.30 Warriors (Hartley) 306, 311, 7.24

wars see American Civil War; American Revolution; American War for Independence, Second; English Civil War; Mexican War; Spanish-American War Spanish Civil War; Vietnam War; World War I; World War II

Washington, DC 285; The Capitol 117, 125, 126, 127, 141, 158, 160–1, 199–201, 203, 4.17–4.19, 4.53, 5.44, 5.47, 5.48; plan of city (L'Enfant) 125, 4.13; Vietnam Veterans' War Memorial (Lin) 379, 8.57

Washington, George 117, 123, 124, 125, 138, 167; portraits 142, 4.32 (Trumbull), 144, 4.36, 4.38 (Stuart); Proposal for Mausoleum (Latrobe) 142–3, 4.34; The Resignation of General Washington (Trumbull) 144–5, 4.37; statues 143, 144, 4.35 (Greenough), 145, 4.39 (Houdon) Washington Arch, Spring (Hassam) 282, 6.56 Watertown, Wisconsin (Richards) 181, 5.22

Watson, Elkanah 137; portrait (Copley) 137, 4.28 Watson and the Shark (Copley) 134–7, 388,

4.26 wax sculptures 121–2, 4.7 (P. Wright),

387–8, *8.66* (Gober)

Weber, Max 299–300; Composition with Three Figures 299, 7.15; New York 300, 7.16 Webster, Daniel: portrait bust (Powers) 180–1, 5.21

Weir, Robert W.: Embarkation of the Pilgrims at Delft Haven, Holland 200, 5.45

West, Benjamin 36–7, 117, 122, 129–30, 138, 144, 152, 175; American Commissioners of the Preliminary Peace Negotiations with Great Britain 138, 4.29; The Death of General Wolfe 116, 130–3, 4.21; The Departure of Regulus from Rome 130, 4.22; "Join or Die" 133, 4.23; The Savage Chief (The Indian Family) 37, 1.24

Weston, Edward 323; Dante's View, Death Valley 323, 7.47

Westover, Charles City County, Virginia 91–2, 3.10, 3.11 Westward the Course of Empire Takes Its Way

(Leutze) 163, 5.1 Wharton, Edith: *The House of Mirth* 232 Whistler, James Abbott McNeill 274, 276, 289; Arrangement in Gray and Black (Portrait of the Artist's Mother) 275, **6.49**; Harmony in Blue and Gold: The Peacock Room 277–8, 280, 6.51; Nocturne in Black and Gold (The Falling Rocket) 276–7, **6.50**; portrait (Chase) 279–80, **6.52**

White, John 16–17, 26–7; *The Flyer or Sorcerer* 27, 29, **1.13**; *Indian Village of Secoton* 13, 16, 27, 28–9

White, Stanford 229, see McKim, Mead, & White

"White City" (Burnham) 239–40, 282, 286, 301, 6.11

White Painting (Rauschenberg) 359, 360 Whitfield, Nathan Bryan 176 Whittier, John Greenleaf 242 Wilde, Oscar 274–5, 279

Willard, Samuel 54 Willard, Solomon 167

William III (of Orange), and Mary II 58, 83 Williams, John: *The "Right" Situation* 122, 4.9

Williams, Roger 42 Williams, William 129; *Deborah Hall* 107–8, 3.25

Williamsburg, Virginia 319; Wren Building 86, **3.6**

Willitts House, Highland Park, Illinois (F.L. Wright) 240–1, *6.14* Winthrop, John 57, 69

Wisconsin: Watertown (Richards) 181, 5.22 Wisdom (W. Rush) 119, 4.4

witchcraft 44

Woman I (W. de Kooning) 329, 351–2, women 44, 117, 120, 173–4, 185, 190, 218–19, 231, 293; African-American 243, 353–4, 380–1; artists 121–2, 190–1, 219–20, 243–4, 258, 266–7, 316, 353–4, 355, 362, 379, 380–2, 384–5; Quaker 58

Women Artists in Revolution (WAR) 380 Wood, Grant: American Gothic 321–2, **7.44** Woodville, Richard Caton 185; War News from Mexico 185, 267, **5.28**

Woolworth Building, New York City (Gilbert) 301, 7.19; Woolworth Building, No. 31 (Marin) 301, 7.18

Works Progress Administration (WPA) 324, 331

World War I 227, 306, 311, 344 World War II 327, 329, 331–2, 340, 350, 367 World's Columbian Exposition, Chicago (1893) 239–40, 241, 282, 286, 301, 6.11, 6.12

Wren, Sir Christopher 61, 86, 91, 97, 98, 2.1, 3.10

Wren Building, Williamsburg, Virginia 86, 3.6

Wright, Frank Lloyd 240, 316–17, 373–4; Fallingwater (The Kaufmann House) 317, 7.38; Guggenheim Museum 374, 375, 8.51; Prairie homes 240–1, 6.14

Wright, Patience 117, 121, 122, 4.9; William Pitt, Earl of Chatham 121, 4.7; portrait (Downman) 122, 4.8

Wright, Peter B. 235; National Academy of Design, New York City 234–5, **6.6** Wright, Willard Huntington 307

Young, Brigham 208 Young Men's Christian Association 254 Your Comfort is My Silence (Kruger) 384, **8.62**

Zenobia (Hosmer) 219, 5.62 Zuni, the 17 Zwingli, Ulrich 41